A Choice Collection

Seventeenth-Century

Dutch Paintings

from the Frits Lugt

Collection

by Quentin Buvelot and Hans Buijs

with an introductory essay by Ella Reitsma

Royal Cabinet of Paintings Mauritshuis, The Hague

Waanders Publishers, Zwolle

The exhibition in The Hague was sponsored by
Oranje-Nassau Groep
Friends of the Mauritshuis Foundation

This publication was made possible by
M.A.O.C. Gravin van Bylandt Foundation

A Choice Collection

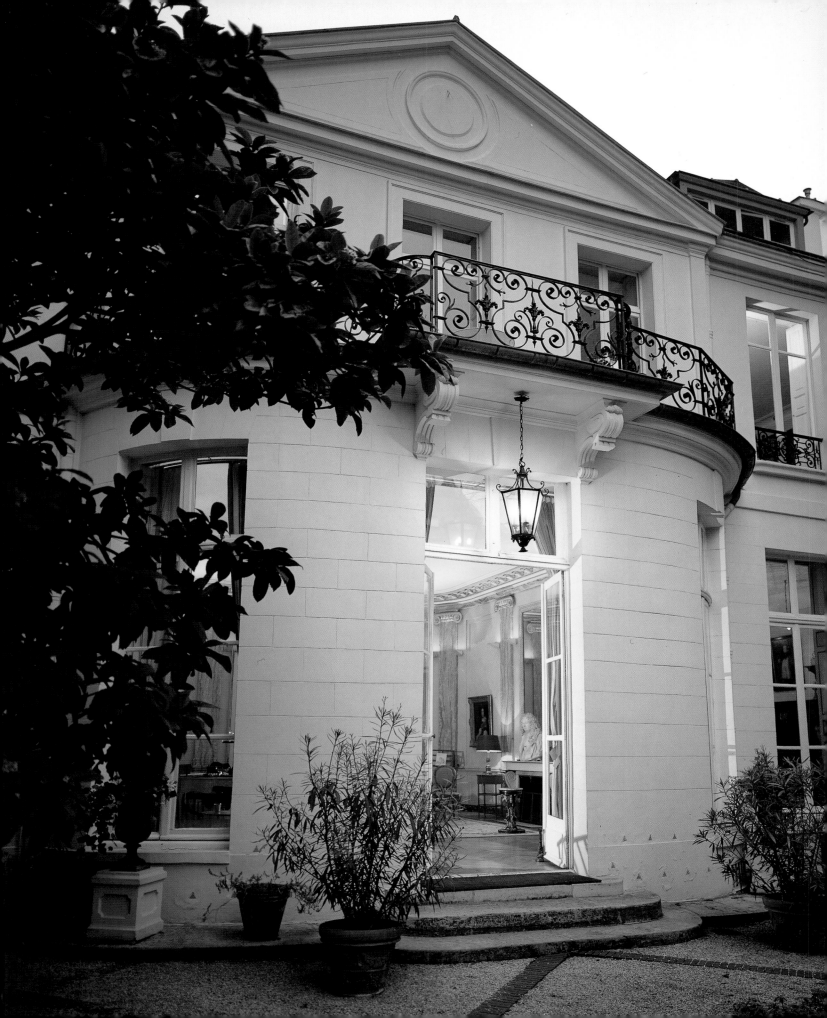

Contents

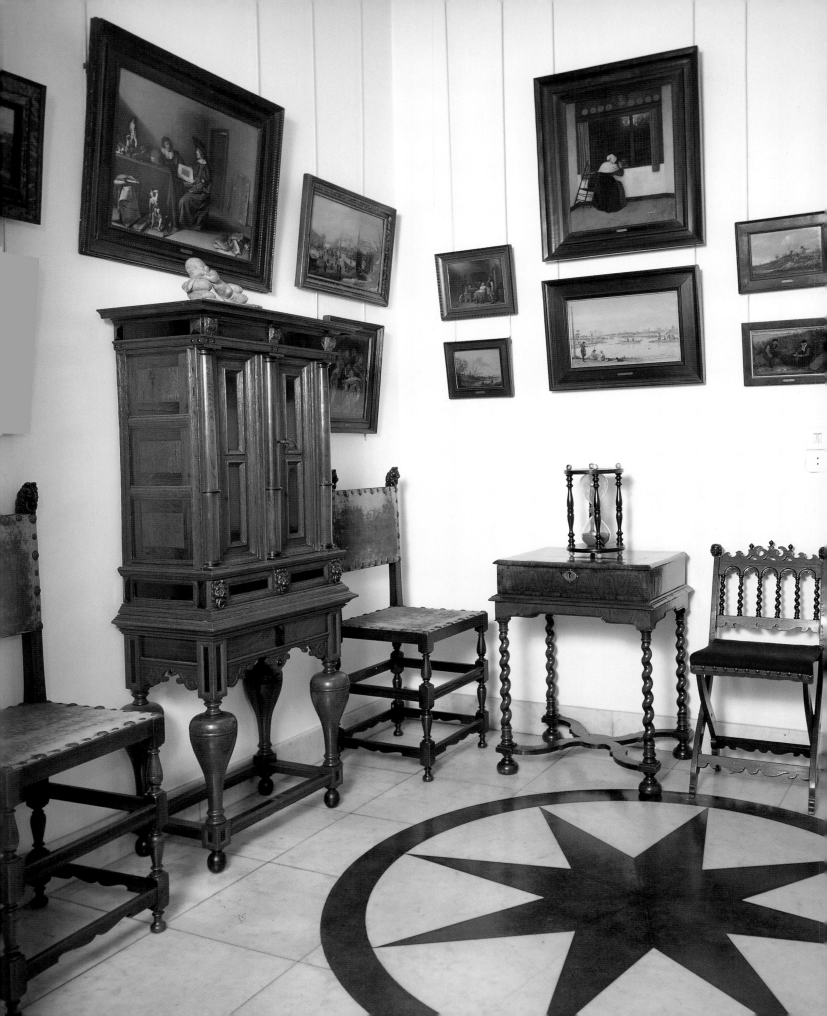

Foreword

On the Rue de Lille in Paris, in the immediate vicinity of such illustrious institutions as the Musée du Louvre and the Musée d'Orsay, lies the Institut Néerlandais, and hidden behind it, the eighteenth-century Hôtel Turgot. This modest mansion, which owes its name to Louis XVI's star-crossed minister, houses a little known but extensive and outstanding collection of old master drawings, prints and paintings. The collection is administered by the Fondation Custodia, established in 1947 by Frits Lugt (1884-1970) and his wife, Jacoba Klever (1888-1969).

Collecting clearly ran in Frits Lugt's blood. In 1892 – he was then only eight years old – he compiled his first catalogue, carefully listing the objects in his collection: a rabbit skull, a pig's tooth, a snake from the East Indies preserved in spirits, and a 'button that once belonged to the bugler of the Second French Regiment at the Battle of Waterloo'. The 'Museum Lugtius', located in young Frits' bedroom, even allowed visitors; a sign on the door read: 'The museum shall be open when the director is at home' (in translation). This urge to collect, classify and describe would continue to develop over the years. From the age of 12 Lugt paid regular visits to the print room of the Rijksmuseum, where he began work on his own catalogue of the drawings. He got as far as Jordaens. A visit to the great Rembrandt exhibition in 1898 led him to write a comprehensive biography of the artist. A year later he acquired his first Rembrandt etching.

This brief sketch evokes the image of a young man with an enormous passion for art and an insatiable curiosity for the facts behind the objects, cursed with an obsession to order and arrange everything that fell into his hands. These characteristics would make him an ideal employee (and later associate) of the Amsterdam auction house Frederik Muller & Cie, where he worked from 1901 to December 1914. They also stood him in good stead in his later research for a variety of art-historical publications, some of which – like *Les marques de collections de dessins & d'estampes* (1921) and the three-part *Répertoire des catalogues de ventes* (1938-1964) – were of such magnitude that even today, with the aid of computers, they would still be considered impracticable. Not surprisingly, in 1930 Lugt became involved in the founding of the Netherlands Institute for Art History (RKD), an organisation that has remained a vital source of information for generations of art historians.

Lugt's contemporaries and fellow scholars have correctly referred to some of his published works as 'classics'. Without detracting from these achievements, however, it seems safe to say that the most impressive aspect of Lugt's legacy is the collection he began to build at the end of the First World War. His activities as a collector were closely tied to his work as a gentleman-dealer. In the period between the wars, for example, he bought a number of ensembles of works on paper *en bloc*; some of the drawings were sold, others were exchanged with museums, and a small number were incorporated into his own collection. By the time of his death in 1970, over 50 years of incessant acquisition had resulted in a store of some 6,000 drawings, 30,000 prints and 200 paintings.

The tide of the times was in Lugt's favour. During the half-century in which he built his collection supplies were generally good and the works of high quality. Few other dealers could boast of having at least six paintings by Pieter Saenredam pass through their hands, among them the rare view of the exterior of the Church of St Mary in Utrecht purchased by the Mauritshuis in 1966 (p. 35, fig. 24). One of these masterpieces Lugt kept for himself (cat. no. 28). But his personal qualities played a role as well. Lugt had trained his eye from an early age, and a not unimportant number of acquisitions resulted from this ability to see things others might have overlooked, as well as his exceptionally developed taste. He himself described the phenomenon of collecting as follows: 'Il ne s'agit pas d'a-masser, mais de choisir' ('The point is not to accumulate, but to make choices'). Some of the most beautiful pictures in the collection are so highly prized today precisely because they are a-typical: a summer landscape by the 'winter painter' Hendrick Avercamp or a view of Loenen aan de Vecht by the Italianate Nicolaes Berchem. These are all examples of conscious choice.

Frits Lugt was a multifaceted art historian: a conscientious scholar, but also an impassioned *amateur*, collector and dealer. The Fondation Custodia, housed since 1957 in the Hôtel Turgot in Paris and neighbouring on the Institut Néerlandais (also established on Lugt's initiative), not only administers his precious collection but also aims to make it accessible – through publications, research and (loans to) exhibitions. It is thanks to the Fondation Custodia that the Mauritshuis is able to present this large selection of splendid seventeenth-century Dutch paintings, and we are most grateful for their cooperation.

In the first instance we would like to thank Mària van Berge-Gerbaud, director of the Fondation Custodia, not only for agreeing to our extensive loan requests but also for her kind and generous cooperation. Our thanks, too, to her staff, who greatly facilitated the realisation of the exhibition, assembled by the Mauritshuis' senior curator Peter van der Ploeg and curator Quentin Buvelot, who was also responsible for the editing and compilation of the present publication. Together with the latter, Hans Buijs, curator of the Fondation Custodia, supplied the catalogue entries. Art critic Ella Reitsma, who has published on Lugt before, wrote a fascinating introduction on the collector's life and work. The authors and organizers further wish to thank the following individuals: Stijn Alsteens, Boudewijn Bakker, Jaap Berghoef, Rhea Sylvia Blok, Bernadette Bonaldi, Beatrice Capaul, Alan Chong, Jan Daan van Dam, Peter Day, Valérie Durey, Rudolphine Eggink, Peter Fuhring, Jan Garff, Eymert-Jan Goossens, Bob Haboldt, Carlos van Hasselt, Freek Heijbroek, Anne-Rachel van der Horst, Anneke Kerkhof, Thomas Kettelsen, Wouter Kloek, E. Munnig Schmidt, Charles Noble, Marie-Louise van der Pol, Marijn Schapelhouman, Laya Stierman, Carel van Tuyll van Serooskerken, Marieke de Winkel, Matthias Wivel, Goedele Wuyts, The Countess of Wymess and March, Rob van Zoest, and – last but not least – Rudi Ekkart and his staff of the Netherlands Institute for Art History, The Hague.

The translation of the catalogue was in the capable hands of Beverley Jackson, Rachel Esner and Diane Webb. The publication's design was entrusted to Victor de Leeuw. Waanders Publishers and Printers, finally, was responsible for the production and distribution.

The exhibition *A Choice Collection: Seventeenth-Century Dutch Paintings from the Frits Lugt Collection* was sponsored by the Oranje-Nassau Groep and the Friends of the Maurits-huis Foundation. The publication of the catalogue was made possible by the M.A.O.C. Gravin van Bylandt Foundation. The exhibition has been insured by Aon Artscope Nederland, fine arts insurance brokers, Amsterdam.

Frederik J. Duparc,
Director

Introduction

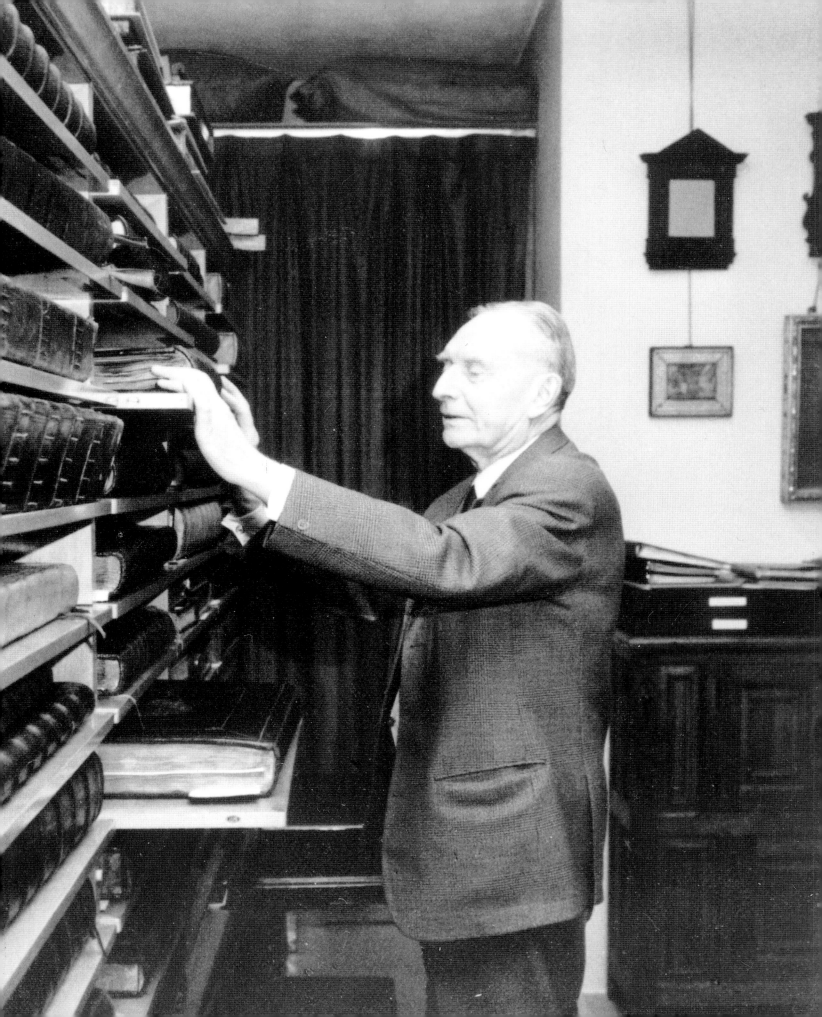

Frits Lugt, a collector with a mission

by Ella Reitsma

The main thing is to look, then to feel, books come afterwards. This, in a nutshell, was the philosophy of collector, art dealer and scholar Frits Lugt, who had his own museum – 'Museum Lugtius' – at eight years old. That was in 1892. At twelve he decided to make a catalogue of the drawings in the print room of the Rijksmuseum in Amsterdam. The absence of such a catalogue seemed to him an unpardonable omission. He set to work to remedy it.

At this youthful age, art became Lugt's vocation. When he died at eighty-six, in 1970, he left behind him, in an eighteenth-century building on the Rue de Lille in Paris, at a stone's throw from the Seine and the Place de la Concorde, a marvellous collection of drawings, prints, artists' letters, paintings, old frames, portrait miniatures, furniture, Egyptian artefacts and Greek ceramics. Drawings and prints make up by far the largest part of this unique collection, for which Frits Lugt and his wife Jacoba Klever had set up a special foundation (figs. 1-2). The purpose was to keep the collection accessible to art lovers and researchers after the founders' death. The collection had to be kept 'alive'.

Lugt detested the cold detachment that was the norm in so many museums and art galleries. He also abhorred the way in which works of art were hung neatly beside one another according to 'sound art-historical principles' and grouped by discipline: paintings in one room, arts and crafts in another. He wanted to engage visitors' imagination by placing works of art in surroundings that were both tasteful and as authentic as possible (fig. 3). Lugt had an ideal – to display art and beauty and in so doing to give people an opportunity to reach a higher plane of existence. It was a typically nineteenth-century aspiration. Even as a boy he had felt an urge to document his possessions – he wanted to show off his finds and share his knowledge. Perhaps it was a need inculcated in part by his Baptist upbringing. Seeing his talents as God-given, he felt it would be wrong to keep them to himself. This too was a conviction to which he would remain faithful until his death.

< **1** Frits Lugt in the safe where the prints and drawings are kept, the core of his collections. Photograph: Fondation Custodia Archives.

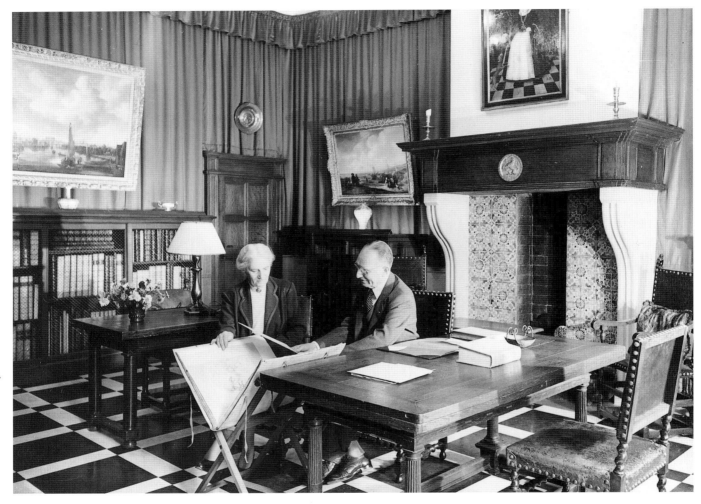

2 Lugt and his wife Jacoba Klever looking at drawings in the 'Dutch Room' in the Hôtel Turgot, *c.*1957. Photograph: Fondation Custodia Archives.

In 1918, just after the end of the First World War, Lugt published a little book entitled *Het redderen van den nationalen kunstboedel* ('The disposition of the nation's art collections'). It was written in response to the Dutch Antiquarian Society report proposing a reorganisation of the country's public museums.[1] Lugt made mincemeat of the proposal in a piece that reads as a personal manifesto. He advocated a completely new approach to art, presentation and collecting in Dutch museums, which to his mind were far too cluttered and heavily oriented towards educating the public. Quality and beauty were his watchwords; a

museum should not be a 'vehicle for instruction'.[2] 'Thus a passion for beauty and for higher things must be the guiding principle behind all our actions, no essential intellectual considerations must be allowed to cloud it'.[3] Contemptuous of art historians who could not use their eyes and trusted to book learning, he complained that this species was acquiring more and more say in museums. He mounted a spirited defence of collectors and art lovers, suggesting that museums forge far closer ties with them. 'Collectors are an essential part of the fabric of society – they are, moreover, the spiritual fathers of our museums'.[4]

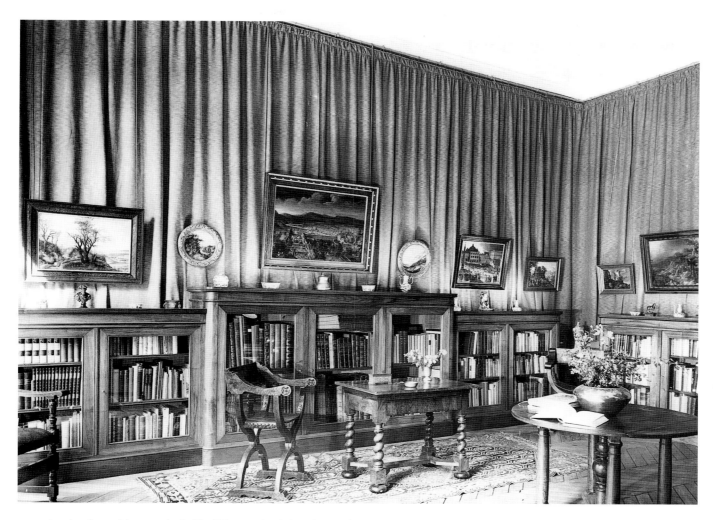

3 Interior of one of the rooms in the Hôtel Turgot in Lugt's day. Photograph: Fondation Custodia Archives.

At this time Lugt scarcely possessed a collection of his own, but he had the firm intention of building one up that would exemplify his ideals. In Lugt's opinion, great collectors should be respected as 'the enlightened arbitrators of art of their day'.[5] It is fascinating to see how he set himself a clear goal at an early age and eventually attained it. His views about art, collecting, documentation and presentation were defined more sharply as the years went by, but they remained essentially the same.

Lugt had the good fortune – or the good sense – to choose an immensely loyal wife with a wealthy father. Joseph

Klever was a founding member of the Coal Trading Association, and Jacoba, who was known as To, was his only child. Klever soon discovered his new son-in-law's gift for turning pennies into pounds and had boundless confidence in him. His encouragement was an added boon. Lugt's wife bore him two sons and three daughters, accompanied him on his many journeys whenever she could, and always supported him with his countless publications and initiatives.

In 1930 Lugt was one of the driving forces behind the establishment of the Netherlands Institute for Art History in The Hague, which soon became an indispensable resource,

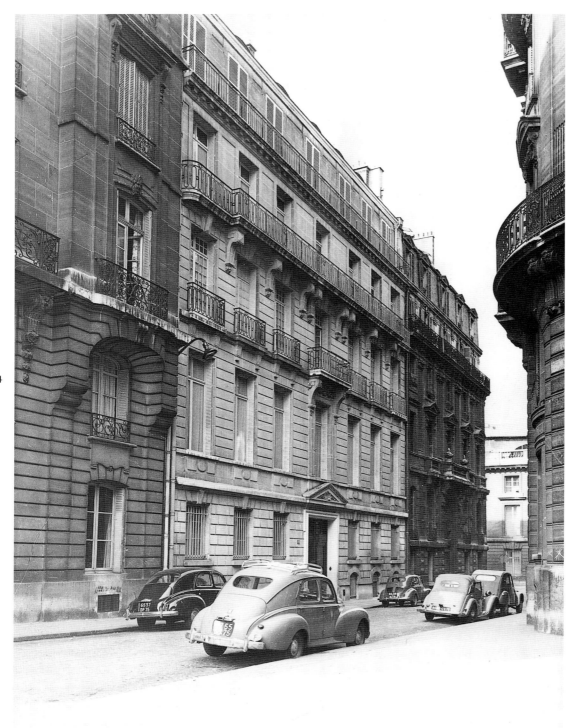

14

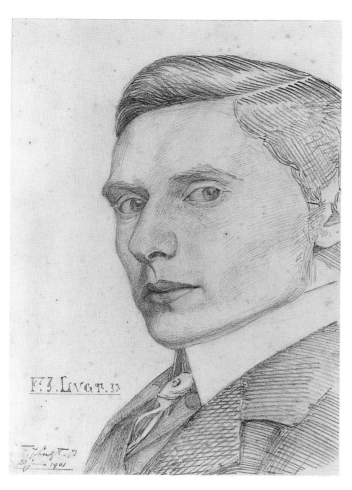

5 Frits Lugt, *Self-portrait*, 1901. Pencil, 25.3 x 17.6 cm.
Paris, Frits Lugt Collection.

man made Lugt reject out of hand any invitation to accept an honorary doctorate.[6]

Lugt's great example was the eighteenth-century French art dealer, connoisseur and collector of drawings, Pierre-Jean Mariette, an art lover who, like Lugt, made drawings of his own (fig. 5). For that is the secret: someone who makes drawings himself will be better equipped to discern the specific characteristics of a style of draughtsmanship. Other inspiring examples in matters of taste were the collectors Cornelis Ploos van Amstel, Baron Jan Gijsbert Verstolk van Soelen, and Jacob de Vos Jbz, who had built up superb collections of seventeenth-century Dutch drawings in the eighteenth and nineteenth centuries.[7]

For Lugt, drawings from that period were the most desirable items, certainly when he first started collecting. The Dutch Golden Age was the prime focus of his interest and he saw Rembrandt as by far the greatest of all seventeenth-century artists. No other private collection has so many drawings by the master – more than twenty – as well as a complete set of his prints.

While as a collector Lugt felt a sense of kinship with the *amateurs* of the eighteenth century, as an art scholar he tended to follow *confrères* of the late nineteenth century. He greatly respected Wilhelm von Bode, for instance, a man known mockingly as the Bismarck of the Prussian museum world. A portrait of this art scholar hung in his study. Von Bode was almost thirty years older than Lugt, and made a deep impression with his nose for excellence and his shrewd approach to purchasing. He did not exhibit paintings separately, but hung them in a context of furniture, sculpture and applied art, enabling visitors to gain a sense of the atmosphere of a particular period.

Abraham Bredius, Director of the Mauritshuis in The Hague, and himself a self-taught scholar, took an immediate liking to the young art lover upon their first meeting in 1899, and helped him build up a network of contacts in the art world. Lugt loved the visionary enthusiasm that seemed to possess Bredius, a specialist in seventeenth-century Dutch art and a great lover of Rembrandt.[8] The director's guiding principle was to let intuition prevail over reason, provided that intuition is based on years of looking and comparing. It was a maxim that struck a chord in Lugt's heart.

especially for research on Netherlandish art of the sixteenth and seventeenth centuries. In 1956 he founded the Institut Néerlandais in Paris – a cooperative venture with the Dutch state – that was accommodated in the front section of the premises at 121, Rue de Lille (fig. 4). The rear section, the eighteenth-century Hôtel Turgot, was designated to house the collection of the Fondation Custodia (frontispiece). The following year Lugt also helped with the launching and accommodation of an institute of art history in Florence.

The Dutch establishment gradually grew to appreciate the uniqueness of the combination of connoisseur, collector, art scholar and patron of the arts. In the last twenty years of his life this appreciation took the form of a range of distinctions and medals of honour, but pride in his status as a self-taught

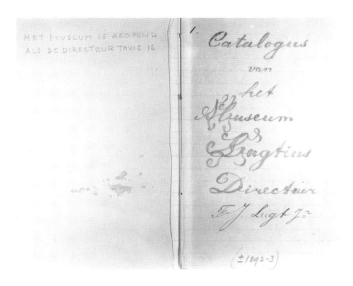

6 Title page of the catalogue of 'Museum Lugtius', written in Lugt's hand. Fondation Custodia Archives.

7 First chapter of Lugt's biography of Rembrandt, written in 1899, intended as a gift to his father. Fondation Custodia Archives.

Childhood

16 Frederik Johannes Lugt was born in Amsterdam on 4 May 1884. His father, after whom he was named, had studied at Delft and worked as an engineer for the Department of Public Works in Amsterdam. His mother, Jeanette Petronella Verschuur, came from an artistic family, loved art, and made drawings of her own. Frits was their only child, an older sister having died just after he was born, before reaching her second birthday. The boy was given a caring and loving, if rather sober, upbringing. From an early age his hobbies and interests were taken seriously and encouraged.[9] He made drawings, accompanied his parents on outings to museums and art galleries, and started to build up a collection in the manner of many small boys: a rabbit skull, a pig's tooth, a snake from the East Indies preserved in spirits, and a 'button that once belonged to the bugler of the Second French Regiment at the Battle of Waterloo'. The difference between Lugt and other small boys was that young Frits compiled a real catalogue for his 'Museum Lugtius' (fig. 6), in which he numbered all the objects and described them in detail, noting the donor in the case of a gift. His later passion for provenance was already clear from this early age. A sign to his bedroom door announced: 'The museum shall be open when the director is at home'.

Father and son shared a strong urge to write down, arrange carefully and document everything they thought important. Hoarding invoices, postcards, tickets, letters and everyday memoranda was something they both did as a matter of course. This is why the catalogue of that eight-year-old's museum still exists today. Unfortunately, in later life Lugt discarded a great deal, and when he and his wife celebrated their fiftieth anniversary with a voyage to America, they reread their most personal correspondence before consigning it to the Atlantic.[10] It created an awkward gap for later researchers.

The young Frits was a serious child for whom everything must have a purpose; idling was not in his vocabulary. In 1898 he accompanied his parents to see the first major Rembrandt exhibition at the Stedelijk Museum, Amsterdam. The show consisted of 124 paintings and 350 drawings; the etchings were hung in the Rijksmuseum. This exhibition, which opened on 8 September in honour of Queen Wilhelmina's coronation, must have made a lasting impression. The fifteen-year-old was astonished to discover that no good biography yet existed of the artist he so admired and determined to produce one himself. It was to be a birthday present for his father. Frits laboured on this book for eighteen months, combing libraries and archives and scouring the city

in search of places that had been important to Rembrandt. Having first produced a rough draft, he copied the biography in his best handwriting into a large ledger on thick lined paper (fig. 7). Wherever he lacked good photographic reproductions, he made his own copies after etchings and drawings and pasted them into his book, first treating the paper with tea for added authenticity.

In 1899 Frits purchased his first work of art at an auction: a small etching by Rembrandt with a portrait of the calligrapher Coppenol. With it he also acquired – for a total of 2 guilders and 50 cents – a page of calligraphic writing by this schoolmaster. Lugt cherished these purchases for a very long time. Rembrandt's etching was framed and hung high in the corridor of his house at Maartensdijk.[11]

Not a day was wasted. From twelve years of age Frits spent every free afternoon studying in the reading room of the Rijksprentenkabinet in Amsterdam, working on his project of cataloguing the drawings. But when he reached *The entombment of Christ* by Jordaens, three years later, having described and documented 955 drawings, he had to stop, because his life suddenly took an unexpected turn.

Frits showed no especial talent at high school (HBS); his only real interests were drawing, and looking at and studying art. There was little prospect of his studying in Delft like his father. Frits took drawing lessons at Hendrick de Keyser art school, and his ambition was to become an artist. His father will certainly not have encouraged him there. A study of art history was not an option, since the subject had not yet been introduced at Dutch universities.

When Lugt senior was presented with the biography of Rembrandt in June 1900, he was so proud that he showed it to everyone – his opposite neighbour Dr Jan Six, the professor and painter August Allebé, and his cousin Frits Adama van Scheltema, the owner of Frederik Muller & Cie, the most important firm of auctioneers in the Netherlands. The future started to take shape. Adama van Scheltema died unexpectedly and Anton Mensing, a partner in the firm, was looking for an assistant for the art department and the department of paintings. Lugt senior must have conceived a clear idea at that moment. Perhaps he derived support from a letter from Abraham Bredius bemoaning the country's 'urgent need of museum directors'.[12] He contacted Mensing,

and at the beginning of January 1901, Frits, who was in the fourth form, was suddenly plucked from school. He was to be allowed to work at Muller's provided he spent a few months in London improving his English. He had already mastered French and German during summer holidays in Switzerland and Germany. It was a striking decision on his father's part, certainly one that would not have been common at that time and in that milieu.

By February Frits had been lodged with a family in London and could start studying. He had a package of letters of recommendation with him, some from Mensing and some from Bredius, whom he had visited before leaving. For in London he wanted to visit all the private and public collections, art dealers and auctions. He made meticulous notes, purchased as many catalogues as his pocket money would accommodate, and built up an extensive network of contacts. He did not close his eyes to contemporary art – he admired Millais and visited the studios of Burne Jones and Alma Tadema. He also went to see the aging Fairfax Murray, a Pre-Raphaelite painter with a fine collection of old and modern art. In the evenings Frits went to the theatre or stayed home to read: Huxley, Tennyson, Spencer, Dickens, and Scott; he was by no means narrowly fixated on the visual arts of the past.[13] After another trip to Edinburgh and to Germany, Frits joined the firm of Frederik Muller in September 1901. His future had been determined. But there was one thing he could not do – staff were forbidden to buy anything for themselves at auctions, whether at Muller's or elsewhere.

Frederik Muller & Cie

Anton Mensing started off by asking his new recruit to create some order in the jumble of engraved portraits. He was to discover the artist's name, the country and year of origin, and the sitter's identity. It was an arduous task, which Lugt took as a baptism of fire and saw through without complaining. The result was to Mensing's satisfaction, and after that he allowed his young assistant to make sales catalogues.

A better training for an art connoisseur and collector would be hard to imagine. Untold paintings, drawings and prints passed through Lugt's hands in the thirteen years that he worked at the auctioneering firm. Each one had to be

subjected to close scrutiny, described, and furnished with a name or attribution and a provenance. Although he could not buy art for himself,[14] there was no ban on collecting sale catalogues. Thirty years after he first entered the service of Frederik Muller, he donated, in addition to tens of thousands of photographs and reproductions, 22,000 sale catalogues to the Netherlands Institute for Art History in The Hague.[15] This donation was to become the basis for a collection that is unique in Europe.

One of Lugt's first and most interesting catalogues was devoted to the paintings and drawings of Jan van Goyen. In the summer of 1903 Muller's had mounted an exhibition in the Stedelijk Museum in Amsterdam and produced a catalogue to accompany it. Its introductory essay, besides providing lyrical accounts of the landscapes of this painter (who was by no means as famous then as he is today) attests to Lugt's personal love of landscapes. This turns up again and again in letters that have been preserved, which include highly evocative descriptions of the landscapes that he passed through on his travels. For his own drawings, too, Lugt preferred open-air subjects. Well into the 1950s he still took a sketchbook along with him whenever he undertook a journey in which study and work did not have priority. He excelled chiefly in landscapes and portraits.

His yearning for a career as an artist continued to haunt him in his first year at Frederik Muller's. Six months after the big Jan van Goyen exhibition of 1903 he discussed his dilemma with his parents and with Mensing. They advised him to take a breather in Paris. His advisers felt he had been working much too hard and had precipitated a personal crisis. In December 1902, in Paris, Lugt made the important decision, at eighteen, of renouncing the idea of a career as an artist. His friends and relatives in Holland breathed a sigh of relief. This struggle in Lugt's youth tells us something about the emotional commitment to art he felt throughout his life, especially to drawings and prints. So many of his writings urge the importance of looking at art with an open mind and heart, something that he believed only children and artists were capable of doing.

In the introduction to the Jan van Goyen catalogue, Lugt firmly rejects the view that Van Goyen's painted landscapes are monotonous and consist only of brown and grey hues. 'You must look more closely. It is made from little or nothing', he writes in French, the lingua franca in the art trade at the time, 'his paintings are masterpieces of light and colour'. And the drawings that look so very simple, writes Lugt, are all about 'space, distance and atmosphere'. He closes on a personal word of thanks to the painter who 'taught us so well to value our dear Dutch landscape'.[16] Later on, as soon as the opportunity presented itself, he would buy two typically Dutch landscapes by Van Goyen, *Skaters on the river Merwede near Dordrecht* and *Country road near a church, with horseman and beggars*, besides more than twenty drawings by him.

After the summer of 1903 he published a steady stream of articles. The following year, an article of his appeared under the pseudonym of F. van Haamstede in *Onze Kunst*, containing the first serious critique of the Dutch painter Jongkind, another landscape specialist.[17] It was to be his only essay on a modern artist active in France in the latter half of the nineteenth century. He did describe works by modern artists in sale catalogues, however. When Frederik Muller organised an auction in May 1904 of paintings, watercolours and drawings from the Dutch period of Vincent van Gogh, Lugt produced the catalogue. Here too, his descriptions were highly expressive, sometimes even poetic, suggesting that he was certainly not unsympathetic to this work.[18]

Among the numerous collectors with whom Lugt became acquainted was the businessman August Janssen, who made all his purchases at Frederik Muller's from 1906 onwards. He became Janssen's adviser and built up a personal relationship with the man he described as 'the greatest collector that our country has known since the middle of the last century'.[19] Janssen died in 1918, and a year later Lugt purchased four paintings from his collection through the mediation of the Amsterdam art dealer Goudstikker. He was supremely aware of the quality of the paintings, which included *Skaters on the river Merwede near Dordrecht* by Van Goyen.[20] After Janssen's death, Lugt wrote a glowing obituary in *De Amsterdammer*. He referred to Janssen as one of the first major collectors, who, after a fifty-year lull of 'bleak indifference among art lovers', started purchasing 'precious paintings by Dutch old masters' after 1900. This is an interesting remark. It seems that the collecting of seventeenth-century Dutch masters did

not really gather momentum again until the early twentieth century. With his knowledge and interests, Lugt was ideally placed to response to this trend.

The subjects of other important sale catalogues compiled by Lugt included Rembrandt's drawings from the collection of J.P. Heseltine, old drawings from the collections of J.P. Heseltine and Dr J. Paul Richter, and the Flemish and Dutch seventeenth-century paintings of *Jonkheer* H.A. Steengracht van Duivenvoorde. The works put up for auction in 1913 were of outstanding quality and came from eminent collectors who had been active for many years. The Steengracht Collection had its roots in the eighteenth century. Heseltine came from Britain, and was a Trustee of the National Gallery in London. Lugt had probably become acquainted with his collection when living in London as a sixteen-year-old boy. He maintained contact with this erudite scholar until the latter's death in 1929, and in 1919 he bought from him personally, eighteen seventeenth-century drawings of the Dutch school and a painting by Jan Steen, 'Portrait of Jan Steen's wife, playing the guitar' (fig. 8).[21]

When Lugt went on a trip to London in January 1927, he also purchased from Heseltine a very beautiful – and to the artist, very significant – painting by Jan Lievens, 'Three old trees' (cat. no. 18). It was valued at 3,000 guilders when it changed hands, and in November of that year Lugt spent 275 guilders framing it.[22] Frames were another enduring passion. He was constantly on the lookout for them when visiting a big city, and he often paid much more for a frame than for a drawing.

In his 'In memoriam' of Heseltine in 1929, which appeared in the art journal *Apollo*, Lugt wrote that this great connoisseur – who had undoubtedly served as an inspiration to him – always had 'a twinkle in his eyes' when talking to someone of the 'learned class'. Upon catching sight of a superb work of art, the Englishman would sometimes cry out solemnly, 'Now go down on your knees!'. Heseltine had built up his collection of drawings by old masters in the last quarter of the nineteenth century, before any system of classification had been introduced for drawings. Shops piled up their sheets higgledy-piggledy. 'When one had discovered something amidst this chaos + examined it at home, it

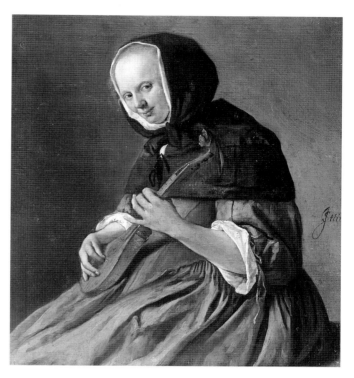

8 Jan Steen, *Woman playing the sistrum*, c.1660-1662. Panel, 31 x 27.5 cm. The Hague, Royal Cabinet of Paintings Mauritshuis (acquired in 1928).

always was better than in the shop. At present the reverse'.[23] Lugt jotted this down on a scrap of paper in 1929 while collecting his thoughts for the *Apollo* article, in which he also remembered Wilhelm von Bode, who had died shortly before Heseltine. In between the words of praise, the article tells us a good deal about Lugt himself and his aspirations.

Lugt was also capable of apt and stinging invective, a case in point being the 'Six pamphlet' of 1907. The heirs of *Jonkheer* P.H. Six van Vromade offered to sell the State a total of thirty-nine paintings for the price of 751,400 guilders. Bredius advised in favour of the acquisition, but Lugt completely disagreed. He thought the price far too high and said that the collection contained only five interesting paintings, including Vermeer's *Milkmaid*. Even of this painting Lugt complained that it was inferior to *The little street*, which also belonged to the collection but was not included in the offer. Lugt put a great deal at stake with his polemic, but his friendship with Bredius weathered the storm.[24]

In 1910 he made the acquaintance of Jacoba Klever. He proposed to her in June, and they were married on 10 December that year. Lugt tackled this new enterprise with his customary energy and resolve. The couple settled at Van Baerlestraat 10 in Amsterdam, and their first son, Jaap, was born in the autumn of 1911.

At the beginning of 1911 Mensing and Lugt became business partners. Lugt was twenty-six, and would continue to help determine the image of the auction-house for another three and a half years. In the meantime he was researching his forthcoming book of collectors' marks. His parents were among those who provided assistance in this project, when they journeyed through the Hapsburg empire, visiting its great cities of Vienna, Prague and Budapest. Their art journey was interrupted by the assassination of Archduke Franz Ferdinand and his wife in Sarajevo on 28 June 1914, the event that was to trigger the First World War. The year marked a watershed in many ways.

Presently friction developed between Mensing and Lugt. It seems that Lugt set himself up as the older man's rival and wanted to take too many risks. He was also chafing at being unable to build up a collection of his own, and at the lack of time to do art historical research.

The tensions erupted into blatant conflict in the summer of 1914, and on 31 December of that war year, the two formally dissolved their partnership. Lugt never harboured a grudge against Mensing. He was relieved that the 'mix of mutual and personal interests' had come to an end and that he would be in a better position to express his respect and gratitude to Mensing in the future. Mensing had helped him acquire 'professional expertise and knowledge of human nature'.[25]

Lugt was now free to spend all his time on his groundbreaking book *Wandelingen met Rembrandt in en om Amsterdam* (Walks with Rembrandt in and around Amsterdam) that appeared in 1915.[26] Two years later, another, far slimmer though significant volume was published in Amsterdam: *Le Portrait miniature, illustré par la collection de S.M. la Reine des Pays-Bas*. On this too he had worked for a number of years. His love of portrait miniatures had now been placed on a scholarly foundation and he started his own collection of tiny, meticulously painted portraits from Britain, France, Italy and the Netherlands.

He earned a living by advising collectors, and in the last year of the war he cautiously started to buy and sell paintings, drawings and prints, primarily of the seventeenth-century Dutch school. He preferred to sell paintings, as they yielded a greater profit. Drawings and prints, in which he took more interest as a collector, were significantly cheaper.

Trade and scholarship

Lugt made his first purchases in November 1915 and January 1916 from galleries in Amsterdam. They were a drawing by Gerard ter Borch the Younger, *Boys at play* and a painting of the Vijverberg in The Hague by Gerrit Berckheyde, which he bought for 120 and 1,500 guilders respectively.[27] A little over a month later he sold the Berckheyde to the art dealer Jacques Goudstikker, with whom he would do business on a regular basis over the next few years. Lugt liked topographical scenes, and the historical significance of the Vijverberg in The Hague will have enhanced its appeal to him. Sixteen years after making this acquisition he would take up residence in that area of The Hague, accommodating his collection in premises on the Lange Vijverberg.[28]

In October 1917, with the war still raging, the collection of Rudolf Goldschmidt, a collector of Dutch and Flemish drawings, was put up for sale by Prestel auctioneers in Frankfurt. It was here that Lugt first purchased a batch of drawings – fifty-seven in total – and a number of prints. At the end of that year he went to Berlin, where he visited Dr M.J. Binder, once the assistant of Wilhelm von Bode, who had been appointed Director of Berlin's Zeughaus in 1913.[29] Binder evidently had a collection of his own, since Lugt purchased four paintings from him, three of which still grace the walls of the Hôtel Turgot. They are *Portrait of Hugo Grotius (1583-1645) aged 16* by Jan van Ravesteyn (cat.no.26), *Landscape with the rest on the flight into Egypt* by Jacobus Mancadan, *Woman at a window, waving at a girl* by Jacobus Vrel (cat.no.35) and *Two whaling vessels off a snow-covered coast* by Hendrick Dubbels.[30] He resold the latter. The piece by Vrel was the most expensive, at 9,000 guilders, while the painting by the then unknown Mancadan cost least, at 1,000 guilders. The Vrel was probably so expensive because its

20

theme evoked associations with the paintings of Vermeer, which were at the top end of the market at this time. Vrel's signature on the strip of paper in the painting is very hard to make out. It may even have been tampered with at some point so as not to exclude an attribution to Vermeer.[31]

In Lugt's early years as an art dealer, father-in-law Joseph Klever helped to finance his expensive acquisitions. Lugt repaid each loan as soon as he resold a work, but was allowed to keep the entire profit for himself. This assistance continued until about 1923, by which time Lugt had built up enough financial reserves of his own.

At the end of April 1919 the Langerhuizen Collection was put up for auction at Frederik Muller's in Amsterdam. Lugt purchased a drawing then attributed to Rembrandt, *House with annexes among trees*, for 210 guilders and *Woman with dish* by Rubens for 175 guilders.[32] The forty-odd drawings went for sums ranging from 50 to 350 guilders, with those described as 'fully elaborated' raising the highest prices. Topographical subjects too were relatively expensive, while the lower end of the price range was taken up with thumb-nail sketches and lightning compositions.

The 1920s were rewarding years for Lugt, both in business and as a collector. He also received important commissions as a connoisseur and researcher. First of all, in 1921, he published *Les marques de collections de dessins & d'estampes*, an encyclopaedic work with extensive biographical and other information about collectors, collections, auctions and the literature. In 1956 followed a voluminous supplement. Throughout his life Lugt took a keen interest in provenance. Provenances forge ties between collectors and between one century and the next, and are crucial to reconstructing the history of taste. Helped by dozens of assistants – including Lucien Huteau, who remained loyal to him from 1920 to the end of his life – Lugt produced what would come to be seen as a bible of cultural history.

His first biographer, his friend Michiel Frederik Hennus, an art critic and 'creditable dilettante' gives a good charac-terisation of this book of collectors' marks.[33] He calls it a monument of patience, meticulousness, perseverance and method, exemplifying the gifts of a detective and explorer.[34] In fact it is even more than that. Detailed though they may be, the descriptive texts are never dry. Guided by a keen sense of understatement, Lugt gives apt character sketches and seeks out memorable anecdotes. Of his own collection he writes, 'it comprises only a few hundred sheets, among which the old Dutch School predominates at present'. You might expect the supplement to expand on this, since by then his collection had won international stature and esteem. But Lugt was too modest for that. The book of collectors' marks appeared to universal acclaim, establishing Lugt's reputation permanently in the mind of every art researcher, dealer and collector.

At the end of 1921 Lugt was given a highly prestigious commission. He was asked to make catalogues of the Flemish and Dutch schools in the print room of the Louvre. Versions still exist of a contract in which L. Demonts, curator of the Musées Nationaux in Paris, undertook to catalogue the German drawings. The authors were to earn 3,000 francs for each volume, payment to be made upon delivery of the manuscript. Albert Morancé publishing house assumed that the series would run to ten volumes, the first of which was due to appear in 1923.[35]

The original commission was evidently altered along the way, since Lugt published the first volume in 1927, on the drawings of the Écoles du Nord in the Dutuit Collection in the Musée du Petit Palais, Paris. In 1929, 1931 and 1933, three volumes appeared on the Dutch School in the Louvre, and in 1936 the drawings of the Écoles du Nord in the Bibliothèque Nationale were described. After this the war made work impossible for many years, and the next three volumes, including one on the Flemish School in the Louvre, did not appear until 1949, 1950 and 1968.

It is not too bold to say that Lugt handled and studied every single Flemish and Dutch drawing that was in a public collection in Paris. This alone must have given him enormous prestige. It is therefore not surprising that he settled there after the war, and when he found the Dutch lukewarm about keeping his collection in the Netherlands, he moved that too to Paris.

Still, he never toned down his views to spare a client's feelings. A rough copy exists of a letter in which he complains furiously about the abominable condition in which the drawing collections in Paris were being kept.[36] The Louvre

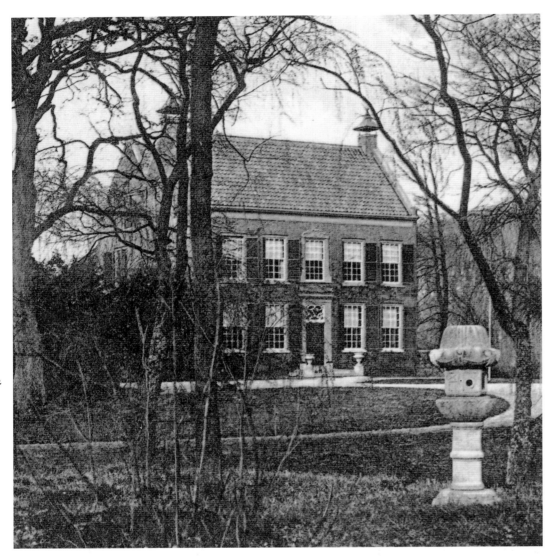

22

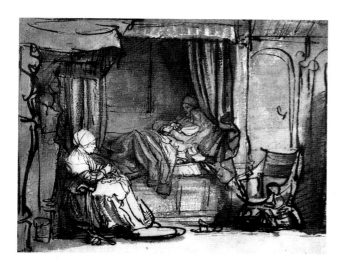

11 Rembrandt, *Interior with Saskia in bed*, c.1640-1641. Pen and brown ink, brown and grey wash, highlights in white body colour, a few lines in red and black chalk, 14.2 x 17.7 cm. Paris, Frits Lugt Collection (acquired in 1919).

12 Frits Lugt's identity card, used during his stay in Italy in 1922. Fondation Custodia Archives.

had a shortage of staff and care, its procedures were unsystematic and its opening hours far too short. In the Bibliothèque Nationale the finest sheets were exposed to so much light that they were being 'consumed by the sun'. The way the magnificent prints of the Dutuit Collection had been stored in cupboards was so disastrous that the donors would have blanched. These are not the kind of letters that make one popular, but Lugt's sense of justice and his concern about preserving what the past has left to us always prevailed over diplomacy and conflict avoidance strategies.

Rustenhoven

In the year of this important commission Lugt moved to *Rustenhoven* in Maartensdijk (fig. 9), a villa with a large piece of land and a wood with several other buildings. After leaving Muller's he had moved to Blaricum, but the house on the Torenlaan was soon too small to accommodate the family, his collection, the art trade and Lugt's studies. Joseph Klever had purchased *Rustenhoven* in 1919, and had the Amsterdam architect D.F. Slothouwer design an additional country home for the Lugt family on the estate in 1920. Twelve months later, the 'big house' itself, built in old Dutch style, was thoroughly renovated.[37] Behind the house Slothouwer designed an oval, glass-roofed gallery measuring 6.5 x 9

metres (fig. 10). Here Lugt could receive collectors, hang his finest drawings and display the paintings he wanted to sell.[38] His own collection was exhibited in the house.

Italian drawings hung on one side of the oval gallery, and on the other were landscape drawings, biblical scenes and Rembrandt's *Interior with Saskia in bed* (fig. 11). Also exhibited in splendid old frames were pieces by Watteau, Bouchard, Fragonard and Goya. Green velvet curtains protected these vulnerable works of art from the injurious light. There was also a black grand piano. Above the chimney hung the *View of Isola San Giorgio* by Guardi and on the table, which was covered by a Persian carpet, lay the album of Rembrandt's etchings. This description of the gallery was provided years later, on the occasion of Lugt's eightieth birthday, by an art dealer from Leipzig. It reflects the situation in the late 1920s.

Italy

Lugt and his wife had four children when they moved to *Rustenhoven* in the spring of 1921.[39] That did not stop them setting off for a four-month trip to Italy in November (fig. 12). Neither had ever been to Florence or Rome before, and they visited and examined all the collections there with the breathtaking pace and discipline that was to be expected of them.

Lugt made detailed notes on his findings and on Florentine architecture. It seems as if he had intended to make them into a book, 'Letters from Italy to a friend', though this project miscarried. The manuscript contains a curious passage. In February 1922 the couple visited the Fondazione Horne, known as Casa Horne, which was a new attraction in Florence. Horne, a British art historian and author of a standard work on Botticelli, had bequeathed his home and collection to the Italian state. Lugt describes the wretched way in which the state took possession of the bequest: everything was numbered and stamped, 'by preference tastelessly' on the front of a carefully composed drawing. 'All those little objects, paintings, drawings and books, which are most pleasurable to see in an occupied home, where the collector himself can express his contagious enthusiasm, have now been made cold and coy', writes Lugt. 'The tiniest ones have been put behind glass, of course, there is nothing by way of explanatory information, and the living book collection has been librarified ... No, in this form, however well-intentioned, preservation means not a new lease of life but entombment... It is a vexed issue, and how to resolve it is something we must discuss further'. In his comments on Casa Horne Lugt wrote frankly that small though their collection was at the time, he and his wife were already toying with the idea of bequeathing it some day, together with their home – to his mind an indispensable combination if a collection was to be kept alive – 'as a permanent gift to the public domain'.[40]

In February Lugt was able to purchase some drawings from the son of Charles Fairfax Murray, who evidently lived in Florence, including *Perseus and Andromeda* by Karel van Mander – which he acquired for five guilders! He had probably seen them in 1900.[41] Once Lugt had set his sights on something, he was not apt to forget it.

After their stay in Italy, Lugt's journeys through Europe to auctions, art dealers and collections picked up immense pace. For his French commission too, of course, he had to view and compare Flemish and Dutch drawings in the main foreign collections. Scholarship and the art trade went hand in hand. And it was the art trade that enabled Lugt to build up his own collection. This collection underwent a significant change of direction when he purchased a batch of superb Italian drawings from an old Veronese collection belonging to Professor Luigi Grassi. He had probably studied this collection before, in Florence. In September 1923 he bought about 480 drawings from Grassi, including some rare fifteenth-century sheets. He exchanged fifty-two of them with the Albertina in Vienna, sold about 390 at auction through Sotheby's and kept the rest for himself.[42] It was a brilliant acquisition, which became the basis for his collection of Italian drawings. He also purchased from Grassi an early Renaissance portrait of a youth, which he resold to the Parisian dealer F. Kleinberger. This was a very lucrative transaction.

Trade by exchange

Exchanges were an important mode of trade. German museums, seriously strapped for cash after the war, offered not only duplicates from their print collections for sale, but also drawings and paintings that they considered of lesser importance for their own collection. After the collapse of the Hapsburg Empire, collections such as those of the Albertina and the imperial court library were nationalised and joined together. Besides yielding a lot of duplicates, this gigantic operation created an acute shortage of space. Pruning was an urgent necessity. Joseph Meder headed the Albertina from 1905 to 1922, when he was succeeded by Alfred Stix. Lugt kept in contact with both of them.[43] He was entrusted with the identification of duplicates and given the right of first purchase. It was a wonderful offer, since the Albertina has one of the largest and most beautiful print collections in the world. Lugt started work in 1923.

He combined his visits to Vienna with short stays in German cities such as Leipzig and Dresden. There too, he had plenty to do. Leipzig frequently had interesting auctions, since the German nobility too had been compelled by the dramatic economic malaise to sell their collections. In Dresden, Prince Johann-Georg, heir to the large collection of prints and drawings of Friedrich August II, king of Saxony, found himself in serious financial difficulties,[44] and decided to sell some prints. On 29 January 1923 Lugt acquired some etchings by Rembrandt and prints by Goltzius (fig. 13), and a few months later he had another opportunity to buy a small

13
Hendrick Goltzius, *Nox*, c.1588-1590. Chiaroscuro woodcut,
34.4 x 26.3 cm. Paris, Frits Lugt Collection (acquired in 1923).

group of Rembrandt etchings. He resold some of them, but
kept many for himself. These prints were of extremely high
quality, and later on, in 1924 and 1925, he also purchased
some eighteenth-century French prints from Prince Johann-
Georg. In that year he regularly journeyed to Vienna and
Dresden as well, to buy and exchange works of art. But the
museums of Berlin, Weimar, Munich, Aachen and Hamburg
were also eager to make exchanges at this time. Later on,
after Hitler's rise to power, they were urged to exchange
foreign drawings and prints for others by German artists.
The gallery of paintings in the Kunsthistorisches Museum,
Vienna, also wanted to part with five sixteenth-century
Flemish and seventeenth-century Dutch paintings. Lugt
exchanged these in June 1923 for a large dune landscape
by Philips Wouwerman. Four of them, including a view of

Rome with St Peter's under construction and a Tower of
Babel, can still be seen in Paris. They were inexpensive
and bore no illustrious names.[45]

Lugt resold most of the paintings he bought to D.G. van
Beuningen, A.F. Philips, J.W. Nienhuys, H.E. ten Cate,
G. Tellander and E.A. Veltman, all of whom belonged to
his established clientele. His father-in-law sometimes
bought paintings from him too. The renowned collector
Franz Koenigs joined this group of buyers in the 1920s.
 Lugt kept for himself small, signed and sometimes
dated paintings, often by lesser masters, but of excellent
quality, such as the four paintings from Vienna. They
were typical paintings for an art lover, who was also keen
on interesting provenances, purchased to embellish the
rooms in his private house. Lugt's preference was for works
that described the visible world: landscapes, portraits,
interiors and still lifes. Scenes from classical antiquity or
Greek mythology did not interest him; for the rest, he
purchased few if any Dutch Mannerist pieces, and the
Feinmaler of Leiden, too, are virtually absent from his
collection.

Another significant accomplishment in the 1920s was
Lugt's catalogue of the Édouard Warneck Collection, which
was auctioned at Galerie Georges Petit in Paris on 27 and
28 May 1926. Lugt had been personally acquainted with
Warneck, an art dealer, and visited him at his home, Hôtel
de Coigny. The house was reminiscent of the Paris of 1850,
wrote Lugt in his lively introduction to the catalogue. It
had no gas or electricity, but contained a fine collection of
Flemish and Dutch masters, built up over sixty years. A
former naval officer, who had lost an eye at the Battle of
Sebastopol in 1855, during the Crimean War, Warneck
detested 'le froid classement scientifique', and 'above all he
warned against overlooking small paintings, however simple
they may be'. Clearly a man after Lugt's heart. Besides five
Rembrandts – not one of which, however, is still attributed
to him today – Warneck owned an uncommonly fine kitchen
interior by Willem Kalf (cat.no.16) and a remarkable dune
landscape by Jacob van Ruisdael,[46] both of which Lugt
purchased for himself.

25

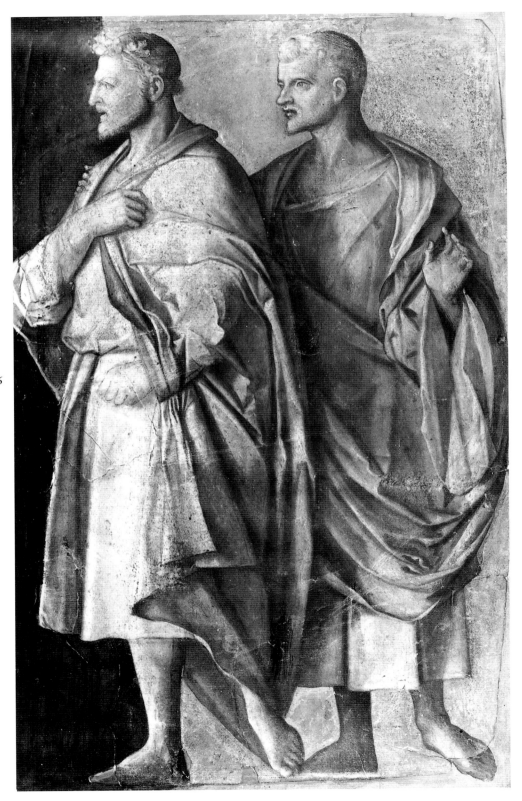

26

Giovanni Bellini, *Two men
standing*, c.1510. Brush with
watercolour and oil on
orange-brown tinted paper,
41.4 x 26.6 cm. Paris, Frits Lugt
Collection (acquired in 1929).

15 The houses at Lange Vijverberg 14 and 15 in The Hague in Lugt's day. Today Museum Bredius occupies no. 14, while no. 15 houses Hoogsteder & Hoogsteder Gallery. Photograph: Fondation Custodia Archives.

The Thirties and the Second World War

After the Wall Street crash of 1929, lean times were ahead for the art trade too. But the consequences did not make themselves felt straight away. In September 1929 Lugt made his second major coup at Luigi Grassi's in Florence: 61 old drawings and 120 medals and plaques. He resold many of them, but kept a number of Italian drawings, including an important study by Giovanni Bellini (fig. 14), for himself.[47] The catalogues for Paris took up much of his time, and he had to stay there for weeks at a time.

A cold wind of change now blew though the family fortunes. The couple's second son, Huib, died at the beginning of 1931, and besides this, there were new tensions between the Lugt family and Jacoba's father. Lugt decided

to move house. Together with his wife and children he left the idyllic *Rustenhoven* for ever, and in November 1931 the family moved into rooms at *Rief* guest house on Bezuidenhout in The Hague.[48]

It was probably only one year later that he had the chance to move his by then very impressive collection into the monumental building at Lange Vijverberg 14 (fig. 15), which today – by a curious whim of fate – houses Museum Bredius. The house behind it, at Hoge Nieuwstraat 25, became the new family home.[49] The building on the Lange Vijverberg was a few hundred yards from the Netherlands Institute for Art History, which had opened in 1932, and opposite the Mauritshuis. It was a site of great historical resonance, once the seat of the stadholders of Friesland. In those days, in the seventeenth century, the three houses at Lange Vijverberg 14-16 had constituted a single building; years later they were divided up into three houses.[50] Around 1900 Maison Artz art dealers had its premises at no. 14. Lugt must have known the building when he visited Bredius at the Mauritshuis.[51]

Trade declined sharply in the first half of the 1930s and Lugt too was buying far less for his collection. But his activities in art history continued unabated. He started, with several assistants, on a huge new project: the compilation of a *Répertoire des catalogues de ventes publiques intéressant l'art ou la curiosité*. The first volume, which was published in 1938, described and analysed 11,065 sale catalogues that had appeared between 1600 and 1825. Another two volumes would appear in 1953 and 1964, covering the catalogues that had appeared in 1826-1860 and 1861-1900, respectively.[52] These books too constitute an indispensable reference work for researchers, art dealers and collectors. Besides a formidable memory, Lugt had a great gift for systematisation and organisation. Nowadays no one would even attempt such a project without a computer.

On 8 November 1935, Joseph Klever died in Vienna, where he had made his home, leaving his daughter a sizeable inheritance. It made the life of the Lugt family a great deal easier. The building at Lange Vijverberg 14 could be bought, followed three years later by the house next door.[53] And suddenly another marvellous opportunity presented itself,

in the form of the auction of Henry Oppenheimer's famous collection of drawings in London in July 1936. Lugt and his wife could now bid without reservation.

From this time onward, Lugt no longer needed to pursue the art trade for a living; he was free to devote himself entirely to research and to expanding his collection. When the threat of war approached the Netherlands, he did not want to take the slightest risk. He sent his drawings and prints in sixty registered envelopes to neutral Switzerland, where they all arrived intact.

In the spring of 1940, Lugt left the Netherlands together with his wife and two daughters and travelled via Switzerland, the south of France, Spain and Portugal to the United States, where their eldest daughter Klaar was already living.[54] They settled in the university town of Oberlin, Ohio, where Lugt was able to continue his research. Also living and teaching in this quiet little town was the art historian Wolfgang Stechow, a friend of theirs and an authority on seventeenth-century Dutch landscapes.[55] It was he who had encouraged Lugt and his wife to settle here for the duration of the war in Europe.

Of the drawings that Lugt had not sent to Switzerland, about 120 vanished. Nor was he able to recover all his books and furniture after the war. A caretaker left to supervise the premises on the Lange Vijverberg had collaborated with the Germans and Lugt's property had been confiscated.[56]

Fondation Custodia

Since this introduction focuses on the origins of the Lugt Collection, and these origins lie largely between the two world wars, the biographical facts relating to the period after the Second World War will be dealt with selectively and very briefly.

In the autumn of 1945, Lugt and his wife boarded a ship for the return voyage to Europe. Accompanying them were fifty chests of books, catalogues, journals and reproductions, most of which were destined for the Institute for Art History in The Hague.[57] Now commenced the quest for their lost possessions. Lugt pursued it with the same perseverance and ingenuity that characterised everything he did, and often found what he was looking for.

Inspired by what they had seen in America, Lugt and his wife now threw all their energy into ensuring that their collection would be permanent and well protected, and that it would be under public ownership. In the United States, such private initiatives in the public interest, including those of collectors, are greatly appreciated and encouraged. This served as their example.

1947 was a landmark year; it was then that the collection was transferred to the Fondation Custodia. The next thing was to arrange suitable accommodation for a centre devoted to scholarship and the arts – no easy proposition in the Netherlands, as it turned out. But Lugt was not easily deterred, and devised interim solutions as he went along. According to the *Nederlandse Staatscourant* of 24 August 1950, Lange Vijverberg 14 would be open to all interested parties, free of charge, from 2 to 4 p.m. every Monday, Tuesday and Thursday,[58] 'provided visitors announce their intention to call beforehand and can show a letter of introduction'. The negotiations with the state of the Netherlands were grinding along at snail's pace, and Lugt and his wife decided to focus instead on Paris, where they were now living most of the time. In 1953 they seized the opportunity to buy the complex consisting of two impressive *hôtels*, one behind the other, at 121, Rue de Lille.[59] After years of thorough renovation, the collection was moved to the rear section, known as the Hôtel Turgot. The Institut Néerlandais opened its doors at the Hôtel Lévis-Mirepoix (the main entrance to which is on the Rue de Lille) on 11 January 1957. Two months later a large exhibition was mounted there – how could it have been otherwise – of drawings and etchings by Rembrandt and his school. Every single sheet came from the Lugt Collection, the show was limited to nineteen days because of the delicate state of the exhibits, and visitors flooded in.[60] Meanwhile, the academic work continued, and Lugt kept on making fresh acquisitions, buying paintings, and especially drawings and prints, which were now far more expensive than before the war.

In 1949, before he had found appropriate premises in Paris, he purchased *Winter landscape* by Jacob van Ruisdael (cat. no. 27) from a French dealer and *Mountain landscape with a bridge* by Jan Both from a dealer in London (cat. no. 6).

Van Ruisdael's winter scene is a unique piece, from an artist known mainly for wooded scenes and vast panoramas. Lugt had a penchant for the atypical. The Italian landscape by Jan Both is the first painting he purchased by an 'Italianate'. Prior to this he had mainly been interested in Dutch scenes: distant horizons with lofty skies, bleaching fields, riverside views and low dunes. Now, possibly because of his contact with Stechow, he had started to take an interest in Dutch painters who had travelled to Italy and tarried there, painting bright sunlight, mountains, Roman ruins and picturesque shepherds and vagrants.[61] In the eighteenth century these Italianate landscapes by Dutch painters had been in great demand – with British as well as Dutch collectors, as Lugt noted with interest. Then came a dip in their popularity that endured well into the twentieth century. So Lugt was a relatively early admirer. Yet it was not a southern landscape that he purchased by the Italianate Jan Asselijn, but a view of a few huntsmen on a snow-covered bridge over a frozen river (cat. no. 1), against a background of high trees, their branches heavy with snow. A wonderful painting, and again an atypical one. And by that painter of true Dutch landscapes Aelbert Cuyp, who never set foot in Italy, he purchased in 1953 a river landscape with steep rocks bathing in an Italian evening light (cat. no. 11) – no ordinary scene for Cuyp.

After purchasing the buildings on the Rue de Lille, Lugt went in search of large paintings to do justice to the high-ceilinged rooms of the Institut Néerlandais. His own cabinet pieces were lost in this vastness. He tried to acquire loans, and obtained some large Dutch and Flemish paintings on loan from the Rijksmuseum, the Mauritshuis and the Musée du Louvre. Meanwhile he remained alert to what was appearing on the market. In 1956 he bought a piece by Nicolaes Berchem, an Italianate, and again it was an atypical choice: *View of Loenen aan de Vecht, with Cronenburch castle* (cat. no. 4). This large painting provides a lyrical image of the famous Vecht region, where the Amsterdam patricians of the seventeenth and eighteenth centuries had their country homes. A little over six years later he purchased another large painting by Berchem, again from a London art dealer. This time it was a real Italian landscape complete with waterfall and a view of the temple of the Sybil at Tivoli.[62]

One of the last major acquisitions was *The council-of-war on board the Eendracht on 24 May 1665* by Willem van de Velde the Younger (cat. no. 33). He had purchased this impressive seascape at Frederik Muller's for the collector August Janssen back in 1913, and he knew exactly where it had gone after Janssen's death – to a private individual who would not loan it to him. After this owner's death in 1965 he had the opportunity to secure this painted moment of Dutch history for himself. By then the prices on the art market were so high that he had to sell a drawing by Dürer for it.[63]

Lugt was now in his eighties, but his zest for work was undiminished. He had appointed a keeper for his collection, Carlos van Hasselt, who helped with exhibitions and publications. Lugt also cooperated on a number of important exhibitions for the Institut Néerlandais and the Musée des Arts Decoratifs (*La Vie en Hollande au XVIIe siècle*) as well as the Musée du Louvre (*Le Cabinet d'un Grand Amateur: P.-J. Mariette 1694-1774*), both in 1967.

The introduction to the catalogue for Mariette has the air of a personal statement, unusual for this taciturn man who had been called 'meticulously polite' and 'decidedly stiff'.[64] In the form of a letter to his illustrious predecessor, Lugt expresses his gratitude for Mariette's inspiring example. The letter opens with the words 'Mon cher grand Patron' and is signed 'votre très humble et très obéissant arrière-petit-fils'.

Jacoba Lugt died in the summer of 1969, and her husband followed her to the grave less than one year later, on 15 July, the day of Rembrandt's birth. In the year of his death Frits Lugt mounted an exhibition of Rembrandt's finest etchings in the Louvre, and sixty paintings and drawings by Saenredam were shown at the Institut Néerlandais the following year. Lugt died with his boots on, as they say. By then the core of his collection consisted of about six thousand drawings, thirty thousand prints and two hundred paintings.

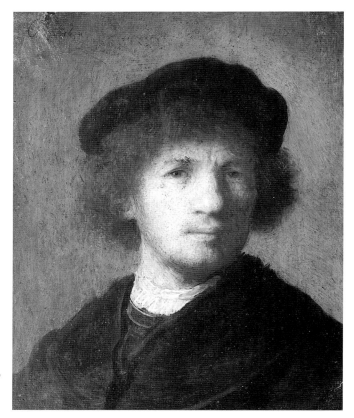

16 Rembrandt, *Self-portrait*, 1630. Copper, 15 x 12.2 cm. Stockholm, Nationalmuseum (acquired in 1956).

Paintings

What kind of paintings interested Lugt most? He loved the Dutch Golden Age – the Republic's early years in particular, rather than the end of the period, when the style of painting had become smooth and 'accomplished'. Artists such as the late Pieter de Hooch and Eglon van der Neer displayed Dutch burghers parading their wealth in sumptuous interiors. Himself a man of abstemious and frugal habits, Lugt loathed such ostentation.

Lugt looked on the seventeenth century in much the same way as the French writers of the eighteenth and nineteenth centuries. Denis Diderot, an admirer of the Republic, firmly believed that Holland's prosperity came from hard work, sober living, virtuousness and marital fidelity.[65] Nineteenth-century art historians such as Theophile Thoré ascribed the same qualities to the Dutch and saw them

reflected in paintings by Metsu and Vermeer. The painted interiors of Jacobus Vrel and Esaias Boursse, which Lugt purchased in 1918 and 1938 respectively (cat. nos. 7 and 35), capture so well that simplicity, care and attention that were exemplified – as Lugt himself would doubtless have agreed – by the industrious seventeenth-century Dutch burgher. Lugt had no taste for scenes of merry feasts, and if he occasionally purchased one, such as *Guests on Shrove Tuesday* by Dirck Hals, it depicted the restrained end of the partying scale.[66] Genre pieces with courting scenes, full of erotic allusions, are also absent from his collection, as one would expect. Landscapes, portraits, still lifes, animal pieces, seascapes and church interiors were his great loves.

In the trade, a business he conducted chiefly between the two World Wars, he applied an extra criterion: big names, such as Rembrandt, Bol, Rubens and Steen. Works by every one of them passed through his hands. Saenredam's light shone far less brightly then than it does today, but Lugt was one of the first to recognise the unique and outstanding quality of his paintings. He owned at least eight of them at various times, one of which, *The choir of the Church of St Bavo in Haarlem, seen from the Christmas Chapel*, purchased in 1919, he kept for himself (cat. no. 28).

Before 1931 Lugt had two big names in his own collection. He will have taken most pride in Rembrandt's self-portrait (fig. 16), which he had purchased from the art dealer J. Gruyer in Paris on 3 March 1924. It cost him 17,250 guilders,[67] no mean sum, but these were halcyon days. He lived at the beautiful, stately mansion of *Rustenhoven* and had several excellent clients. The self-portrait executed on copper, with the early date of 1630, is almost the same size as a postcard, 15 x 12.2 cm. It hung downstairs in the living room of the great house.[68] Lugt's father-in-law Joseph Klever took it with him to Vienna in 1931, after which it was shown for the first time in 1956, in the Rembrandt exhibition at the Nationalmuseum, Stockholm. Then the museum purchased the little self-portrait, the authorship of which was questioned by the Rembrandt Research Project (although an attribution 'must not be ruled out').[69] Lugt was not mistaken. After restoration and in particular the exhibition *Rembrandt by himself*, held in London and The Hague in 1999-2000, the work's authenticity is no longer challenged.[70]

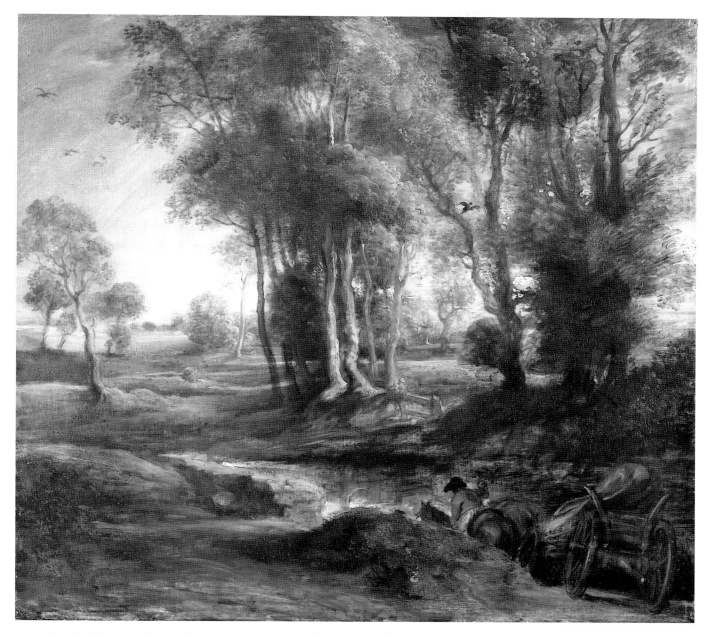

17 Peter Paul Rubens, *Landscape with a wagon at sunset*, c.1635. Panel, 49.5 x 54.7 cm. Rotterdam, Museum Boijmans Van Beuningen (acquired in 1958).

Another 'big name' hung at *Rustenhoven*, in the dining room: *Evening landscape with drunken peasants* by Rubens. Lugt had purchased this painting from a London art dealer on 30 January 1920.[71] His father-in-law took this piece too with him when he moved to Vienna, since he had put up the money for the purchase. After this it went missing. On

23 June 1927 Lugt purchased another painting by Rubens directly from the heirs of the famous collection of the Earl of Northbrook in London. He made a real coup there, acquiring not only *Landscape with a wagon at sunset* by Rubens (fig. 17), but several other paintings including Ferdinand Bol's *Pearl necklace* and *Revolt at school* by

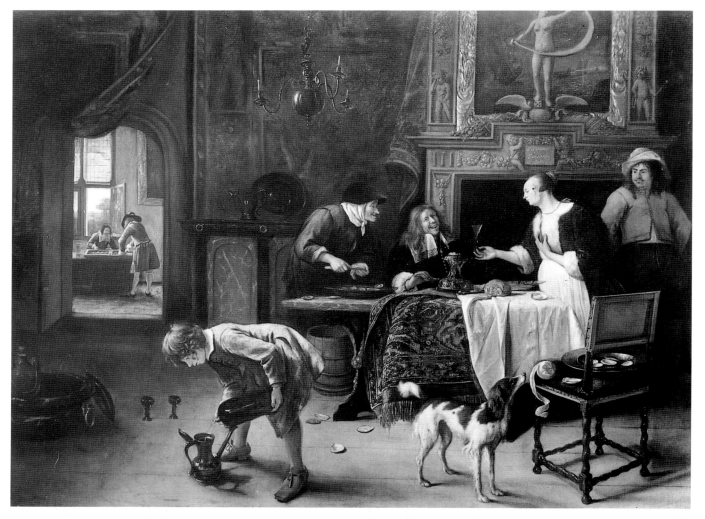

18 Jan Steen, *'Easy come, easy go'* *('Soo gewonne, soo verteert')*, 1661. Canvas, 79 x 104 cm. Rotterdam, Museum Boijmans Van Beuningen (acquired in 1958).

Jan Steen. He resold the Rubens at the beginning of July 1927 to Franz Koenigs, after which the work ended up, via D.G. van Beuningen, in Museum Boijmans Van Beuningen, Rotterdam.[72] Lugt resold the Bol to A.F. Philips, in whose collection it is still preserved today, but the whereabouts of the Steen, which he also resold quite quickly to P. van Leeuwen Boomkamp, cannot be traced at present.[73] Lugt took a special interest in Jan Steen. He purchased several paintings by him in the 1920s, some even earlier, which he resold (cf. fig. 8). The most striking of these is the large painting *'Easy come, easy go'* which he purchased at the Neumann auction held at

Colnaghi's in London on 4 July 1919. At 50,254 guilders it was an expensive piece, and he resold it a little over a month later to D.G. van Beuningen. This painting too is now housed in Museum Boijmans Van Beuningen (fig. 18).

Paintings by Steen were much in demand at the time, and hence expensive. Lugt kept two for himself: *The writing lesson*, which he was able to buy cheaply from Carl Löwe in Berlin on 21 December 1917, and *Dovecote*, which he purchased from a Parisian art dealer in 1938. Today, connoisseurs have challenged the authenticity of both. Still, they remain remarkable little paintings.[74]

Saenredam

Saenredam was another favourite among eighteenth-century collectors and art dealers. Later on, the painter slipped into obscurity. The art historian Hofstede de Groot, a contemporary and acquaintance of Lugt, revived interest in this artist at the end of the nineteenth century, but chiefly valued his drawings. The tide of appreciation changed in the 1920s and 1930s, with the appearance of several publications on Saenredam, and one noteworthy exhibition in Rotterdam (1937-1938).[75] Lugt was one of the rediscoverers. In April 1918 he purchased his first work by the artist, an interior of the Church of St Mary in Utrecht. He acquired this large drawing for 812 guilders, a considerable sum because it was fully elaborated and had a topographical subject.[76] Drawings of this kind, for which Lugt too had an affection, raised relatively high prices in this period. This one was in black chalk, touched with pen and brown ink, came from the collection of E.J. Poynter, and was sold at Sotheby's on 24 April 1918.[77]

A little over one year later, Lugt purchased his first painting by Saenredam. It was a work he knew well, having once advised the collector August Janssen to buy it. Now the Amsterdam art dealer Goudstikker was offering it for sale. Lugt purchased *The choir of the Church of St Bavo in Haarlem, seen from the Christmas Chapel*, from 1636, for 3,500 guilders (cat. no. 28).[78] For *Skaters on the river Merwede near Dordrecht* by Jan van Goyen, another of Lugt's favourite artists, also originally from the Janssen Collection and now, in 1919, being offered for sale by Goudstikker, he paid the sum of 12,000 guilders. These prices show that Saenredam, in contrast to Van Goyen, was not yet highly regarded in the art world at the time. In the 1920s Lugt was particularly fortunate in acquiring paintings by Saenredam. The best year of all was 1927. In total he was able to gain possession of six paintings by the master. This is a particularly impressive number given the modest size of Saenredam's oeuvre. In January 1927 he purchased three paintings from the art dealer Paterson in London in the space of one day. He also bought a splendid nineteenth-century view of Venice by Bonington and two watercolours, church interiors, by the nineteenth-century artist Bosboom. When Lugt could acquire a fine work of art for a reasonable price, he did not restrict his focus to

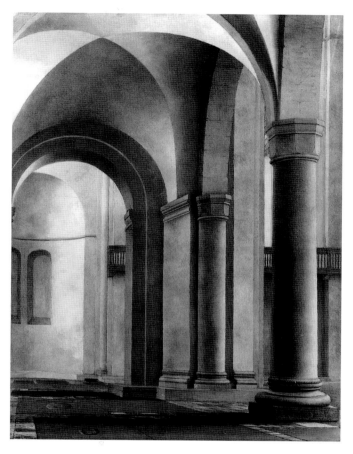

19 Pieter Saenredam, *Northern aisle of the Church of St Mary, Utrecht*, 1651. Panel, 48.6 x 35.8 cm. Los Angeles, Collection of Mr and Mrs Edward William Carter (acquired in 1977).

the Dutch Golden Age. All these paintings, which were of exceptionally high quality, derived from the collection of W.A. Coats in Edinburgh. He purchased a work by Saenredam that was then known as 'View in the Church of Our Lady', from 1651 (fig. 19),[79] along with 'View in a church interior (Haarlem)', dated 1654 (fig. 20) and 'Small round view in St Bavo's, Haarlem'. 'View in the Church of Our Lady' cost him 5,000 guilders, while the little circular painting went for 500 guilders; the third was priced in between.[80]

A month later Lugt discovered another Saenredam at Arthur Tooth & Sons, again in London: 'Haarlem town hall with troops marching past', then attributed to Gerrit Berckheyde. It came from the collection of the renowned

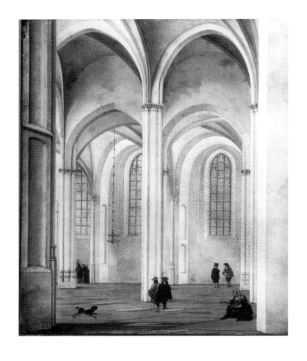

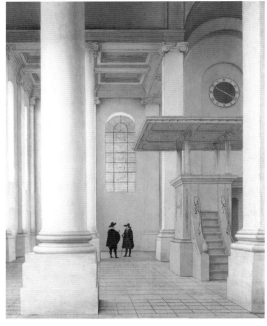

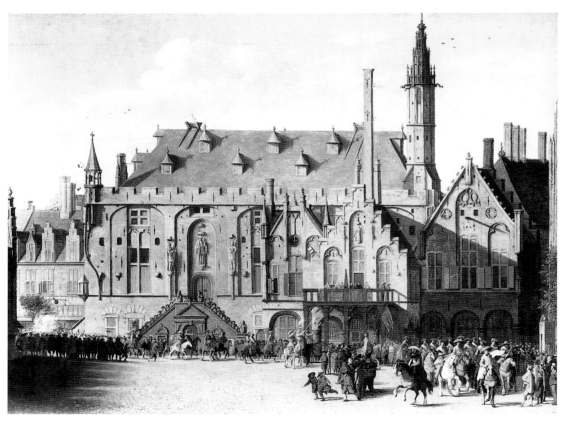

20
Pieter Saenredam,
*Nave of the Buurkerk,
Utrecht,* 1654.
Panel, 40.7 x 33.5 cm.
Private collection.

21
Pieter Saenredam,
*Interior of the Nieuwe
Kerk, or Church of
St Anne, Haarlem, c.*1655.
Panel, 43.5 x 35 cm.
Enschede, Rijksmuseum
Twenthe (on loan from
a private collection).

22
Pieter Saenredam,
*Haarlem town hall, with
Prince Maurits arriving
to replace the city council
in the foreground, c.*1630.
Panel, 38.5 x 49.5 cm.
Private collection.

eighteenth-century Baron van Leyden and is now once more in a private collection (fig. 22).[81] That same year he purchased from Douwes art dealers in Amsterdam 'Interior of St Anne's Church, Haarlem, with pulpit', which he sold to M.G. van Heel in Rijssen and which is now to be seen at the Rijksmuseum Twenthe (fig. 21).[82]

It seems that J.W. Nienhuys, one of Lugt's best customers, also took an interest in Saenredam. That same year Lugt managed to acquire, again from Douwes, 'The Church of Our Lady, Utrecht, from the outside with a view of the choir', from 1659 (fig. 24). One year later he purchased another Saenredam from Van Diemen & Co gallery in Berlin for the same collector: 'Interior of St Peter's Church, Utrecht', dated 1654 (fig. 23). Years later, in 1966, after the death of Nienhuys's widow, the couple's sons enlisted Lugt's help to advise them on the donation and sale, respectively, of these two paintings to the state of the Netherlands. They wanted to donate the interior of St Peter's, stipulating that the painting should preferably be displayed in the Frans Halsmuseum, Haarlem, in which city their mother had spent many years of her life. They offered the external view of the Church of Our Lady for sale to the Mauritshuis, a state-funded museum.[83] At 600,000 guilders the price was reasonable for the time, and they chose this museum because it was celebrating its 150th anniversary that year. Their donation was accepted and the Mauritshuis too agreed to the terms. The latter painting occupies a unique place in Saenredam's oeuvre.

The last exhibition that Lugt organised in the year of his death, for the Institut Néerlandais – it opened to the public in January 1970 – was *Saenredam 1597-1665: Peintre des Églises*. In the introduction to its catalogue he wrote, 'These drawings [and paintings] are like a confession of a tender soul, ever seeking to give of his best, and not to err'.[84] Lugt loved this artist's precision, commitment and gravity. They were characteristics that applied to him too.

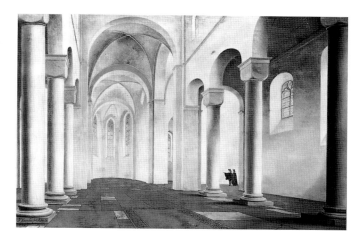

23 Pieter Saenredam, *Nave and choir of the Church of St Peter, Utrecht*, 1654. Panel, 50 x 72.5 cm. Haarlem, Frans Halsmuseum (on loan from the Netherlands Institute for Cultural Heritage, Amsterdam/Rijswijk since 1966).

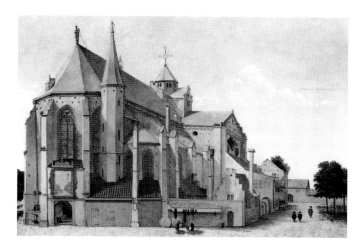

24 Pieter Saenredam, *The Mariaplaats with the Church of St Mary, Utrecht*, 1659. Panel, 44 x 63 cm. The Hague, Royal Cabinet of Paintings Mauritshuis (acquired in 1966 with the support of the Rembrandt Society, the Prince Bernhard Fund, the Johan Maurits van Nassau Foundation and the 'Openbaar Kunstbezit' Foundation).

25
Letter from Rembrandt to Constantijn
Huygens (Amsterdam, January 1639), one
of the seven letters by the artist that have
been preserved. Paris, Frits Lugt
Collection (acquired in 1918).

26
Fragments of letters from Titian, Mariette
and Michelangelo. Paris, Frits Lugt
Collection (acquired in 1939, 1936 and
1949 respectively).

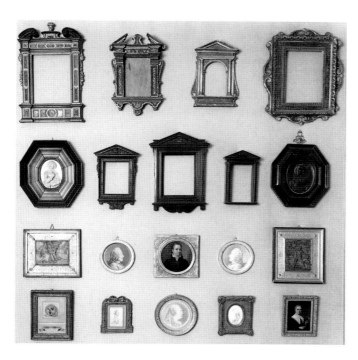

27 Wall with frames and miniature portraits in the safe where the prints and drawings are kept. Photograph: Fondation Custodia Archives.

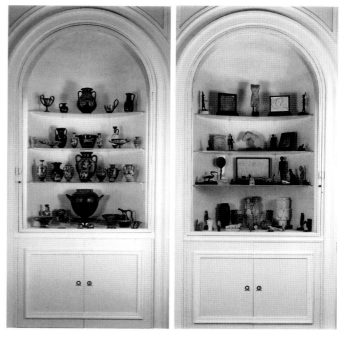

28-29 Display cases with Greek vases and Egyptian antiquities in the entrance hall of the Hôtel Turgot. Photographs: Fondation Custodia Archives.

The situation today

Any present-day visitor to the eighteenth-century Hôtel Turgot at 121, Rue de Lille will marvel at the tranquillity and beauty that reign there, amid an atmosphere of studiousness and meticulous care. Upon request, the interested caller can inspect drawings or prints at a table by the window looking out onto the gardens, where grey lead pelicans perch at the edge of a pond, poised as if to catch fish. Sometimes this imposing building is the venue for small exhibitions from its own collection. At such times artists' letters (figs. 25-26), watercolours, sketchbooks, drawings and prints, all selected for their common theme, are displayed in display cases in the entrance hall. Or they may be hung on the high walls in beautiful old frames (fig. 27), one of Lugt's great passions. In the corners of this entrance hall Roman glassware, Greek black-figure and red-figure vases, dishes and jugs and Egyptian jewels are shown in display cases (figs. 28-29). These too Lugt and his wife collected, not as systematically as drawings and prints, but as the occasion arose, to put in their home and to enjoy. Even while on honeymoon in North Africa in 1910 they combed the antique stalls, especially in Cairo, for small, singular objects. They continued to do so for years, being collectors by inmost need.

Mària van Berge-Gerbaud is now the director of the Fondation Custodia, having taken over from Carlos van Hasselt in 1994. Van Hasselt, another original connoisseur, had been appointed by Lugt and had expanded the collection highly inventively with items such as Indian miniatures, artists' letters, and drawings by French and Danish artists of the eighteenth and nineteenth centuries. During his term of office the market thinned out and prices soared. To purchase drawings of high quality, Lugt's main criterion, became well-nigh impossible for a private institution. Yet the Fondation Custodia did it, and still does today.

The director's office, dubbed the 'Dutch room', still looks roughly as it did in Lugt's day. It is fuller though, with a laptop on the desk, and some of the paintings have been rehung. The black and white marble tiled floor recalls seventeenth-century paintings of Dutch interiors. Shelves of old books are ranged along the walls and a small seventeenth-century bookcase holds works by Erasmus, Junius, Heinsius and Huygens. The Dutch fireplace in the office is a copy, but its tiles are authentic seventeenth-century, and can be seen in the painting by Esaias Boursse (cat. no. 7) on the opposite wall. For the rest, there are seascapes, beach views and portraits.

Adjoining this room is a kind of connecting room, where tiny paintings in tortoiseshell and ebony frames have been hung in two rows, one above the other (fig. p. 6). A summer scene by Avercamp (cat. no. 2), a winter scene by Jan van de Velde, *Woman at a window, waving at a girl* by Jacob Vrel (cat. no. 35) and *An artist and a connoisseur in conversation* formely attributed to Pieter Codde (cat. no. 10) – intimate cabinet pieces. Standing against the wall are a small seventeenth-century Dutch cupboard and imitation seventeenth-century chairs with lion's heads. At the rear is a room, or rather sanctuary, known as the 'safe'; a narrow space with shelves on both sides accommodating albums bound in red, brown or reddish-brown leather, with an occasional inscription in gold (fig. 1). Some once belonged to famous collectors before Lugt – Louis XIV, Cornelis Ploos van Amstel, or William Esdaile. It is in these superb

albums that the drawings are preserved. This is quite unique. Not a single print room still keeps its drawings in this way. It is an eighteenth-century tradition, which is immensely labour-intensive and irreconcilable with large numbers of visitors. Here in the 'safe' the sheets are classified by subject: landscapes, animal pieces, seascapes and figure studies. The drawings of Rembrandt, the school of Rembrandt, Van Dyck and Rubens each have separate albums. Yet time has not stood still altogether. 'Modern' French, Danish and Dutch drawings and Indian miniatures are kept in non-acidic passe-partouts in boxes lined with dark red linen, classified by country and name.

Mària van Berge and her staff dedicate themselves imaginatively and with true devotion to maintaining Lugt's life's work. Van Berge buys drawings, arranges loans, gives lectures all over the world and mounts exhibitions accompanied by superbly produced catalogues. She recently embarked on a joint initiative with the Musée du Louvre and the Netherlands Institute for Art History to issue a new edition, brought up to date, of *Les marques de collections de dessins & d'estampes*, which Lugt published in 1921 and furnished with a *Supplément* in 1956. This time all the wonders of computer technology can be used, but the new publication is nonetheless a mammoth task in the best tradition of Lugt. For researchers, art dealers, collectors and art lovers alike, it will once more be an indispensable resource.

> Frits Lugt in his foreword to the catalogue of the exhibition on the eighteenth-century collector Pierre-Jean Mariette (1694-1774).* This dealer, collector and connoisseur was Lugt's great example and 'bien cher Patron' throughout his life.

'Il ne s'agit pas d'amasser,

mais de choisir'

('The point is not to accumulate, but to make choices')

Jan Asselijn

Dieppe c.1610/14-1652 Amsterdam

1 *Winter landscape with huntsmen on a bridge, c.1647*

Canvas on panel,[1] 49.7 x 35.8 cm / Monogrammed at lower right: *JA* (in ligature) / Acquired in 1953

Provenance

Jan Jacob de Bruyn, Amsterdam (sale Amsterdam, Van der Schley-Roos, 12 September 1798, lot 2, for 345 guilders to Van der Werff);[2] Arend van der Werff van Zuidland (d.1807), Dordrecht (sale Dordrecht, Versteegh-Schouman, 31 July 1811 and following days, lot 1, for 175 guilders to Meulemans);[3] Adriaan Meulemans (1766-1835);[4] Jan Hulswit (1766-1822), Amsterdam (sale Amsterdam, De Vries-Roos, 28 October 1822, lot 2, for 285 guilders to Brondgeest);[5] Albertus Brondgeest (1786-1849), Amsterdam;[6] Richard Le Poer (1767-1837), Second Earl of Clancarty, Marquis of Heusden; Lady Katherine Anne Le Poer Trench (1871-1953), by inheritance (sale London, Christie, Manson & Woods, 10 July 1953, lot 31, for 157 guineas and 10 shillings to Charles Duits for Lugt);[7] Frits Lugt, Paris; inv. no. 6611

Exhibitions

Paris 1983, no. 2; Atlanta 1985, no. 1; The Hague 2001-2002, no. 2

Literature

Steland-Stief 1963, vol. 1, pp. 83-84, 85, vol. 2, unpaginated, no. 232; Van Gelder 1964, p. 23 (ill.); Steland-Stief 1964, p. 102 note 13; Stechow 1966, pp. 91-92, 203 note 37 and fig. 180; Steland-Stief 1970, pp. 61-62 and fig. 4; Steland-Stief 1971, pp. 55-56, 163, no. 232, fig. XXII; Nash 1972, fig. 94; Slive 1974, vol. 1, pp. 77, 78 note 1; S. Nihom-Nijstad in Paris 1983, pp. 5-6, no. 2 and fig. 23; Faton 1983, p. 67 (ill.); Hecht 1984, p. 357; F.J. Duparc in Atlanta 1985, pp. 16-17, no. 1 (ill.); König 1985, p. 3323; Kingzett 1986, p. 21; P.C. Sutton in Amsterdam-Boston-Philadelphia 1987-1988, p. 43, fig. 57; A. Chong in *idem*, p. 251 and note 3; B. Broos in The Hague-San Francisco 1990-1991, p. 139 note 15; Priem 1997, p. 146 and fig. 47; A. van Suchtelen in The Hague 2001-2002, pp. 74-75, no. 2, pp. 90, 158 (ill.; detail on p. 155)

Jan Asselijn, one of the many Dutch painters who undertook a trip to Italy in the seventeenth century, is celebrated for his sun-drenched, Italianate landscapes.[8] The painting shown here, which bears the artist's characteristic monogram at lower right, is one of his few winter scenes. While Asselijn generally bathed his landscapes in southern sunlight, winter scenes gave him an opportunity to experiment with dark skies in which the sun is breaking through. Today a total of four paintings by Asselijn in this genre are known, and old accounts refer to two others attributed to him.[9] The painter's earliest winter landscape is an undated painting in St Petersburg (fig. 1a), which was conceived, following an old tradition, as a pendant to a summer landscape.[10] The two pendants were probably made a little earlier than the work described here, and are among the paintings that the artist produced shortly after his return to the Netherlands.[11] Dating the painting in the Frits Lugt Collection is no easy task given that very few of Asselijn's known paintings are dated.[12] Not one is dated in the years between 1635 and 1646, when he was working in Italy and France.

However, it seems likely that most of his oeuvre, like that of other Italianate painters, was produced in the Netherlands.[13] The painting discussed here – with its typically Dutch subject – was probably made in Amsterdam, where he settled in 1646 or 1647, and where Rembrandt (1606-1669) etched his portrait around 1647.[14]

Together with Nicolaes Berchem (cat.no.4), Jan Both (cat.no.6) and Jan Baptist Weenix (1621-1660/61), Asselijn is considered one of the most original and influential figures of the second generation of Italianate painters. Born in Dieppe, France, he came to Amsterdam in 1621, where he evidently trained with Jan Martszen the Younger (c.1609-after 1647), as can be inferred from his earliest dated works from 1634 and 1635, depicting cavalry battles.[15] Shortly after November 1635 he probably left and travelled through France to Rome, where he joined the *Bentvueghels* ('birds of a flock'). This unofficial group of painters from northern Europe would often hold a party to celebrate the arrival of fellow painters in Rome, giving the new members nicknames or 'bent-names'.[16] Asselijn found himself dubbed unflatteringly

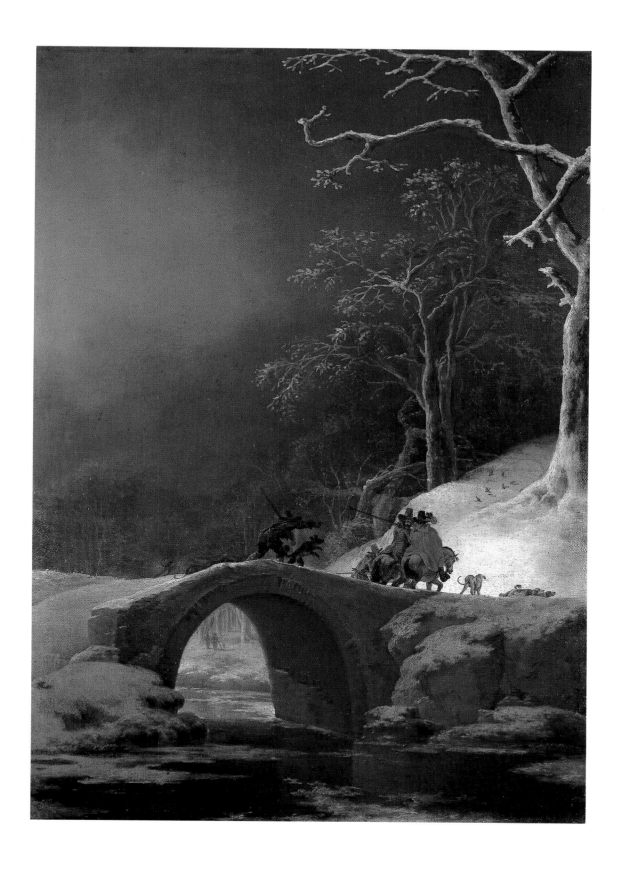

1a

1b

1c

1a Jan Asselijn, *Winter landscape with figures*, c.1647. Copper, 15 x 38 cm.
 St Petersburg, Hermitage (acquired in 1920).
1b Jan Asselijn, *Frozen canal near city walls*, c.1647-1650. Canvas,
 67.4 x 106 cm. Worcester, Massachusetts, Worcester Art Museum
 (acquired in 1969).
1c Jan Asselijn, *Frozen river*, c.1650. Canvas, 66.8 x 81.5 cm.
 Formerly Schwerin, Staatliches Museum (lost in 1945).

'Krabbetje' (little crab), on account of his deformed left hand. In the Italian capital he produced drawn and painted copies after, and variations of, everyday scenes of Italian life by influential artists such as Pieter van Laer (1599-after 1642), and Jan (c.1618-1652) and Andries Both (1606/12-1641).[17] But as time passed, he increasingly focused on landscapes with ruins, herdsmen and cattle, panoramic vistas, river scenes with bridges and even sea views. Back in the Netherlands, Asselijn adapted to the latest trends in landscape painting, while he in turn influenced other artists, most notably the Amsterdam painter Willem Schellinks (1634-1678).[18] A certain interplay seems to be discernible between Asselijn's work and that of Nicolaes Berchem (1620-1683), who also made his reputation with Italianate scenes.[19] Berchem was one of the few other Italianate painters who occasionally turned his hand to winter scenes.[20] Asselijn's large painted winter landscape at Worcester (fig. 1b), which was probably made not long after the painting shown here, is even linked to a similar picture by Berchem from 1647 (Amsterdam, Rijksmuseum).[21] However, it is unclear whether Berchem's painting served as an example for Asselijn's undated work, as some recent scholars continue to assume, or vice versa.[22] A fourth winter landscape that may have been completed around 1650 (fig. 1c), is now known only from old photographs,[23] as it was lost in 1945. One of the buildings in this painting, which is very similar to the landscape in Worcester, is based on the circular tomb of Caecilia Metella, a famous ancient monument in Rome. In the wintry landscape it has been placed rather inconspicuously on the far left. The monument is an unusual pictorial element in this context, since although Asselijn frequently inserted recognisable Italian buildings or ruins into his Italianate landscapes, he did not do so in any of his other winter scenes.[24] A winter landscape signed in full by the artist Schellinks (private collection), whose work was often attributed to Asselijn in the past, is one of the few examples in the genre depicting several Roman buildings, set on the banks of an incongruously frozen Tiber. The bridge in Schellinks' painting is immediately identifiable as the Ponte Molle, a well-known motif in the work of the Italianate painters, while the tomb of Caecilia Metella is again visible behind it.[25]

In the *Winter landscape with huntsmen on a bridge* the architecture has been kept to a minimum. Here, the simple bridge is the primary motif because of the painter's choice of a low vantage point. Bridges were popular with Asselijn, occurring in over one-tenth of the 250 paintings known by him.[26] Here, the stone structure ingeniously separates foreground from background. Under the arch, which is convincingly reflected in the frozen water,[27] two walking figures can only just be made out. The hunting company on the bridge, on the other hand, instantly attracts the viewer's attention. Two servants accompanying two mounted huntsmen are marshalling a pack of dogs. The clothing of the four figures, and one huntsman's red cloak in particular,[28] add lively colour accents to the scene, which is otherwise dominated by snow and ice. Perhaps the painter deliberately rendered the horses too small, to allow the front three figures to be silhouetted against the snow-clad hill. Some birds are searching for food between the two trees, a traditional motif in winter landscapes that is found as early as the famous calendar scenes in *Les très riches heures du Duc de Berry* from the second decade of the fifteenth century (Chantilly, Musée Condé), traditionally attributed to the Limbourg brothers.[29] The narrative elements of the scene – the birds and the huntsmen, motifs that Pieter Bruegel the Elder (*c*.1520/25-1569) had included in his famous winter landscape as early as 1565 –[30] are dominated by the landscape, however: the snow-clad twigs of the trees on the right stand out clearly against the dark sky, and the branches of the enormous tree at far right are abruptly cut off by the edge of the picture.[31] The trees in the left half of the scene, on the other hand, are painted in rather soft tones, while the sun breaks through above. The vertical format is an unusual choice; landscape painters usually gravitate almost automatically to a horizontal format.[32] Asselijn often used the vertical format to enhance architectural elements, which play an important role in his landscapes. Here the shape of the support emphasises the monumental character of the trees.

The painting is a very successful example of a seventeenth-century 'wintertje' (winter scene), a popular genre among Dutch painters.[33] With its dramatic light-dark effects and refined palette, it can be regarded as one of the early high points in the painter's oeuvre and possibly as his subtlest winter landscape.[34] While the impact of other artists' winter scenes is often weakened by an abundance of figures and details,[35] Asselijn has kept the staffage to a minimum, so that nothing detracts from the monumentality of his composition. It is therefore not surprising that this painting, the provenance of which can be traced back to the eighteenth century, for a long time enjoyed a certain fame among collectors.[36]

Frits Lugt acquired *Winter landscape with huntsmen on a bridge* through Charles Duits, who purchased it on his behalf at a public sale. The London-based art dealer, from whom Lugt would buy at least three other paintings,[37] had already sold Asselijn's largest winter scene to an English private collector in 1950, prior to its acquisition by the museum in Worcester in 1969 (fig. 1b).[38] Lugt knew this painting and jotted down his verdict in 1950: 'good, but stiff in composition'.[39] In 1953 he would eventually purchase the painting described here for his collection, which also included winter landscapes by Jan van Goyen (1590-1656), Isack van Ostade (1621-1649), Jan van de Capelle (cat. no. 9), Jacob van Ruisdael (cat. no. 27) and Antonie Verstralen (1593/94-1641).[40] It is typical of Lugt's taste that besides characteristic paintings by Italianate landscape painters – Both, Berchem, Bartholomeus Breenbergh (1598-1657), Karel du Jardin (cat. no. 15), Willem Romeyn (*c*.1624-after 1694) and Adriaen van de Velde (cat. no. 32) –[41] he also added uncharacteristic works by this group of artists to his collection. For besides this rare winter landscape by Asselijn he also secured Berchem's rare view of Loenen (cat. no. 4) in 1956. On the other hand, the two drawings in the Frits Lugt Collection that are attributed to Asselijn – one sheet is definitely by him – display the usual Italian buildings.[42] *QB*

43

Hendrick Avercamp

Amsterdam 1585-1634 Kampen

2 *Riverscape at Kampen, c.1620-1625*

Panel, 24 x 39.2 cm / Acquired in 1926

Provenance

Hermann Emden, Hamburg (sale Berlin, Lepke, 3 May 1910, lot 38);[1] probably E. Douwes, art dealer, Amsterdam; Asscher, Koetser & Welker, art dealers, London; Frits Lugt, Maartensdijk and Paris, purchased from Asscher *et al.* on 30 October 1926; inv. no. 2689

Exhibitions

Rotterdam 1927-1928, no. 2; The Hague 1946, no. 12; Kampen 1949, no. 10; Paris 1950-1951, no. 4; Paris 1967, no. 56; Paris 1983, no. 3; Paris 1989, no. 1

Literature

Zwartendijk 1928, fig. p. 68; Koomen 1932, fig. p. 173; Welcker 1933, p. 232, no. S V (identical to no. S 327) and fig. III; Van Gelder 1934, p. 78; Bruyn 1950 (ill.); Bloch 1951, p. 167 and fig. 26; Leymarie 1956, p. 82; Van Gelder 1959, fig. 7; Gudlaugsson 1964a, pp. 158-159 (ill.); Berlin 1974, p. 3 (under no. 4); Reitsma 1976, p. 251, fig. 4, pp. 253-254; Welcker ed. Hensbroek-van der Poel 1979, pp. 215, 232, 241, no. S 71.1 (identical to nos. S 327 and S V); S. Nihom-Nijstad in Paris 1983, pp. 6-8, no. 3 and fig. 12; Charensol 1983, fig. p. 433; Dauriac 1983, fig. p. 279; Brown 1984, pp. 89-90 (ill.); Hecht 1984, p. 357; M. van Berge-Gerbaud in Paris 1989, p. XIII; C. van Hasselt in *idem*, pp. 3-4, no. 1 and fig. 1; Dunthorne 1991, fig. p. 30; D.B. Hensbroek-van der Poel in *Allgemeines Künstler-Lexikon*, vol. 5 (1992), p. 729; White-Crawley 1994, p. 164 (under no. 263)

Hendrick Avercamp was born in Amsterdam, where his father worked as a teacher and apothecary.[2] In 1585 the family moved to Kampen, where Avercamp senior had been appointed town apothecary and where he would later become town surgeon. His son was deaf and dumb and is therefore referred to in documents – and in older auction catalogues as well – as 'de stom(me)' or 'de stomme van Kampen'. He was probably sent back to Amsterdam to study with Pieter Isaacksz (1569-1625), but may have returned to Kampen following the latter's move to Denmark in 1607. Avercamp's early work was strongly influenced by the Flemish landscape tradition, and it seems possible that he also trained with one of the southern Netherlandish emigrant artists, for example David Vinckboons (1576-c.1632). We know that by early 1613 he was back in Kampen, however, where he would spend the rest of his life.[3] Avercamp remained unmarried and was referred to by his mother in 1633 as her 'mute and needy son', allowing her to bequeath him a yearly allowance. Notwithstanding, his work was much sought after and expensive. He was a friend of

the Kampen wine merchant and amateur artist Gerrit van der Horst (1581/82-1629), and taught his nephew and follower Barent Avercamp (1612/13-1679) how to paint. His precise relationship with the Amsterdam painter Arent Arentsz, called Cabel (1585/86-1635), who imitated his work and seems to have had access to his drawings, remains unclear.

Avercamp worked solely as a landscape painter. His oeuvre consists primarily of winter scenes in the tradition of Pieter Bruegel the Elder (c.1525/30-1569), enlivened – particularly early on – with countless tiny figures. Summer landscapes, such as the one described here, are far less common, and are mainly found among the artist's highly finished drawings, which he worked up in watercolour or gouache. Among the paintings in this genre the most important is an atmospheric riverscape dating to the last decade of the artist's career (fig. 2a).[4]

The work in the Frits Lugt Collection also depicts a watery scene: a lake or river arm, with submerged spits of land and little islets, and, on the right, a dike with a road. Humans and animals are strewn along the various

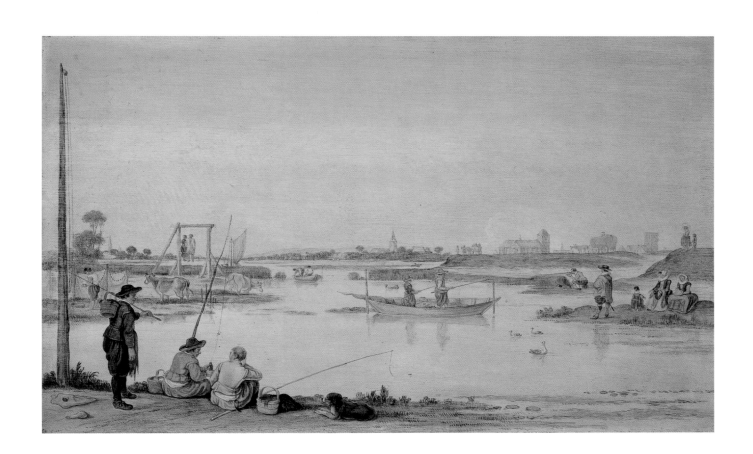

2a Hendrick Avercamp, *Riverscape*, c.1630. Panel, 28.5 x 51 cm. Private collection (photograph: RKD, The Hague).

2b Hendrick Avercamp, *Fishermen on a canal near Kampen*, c.1625-1630. Grey and brown ink, watercolour heightened with gouache, 15.2 x 21 cm. Paris, Frits Lugt Collection (acquired in 1919).

2c Hendrick Avercamp, *Riverscape*, c.1615-1620. Brown ink, watercolour, 18 x 27 cm. Present whereabouts unknown (photograph: Fondation Custodia Archives).

2d Hendrick Avercamp, *Study of a boy with a fishing rod*, c.1620. Graphite, red wash, 14.7 x 8.3 cm. The Royal Collection © 2001 Her Majesty Queen Elizabeth II.

2e Hendrick Avercamp, *Winter landscape*, c.1620-1625. Panel, 24 x 39 cm. Private collection (photograph: Mauritshuis, The Hague).

planes in a somewhat isolated manner: seated in the foreground are two fishermen with a tackle;[5] two more men fish from a boat, while a fifth repairs his nets; a hunter shoots duck; a well-dressed city family rests at the water's edge; and carts and wagons ride along the dike, one laden with hay. Although comparatively few in number, as in Avercamp's other works these figures represent a range of activities and social ranks.

A macabre detail is the gallows bearing the corpses of a man and a woman. Avercamp frequently included a gallows in his paintings and drawings, in order, it has been suggested, to give his work a moral message.[6] It is equally plausible, however, that he simply found it a suitable motif for marking the transition from one picture plane to the next, being otherwise just as indifferent to it as the figures in his painting.[7] The fisher-

men here, for example, simply carry on with their work, and even the respectable couple seems to be unafraid of confronting their child with such a spectacle.

As in so many other Avercamp paintings, the silhouette of Kampen can be seen on the horizon. The view is taken from the far bank of the IJssel with, on the left, the Church of St Nicholas (also known as the Bovenkerk) and, on the right, the Church of Our Lady (or the Buitenkerk). Without aiming to give an exact description of the site – in other works, too, the artist appears to have been less than scrupulous in his topography – Avercamp nonetheless sought to evoke the typical landscape of the IJssel in the environs of his hometown. A finished drawing in the Lugt Collection, worked up in watercolour and gouache, reproduces a similar scene, again with Kampen in the background. The broad stretch of water in the foreground, however, is clearly meant to represent an inlet of the IJssel, itself shown in the distance, while the towers of the town's churches appear to have changed places (fig. 2b).[8]

The painting is executed in soft colours over an underdrawing in graphite or black chalk that has remained visible in certain areas, for example, in the reflection of the two men in the boat.[9] The paint layer is quite thin and must have worn down over time. The artist has made noticeable use of contour lines, particularly in the depiction of the figures, a technique we also find in his coloured drawings. These works on paper, too, were destined for sale, designed, as demonstrated by a surviving example, to be framed and hung on the wall.[10] The composition is comparable to that of a monogrammed watercolour formerly in the collection of Oskar Huldschinsky (1845/47-1931) in Berlin (fig. 2c).[11] The topographical situation is the same, with the skyline of Kampen rising above the dike – once again with the churches reversed. In several cases the figures are almost identical as well, particularly in the group of fishermen with their dog in the foreground and the family at the right. Avercamp must have had a large collection of figure studies from which he created these composite works.[12] The standing boy in the left foreground in both works was apparently adopted from a study in the Royal Collection, although the resemblance is not exact (fig. 2d).[13] Even though he only appears in the painting, the duck hunter must have been based on a study as well: we find him again, complete with his recumbent dog, in two pictures by Avercamp's follower Arent Arentsz.[14]

In the past, the rather unusual character of the Lugt painting has led some to doubt its attribution. Barent Avercamp, one of the alternative names suggested, certainly imitated the work of his uncle, but his figures are clumsier and lack the 'true to life' feeling and pithy observation of his role model.[15] Having taken the less-than-perfect condition of the paint layer into consideration, there is nothing in either the technique or quality to cast doubt on Avercamp's authorship. The picture appears to have been painted some time in the middle of his career, probably in the early 1620s. Avercamp's work is notoriously difficult to order chronologically, given the fact that with the exception of a handful of pictures of 1608 and 1609 only one other landscape, from 1620, is actually dated. In the Lugt painting the horizon is rather low and the landscape stretches towards it, empty and open. Only the hoist at the left recalls the trees or other vertical elements the artist liked to use to bracket his early compositions. From around 1620 the number of figures also starts to diminish, and they become larger and more important in relation to the whole.[16] Finally, details in the dress also provide a clue: the elegant man with his sword in the family group at the right wears a hat with a wide brim and a low crown, a type that became fashionable only around 1620. The hats in the drawing formerly in Berlin (fig. 2c), even those worn by the fishermen, are of a more archaic style, indicating that the drawing must have been executed some time before the painting.[17]

It is possible that the panel once had a companion piece, similar to the works already noted in eighteenth-century auction catalogues as pendants depicting summer and winter.[18] One possible candidate is a recently discovered winter landscape of the same size as the picture in the Lugt Collection. It shows a rather odd scene of two men transporting a calf on a sledge, and was undoubtedly painted in the same period (fig. 2e).[19]

In addition to this exceptional painting, Frits Lugt also acquired a wonderful ensemble of 13 Avercamp drawings, illustrating the full range of his draughtsman's talent: figure studies, sketches and more worked up sheets, as well as several of his rare finished and coloured drawings, one of which is discussed above (fig. 2b). Among these is also the earliest drawing to have been preserved.[20] In addition, Lugt purchased a characteristic small painting by Avercamp's follower, Arent Arentsz.[21] *HB*

Ludolf Backhuysen

Emden 1630-1708 Amsterdam

3 *Ships on a canal with a windmill, c.1665-1667*

Canvas, 43 x 38 cm / Signed with initials, at lower left: *L.B.* / Acquired in 1924

Provenance

François-Xavier-Jean-Marie-Joseph comte de Robiano (1778-1836), Brussels (sale Brussels, Barbé, 1 May 1837 and following days, lot 20, for 520 *francs*);[1] Arthur Kay (1860-1939), Edinburgh and Glasgow;[2] Frederik Muller & Cie, auctioneers, Amsterdam; August Janssen (1865-1918), Amsterdam and Baarn; Jacques Goudstikker (1897-1940), art dealer, Amsterdam, 1919; Frits Lugt, Maartensdijk and Paris, purchased from Goudstikker on 27 October 1924; inv. no. 1919

Exhibitions

London 1904, no. 376 (as Adriaen van de Velde); Amsterdam 1906, no. 123 (as Adriaen van de Velde); Rotterdam 1931-1932, no. 5; The Hague 1946, no. 13; Paris 1983, no. 4; Paris 1989, no. 2

Literature

Hofstede de Groot 1907-1928, vol. 7 (1918), p. 278, no. 157; S. Nihom-Nijstad in Paris 1983, p. 9, no. 4 and fig. 54; Kingzett 1983, p. 503; M. van Berge-Gerbaud in Paris 1989, p. XVII; C. van Hasselt in *idem*, pp. 4-5, no. 2 and fig. 13; Middendorf 1989, pp. 45, 128, no. 66 (ill.)

Ludolf Backhuysen started out as a calligrapher, in which capacity he entered the service of the Amsterdam merchant Guglielmo Bartolotti, who like himself came from Emden, in about 1650.[3] At roughly the same time he evidently started drawing ships and possibly already making pen and ink paintings with marine subjects. The technique of painting in ink was much like that of calligraphy, and it was used, following Willem van de Velde the Elder (1611-1693), by many marine painters.[4] According to Arnold Houbraken, Backhuysen was initially self-taught and later learnt the art of painting from Allaert van Everdingen (1621-1675) and Hendrick Dubbels (1621-1707).[5] When he married for the first time, in 1657, he gave his profession as draughtsman, and did so again in 1660, upon marrying for the second time, but dated paintings by him are known from 1658 onwards.[6] In 1663 he registered with the Guild of St Luke, after which his career progressed rapidly. The *View of Amsterdam and the IJ* from 1666 (Paris, Musée du Louvre), a gift from the city of Amsterdam to the French foreign minister Hugues de Lionne (1610-1671),

was the first in a long series of large paintings depicting naval battles and other maritime events.[7] After the Van de Veldes (see cat. nos. 33-34) moved to London in 1672-1673, Backhuysen was the city's leading specialist in marine pieces. He was also a prominent member of society. Foreign princes visited his studio, he numbered many artists and poets among his friends, and after the death of his third wife, in 1680, he married into a distinguished family of silk merchants. Many marine painters trained with Backhuysen, who carried on working as a painter to an advanced age.

Backhuysen's work in marine painting represents the same stylistic phase as that of Willem van de Velde the Younger, but it often displays a stronger sense of the dramatic. Even in the eighteenth century, every Dutch collection had to include a storm at sea by Backhuysen – just as it had to include a 'calm' by Van de Velde – and the painter is still chiefly associated with this area of his work today.[8] Yet he produced every kind of seascape, besides which there are portraits, landscapes, topographical scenes, genre pieces and even biblical

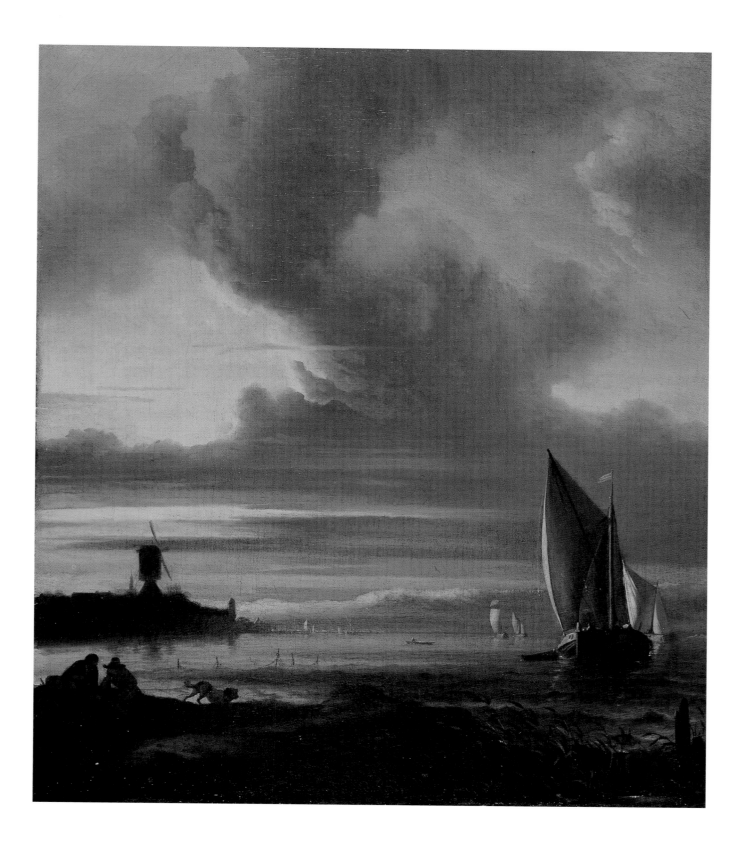

3a

3b

3c

3d

3e

figure pieces by him. The work exhibited here is one of the few calm water scenes in Backhuysen's oeuvre, and reveals an unexpectedly poetic side of the painter's art. The motif is characterised by great simplicity: small sailing vessels in a waterway at the base of the city ramparts, against which a windmill is silhouetted. The soft light of sunset glints on the sails, and a glorious evening sky, which takes up more than three-quarters of the canvas, endows the painting with a dreamy, almost romantic mood. The only staffage of any significance consists of the two fishermen in the foreground. They have cast their nets and are talking animatedly while their dog trots along the waterside. But the gathering dusk shrouds this section in dark tones, so that their presence scarcely touches the serene atmosphere of the piece as a whole. Only upon careful study do we discover further signs of human activity in the sailing vessel at right and a small rowing boat in the distance. The atypical character of this painting and the almost illegible signature have sometimes led to it being attributed to other artists. The first known reference to it, in 1837, gave the maker's name correctly. In the collection of Arthur Kay, to which it belonged at the beginning of the twentieth century, however, it was attributed to Adriaen van de Velde (cat. no. 32), which was not changed when it was shown by Frederik Muller auctioneers in 1906. It was probably there that Hofstede de Groot saw it; he later included it in the section of his major catalogue devoted to Backhuysen (1918).[9] Recently still another attribution was suggested, this time to Hendrick Dubbels, a marine painter from Amsterdam named by Houbraken as one of Backhuysen's teachers.[10]

3a Ludolf Backhuysen, *View of Amsterdam and the IJ*, c.1680-1690. Canvas on panel, 42 x 62 cm. Copenhagen, Statens Museum for Kunst (acquired in 1810).

3b Rembrandt, *The bastion Blauwhoofd*, c.1645. Pen and brown ink, brown and greyish-brown wash, 11.6 x 19.8 cm. Paris, Frits Lugt Collection (acquired in 1937).

3c Ludolf Backhuysen, *View of the IJ with ships and the bastion Blauwhoofd*, 1697. Canvas, 55 x 79.5 cm. Sale of the Komter Collection, Amsterdam, 9 March 1926, lot 3 (photograph: RKD, The Hague).

3d Ludolf Backhuysen, *View of the IJ from the bastion Blauwhoofd*, 1673. Canvas, 39.7 x 48 cm. Leipzig, Museum der bildenden Künste (acquired in 1908).

3e Ludolf Backhuysen, *Repairing a warship*, 1701. Etching with corrections in pen and grey ink, 18.1 x 23.8 cm. Paris, Frits Lugt Collection (acquired in 1973).

It is proposed as part of a theory that financial problems compelled Dubbels to work in the studio of his former pupil and to sign them with his name. The paintings that Dubbels did sign in his own name, however – and there are a great many of them – reveal someone with little artistic independence, who tried successively to imitate the style of all the leading marine painters from Simon de Vlieger (1600/1-1653) onwards. His execution is not on a par with that of his examples, and his work often looks flat and schematic. The painting under discussion here, on the other hand, is masterfully executed, which is particularly striking in the gossamer-fine rendering of the little ships and the bank on the horizon. The style of the two tiny, vigorously gesticulating figures – so different from Dubbels' lifeless puppets – unmistakably reveal Backhuysen's hand.

Not only in atmosphere but also in the details such as the design of the little sailing boat in the right foreground and the rendering of the tiny ships in the distance, the painting displays similarities to another small water scene by Backhuysen in Copenhagen (fig. 3a).[11] This painting and its pendant have been known since they were first mentioned in 1733 as 'Morning' and 'Evening'. The similarities even extend to the subject, since the Amsterdam skyline that encloses the background displays the same fortifications and windmill as in the painting discussed here. The latter evidently depicts an existing view of the city: the last bastion of Amsterdam's western ramparts, Leeuwenburgh, better known, because of its bluestone surface, as the Blauwhoofd (Blue Head). The bastion extended for a great distance into the IJ, and had a post-mill on it known as De Bok.[12] Behind this windmill, the spire of the Haarlemmerpoort can be seen at left in the distance. The bastion was depicted by numerous seventeenth-century artists, notably in a drawing by Rembrandt, one of the most beautiful drawings that Frits Lugt ever acquired for his collection (fig. 3b).[13] But Backhuysen too, who though originally from Emden spent the rest of his life in Amsterdam, clearly felt an affinity to the location. One of his last paintings, made in 1697, the whereabouts of which are unknown today, depicts the River IJ near the Blauwhoofd looking in the direction of the tollhouse (fig. 3c), also with the windmill on the bastion, though viewed from the other side.[14] A painting produced more than twenty years earlier looks out over the IJ to the north from the Blauwhoofd, with soldiers in the foreground standing around one of the guns that were installed there (fig. 3d).[15] A preliminary sketch

for this latter painting is known, and the painting under discussion here too is undoubtedly based on a drawing of the bastion that the artist must have made from the IJ.[16]

Backhuysen altered many features of the scene for his painting, no doubt for artistic reasons. The most drastic change is to the surrounding landscape: in reality, the bastion did not extend into an expanse of water but into a polder. But he also omitted the rows of posts that bounded the Amsterdam's harbour across the entire width of the IJ, and on one side of the bastion he changed the stone surface into a grassy bank with trees. On the bastion itself Backhuysen changed the revolving wooden sentry-box, which is clearly visible in the View of the IJ from the bastion Blauwhoofd (fig. 3d) dated 1673, into a small stone corner tower – unless the wooden sentry-box was actually replaced by a stone structure at some unknown point in time.[17] The painting has thus far been dated 1665, but may well have been produced later.[18] The related work in Copenhagen (fig. 3a) displays great similarities to two dated harbour views that Backhuysen produced in later life: a drawing dated 1690[19] and one of the etchings in the series The River IJ and sea views from 1701, which likewise depicts the windmill on the Blauwhoofd at far right (fig. 3e).[20] On the basis of the clothes worn by the little figures in the Amsterdam rowing and sailing vessel in the foreground – one is wearing a huge periwig – the painting in Copenhagen cannot have been made before about 1680.

Frits Lugt must have become acquainted with the painting described here at the exhibition at Frederik Muller's in 1906. Perhaps it was he who brought it to the attention of August Janssen (1865-1918), to whom he provided considerable assistance in building up his collection (see cat. no. 28). Six years after Janssen's death he purchased it for himself. 'Unusual painting by the master', he noted on an inventory card, and that is probably what attracted him to it.[21] It would remain the only painting by Backhuysen in his collection. As a draughtsman, of course, the artist is very well represented in the beautiful ensemble of 'Dutch marine pieces' that Lugt collected.[22] Furthermore, the small group of items representing Dutch calligraphy contains a sample of his work.[23] It is a two-line panegyric on the coins and antiquities of the Amsterdam collector Jacob de Wilde (1645-1721), undoubtedly taken from De Wilde's visitors' book.[24] The sheet dates from 1691 and shows that Backhuysen also remained faithful to the art of calligraphy until the end of his life.[25] *HB*

51

Nicolaes Berchem

Haarlem 1620-1683 Amsterdam

4 *View of Loenen aan de Vecht, with Cronenburch castle, c.1655-1660*

Canvas, 91.3 x 114.5 cm / Signed at lower centre: *Berchem f.*; on the stretcher, with pen and black ink: *Berchem* / Acquired in 1956

Provenance

Jacob van Hoek (1671-1718), Amsterdam (sale Amsterdam, Zomer-Sorgh, 12 April 1719, lot 16, for 290 guilders);[1] Christophe Nicolau de Montribloud (d. 1786), Montribloud, Lyons and Paris (sale Paris, Paillet-Julliot fils, 9-12 February 1784, lot 52, to Dubois for 5,140 *francs*);[2] Claude Tolozan (1728-1798), Paris (sale Paris, Paillet-Delaroche, 23-26 February 1801, lot 7, to Delessert for 4,800 *francs*);[3] Étienne Delessert (1735-1816), Lyons and Paris; Corneille Louis Reijnders, Brussels (sale Brussels, Nieuwenhuys-De Man, 6 August 1821, lot 4, to Nieuwenhuys for 9,000 guilders);[4] Chrétien Jean Nieuwenhuys (1799-1883), Brussels and London; sold by him in July 1822 to Lapeyrière for 20,000 *francs*; Lapeyrière, 'receveur-général des Contributions du Département de la Seine', Paris (sale Paris, Lacoste-Henry, 19-29 April 1825, lot 88, to Nieuwenhuys for 16,000 *francs*);[5] Chrétien Jean Nieuwenhuys (1799-1883), Brussels and London; Baron Frederick von Mecklenburg, Berlin (sale Paris, Genevoix-Febure, 11 December 1854, lot 1, to Éd. Roux for 19,000 *francs*);[6] Jacob-Émile (1800-1875) and Isaac Pereire (1806-1880), Paris (sale Paris, Pillet-Petit, 6 March 1872, lot 110, for 42,000 *francs*);[7] A. Popoff & Cie, art dealers, Paris, in or before 1936 (sale London, Sotheby, 16 November 1955, lot 80, to Colnaghi);[8] P. & D. Colnaghi & Co, art dealers, London; Frits Lugt, Paris, purchased from Colnaghi on 8 February 1956; inv. no. 6811

Exhibitions

Amsterdam 1936, no. 12; London 1956, no. 1; The Hague 1970-1971, no. 58; London 1971, no. 51; Paris 1983, no. 5; Atlanta 1985, no. 4

Literature

Hoet-Terwesten 1752-1770, vol. 1, p. 221; Feitama 1764, p. 282; Nieuwenhuys 1834, pp. 81-82; Smith 1829-1842, vol. 5 (1834), pp. 31-32, no. 82; Blanc 1857-1858, vol. 2, pp. 88, 502; Thoré-Bürger 1864, p. 306 (reproduction engraved by Maxime Lalanne [1827-1886]); E.W. Moes in *Thieme-Becker*, vol. 3 (1909), p. 371; Hofstede de Groot 1907-1928, vol. 9 (1926), p. 82, no. 114, p. 117, no. 228; Roosenschoon 1940, pp. 35-36; Roosenschoon 1941, ill. p. 22; Van Luttervelt 1948, p. 81 note 4; Van den Berg 1953, p. 133, fig. 2; Van der Linde 1954, ill. facing p. 87; Schaar 1957, pp. 22-23, 48; Plietzsch 1960, p. 151; Reitsma 1976, pp. 252, 255, fig. 8; S. Nihom-Nijstad in Paris 1983, pp. 10-12, no. 5 and fig. 43; F.J. Duparc in Atlanta 1985, pp. 22-23, no. 4 (ill.); W. Kloek in Van der Wyck-Niemeijer-Kloek 1989, vol. 2, p. 50; Edwards 1996, p. 243, no. 52, p. 294, no. 7; J. Kilian in *The Dictionary of Art*, vol. 3 (1996), p. 759; Peronnet-Fredericksen *et al.* 1998, vol. 1, p. 136; J. Kilian in Turner 2000, p. 18

Claes, or as he signed in the last years of his career, Nicolaes, Berchem was born in Haarlem, the son of the still-life painter Pieter Claesz (1596/97-1661). In addition to his father, Arnold Houbraken (1660-1719) mentions five other artists with whom Berchem studied in succession: Jan van Goyen (1596-1656), Nicolaes Moeyaert (1592/93-1655), Pieter de Grebber (*c.*1600-1653), Jan Wils (*c.*1610-1666) and Jan Baptist Weenix (1621-1660/61). The latter at least seems highly unlikely: Weenix was Berchem's cousin and his junior by a year. Berchem registered with Haarlem's Guild of St Luke in 1642, and in the same year took on three pupils. The painter spent most of his life in his native town. He is recorded in Amsterdam in 1660, however, and permanently settled there in 1677.

Berchem was one of the most important representatives of the second generation of Italianate painters, and must have journeyed south of the Alps although no such trip is documented.[9] His earliest works, dating to the 1640s, resemble the typical Dutch landscapes of the period, but already include a number of exotic motifs and figures. He was probably initially inspired by the innovative art of painters such as Pieter van Laer (1599-after 1642), Jan Both (cat. no. 6) and Jan Asselijn (cat. no. 1), all of whom had recently returned from Italy. In the decades that followed, his affinity with these Italianate artists increased, culminating from around 1653 in the type of painting for which he is best known: sun-drenched Mediterranean landscapes populated by carefree herdsmen and peasants with

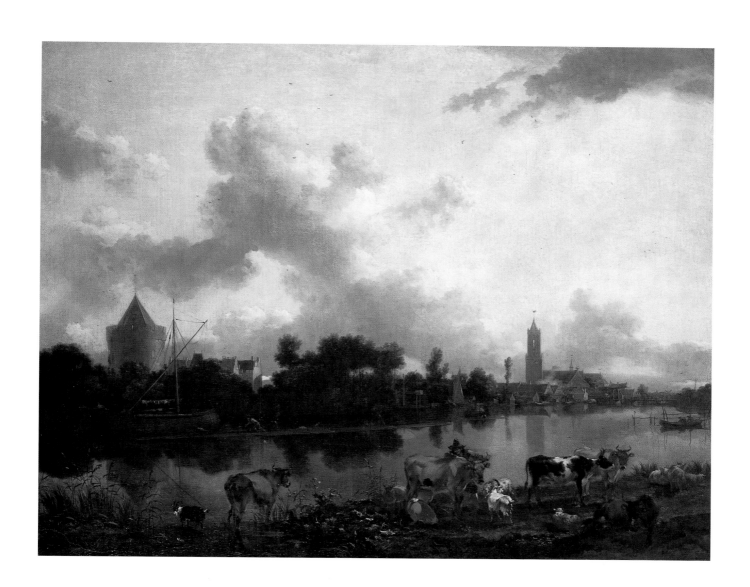

4a

54

their livestock, effortlessly rendered with a lively brush. In addition to landscapes, he also painted allegories and figural works, and executed the figures in landscapes by other painters. His work was very popular and quite expensive even during his own lifetime. According to Houbraken, he trained a large number of artists, among them Willem Romeyn (c.1624-after 1694), whose period in his studio is well documented, Karel du Jardin (cat. no. 15) and Abraham Begeyn (1637-1697).

The picture illustrated here is one of a small group in Berchem's extensive oeuvre to depict a topographically exact location. Such scenes seem to have interested him particularly in the early 1650s, following a journey to the Dutch-German border region in the company of another Haarlem painter, Jacob van Ruisdael (cat. no. 27). It was probably on this occasion that the artists sketched Bentheim castle, which became a recurring motif in Van Ruisdael's work in the years that followed.[10] Works by Berchem incorporating the castle include a drawing of 1650 (probably executed in the studio) and two paintings of 1656 (fig. 4a).[11] Castles and castle ruins closer to home also appear in a number of other drawings. Some of these, like the one mentioned above, are strongly reminiscent of Van Ruisdael, who – according to Houbraken – was a 'great friend' of Berchem's.[12] The ruins of Brederode castle near Haarlem were a particular favourite of many seventeenth-century artists, including Berchem. A large number of his drawings of the ruins have survived, most of them in the decorative style of his later years. They are also the main subject of an earlier painting, similar in composition to the work here under discussion (fig. 4b).[13] As in the painting of Bentheim castle (fig. 4a), here, too, the foreground is occupied by a group of herdsmen and animals that seems to have just escaped from one of the artist's Italianate landscapes, contrasting oddly with the castle and its environs.

Cronenburch castle was of medieval origin and lay on the Vecht River just south of the town of Loenen. In 1618 it fell into the hands of one Anthonis van Lynden (d. 1626), Lord of Cronenburch, and remained in his family until 1710, when it was sold to the Leiden patrician Adriaen Wittert van der Aa (d. 1713). It was badly damaged in 1672 by the French, who blew up the large dungeon. The restoration that followed transformed it into a country manor, as a pair of engravings from *De zegepraalende Vecht* illustrate.[14] It was finally demolished in 1837.[15] Like Brederode, Cronenburch

was of a venerable age and, moreover, was linked to an important historical event. It was during a hunting party here in 1296 that the powerful count of Holland, Floris V (1254-1296), was taken prisoner. He was later murdered and one of the conspirators, Gerard van Velsen – a relative of the Lord of Cronenburch – took refuge there, where he was eventually captured. The story continued to fascinate historians and playwrights into the seventeenth century, and it is described in detail in the legend to an anonymous engraving of the castle dating to 1620.[16] This historical aspect may also explain Berchem's choice of the motif. His painting was not the first to depict the castle. Seen from the south side, it appears in a work by Adam Willaerts (1577-1664) for which there is a preliminary drawing dating to 1639; and in 1652 Salomon van Ruysdael (1600/3-1670) had included it in the background of a riverscape.[17]

Although Berchem took some liberties in his rendition – he simplified the side wall of the main building and enlarged the dungeon – the layout of the castle and its siting conform perfectly to the facts known from maps and other visual sources.[18] A drawing by Antoni Waterloo (1609-1690) shows the place surrounded by heavy trees (fig. 4c).[19] The towpath along the Vecht had yet to be constructed and the riverbanks were still irregular, bordered by willows and mud flats. The stepped gable of the free-standing gateway – to the left of the sun-drenched side wall of the central structure – must indeed have born traces of the pigeons inhabiting it; and given that the Loenen lift bridge, installed in 1624 by the Lord of Cronenburch, had a special toll for them, it seems equally unlikely that the large timber raft was a product of the artist's imagination.[20] The same may be said of the beer barrels that can be made out to the left of the bridge in the finely painted village scene, which certainly belonged to the local brewery, *'t Merk de Aa*.[21]

The painting is undoubtedly based on *plein-air* sketches. The colouration is rather heavy and the manner of execution unusually detailed, making it difficult to place the work within Berchem's oeuvre. Nonetheless, the elegant, briskly painted figures suggest a date of around 1653 or after, while similar contrasts between an Italianate foreground scene and a 'native' landscape are also to be found in other works of the 1650s.[22] The signature also offers a clue: the artist seems to have spelled his name 'Ber(ri)ghem' until around 1656, when he began to use 'Berchem', as we see here.[23] It seems

4c

56

4d

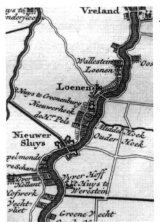

4e

4c Antoni Waterloo, *View of Loenen aan de Vecht, with Cronenburch castle, c.*1650. Black chalk, black and grey ink, 20.1 x 31.6 cm. Amsterdam, Rijksmuseum, Rijksprentenkabinet (acquired in 1879).

4d Ludolf Backhuysen, *View of Loenen aan de Vecht, with Nieuwerhoek manor and Cronenburch castle,* 1672 or later. Brown ink, brown wash, 11.6 x 19.5 cm. London, British Museum, Department of Prints & Drawings (acquired in 1836).

4e *Loenen aan de Vecht and environs around 1719,* detail of a map of the Vecht between Utrecht and Muiden. From: A. de Leth, C. Bruin and D. Stoopendael, *De zegepraalende Vecht,* Amsterdam 1719 (photograph: Fondation Custodia).

likely, then, that the painting – as well as the related work in Chatsworth – was executed in the later 1650s, following on the heels of the artist's landscapes with Bentheim castle.[24]

The painting was owned in the early eighteenth century by the Amsterdam silk merchant Jacob van Hoek (1671-1718), who appears to have been a true amateur. His collection, which was auctioned a year after his death, included a number of masterpieces of Dutch painting, among them *The milkmaid* by Johannes Vermeer (1632-1675), *'The pissing cow'* by Paulus Potter (cf. cat. no. 25) and a now-lost triptych by Gerrit Dou (1613-1675), at the time already considered the artist's most important work in Holland.[25] Berchem's picture is not mentioned by Houbraken, who must have visited the collection in the months between Van Hoek's death and the auction,[26] but it is described in a poem by the collector's friend and fellow Mennonite Sybrandt II Feitama (1694-1758), written in 1717.[27] The work certainly had a more than merely artistic significance for Van Hoek, whose own country manor on the Vecht, Nieuwerhoek, lay just south of Cronenburch castle.[28] He may even have purchased the painting for this reason, although it seems equally plausible that it was originally commissioned by a member of his family and passed on to him. Adriaen van Hoek Jansz (1638-1703), Jacob's father, who either built or renovated Nieuwerhoek, also owned a large collection of paintings, some of which were auctioned in 1706.[29] Among them was a view of the same location by Ludolf Backhuysen (cf. cat. no. 3), depicting both Nieuwerhoek and the now-towerless Cronenburch, a preliminary study for which is illustrated here (fig. 4d).[30] A number of more distant relatives could also have requested the painting from Berchem: two other houses in the environs of Nieuwerhoek and Cronenburch were the property of the wealthy Van Hoeks, giving this part of the Vecht the nickname 'Mennonites' Heaven' (fig. 4e).[31]

By the end of the eighteenth century Berchem's reputation had reached its zenith, making him one of the most sought-after and expensive artists of the Dutch School. The painting is thus next found in important collections in France: namely, that of the Lyons tax inspector Christophe de Montribloud (d. 1786), where it was one of an ensemble of five works by the artist; and that of Claude Tolozan (1728-1798), who owned a total of six.[32] It then made its way into the possession of another native of Lyons, the banker Étienne Delessert (1735-1816), and then the land speculator Lapeyrière, one of the major developers of the splendid Nouvelle Athènes quarter in Paris.[33] In 1834 the art dealer Chrétien Jean Nieuwenhuys (1799-1883), who had originally sold the picture to Lapeyrière and then reacquired it at the auction of his collection, included it in his book on the best works that had passed through his hands.[34] Even Théophile Thoré (1807-1869) – more than any other critic responsible for the new image of Dutch art developed in the late nineteenth century, in which artists like Berchem and Philips Wouwerman (1619-1668) had to make way for more 'realistic' masters such as Frans Hals (1582/83-1666) and Vermeer – was surprisingly charitable in his judgement of the painting. For him, *View of Loenen aan de Vecht, with Cronenburch castle* was a rare pearl in an oeuvre otherwise characterised by artificiality and standardisation: inspired by his native landscape, unhindered by his usual 'procédé', the artist here revealed a surprising sensitivity towards nature.[35] Thoré – who published under the pseudonym William Bürger – made this comment in an article on the private gallery of the brothers Jacob-Émile (1800-1875) and Isaac Pereire (1806-1880), bankers and railway entrepreneurs. The collection was to a great extent Thoré's own creation, and it is possible he even sold the canvas to the Pereires himself.[36] The picture's exceptionality within Berchem's oeuvre must also have played a role for Frits Lugt.[37] Overall, however, his attitude towards Berchem – and the Italianate painters in general – was quite positive. He brought together a total of 13 drawings by the artist, and in 1962 he acquired a second major painting, *Landscape with a waterfall and the Temple of the Sibyl at Tivoli*.[38] *HB*

57

Gerrit Berckheyde

Haarlem 1638-1698 Haarlem

5 *The construction of the new ramparts at Haarlem in 1671,*
c.1671-1672

Panel, 41.3 x 63 cm / Signed lower centre: *G. Berck.Heijde.* / Acquired in 1920

Provenance

Mrs S.S. Joseph, London;[1] Frederik Muller & Cie, auctioneers, Amsterdam, 1911; August Janssen (1865-1918), Amsterdam and Baarn (purchased from Muller's);[2] Jacques Goudstikker (1897-1940), art dealer, Amsterdam, 1919; Frits Lugt, Maartensdijk, purchased from Goudstikker on 11 March 1920 for 6,000 guilders, with a painting by Hendrick Martensz Sorgh;[3] his father-in-law, Joseph Klever (1861-1935), Maartensdijk and Vienna; Martha Klever-Schmidt, Vienna; her brother, Karl Schmidt, Basle, passed to his widow; her son, Gerald Smith, Basle; acquired by the Fondation Custodia on 12 April 1972;[4] on loan to the Rijksmuseum, Amsterdam, Dutch History Department, since 1998 (inv. no. SK-C-1655); inv. no. 508

Exhibitions

Amsterdam 1911, no. 2; The Hague 1919, no. 8; Amsterdam 1919-1920, no. 6; Amsterdam 1978, without no.; Paris 1983, no. 7

Literature

F. Lugt in Amsterdam 1911, no. 2; Biermann 1911, pp. 665-666 (ill.); Hirschmann 1920, p. 26 and fig. 10; Taverne 1978, pp. 370-371 and fig. 89; S. Nihom-Nijstad in Paris 1983, pp. 14-15, no. 7 and fig. 41; Faton 1983, pp. 68 (ill.) and 69; Nihom-Nijstad 1983, n.p. (ill.); Lawrence 1991, p. 34 note 25; Davies 1992, p. 39 note 37, p. 225 (under no. D 5) and fig. 20; Brinkgreve 1994, p. 30 (ill.); Slive 1995b, pp. 452 and 454, fig. 46 (detail of the mud-mill); Slive 2001, pp. 51 (ill.) and 560

Frits Lugt first saw this unique Berckheyde painting in 1911, at an exhibition organised by the famous auction house Frederik Muller & Cie, where he was then working. He was unable to purchase it, however, as employees were prohibited from acquiring works for themselves. The panel instead went to August Janssen (1865-1918), a resident of Amsterdam and Baarn whose collection the young Lugt had helped to build (cf. cat. no. 28). Following Janssen's early death, his paintings were sold to the well-known Amsterdam art dealer Jacques Goudstikker (1897-1940). Lugt finally acquired the Berckheyde in 1920, having previously bought several other works from the former Janssen Collection from Goudstikker, among them a church interior by Pieter Saenredam (cat. no. 28). Lugt was fond of topographical pictures – he owned not only drawings and paintings by Dutch and Flemish masters in this genre, but also beautiful views of Venice by Francesco Guardi (1712-1793) and Richard Bonington (1802-1828) – and the Berckheyde undoubtedly pleased him immensely (cf. also cat. no. 4).[5]

Gerrit Berckheyde was a true Haarlemmer – he was both born and buried there – but he also worked in other cities. In addition to many views of his native town he also depicted characteristic locations in Amsterdam and The Hague, as well as vistas of Cologne and Heidelberg, which he visited on a trip through Germany in the 1650s with his older brother and probable teacher, Job (1630-1693). Gerrit Berckheyde, who became a member of the Guild of St Luke in 1660 (the year noted on his earliest dated work), painted mainly cityscapes, although he occasionally also did church interiors, landscapes, Italianate pictures and genre scenes.[6]

Among the views of Haarlem there are almost none that show anything beyond the city walls. Berckheyde's preferred subject was the Grote Markt, the main square, which he depicted from various angles in a large number of works. He only rarely chose motifs outside the town centre, for example Haarlem's gates,[7] although he did once portray the walls themselves with the Kruispoort (fig. 5b, see below). He also did 'portraits'

5a

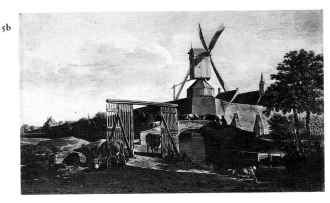

5b

5c

5a Gerrit Berckheyde, *View of Haarlem*, c.1670. Panel, 43 x 61 cm.
Present whereabouts unknown (photograph: RKD, The Hague).

5b Gerrit Berckheyde, *The city walls of Haarlem with the Kruispoort
and a mill*, c.1670. Panel, 41.3 x 62.9 cm. Philadelphia, Philadelphia
Museum of Art, John G. Johnson Collection (acquired in 1933).

5c Jacob van Ruisdael, *Mud-mill with a view of buildings*, c.1650-1660.
Black chalk, pen and black ink with grey wash, 19.1 x 15.1 cm.
New York, The Metropolitan Museum of Art (acquired in 1994).

of the nearby country manors at Egmond, Heemstede and Elswout.[8] The painting in the Lugt Collection, a view likewise taken from outside the city's historical heart, is unique in the painter's oeuvre, delineating not a pre-existing urban fabric but rather an expansion project still very much underway. It is an important historical document, the only surviving illustration of a significant contemporary event: the creation of Haarlem's Nieuwe Gracht (New Canal), or rather the relocation of the ramparts it necessitated. As a result of the enormous growth in the local population, on 7 March 1671 the magistrates decided to considerably increase the size of the town through the creation of a new district to the north. The plan was the work of surveyor Erasmus den Otter and was to expand the municipality by half. Already in 1642 the architect and painter Pieter Post (cat. no. 24) had worked on the practical aspects of enlargement, while in 1660 Salomon de Bray (cf. cat. no. 8) had taken his turn at presenting a plan. Work on the new outer canals and walls began in earnest on 2 June 1671.[9] Berckheyde shows the city from the northwest – he must have stood near the small lock known as the 'Garenkokerssluisje' – during the construction of the first bulwark, lying to the north of the first, already extant, canal.[10] Haarlem's wealth of churches and towered buildings are visible on the skyline, foremost among them St Bavo, which stands out sharply in the background, rising up behind the fortifications against the cloudy sky. From left to right we can distinguish the spires of the Bakenesserkerk, the Waalse Kerk (Walloon Church, formerly the church of the beguines), St John's (the painter's final resting place), the so-called Klokhuis, St Bavo's (see cat. no. 28), the Kampkerk, the town hall, the Heilige Geesthuis (Holy Ghost Hospital), the lantern of the children's poorhouse (Kinderarmenhuis), the Zijlklooster and the Nieuwe Kerk.[11] In contrast to Berckheyde's other works, however, the buildings do not play the major role; the artist was clearly more interested in the workers and their activities.

Like most of Berckheyde's Dutch town views, this one, too, can be regarded as topographically accurate – in contrast to his German cityscapes, which are of course based on real motifs but generally rearranged to form a new artistic whole.[12] The artist reproduces the

Haarlem skyline in only one other picture, which should also be dated to the same period. It clearly shows the city's medieval walls, but whereas in the Paris painting the town stretches far to the west, here we see only a small portion of it, this time depicted from a more eastern point of view (fig. 5a).[13] The windmill in the distance – with its strikingly narrow stairway – is repeated in slightly varied form in the work in Philadelphia (fig. 5b).[14] The building behind the mill, like the mill itself, is shown from a different angle. Despite some small variations it must be the same edifice as in the Paris picture, recognisable by its characteristic spire. The Philadelphia work, which is the same size and probably painted around the same time, appears to reproduce a somewhat earlier state of affairs, before the expansion of 1671. The undated Paris painting cannot have been executed before this date. In 1672 construction work had already come to a halt – it would recommence in 1674, and in 1686 the first houses would be built – so that one may assume Berckheyde's picture was completed in 1671, or 1672 at the latest. The artist must have made sketches on the spot; these then served as the basis for the painting, which was later carried out in the studio. Unfortunately, none of Berckheyde's preserved drawings – and there are only a few that can be securely attributed to him – can be linked to the work in the Lugt Collection.[15]

In contrast to what one might expect in a country where all facets of the visible world were captured in paintings and drawings, there are almost no depictions of the construction work taking place in this period, not only in Haarlem but in Amsterdam as well.[16] Berckheyde's dozen or so workmen – the well-dressed gentleman with the broad-brimmed hat appears to be the supervisor – are a highly unusual subject for seventeenth-century Dutch art. As far as we know, workers only appear in paintings depicting buildings being built or renovated or in drawings, particularly those of Jacob van Ruisdael, who several times included scenes of human labour in his landscapes as well (cf. fig. 24b for women at work).[17] A print by Abraham Blooteling (1640-1690), from a series of six etchings after drawings by Van Ruisdael probably from around 1662-1664 depicting the environs of the Amstel River, shows labourers digging up the old walls in connection with the completion of Amsterdam's famous canal zone.[18] A local artist, Jan van Kessel (1641-1680), also visited the city's construction sites. In a drawing of 1664 he gives us a unique and realistic representation of men destroying the Heiligewegspoort to allow for the extension of the Herengracht, where Van Kessel himself lived for a short time.[19] It seems, then, that although such topical subjects were treated in drawings few of these were ever turned into full-fledged paintings.

The mud-mill (in Dutch 'moddermolen' or 'baggermolen'), here driven by two horses, is an equally unusual motif, otherwise immortalised only by Van Ruisdael (fig. 5c), who can probably be credited with its earliest depiction.[20] It consists of a large, horizontal wheel, held in place by a cage-like wooden construction. The horses turn the wheel on a vertical axis, thereby setting the digging mechanism in motion. Such mud-mills could certainly be found everywhere in the seventeenth-century Netherlands, as they were used not only in the enlargement of cities and towns but also in the creation of new polders.[21] The scene at the right, cows in a meadow – three of them sheltering under a tree – recalls the work of Paulus Potter (cat. no. 25)[22] and gives a good impression of the still-rural character of Haarlem's surroundings.

The enormous growth in population led not only to the expansion of Haarlem but also of Amsterdam as well, and Berckheyde frequently depicted the buildings in the city's newly reclaimed areas.[23] He may well have seen a market for this type of 'up-to-the-minute' picture. The popularity of these works is demonstrated by the publication in 1672 of a poem by Joost van den Vondel (1587-1679) praising a Berckheyde painting of the Herengracht, one of the city's new canals.[24] Whereas it seems most of the Haarlem cityscapes were painted for local residents – wealthy, chauvinistic patricians are thought to have formed the artist's main clientele[25] – it seems not unreasonable to assume that the unique picture in the Lugt Collection was painted on commission, perhaps for the city government itself, which had decided on the expansion and may have wished to have it recorded for posterity.[26] However, the painting, whose provenance can unfortunately be traced no further back than the beginning of the twentieth century,[27] is not only a trustworthy document but also a work of extraordinary pictorial quality.[28] The sunlight gives it a particular mood, and the touches of colour in the workmen's clothes provide an accent in an otherwise almost monochrome representation. *QB*

61

Jan Both

Utrecht *c.*1618-1652 Utrecht

6 *Mountain landscape with a bridge, c.*1642

Panel,[1] 47 x 62.4 cm / Signed at lower left:*JBoth* (*JB* in ligature) / Acquired in 1949

Provenance
(?) Sale London, Christie's, 30 April 1920, lot 151, to Mellaert;[2] Charles Duits (1882-1969), art dealer, London, 1948; Frits Lugt, The Hague and Paris, acquired from Duits on 27 January 1949; inv. no. 6040

Exhibitions
Paris 1983, no. 12

Literature
A. Blankert in Utrecht 1965, p. 121 note 6; C. van Hasselt in Florence 1966, p. 71; C. van Hasselt in Brussels-Rotterdam-Paris-Bern 1968-1969, p. 150 note 2; Burke 1976a, pp. 234-236, no. 89 and fig. 80; Burke 1976b, p. 386 note 8; Blankert 1978, p. 121 note 6; S. Nihom-Nijstad in Paris 1983, pp. 22-24, no. 12 and fig. 35; Faton 1983, pp. 70-71 (ill.); F.J. Duparc and L.L. Graif in Montreal 1990, p. 85, fig. 37; E. Buijsen in Tokyo-Kasama-Kumamoto-Leiden 1992-1993, p. 214, fig. 2; J. Bruintjes and N. Köhler in Den Bosch-Rome 1992-1993, p. 68; Oehler 1997, p. 67 note 21

Jan Both, son of the Utrecht glass painter Dirck Joriaensz Both (d. 1664), must have received his training between 1634 and 1637 in Utrecht, possibly in the studio of Abraham Bloemaert (1566-1651), who had taught his elder brother Andries (1606/12-1641).[3] After completing his training, Jan Both travelled to Rome to join his brother, who had moved to the 'eternal city' several years before. In Rome the brothers most likely fell in with the colourful group of Dutch and Flemish artists who had banded together to form the 'Bent-vueghels' ('Birds of a feather'), although there is no proof that the Boths were actually members of this legendary fraternity. Andries was well acquainted with Pieter van Laer (1599-after 1642), and painted humorous representations of Roman low life in the same style. Jan Both, too, produced similar 'bambocciades' – after 'Bamboccio' (clumsy chap), Van Laer's fraternity nick-name referring to the artist's odd physique – though he devoted himself mainly to landscape painting. In 1639 he received an important commission to paint several landscapes for Buon Retiro, the Spanish king's new summer palace at Madrid. Jan Both's paintings were part of a series to which other foreign artists living in Rome also contributed, such as Herman van Swanevelt (*c.*1600-1655) and Claude Lorrain (1600-1682). In early 1642 the Both brothers left for Venice, undoubtedly planning to return from there to the Netherlands. Tragedy struck, however, when Andries drowned in a canal and Jan was forced to undertake the journey home alone. He spent the rest of his short life in Utrecht and died there, still unmarried, in 1652. Jan Both, together with Jan Asselijn (cat. no. 1), was one of the most important and influential artists belonging to the second generation of Dutch Italianate painters. His sun-drenched southern landscapes were imitated early on, and their influence is also seen in the work of such artists as Aelbert Cuyp (cat. no. 11), who does not belong to the core group of Italianate painters.

The layout of this landscape is characteristic of the work of Jan Both: a mountain face rising up like a wall closes off the depiction on one side and leaves the other side open for a view to the distance. The painting's

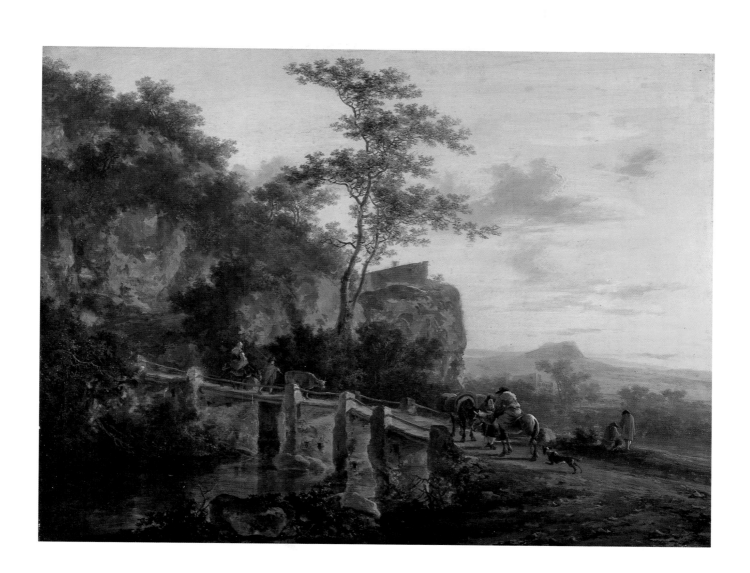

6a

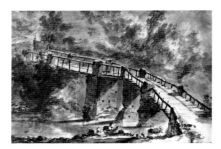

6b

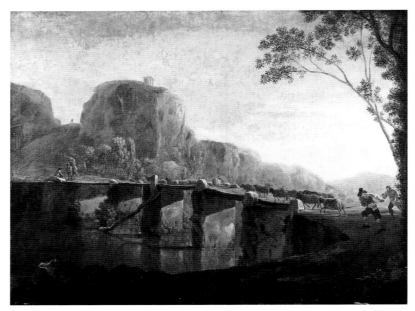

6c

6a Herman van Swanevelt, *The Ponte Acquoria near Tivoli*, *c*.1630. Pen and brown ink, brown and grey wash, over a sketch in black chalk, 23.8 x 35.6 cm. Paris, Frits Lugt Collection (acquired in 1937).

6b Unknown artist, *The Ponte Acquoria near Tivoli*, *c*.1640. Pen in brown, grey wash, heightened in white, over a sketch in black chalk, 24.4 x 36.8 cm. Berlin, Staatliche Museen, Kupferstichkabinett (as Adam Pynacker).

6c Jan Asselijn, *Landscape with the Ponte Acquoria*, *c*.1650. Canvas, 52 x 67 cm. Vaduz, Sammlungen des regierenden Fürsten von Liechtenstein.

6d Jan Both, *Southern landscape with travellers*, *c*.1645-1650. Canvas, 50.6 x 66 cm. Montreal, Museum of Fine Arts (acquired in 1988).

6d

principal motif – a bridge crossing a river at the foot of a rocky mountain face – contributes greatly to the diagonal effect of the composition. On and near the bridge are several figures: at the abutment two men converse, one of whom has alighted from his donkey; a peasant couple leading a cow approach from the other side, the woman also riding a donkey. To the right of the bridge are two more men, seen from the back, who face the landscape unfolding below them. The seated figure is undoubtedly drawing the view: Both often depicted such duos – a draughtsman and his companion – in his landscapes.[4] The simple, compact design of this work is obscured somewhat by the general profusion of greenery – from which rises one of Both's characteristically tall trees – and especially by the low angle of the sunlight, which lights up the piers of the bridge and suffuses the whole landscape with a warm glow. The painting was done with loose and, in places, extremely free brushstrokes, which are especially noticeable on the right side of the mountain face, below the building. In several places the painter ingeniously left the pink preparation layer uncovered, using it as a colour value amidst the other hues.

The bridge has been identified as the Ponte Acquoria, the bridge to the west of Tivoli which takes the Via Tiburtina over the river Anio, whose clearness at that spot gave the bridge its name. By the seventeenth century, all that remained of the original bridge – which in Roman times had been called the Pons Gellii – were the piers, which were connected with wooden planking, causing the bridge also to be known as the Ponte di Ligno (after 'legno', wood).[5] This bridge was very popular indeed with the Dutch artists at Rome, as witnessed by its appearance in a great number of drawings,[6] one of which is to be found in the Frits Lugt Collection (fig. 6a).[7] Jan Asselijn, who arrived in Rome some time between 1635 and 1638, was inspired by the bridge to produce two paintings, both of which are undoubtedly based on an unknown drawing by his hand (fig. 6c).[8] Jan Both and he had become acquainted in Rome and probably drew together occasionally.[9] Asselijn placed the motif in a completely different landscape, however, as was the case in many drawings of this bridge. Both's rendering is certainly not topographically correct, though he did reproduce the actual situation to some degree by situating the bridge at the foot of a mountain face.[10] The artist doubtless based his depiction of the bridge on a sketch made on the spot. A drawing in Berlin which is attributed to Adam Pynacker (1620/21-1673) has in the past

been ascribed to Both. The sheet, however, whose bridge does in fact display remarkable similarities to the bridge in the painting, cannot be attributed unreservedly to Both (fig. 6b).[11]

It is generally assumed that the majority of Both's known paintings, which number more than a hundred, originated after his return to the Netherlands. Establishing the chronology of his work is hampered by the fact that only two of his landscapes are dated: a southern landscape dating from 1649,[12] and a landscape with Mercury and Argus stemming from 1650.[13] In addition, there is a small group of works which can be dated with certainty to the artist's Roman years, such as the paintings made for Buon Retiro, now in the Museo del Prado at Madrid.[14] These display the influence of Herman van Swanevelt, who also contributed to the series destined for the royal palace, and are generally characterised by broad brushwork, powerful contrasts of light and a predominately brown ground, all of which also typify the painting discussed here. Its simple composition and rather unstable spatial organisation suggest that the painting originated early on, in the first years after Both's return from Rome. We know a few other works by Jan Both which also depict the Ponte Acquoria, the most important being a painting in Montreal in which the bridge is depicted more from the side and framed in a much wider landscape (fig. 6d).[15] Judging from its much more refined manner of painting, the Montreal canvas – characterised by a composition displaying much greater spatial differentiation and a less uniform, gold-brown palette – probably dates from the second half of the 1640s. Two other paintings are more closely related in design to the work discussed here, with a mountain face at the left and a distant view on the right. However, the authenticity of these works, known only from photographs, is by no means certain.[16]

Of the works by Dutch Italianate artists in the collection of the Fondation Custodia, this painting was the first to be acquired by Frits Lugt, who eventually formed an ensemble of beautiful works by such artists as Jan Asselijn (cat. no. 1), Nicolaes Berchem (cat. no. 4), Bartholomeus Breenbergh (1598/1600-1657), Karel du Jardin (cat. no. 15), Carel de Hooch (d. 1638), Willem Romeyn (c.1624-after 1694), Jan Sonjé (c.1625-1707) and Caspar van Wittel (1652/53-1736). All these purchases were made after the Second World War, at a time when interest in this group of painters was clearly on the increase.[17] Of the four drawings assigned to Jan Both in the Frits Lugt Collection, only one can be attributed to him with certainty.[18] *HB*

65

Esaias Boursse

Amsterdam 1631-1672 at sea

7 *An old woman doing needlework, c.1655-1660*

Panel, 28.5 x 22.3 cm / Signed with initials at far left, on the piece of furniture to the left of the chair: *E B* / Acquired in 1938

Provenance
Bethmann-Hollweg Collection;[1] unknown English collection (sale London, Christie, Manson & Woods, 30 May 1919, no. 57, to Wise for
29 pounds and 8 shillings);[2] Mr A.V. Scully, London, 1938; Thomas Agnew & Sons, art dealers, London, March 1938 (purchased from Scully);[3]
Frits Lugt, The Hague and Paris, purchased from Agnew on 27 May 1938;[4] inv. no. 5471

Exhibitions
London 1938, no. 20; Paris 1965a, no. 29 (as Pieter de Hooch); Paris 1983, no. 13

Bibliography
Plietzsch 1949, p. 259 and fig. 138; Brière-Misme 1954, pp. 25, 156, 158 (and note 62), 166 and fig. 10; F. Lugt in Paris 1965a, p. 27, no. 29 and fig. x
(as Pieter de Hooch); Régnier 1968, p. 277 (as Pieter de Hooch); Huyghe *et al.* 1971, unpaginated, under no. 14; S. Nihom-Nijstad in Paris 1983,
pp. 24-26, no. 13 and fig. 80; Prat 1983, p. 132; Schlumberger 1983, p. 52; Hecht 1984, p. 357; P.C. Sutton in Philadelphia-Berlin-London 1984, p. 156
note 5 (to his cat. no. 16); Sumowski 1983-1994, vol. 3 (1986), pp. 1962, 1966 note 100 and fig. p. 2004; F.G. Meijer in *Allgemeines Künstler-Lexikon*,
vol. 13 (1996), p. 393

Esaias Boursse is thought to have apprenticed himself
before 1650 to a local painter in his home town of
Amsterdam, possibly none other than Rembrandt
(1606-1669).[5] After all, his parental home was in Sint-
Anthonisbreestraat (now Jodenbreestraat),[6] where
Rembrandt had purchased an elegant merchant's house
in 1639. On stylistic grounds too, Boursse's work has
been related to the great master.[7] He evidently registered
with the painters' guild in Amsterdam around 1651,[8]
after which he spent some time in Italy, in any case
before 1656, a journey paid for by his brother Jan
(1622-1671).[9] In 1661 the painter left to serve for two
years as an officer candidate on a ship of the Dutch
East India Company (VOC), which put in at the Cape
of Good Hope and Ceylon (now Sri Lanka) on its way
east.[10] The drawings he produced at these places are
among those mentioned, together with some of his
paintings, in the 1671 inventory of the estate of his
brother Jan, whose collection also included works by
Rembrandt.[11] Boursse died on board a VOC ship on
16 November 1672, while undertaking a second voyage
to the East Indies.[12]

Born of Flemish parents in 1631, the painter belonged
to the same generation as Pieter de Hooch (1629-1684)
and Johannes Vermeer (1632-1675). There is a world of
difference in both style and quality between his work
and that of the two famous painters, although Boursse's
compositions are undoubtedly original. Nonetheless,
his small oeuvre – no more than 25 or 30 works are
known[13] – has been attributed variously to both artists
in the past. Frits Lugt catalogued this picture optimisti-
cally under De Hooch's name in 1965 for an exhibition
held in the Institut Néerlandais in Paris.[14] The initials
'E B', clearly visible today on the piece of furniture to
the left of the chair, had evidently escaped his attention
at the time.[15] The same exhibition included a painting
by Boursse dated 1661, likewise depicting a woman
sewing (fig. 7b).[16] When the two works are compared
one is struck by the fact that the old woman has been
endowed with personalised facial features, whereas the
faces of the figures in the painting from 1661 are totally
indistinct. Like much of Boursse's work, the painting
from 1661, acquired by the Rijksmuseum in 1882 as by
De Hooch on the basis of a forged signature,[17] exhibits

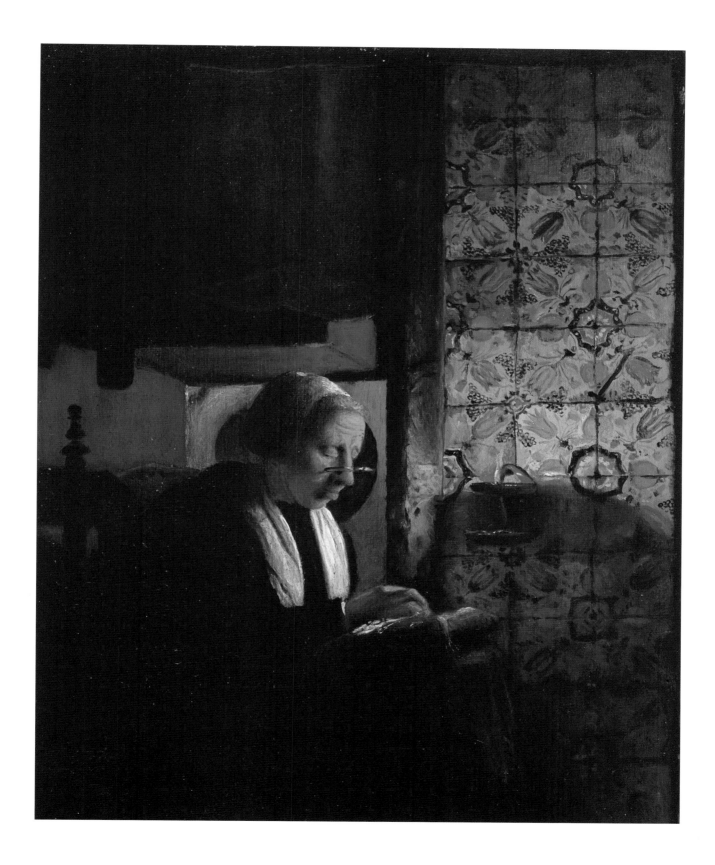

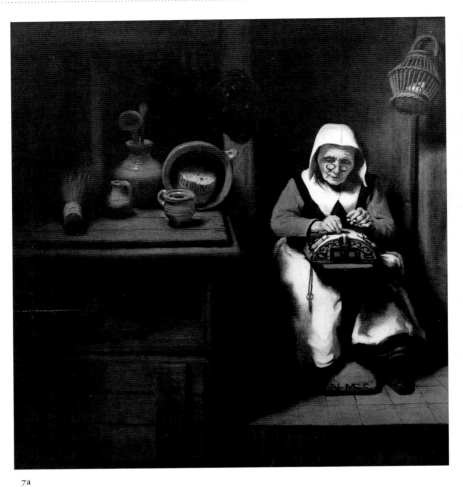

7a

7b

7c

7a Nicolaes Maes, *The old lace-worker*, c.1655. Panel, 37.5 x 35 cm. The Hague, Royal Cabinet of Paintings Mauritshuis (acquired in 1994).

7b Esaias Boursse, *Interior with woman at spinning-wheel*, 1661. Canvas, 60 x 49 cm. Amsterdam, Rijksmuseum (acquired in 1882).

7c Delft Studio, *Array of 48 tiles (detail)*, c.1600-1625. Amsterdam, Rijksmuseum (acquired in 1955).

clear similarities with compositions by the latter, whose earliest dated work is from 1658. De Hooch, however, seldom portrayed women engaged in needle-work.[18] Another artist from whom Boursse is generally believed to have derived inspiration is Quiringh van Brekelenkam (c.1620-1668), although no unequivocal borrowings have been identified and the stylistic corres-pondences between their pictures are not very great.[19]

Boursse mainly depicted women in interiors going about their domestic tasks. He also produced a few outdoor scenes, generally set in courtyards. The composition of the interior scene shown here is rather uncharacteristic, however.[20] While Boursse's paintings often adopt something of a wide-angle view of the

7d The array of tiles that Frits Lugt had inserted in the fireplace of the 'Salon hollandais' of the Hôtel Turgot in Paris (source: Huyghe *et al.* 1971, fig. 14).

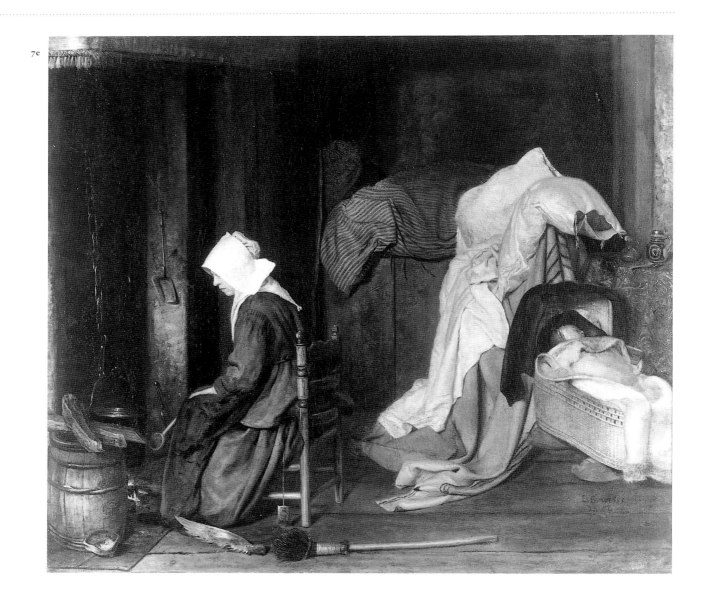

7e **Esaias Boursse**, *Interior with woman cooking*, 1656. Canvas, 51 x 57.8 cm. London, The Wallace Collection (acquired in 1872).

interior, here he zooms in, as it were, on the human action, and the spatial context is less prominent. He has not even painted the mantelpiece above the hearth, only the tiled wall beneath it. In other paintings by Boursse, including those in the Gemäldegalerie in Berlin and the Rheinisches Landesmuseum in Bonn,[21]

the viewer's attention is distracted to a greater or lesser extent by the cluttered space around the figures who are depicted, as here, near a fireplace.

The painting bears an unmistakable resemblance to scenes with needlewomen by one of Rembrandt's most notable pupils, Nicolaes Maes (1634-1693), which exude

a similarly serene and hushed atmosphere. The panel reproduced here by Maes, whose first dated picture of a needle-woman is from 1654,[22] has a compositional divide like the painting under discussion (fig. 7a).[23] The left side of the painting by Maes is dominated by a still life, while at the right all attention focuses on the old woman. Boursse has placed his needle-woman on the left and filled the right half of his work with the tiled wall. The woman's movements are accentuated by the positioning of her hand immediately below the vertical line dividing the tiles from the plastered wall. But whether she is indeed making bobbin lace, as in the painting by Maes, is open to doubt. In Maes, as in Vermeer's famous *Lacemaker* from about 1670 (Paris, Musée du Louvre), the lace pillow has the distinctive bulging shape that ensures that the bobbins do not rest on the lacework itself, but hang at the sides.[24] The woman depicted by Boursse, whom all authors take for granted is making lace,[25] may be using an older model of pillow that was a cross between an ordinary sewing cushion and a bobbin lace pillow as depicted by Maes and Vermeer, and making only very rudimentary lacework.[26] However, Boursse has not depicted bobbins at the ends of the threads, an essential component in making lace, which suggests that his subject is doing simple needlework. Whatever the case may be, she is certainly engaged in a task exemplifying the virtues of domesticity.[27]

Like Maes, Boursse was interested in light and dark effects. Maes, however, did not show the artificial light source in his picture, while Boursse assigned it a prominent place. The light from the earthenware oil lamp falls on the woman's hands and face, emphasising her movements. The painter has conveyed the flame's reflection with white accents on the pince-nez that stand out sharply against the black background. This type of oil lamp, which is rendered in meticulous detail, was used only in kitchens, where it often hung, as here, against the tiled wall behind the fireplace.[28] The brightly illuminated yellowish-white tiles, which stand out in the otherwise dimly lit space, are decorated with a four-tile motif. It comprises four pomegranates arranged around an eight-pointed star, divided by red or blue tulips that reach into the corners and surrounded by foliage and bunches of grapes. There is an additional floral motif where the four tulips meet. In spite of his wide strokes, the artist has rendered the decoration in convincing detail. Where the light is dimmer, the patterns on the tiles are depicted less

accurately, enhancing the realism of the light effects. The shadow beneath the little lamp falls on the lowest tiles, with a sort of semicircle suggested to the left and right of the modest light source. The motif on the tiles was certainly no invention of the painter. It was evidently based on existing examples made at tile factories such as Rouaen (also known as 't Lage Huys) in Delft in the first quarter of the seventeenth century. In an inventory of the factory owner's property dating from 1620, tiles with this pattern are called 'Schoone Tulpen' (Fine Tulips).[29] The Rijksmuseum in Amsterdam has an array of forty-eight tiles exhibiting virtually the same symmetrical pattern as that depicted by Boursse (fig. 7c).[30] Frits Lugt had tiles with this decoration, salvaged from bombed houses in Rotterdam, inserted in the fireplace of the 'Dutch room' of Hôtel Turgot in Paris (fig. 7d).[31] The painting shown here, acquired in 1938, generally hung in this room of the eighteenth-century building, which has housed Lugt's collections since 1957. Lugt spent hours working at his desk there.

Since Boursse rarely dated his work,[32] the chronology of his oeuvre is hard to establish. However, his later works seem to exhibit a rather more open composition, as the painter no longer crammed them full of numerous objects.[33] The scene depicted here may date from 1655-1660, that is, the same period as the painting in London dated 1656 (fig. 7e), the artist's earliest dated work with a similar emphasis on light and dark effects.[34] It seems in any case to have been made before 1661, the date on the painting in Amsterdam (fig. 7b), in which the interior is spacious and empty and above all more evenly illuminated. The relatively early date of the painting described here, which because of its highly original composition is difficult to fit into the painter's small oeuvre, is in part indicated by certain elements of the composition that are executed rather unconvincingly. For instance, it is unclear what the painter has depicted at upper left; the wooden structure adjoining the fireplace is perspectivally ill-construed. It could be some sort of cupboard for storing food or other goods, partly screened by a simple curtain.[35] Boursse also appears to have had difficulty with the woman's hands: the middle finger of the left hand is rather clumsily done and the right hand has been left out altogether for the sake of convenience. Despite these shortcomings, the convincing rendering of the light reflected on the tiled wall creates an atmosphere of intimacy that gives the painting its appeal. *QB*

Jan de Bray

Haarlem *c.*1627-1697 Haarlem

..

8 *Portrait of a woman,* 1667

Canvas, 77.3 x 63 cm / Signed and dated at lower right: *JDBraij. 1667 (JDB* in ligature)[1] / Acquired in 1978 as a gift from Louise Thurkow-van Huffel

Provenance
W.E. Duits, art dealer, Amsterdam, October 1923;[2] A.V. Scully, London, 1925;[3] H. Burstenshurst, Kingston-on-Thames;[4] private collection, Germany;[5] Jacques Goudstikker (1897-1940), Amsterdam, 1936;[6] C.T.F. Thurkow (1882-1970), The Hague, in or before 1937;[7] Louise Thurkow-van Huffel (1900-1987), The Hague; donated to the Fondation Custodia on 21 April 1978;[8] inv. no. 1978-S.2

Exhibitions
Haarlem 1936, no. 6; Rotterdam 1936-1937, no. 3; Rotterdam 1938, no. 59; Zürich 1953, no. 15; Rome 1954, no. 19; Milan 1954, no. 23; Rotterdam 1955, no. 48; Oslo 1959, no. 8; Paris 1983, no. 14; Atlanta 1985, no. 14; Paris 1994, no. 128

Literature
Von Moltke 1938-1939, p. 481, no. 152 and p. 480, fig. 53; R. Jørgensen in *Kunst og Kultur* 42 (1959), p. 120, fig. 4 (detail); S. Nihom-Nijstad in Paris 1983, pp. 26-27, no. 14 and fig. 68; F.J. Duparc in Atlanta 1985, pp. 42-43, no. 14 (ill.); König 1985, p. 3323; S. Walden in Paris 1994, pp. 268-269, no. 128 (ill.); R.E.O. Ekkart in *Allgemeines Künstler-Lexikon*, vol. 14 (1996), p. 31

..

The Haarlem artist Jan de Bray painted this unidentified woman in 1667. De Bray's oeuvre is dominated by portraits and regent pieces painted on commission, all of which were made in a rather personal style.[9] He was not exclusively a portraitist, however; he also produced narrative scenes, generally with biblical themes, such as *The adoration of the shepherds* from 1665 (fig. 8a).[10] Besides small intimate scenes of this kind and an occasional genre piece he also painted large history paintings to hang in buildings such as the town hall and the Prinsenhof in Haarlem (now in the Frans Halsmuseum). His work is characterised by clear light effects, a striking use of colour and bold contours, and hence exemplifies the classicist trend that is visible in Haarlem painting from about 1650. Indeed, Jan de Bray's work can be ranked together with that of Caesar van Everdingen (*c.*1617-1678) among the best that this school produced in the northern Netherlands.[11] In his own day the painter was certainly appreciated as much – and in the same circles – as the famous Haarlem portrait painter Frans Hals (1581/85-1666),

by then advanced in years, or his contemporary Jacob van Ruisdael (cat. no. 27).[12] De Bray made portraits of many of Haarlem's notables – from about 1660 onwards he was the city's leading portrait painter – and was given several major commissions.

The earliest dated drawings and paintings by Jan de Bray were made in 1648 and 1650, respectively. He was the eldest son of the Haarlem painter and architect Salomon de Bray (1597-1664),[13] who was undoubtedly his teacher. The work of father and son are so similar, in style as well as theme, as to be almost indistinguishable at times. The painting described here is signed at lower right and dated 1667, with the first three letters of the signature 'JDBraij', as usual, in ligature. It therefore dates from the decade in which Jan de Bray's work was at its very best, strangely enough in the very period during which several members of his family – his father, sisters and brothers – died in the plague epidemic that consumed Haarlem in 1664. From 1667 to 1685 the painter held positions in the board of the Haarlem painters' guild, the 'headmen' of which he portrayed in

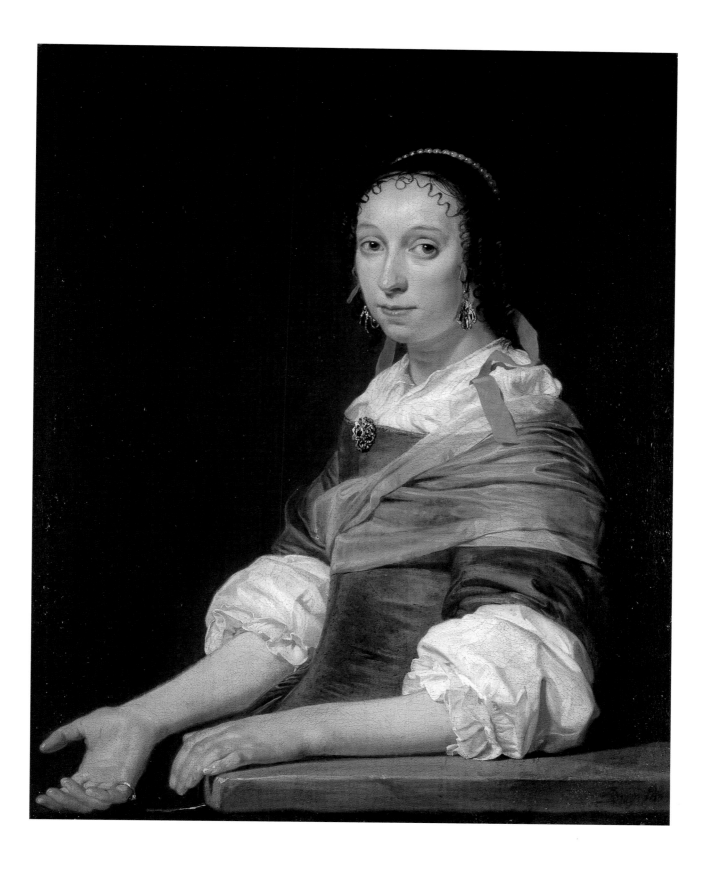

8a

8b

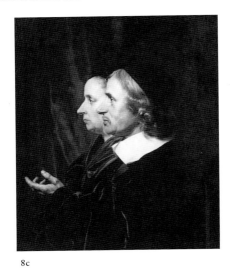

8c

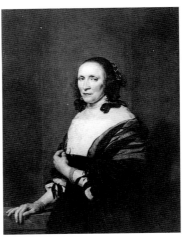

8d

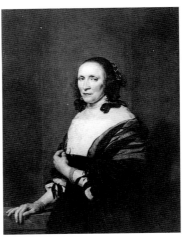

8e

74

8a Jan de Bray, *The adoration of the shepherds*,
 1665. Panel, 63 x 48 cm. The Hague,
 Royal Cabinet of Paintings Mauritshuis
 (acquired in 1997).

8b Jan de Bray (?) after Salomon de Bray,
 Young woman behind a balustrade, 1650.
 Red and black chalk, 24 x 19 cm. Private
 collection (photograph: RKD, The Hague).

8c Jan de Bray, *Double portrait of Salomon
 de Bray and Anna Westerbaen, the artist's
 parents*, c.1660. Panel, 79.5 x 64.5 cm.
 Private collection (on loan to the National
 Gallery of Art, Washington).

8d Jan de Bray, *Portrait of a 45-year-old woman*,
 1660. Canvas, 95.9 x 75.8 cm. Private
 collection (photograph: RKD, The Hague).

8e Titian, *Portrait of a man*, c.1512. Canvas,
 81.2 x 66.3 cm. London, The National
 Gallery (acquired in 1904).

1675 (Amsterdam, Rijksmuseum).[14] With the exception
of a brief stay in Amsterdam in the years 1686-1688, the
artist would live and work in Haarlem until his death.
It is therefore tempting to assume that the lady blushing
with health in this portrait is from Haarlem's burgher
circles. This portrait of a married woman – she wears
a wedding ring on her little finger[15] – may have had a
pendant: the striking pose of her right hand, palm
upturned, is suggestive of interaction with a lost
portrait of her husband, although it could also be
interpreted as a proud allusion to her married state.
In any case, the painter often devoted much attention
to sign language, though here he does so in a relatively
inconspicuous manner.[16]

This well-preserved portrait displays all the characteristics of the classicist style that was so fashionable in Haarlem at this time. The composition is fairly simple: De Bray has portrayed the woman standing behind a stone balustrade against a dark brown background, a structure probably inspired by some of his father's paintings. A painting by De Bray senior from 1650, known only from a copy that was in fact probably made by his son Jan and in any case belonged to the artists' stock of drawings (fig. 8b),[17] shows a young woman behind a balustrade which – unlike the one depicted here – takes up the entire width of the scene. Both the even, rather bare background of the painting described here – against which the contours of the woman's hands and clothing stand out clearly – and the balustrade in the foreground belong to the standard repertoire of classicist paintings in the northern Netherlands.[18] Nonetheless, the composition of this particular work is unique in Jan de Bray's oeuvre. As far as is known he used the balustrade as a motif in only two other portraits: a drawn portrait from 1657 shows the artist's father behind a balustrade, which however again stretches across the entire width of the composition,[19] and there is a portrait from 1660, in which De Bray placed his sitter in front of the balustrade, not behind it (fig. 8d).[20]

The most striking elements of this painting, the even background and the balustrade in the foreground, recall portraits from the Italian Renaissance, such as the famous portrait of a man by Titian (1477-1576) from about 1512 (fig. 8e). This painting, which was part of an Amsterdam collection until 1641, is known to have served as the primary source of inspiration for Rembrandt's *Self-portrait, leaning on a stone wall* (an etching from 1639, p. 64, fig. 30-31a) and his best-known painted self-portrait 'à l'antique' from 1640 (in the National Gallery, London).[21] In the seventeenth century Dutch painters saw sixteenth-century Italian artists not only as their immediate predecessors but also – and more importantly in this context – as the direct heirs of classical antiquity. So this is no chance similarity. The double portrait that De Bray made of his parents in 1660 or later (fig. 8c), can unmistakably be linked to the double portraits that are seen on Roman coins – Salomon de Bray and his wife Anna Westerbaen are hence depicted in very sharp profile like a Roman emperor and empress.[22]

In the portrait shown here we are struck by the importunate – self-conscious? – expression on the face of the subject, who gazes sideways at the viewer, wide-eyed, while stretching out her right hand. Her dark corkscrew curls are not immediately noticeable against the dark background – the string of pearls tied with ribbons serves to fasten a barely perceptible hairnet. Her high forehead is accentuated by the elegant lines of decoratively 'plastered' curls. The hands are rather large (a common feature of De Bray's work) and have been rendered painstakingly. The light flesh tints of the hands and the white sleeves play an important part in creating an effect of depth, as these light-coloured surfaces contrast powerfully with the darker, subdued hues of the balustrade, clothes and background. With masterful technique De Bray has depicted white highlights in the jewel on the woman's dress (which is fastened tightly at the back), the pendants attached with green ribbons and the string of pearls, conspicuous elements which, like the striking hair style, were the latest fashion. Reflected light is conveyed in gleams in the nose, the ring and a nail of the right hand, and the shadow of the hand on the balustrade is equally convincing. The confident brushwork is evident in the wonderfully vigorous strokes with which the folds of material have been rendered, especially in the grey satin shawl. At the same time, a subtlety of approach speaks from the suggested play of light on the wrinkled material of the satin dress and shawl. The ribbon fastening the string of pearls is draped playfully over the woman's right shoulder. This red hair-ribbon is a strikingly colourful accent – more so even than the woman's rouge and red lips – in a portrait that is otherwise executed in fairly sober hues.

The classicist artists of the Dutch Golden Age have been restored to favour in the past decades.[23] This painting is exceptional in that it has been included in many exhibitions since 1936. It was acquired in 1978, eight years after the death of Frits Lugt, from the collection of C. Thurkow (1882-1970) as a gift from his widow Louise Thurkow-van Huffel (1900-1987). The Lugt Collection contains a substantial number of drawings by Jan de Bray, most of which were acquired by Lugt himself, including the *Portrait of a girl aged twelve* from 1663.[24] Thurkow-van Huffel enriched the collections of several Dutch museums, including the Mauritshuis,[25] with old masters. To the Museum Catharijne-convent in Utrecht she bequeathed an important history piece by Salomon de Bray.[26] This bequest inspired the Utrecht museum to mount an exhibition in 1988 dedicated to the Thurkow Collection in The Hague, to which this painting belonged for over 40 years.[27] *QB*

Jan van de Capelle

Amsterdam 1626-1679 Amsterdam

9 *Winter landscape with colf players*, 1653

Canvas, 45.5 x 53.5 cm / Signed and dated lower right: *I V Cappelle A° 1653* / Acquired in 1920

Provenance

Unknown collection (sale London, Christie's, 25 February 1893, lot 140);[1] Nicolaus Steinmayer, Cologne; Charles Sedelmeyer (1837-1927), art dealer, Paris, October 1894; Max Wasserman, Paris, 1895; François Kleinberger, art dealer, Paris; Jacques-Édouard Kann, Paris; Thomas Agnew & Sons, art dealers, London, 1919; Frits Lugt, Maartensdijk and Paris, purchased from Agnew's on 25 March 1920; inv. no. 528

Exhibitions

Paris 1895, no. 1; Paris 1911, no. 13; London 1929, no. 296; Rotterdam 1938, no. 62; The Hague 1946, no. 17; Paris 1950-1951, no. 16; Paris 1967, no. 87; Paris 1983, no. 19; The Hague 2001-2002, no. 12

Literature

C. Sedelmeyer in Paris 1895, pp. 4-5, no. 1 (ill.); Dayot 1912, p. 118, no. 14, fig. facing p. 40; Martin 1911, p. 434, no. 13; Hofstede de Groot 1907-1928, vol. 7 (1918), p. 222, no. 155; *Commemorative catalogue* 1930, p. 27, no. 296 and fig. XII; Gerson 1952, p. 48, fig. 139; Stechow 1963a, p. 115; Gudlaugsson 1964b, fig. p. 618; Stechow 1966, pp. 95-96 and fig. 186; C. van Hasselt in Brussels-Rotterdam-Paris-Bern 1968-1969, p. 33 (under no. 29); Russell 1975, pp. 30, 84, no. 155 and fig. 23; Reitsma 1976, pp. 252, 254, fig. 6; C. van Hasselt in New York-Paris 1977-1978, p. 40 note 2; S. Nihom-Nijstad in Paris 1983, pp. 33-34, no. 19 and fig. 28; Kingzett 1983, p. 503; P.C. Sutton in Amsterdam-Boston-Philadelphia 1987-1988, p. 287; Sutton 1992, p. 45 and fig. 2; P.C. Sutton in Madrid 1994, p. 94 and fig. 1; M. Russell in *The Dictionary of Art*, vol. 5 (1996), caption fig. p. 681 (with photograph of another painting); F. Lammertse in *Allgemeines Künstler-Lexikon*, vol. 16 (1997), p. 265; Russell 1997, p. 35; sale catalogue Christie's, London, 4 July 1997, p. 34, under lot 16; sale catalogue Christie's, London, 12 December 2001, p. 91, under lot 44; A. van Suchtelen in The Hague 2001-2002, pp. 96-97, no. 12 (ill.)

76

It was only in 1674 that Jan van de Cappelle's aged father died, leaving his dye-works to his son.[2] Until that time the latter had probably been able to devote himself almost entirely to his favourite pastime, namely painting. He is referred to in the will as a 'konstrijck schilder' (artful painter), and a large number of his pictures have been preserved. He was never a member of the Guild of St Luke, however, and the opening lines of a poem by Gerbrandt van den Eeckhout (1621-1674), who also painted Van de Cappelle's portrait, indicate that he was in fact self-taught. The quatrain, composed in 1654, accompanies Van de Cappelle's drawing of a winter landscape with people playing *colf* – an early form of the game played on grass – and appears in the *album amicorum* of the Amsterdam headmaster Jacob Heyblocq (1623-1690), which doubtless provides a good impression of the artistic and scholarly milieu in which the artist moved.[3] At his death in 1679 his seven children inherited not only the dye-works but also a number of properties and a large fortune, made up in part of a fabulous art collection that included nearly

200 paintings – among them a pair of pendant portraits by Rembrandt of Van de Cappelle and his wife – and nearly 6,000 drawings. The sizeable groups of sheets by Rembrandt (1606-1669), Hendrick Avercamp (cat. no. 2), Esaias van de Velde (1587-1630) and Jan van Goyen (1596-1656) were probably originally part of these artists' own studio stocks, purchased by Van de Cappelle *en bloc*. He owned a total of nine paintings and 1,300 drawings by Simon de Vlieger (1600/1-1653), who was undoubtedly an important source of inspiration.

Van de Cappelle himself was mainly a marine painter and along with Willem van de Velde the Younger (cat. nos. 33-34) can be considered one of the innovators in this genre at mid-century. His seascapes – the earliest dates to 1645 – are mostly what are known as 'calms', with ships calmed near the shore. They are characterised by a certain serenity and an emphasis on the changing lights and colours produced by the vaporous atmosphere of the seaside. Something of this fascination for the effects of light can be found in the

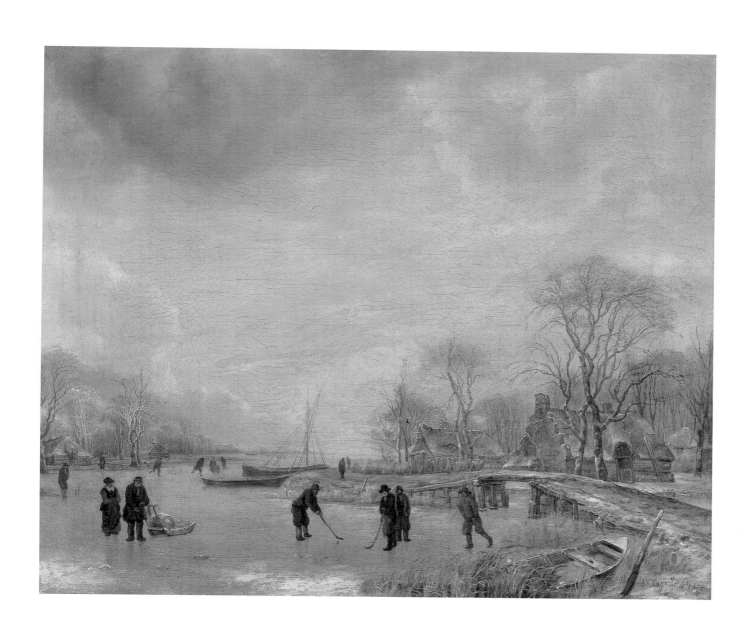

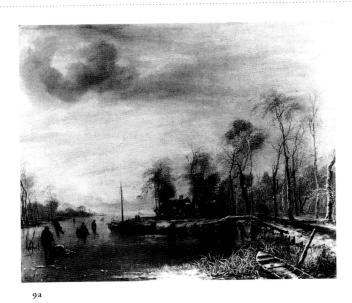

9a

9c

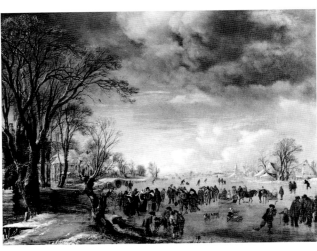

9b

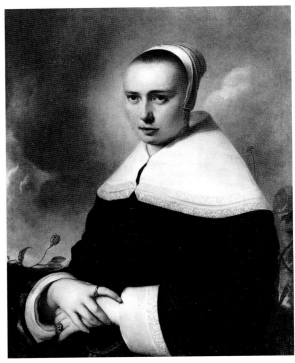

9d

9a Jan van de Cappelle, *Winter landscape*, 1653. Canvas, 48 x 56 cm. Private collection (photograph: RKD, The Hague).

9b Aert van der Neer, *Winter landscape with skaters*, 1645. Panel, 54.5 x 70 cm. Washington, The Corcoran Gallery of Art, William A. Clark Collection (acquired in 1925).

9c Jan van de Cappelle, *Winter landscape with colf players*, c.1655? Black ink, grey wash, 10.4 x 20.6 cm. Paris, Frits Lugt Collection (acquired in 1925).

9d Jan van Noordt, *Portrait of Annetje Jans Grotingh (1632-1677)*, c.1653. Canvas, 74.7 x 58 cm. Paris, Frits Lugt Collection (acquired in 1965).

painter's rare winter landscapes as well, although these are in fact influenced by other traditions and are far more sombre in tone.

The painting in the Frits Lugt Collection depicts a frozen waterway or river, with farmhouses nestled between the trees along the shore.[4] A few figures populate the ice: skaters, colf players, a couple transporting a barrel, and a mother with her child.[5] The light-hearted mood that generally predominates in seventeenth-century Dutch winter landscapes is conspicuously absent. The colf players appear almost immobile; the overall feeling is of an all-embracing icy chill. There are no signs of life around the low farmhouses either, only two figures hunched up against the cold as they make their way along the towpath. The painter's aim appears to have been to create a realistic and coherent image of the Dutch winter, without distracting details. The painting is executed in unaccented shades of brown and grey that perfectly capture the dingy light of a frosty day. The setting sun on the horizon, pierced by the rigging of two moored boats, can do little more than weakly illuminate the passing clouds. The emptiness of the landscape and the high sky, with its subtle nuances of light and colour, make this one of the artist's most impressive winter scenes. His oeuvre comprises around 15 such pictures, six of which bear the date 1652 or – as here – 1653.[6] A painting of more or less the same size, also completed in 1653, can be regarded as a variation on the work in the Lugt Collection (fig. 9a).[7] Van de Cappelle's other winter landscapes are undated.

In both structure and colouration Jan van de Cappelle's winter scenes evoke the somewhat older works of Aert van der Neer (cat. no. 21), who began painting similar subjects in the 1640s. Oddly enough, however, the 1680 inventory of Van de Cappelle's collection does not mention a single picture by this artist, although the two could easily have known each other. Van der Neer was also active in Amsterdam and he, too, contributed to the aforementioned Heyblocq album: namely, two sketches, one a winter scene with skaters near the Montelbaanstoren.[8] In the Lugt painting the artist has employed a compositional scheme often found in Van der Neer, with a body of water stretching towards the horizon as the main motif. The arrangement of the other landscape elements even recalls one of the latter's earliest winter

landscapes, albeit in reverse (fig. 9b). In the Van der Neer emphasis is placed on the left bank, where we also find farmhouses tucked among slender bare trees with flaring crowns and a towpath with a bridge. But the comparison also illustrates the difference between the two artists. The figures in the Van der Neer are not only more numerous but also livelier, making the mood of the work far less bleak. It therefore seems probable that Van de Cappelle had other sources of inspiration as well.[9] According to the inventory he also owned a number of winter landscapes by Jan van Goyen and Esaias van de Velde, as well as almost 900 drawings by Hendrick Avercamp – all three artists of the previous generation who had played an important role in the development of the genre.[10] Interesting, too, is the mention of a winter scene among the 19 works by Jan Porcellis (before 1584-1632). His monochrome seascapes were after all of great significance for Van de Cappelle's work on his other favourite theme.[11]

The 1680 inventory also makes mention of nearly 750 drawings by Jan van de Cappelle himself. Of these only 20 have come down to us today. In 1925, a year after acquiring one of Aert van der Neer's extremely rare drawings – in this medium, too, the work of the two artists is closely related – Frits Lugt purchased a winter landscape on paper by Van de Cappelle (fig. 9c).[12] The bridge in the right foreground of our painting is here transformed into the main motif. In addition, two small seascape drawings in the collection are traditionally attributed to the artist as well.[13] Finally, in 1965 Lugt acquired – unbeknownst to him – a portrait of the painter's wife, Annetje Jans Grotingh (fig. 9d), by Jan van Noordt (1623/24-1676?).[14] Its pendant, a likeness of Van de Cappelle himself dated 1653, had just been sold by the same London dealer. At the time the pictures were believed to depict an anonymous couple and to have both been painted by Gerbrandt van den Eeckhout. Only in 1981 was Saskia Nihom-Nijstad able to identify the sitters with the help of the 1680 inventory and to attribute the woman's portrait to Jan van Noordt.[15] Frits Lugt had thus missed acquiring the portrait of one of the most interesting artist-collectors of the seventeenth century, probably once the owner of some of Rembrandt's most beautiful drawings in his own collection, by little more than a hair's breadth.[16] *HB*

Pieter Codde (circle of)

Amsterdam 1599-1678 Amsterdam

10 *An artist and a connoisseur in conversation, c.1630*

Panel, 41.7 x 55.1 cm / Acquired in 1959

Provenance

Comte de Colombi, 'ancien chargé des affaires d'Espagne à Paris', Paris (sale Paris, Wéry-Bonnefons, 30 January 1843, lot 39);[1] Galerie Cailleux, Paris, 1956; Thomas Agnew & Sons, art dealers, London, purchased from Galerie Cailleux on 6 April 1959; Frits Lugt, Paris, purchased from Agnew's on 14 May 1959; inv. no. 7335

Exhibitions

Delft-Antwerp 1964-1965, no. 22; Brussels 1971, no. 21; Amsterdam 1976, no. 12; Paris 1983, no. 20

Literature

G.T.M. Lemmens in Delft-Antwerp 1964-1965, pp. 20, 26, 44, no. 22; Van Gelder 1964, pp. 21 (ill.) and 24; Brussels 1971, pp. 36 (ill.) and 38, no. 21; J.B. Bedaux *et al.* in Amsterdam 1976, pp. 72-75, no. 12 (ill.); Reitsma 1976, p. 256 and fig. 9; Schulz 1978, p. 15; Gaskell 1982, pp. 17-18 and fig. 3; Van de Wetering-Franken 1983, pp. 4-5 and fig. 5; S. Nihom-Nijstad in Paris 1983, pp. 35-37, no. 20 and fig. 75; Nihom-Nijstad 1983, n.p. (ill.); Prat 1983, pp. 125-126 (ill.); Raupp 1984, p. 278 note 490, p. 329; Jensen Adams 1985, vol. 1, p. 160 note 183; Zaremba Filipczak 1987, p. 230 note 15; B. Werche in Frankfurt 1993-1994, p. 218 note 1 (under no. 48); G. Luijten in Amsterdam 1997, p. 352 note 5 (under no. 74); D. Beaujean in *Allgemeines Künstler-Lexikon*, vol. 20 (1998), p. 97; Lammertse *et al.* 1998, p. 40 note 9; Költsch 2000, p. 253, fig. 186; A. Laabs in Leiden 2001, p. 29 note 15; E. van de Wetering in Kassel-Amsterdam 2001-2002, p. 31 and fig. 11

It was probably above all his love of drawings that led Frits Lugt to add this painting to his collection in 1959. One of the two earnest-looking gentlemen holds an open album – apparently a series of figure studies, like the visible sheet – and is making a gesture with his left hand that suggests he is giving strength to an argument. The otherwise bare room is crowded with albums and portfolios, and even loose drawings and prints – rolled up, mistreated or creased, like the winter landscape peeking out from under a pile at the lower left.[2] The unpainted panels against the wall indicate that this is a painter's studio, although none of the tools of his trade can be seen, save for a box containing chalk and a small knife for sharpening it. Few seventeenth-century paintings take the art of drawing as their subject. The meticulous rendering of the unfastened album gives a clear indication of how drawings were kept at the time (cf. cat. no. 22). Lugt was not only interested in the history of the collecting of drawings – he himself had made an important contribution to the field with his monumental handbook on collectors' marks (1921, with

a supplement published in 1956) – but also in their proper conservation. Even today the core of his collection is preserved in historical albums acquired explicitly for this purpose (cf. introductory essay, fig. 1).

The artist's studio was a popular theme in seventeenth-century Dutch art.[3] Among the usual props found in such scenes are numerous, picturesquely arranged objects that refer to the fundamentals of artistic praxis. These include the casts of antique sculptures, the *écorché* and the plaster foot seen in the Lugt painting, all of which artists were required to sketch as part of their training.[4] One of the sculptures depicted has been identified, namely the group of Hercules and Cacus in the foreground, a reproduction of a sixteenth-century Florentine bronze attributed to various artists and based on an unexecuted model by Michelangelo (1475-1565).[5] Casts of the group must have been found in many Dutch studios at the time, as it also appears in the work of Gerrit Dou (1613-1675) and Jan van der Heyden (1637-1722).[6] The largest of the two pieces on the table appears to represent Hercules as well, while the *écorché*

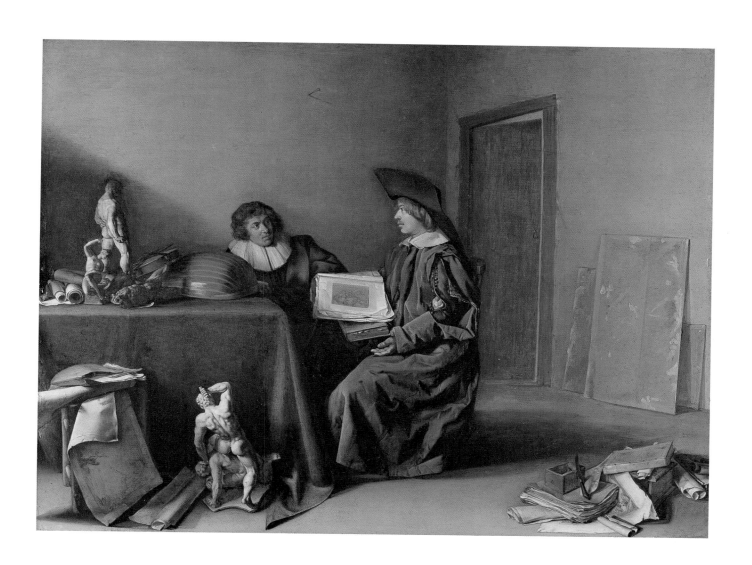

10a Pieter Codde, *A student with a pipe in his hand*, c.1630-1635. Panel, 46 x 34 cm. Lille, Musée des Beaux-Arts (acquired in 1885).
10b Pieter Codde (circle of), *Boy drawing after a sculpture*, c.1630. Panel, 28 x 36.5 cm. Brussels, Musées Royaux des Beaux-Arts (acquired in 1922).
10c Pieter Codde (circle of), *An artist in his studio, tuning a lute*, c.1630. Panel, 41 x 54 cm. Present whereabouts unknown (photograph: RKD, The Hague).

seems to be the torso of the so-called 'walking muscle man', which also turns up in a number of seventeenth-century paintings.[7]

Studio scenes generally focus on the artist at his easel; here, however, we see two well-dressed gentlemen engrossed in quiet conversation. The painting has thus always been interpreted as the studio visit of a connoisseur, a subject only rarely treated in Dutch art.[8] Such visits were common practice in the seventeenth century and frequently led to discussions on art. In his autobiography Constantijn Huygens (1596-1687) describes in detail his call to the studio of Jan Lievens (cat. no. 18) and Rembrandt (1606-1669), which took place in 1628

or 1629, shortly before the completion of the work in the Lugt Collection.[9] Of the two young men shown here the one with the album appears to be the visiting *amateur*: he has not removed his hat and his fur-lined robe is certainly much too fancy a costume for a painter.[10] The other would then be the artist, although his dress is also rather too distinguished. Furthermore, it is odd that his work should be exemplified only by drawings, which – according to seventeenth-century theory – represented merely the preparatory phase of artistic creation. It therefore seems possible that both are connoisseurs, perhaps discussing the bases of art, or even two laymen practitioners.

The palette is extremely sober, consisting mainly of brown and grey tones, with the subdued dark green of the tablecloth as the only accent. The execution and the placement of the figures and objects against an empty background, bathed in a single, strong beam of light, recalls the monochrome still lifes produced in Haarlem and Leiden at around this time, for example the *Still life with books* by Jan Davidsz de Heem in the Lugt Collection (cat. no. 14). The seemingly careless arrangement of the jumbled albums and rolls of paper is reminiscent of these works as well.

At the time of acquisition, the picture was attributed to Pieter Codde,[11] an Amsterdam painter best known for his small-format 'merry companies' and guard-room scenes, all of which are unmistakably stylistically related to the work illustrated here.[12] Codde's compositions often consist of only a few figures placed in empty, box-like rooms, and he was extremely good at depicting expensive, satiny materials. Moreover, a signed panel now in Stuttgart (Staatsgalerie) shows a very similar scene of three gentlemen-connoisseurs paying a call to an artist.[13] The 'vanitas (of) Johannes de Heem' mentioned in the painter's 1636 inventory would also explain the picture's resemblance to that artist's still life with books.[14]

Nonetheless, the repeated doubts concerning this attribution appear to be justified.[15] Codde's figures are generally more subtly and finely modelled and his palette more colourful, even when he employed the almost entirely monochrome style popular around 1630 in genre painting. His most notable work in this context is the signed likeness of a young student, a picture with obvious similarities to the one here under discussion but with equally evident stylistic differences (fig. 10a).[16] The brushstrokes are suppler and the melancholy figure's pose and expression are more tellingly captured than those of the two connoisseurs, who are somewhat heavy and even awkward. The work in Paris is thus probably by another hand, possibly the same one responsible for a painting of an analogous subject that includes some of the aforementioned sculptures (fig. 10b).[17] A depiction of an artist tuning a lute in a bare studio, now known only through an old photograph, is also conceivably the work of the same painter (fig. 10c).[18] Here, too, we find a still life of albums and rolls of paper, one of which is unfurled and appears to show a drawing, and the artist's physiognomy strongly recalls that of the *amateur* in the Paris picture. The identity of the anonymous painter of this series of works should undoubtedly be sought among the Amsterdam members of the circle of Pieter Codde and his peer Willem Duyster (1599-1635). The unfinished painting on the artist's easel (fig. 10c) shows a group of soldiers (a so-called *cortegaerd*), while the figure study in the open album in the Lugt painting depicts a man propping his leg on a stool in order to tie his stocking, a motif often found in such guard-room scenes.[19]

Studio interiors were certainly not (or not only) meant as simple illustrations of the painter's working space. They frequently include strange combinations of objects that undoubtedly refer to artistic theory and practice, and are thus somewhat mystifying for today's viewer. This has led to much speculation regarding their deeper meaning. With reference to the work in the Lugt Collection, for example, a link has been made between the Hercules and Cacus group and a passage in Karel van Mander's pedagogical poem *Den grondt der edel vry schilder-const* (1604), in which fledgling artists are advised to follow the virtuous example of this ancient hero.[20] The two musical instruments on the table – a violin and a lute – have also been viewed as the key to understanding the painting: they have been construed as representing the principles of harmony to which, according to Van Mander, both musical and pictorial composition should adhere,[21] or of the harmony expressed in the proportions of the human body, considered the most elevated subject for painting.[22] Such interpretations, however, are unconvincing. Musical instruments can equally stand for vanity and transience, a metaphor often employed in the seventeenth century and that lies at the heart of many *vanitas* still lifes in which they are included. A similar idea is certainly expressed in the depiction of the music-making painter (fig. 10c), who neglects his art for the ephemeral pleasures of the ear.[23] The impending complete deterioration of the drawings and albums in the painting in the Lugt Collection points in the same direction. The picture undoubtedly contains the identical message as the stylistically related still life with books by Jan Davidsz de Heem (cat. no. 14), and is probably also meant as an ironic commentary on the two art lovers, so preoccupied with their conversation. References to mortality are far from unusual in seventeenth-century studio scenes and artists' (self-)portraits, sometimes appearing as representations of the notion that the painter will live on through his work even after his death, sometimes as illustrations of the fact that in the final analysis his creations are nothing more than spurious illusions.[24] *HB*

Aelbert Cuyp

Dordrecht 1620-1691 Dordrecht

11 *River landscape, c.1655*

Panel, 27.4 x 36.8 cm (enlarged with narrow strips on all sides to 29 x 38.4 cm) / Signed at lower right: *A. cuyp* / Acquired in 1953

Provenance

Sir Luke Schaub (1690-1758), London, acquired from 'Mr. Ho[u]lditch', art dealer, in or before 1751 (sale London, Langford, 26-28 April 1758, first day's sale, lot 10,[1] to Colonel Fitzwilliams for Lord Ashburnham for 9 pounds and 9 shillings; John, Second Earl of Ashburnham (1724-1812), Ashburnham House, Westminster;[2] Lady Catherine Ashburnham (d. 1953), Ashburnham Place near Battle, Sussex, by inheritance (sale London, Sotheby's, 24 June 1953, lot 64,[3] to Carritt for Lugt for 5500 pounds); Frits Lugt, Paris; inv. no. 6608

Exhibitions

London 1819, no. 122; London 1952-1953, no. 474; The Hague 1970-1971, no. 63; London 1971, no. 56; Dordrecht 1977-1978, no. 33; Paris 1983, no. 23; Paris 1989, no. 3

Literature

Smith 1829-1842, vol. 5 (1834), p. 308, no. 89; Hofstede de Groot 1907-1928, vol. 2 (1908), p. 187, no. 658; Reiss 1953, p. 46; Gaunt 1975, p. 46, fig. 36, p. 49; Reiss 1975, p. 146, no. 107 (ill.); J.M. de Groot in Dordrecht 1977-1978, no. 33 (ill.); S. Nihom-Nijstad in Paris 1983, pp. 40-41, no. 23 and fig. 48; Faton 1983, p. 72 (ill.); Kingzett 1983, p. 503; G. Jansen and G. Luijten in Rotterdam 1988, p. 40, in no. 6; M. van Berge-Gerbaud in Paris 1989, p. xv; C. van Hasselt in *idem*, pp. 5-6, no. 3, figs. IV and 7; Chong 1991, pp. 611-612 and note 38; Chong 1992, pp. 375-376, no. 134; Van Zoest 1994, fig. p. 4; A. Chong in *The Dictionary of Art*, vol. 8 (1996), p. 298; G. Seelig in *Allgemeines Künstler-Lexikon*, vol. 23 (1999), p. 237; A. Chong in Turner 2000, p. 85

Aelbert Cuyp, the best-known scion of a family of painters from Dordrecht, was probably trained by his father Jacob Gerritsz Cuyp (1594-1651/52) with whom he would often collaborate in the 1640s.[4] Although Aelbert also worked in other genres – portraiture, figure painting, cattle pieces and pictures of stable interiors – he was first and foremost a landscape painter. Some of his earliest dated works in this genre, from 1639, hark back to mountain motifs, for which Esaias van de Velde (1587-1630) and Hercules Segers (1589/90-1633/38) have been named among his possible examples. Under the influence of Jan van Goyen (1596-1656) and Herman Saftleven (1609-1685) he soon gravitated instead to the largely flat Dutch landscape, executed in a tonal style of painting. From about 1645 onwards the work of Utrecht Italianates such as Jan Both (cat. no. 6), Cornelis van Poelenburch (1594/95-1667) and Herman van Swanevelt (*c*.1600-1655) became important sources of inspiration for the painter, whose mother came from Utrecht. From them Cuyp derived the warm, southern sunlight that came to characterise the best-known and most original

part of his work, starting in about 1650. By applying this light to traditional Dutch river landscapes, sometimes combined with decidedly un-Dutch hills and mountains, Cuyp created a new type of highly poetic landscape. Staffage – herdsmen, horsemen and cattle – plays a key role in the idyllic atmosphere that these works evoke. Depicting animals was from the outset one of Cuyp's specialisms, and his oeuvre includes several equestrian portraits set against a landscape. Cuyp lived until 1691, but it is unclear how much he painted in the last thirty years of his life. After his marriage in 1658 to the wealthy regent's widow Cornelia Boschman (1617-1689) he held a number of public positions, and it is thought that he gradually abandoned his brush from then on.[5] Cuyp's pupils included Barent van Calraet (1649-1737), mentioned as such by Cuyp's biographer Arnold Houbraken, and probably Barent's brother Abraham (1642-1722).

The effect of hazy sunlight, if nothing else, iden-tifies this small painting of a rugged river valley as

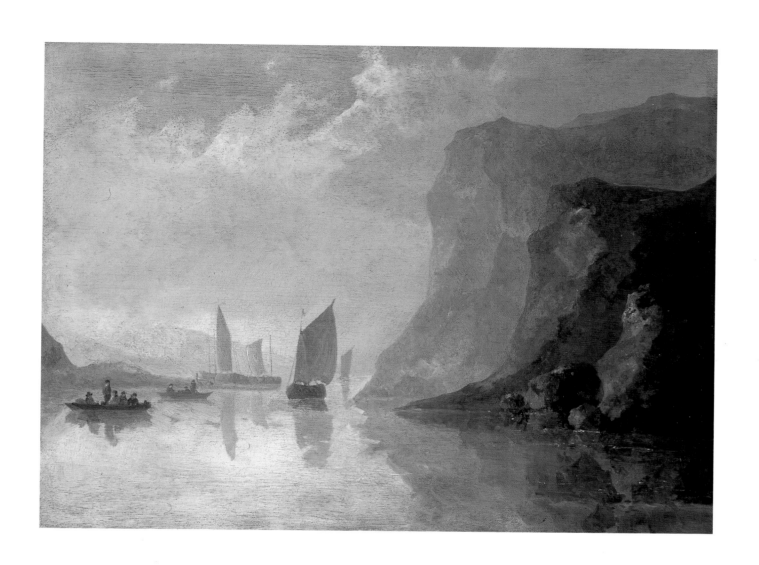

11a

11c

11b

86

11a Aelbert Cuyp, *River landscape*, c.1650. Panel, 40.5 x 55 cm.
Rotterdam, Museum Boijmans Van Beuningen
(acquired in 1847).
11b Aelbert Cuyp, *Herdsmen and cattle in a landscape*, c.1645.
Canvas, 99 x 144 cm. London, Dulwich Picture Gallery
(acquired in 1811).
11c Thomas Major after Aelbert Cuyp, *River landscape*, 1751.
Engraving, 22.2 x 28.1 cm (image), 26 x 30.9 cm (plate).
London, British Museum, Department of Prints &
Drawings.

a product of Cuyp's later years as a landscape painter.
Its simple composition and inconspicuous staffage
rather set it apart in the oeuvre of the artist, in whose
landscapes anomalous combinations of elements
sometimes create an air of artificiality.[6] A steep rock
face takes up the entire right foreground, leaving the
gaze free on only one side to roam over the river,
which is also bounded on the opposite side by barren
rocks. The tiny passengers of two little rowing boats
and a few small sailing vessels in the distance are the
only signs of life in the landscape, which, with the

numerous shapes reflected in the calm water, makes
a limpid, almost incorporeal impression.

There is a slightly larger variant of the composition
in Museum Boijmans Van Beuningen, Rotterdam
(fig. 11a).[7] The panel in the Frits Lugt Collection has
sometimes been taken for a preliminary study for this
painting, but this does not accord with what is known
of the artist's working methods.[8] On his travels around
the Netherlands Cuyp always recorded the motifs that
interested him in drawings that he would later – some-
times years later – incorporate with striking verisimili-

tude into his paintings. There are no known instances of his having first elaborated an entire composition in a small oil sketch. Besides, the painting described here is nothing like a sketch. The rocks in the foreground have been elaborated carefully and in meticulous detail, and since the little rowing boats with their passengers and the sailing vessels in the distance have not been perfectly preserved, they appear more sketchlike than originally intended.[9] The two paintings should probably be regarded as distinct elaborations of a similar composition. There are substantial differences in the contours of the rocks, in the number and positioning of vessels and in the horizon, which is higher in the painting under discussion, creating a different effect of depth. Moreover, with its cattle quenching their thirst and two herdsmen in the foreground, and the little town shrouded in mist on the opposite bank, the Rotterdam variant seems less uninhabited, while overgrowth softens the forbidding aspect of the rocks.

The type of landscape that is depicted in the two paintings is suggestive of the Rhine, and both paintings have sometimes been described as views of the Rhine valley.[10] Several topographically accurate drawings by Cuyp are known of towns on the banks of the Rhine and landscapes near the river in the border region with Germany. A drawing with a view of Kalkar (New York, The Metropolitan Museum of Art) is one of a group of sheets that evidently date from about 1642-1646,[11] while at least sixteen drawings attest to a second journey, which, judging by the details of the locations depicted, must have taken place in about 1651-1652.[12] The artist would subsequently incorporate many of the motifs from this latter group of drawings into paintings.[13] No drawing is known, however, that could have served as a basis for either the painting discussed here or the related piece in Rotterdam. Nor do any of the extant drawings suggest that the painter ever followed the river further upstream than Cleves. So he probably never visited the most picturesque part of the Rhine valley, between Bonn and Bingen, where it narrows and sheer rock faces rise from the water.[14] What is more, the differences between the two paintings make it clear that the scene is imaginary, and the choice of motif probably sprang from the work of other artists. In a painting from about 1645, perhaps one of Cuyp's earliest efforts to master the rendering of light and choice of motif that characterised the Italianate painters, the composition is bounded at right by a very similar rock face (fig. 11b).[15]

After 1645 the painter apparently no longer thought it necessary to furnish his landscapes with a date, so his later work can only be dated roughly.[16] The painting discussed here and the related one in Rotterdam are generally assumed to have been made in the late 1650s.[17] In theory they could date from somewhat earlier, since dendrochronological analysis reveals that the panel used for the Rotterdam landscape had been prepared for painting by about 1649.[18] Stylistically, however, there is little reason to abandon the traditional dating of the two works, particularly since there are no other truly comparable works in the painter's oeuvre.

The painting discussed here, like so many others by Aelbert Cuyp, found its way to Britain in the eighteenth century, and it was here, rather than on the Continent, that the artist was first ranked among the great masters of the Dutch school of painting. The art dealer Noël Desenfans (1745-1807) wrote famously about the discovery of Cuyp in the 1802 sale catalogue of his collection, which would eventually form the basis for Dulwich Picture Gallery in London. He related that the great exodus of Cuyp's paintings from Holland to Britain began around 1740, when the artist was still virtually unknown outside his native town; the Swiss watchmaker Grand Jean brought several of his works into the country, unleashing a collectors' rage.[19] Other accounts confirm that the collection of Cuyp's paintings in Britain must have started around 1740.[20] The diplomat and art connoisseur Sir Luke Schaub (1690-1758) must therefore have belonged to the first wave of enthusiasts, as the river landscape in the Frits Lugt Collection can be traced back to Schaub's famous collection as early as 1751.[21] That same year, Thomas Major (1720-1790) made an engraving after it, as a work by 'Knyp' and with a dedication to Schaub, one of the earliest reproductive prints made of Cuyp's work (fig. 11c).[22] In the sensational sale of the Schaub Collection in 1758, the painting was acquired cheaply by Lord Ashburnham, in whose family it then remained for almost two hundred years.[23] In 1953 Frits Lugt added it to his collection, which by then already contained eleven drawings by Cuyp.[24] He must have viewed the serene river scene not only as a splendid addition to his paintings, but also as a complement to another, less well-known part of his collection – the early nineteenth-century British landscape painters and landscape draughtsmen he so admired, to whom Cuyp's luminous style of painting had served as such an important example.[25] *HB*

Jacob Esselens

Amsterdam 1626/28-1687 Amsterdam

12 *Beach view with fishermen selling their catch, c.1650*

Canvas, 28.5 x 34.5 cm[1] / Signed with initials at lower centre, on the scroll: *J.E.* / Acquired in 1949

Provenance
Alphonse-Claude-Charles-Bernardin, Count of Perregaux (1785-1841), Paris (sale Paris, George-Ridel, 8-9 December 1841, lot 10, to Pelletier for 590 *francs*);[2] Martial Pelletier, Paris (sale Paris, Hôtel Drouot, Barre-Oudart, 28 April 1870, lot 10);[3] (?) *jonkheer* Cornelis Ploos van Amstel, Amsterdam;[4] André Giroux (1801-1879), Paris? (his sale, Paris, Hôtel Drouot, Lair-Dubreuil-Féral, 8 February 1904, lot 83, for 690 *francs*);[5] Adolphe Schloss (1842/43-1910), Paris; his widow, Mathilde Schloss née Hass (1858-1938), Paris; their heirs (sale Paris, Galerie Charpentier, Rheims-Baudoin, 25 May 1949, lot 18, to Lugt for 310,000 *francs*);[6] Frits Lugt, The Hague and Paris; inv. no. 6103

Exhibitions
Paris 1950-1951, no. 24; Paris 1983, no. 27; Paris 1989, no. 4

Literature
K. Lilienfeld in *Thieme-Becker*, vol. 11 (1915), p. 43; Stechow 1966, pp. 109, 207 note 37 and fig. 217; Bol 1973, p. 249; C. van Hasselt in New York-Paris 1977-1978, p. 58 note 1; S. Nihom-Nijstad in Paris 1983, pp. 27-28, no. 27 and fig. 46; Kingzett 1983, p. 503; M. van Berge-Gerbaud in Paris 1989, p. xv; C. van Hasselt in *idem*, pp. 6-7, no. 4 and fig. 5

Jacob Esselens traded in precious materials and may have practised art, like Jan van de Capelle (cat. no. 9), largely as a hobby.[7] Yet his work is of excellent quality, and his paintings are recorded in Amsterdam collections even during his lifetime. Few details of his life are documented, and who taught him to paint, for instance, is unknown. He was referred to as a painter when he married in 1668, but documents dating from 1677 and the period 1681-1685 call him a merchant. He employed velvet and silk weavers in Amsterdam and exported their products to other parts of Europe, and some of the artist's journeys were doubtless related to his trading activities. This would include his known drawings of scenes in England.[8] In addition, an album from 1720-1724 is mentioned in the collection of the Amsterdam art dealer Jan Pietersz Zomer (1641-1724) with twenty 'landscapes in France drawn from life by Jacob Esselens'.[9] In 1663 he is said to have travelled through the province of Gelderland with Gerbrandt van den Eeckhout (1621-1674) and Jan Lievens (cat. no. 18), probably with Cleves as their final destination, all

of them recording numerous locations in drawings along the way.[10] Jacob Esselens died in 1687, having designated the Amsterdam silk merchant Abraham Rutgers (1632-1699), another amateur draughtsman and evidently a good friend, as the guardian of his minor children.[11]

Aside for a few portraits – a sign that Esselens did sometimes paint for a living[12] – only landscapes are known by him. They vary greatly in style and character. Besides naturalistic Dutch landscapes, some of them topographically accurate,[13] they range from expansively painted mountain landscapes in the style of Roelant Roghman (1627-1692) to views of stately houses and parks in the classicistic style of Johannes Glauber (1646-1726).[14] The Dutch landscapes include not only beach scenes such as the little painting under discussion here, but also riverside and wooded landscapes, the latter sometimes furnished with mythological staffage. His drawings depict an equally varied range of landscapes, in a style of draughtsmanship sometimes recalling Gerbrandt van den Eeckhout or Jan Lievens and in

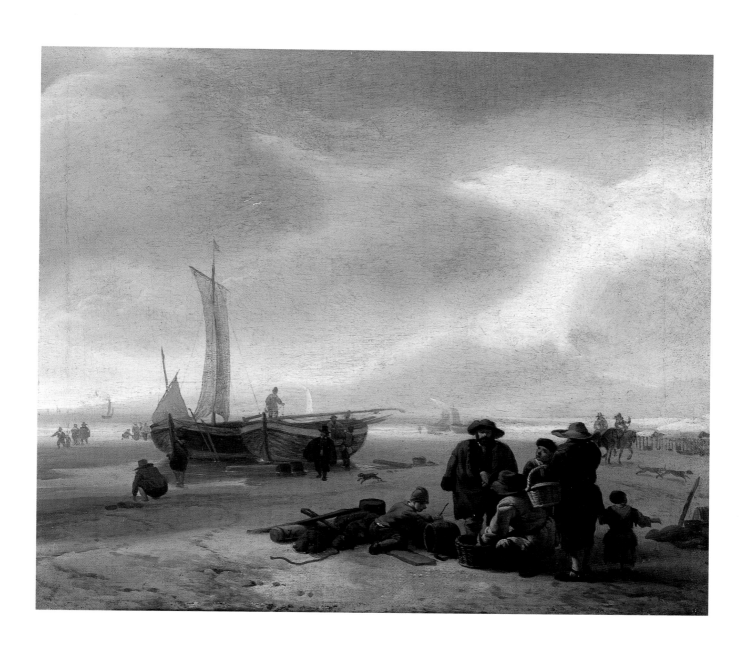

12a

12b

12c

12a Simon de Vlieger, *Beach view with fishermen selling their catch*, c.1645-1650. Black chalk, brush in grey and graphite pencil,
14.5 x 19.3 cm. Amsterdam, Amsterdams Historisch Museum (acquired in 1860).

12b Jacob Esselens, *Beach view with fishermen and fishing boats*, c.1650-1660? Pen in brown, grey wash, over a sketch in black chalk,
15.8 x 30.9 cm. Paris, Frits Lugt Collection (acquired in 1931).

12c Jacob Esselens, *Beach view*, c.1660-1665. Canvas, 80 x 107.3 cm. Paris, Frits Lugt Collection (acquired in 1925).

other cases more like Antoni Waterloo (1609-1690). On occasion we can identify drawings and etchings by Rembrandt as his examples (1606-1669).[15]

Today, Esselens' beach scenes are among the best known and most highly appreciated works by this artist, who was not rediscovered until the nineteenth century.[16] Besides their fresh colours and authentic seaside atmosphere, they derive their charm from the lively little figures dispersed in groups around the beach. As in countless other Dutch seventeenth-century beach views, their primary motif is that of fishermen offering their fresh catch for sale in baskets.[17] In this small painting the foreground is taken up with three fishermen, two of whom are bargaining with customers. Some distance away two fishing pinks are being unloaded,[18] while a smart gentleman walks past with his dog and children are apparently searching the pools for shells. In the distance we see more figures and little ships, thinly painted in drab hues and less well preserved than one would wish. Fortunately, this does not detract the overall effect of the painting, which convincingly evokes the near-empty beach at low tide.

Of the previous generation of painters, Simon de Vlieger (1600/1-1653) played the most important role in the development of the beach view as a genre.[19] His expansively conceived beach scenes are striking chiefly for their superb atmosphere. It is not known whether Esselens ever had any contact with De Vlieger, who was active in Amsterdam in the years 1638-1649. However, the inventory drawn up after Esselens' death lists 'two grisailles painted on paper, one by De Vlieger and the other by the deceased'.[20] What is more, the artist's work is clearly inspired by De Vlieger's example. In works such as those shown here, it seems to have been not so much his paintings with their numerous little figures but the drawings of the older artist that inspired Esselens. In any case, the painting discussed here shows striking similarities, in structure as well as theme, to *Beach view*

with fishermen selling their catch (fig. 12a).[21] In De Vlieger too, fishermen and their customers, surrounded by nets and baskets, barrel and roller, form a picturesque group in the foreground, while the beach and the sea behind it are both rendered parallel to the pictorial surface. Similar drawings of beach views are known by Jacob Esselens (fig. 12b).[22] Whether the artist made these sketchlike, but evenly and carefully executed drawings as compositional sketches for paintings or to sell to collectors is not known. To date, only a single drawing by Esselens can be linked to one of his paintings. This is a life study of a single sitter, the style and technique of which are poles apart, however, from the light-hearted beach views he drew using a pen.[23]

When Frits Lugt purchased the painting in 1949, he already possessed another beach view by the painter, a much larger canvas containing far more activity, looking down on the beach from a dune (fig. 12c).[24] The painting is warmer in tone than the one discussed here, with richer contrasts of light and colour. In the staffage the contrast between the poor fishermen and their rich customers is developed in greater detail, especially in the isolated little group in the left foreground, in which the paterfamilias of a fashionable family is giving alms to a fisherman's wife. Judging by the clothing of the figures, one of whom is wearing rhinegraves, wide breeches that came into fashion in about 1655, this piece cannot have been made before about 1655-1660.[25] The smaller painting under discussion here was probably made a few years earlier, in about 1650. In this scene the figures' simple apparel, scarcely subject to the vagaries of fashion – certainly where those in the foreground are concerned – provide few clues for the purposes of dating. However, the muted palette, the emphasis on atmosphere and the rather stocky figures strongly recall the work produced by Simon de Vlieger in the 1640s.[26] *HB*

91

Jacob van Geel

Born *c*.1585 / Active in Middelburg, Delft and Dordrecht *c*.1615-1637

13 *Imaginary mountain landscape, c.1625-1630*

Panel (circular), diameter 32 cm / On the back, in black ink: *Paysage [or]iginal de Brughle /... Museum Nal que 2 tableaux de ce Maitre* (original painting by Bruegel / in the National Museum [only?] two paintings by this master) / Acquired in 1946

Provenance
Unknown French collection, *c*.1790-1800 (as is clear from the inscription on the back, which dates from this period; see above and note 16); Curt Benedict, art dealer, Paris; Frits Lugt, Paris, purchased from Benedict on 12 December 1946;[1] inv. no. 5920

Exhibitions
Paris 1983, no. 31

Bibliography
Bol 1980, p. 137 note 9, no. e (as Jacob van Geel); Bol 1982, p. 13 note 9, no. e; S. Nihom-Nijstad in Paris 1983, pp. 53-54, no. 31 and fig. 4

Little is known about the life of Jacob van Geel,[2] although records are indicative of financial and marital problems. His name first appears in the books of the Guild of St Luke in Middelburg in 1615.[3] Eleven years later Van Geel's presence is documented in Delft, and in 1628 he is named there as a member of the local painters' guild.[4] In 1633 a document shows that he was working in Dordrecht, where he started dating his paintings. His earliest dated panel was produced in 1634,[5] the last in 1637,[6] after which the artist disappears from the records. His extant oeuvre consists of about thirty imaginary landscapes.[7] In the second quarter of the seventeenth century Van Geel was something of an exception, since his fellow artists, especially in Haarlem, were increasingly intent on the realistic rendering of Holland's flat landscape.[8] A rare kindred spirit was Hercules Segers (1589/90-1633/38), who, like Van Geel, continued the tradition of the Flemish imaginary landscape in a highly personal way.[9]

Van Geel worked in Middelburg for more than ten years, but his place and date of birth are unknown.[10] He probably came from the southern Netherlands. In any case his work owes a clear thematic and stylistic debt to Flemish tradition. In his style and choice of subjects, he calls to mind artists such as Gillis van Coninxloo (1544-1606),[11] Roelant Savery (1576-1639),[12] Gillis de Hondecoeter (1575/80-1638)[13] and Alexander Keirincx (1600-1652), all of them Flemish artists who sought refuge in the Republic in the early seventeenth century.[14] Moreover, the atmospheric perspective he uses in much of his work is characteristic of Flemish landscape painting. Here, the foreground is painted in brownish-yellow, the middle ground in yellowish-green and the horizon in blue hues. The calculated effect of depth this produces is enhanced by the dark foreground areas – stones and bushes on the banks of the mountain lake – that serve as *repoussoir*. The Flemish painters working in Middelburg in the first quarter of the seventeenth century all evolved their own distinctive styles in spite of their common roots. Thus in Van Geel the lines, the treatment of paint and the use of colour all bear his clear signature.[15] Even so, this unsigned picture was once optimistically attributed to the well-known landscape painter from

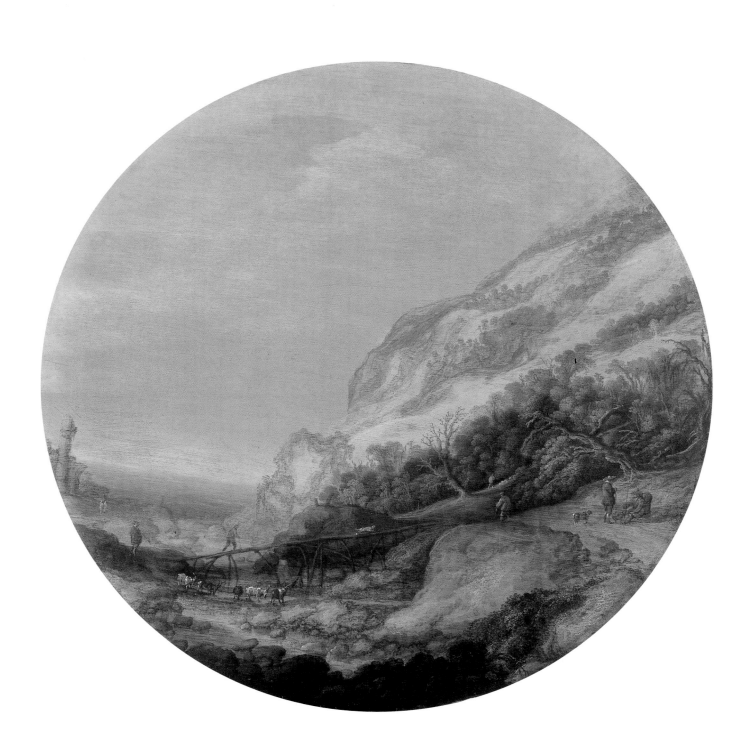

13a

13b

13c

13a Jacob van Geel, *Imaginary mountain landscape*, c.1620. Panel, 20 x 32 cm. Rotterdam, Museum Boijmans Van Beuningen (acquired in 1976).
13b Jacob van Geel, *Imaginary rocky landscape with waterfall*, c.1636. Panel, 41.3 x 38 cm. Stuttgart, Staatsgalerie (acquired in 1975).
13c Jacob van Geel, *Imaginary wooded landscape*, c.1636. Panel, 15.2 x 25.4 cm. Private collection (on loan to the Mauritshuis, The Hague, since 1996).

Antwerp, Jan Brueghel the Elder (1568-1625), according to the remaining fragment of an eighteenth-century inscription on the back of the panel.[16]

Like other landscapes by Van Geel, this is an imaginary scene: a variety of authentic-looking motifs have been combined convincingly, although no such location existed. In some cases Van Geel abandoned this attempt at ostensible verisimilitude, as in the painting in Stuttgart that is attributed to him (fig. 13b),[17] where the landscape is quite obviously a product of the artist's imagination. Van Geel's oeuvre can roughly be divided into scenes with clumps of trees on the one side and a panoramic vista on the other; mountain and rocky landscapes (figs. 13a-b); and wooded scenes (fig. 13c). The lack of any dated work preceding 1634 makes it hard to reconstruct a chronology of his oeuvre, though attempts have been made to do so.[18] This painting, which is dominated by a mountainside, displays the diagonal structure that characterises all Van Geel's mountain and rocky landscapes. These have been dated collectively to approximately 1625, but on the basis of a questionable criterion. It is argued that in about 1625 Van Geel started depicting his primary motif – such as a clump of trees or a mountain face – on the right of his paintings (as here), whereas in his earlier work he placed such motifs on the left.[19] Rightly or wrongly, this panel is therefore traditionally dated to around 1625, which would make it one of the few works from Van Geel's Middelburg period.[20] We cannot rule out the possibility that it was actually produced in Delft, somewhat later, although the three-colour atmospheric perspective supports the earlier dating. There is no doubt at all that this superbly executed mountain landscape was made later than the signed landscape in Rotterdam that is datable to about 1620 (fig. 13a).[21] The latter's traditional composition, in particular, betrays its earlier origins.[22] In both paintings, the mountainside is rendered in the same characteristic, almost drawing-like fashion, and the sky is an almost uniform colour. The composition described here is also related to the signed panel in Copenhagen, in which the mountain landscape likewise rises along an imaginary diagonal line,[23] and to another mountain landscape, convincingly attributed to the artist, that formerly belonged to the collection of F.C. Butôt (1906-1992) in Sankt-Gilgen.[24]

Van Geel is known for his idiosyncratic rendering of trees, which tend to be crooked and gnarled, like some of the capriciously shaped trees in the landscape described here. In this panel the clump of trees at the foot of the mountain is unusually modest in comparison, for instance, to a more characteristic scene dominated by trees that he produced around 1636 (fig. 13c).[25] The staffage in Van Geel's landscapes, which are often dominated by large trees, is sometimes confined to a few hikers or travellers,[26] whereas this picture is enlivened by no fewer than eight little figures. In the foreground at left we see a man – a hiker? – and a herd of goats; a man stands on the peculiarly narrow bridge while a dog runs on ahead of him.[27] Further to the right we see a herdsman, whose herd is indicated very cursorily with a few white strokes, and a hiker with a walking stick. In the far right foreground two men with sticks are engaged in conversation – these figures with walking sticks are a common feature of Van Geel's paintings (see e.g. fig. 13c) – and at the far left we can just make out two more figures, so light in colour that they all but blend into the background.

While most of Van Geel's paintings were executed on panels or occasionally on wide rectangular copperplates,[28] this one takes the form of a tondo (cf. also cat. no. 26). It may have had a counterpart, as is suggested by the existence of two pendants in the Dordrechts Museum dating from about 1636, also made in a circular format, though smaller in size.[29] This would help explain the lack of a signature, since Van Geel may have signed only one of the two panels, as in the case of the Dordrecht pendants.

The publications of Laurens J. Bol (1898-1994), Director of the Dordrechts Museum from 1949 to 1965, have been crucial in giving Van Geel and many other Middelburg painters their rightful place in the history of art (see also cat. nos. 30-31).[30] Bol called Van Geel an 'underrated talent'.[31] Lugt acquired this *Imaginary mountain landscape* as a work by Van Geel in 1946, that is to say before the appearance of Bol's important monograph article on the painter, which was published in 1957.[32] Lugt's keen eye is evident from Bol's eventual addition of the painting to Van Geel's oeuvre, in 1980.[33] It is one of the many examples in the Frits Lugt Collection of an appealing and above all rare painting by a master who is still unknown to the general public. *QB*

Jan Davidsz de Heem

Utrecht 1606-1683/84 Antwerp

14 *Still life with books*, 1628

Panel, 31.2 x 40.2 cm / Signed and dated on the book overhanging the edge of the table: *Johannes.de / Heem.Fecit / A° j628*
On the books, clockwise from the lower left: *DANOYE; VAN AMADIS den; .NO.BENE. / .I.WESTERBAENS / KVSIENS.CLACHTEN. R; G. A. BRDEROOS / Treur-spel. / van / RODD.RICK / ende / ALPHONSVS / [...] / De vrijnden [...] / Maer [...] / T'AMSTEL [...]*; the letter under the book with the signature and date ends: *W.L. Dienstwilgen Vriendt / Evertt* [1] / *Acquired in 1918*

Provenance

G.H.G. Braams, Arnhem (sale Arnhem, De Wilde-Frederik Muller & Cie, 24-26 September 1918, lot 88, for 3,000 guilders to Lugt);[2] Frits Lugt, Maartensdijk and Paris; temporarily on loan to the Rijksmuseum, Amsterdam, October 1931, mentioned in 1933;[3] inv. no. 183

Exhibitions

The Hague 1926, no. 45; Amsterdam 1933, no. 143; Paris 1960b, no. 22; Paris 1965a, no. 24; Amsterdam 1968, no. 36; Paris 1983, no. 35; Amsterdam-Cleveland 1999-2000, no. 27 (Amsterdam only); Paris 2000, no. 19

Literature

Martin 1925, p. 43; Vorenkamp 1933, pp. 103-104; Martin 1935-1936, vol. 1, pp. 417-418; Van Gelder 1950, p. 93; Bruyn 1951, p. 225 and note 2; Bergström 1956, pp. 163, 308 note 45; Seifertová-Korecká 1962, p. 60 note 6; F. Lugt in Paris 1965a, p. 26, no. 24 and fig. VII; M.L. Wurfbain in Leiden 1970, p. 14; Reitsma 1976, p. 257 and fig. 17; Greindl 1983, p. 361, no. 105; S. Nihom-Nijstad in Paris 1983, pp. 59-61, no. 35 and fig. 93, p. 109; Charensol 1983, p. 432; Dauriac 1983, p. 279; Kingzett 1983, p. 503; Prat 1983, pp. 130-131 (ill.) and 132; Schlumberger 1983, p. 52 (ill.); Munière 1984, pp. 59-60; Schenkeveld-van der Dussen 1985, p. 42, fig. 22 (detail); Geesink 1986, p. 410, note 44 and fig. 5; B. Broos in Paris 1986, pp. 241, 242 and fig. 1; Broos 1987, pp. 187, 188 and fig. 1; Meijer 1988, p. 36 note 3; Le Bihan 1990, p. 145 note 12; S. Segal in Utrecht-Braunschweig 1991, p. 130 (also in note 3), 131 note 11 and fig. 3a; Slive 1995a, p. 283 and fig. 384; Schreuder 1997, pp. 17, 18 note 2, no. b; B. Wieseman in Amsterdam-Cleveland 1999-2000, pp. 166-167, no. 27 (ill.), pp. 168, 169 note 1; M. van Berge-Gerbaud in Paris 2000, p. 20, no. 19 (ill.)

Jan (Johannes) Davidsz de Heem is regarded as the most eminent and multifaceted still-life painter of the Golden Age.[4] The artist – whose master remains unknown but whose earliest dated works from 1626 recall those of Balthasar van der Ast (1593/94-1657) – was born in Utrecht, the son of a musician from Antwerp. He moved to Leiden in or around 1625. In the course of the 1630s he then settled in Antwerp – his registration with the local guild dates to 1635 or 1636 – where he mainly executed lavish still lifes, known in Dutch as *pronk-stilleven*. It was here that he came into contact with the work of Daniël Seghers (1590-1661), who specialised in flower pieces and garlands.[5] Under his influence (among others) De Heem went on to paint flower still lifes, which, despite their small number, nonetheless had a considerable impact on the future of the genre. In 1667 the artist and his family returned to Utrecht, a town he had already revisited several times since 1658 and where his work would inspire a whole new generation of flower painters. In addition to his son Cornelis de

Heem (1631-1695), Abraham Mignon (1640-1679) and Maria van Oosterwyck (1630-1693) are considered his most important pupils. The French invasion of 1672 forced the artist to return to Antwerp, where he died in late 1683 or early 1684. Because he worked in both the northern and southern Netherlands – in the north still life painting was somewhat more subdued than in the south – De Heem functioned as a kind of *trait d'union* between the two territories. His innovative oeuvre was thus of seminal importance for the development of both flower painting and the *pronkstilleven*.

This signed and dated *Still life with books* was painted during De Heem's Leiden period and is one of his earliest surviving works. He executed six further variations in 1628 and 1629, as well a genre scene (1628) in which he included not only a self-portrait but also a table piled high with books (Oxford, Ashmolean Museum).[6] The date on one of the works in the series (formerly Aachen, Suermondt-Ludwig Museum) is not, as previously thought, 1625 but rather 1629,[7] as in the

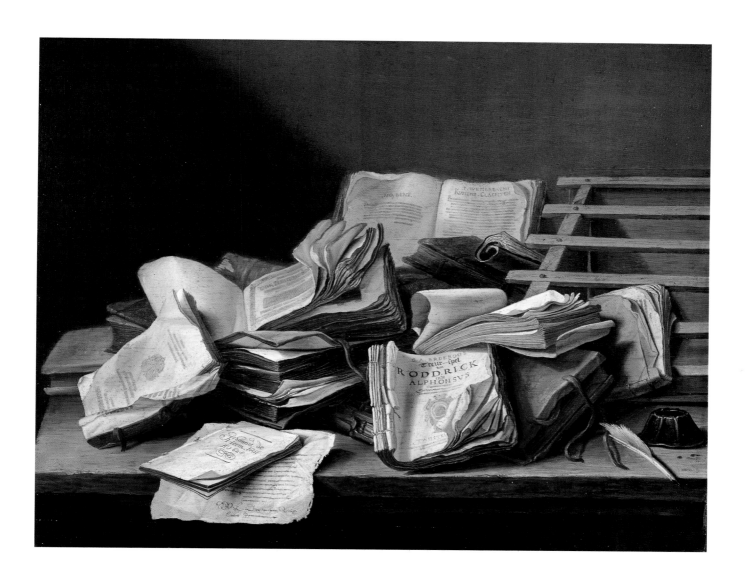

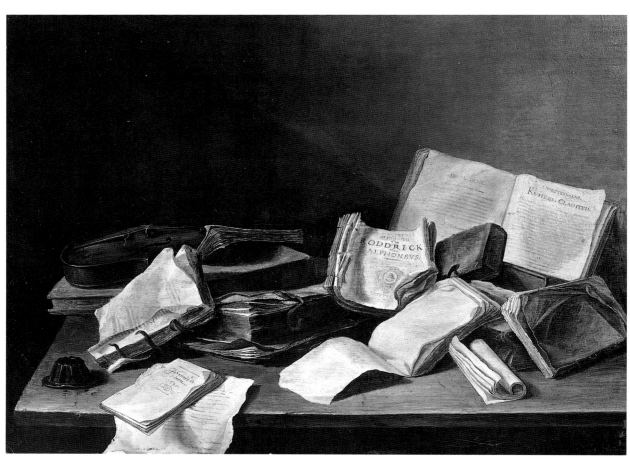

14a

14b

14a Jan Davidsz de Heem, *Still life with books and a violin*, 1628.
Panel, 36.1 x 48.4 cm. The Hague, Royal Cabinet of Paintings
Mauritshuis (acquired in 1912 with the support of the Rembrandt
Society).

14b Title page of Gerbrand Adriaensz Bredero, *Treur-spel van
Rodd'rick ende Alphonsus*, Amsterdam 1620
(photograph: University of Utrecht Library).

panel now in the Oblastní Gallery in Liberec.[8] The picture in the Lugt Collection is dated 1628, the year De Heem painted its most closely related example (fig. 14a).[9] In the Hague variation on the Paris composition we once again find a table laden with old tomes, some of which bear titles identical to those in the work in question. The still life in Leipzig was executed the same year (Museum der bildenden Künste).[10] A fifth painting on the theme, again dated 1628, has also recently reappeared (fig. 14c).[11] Finally, the undated De Heem still life with books in the Rijksmuseum in Amsterdam should certainly be assigned this date as well.[12] In all these works, including the one in the Lugt Collection, the subtly lit rear wall is depicted with exceptional beauty. The source of illumination is revealed in the earliest of the seven pictures (fig. 14c), which shows a window at the upper right, while to the left of the table standing against the wall in the panel in Liberec we see the wooden partition the artist apparently used to manipulate the light.[13]

Still lifes with books were extremely popular in the second quarter of the seventeenth century, particularly among painters in Leiden.[14] It is not entirely clear who first brought the genre to the Netherlands, but its earliest practitioner appears to have been Jacques de Gheyn II (1565-1629), who is believed to have painted a still life with this motif already in 1621.[15] In any case, the subject was tackled by the pick of the Leiden painters,[16] among them two famous artists who in 1628 had yet to make a name for themselves: Jan Lievens (cat. no. 18) and Rembrandt (1606-1669).[17] As in their contemporaneous works, De Heem, too, scratched into the wet paint with the handle of his brush in order, for example, to indicate the pages of several of the closed or half-open tomes.[18] One cannot help thinking that De Heem, who was nothing if not chameleon-like in his style, was in some way inspired by these two young painters active in his new place of residence. During his sojourn in Antwerp, which followed directly on the years in Leiden, he would adopt an entirely different manner, this time influenced by Flemish artists like the aforementioned Daniël Seghers.

With their bent and torn pages and partially missing bindings, De Heem's books appear both well thumbed and worn. Nonetheless, the titles are in some cases entirely legible, most strikingly on the book in the foreground. The artist here accurately reproduces the 1620 edition of a tragedy by Gerbrand Adriaensz Bredero (1585-1618), including not only the printer's mark on the title page – a beehive – but also the misprint in the author's name (fig. 14b).[19] The play was first performed in 1611 and was published in book form in 1616, with a dedication to Grotius (see cat. no. 26). The subtitle of Bredero's *Treur-spel van Rodd'rick ende Alphonsus* (The tragedy of Rodd'rick and Alphonsus), incorporated into the Hague version of the painting, summarises the moral of the piece, which tells the story of two men whose friendship is put to the test by their love of the same woman: 'De vrunden mogen kyven, maar moeten vrunden blyven' (The friends may fight, but must stay friends). The plot is based on the Spanish romance *Palmerin d'Oliva*, itself related to the tales of Amadis. *Amadis* is also depicted: one of the books at the left bears the inscription 'van amadis den [Gaule]', apparently a volume of the Dutch translation of this *chanson de geste*, which features a knightly hero of the same name.[20]

Another of the books in De Heem's painting was never actually published in the form seen here – the title page is in the middle of the tome – although the artist must certainly have known better. On the right-hand page we find the name of the author, Jacob Westerbaen (1599-1670), a Hague poet who had studied in Leiden. In 1624 he published a Dutch adaptation of *Basia* by Joannes Nicolai (1511-1536), also known as Janus Secundus, under the title *Kusjes* (Kisses). The translation was included in Westerbaen's *Minne-dichten* (Poems on love) and only appeared in a separate edition in 1631.[21] That De Heem here reproduces an imaginary title page is indicated by the Hague painting as well, where the left-hand page – in contrast to the work in Paris – is signed with the initials 'I. W(esterbaen)' and includes several more lines of (illegible) text. Furthermore, Westerbaen never translated Secundus' *Elegies*, so that the word 'clachten' (complaints) must also be a product of the artist's imagination.

Both the story of Roddrick and Alphonsus and the poems of Secundus – who, incidentally, died at a very young age – deal with destiny and the transience of earthly life. The inclusion of these publications thus serves to underline the *vanitas* aspect traditionally associated with the still life with books: in De Heem's other works on the theme there are even more explicit references, such as a skull, a globe (fig. 14c), the word 'finis', or the phrase 'vanitas vanitatis' ('Vanity of vanities'), which actually appears twice.[22] The notion is also openly mentioned in the finale of Bredero's play: 'Man's life is a battle … a mere

14c

14c Jan Davidsz de Heem, *Still life with books*, 1628. Panel, 28.1 x 33.3 cm. Fondation Aetas Aurea.

nothing, if one considers it well, a stage full of transformations'.[23] The tales of Amadis, Westerbaen's translation of *Basia* and the tragedy, which describes love's threat to friendship, can all be regarded as works in the romance mode, serving to further characterise De Heem's symbolism. Books were often given an important role in moral thought, being regarded as a source of wisdom and knowledge. In an emblem book of 1611 by Gabriël Rollenhagen (1583-1619?), for example, the reader is encouraged to renounce worldly goods and devote himself to study.[24] It has often been thought that De Heem, too, sought to deliver a similar message, particularly given the text '.NO.BENE' opposite Westerbaen's title page, which appears in slightly varied form in the Hague still life as well.[25] Here, however, this phrase, which can occasionally be found in seventeenth-century publishers' forewords, seems rather to have been given its prominent position in order to make clear to the viewer that the book was never printed in this form.

It seems likely that there was a large market in Leiden for still lifes with books: the local university, the country's oldest, drew many students, scholars and writers who would have appreciated the motif.[26] In this context it is interesting to note that Johan Coornhert, De Heem's stepfather, was a bookseller and he may even have been helpful in finding buyers for the painter's work. A not inconspicuous place in the painting, namely below the book on which the artist signed and dated his picture, is given over to an otherwise illegible letter bearing the signature 'W.L. Dienstwilgen Vriendt / Evertt' (W.L. Your obedient friend Evertt).[27] Given the inclusion of the Bredero tragedy, which deals with issues of friendship, it is not unthinkable that this Evert – an author? – commissioned the picture or even that he was a friend of the artist's. Considering the close relationship between the two works and the fact that De Heem's other still lifes with books are more 'stand alone', it is not impossible that the painting in the Lugt Collection

and/or the Hague picture were executed on demand. In the former, literary aspects are emphasised, perhaps at a patron's request: the violin and bow found in the latter have been left out and a lectern added, along with the quill and inkstand,[28] while a third book is clearly specified as one of the Amadis romances. In the past it has also been suggested that the Paris picture was painted for Westerbaen or rather for someone intimately acquainted with his work,[29] seeing that the book depicted – which has a less prominent place than in the Hague painting – was only published in 1631.

Frits Lugt acquired the still life in 1918, almost four years after leaving his job at the Amsterdam auction house Frederik Muller & Cie, and once he no longer needed to refrain from collecting for himself. He bought it at the sale of the Braams Collection,[30] six years after the Mauritshuis had obtained its variation (fig. 14a),[31] an event that had not gone by unnoticed.[32] The picture's aesthetic qualities – its fine composition, monochrome colouration and thick brushwork – were probably not the sole motivating factors in the acquisition. Lugt had a lively interest in penmanship, as appears from his very first purchase in 1899, when he was still a schoolboy: a page of calligraphy by Lieven Coppenol (1599-1671) of 1653, accompanied by his portrait as etched by Rembrandt.[33] De Heem's own calligraphic signature and the writing on the letter beneath it must have attracted Lugt to the work, particularly considering his own impressive collection of artists' letters, exercise books and calligraphy.[34] More important still is the fact that Lugt was a passionate book collector. His sizeable art-historical library, on long-term loan to the Netherlands Institute for Art History in The Hague, is well known to scholars. He also owned a large number of sixteenth-, seventeenth- and eighteenth-century volumes of Dutch literature, many of them extremely rare.[35] He was particularly interested in those that were well preserved, preferably with their original binding – quite in contrast to the books depicted in the De Heem.[36] *QB*

Karel du Jardin

Amsterdam 1626-1678 Venice

15 *River landscape with cattle and small figures, c.1660*

Panel,[1] 28.7 x 36.5 cm / Signed lower right, in brown paint: *K. DV. IARDIN.* / Acquired in 1951

Provenance
Johan Aegidiusz van der Marck (1707-1772), Leiden (sale Amsterdam, De Winter-Yver, 25 August 1773 and following days, lot 143, for 130 guilders to Foucquet);[2] Pieter Foucquet Jr (1729-1800);[3] unknown private collection (sale Pieter van den Bogaerde *et al.*, Amsterdam, De Winter, 16 March 1778 and following days, anonymous section, lot 42);[4] Chevalier Sébastien Érard (1752-1831), Château de La Muette, Passy, near Paris (sale Paris, Lacoste-Coutellier, 23 April 1832, moved to 7-14 August 1832, lot 89, for 1,100 *francs* to Delahante);[5] Alexis Delahante, Paris;[6] S. Nijstad, art dealer, The Hague, 1951; Frits Lugt, purchased from Nijstad on 24 December 1951;[7] inv. no. 6462

Exhibitions
Paris 1983, no. 26

Literature
Hofstede de Groot 1907-1928, vol. 9 (1926), p. 350, no. 211, p. 354, no. 221; Brochhagen 1957, pp. 249-250, note 23 and fig. 17; Brochhagen 1958, pp. 131-132 and note 433; Van Gelder 1964, pp. 23-24; A. Blankert in Utrecht 1965, p. 139 note 6, p. 207 notes 2 and 3; Stechow 1966, p. 159 and fig. 319; Brötje 1974, pp. 44-46 and fig. 1; Calzoni 1975-1976, p. 196; Reitsma 1976, p. 255 and fig. 11; Blankert 1978, p. 139 note 6, p. 207 notes 2 and 3; Trnek 1982, p. 64 note 2; S. Nihom-Nijstad in Paris 1983, pp. 45-46, no. 26 and fig. 34 (measurements reversed); Faton 1983, p. 71 (ill.); R. Trnek in Minneapolis-Houston-San Diego 1984-1985, p. 26 note 1, p. 38 and note 3; R. Trnek in Salzburg-Vienna 1986, p. 36 note 1; A. Chong in Amsterdam-Boston-Philadelphia 1987-1988, pp. 361-362 (also in note 1) and fig. 3 (measurements reversed); Trnek 1992, p. 40 note 1; Kilian forthcoming, pp. 144, 337-338, no. 66 and fig. 66

River landscape with cattle and small figures is quite unique within Karel du Jardin's oeuvre, which includes not only Italianate landscapes but also animal pieces, genre scenes, history paintings and portraits. This multifaceted and productive artist – in addition to a large number of paintings he also executed engravings and many drawings – travelled several times to Italy, where he gathered inspiration for this and other works. Following his first journey, which probably took place in 1650, he settled in Amsterdam and then in The Hague; in 1675 he embarked on his second trip to Rome and died in Venice in 1678. We know little about his training. Houbraken's claim that he was Nicolaes Berchem's most talented pupil cannot be verified from the sources, although their work is unmistakably related.[8] It seems possible he received his earliest instruction from his second cousin, the portraitist Pieter Nason (1612-*c.*1689).[9] Du Jardin's animals, particularly in works of the 1650s, are clearly influenced by the work of Paulus Potter (cf. cat. no. 25), who also resided in Amsterdam in this period.[10]

Frits Lugt acquired this handsome little picture by Karel du Jardin in 1951, having already purchased his first work by the artist, *Piazza di Santa Maria Maggiore in Rome*, in 1927 (fig. 15a).[11] Interestingly, this rare topographical drawing dated 1653 was executed after the painter had returned to the Netherlands from Italy,[12] using either sketches made on the spot or a depiction by another artist. This undated painting, too, previously thought to have been produced in Rome in the last years of Du Jardin's life, was in fact probably painted in Amsterdam in around 1660, again utilising studies made in the south.[13] This earlier dating is based on the picture's similarity to two of the artist's panoramic landscapes of the same period, also with almost no staffage, one in the Musée du Louvre in Paris (fig. 15b) and the other in the Fitzwilliam Museum in Cambridge. These three works, which taken together anticipate developments in Du Jardin's oeuvre in the 1670s, are far more finished and carefully modelled (particularly in the delineation of the mountains) than the landscapes of his later career.[14] As time went on, the painter's

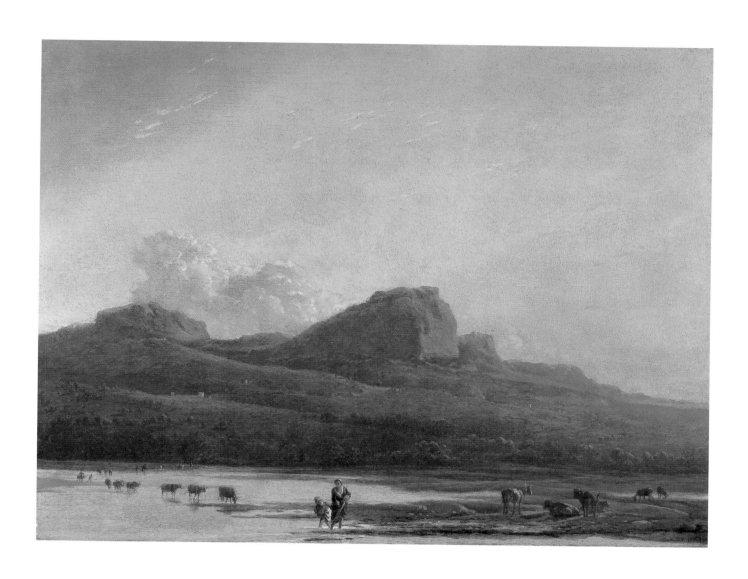

15a

15b

15c

15a Karel du Jardin, *Piazza di Santa Maria Maggiore in Rome*, 1653. Black chalk, washed in grey, 17.7 x 31.4 cm.
Paris, Frits Lugt Collection (acquired in 1927).

15b Karel du Jardin, *Landscape with a church and a ford with figures*, c.1660. Panel, 23 x 30 cm. Paris, Musée du Louvre
(acquired in 1784).

15c Jan Asselijn, *Mountainous landscape with a herd of cattle*, c.1650. Panel, 43 x 67 cm. Vienna, Gemäldegalerie der
Akademie der bildenden Künste (acquired in 1822).

technique became more free and his works more dominated by *chiaroscuro*; by contrast, the Lugt painting – which appears slightly worn, particularly in the sky area – is still quite refined in style. Finally, a link can be established with Du Jardin's landscape etchings of the 1660s, which again have little or no staffage.[15]

Despite the small format and relatively few means, Du Jardin has here created a monumental landscape. The flat land in the foreground contrasts with the large mass of rocks in the background, which occupy the entire breadth of the picture. The smooth surface of the water serves to set off the roughness of the mountain range.[16] The Dutch Italianate painters are generally known for their 'idyllic' landscapes (cf. cat. no. 6), but this work can hardly be described as such. Du Jardin's aim appears instead to have been to capture something of the sublime grandeur of the southern landscape.[17] The tiny figures, both human and animal – herdsmen with their cattle crossing a ford, and a woman with her child – are completely overwhelmed by their rugged surroundings, practically disappearing into them. The almost infinitesimal livestock in the background are in fact made up of nothing more than expertly placed reflections. The mood of the scene, which includes a particularly lovely

cloudscape – the mountaintops are sharply silhouetted against the blue-orange of the setting sun – is beautifully captured. The red and blue clothes of the woman and child in the foreground give an accent to the painting's otherwise rather limited palette, restricted to shades of grey, brown, blue and green.

It was Jan Asselijn's *Mountainous landscape with a herd of cattle*, dating to around 1650, that seems to have introduced this type of landscape painting into the Netherlands (fig. 15c; for Asselijn, see cat. no. 1).[18] Asselijn's composition influenced not only Du Jardin, but also Nicolaes Berchem (cf. cat. no. 4), perhaps Du Jardin's master, and Jan Hackaert (1628-in or after 1685), who painted both woodland scenes and Italianate vistas.[19] By placing horizontal parallel planes one behind the other, with no vertical interruptions at all, Du Jardin gave his picture a great sense of depth. This effect is enhanced by the absence of a repoussoir: the viewer's gaze is completely unhindered, creating the impression of an endless landscape stretching even beyond the limits of the frame.[20] The string of cattle being driven over the water by the herdsmen at the left forms a striking diagonal, while the donkey at the right, seen from behind, draws the viewer into the painting.[21] *QB*

Willem Kalf

Rotterdam 1619-1693 Amsterdam

16 *Kitchen interior, c.1642*

Panel, 25.1 x 21.3 cm / Signed at centre, on the chest: *W. KALF* / Acquired in 1926

Provenance

(?) Rémond Collection, 'Ancien Maître d'Hôtel du Roi', Paris (sale Paris, Rémy-Girardin, 6 July 1778 and following days, lot 35);[1] Jean-Baptiste-Pierre Lebrun (1748-1813), Paris, 1779 (sale Paris, Lebrun-Chariot, 2-4 and 9-11 February 1813, lot 225, for 130 *francs*;[2] sale Paris, Paillet-Constantin-Chariot, 26 May 1814, lot 72, for 103 *livres* to Didot);[3] Didot Collection, Paris; Édouard Warneck, Paris, before 1906 (sale Paris, Galerie Georges Petit, Baudoin-Féral, 27-28 May 1926, lot 51, for 195,000 *francs* to Lugt);[4] Frits Lugt, Maartensdijk and Paris; inv. no. 2493

Exhibitions

Amsterdam 1906, no. 67; Rotterdam 1938, no. 93; The Hague 1946, no. 29; Paris 1983, no. 40

Literature

Lebrun 1792-1796, vol. 2 (1792), facing p. 70 (print after the painting described here); F. Lugt in Amsterdam 1906, p. 23, no. 67; Sambon 1925, p. 67 and fig. XVI; Lugt 1926, pp. 66-67, no. 51 (ill.); Grisebach 1974, pp. 37, 46, 49-51, 72, 213 (in no. 10), 213-214, no. 12, p. 217 (in no. 18), p. 289 (in no. C 11) and fig. 19; Sutton 1976, p. 335, fig. 3; S. Nihom-Nijstad in Paris 1983, pp. 66-67, no. 40 and fig. 83; Dauriac 1983, p. 279; Schlumberger 1983, pp. 51 (ill.) and 52; Q. Buvelot in Paris-Montpellier 1998, p. 97 and fig. 27a; A. Forderer and J. Hietschold in Karlsruhe 1999, p. 358, in no. 191 (print after the painting described here)

Few details are known of the life of Willem Kalf, one of the most highly esteemed and sought-after Dutch still life painters of the seventeenth century.[5] Born in Rotterdam in 1619, he travelled abroad while quite young, probably by virtue of an inheritance following his mother's death in 1638. He had already lost his father, a wealthy merchant and holder of diverse senior positions in Rotterdam city council. In the well-known neighbourhood of Saint-Germain-des-Prés in Paris, he rubbed shoulders with numerous painters, French as well as Flemish. The travel journal of the Antwerp painter Philip(pe) Vleughels (1619-1694) and the signed and dated *Farmstead with a view of Paris* (private collection) make it clear that in 1642, at any rate, he was living in the French capital.[6] Kalf befriended Vleughels and introduced him to Jean-Michel Picart (*c*.1600-1682), another Flemish artist. Willem Kalf's French oeuvre consists of small paintings of farmsteads and farmhouse interiors and large still lifes featuring precious objects. After he took up permanent residence in Amsterdam, in 1653, he specialised exclusively in

still life displays. The time he spent between leaving Paris and moving to Amsterdam remains obscure; all we know is that in 1651 he went to Hoorn, where he married Cornelia Pluvier (*c*.1626-1711), an artistic woman whose many accomplishments included a gift for diamond engraving in glass.[7] His superb still-life technique earned Kalf the ceaseless admiration of his contemporaries. Indeed, his work was extolled in poems by such luminaries as Jan Vos (*c*.1615-1667) and Joost van den Vondel (1587-1679).[8] Kalf had many followers both at home and abroad, most notably Willem van Aelst (1627-after 1683).[9]

The interiors of stables and farmhouses that Kalf painted in Paris, probably from about 1640 to 1645 or 1646, display an affinity with the work of Rotterdam painters such as Pieter de Bloot (1601-1658), Hendrick Martensz Sorgh (1610/11-1670), Cornelis (cat. no. 29) and Herman Saftleven (1609-1685) and above all with that of the Middelburg artist François Rijckhals (1609-1647).[10] Rijckhals too produced still life displays as well as farmhouse interiors with still-life elements

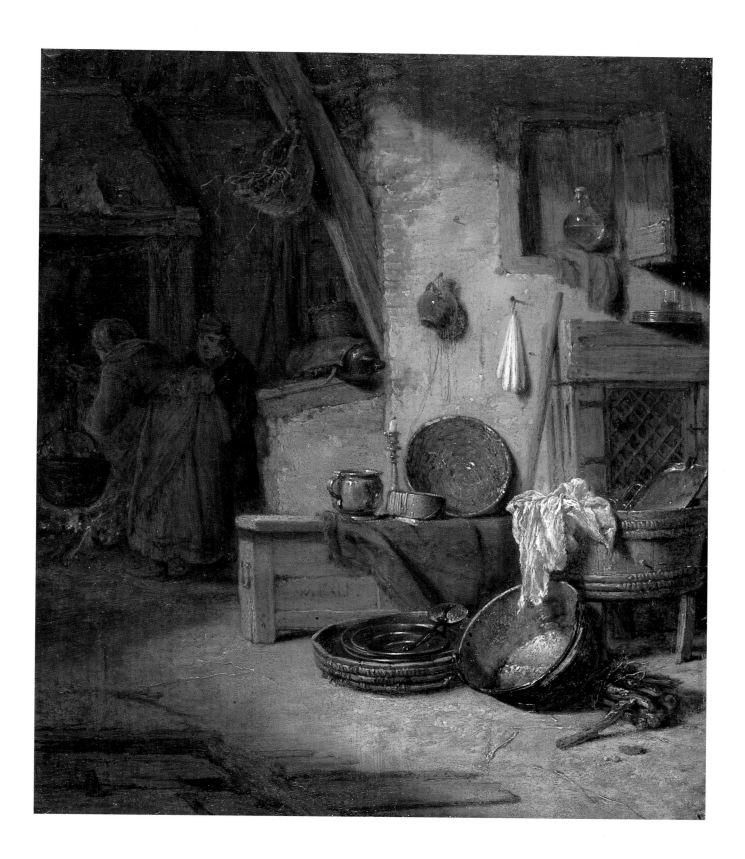

16a

16b

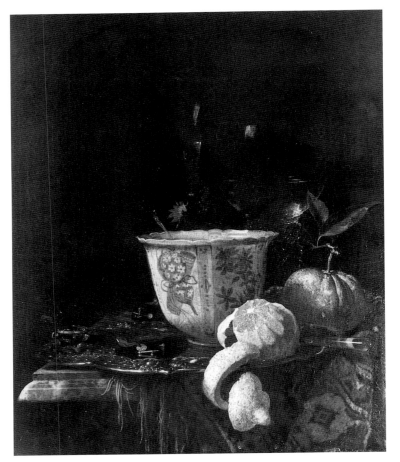

16c

16a
François Rijckhals, *Still life in a farmyard*,
1640. Panel, 35 x 33 cm. Haarlem,
Frans Halsmuseum (acquired in 1894).
16b
Carl Wilhelm Weisbrod after Willem Kalf,
Kitchen interior, 1779. Etching and engraving,
23.5 x 18 cm. From Lebrun 1792-1796, vol. 2
(1792), facing p. 70 (photograph: RKD, The
Hague).
16c
Willem Kalf, *Still life with Chinese bowl*,
c.1662. Canvas, 52.5 x 42.8 cm. Paris,
Frits Lugt Collection (acquired in 1919).

(fig. 16a), quite an unusual combination in seventeenth-century Dutch painting. Given that the latter is known to have worked in Rotterdam, it is possible that Rijckhals was Kalf's teacher.[11] It may have been Rijckhals (or alternatively Herman Saftleven) who introduced the stable interior with a pronounced still life element as a distinct type of painting in Rotterdam. It is unclear, however, when and by whom the genre, which despite its affinity with the work of Flemish painters such as David Teniers the Younger (1610-1690) can rightly be called specific to Rotterdam, was first practised there.[12]

As exemplified by the painting in the Frits Lugt Collection, Kalf's interiors are largely painted on small panels and display a stable or farmhouse including a still life of food and cooking utensils. Most scenes of this kind – frequently variants of the same basic composition – are dominated by the still life, containing only a few figures that merge seamlessly into a misty background.[13] Sometimes the figures are not even elaborated. The painting by Kalf in Paris exhibits all the features just described, and with its attractive composition it is a superb example of the work he did in this genre, all of which he is thought to have produced during his stay in France. After his return to the Netherlands, Kalf dropped farmhouse interiors from his repertoire, focusing instead on the still lifes with which he would establish his reputation (fig. 16c). It remains odd, of course, that the Dutch painter should have chosen to paint simple interiors and stables in Paris, of all places, subjects that one would rather associate, as already noted, with the art of Rotterdam. Comparison with his other interiors, not one of which is dated, suggests that this piece was made quite early on in the series, in about 1642.[14] One detail possibly indicative of a relatively early date is the small group of objects in the foreground, which instead of being integrated into the scene constitutes a dominant motif, as in other works from Kalf's earliest period. There are striking light-dark contrasts between foreground and background, which are clearly separated by the vertical line of the strikingly illuminated wall and the horizontal lines of the furniture. The actions of the figures add an inconspicuous narrative element: a woman is cooking under the watchful gaze of a man. Kalf's *Kitchen interior* in the Frits Lugt Collection is one of his finest compositions in this genre.

Characteristic of Kalf's style are the effective gleams of light with which he endowed the objects and food in his still lifes. The painting shown here is no exception, and these little glimmers lend authenticity to what is unmistakably an arranged display. At first sight, this painting, whose appeal is enhanced by its warm tones, would not appear to call for a specific interpretation. In general, however, scenes of this kind with figures going about their domestic duties amid household objects could be construed, in the seventeenth century, as allusions to the brevity of earthly matters in general and of human life in particular. There is no explicit connotation here, although the Amsterdam poet and etcher Jan Luiken (1649-1712) urges his readers in a publication dating from 1711, invoking a print depicting a kitchen interior, not to spend too much time preparing and eating food but instead to develop their spiritual life, before it is too late.[15] It cannot be ruled out that a similar admonition is couched in the scene depicted here, which was made some time earlier, though there are no written sources to corroborate it.

All the information that has been handed down concerning the provenance of this work suggests that the painting – which we may assume was made in Paris – was never out of that city until Lugt purchased it. The earliest reference to the painting dates from the eighteenth century, when it was in the possession of the well-known Parisian painter and art dealer Jean-Baptiste-Pierre Lebrun (1748-1813). This is clear from a text on a reproduction of the painting, dated 1779 (fig. 16b), made almost to scale by Lebrun's German contemporary Carl Wilhelm Weisbrod (1743-1806) and published in Lebrun's influential work *Galerie des peintres flamands, hollandais et allemands* (Paris 1792-1796).[16] Frits Lugt acquired the panel in 1926, when it was auctioned for the third – and possibly the fourth – time in Paris. The descriptive text in the sale catalogue was written by Lugt himself, who had already catalogued the painting in 1906.[17] In 1926, the same year as the auction just mentioned, a copy after the print reproduced here, turned up in London.[18] In 1917 Lugt had managed to acquire one of the rare drawings attributed to Kalf,[19] and two years later he secured a still life from the painter's Amsterdam period (fig. 16c).[20] Thanks to these three purchases – made in the space of less than ten years – the artist is well represented in the Lugt Collection. *QB*

Thomas de Keyser

Amsterdam 1596/97-1667 Amsterdam

17 *King Cyrus returns the treasures of the temple, 1660*

Canvas, 118.8 x 92 cm / Signed and dated at lower centre: *PLASMAN INVENTOR.* (*PL* in ligature) / *TDKEYSER PINXIT.1660.* (*TDK* in ligature)
Acquired in 1955

Provenance
Unknown private collection, Utrecht or surrounding area (sale Utrecht, De Wild, 7 November 1810, lot 20, for 16 guilders);[1] Willem Godart Johan van Gendt, The Hague (sale The Hague, Immerzeel, 25 October 1830, lot 2);[2] Lord Deramore, Heslington Hall, county York;[3] Martin B. Asscher (1904-1983), art dealer, London, 1952; Frits Lugt, Paris, acquired from Asscher in March 1955; inv. no. 6781

Exhibitions
Washington-Detroit-Amsterdam 1980-1981, no. 60; Nice 1982, no. 142; Paris 1983, no. 43; Atlanta 1985, no. 39; Berlin 1989, no. 8/15

Literature
Oldenbourg 1911, pp. 61, 80, no. 67; Sumowski 1975, pp. 151-152, 180 note 18, fig. 3; Ter Molen 1978, pp. 65-67, 74 notes 10-11 and figs. 2-3; Ter Molen 1979, p. 483; J.R. ter Molen in Amsterdam-Toledo-Boston 1979-1980, p. 40 (in no. 19); A. Blankert in Washington-Detroit-Amsterdam 1980-1981, pp. 222-223, no. 60 (ill.); S. Nihom-Nijstad in Paris 1983, pp. 71-72, no. 43 and fig. 84; Hecht 1984, p. 357; Ter Molen 1984, vol. 1, pp. 67-68, vol. 2, p. 37 (in no. 117); I. van Zijl in Utrecht 1984-1985, p. 52 (in no. 29); F.J. Duparc in Atlanta 1985, pp. 90-91, no. 39 (ill.); Jensen Adams 1985, vol. 2, pp. 440-441, 449-454, vol. 3, p. 153, no. 89 (ill.); Schapelhouman 1987, p. 164 (in no. 98); V. Manuth in Berlin 1989, pp. 749-751 and fig. 826; Scott 1989, p. 30 note 18; Yamey 1989, pp. 63-64; P. Schatborn in Amsterdam 1991, p. 150 (in no. 28) and fig. 28.1; J. Boonen in Amsterdam-Jerusalem 1991, p. 118 note 1; Broos 1993a, p. 191; P. Schatborn in Amsterdam 1993-1994, pp. 572-573 (in no. 245); Ter Molen 1994, pp. 26, 64, fig. 16; Fredericksen-Priem-Armstrong 1998, pp. 47, 357

As the second son of the famous sculptor and architect Hendrick de Keyser (1565-1621), Thomas was trained by his father, like his three brothers, for the same profession.[4] The early part of his career would be devoted entirely to painting, however. Even before his apprenticeship in his father's workshop, from 1616 to 1618, he may have already trained with an Amsterdam painter, Cornelis van der Voort (1576-1624?). De Keyser's earliest dated painting was made in 1622,[5] the year in which he joined the local Guild of St Luke. His oeuvre consists almost exclusively of portraits. He was one of Amsterdam's leading specialists in the genre, certainly until Rembrandt (1606-1669) settled in Amsterdam in 1631. With his small, delicately fashioned portraits, in which he placed his sitters in fully elaborated interiors, he introduced a new type of Dutch portraiture. He also made large paintings, including militia pieces and other group portraits, and a few figure paintings in the style of Pieter Lastman and painters in his circle, a group known as the 'pre-Rembrandtists'. In 1640 he bought a mason's workplace, and he and his brother

Pieter went into business as dealers in building materials, after which he seems to have painted less. As far as his later output is concerned, it is worth mentioning a few small equestrian portraits, which he sometimes produced in collaboration with landscape painters. He was also commissioned to make a large history piece for Amsterdam town hall in 1652 (fig. 17c). The last year found on his works is 1661. It was probably his appointment the following year as city architect, a position held by his father and two of his brothers before him, that led De Keyser to renounce the paintbrush for good.

The painting discussed here is unique in the artist's oeuvre because he did not design and elaborate it himself: it is a copy of an existing composition by Pieter Lastman (*c.*1583-1633). The example was a stained-glass window after a design by Lastman for the Zuiderkerk, Amsterdam. The sixteen large windows of the church, the first Protestant church in the Netherlands (completed in 1611), were all originally furnished with stained-glass panes, one of which was

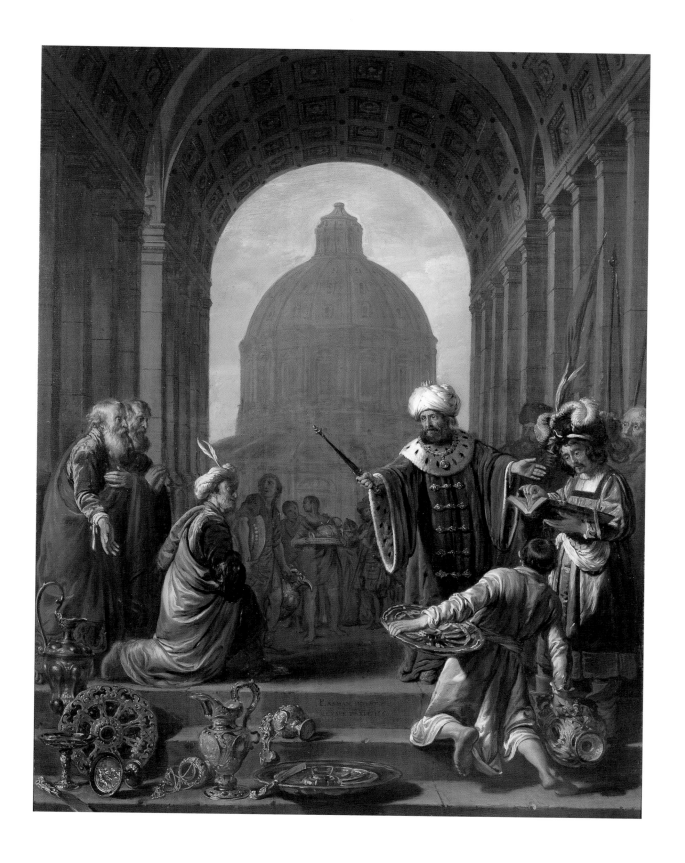

17a
Pieter Lastman, *King Cyrus returns the treasures of the temple*, 1611. Pen and brown ink, brown wash, 38.8 x 18.2 cm. Berlin, Kupferstichkabinett der Staatliche Museen zu Berlin.

17b
Paulus van Vianen, *Tazza with Suzanna and the Elders*, 1612. Silver-gilt, diameter 20.5 cm. Rotterdam, Museum Boijmans Van Beuningen (acquired in 1958).

paid for by the Amsterdam admiralty and the rest by civic trade guilds. Partly because the church was surrounded by houses, the stained-glass windows let in too little light, and in 1658 it was decided to replace them with blank glass decorated only with Amsterdam's coat of arms.[6] It is not known what happened to the original panes.[7] Lastman's design for his pane has fortunately been preserved (fig. 17a).[8] It is dated 1611 and has a cartouche inscribed with two lines of verse explaining that the pane was a gift from the guild of goldsmiths and silversmiths.[9] This sheet and a design by David Vinckboons (1576-c.1632) for the pane donated by the cobblers, hide merchants and tanners constitute the only tangible remains of what must have been the most important ensemble of monumental church panes in the northern Netherlands of the early seventeenth century.[10]

The large figure scene on the pane depicted Cyrus, the Persian king who allowed the Jews to return to Israel in 538-537 BC and gave them back the silver vessels that Nebuchadnezzar had pillaged from the temple of Jerusalem (Ezra 1: 7-11). This brought to an end the Babylonian captivity of the Jewish people, which had lasted seventy years. The subject was hardly ever depicted except in tapestry series devoted to the life of Cyrus the Great, and was undoubtedly chosen here for the aptness of the silver-ware motif to the goldsmiths' work.[11] For the other panes too, efforts were probably made to find Old Testament subjects that would be acceptable to Calvinism and bore some relation to the guild concerned, to replace the banished patron saints.[12] Thus Vinckboons' design for the cobblers' pane depicted Moses and the burning bush, a story in which God tells Moses to remove his shoes. In Lastman's design, Cyrus stands to the right of centre, wearing a crowned turban and holding his sceptre. The figure kneeling before him is Sheshbazzar, prince of Judah, and the man to the king's right, wearing a plumed hat, is his treasurer Mithridates. The latter is using an inventory to check off the 5,400 pieces of the temple's treasure that are being brought to him from all sides. Following a fifty-year-old tradition in northern Netherlandish stained glass, Lastman depicted the scene before a vaulted open Renaissance-style structure, permitting an unobstructed view of a freestanding building with a dome.[13] The latter can scarcely be meant to convey the temple at Jerusalem, as some have suggested,[14] since the episode is set in Babylon. It is probably Cyrus's palace.[15] The

dome is modelled on that of the St Peter's in Rome and occurs in other compositions by Lastman.[16] The artist has placed the scene on an elevated stage by inserting two steps, an illusionist motif that also created space for a still-life display of precious silver plate.

De Keyser's painting was undoubtedly made with the aim of preserving for posterity the composition of the doomed pane. The dual Latin signature makes this quite plain – it translates as 'designed by Pieter Lastman, painted by Thomas de Keyser', emphasising the authorship of the composition, while the painter generally furnished his works with nothing more than a monogram, 'TdK'. Lastman, who died in 1633 but greatly influenced the young Rembrandt and can be seen as the first exponent of a specifically Amsterdam tradition in history painting, was evidently still greatly respected in 1660. Still, De Keyser confined himself to the figure scene and avoided anything – the division into lights, the elongated format – that might suggest that his example was a church window. His painting also differs from the extant design in several points of detail: Cyrus points his sceptre upwards, Sheshbazzar is wearing a turban, the figure behind the treasurer has been replaced by two old men, and the two freestanding halls that rise one behind the other in the design are linked by cross-vaulting. The still life display with silver and gold objects also contains changes: the nautilus cup has become a large flagon, for instance. Lastman's preliminary design is undoubtedly a *vidimus*, a sketch presented to the clients for approval, and it is possible that these changes were already visible in Lastman's elaborated cartoon, the final detailed drawing made to scale, and on the stained glass window itself.

Alternatively, De Keyser may have made the alterations himself. This possibility is particularly worth considering in the case of the tazza lying on its side in the left foreground, the only piece of silver in the objects depicted that has been identified – as an extant tazza by Paulus van Vianen (c.1570-1613) engraved with a picture of Suzanna and the Elders (fig. 17b).[17] Lastman, whose brother, Seger Pietersz Coninck (1578-1650), was a goldsmith, liked to incorporate richly decorated precious metalwork into his paintings, rendering it with great precision.[18] His admiration for the work of the Van Vianen brothers is especially clear, as the famous flagon that Adam van Vianen (1568/69-1627) made in memory of his deceased brother for the Amsterdam guild of goldsmiths

17c

17d

17c
Thomas de Keyser, *Odysseus and
Nausicaa*, 1657. Canvas, 200 x 167 cm.
Amsterdam, Royal Palace (since 1657).
17d
Pieter Lastman, *The baptism of the
eunuch*, c.1615-1620. Panel, 63.5 x
98.8 cm. Paris, Frits Lugt Collection
(acquired in 1935).

and silversmiths in 1614 found its way into one of his paintings the very next year.[19] But the tazza depicted by De Keyser was not made until 1612, a year later than the date on Lastman's design for the pane – and in far-off Prague. If it was depicted on the window, the final cartoon must have been made later than the date on the drawing.[20] Alternatively, perhaps De Keyzer added the tazza to his painting.[21] The 'Suzanna tazza' by Paulus van Vianen – or a cast of it – must have been well known in Amsterdam around the time when the painting described here was made. For in 1657 the Amsterdam goldsmith Lucas Draef (1615-1679) had made a wavy-rimmed dish on which he faithfully reproduced the figure scene on the tazza.[22]

We can only hazard a guess as to who may have commissioned the painting in the Frits Lugt Collection. Perhaps it was ordered by the guild of goldsmiths and silversmiths, with which De Keyser had close ties.[23] After all, his first wife came from a family of goldsmiths, and a number of his portraits and three of his group portraits depict these craftsmen, in some cases his own relatives by marriage.[24] Or perhaps the painting was a personal initiative of De Keyser, who must have known Lastman well. He had painted Lastman's portrait and collaborated with him on a triptych in 1628, Lastman providing the central scene and De Keyser the wings with donors' portraits.[25] The few figure pieces with biblical subjects that are known by De Keyser reflect Lastman's influence.[26] What is more, his father, as the architect of the Zuiderkerk, had undoubtedly been closely involved in the making of the building's stained-glass windows.[27] With his far more fluid brushwork, De Keyser even tried to imitate Lastman's style, although this would not have been noticeable in the pane itself.

But the highly finished style of painting, glowing colours and powerful light and dark contrasts all bear the imprint of De Keyser's own style and technique. The painting from 1660 that is described here can therefore be compared with his large history piece for Amsterdam town hall, completed three years before (fig. 17c).[28] Still, this painting's composition too has echoes of Lastman's renderings of the same subject.[29]

This painting by De Keyser is one of the few narrative scenes in the Frits Lugt Collection. One of the most important of the small group of history pieces assembled by Lugt is Lastman's *Baptism of the eunuch* (fig. 17d),[30] besides which the collector had also secured an extremely rare monogrammed little panel by Lastman's brother-in-law François Venant (*c*.1592-1636).[31] His collection also includes a few other works by pre-Rembrandtists.[32] Lugt had a special reason for wanting to acquire the painting discussed here. It was he who had identified the drawing preserved in Berlin's Kupferstichkabinett (fig. 17a), in his notorious attack on that institution's 1930 catalogue of its Dutch drawings, as a design for the goldsmiths' pane in the Zuiderkerk. Following up an idea mooted by Elisabeth Neurdenburg – the author of a monograph on Hendrick de Keyser – he therefore tentatively suggested an attribution to Lastman, about whose style of draughtsmanship little was known at the time.[33] When the completely unknown painting turned up on the London art market in 1952, Lugt must have immediately recognised it as an elaboration of the Berlin design, in which the double signature, identifying Lastman unequivocally as the inventor of the composition, proved that the attribution he had proposed over twenty years before had been correct.[34] *HB*

Jan Lievens

Leiden 1607-1674 Amsterdam

18 *Landscape with three pollard willows, c.1640-1650*

Panel,[1] 28 x 41.3 cm / Acquired in 1927

Provenance

(?) Joan Baptista Anthoine (d. 1691), Antwerp, in or before 1691;[2] John Postle Heseltine (1843-1929), London; Frits Lugt, Maartensdijk and Paris, acquired on 30 January 1927; on loan to the Rijksmuseum, Amsterdam, 1932-1937; inv. no. 2787

Exhibitions

Rotterdam 1927-1928, no. 8; Amsterdam 1932, no. 193; Rotterdam 1938, no. 99; The Hague 1946, no. 32; Paris 1950-1951, no. 49; Braunschweig 1979, no. 42; Paris 1983, no. 46

Literature

Zwartendijk 1928, p. 70 (ill.); Schneider 1932, pp. 61, 164-165, no. 308; Böhmer 1940, p. 45; Bloch 1955, p. 320; Larsen 1960, p. 39; Stechow 1966, p. 180 and fig. 362; J. Foucart in Paris 1970-1971, p. 132 (under no. 136); Scheider ed. Ekkart 1973, pp. 61, 164-165, no. 308, p. 338; Reitsma 1976, pp. 251, 254 and fig. 5; S. Jacob in Braunschweig 1979, pp. 23, 124-125, no. 42 (ill.); Brown 1979, p. 745; Sumowski 1980, p. 12; S. Nihom-Nijstad in Paris 1983, pp. 77-78, no. 46 and fig. 20; Charensol 1983, p. 433; Sumowski 1979- , vol. 7 (1983), p. 3712 (under no. 1666); Haak 1984, p. 371 and fig. 783; Sumowski 1983-1994, vol. 3 (1986), p. 1813, no. 1305 (ill.); E. Domela Nieuwenhuis in *The Dictionary of Art*, vol. 19 (1996), p. 349; E. Domela Nieuwenhuis in Turner 2000, p. 199; Dickey 2001, p. 302 note 51

Jan Lievens is today best known for his early work, created in artistic competition with the young Rembrandt (1606-1669).[3] The latter had returned to Leiden in 1625, having spent several months in Amsterdam in the studio of Pieter Lastman (*c.*1583-1633), with whom Lievens had also studied. In the years that followed the two artists influenced one another in their choice of subject matter, their compositions and technique. They went their separate ways, however, in 1631, when Rembrandt moved to Amsterdam and Lievens departed for England, where his style was to change as well. Here he came into contact with the work of Anthony van Dyck (1599-1641), court painter to Charles I, which now served as his inspiration. Having finally decided to leave England, he returned not to the Republic but settled instead in Antwerp, joining the Guild of St Luke and marrying a daughter of the sculptor Andries Colyn de Nole (1540-1636). Financial difficulties forced him to move to Amsterdam in 1644. In his later career he made a name for himself as a history painter and much sought-after society portraitist.

Lievens was above all a figural painter, mainly of so-called *tronies* and half-figures, as well as biblical and mythological scenes. There are, however, several land-scapes by his hand, a group of fewer than 15, mainly small works characterised by their unconventional style and southern Netherlandish tenor. The painting in the Lugt Collection depicts a small hill with three monumental pollard willows; the view opens out to the right over a gleaming low-lying valley with farmhouses. A man and woman rest beneath the trees, he stretched out on his stomach, she propping herself up on her elbow. They tend a group of goats, some of which have wandered off to a second hilltop with tall trees. The painter's aim was clearly to create a pastoral image of peace and harmony. The couple recalls a series of prints after designs by Abraham Bloemaert (1566-1651) in which peasants and herdsmen in similar poses are meant to personify the blessings of rest.[4] The painting has a rather mysterious feeling to it and has sometimes been described as a kind of nocturne, although the willows seem rather to be set against the setting sun.

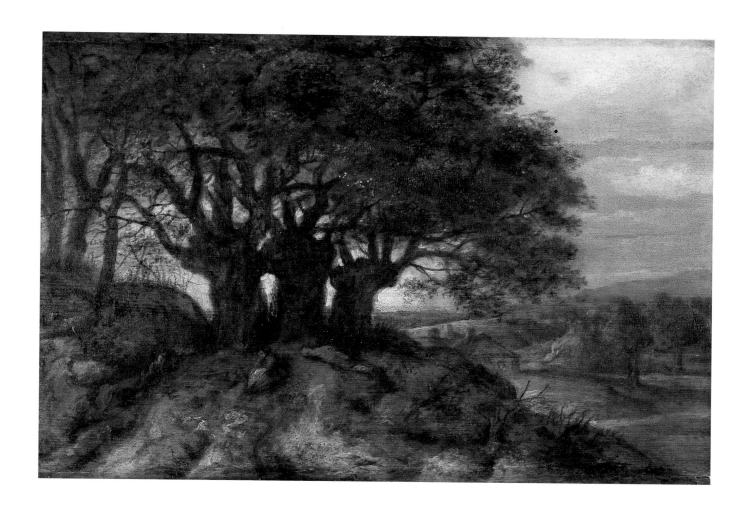

18a

18b

18c

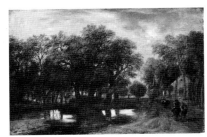

18d

18a Jan Lievens, *Portrait of Adriaen Brouwer*, c.1635-1638. Black chalk, 22.1 x 18.5 cm.
Paris, Frits Lugt Collection (acquired in 1923).

18b Jan Lievens, *Portrait of a man*, c.1660. Canvas, 96.2 x 77 cm.
London, The National Gallery (acquired in 1912).

18c Jan Lievens, *Landscape with trees*, c.1650. Panel, 41.5 x 35.5 cm.
Rotterdam, Museum Boijmans Van Beuningen (acquired in 1929).

18d Jan Lievens, *Landscape with setting sun*, c.1640? Panel, 28 x 48 cm.
Berlin, Staatliche Museen, Gemäldegalerie (acquired in or before 1811).

The somewhat unorthodox composition is characteristic of Lievens' landscapes, in which the disproportionately large main motif is often placed in the immediate foreground. The irregular, almost improvised technique is also typical. The reddish brown ground shimmers through the paint layers or is even left bare. It contrasts with the blue of the sky, giving the painting a warm, glowing tone that recalls the work of sixteenth-century Venetian masters. The paint has been applied opaquely in certain areas, particularly in the foreground, where the structure of the terrain is suggested through nearly formless brushstrokes. The trunks and branches of the willows appear as dark stripes against the ruddy ground and have few colour nuances; the treetops are indicated with little more than a pattern of patches and dots, which again leaves much of the underlayer exposed. The white and blue sky between the branches was only painted in later.

It is generally thought that Lievens' interest in landscape was kindled during his Antwerp period by the contemporaneous work of Peter Paul Rubens (1577-1640) and Adriaen Brouwer (1605/6-1638).[5] Lievens and Brouwer knew each other: along with Jan Davidsz de Heem (cat.no.14) the latter was a witness at the signing of a contract between Lievens and a new pupil in 1636. Lievens also drew his portrait, now in the Lugt Collection (fig.18a).[6] Most of Lievens' landscapes were once attributed to Brouwer, who painted a few similar pieces in the last years of his life, like Lievens in a small format.[7] Van Dyck was presumably also partly responsible for the artist's interest in the genre. Lievens' print after Van Dyck's now-lost portrait of the lutenist Jacques Gautier (d. 1660), certainly made while he was still in England, already includes a landscape in the background. The woodland scene described here recalls both the vistas found in Van Dyck's portraits and his

landscape drawings.[8] Lievens probably continued to paint such works even after moving to Amsterdam. Many of his late portraits include scenery in the background and a large number of drawings, mainly of woods and also executed during his last years in Amsterdam, bear witness to his continuing love of this theme.[9]

The rather fitful nature of Lievens' artistic development makes it difficult to order his oeuvre chronologically. The painting in the Lugt Collection has always been assigned to his Antwerp period and dated to around 1640, likely executed not long after the *Landscape with setting sun* now in Berlin, which is painted on a panel with an Antwerp brand-mark and is strongly reminiscent of Rubens (fig. 18d).[10] It is not impossible, however, that it was done at a subsequent stage. Recent research has shown that a number of pictures traditionally dated to Lievens' Antwerp years may have been produced much later. This is true, for example, of a portrait that was generally considered to be a key work of the period and also believed to be the artist's own likeness (fig. 18b).[11] The landscape in the background, recalling the work of both Rubens and Brouwer, is comparable in technique and colouration to the painting in the Lugt Collection.[12] It has been noted, however, that the figure's clothing – a kind of robe-like garment that came into fashion in the 1650s – points to a later date, casting doubt on the identification of the sitter as well.[13] It now seems that the artist continued to employ a pseudo-Flemish technique even in Amsterdam. Dendrochronological analysis has also demonstrated that a very freely painted landscape in Rotterdam, similar in composition to the picture in Paris, was likely carried out only around 1660 (fig. 18c).[14] Even the *Landscape with setting sun* (fig. 18d) may well have been painted after Lievens' move to Amsterdam. The staffage in particular appears to be inspired by the kind of figures found in the art of northern Italianate painters.[15]

Inventories show that Lievens' unusual landscapes were popular and sought-after already in the seventeenth century.[16] As early as 1650 Lambert van den Bos (1610-1684) dedicated a stanza of his rhymed description of the collection of the art dealer Martin Kretzer (1598-1670) to a Lievens landscape.[17] Six years later we discover that Rembrandt owned three landscapes by his old friend, among them a 'manen schijntie' (moon shining) – perhaps the same work noted in Samuel van Hoogstraten's (1627-1678) *Inleyding tot*

de hooge schoole der schilderkonst (1678) as a model for the depiction of pale moonlight.[18] Records indicate that Lievens also painted mountain landscapes, although no examples have survived.[19] At the end of the seventeenth century the Lugt painting may have been part of the collection of the Antwerp postmaster Joan Baptista Anthoine (d. 1691), who had brought together one of the best groups of pictures in the city.[20] He also owned two other works by Lievens, one of which was painted in collaboration with Jan Davidsz de Heem (cat. no. 14).[21] Due to the brevity of the description, however, this identification remains uncertain. If it is indeed correct then it once again seems plausible to date our work to the artist's Antwerp period.

Lugt acquired the painting in 1927 from John Heseltine (1843-1929), a wealthy retired stockbroker with artistic leanings – his landscape etchings are in fact more than praise-worthy – and once-passionate collector of old drawings.[22] Heseltine was 84 years old at the time and Lugt had been in close contact with him for several decades. Already during his sojourn in London in 1901, which directly preceded his employment at Frederik Muller & Cie, Lugt – then aged only 17 – had been invited to visit Heseltine's drawings collection. Later, when the collector found it necessary to sell a large part of his holdings, it was Lugt who compiled the catalogue for the auction of the Dutch drawings, among them a beautiful group of Rembrandts.[23] It was Lugt, too, who wrote the obituary upon his death in 1929.[24] We do not know when exactly Heseltine purchased the Lievens, or even if it was already attributed to the artist while in his possession.[25] In any case, Lugt himself was certainly aware that it was one of the painter's rare landscapes, as he recorded it under his name in his inventory. Of the landscapes now known to be the work of the artist only one, the *Landscape with setting sun* in Berlin (fig. 18d), was then traditionally attributed to him. In 1929, the same year Lugt bought his picture, Museum Boijmans in Rotterdam purchased its landscape, also already as a Lievens (fig. 18c), and several years later Hans Schneider in his monograph would show the painter to have been a talented practitioner of the genre. Lugt's admiration for Lievens extended to his draughtsman-ship, and there are several of his drawings in the collection. In addition to the aforementioned portrait of Adriaen Brouwer (fig. 18a) these include two other portraits and, most interesting, a lovely series of seven landscapes.[26] *HB*

Dirck van der Lisse

The Hague 1607-1669 The Hague

19 *Portrait of a man, c.1645-1650*

Copper (oval), 15.9 x 12.8 cm / Acquired in 1958

20 *Portrait of a woman, c.1645-1650*

Copper (oval), 16 x 12.8 cm / Acquired in 1958

Provenance

Oscar Nottebohm, Antwerp (sale Brussels, Palais des Beaux-Arts, 17 December 1957, lot 100, as Pieter van Slingelandt);[1] P. de Boer, art dealer, Amsterdam, 1958;[2] Frits Lugt, Paris, purchased from De Boer on 5 August 1958;[3] inv. nos. 7179 A-B

Exhibitions

Antwerp 1935, nos. 284-285 (as Pieter van Slingelandt); Amsterdam 1958, unnumbered (as Jan Olis); Paris 1983, nos. 38-39 (as Cornelis Jonson van Ceulen)

Literature

S. Nihom-Nijstad in Paris 1983, pp. 64-65, nos. 38-39 and figs. 62-63 (as Cornelis Jonson van Ceulen); Dauriac 1983, p. 279 ('anonymes'); Hecht 1984, p. 357 (as Dirck van der Lisse)

Over the years, these unsigned and undated small portraits of an unknown couple have been attributed to a range of artists active in various decades. Previously thought to have been the work of either Pieter van Slingelandt (1640-1691) or Jan Olis (*c.*1610-1676), Frits Lugt ascribed them to Daniël Mijtens the Elder (*c.*1590-1647), a portrait painter who had worked in The Hague and London, thereby bringing the date of execution still further forward.[4] In 1983, finally, they were catalogued as Cornelis Jonson (Janssen) van Ceulen (1593-1661).[5] This London-born portraitist left England in 1640 in connection with the outbreak of the Civil War, and first appears in the Netherlands in 1643. He worked at a number of locations, not only in Amsterdam and Middelburg, but in The Hague as well.[6] It was here that the portraits in question were undoubtedly made – not, however, by Van Ceulen but by Dirck van der Lisse, better known as a landscape painter. A second, nearly identical version of the woman's portrait, now in the Royal Collection in London, bears the artist's characteristic monogram, 'DVL' (fig. 19-20a).[7] It is more

or less the same size and is also painted on an oval copper support, although the sitter is viewed from closer by and there are several deviations in the dress as well. In 1983, on the occasion of the exhibition *Reflets du siècle d'or* in Paris, the Lugt pendants were independently identified as the work of the Hague painter by both Sir Oliver Millar and C.J. de Bruyn Kops on the basis of the portrait in London.[8]

Given the monogram on the London picture, one might suppose it to have been the model for the portrait of a woman described here. It is interesting to note, however, that the clothing in the former is rather different from that in the portrait in the Lugt Collection, although it certainly dates to the same period (see below). Not only is more of the sitter's black outer garment visible in the Lugt portrait, she also wears a different type of lace collar and an earring in her left ear. Nonetheless, the cap is the same in both pictures and the pattern of the lace is similar as well. We do not know if the London work once had a pendant as well, but it seems likely. The copying of

19-20a

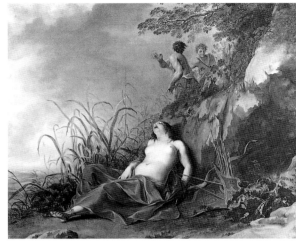
19-20b

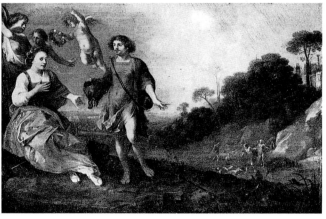
19-20c

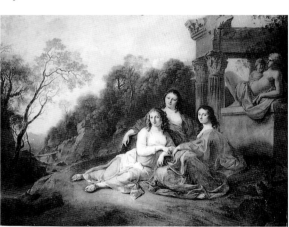
19-20d

19-20a Dirck van der Lisse, *Portrait of a woman*, c.1645-1650. Copper (oval), 16.2 x 13 cm.
London, The Royal Collection © Her Majesty Queen Elizabeth II (acquired before 1909).
19-20b Dirck van der Lisse, *Sleeping nymph, with two men in the background*, c.1640-1650. Panel, 44 x 51.8 cm.
The Hague, Royal Cabinet of Paintings Mauritshuis (acquired in 1993).
19-20c Dirck van der Lisse, *'Portraits historiés' of a couple in a landscape as Meleager and Atalanta*,
c.1640-1650. Panel, 27 x 38.5 cm. Formerly The Hague, Gemeentemuseum (photograph: RKD, The Hague).
19-20d Dirck van der Lisse, *Portrait of Johan van Reede van Renswoude's daughters in a landscape*, c.1650.
Canvas, 102 x 135.5 cm. Private collection (photograph: Iconografisch Bureau, The Hague).

portraits – whether by the artist himself or others –
was not an unusual phenomenon. The will of Baertjen
Martens, wife of the picture-framer Herman Doomer,
for examples, stipulates no less than three times that
the portraits of her and her husband painted by Van
der Lisse's contemporary Rembrandt (1606-1669) in
1640 were to be copied for her children by her son,
Rembrandt's pupil Lambert Doomer (1622-1700).[9]
Unfortunately, nothing is known of the couple portrayed
by Van der Lisse. We can therefore only speculate on the
function of these and other possible replicas, although
it may be that they were made for the same reasons.

Van der Lisse was the scion of a wealthy Hague family and married well at the age of 32.[10] He probably received his early training in The Hague, although we do not know from whom, and by 1626 he was already active in a workshop in Utrecht. He is generally thought to be the most talented pupil of Cornelis van Poelenburch (1594/95-1667), with whom he studied there.[11] Around 1635 he carried out work for Huis Honselaarsdijk, part of a large-scale commission given to Van Poelenburch and other local artists. Two canvases that can be precisely dated – one a scene from Battista Guarini's (1538-1612) play *Il pastor fido*, the other a landscape with shepherds – were painted for the private apartments of Amalia van Solms (1602-1675), wife of Stadholder Frederik Hendrik (1584-1647).[12] In 1640 Van der Lisse settled in Utrecht, having commuted back and forth to The Hague for a number of years.[13] Finally, in 1644, after living for a brief period in Amsterdam, he joined the painters' guild in The Hague, where he remarried in 1648. In 1656 he became a founding member of the *Schilders-Confrerie Pictura*, a group of artists who had broken their ties with the guild. From 1659 until his death in 1669 Van der Lisse several times held the post of burgomaster, having previously served in a number of other official functions.[14] He died a rich man, leaving behind a personal collection of more than one hundred paintings, among them family portraits and much of his own work. Also included were pictures by Van Poelenburch and copies after him, probably painted by Van der Lisse himself, as well as pieces by other masters such as Lucas van Leyden (1489-1533) and Jacob Jordaens (1593-1678).[15]

Van der Lisse's own oeuvre consists mostly of Italianate landscapes with nymphs, satyrs and animals, as well as history paintings, which, despite their kinship with those of Van Poelenburch, nonetheless have a character of their own (fig. 19-20b).[16] In addition, he was occasionally active as a portraitist, as we see from the two examples here and the picture in London. Given that his administrative positions provided him with a regular income, it seems unlikely that Van der Lisse would have taken on portrait commissions indiscriminately; instead, he likely portrayed only members of his own intimate circle, mainly wealthy citizens and aristocrats.[17] In addition to the three surviving portraits on copper, we know of at least two works in which likenesses have been incorporated into landscape paintings. There can be no doubt, for example, that the Meleager and Atalanta in the foreground of a signed landscape are

portraits historiés of an unknown couple (fig. 19-20c).[18] Van der Lisse's most ambitious work in this genre, completed in about 1650, is an elegant group portrait of the three daughters of Johan van Reede van Renswoude (1593-1682), ambassador to the States General. Here, the figures are dressed in colourful robes, 'op zyn antycks', and posed in an Arcadian setting (fig. 19-20d).[19] The painting, monogrammed at the lower left on the socle, should be viewed as an 'occasional portrait', although executed on commission. Finally, we know from various sources that Van der Lisse painted a large-scale likeness of his brother (d. 1658) with his wife and children.[20]

Van der Lisse is best known, however, for his landscapes. They make up the largest part of his oeuvre and were more or less inspired by the art of Van Poelenburch.[21] Oddly enough, the figures in them are often quite stiff and artificially posed, which cannot at all be said for his rare portraits. Van der Lisse undoubtedly learned the techniques of portrait painting from Van Poelenburch, who also executed the incidental work in this genre. The faces in the Lugt Collection paintings are vaguely reminiscent of Van Poelenburch, although his portraits have an entirely different feel, with the sitters dressed not in their everyday clothes – as here – but rather in fantastical costumes.[22]

The mode of dress allows us to date the Van der Lisse portraits to around 1645-1650,[23] the period when the painter finally settled definitively in The Hague. Their superficial resemblance to the 'slick' portraits of the Utrecht painter Gerrit van Honthorst (1590-1656) is not entirely accidental: Van Honthorst was active at the stadholder's court between 1637 and 1652, and his portraits – replicated many times – were certainly known to Van der Lisse.[24] The style and idealised features of the abovementioned group portrait, on the other hand, are reminiscent of the work of Jan Mijtens (c.1614-1670), one of the most important Hague portraitists.[25] Finally, one can also link the Lugt pendants to the fashionable burgher portraits of Jan van Ravesteyn (see cat. no. 26).[26] Unfortunately, Van der Lisse's 'Register Boeckje van schilderijen... gemaeckt en [ver]koft' (Register booklet of paintings... made and sold), mentioned in an inventory compiled after his death in 1669, has since disappeared.[27] It would not only aid in the chronological ordering of his oeuvre – in which not a single work is actually dated – but also provide essential information on his activity as a portrait painter. *QB*

123

Aert van der Neer

Gorinchem 1603/4-1677 Amsterdam

21 *Panoramic landscape, c.1645*

Panel,[1] 21.8 x 38.3 cm / Monogrammed at lower left: *AVN* (in ligature) / Acquired in 1938

Provenance
(?) Gabriel van Rooijen (1752-1817), Amsterdam (G. van Rooijen *et al.* sale, Amsterdam, Luytjes, 27 January 1818, lot 26, for 1 guilder to Vinkeles);[2] H. Vinkeles Jansz, Amsterdam; Sir George Alexander Drummond (1829-1915), Montreal (sale London, Christie's, 26-27 June 1919, lot 195, for 178 pounds and 10 shillings to Colnaghi);[3] (?) Frederik Muller & Cie, auctioneers and art dealers (Mrs U.M. Kneppelhout-van Braam *et al.* sale, Amsterdam, Frederik Muller & Cie, 16 December 1919, lot 73);[4] E. Hirschler & Cie, art dealers, Vienna; Anton Willem Mari Mensing (1866-1936), Amsterdam, in or before 1921 (sale Amsterdam, Frederik Muller & Cie, 15 November 1938, lot 72, for 4,800 guilders to Lugt);[5] Frits Lugt, The Hague and Paris; inv. no. 5504

Exhibitions
Madrid 1921, no. 41; The Hague 1946, no. 39; Paris 1983, no. 55; Paris 1989, no. 8

Literature
Hofstede de Groot 1907-1928, vol. 2 (1918), pp. 345, no. 95 A (?) and 353, no. 58; Hennus 1950, fig. p. 120; Stechow 1966, pp. 134-135, 177, 211 note 15 and fig. 271; S. Nihom-Nijstad in Paris 1983, p. 90, no. 55 and fig. 14; Kingzett 1983, p. 503; C. van Hasselt in Paris 1989, pp. 10-11, no. 8 and fig. 2

The little we know about the life of Aert van der Neer suggests he suffered a certain amount of misfortune.[6] The artist was born in Gorinchem, where he probably spent his youth. At the time of his marriage in 1629 he was recorded as a resident of Amsterdam, the city where he spent the rest of his life, at any rate from 1640 onwards. Van der Neer did not start painting until later in life, starting in 1630. Possibly a dilettante at first, he was encouraged to paint by two friends, the brothers Raphael Govertsz (*c.*1597/98-1659) and Jochen Camphuysen (1601/2-1638), also natives of Gorinchem. Van der Neer's earliest dated landscape – from 1632 – was signed, interestingly enough, not by the artist alone but also by Jochen Camphuysen.[7] From 1659 Van der Neer is recorded as an innkeeper and tapster, though he went bankrupt already in 1662. After this, fate does not seem to have been kind to him: in 1677 his possessions had to be sold to pay for his burial. Apparently his work was not much esteemed by contemporaries, as evidenced by the inventory drawn up after his death, in which his paintings were assigned very little value. Nevertheless,

Aert van der Neer was an important and original painter and the author of a large oeuvre. Apart from several 'cortegaerden' (guardrooms with soldiers) done at the beginning of his career, he devoted himself entirely to landscape painting. His eldest son, Eglon van der Neer (1635/36-1703), was also a painter, but in a completely different genre and with much greater social success. By the artist's second son, Johannes van der Neer (1637/38-1665), we know several landscapes painted in the style of his father.

Aert van der Neer's early landscapes are connected with the work of Gillis Claesz de Hondecoeter (1575/80?-1638) and Alexander Keirincx (1600-1652), representatives of the tradition previously established by Gillis van Coninxloo (1544-1606). The work of the Camphuysen brothers also belongs to this group. From the early 1640s onwards Van der Neer confined himself primarily to one type of landscape of his own invention, which he continued tirelessly to modify in countless variations. Nearly all his paintings depict a view across a canal or wide inland waterway surrounded by trees

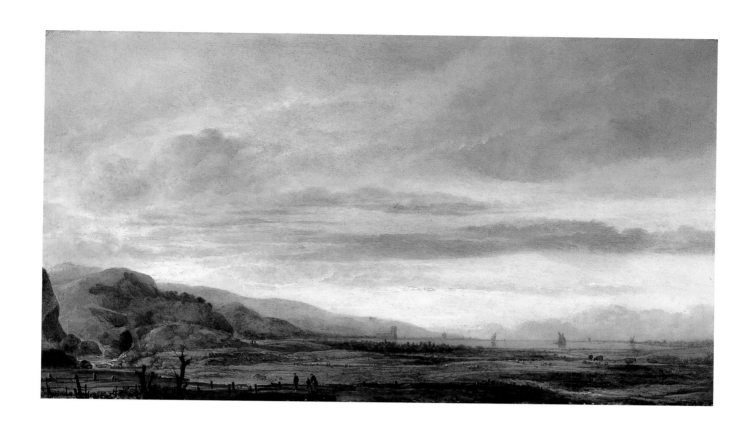

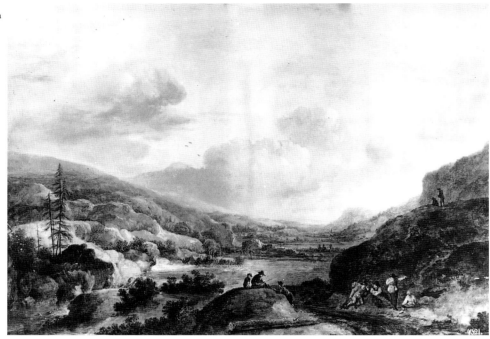

21b

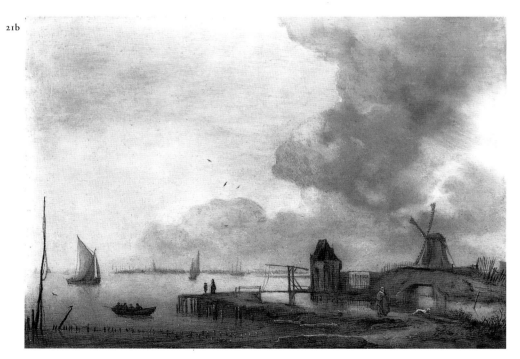

21a Aert van der Neer, *Mountainous landscape*, 1647. Panel, 57 x 84 cm. St Petersburg, Hermitage (acquired in or before 1797).
21b Aert van der Neer, *River landscape with windmill*, c.1640. Panel, 26.2 x 36.8 cm. Paris, Frits Lugt Collection (acquired in 1917).

and buildings, running from the foreground straight back to the horizon. In these depictions Van der Neer concentrated on the rendering of a few special light effects: the setting sun, the sky at dawn or sunset, a moonlit night or the light produced by a conflagration, often a burning house or farmstead. Winter landscapes, laid out along the same lines, were also an important specialism of his.

The small landscape exhibited here does not seem at first glance to be characteristic of Van der Neer, who usually depicted flat Dutch landscapes. This small panel – displaying minutely fine execution and, at the lower left, a monogram so small as to be almost invisible – depicts a nearly treeless area around a lake or inlet, bordered on the left by mountains whose foothills run down to the shores of the water. In the foreground a stream makes its way between rocks as it runs down to flow next to a path which stretches across the width of the painting at the front. The viewer's eye is drawn to the foreground by the fence running along the path, a few people strolling and a frail-looking tree. Further away, in the marshy lowland, cows and sheep graze, two sailing boats stand out against the placid water, and the silhouettes of two churches and a windmill are vaguely visible on the shore. The landscape is seen from a raised vantage point some distance away. The indirect light of the setting sun – hidden from view by a bank of clouds displaying pink, blue and grey hues – creates a slightly unreal atmosphere.

Although not immediately recognisable, the compositional scheme usually to be found in Aert van der Neer's work can also be discerned in this landscape. Here, though, the broad surface of water, around which the artist generally grouped all the elements of the landscape, has been moved towards the horizon and a mountain face has been added on one side. Depicted on the shore are the artist's customary windmills and village churches. The complicated light effects – sun- or moonlight partly breaking through the clouds – can be viewed as the artist's speciality. Van der Neer's authorship, however, is betrayed in particular by his characteristic manner of painting and his fine feeling for tonal values, which enabled him to take elements from different types of landscape and integrate them into a plausible whole. This small work is very transparently painted over a reddish ground, which shines through the paint layer everywhere and is almost completely exposed in the mirror-like surface of the water. The extremely varied brushwork is especially noticeable in the lowland, where he drew whimsical patterns with a fine brush over the first layer of paint, thus suggesting irregularities in the terrain. Here and there he pointedly applied sharp accents in pastose paint, such as the dots which portray grazing sheep. The palette of the landscape is confined to brown, grey and ochre hues. Only the small figures display the barest trace of colour.[8]

In the early 1640s Aert van der Neer's personal style clearly emerged, and in 1643 he began to paint the moonlit landscapes for which he is so well known. The small painting discussed here is dated to around 1645 on stylistic grounds.[9] The artist's oeuvre contains a few other mountainous landscapes, though only one of these is immediately comparable to the painting in the Frits Lugt Collection: a depiction of a mountain lake between bare rocks, which was not recognised as an autograph painting until restoration work carried out in 1960 revealed the artist's monogram (fig. 21a).[10] The painting is much larger than the present panel, and its more complicated design features ever more distant ranges of mountains functioning like the wings of a stage. The rock structure, however, is very similar to that seen in the painting discussed here, and in both works a small waterfall is visible on the left in the middle distance. The date on this panel – 1647 – lends support to the date suggested for the small painting in the Lugt Collection.[11]

Van der Neer's *Panoramic landscape* is exemplary of Lugt's penchant for collecting works representative of an extraordinary moment within an artist's oeuvre. This painting, too, must have been a piece he set his sights on while still an employee of the Amsterdam auction house of Frederik Muller, at a time when he could not have acquired it for himself. It was sold there in 1919 and changed hands twice before Lugt was able to add it to his collection nearly twenty years later. Before this, however, Lugt had already purchased a painting by Aert van der Neer, one of the first paintings he ever bought for himself, in fact. It is a signed panel which is difficult to place – both chronologically and stylistically – within his oeuvre, though it is clearly one of his early works (fig. 21b). In 1924 Lugt was also fortunate enough to lay his hands on one of the artist's ten known drawings – all very freely executed sheets – and of these ten 'the most important and most beautiful [one] that I know' (de belangrijkste en fraaiste die ik ken), as Lugt proudly wrote on the inventory card.[12] *HB*

127

Caspar Netscher

Heidelberg or Prague 1635/36-1684 The Hague

22 *Portrait of the collector Abraham van Lennep (1627-1678),* 1672

Canvas, 55 x 45.3 cm / Signed and dated on the rung of the chair: *CNetscher 1672* (*CN* in ligature) / Acquired in 1976 with the support of the Rembrandt Society

Provenance
Abraham van Lennep (1627-1678), Amsterdam; by inheritance to his brother, Jacob van Lennep (1631-1704), Amsterdam;[1] bequeathed to his great-grand-daughter, Catharina van Lennep (1726-1793) and her husband, Leonard Thomas de Vogel (d. 1794), Amsterdam (sale De Vogel, Amsterdam, Posthumus-Ter Maat, 20 October 1794 and following days, part 21 October, lot 8);[2] unknown collection (sale Paris, Constantin-Boileau, 23 November 1801 and following days, lot 61, for 850 *francs* to Simon);[3] J.B. Guyot, Tours (sale Paris, Elie-Destouches, 8 March 1809 and following days, lot 171, with lot 230, a painting by Andrea del Sarto, for 19 or 46 *francs* to Bellier);[4] Joseph, Cardinal Fesch (1763-1839), Rome (sale Rome, Palazzo Ricci, 17-18 March 1845 and following days, lot 168, for 405 *scudi* [4,050 *francs*] to George);[5] Charles Moret-Saint-Hilaire (d. 1849), Paris (sale Paris, Febure-Pillet, 12 February 1857, lot 17, for 5,950 *francs*);[6] Marquis du Blaisel, Paris (sale Paris, Febure-Pillet, 16-17 March 1870, lot 89, for 5,500 *francs*;[7] sale London, Christie, Manson & Woods, 17-18 May 1872, sold on 18 May, lot 141, for 140 guineas or 147 pounds;[8] sale Paris, Mannheim-Féral-Pillet, 9-10 May 1873, lot 79);[9] J. & A. Le Roy frères, art dealers, Brussels, 1892; Charles Rutten, Brussels, acquired from Le Roy frères on 1 February 1892 for 4,600 *francs*;[10] bequeathed to his heirs in Brussels and Antwerp; Jean-Paul de Meulenmeester, art dealer, Brussels, 1975 (acquired from Rutten's heirs); Fondation Custodia, Paris, purchased from De Meulenmeester on 6 April 1976 with the support of the Rembrandt Society;[11] inv. no. 1976-S.1

Exhibitions
Paris 1983, no. 56; Amsterdam 1989-1990, no. 35; Paris 1994, no. 129; Amsterdam 2000a, no. 182

Literature
Fesch 1841, p. 8, no. 142; Blanc 1857-1858, vol. 2, p. 554; Kramm 1857-1864, vol. 4 (1860), p. 1193; Déon 1860, p. 157; Wessely 1881, p. 30, no. 50 (with reference to the Vaillant mezzotint discussed below); Van Someren 1888-1891, vol. 2 (1890), p. 397, no. 3211 (Vaillant mezzotint); Van Lennep 1900, p. 155 (*idem*); Hofstede de Groot 1907-1928, vol. 5 (1912), p. 170, no. 42; Dudok van Heel 1975a, pp. 147 (ill.) and 148; Van Hasselt 1977, pp. 34-36 (ill.); Van Gelder 1978, pp. 227-238, figs. 1 and 5; S. Nihom-Nijstad in Paris 1983, pp. 91-93, no. 56 and fig. 69; Charensol 1983, p. 432; Dauriac 1983, p. 279; Prat 1983, fig. p. 129; Hijmersma 1983, p. 162; Broos 1984a, p. 36 and fig. 21; Van Gelder-Jost 1985, pp. 154, 156; J.A. Poot in Rotterdam-Washington 1985-1986, p. 62 note 2; G. Luijten in Hollstein, vol. 31 (1987), p. 179, in no. 185; P. Hecht in Amsterdam 1989-1990, pp. 172-175, no. 35 (ill.); Ydema 1991, p. 168, no. 567; H.T. van Veen in Amsterdam 1992, p. 115 and p. 113, fig. 89; Wieseman 1993, pp. 384-385, no. 107; Van der Meulen 1994, vol. 2, p. 66; P. Hecht in Paris 1994, pp. 270-271, no. 129 (ill.); Van Zoest 1994, fig. p. 3; Peronnet-Fredericksen 1998, vol. 1, p. 771, no. 0061, p. 772, no. 0171; J. Kiers and F. Tissink in Amsterdam 2000a, pp. 261, 271 and fig. 182; J.P. Filedt Kok in *idem*, p. 343, no. 182 (ill.); Plomp 2001, p. 8, fig. 6, p. 86 and fig. 61 (detail)

128

Caspar Netscher entered the Arnhem studio of the little-known still life and portrait painter Hendrick Coster (active *c*.1638-1659) at a very early age, and completed his training with the famous genre and portrait painter Gerard ter Borch (1617-1681) in Deventer from around 1654. He married in Bordeaux in 1659, during a sojourn in France, and in 1662 he settled definitively in The Hague, where he initially specialised in genre scenes in the style of Ter Borch, later going on to do historical subjects as well.[12] The painting in the Frits Lugt Collection, signed in full and dated 1672, belongs to the period when Netscher – an extraordinarily prolific

artist – was producing mainly portraits, a lucrative genre to which he had begun devoting himself in 1667. Netscher's elegant and courtly style can be compared to that of the Hague portraitists Jan de Baen (1633-1702), Jan Mijtens (*c*.1614-1670) and Adriaen Hanneman (*c*.1604-1671), all of whom were strongly influenced by Anthony van Dyck (1599-1641). Netscher's likenesses, however, were invariably executed in a relatively small format, while his colleagues preferred to paint life-size. Netscher mainly followed the example of Ter Borch in his early genre and portrait paintings; in his later portraits, on the other hand, he drew inspiration from

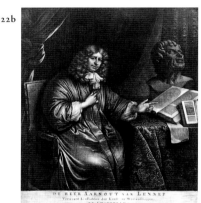

22a Rembrandt, *Portrait of Abraham Francen*, c.1657.
 Etching (second state), 15.8 x 20.8 cm. Amsterdam,
 Rijksmuseum, Rijksprentenkabinet.
22b Wallerant Vaillant after Caspar Netscher, *Portrait of
 Abraham van Lennep (1627-1678)*, c.1675-1676. Mezzotint,
 41.3 x 34.5 cm. Berlin, Kupferstichkabinett der Staatliche
 Museen zu Berlin (photograph: Jörg P. Anders).
22c Jan de Bisschop after Jacques de Gheyn III, *'Homerus'*,
 1669. Etching, 21.5 x 7.9 cm. From: Jan de Bisschop,
 Signorum Veterum Icones, The Hague 1668-1669, no. 72
 (photograph: Koninklijke Bibliotheek, The Hague).

the French. For this reason many of these works are
closer to the late portraits of Nicolaes Maes (1634-1693)
than to those of either Ter Borch or his Hague contem-
poraries.[13] As a rule, Netscher placed his subject in
front of a park-like landscape – often partially hidden
by drapery – containing statuary and/or a fountain,[14]
motifs intended to give the image a deeper meaning.
This portrait type brought the artist fame and fortune;
he had a large circle of patrons, drawn not only from
the courtiers, nobility and haute bourgeoisie of The
Hague, but also from outside the city and even beyond
the borders of the Netherlands itself.[15] Already during
his lifetime, Netscher's studio was manned by his sons
Theodorus (1661-1728) and Constantijn (1668-1723),
who assisted him in the production of his portraits –
not always to great advantage. In order to meet the
large demand use was frequently made of 'ready-made'
canvases with standardised bodies and costumes,
leaving only the face to be filled in.[16]

 The work in the Frits Lugt Collection, however,
is unique in Netscher's oeuvre. It does not follow the
established pattern but shows instead a collector
amongst his prized prints and drawings; he points
authoritatively to the album in front of him, under-
lining his status as owner. His pose is rather formal,
certainly when compared to Rembrandt's etched portrait
of the apothecary and art lover Abraham Francen
(1612-after 1678) of around 1657 (fig. 22a), another
rare seventeenth-century collector's likeness.[17] Unlike
Netscher's painted work, Rembrandt's etching is an
intimate portrait of a good friend and devoted *amateur*,
whom he depicts carefully studying a single sheet.

 The man in Netscher's painting has been identified
thanks to an inscription on a mezzotint after the
original (fig. 22b), discussed in detail below. Abraham
van Lennep (1627-1678), like Frits Lugt himself, was
a passionate collector of works on paper.[18] He owned
'four and thirty albums of prints and drawings, many
of Italian art'.[19] Unfortunately, no inventory or auction
catalogue was ever compiled, meaning the artists in his
collection have remained unknown. Some of the albums
may be depicted in the cabinet on the left, and one lies
open on the table – the drawings appear to be glued
to the pages. On the right-hand page we seen an oval
containing a prophet figure; the subjects of two images

on the left are indiscernible. The three drawings are too imprecise to be attributable, and the same can be said of the red-chalk drawing of Adam and Eve balancing on the edge of the table. The illuminated – fifteenth-century? – manuscript with a miniature on the table at the far left proclaims the collector's interest in medieval art. Van Lennep died at the age of 51, just six years after the completion of the portrait. His collection of works on paper was dispersed only in 1711, when it was sold by his brother and heir, Jan van Lennep, at a public auction. An announcement for the sale indicates that Abraham had acquired a number of his drawings from the famous collection of Thomas Howard (1585-1646), Count of Arundel.[20]

The latter was also the owner of the statue behind the table, known as the 'Arundel Homer'. Decapitated and badly damaged, it is now housed in the Ashmolean Museum in Oxford. It is no longer believed to be the portrait of the Greek poet Homer (c.800-750 BC) but rather of an unknown philosopher. The sculpture has not left England since Arundel acquired it sometime between 1613 and 1615, and no copies or plaster casts are known. It could therefore never have been part of Van Lennep's collection and is included here only to indicate the provenance of his prints and drawings,[21] a provenance that even as late as 1711 was considered a strong selling point.[22]

Netscher undoubtedly copied the 'Homer' from a print published by Jan de Bisschop (1628-1671) in his *Signorum Veterum Icones* (1668-1669; fig. 22c), a handbook of ancient sculpture. The painter owned a copy of the album and had incorporated images from it into at least two previous portraits.[23] De Bisschop based his engraving on a now-lost drawing by Jacques de Gheyn II (1565-1629), executed in England in 1618.[24] The statue was also sketched by none other than Peter Paul Rubens (1577-1640).[25] In the seventeenth century the bust beside it was believed to be a likeness of the Roman literator Seneca (c.5 BC-65 AD), although this designation has now also been abandoned. The inclusion of both portrait head and figure seem to indicate that the collector wished to be seen as a connoisseur of classical antiquity. We may safely assume he requested the artist to include the bust as a Roman 'counterpart' to the statue, then thought to be a portrait of the Greek poet Homer. Many reproductions were in circulation at the time and a similar example, known from casts and copied by, among others, the above-

mentioned De Gheyn (Rotterdam, Museum Boijmans Van Beuningen), was in the collection of the painter Rubens.[26]

Wallerant Vaillant (1623-1677), who between 1675 and 1677 resided across from the collector on Fluwelenburgwal in Amsterdam, engraved the portrait while Abraham van Lennep was still alive.[27] Oddly enough, the statue of the Greek poet is not included in his otherwise faithful mezzotint. The reason for this remains a mystery, although one might speculate that it was omitted because it was not actually part of Van Lennep's collection.[28] The undated print never appeared in a commercial edition, probably due to Vaillant's death in 1677. No inscribed versions are therefore known, although there are several proofs, two of which are annotated. Thanks to the examples in Berlin (fig. 22b) and Lille – the former with the explication: 'DE HEER AARNOUT [sic] VAN LENNEP / Vermaard Liefhebber der Konst and Weetenschappen. / *TE AMSTERDAM*.' – the Netscher portrait could be linked to Van Lennep, although a definitive identification only became possible in 1975 as a result of new information regarding its provenance.[29]

It is no surprise that Netscher was one of the most popular portraitists of his time. He was highly respected for his refined use of colour, but above all for his inimitable technique, particularly in the reproduction of different fabrics and textures. In the Lugt painting the sitter's silk-trimmed robe has been recreated with almost invisible brushstrokes, and the woolly Persian carpet is also extremely convincing. It is not true, however, that there are no traces of the brush stroke at all, as some of Netscher's early admirers would have us believe:[30] indeed, the curtain is executed with relatively broad strokes, particularly in the illuminated areas, while the style of the carpet is reminiscent of the painter's teacher, Ter Borch.[31]

Netscher's portrait of Abraham van Lennep was acquired with the support of the Rembrandt Society in 1976, six years after the death of Frits Lugt, who, besides some portrait miniatures had no other paintings by the so-called *Feinmaler* in his collection. He did, however, own a number of drawings by Netscher and other artists associated with the group.[32] The French museums to whom the work was also offered declined, believing the Lugt Collection was the best place for this unique picture.[33] The acquisition, a rare Golden Age portrait of a collector among his treasures,[34] demonstrates that even after Lugt's death paintings were occasionally still purchased.[35] *QB*

Isaak van Nickele

(?) Haarlem c.1633-1703 Haarlem

23 *Interior of the Church of St Bavo in Haarlem, seen from the Christmas Chapel, 1670*

Panel, 46 x 30.2 cm / Signed and dated on the pier at right: *JAN[S?]*; below: *1670*; below: *J:v:Nickele.* / Acquired in 1958

Provenance

Jean-Baptiste-Pierre Lebrun (1748-1813), Paris (sale Paris, Lebrun, 15 April 1811 and following days, lot 205, sold on 20 April for 250 *francs*);[1] Edward Speelman (1910-1994), art dealer, London; Frits Lugt, Paris, purchased from Speelman on 14 July 1958;[2] inv. no. 7161

Exhibitions

Nice 1982, no. 135; Paris 1983, no. 57; Rotterdam 1991, no. 57

Literature

Van Gelder 1964, p. 24; Liedtke 1982, p. 74 note 71; P. Provoyeur in Nice 1982, p. 135, no. 135 (ill.); S. Nihom-Nijstad in Paris 1983, pp. 94-95, no. 57 and fig. 56; Hecht 1984, p. 357; Biesboer 1985, p. 106 and p. 98, fig. 61; G. Jansen in Rotterdam 1991, pp. 268-270, no. 57 (ill.)

In all probability, Isaak van Nickele(n) was born around 1633 in Haarlem. He is first recorded there in 1654, and on 7 October 1659 he registered with the Guild of St Luke.[3] His son, Jan (1656-1721) – whom we know for certain was born in the town – was also active as a painter, albeit after 1712 for the most part in Germany.[4] The elder Van Nickele had hoped to earn his living with more than painting: in 1678 he established a silk manufactory, but its lack of success and the ensuing financial difficulties resulted in his being declared bankrupt.

Van Nickele, who died in 1703, was among the last generation of seventeenth-century Dutch architectural painters. He worked in the style of the brothers Gerrit (1638-1698) and Job (1630-1693) Berckheyde, and of Pieter Saenredam (1597-1665), who played the most important and influential role in his art. Nonetheless, it is probably inaccurate to describe him as the latter's pupil.[5] It is possible, however, that the two painters worked closely together, as it appears Van Nickele may have been responsible for some of the figures in Saenredam's *Interior of the Church of St Catherine in*

Utrecht (Warwickshire, Upton House), completed between 1655-1660.[6] Like Saenredam, Van Nickele also painted numerous views of the interior of the Haarlem Church of St Bavo (see cat. no. 28), the monumental medieval church depicted in the work described here and the place where both artists would eventually be buried – Saenredam in 1665, Van Nickele in 1703. In addition to his views of the Church of St Bavo, the latter painted topographical scenes of Amsterdam (with figures executed by other artists) and even the occasional interior of the city's New Church.

The signed and dated painting in the Frits Lugt Collection is an important work in the documentation of Van Nickele's oeuvre.[7] Most of his other dated pictures are found around 1690 and later,[8] whereas this one bears the year 1670. It is Van Nickele's earliest image of the Church of St Bavo. Only one other dated painting, a 1668 interior of a more or less imaginary Catholic church, partially based on Antwerp cathedral and now in the Fitzwilliam Museum in Cambridge,[9] can be assigned to this period. In comparison with the

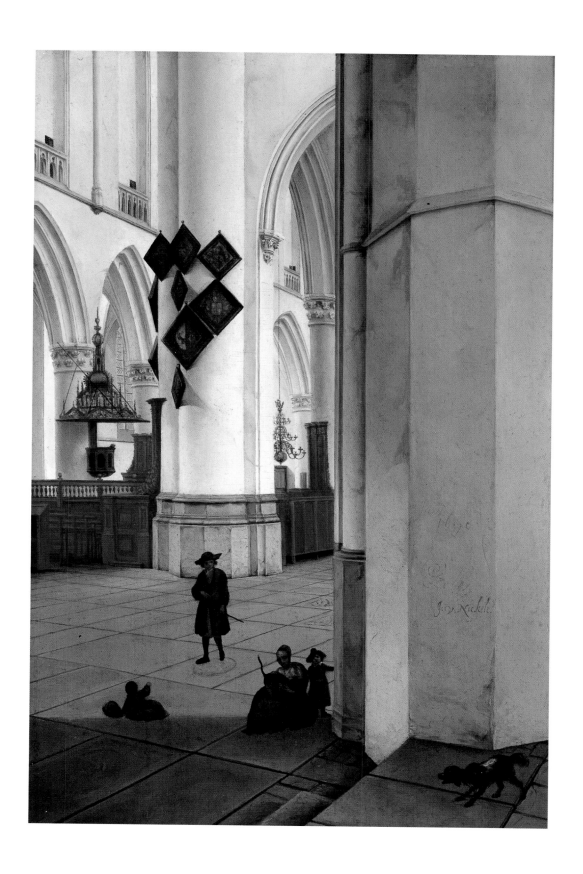

23a

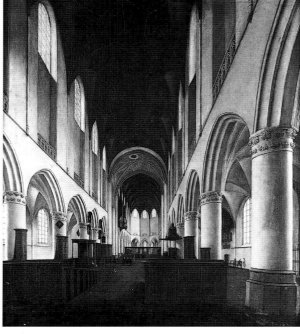

23b

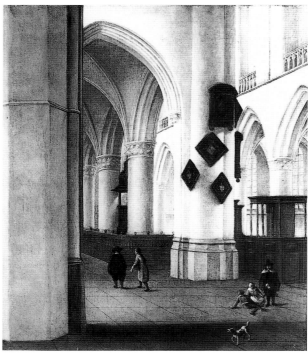

23c

23a After Isaak van Nickele, *Interior of the Church of St Bavo in Haarlem, seen from the Christmas Chapel*, eighteenth century. Pen and watercolour, 46.5 x 33.5 cm. Konstanz, Städtische Wessenberg-Gemäldegalerie (acquired in 1907).

23b Isaak van Nickele, *Interior of the Church of St Bavo in Haarlem, looking towards the choir*, c.1675-1700. Canvas, 158.5 x 139 cm. Copenhagen, Statens Museum for Kunst.

23c Isaak van Nickele, *Interior of the Church of St Bavo in Haarlem, seen from the Brewers' Chapel*, c.1670. Canvas, 41 x 35.5 cm. Present whereabouts unknown (photograph: RKD, The Hague).

artist's other works, the monumental composition here is striking: the painting is dominated by the large pier at the right, which acts as a repoussoir device. Information on the dimensions given in an auction catalogue of 1811 indicates that the picture was subsequently cut down on the right-hand side, so that its impact must once have been even greater. A good impression of the painting's original appearance can be gleaned from a full-size drawn copy made by an anonymous artist in the eighteenth century (fig. 23a). It shows that a portion of the adjoining wall was once visible as well.[10] The pier itself, which occupies not less than one third of the composition, overlaps the other elements of the interior, creating a strong perspectival effect that is further underlined by the contrast between the shadowy foreground and the brightly lit nave behind, as well as by the rather small staffage figures, consisting of a man, a woman and two children. The artist may thus have sought to give his work a symbolic dimension as well, opposing the impressive, solid church – with its centrally placed memorial plaques – and the tiny, fragile figures to remind the viewer of the transience of earthly life.[11] The addition of the animals, on the other hand, gives the work a lighter, more narrative note. A dog is shown barking at a cat in the woman's lap, with the animosity between the two further emphasised by the cat's raised tail. This scene appears to be unique in Van Nickele's oeuvre: ten or more interiors of the Church of St Bavo by him include one or even several dogs,[12] but this seems to be the only cat.

The picture is also one of the few in which Van Nickele deviated from his usual practice of depicting the whole length of the church (fig. 23b),[13] choosing instead to show one of the piers in close up while simultaneously allowing the spectator a glance into the nave. In another, undated, interior of the Church of St Bavo – one not previously linked with the work in question – Van Nickele chose a similar point of view, namely from the Brewers' Chapel just opposite, with a large pier dominating on the left (fig. 23c).[14] The artist generally avoided such complicated compositional schemes, embroidering instead on the tradition established by Saenredam. The painting in the Lugt Collection, which is comparatively fresh and imaginative, may perhaps be seen as an attempt to innovate within the genre. In any case, it leads one to believe that Van Nickele possessed more vision and

originality than art historians have previously thought,[15] although it remains unclear to what extent the composition – still reminiscent of Saenredam and Job Berckheyde in both atmosphere and design[16] – is the artist's own invention. Incidentally, as demonstrated by two church interiors dated 1694 and 1698, respectively, Van Nickele employed a similar compositional scheme even years later.[17]

Frits Lugt, a 'gentleman-dealer' who had bought and sold a large number of such architectural pieces himself, acquired this church interior in 1958 from the famous London-based dealer Edward Speelman (1910-1994).[18] It was not known at the time that the picture had once been part of the collection of the well-known Paris painter and art dealer Jean-Baptiste-Pierre Lebrun (1748-1813), who in 1779 had also been the owner of the Willem Kalf now in the Lugt Collection (cat. no. 16).[19] Lugt had already purchased a somewhat larger interior of the Church of St Bavo seen from the Christmas Chapel by Pieter Saenredam (1636) in 1919 (cat. no. 28). Whereas Saenredam literally frames the space with one of the arches of the ribbed vault and two piers, Van Nickele has changed the point of view in such a way that the viewer looks past one of the chapel piers and through the transept into the nave. The pews and the memorial plaques, with their striking lozenge shape and black frames, together with the carved capitals and other wooden furnishings, are the only decorative elements in this otherwise extremely austere interior. The way the artist has rendered the various colour nuances on the damaged and apparently damp pier in the foreground is particularly handsome. Like Saenredam, Van Nickele bathes the interior in an even, diffuse light, which clearly defines the forms without creating sharp contrasts. The atmosphere and staffage, too, are reminiscent of Saenredam. The pulpit, with its extraordinary baldachin, serves as a reminder that the church was no longer used for Catholic services but instead by the Protestant community.[20] The white walls and vaults – the painted decoration was either removed or covered up during the Reformation – are of course among the most conspicuous and typical characteristics of the seventeenth-century Dutch church interior. It is all the more striking, then, that Van Nickele depicts the almost illegible date as if it had been scratched into the pier, while the signature recalls the graffiti other detail-loving artists often added to their own church views. *QB*

Pieter Post

Haarlem 1608-1669 The Hague

24 *View of the bleaching fields near Haarlem*, 1631

Panel, 43.7 x 61.5 cm / Signed and dated at lower right: *P.I. Post. / 1631.* / Acquired in 1950

Provenance
Martin B. Asscher (1904-1983), art dealer, London; Frits Lugt, The Hague and Paris, purchased from Asscher on 20 January 1950;[1] temporarily on loan to the Mauritshuis, The Hague, 1956-1960;[2] inv. no. 6331

Exhibitions
The Hague 1953, no. 9; Paris 1983, no. 63

Literature
Gudlaugsson 1954, pp. 59-60, 62 and fig. 5; De Vries 1958, p. 68, no. 931; De Vries 1960, p. 68, no. 931; Plietzsch 1960, p. 114; Larsen 1962, pp. 49, 94, 131-132, 133, 135, 154, 220 note 136; Stechow 1966, pp. 38, 169; Bol 1969, pp. 148, 369 note 202; De Sousa-Leão 1973, pp. 23-24, 42, 43 note 3; Reitsma 1976, p. 253 and fig. 3; E. Bergvelt in Amsterdam 1978, p. 147 and fig. 19; S. Nihom-Nijstad in Paris 1983, pp. 104-105, no. 63 and fig. 15; Kingzett 1983, p. 503; Haak 1984, p. 260 and fig. 550; Broos 1987, pp. 262, 264 and fig. 2; A. Chong in Amsterdam-Boston-Philadelphia 1987-1988, p. 416 note 4, p. 519 and fig. 2; Terwen-Ottenheym 1993, p. 246; Van Zoest 1994, p. 5 (ill.)

Although Pieter Post became known as an architect of classicist buildings,[3] he started life as a painter, a far from uncommon trajectory at the time. Since arithmetic and geometry were compulsory subjects for student painters, their training was also apt preparation for a career in architecture. Other prominent architects of the day who started out as painters include Salomon de Bray (1597-1664) and most notably Jacob van Campen (1596-1657), who was a major influence on the young architect Post in the 1630s.[4] About a dozen paintings by Post are known today, and of these only a few are signed and dated.[5] This subtly painted *View of the bleaching fields near Haarlem*, which is signed in full and dated 1631, marks a high point in Post's tiny oeuvre. This is the earliest known date for the artist.[6] His other work dating from this period includes four combat scenes, two of which were also completed in 1631,[7] three imaginary landscapes with ruins,[8] and three dune landscapes, which will be discussed below. The last digit of the year in the *Dune landscape with haystack* in the Mauritshuis is now illegible (fig. 24a), although

this panel, dated '163.', is assumed to have been made before Post's involvement, in 1633, in the building of the monumental mansion of Johan Maurits, Count of Nassau-Siegen (see below), which is now used as a museum.[9] Around 1630 Post probably added the figures to a painting by Pieter Saenredam (p. 34, fig. 22); the two painters both joined Haarlem painters' guild in 1623, and their collaboration may have been more than incidental.[10] Post would also sometimes make paintings attuned to their designated surroundings. Thus in 1637-1638, he and Albert de Valck (active c.1636-1646) painted two illusionist pieces of scenery for the theatre designed by Van Campen on Amsterdam's Keizersgracht.[11] More ambitious is the history piece from 1655 in which the figures were painted by Caesar van Everdingen (c.1617-1678), with Post providing the architecture.[12]

The painting shown here depicts the picturesque area of the Haarlem dunes, with a few farmhouses on a sandy path. Linen is being bleached on the fields at left. The preparation of cloth was a complicated business in

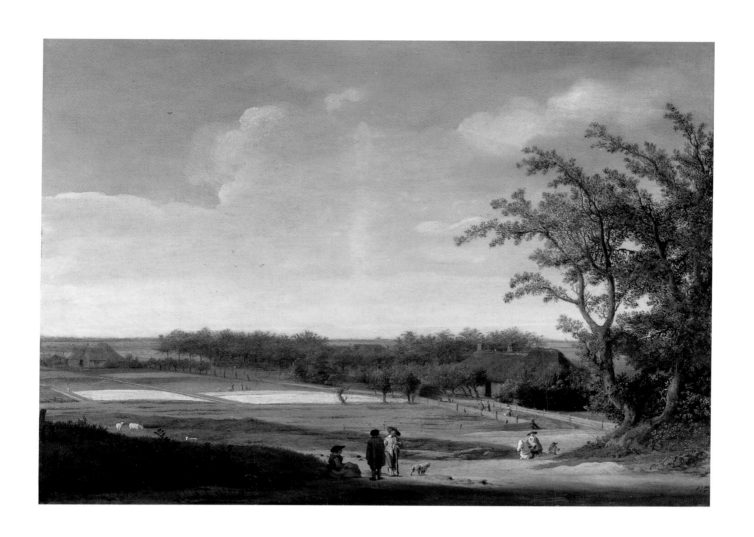

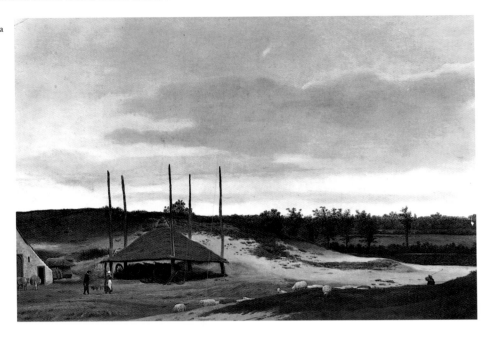

24a

138

24b

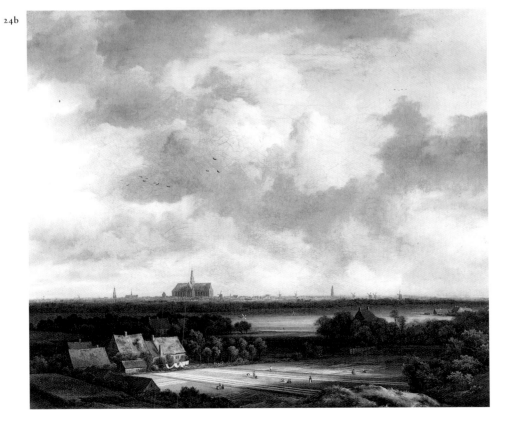

24a
Pieter Post,
*Dune landscape
with haystack*, in or
before 1633.
Panel, 53.3 x 79.5 cm.
The Hague, Royal
Cabinet of Paintings
Mauritshuis
(acquired in 1975).

24b
Jacob van Ruisdael,
*View of Haarlem with
bleaching fields*,
c.1670-1675. Canvas,
55.5 x 62 cm.
The Hague, Royal
Cabinet of Paintings
Mauritshuis
(acquired in 1827).

the seventeenth century: materials that had been imported or woven locally would be washed, rinsed, and then dried on the grass, after which they would be treated with lye and laid back on the grass for about a week to be bleached by the sun before undergoing further processing.[13] Linen weaving was one of the two main industries in Haarlem, Post's native town, the other being brewing.

The scene is enlivened by only a handful of figures, including a seated woman in the foreground and two men engaged in conversation. Their presence adds to the rural atmosphere. The horseman riding up on a white horse from the right is cut off strikingly by a rise in the road and hence contributes to the effect of depth in the painting, more than half of which is full of the cloudy skies that are so characteristic of Dutch landscapes. While the figures in the foreground are talking and riding, others are hard at work: a woman on the path at right is carrying two buckets on a yoke resting on her shoulders, while the women in the fields are busy laying out the long strips of linen to be dried or bleached by the sun. These bleaching fields were a favourite motif of Jacob van Ruisdael (1628/29-1682) who produced ten views of Haarlem in which the strips of cloth constitute light accents in the landscape.[14] In his *View of Haarlem with bleaching fields*, made about forty years after Post's painting, we see the contours of the dunes depicted in the foreground (fig. 24b).[15] We also see the city's skyline, in which the most important buildings are recognisable, in particular the towering church of St Bavo (cf. cat. no. 28). Post, on the other hand, has not included any identifiable buildings or other elements that could help to establish the location.

The picture exemplifies Post's original, if modest, contribution to Dutch landscape painting.[16] It was in Haarlem that the seeds were sown for the flourishing of this genre, to which the painter and art theorist Karel van Mander (1548-1606) devoted a whole chapter of his *Schilderboeck* in 1604. He urged aspiring painters to immerse themselves in the beauty of the Dutch landscape and wrote two long poems about the city of Haarlem and its delightful surroundings.[17] The drawings that Hendrick Goltzius (1558-1617) made of the dunes near Haarlem around 1600 are among the earliest renderings of the specifically Dutch landscape with its beaches, lakes and windmills beneath lofty skies. In this regard Goltzius's realistic panorama from 1603 in the Frits Lugt Collection (fig. 24c)[18] bears

an unmistakable resemblance to the scene from 1631 described here.[19]

Stylistic similarities with the painting in the Lugt Collection and the similar scene in The Hague enable us to attribute two other dune landscapes to Post: *Landscape with horsemen on a sandy path* (Copenhagen, Statens Museum for Kunst), probably dating from before 1630, and *Vista from the dunes of Haarlem* (fig. 24d), which was probably completed shortly before or after the painting shown here.[20] Characteristic of these landscapes are the clump of trees serving as repoussoir, the painter's fairly high viewpoint, and the grand panorama. The marked rise in the foreground of this painting is a motif that recurs in the piece in The Hague, which is from the same period.

Little is known about Post's training as a painter.[21] It may be unduly optimistic to assume that he received his first drawing lessons from his father, Leiden's glass engraver or stained-glass artist Jan Jansz Post (c.1575-1614),[22] who died when Pieter was only six years of age. It is unclear to what extent the Hague painter Anthoni Goe(l)terus (1574-c.1662), who appears to have helped Post's widow raise her children, played a role in the training of Post, who joined the Guild of St Luke in Haarlem in 1623.[23] In 1628 Post is mentioned as a local painter in Samuel Ampzing's description of Haarlem and in 1634 the Guild's register lists him as a 'master painter'.[24] The style and choice of subject-matter in Post's oeuvre suggest that he was previously apprenticed to a Haarlem painter. The four fighting scenes, none of which depicts a historical event, recall those of Esaias van de Velde (1587-1630), who had also reinvigorated the tradition of the painted landscape.[25] Post probably absorbed the influence of Van de Velde, who had moved from Haarlem to The Hague in 1618, through other Haarlem painters working in his style, such as Cornelis Vroom (1590/91-1661) and Pieter de Molijn (1595-1661).[26] One of these two may well have been Post's teacher.[27] In the tonal dune landscapes of De Molijn from 1626 and later, weather conditions play a major role and the use of colour has been kept to a minimum.[28] To a somewhat lesser degree the same features characterise this dune landscape by Post, in which besides the largely cloud-covered blue sky only the clothes of the figures in the foreground add colour accents to the landscape, which is otherwise dominated by green, brown and yellow hues. Post blends the diverse hues with great subtlety, producing

24c

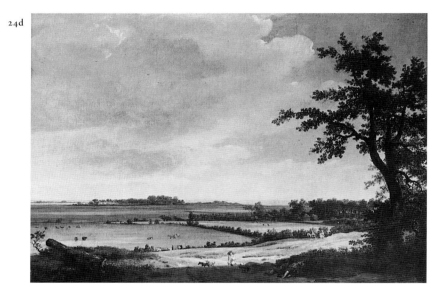

24d

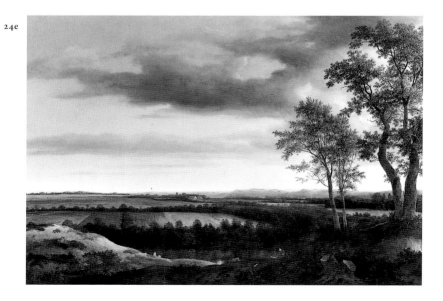

24e

24c
Hendrick Goltzius, *Panorama*, 1603.
Pen and brown ink, 7.8 x 19.7 cm.
Paris, Frits Lugt Collection
(acquired in 1926).

24d
Pieter Post, *Vista from the dunes of
Haarlem*, c.1631. Canvas, 74.5 x 99 cm.
Private collection.

24e
Cornelis Vroom, *View of the Haarlem
dunes*, c.1635-1640? Panel, 73 x 105 cm.
Heino, Hannema-de Stuers Fundatie
(acquired in 1934).

a remarkably harmonious result. Yet this painting also displays a perceptible affinity to the work of the somewhat older Cornelis Vroom, it being unclear whether one painter influenced the other or both were treading in the footsteps of Van de Velde. The low horizon uninterrupted by vertical obstacles and the expansive panorama with a clump of trees as repoussoir are in any case related to a dune landscape, which must be dated later, by Vroom in Heino (fig. 24e), which also has a figure that is cut in half by the foreground (cf. also fig. 24d).[29] A painter who was certainly influenced by the work of Pieter Post is his younger brother Frans Post (c.1612-1680), to whom the paintings of the later architect were sometimes attributed in the past.[30] Pieter introduced Frans to Johan Maurits, Count of Nassau-Siegen (1604-1679), for whom he acted as overseer in the building of his Hague mansion, designed by Jacob van Campen. Together with Albert Eckhout (c.1610-c.1666) Frans Post would spend the years 1637 to 1644 in Brazil in the retinue of Johan Maurits, governor-general of the then Dutch colony. The composition of the seven extant Brazilian landscapes that Frans produced

there, in each of which the horizon is virtually a straight line, bears many similarities to his elder brother's landscapes, especially to the piece in the Mauritshuis.[31] The work of both brothers is striking for its uncontrived response to the natural scenery and for its sober and atmospheric representation of it.

This *View of the bleaching fields near Haarlem* was purchased by Frits Lugt from an art dealer in London in 1950 and presented to the public at an exhibition about Johan Maurits in the Mauritshuis in 1953.[32] The painting was then loaned to the Hague museum, which was eager to exhibit a representative landscape by Post, from 1956 until the end of 1960.[33] The gap in the Mauritshuis collection was finally consigned to the past in 1975, with the purchase of the *Dune landscape with haystack* depicted here, which had also previously hung in the museum on loan from a private individual.[34] In 1979, after Lugt's death, the Fondation Custodia acquired three letters from Post about his work for Constantijn Huygens and Stadholder Frederik Hendrik.[35] *QB*

Paulus Potter

Enkhuizen 1625-1654 Amsterdam

25 *Landscape with cattle and milkmaid*, 1643

Panel, 35.8 x 49.7 cm / Signed and dated at lower left: *Paùlùs.Potter.f.@.i643.* / Acquired in 1948

Provenance
Klaas van Winkel, Rotterdam (sale Rotterdam, Holsteyn, 20-21 October 1791, lot 1, for 600 guilders to Waesbergen);[1] Henry R. Willet, Canford near Wimborne, Dorset, 1847 (subsequently the property of his heirs, until *c*.1945);[2] Frank T. Sabin, art dealer, London, 1948;[3] Frits Lugt, Paris, purchased for 1,500 pounds from Sidney F. Sabin on 8 March 1948;[4] on loan to the Mauritshuis, The Hague, 1948;[5] inv. no. 5982

Exhibitions
London 1847, no. 110; Paris 1960a, no. 147; Paris 1983, no. 65; The Hague 1994-1995, no. 3

Literature
Hennus 1950, fig. p. 110; F. Lugt in Paris 1960a, p. 29, no. 147; S. Nihom-Nijstad in Paris 1983, pp. 108-109, no. 65 and fig. 31; Walsh 1985, pp. 137-138, 146, 473, no. B 14; C.J. de Bruyn Kops in Amsterdam-Boston-Philadelphia 1987-1988, pp. 421, 422 note 7; G. Jansen in Dordrecht-Leeuwarden 1988-1989, p. 165; E. Buijsen in The Hague 1994-1995, pp. 62-63, no. 3 (ill.), pp. 68, 84; A. Walsh in *idem*, p. 24; Brown 1995, p. 266; A. Walsh in *The Dictionary of Art*, vol. 25 (1996), p. 369; A. Walsh in Turner 2000, p. 257; A. Rüger in New York-London 2001, p. 335

Paulus Potter, whose earliest dated painting is from 1641,[6] received his first lessons from his father Pieter Potter (*c*.1597/1600-1652),[7] a painter who practised a variety of genres.[8] Through his father's acquaintances, Paulus grew up in a culturally sophisticated world. He reached artistic maturity quite young in Amsterdam, soon outstripping his father. Other artists who manifestly influenced his early work besides his father include Claes Moeyaert (1590/91-1655),[9] who may have been his second teacher. In 1642 a 'P. Potter' – probably Paulus – is recorded as a pupil of the Haarlem history painter Jacob de Wet the Elder (*c*.1610-1675). In 1646 Potter registered with the Guild of St Luke in Delft. His marriage to Adriana van Balckeneynde in 1650 introduced him to fashionable Hague circles.[10] Potter's known work from the period 1641-1644 comprises several paintings with biblical subjects and a few pastoral scenes (see fig. 25b).[11]

This painting, signed in full and dated 1643, is a crucial piece in the oeuvre of the artist, who celebrated his eighteenth birthday that year. For the first time he departed from the theme of historical or pastoral subjects embedded in a southern landscape and depicted a scene from everyday life that is unmistakably set in the Dutch countryside.[12] The eight animals in the foreground are clearly the main subject of the painting, while a view of a meadow with cows is also shown in the background. Careful study of the picture with its atmospheric lighting and restrained palette reveals that unlike *Cattle by a fence* from 1644 (Kassel, Staatliche Museen, Gemäldegalerie Alte Meister) this is not a pure animal piece.[13] Partly concealed behind the massive body of the standing cow is the figure of a milkmaid, who is hard at work.[14] She catches the milk in the bucket clasped between her knees. The cow's rear legs have been tied together to prevent it from making sudden movements. The viewer's attention is partly distracted from this activity by the two little kids playing on and around their mother and the cow lying behind the woman. Potter had initially portrayed part of her face, but he later painted it out again: in our own times the vague contours of an ear have become

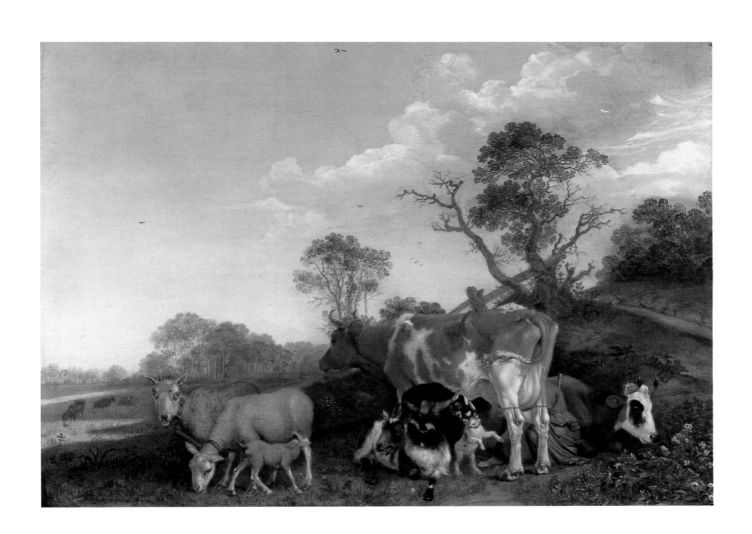

25a

25b

25c

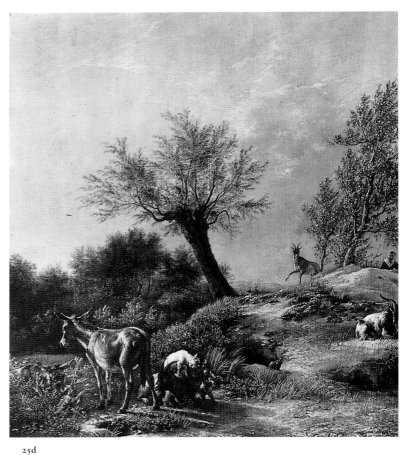

25d

25a Paulus Potter, *River landscape with cattle*, 1642. Panel, 66 x 114.5 cm. Private collection (photograph: Mauritshuis, The Hague).

25b Paulus Potter, *Landscape with a shepherdess and fluting shepherd*, c.1642-1643. Panel, 67 x 114.5 cm. Budapest, Szépmüvészeti Múzeum (acquired in 1951).

25c Paulus Potter, *The herd*, 1643. Etching (second state), 18 x 26.5 cm. Amsterdam, Rijksmuseum, Rijksprentenkabinet.

25d Paulus Potter, *Landscape with donkeys and goats ('The rabbit-hole')*, 1647. Panel, 39.5 x 36 cm. Private collection (photograph: RKD, The Hague).

visible again through the tail of the standing cow, and other *pentimenti* too are discernible, in the clump of trees behind the woman, for instance, and near the right ear of the sheep at far left.

Comparison with a painting that Potter completed only twelve months earlier (fig. 25a),[15] shows the young artist's rapid development. While in 1642 he still had

difficulty achieving the faithful rendering of cattle, a year later he had mastered the convincing representation of a variety of farm animals – cows, sheep, goats and a little lamb – conveying both their build and their different coats to perfection. A few years later, Potter would complete one of his greatest and best-known paintings, *The bull* from 1647 (The Hague, Maurits-

huis).[16] The painting discussed here has the relatively small size associated with 'cabinet pieces', small panels that make up the largest part of Potter's oeuvre.

It will be clear that Potter studied the animals in their natural surroundings. Nicolaes van Reenen, a son of Potter's widow from her second marriage, wrote in a letter to the painters' biographer Arnold Houbraken (1660-1719) that Potter was accustomed to drawing in the countryside.[17] There he will have derived inspiration for the two sheep at left, yoked together as a restraint.[18] Details of this kind, together with the contemporary dress of the barefoot milkmaid and the cow's bound feet, will have greatly enhanced the scene's realism to seventeenth-century viewers.[19] No sketch or preliminary study has been found for this painting, but the fact that certain motifs recur in other works by Potter shows that they were based on studies from life. For instance, Potter depicted the standing cow also in a landscape in Budapest that can be dated earlier than this one (fig. 25b)[20] and repeated it in an etching completed in 1643, the same year as the painting described here (fig. 25c),[21] although the etched variant turned out rather more angular and is not swishing its tail. Potter would repeat the motif of the little goats playing around their mother years later in a landscape from 1647 (fig. 25d),[22] again making some minor changes, this time in the animals' coats. The frequent repetition of certain pictorial motifs is a characteristic feature of Potter's oeuvre. In this scene too he therefore probably combined a number of his own studies of animals observed in the meadows into a lifelike and lively scene that can never have existed as such in reality. For the playful kids are remarkably close to the milking cow, and the cow lying behind scarcely leaves any space for the milkmaid to get on with her work.

Potter's acute powers of observation are evident not only from the detailed image of the cattle, the fur of the animals' coat making a highly realistic impression, but also from his rendering of the landscape itself. Whereas in the painting in Budapest from about 1642-1643 the vegetation is so profuse as to constitute a dominant motif (fig. 25b), here the plant growth is less conspicuous. The plant life in the right

foreground is rendered down to its diminutive occupants, including a butterfly (on the red flower) and a frog (in the immediate foreground). The adjacent landscape in the background, on the other hand, is indicated only cursorily and painted in near-monochrome brownish hues. The painting's composition, in which the hillock with trees and bushes at right and the way it is positioned are characteristic of Potter's early work,[23] is built up according to a scheme he often used, with the transition between foreground and background forming a diagonal line.

The different positions of the animals recall the prints of Pieter van Laer (1599-after 1642), whose cattle series from 1636 greatly influenced the young Potter.[24] As in Van Laer's cattle, the direction of the animals' gaze plays an important role: the viewer is drawn into the picture, as it were, by the eyes of the standing sheep at left and the recumbent cow at right, and also meets the gaze of the playing kid.

From 1644 onwards Potter would focus all his energy on cattle pieces: landscapes with cows, horses and other farm animals, including a few rare 'portraits' of individual animals. In 1652 the prolific artist settled in Amsterdam, where he died in 1654 at only 29 years of age. Potter was an innovative and very influential artist, who left behind a large oeuvre in spite of his premature death. Karel du Jardin (cat. no. 15) and Adriaen van de Velde (cat. no. 32) were clearly influenced by him, as were many generations of painters of cattle pieces well into the nineteenth century. In the introduction to the exhibition catalogue *Bestiaire hollandais* (Paris, Institut Néerlandais, 1960) – which included this painting – Frits Lugt praised Potter, along with Nicolaes Berchem (cat. no. 4), Van de Velde and Melchior d'Hondecoeter (1636-1695), as the best animal painters in seventeenth-century Dutch painting.[25] Besides this work, Lugt also acquired several drawings by the artist.[26] It is not known whether Potter intended his painting to convey a deeper meaning. It is fair to assume, however, that prosperous town-dwellers would have interpreted this predominantly idyllic scene as an image of the 'unspoiled' life of the countryside,[27] much as their descendants do today. *QB*

Jan van Ravesteyn

(?) *c.*1572-1657 The Hague

26 *Portrait of Hugo Grotius (1583-1645) aged 16, 1599*

Panel (circular), diameter 31 cm / Signed and dated at left: *Jo: a. Ravesteÿn Pinxit. An°. 1599*; at right the inscription: *Æta. meæ. 16*; below: *Hugo de Groot.* / Acquired in 1918

Provenance

Dr Eckhard;[1] Moritz Julius Binder (1877-in or after 1933), Berlin, seen there by Lugt in 1917; Frits Lugt, Maartensdijk and Paris, acquired with three other paintings from the Binder Collection on 2 March 1918 (see below); inv. no. 175

Exhibitions

The Hague 1925, no. 12; The Hague 1936-1937, no. 159; The Hague 1946, no. 44; London 1964, no. 55; Paris 1965b, no. 223; Amsterdam 1975, no. A 129; Utrecht 1979, unnumbered [pp. 164-165]; Paris 1983, no. 67; Delft 1983, unnumbered [p. 44]; Amsterdam 1993-1994, no. 54; Paris 2000, no. 22

Literature

Archiv für Kunstgeschichte 2 (1914), fig. 79; Ter Meulen 1925, frontispiece; Van Beresteyn 1925, column 189, fig. beside column 17; Van Beresteyn 1929, p. 30, no. C, p. 44, no. 2, fig. 4; Stechow 1929-1930, p. 206; H. Gerson in Thieme-Becker, vol. 28 (1934), p. 53; Van Thienen 1937, p. 68, ill.; Hennus 1950, fig. p. 105; Slive 1961, pp. 173-174, fig. 4; Berendsen 1962, fig. 28; Renckens 1962a, pp. 64-65, fig. 4; Sutton 1964, p. 348, fig. 3; Reitsma 1976, pp. 254, 256, fig. 14; Schapelhouman 1979, p. 55 (in no. 28) note 6; Eyffinger 1980, p. 138; Van Thiel 1980, p. 115 note 4; Eyffinger 1981, cover ill. and facing p. 1; S. Nihom-Nijstad in Paris 1983, pp. 110-112, no. 67 and fig. 59; Charensol 1983, fig. p. 431; Dauriac 1983, p. 279; Kingzett 1983, p. 503; Schlumberger 1983, fig. p. 51; Ekkart 1991, pp. 9 (fig. 5), 10; Lademacher 1993, fig. 26d; W.T. Kloek in Amsterdam 1993-1994, p. 31; A. van Suchtelen in *idem*, pp. 399-400, no. 54 and fig. p. 249; Van Berkel 1994, ill.; F. van Kretschmar in Paris 1994, p. 260; R.E.O. Ekkart in *The Dictionary of Art*, vol. 26 (1996), p. 37; R.E.O. Ekkart in Buijsen *et al.* 1998, p. 230, fig. 1; H. Miedema in Van Mander ed. 1994-1999, vol. 6 (1999), p. 123; Arian 1999, fig. p. 29; R.E.O. Ekkart in Turner 2000, p. 265; Becker 2002, pp. 54-55, 57

Jan van Ravesteyn registered with the Guild of St Luke in The Hague on 17 February 1598, together with his younger brother Anthony (*c.*1580-1669), and he spent his entire life working in the city.[2] In 1604 Karel van Mander described Jan van Ravesteyn in his *Schilder-boeck* as 'a very fine painter / and portraitist ... with a beautiful and accomplished technique'.[3] For decades he was the leading portrait painter in The Hague. As far as is known, Van Ravesteyn never depicted other subjects. His main commissions include a series of 25 officers' portraits from the years 1611-1624 (The Hague, Mauritshuis), probably made for Prince Maurits (1567-1625),[4] and five portraits of members of the civic guard, the earliest of which was made in 1612 and the last is dated 1638. Dated portraits exist up to and including 1641, after which Van Ravesteyn, by then advanced in years, probably laid his brush down for good. Foremost among his pupils was Adriaen Hanneman (1604-1671), portraitist of the city's next generation of prominent citizens. He married Maria van Ravesteyn, the painter's daughter, in 1640.

Van Ravesteyn's brother Anthony and the latter's son Arnold (*c.*1605-1690) also worked as painters in The Hague, but not exclusively as portraitists.

This portrait of Hugo Grotius – in the Netherlands better known as Hugo de Groot – is the earliest dated work by Jan van Ravesteyn and is something of a special case, not only within his oeuvre but in the northern Netherlandish painting of this period in general. Both the circular shape of the panel (known as a *tondo*) and the rendering of the sitter are unusual.[5] Only the head and shoulders are depicted, and the subject is depicted leaning backwards slightly and at very close range, against a dark background. The strong chiaroscuro make the head and collar stand out sharply, and the effect of plasticity is enhanced by the close-fitting frame. The shape and circumferential inscription are reminiscent of portrait medallions or miniatures. The strong modelling, on the other hand, does not belong to this idiom, and the piercing gaze of the large eyes, directed away from the viewer, rather impart a personal, informal quality.

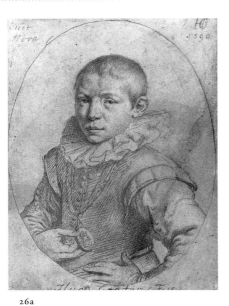

26a

26b

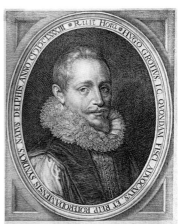

26c

26d

26a Jacques de Gheyn II, *Portrait of Hugo Grotius aged 15*, 1598-1599. Silverpoint on small prepared tablet, yellow, 8.9 x 6.6 cm. Amsterdam, Amsterdams Historisch Museum (acquired in 1860).

26b Jacques de Gheyn II, *Portrait of Hugo Grotius aged 15*, 1599. Engraving, 10.6 x 7.5 cm. Amsterdam, Rijksmuseum, Rijksprentenkabinet.

26c After Jan van Ravesteyn, *Portrait of Hugo Grotius aged 31*, 1614. Engraving, 21.5 x 13.4 cm. Leiden, Prentenkabinet der Rijksuniversiteit.

26d Pieter Pietersz, *Portrait of a man*, 1597. Panel (circular), diameter *c*.42 cm. The Hague, Royal Cabinet of Paintings Mauritshuis (acquired in 1953).

The portrait dates from the period in which the young Hugo Grotius (1583-1645) settled in The Hague, where he was registered as a lawyer in December 1599, at only sixteen years of age.[6] A year earlier, having completed his studies at Leiden University, the future jurist and ambassador had been attached to a Dutch diplomatic mission to Henry IV of France (1589-1610), after which he was awarded a doctorate in Orléans. His first publication, which appeared in 1599, was an edition of the *Satyricon* by Martianus Capella.

Scholars and administrators alike recognised his enormous potential, and it is not surprising that several portraits of him are known from this early period.[7] Less than a year before Jan van Ravesteyn produced his portrait, a small silverpoint drawing was made by Jacques de Gheyn II (fig. 26a), possibly a preparatory sketch for the print by him that was included in Grotius's edition of the *Satyricon* (fig. 26b).[8] The 'miracle d'Hollande' is holding the medallion that Henry IV had given him at Angers, and the drawing

must therefore have been made after his return from France – probably in May 1598 –[9] but before 10 April 1599, his sixteenth birthday, since the marginal inscription of the print gives his age as fifteen. The artist and his sitter were evidently on terms of friendship, as Grotius had been supplying captions to prints by De Gheyn (1565-1629) since he was thirteen. Nothing is known of the personal relations between Grotius and Van Ravesteyn, although the unconventional nature of this portrait suggests that they were on familiar terms. When Grotius decided to have another portrait made around 1613, the commission again went to Van Ravesteyn. Like De Gheyn's drawn portrait, this far more formal portrait was made into an engraving, and as a result became very well known (fig. 26c).[10]

There is a gap in our reconstruction of Van Ravesteyn's development since there are no dated works between the portrait described here, dated 1599, and 1610. From then on, the painter clearly emulated the Delft portraitists Jacob Willemsz Delff (c.1540/41-1601) and Michiel Jansz van Mierevelt (1567-1641), whose style was chiefly characterised by a down-to-earth rendering of the sitter. Van Ravesteyn would keep to this approach until the end of his career, although many of his portraits are livelier than those of Van Mierevelt.[11] Some scholars have assumed that he must have studied under the latter, partly because the public records in Delft contain several references to him in October 1597.[12] But the early *Portrait of Hugo Grotius aged 16* makes this an implausible supposition.[13] Stylistically speaking, the painting is more akin to portraits by Amsterdam artists from the same period. The schematic mode of painting and the stylisation of certain elements such as eyelids and eyelashes strongly recall the work of the Amsterdam portrait painter Pieter Pietersz (1540/41-1603).[14] The lettering used for the marginal inscription as well as its wording – 'Aetatis meae' instead of 'suae' – also correspond to the inscriptions found on portraits by Pietersz. What is more, Pietersz produced a set of round portraits in 1597, two years earlier than the portrait described here (fig. 26d),[15] leading one scholar to suggest, recently, that Van Ravesteyn may have been trained by this Amsterdam painter.[16]

Also worth exploring is Jan van Ravesteyn's possible influence, at this stage of his career, by 'Mannerist' painters in the circle of Karel van Mander (1548-1606), who were experimenting with new compositions for portraiture.

The *Portrait of Hugo Grotius aged 16* recalls in particular some equally informal portraits by Cornelis Ketel (1548-1616), who like Pietersz worked in Amsterdam, portraits in which the sitter is depicted at very close range, from an unusual angle and sharply cut off by the frame.[17] It can also be compared to certain portraits by the Haarlem painter Cornelis Cornelisz (1562-1638).[18] Unfortunately, no other works dating from this evidently very inspired early period in Van Ravesteyn's career are known.[19] Constantijn Huygens (1596-1687), the well-known poet and secretary to three successive stadholders, who must have known Van Ravesteyn well, relates in his autobiography that the painter himself was aware that his later work could not withstand comparison to the fruits of his youth. According to Huygens, this 'delightful and fresh style of painting' was a consequence of the artist's journey to Italy, although no other source refers to such a trip.[20]

Frits Lugt acquired this handsome portrait in 1918, along with three other paintings (including cat. no. 35), from the Berlin museum director and collector Moritz Julius Binder (1877-in or after 1933), in whose collection he had seen it the previous year.[21] The four paintings from Binder's collection are among the connaisseur's earliest purchases. Lugt greatly admired Hugo Grotius and must have been elated to discover an unknown early portrait of him. Moreover, the sitter's youthfulness will have reminded him of his own boyhood (p. 15, fig. 5).[22] The portrait became the starting point for a small Grotius ensemble in his collection, which, besides a number of early editions, contained a page in the great jurist's handwriting.[23] The unique little portrait occupies a place of its own in Lugt's collection of paintings. In his correspondence with Binder, Lugt described it as nothing more than a historical curiosity, but this was obviously a gambit to lower the asking price for the four paintings.[24] The superb ensembles of drawings that Lugt amassed by Hendrick Goltzius (p. 140, fig. 24c) and above all by Jacques de Gheyn II, show that he was very capable of appreciating the artists of the Mannerist generation at their more naturalistic moments. In 1928 Lugt would purchase another major work by Jan van Ravesteyn, namely his only known drawing, *The Hague magistrate receiving the officers of St Sebastian's militia*, a preliminary study for the large group portrait, dating from 1618, in the Hague Historical Museum.[25] *HB*

Jacob van Ruisdael

Haarlem 1628/29-1682 Amsterdam

27 *Winter landscape, c.1670-1675*

Canvas, 37.3 x 46 cm / Signed lower right: *JVRuisdael* (*JVR* in ligature) / Acquired in 1949

Provenance

(?) Gerrit van der Pot (1732-1807), Heer van Groeneveld;[1] J.J. (van) Allen, Edinburgh;[2] Alexander Dennistoun, Golfhill (sale London, Christie's, 9 June 1894, lot 87,[3] for 385 guineas to Agnew's); Thomas Agnew & Sons, art dealers, London; Charles Sedelmeyer (1837-1925), art dealer, Paris, purchased on 22 June 1895; Adolphe Schloss (1842/43-1910), Paris, purchased on 19 July 1895; his widow, Mathilde Schloss née Hass (1858-1938), Paris; their heirs (sale Paris, Galerie Charpentier, Rheims-Baudoin, 25 May 1949, lot 53, to Lugt);[4] Frits Lugt, The Hague and Paris; inv. no. 6104

Exhibitions

Paris 1895, no. 37; Paris 1950-1951, no. 73; The Hague 1970-1971, no. 90; London 1971, no. 83; The Hague-Cambridge 1981-1982, no. 53; Paris 1983, no. 71; Atlanta 1985, no. 48; The Hague 2001-2002, no. 23

Literature

Smith 1829-1842, vol. 6 (1835), p. 51, no. 164; C. Sedelmeyer in Paris 1895, p. 44, no. 37 (ill.); Hofstede de Groot 1907-1928, vol. 4 (1911), p. 301, no. 1002; Rosenberg 1928, p. 111, no. 622; Simon 1930, p. 58; Hennus 1950, fig. p. 119; Stechow 1966, p. 97 and fig. 192; S. Slive in The Hague-Cambridge 1981-1982, pp. 148-149, no. 53 (ill.); Sutton 1982, pp. 184-185 and fig. VII; Ashton-Slive-Davies 1982, pp. 18, 21 and fig. 16 (detail); S. Nihom-Nijstad in Paris 1983, pp. 117-118, no. 71 and fig. 29; Kingzett 1983, p. 503; F.J. Duparc in Atlanta 1985, pp. 108-109, no. 48 (ill.); Kingzett 1986, p. 21; A. Chong in Amsterdam-Boston-Philadelphia 1987-1988, p. 459 and fig. 1; Le Bihan 1990, p. 337 (under no. 105); Walford 1991, pp. 169-170; Slive 2001, p. 484, no. 686 (ill.); F.J. Duparc in The Hague 2001-2002, pp. 120-121, no. 23 (ill.); P. van der Ploeg in *idem*, p. 68

The work of Jacob van Ruisdael is generally considered one of the highlights of seventeenth-century Dutch landscape painting.[5] In a career spanning less than 40 years Van Ruisdael undertook almost all the themes popular among his contemporaries – with the exception of the Italian landscape – giving them a novel and, in the eyes of posterity, even classical treatment. The artist was probably trained by his father, Isaack van Ruisdael (1599-1677), who was not only a painter but also a picture-framer and art dealer, and perhaps also by his uncle, the landscapist Salomon van Ruysdael (1600/3-1670). We know of dated landscapes by Jacob from as early as 1646, two years before his registration with the Guild of St Luke, depicting such typical northern Netherlandish motifs as dunes and country roads, frequently incorporating topographical elements. Around 1650 a trip to the Dutch-German border region with his friend Nicolaes Berchem (cat. no. 4) supplied him with new subject matter, such as half-timbered houses and watermills. In about 1656 Van Ruisdael moved to Amsterdam, taking in the young Meindert Hobbema (1638-1709), an orphan who was soon to become his most talented pupil and follower.

The winter landscape was one of the themes the artist took up upon settling in Amsterdam, where he also broadened his repertoire to include beach scenes and seascapes, as well as mountain vistas with waterfalls. More than 30 of his winter pictures have survived; none of them, however, are dated.[6] Several, including the work in the Rijksmuseum in Amsterdam (fig. 27a), are peculiarly sombre in tone.[7] The format is modest and the motifs simple: a group of houses with a few trees, frequently set along a road or canal that runs diagonally from the foreground into the distance. Heavy clouds hang threateningly in the sky and the palette is limited to shades of brown and grey, with white used for the snow. Figures play only a minor role. These pictures are generally dated to the 1650s, although one could not have been executed before the end of the decade.[8] Van Ruisdael's work represents a new direction in the Dutch winter landscape, traditionally devoted to the depiction of fun and games on the ice. The artist was

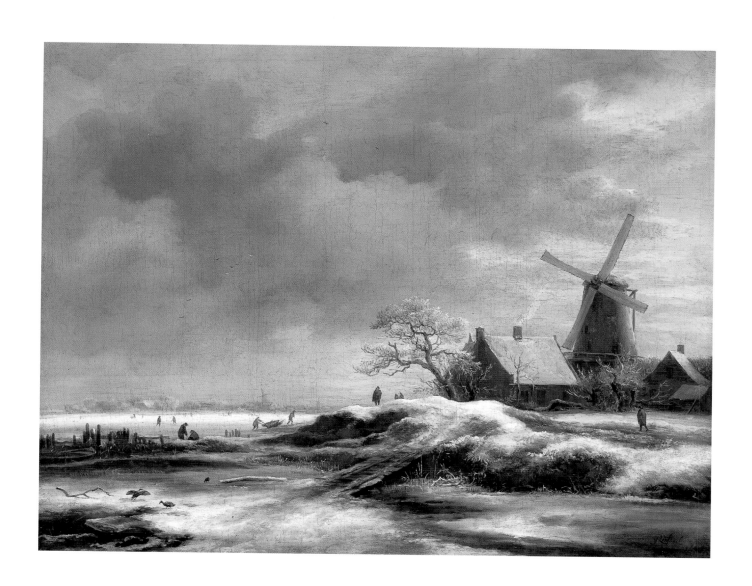

27a

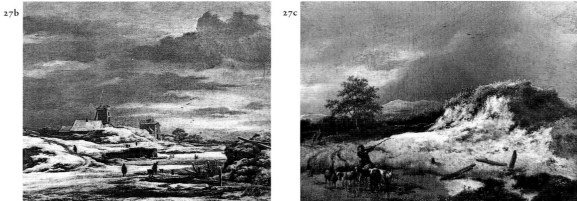

27b 27c

27a Jacob van Ruisdael, *Winter landscape, c.*1665. Canvas, 42 x 49.7 cm. Amsterdam, Rijksmuseum (acquired in 1870).
27b Jacob van Ruisdael, *Winter landscape, c.*1675-1680. Canvas, 43.2 x 52 cm. Private collection (photograph: RKD, The Hague).
27c Jacob van Ruisdael, *Dunes with a shepherd and his flock, c.*1655. Panel, 19.5 x 26.3 cm. Paris, Frits Lugt Collection (acquired in 1952).

not alone in his approach: in the early 1650s his fellow townsman Jan van de Cappelle also began painting nearly figureless winter scenes with more focus on atmospheric effects, an excellent example of which can be found in the Lugt Collection (cat. no. 9). Van de Cappelle's compositions are generally more expansive and the overall tenor more neutral, but in one case the mood is just as desolate as in Van Ruisdael.[9]

The Lugt painting is one of a small group usually dated somewhat later, namely to the 1670s, in which a windmill serves as the focal point.[10] Mills appear most frequently in Van Ruisdael's early work, but around 1670 he took up the motif once again, giving it monumental form in his *Windmill at Wijk bij Duurstede* (Amsterdam, Rijksmuseum).[11] The one in our picture is a tower mill of the smocked type, with a rotating cap to allow the sails to catch the wind, of which there were already a large number in the environs of Amsterdam in Van Ruisdael's time.[12] It stands at the centre of a group of houses lining the banks of a frozen waterway. Across the icy expanse lies a village with a second mill, shrouded in mist. Here and there figures dot the landscape. They are very varied and carefully painted but are so tiny as to be of almost no significance.

Frits Lugt was certain his painting represented a bastion along Amsterdam's old walls, one of those destroyed during the last phase of the city's expansion after 1660.[13] Jacob van Ruisdael did in fact sketch on and around the ramparts in the period 1662-1664 and again in the 1670s.[14] Two other winter landscapes from this group show unfinished structures that appear to be part of what looks like fortifications under construction, and that recall the new gates erected during the enlargement of the 1660s (fig. 27b).[15] The resemblance, however, is rather general and as far as we know the windmill depicted in our painting is not one that ever existed.

In comparison to the winter landscapes of the 1660s, the composition here creates a vast sense of space, and this is true for the group as a whole. The main motif is seen at a greater distance, making it seem less monumental. The imposing diagonal has been abandoned, and the lack of clear accents in the foreground allows the flat landscape to stretch unhindered towards the horizon. The slightly cloudy sky is no longer threatening and the atmosphere is that of a bright winter's day. Van Ruisdael's technique has changed as well. The brushstrokes are finer and more transparent and the palette is softer, with fewer contrasts. This harmonious, serene mood predominates in the other pictures as well. The painter's later winter scenes have been compared to his so-called 'Haarlempjes', distant views of Haarlem and environs painted in the same years. These, too, are delicate, almost pastel-like in tone, with an extraordinary openness and height.[16] It seems possible Van Ruisdael may have been inspired by the rare winter landscapes of Adriaen van de Velde (cat. no. 32), produced between 1668 and 1670. Van de Velde seems to have been even more interested in capturing the flavour of a beautiful, cold day, and in some cases we find staffage figures similar to Van Ruisdael's dotted sparingly throughout the scene. The composition of one of his paintings even strongly resembles the work here under discussion.[17]

The Lugt Collection contains a second picture by Jacob van Ruisdael, a small view of dunes that was probably painted in collaboration with Adriaen van de Velde and that dates to the mid-1650s (fig. 27c),[18] as well as a group of four drawings attributed to the artist.[19] *HB*

153

Pieter Saenredam

Assendelft 1597-1665 Haarlem

28 *The choir of the Church of St Bavo in Haarlem, seen from the Christmas Chapel*, 1636

Panel, 49 x 36.6 cm / Signed and dated at lower right:[1] *P. Sardam. fecit. / A.° 1636.* / Acquired in 1919

Provenance

Van Iddekinge van Drogershorst Collection, The Hague (sale Amsterdam, Frederik Muller & Cie, 27-28 November 1906, lot 24,[2] for 1,100 guilders to Janssen); August Janssen (1865-1918), Amsterdam and Baarn;[3] Jacques Goudstikker (1897-1940), art dealer, Amsterdam, 1919; Frits Lugt, Maartensdijk and Paris, purchased from Goudstikker on 16 July 1919 for 10,000 guilders, with a painting by Hendrick Gerritsz Pot;[4] inv. no. 396

Exhibitions

Rotterdam 1929-1930, no. 13; Rotterdam 1937-1938, no. 8; Amsterdam 1938, no. 8; The Hague 1946, no. 56; Utrecht 1953, no. 82; Utrecht 1961, no. 41; Paris 1970, no. 11; Paris 1983, no. 72; Rotterdam 1991, no. 15

Literature

Von Wurzbach 1906-1911, vol. 2 (1910), p. 547; Jantzen 1910, p. 169, no. 405∗; Koomen 1933, fig. p. 267; Swillens 1935, p. 94 (in no. 83), p. 97 (in no. 94), p. 98, no. 97 and fig. 92; Meischke 1953, p. 318 and fig. 4; Leymarie 1956, p. 150; Zürich 1958, in no. 77; Brinkgreve 1960, p. 41 (ill. on cover and title page); Plietzsch 1960, p. 121; Utrecht 1961 (Dutch edition), pp. 86-87, no. 41 and fig. 35; Utrecht 1961 (English edition), pp. 85-86, no. 41 and fig. 35; Manke 1963, p. 28 and fig. 6; Liedtke 1971, p. 138 note 51; Nash 1972, fig. 14; Liedtke 1975-1976, p. 152 note 16; Reitsma 1976, p. 256 and fig. 13; Wheelock 1977, p. 234 and fig. 53; Jantzen 1979, p. 232, no. 405∗; S. Nihom-Nijstad in Paris 1983, pp. 119-121, no. 72, fig. 57 and cover; Charensol 1983, p. 432; Dauriac 1983, p. 279 (ill.); Kingzett 1983, p. 503; Prat 1983, pp. 127 (ill.) and 132; Schlumberger 1983, fig. p. 53; Hecht 1984, p. 357; Biesboer 1985, pp. 88-89 and fig. 59; Foucart 1985, p. 67; P. ten Doesschate-Chu in Basel 1987, p. 232 note 3; Foucart 1987, p. 94; Van Swigchem 1987, pp. 215, 216 a nd fig. 2; Ruurs 1987, p. 146; Ruurs 1988, p. 42 notes 1 and 4; Schwartz-Bok 1989, p. 124, fig. 136, pp. 200, 260, no. 41, 295 [1636], 309 note 9; J. Giltaij in Rotterdam 1991, pp. 108-111, no. 15 (ill.), p. 129; W. Liedtke in *The Dictionary of Art*, vol. 27 (1996), p. 508; N. Middelkoop in Perth-Adelaide-Brisbane 1997-1998, p. 18, fig. 21; W. Liedtke in Turner 2000, p. 317; Mochizuki 2001, p. 161 and fig. 3.16

In 1608, a year after the death of his father – the well-known engraver Jan Saenredam – Pieter Saenredam moved with his mother to Haarlem, where he would spend the rest of his life.[5] In the years 1612-1622 he was a pupil at the studio of the history and portrait painter Frans de Grebber (1573-1649), who played an important role in Haarlem's artistic circles.[6] On 24 April 1623 Saenredam was registered as a master by the city's guild of painters.[7] His earliest church interior is a design from 1627 for a print by Jan van de Velde the Younger (1593-1641), which was published in Ampzing's description of the city of Haarlem a year later.[8] In 1628 Saenredam completed his first painted church interior (*Interior of the Church of St Bavo in Haarlem*, Los Angeles, The J. Paul Getty Museum),[9] a genre that he would practise for the rest of his life. Incidentally, he also depicted exteriors of churches and other old buildings. From 1632 onwards Saenredam undertook study trips to various Dutch cities. In 1636, after completing this painting, he stayed in Utrecht for some time, when Haarlem was hit by an epidemic of the plague. Perhaps it was his friend and contemporary Jacob van Campen (1596-1657) – the well-known painter and architect made a portrait of Saenredam in 1628 and had also contributed to Ampzing's publication – that encouraged him to make countless largely faithful representations of Romanesque and Gothic churches.[10] The only 'modern' or contemporary church building that Saenredam depicted was the New Church (Nieuwe Kerk) in Haarlem, designed by Van Campen.[11] Saenredam's master in the realm of perspective was probably the surveyor Jan Wils,[12] although Van Campen will also have given him the benefit of his expertise.

In this painting from 1636, Saenredam has depicted the interior of the Church of St Bavo (Bavokerk) in Haarlem. He would make many such 'portraits' of

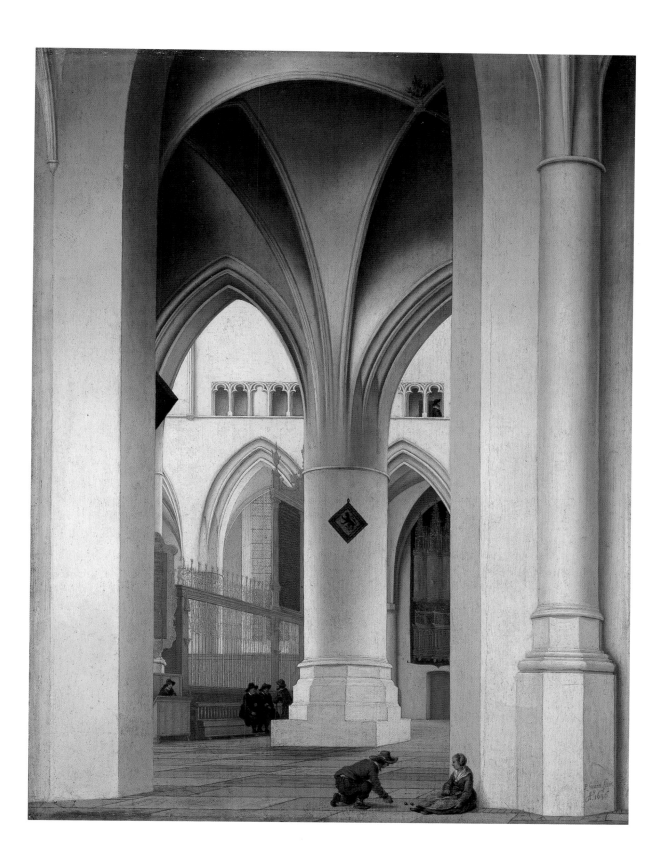

28a

28b

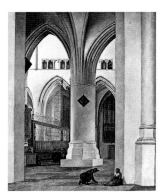

28c

28a Pieter Saenredam, *The choir of the Church of St Bavo in Haarlem, seen from the Christmas Chapel*, 1636. Pen and watercolour, 48.2 x 37 cm. Haarlem, Archiefdienst voor Kennemerland (acquired in 1877).

28b Pieter Saenredam, *The choir of the Church of St Bavo in Haarlem, seen from the Christmas Chapel*, 1636. Panel, 43 x 37.5 cm. Zürich, Stiftung Sammlung E.G. Bührle (acquired in 1955).

28c Johannes Pieter de Frey after Pieter Saenredam, *The choir of the Church of St Bavo in Haarlem, seen from the Christmas Chapel*, c.1800? Watercolour, 37.5 x 30 cm. Haarlem, Archiefdienst voor Kennemerland (acquired in 1875).

this mediaeval church from 1627, when he made the preliminary sketch for the print mentioned above, until 1637. After that the interior occurs in two panels from 1648 and 1660. The painter drew the building many times and from various angles, particularly in the period 1634-1636, and back in his studio he would immortalise his impressions in oil. In total 12 paintings and 27 drawings by Saenredam of the interior of the Haarlem church or specific parts of it have been preserved.[13]

We know how Saenredam worked in some considerable detail. A meticulous and methodical artist, he almost invariably started out by making a site plan, a sketch that he almost always dated. Occasionally he also made studies of details, and in some cases even measured the floor plan of the building he planned to depict. He evidently sketched a site plan for the view depicted in this painting, but it was unfortunately lost.[14] The 'construction drawing', as it is called, dating from the same year as the painting and based on the lost sketch, has been preserved, however (fig. 28a).[15] This is a sheet made using a form of calibration,

which besides displaying Saenredam's sketch of an interior from a particular vantage point incorporates his notes on the sizes and distances of all the key elements, with the horizon positioned at the painter's eye level in each case. The scene depicted in the construction drawing of this painting corresponds exactly to the finished work, with the exception of the lozenge-shaped plaques and the figures, and – as is customary in Saenredam's work – has the same measurements. The artist wrote on the drawing, 'this drawing completed / on 3 January 1636 / and the painting completed / on 23 May / in the year 1636. The latter / is the same size / and is a / view of the great church / in Haarlem' (in translation).[16] He therefore finished the painting a mere five months after the drawing. He placed a dot in a circle at far right in the drawing, beside which he wrote 'oogh' (eye), to denote the central vanishing point where all the perspectival lines converge. Saenredam transferred the drawing to the panel by blackening the back of the paper with chalk and then tracing the main lines; marks have been identified that bear

witness to this process.[17] The interior could then be rendered in oil using the impression on the prepared panel. The painting depicts the choir of the church as seen from the Christmas Chapel, the first chapel in the northern ambulatory from the crossing. A painting in Zürich from the same year, completed exactly two weeks earlier (fig. 28b),[18] shows at left the pillar that bounds the picture shown here on the right. In the painting under discussion, we are looking left from this pillar through the ambulatory into the church, while in the other painting our view is to the right.[19]

The image is framed, as it were, by one of the arches of the cross-rib vaulting and the two large pillars that are cut off along the top by the edge of the picture. The decorations of the originally Catholic church were removed or whitewashed after the Reformation; only around the coping stone is some of the painted decoration still visible (not depicted by the artist in fig. 28a). The case of the small organ (its shutters are closed), the richly moulded choir screen from 1509 and the frames of the two large plaques are the only other decorative elements in this otherwise very sober interior. The plaque on the choir screen was probably painted on the west side with the text of the Ten Commandments and on the east side with the *Apostolicum* – quotations from the Letters and Acts in the New Testament – and with the Lord's Prayer. The plaque on the pillar to the left of the choir screen displays texts from the Scriptures in a rectangle framed with scrolls and garlands.[20] On the pillar at the centre of the painting is a square escutcheon with a lion rampant, hung from one corner; it features in other paintings and drawings by Saenredam, although not in the same place.[21] At left, at roughly the same height, is depicted a fragment of another lozenge-shaped plaque of roughly the same size, a pictorial element that, overlapping as it does with the Gothic arch, contributes substantially to the effect of depth. Saenredam's artistic mastery is evident not only from the ingenious composition, but also from his control of the brush and the tonality of the painting, with its restrained palette. The convincing reflection of the daylight in the rungs of the brass choir screen is but one example. The painter has rendered the paving stones and tombstones on the floor playfully in different shades of pale green, pale grey and pale pink, nuances that are noticed only under close scrutiny.

In Saenredam's paintings, in which serenity and harmony are the defining features, people are subordinate to architecture. Here, a few figures enliven a scene dominated by heavy pillars, walls and vaults. Three men are conversing in front of the choir screen: two are seated on a bench, while a third leans on his stick close by. To their left we see a seated man completely absorbed in his thoughts. In the foreground, two children, a boy and a girl, introduce a lighter note: they are playing marbles.[22] Their diminutive size makes the architecture appear even more impressive than it is. Only upon further inspection do we discover another man, rendered in sharp profile, in the gallery of the nave (the triforium) above the small organ and the door to the sacristy. The painter 'hid' similar figures in other interiors – completed both before and after this one – of the Haarlem church, where he himself would be laid to rest in 1665.[23]

The municipal archives in Haarlem possess not only Saenredam's autograph construction drawing (fig. 28a) but also a drawn copy after this painting, by Johannes Pieter de Frey (1770-1834), an Amsterdam-born artist who worked in Paris from about 1802 onwards (fig. 28c). Unfortunately we do not know where he saw the original.[24] Until 1919, the year in which Lugt purchased the painting, it was in the collection of August Janssen (1865-1918), whom the former compared in an article to famous collectors such as Six and Braamcamp.[25] Janssen purchased his pieces from 1906 onwards at Frederik Muller & Cie auctioneers, where Lugt worked from 1901 to the end of 1914 (see pp. 17-20). The young Lugt helped the collector to build up his collection of old masters. The painting under discussion, which was sold to Janssen at Muller's in 1906, happens to have been one of his earliest purchases. Lugt had evidently had his eye on the painting, since he purchased it in 1919 – a year after the owner's death – from the art dealer Goudstikker, who had bought Janssen's entire collection. Of the paintings by Saenredam that Lugt owned at some time – including *The Mariaplaats with the Church of St Mary, Utrecht* from 1659 in the Mauritshuis (p. 35, fig. 24) – this is the only one he kept for his collection.[26] Until 1983, the year in which the Musée du Louvre acquired the artist's interior of the Church of St Bavo from 1630,[27] it was the only example of Saenredam's work in France.[28] The Frits Lugt Collection also has five drawings by the master,[29] including a study of the great organ in the Church of St Bavo and a very rare portrait study of a man, possibly the verger of a Haarlem church according to one recent writer.[30] He may even have been the verger of St Bavo's. *QB*

Cornelis Saftleven

Gorinchem 1607-1681 Rotterdam

29 *Self-portrait, c.1625-1627*

Copper, 21.1 x 15.5 cm / Acquired in 1962

Provenance
Galerie Koti, Paris; Alfred Brod (1914-1973), art dealer, London; Frits Lugt, Paris, purchased from Brod on 8 May 1962; inv. no. 7640

Exhibitions
Paris 1983, no. 73

Literature
Renckens 1962b, pp. 59-60 and fig. 12; Van Hall 1963, p. 288, no. 1829-2; Schulz 1978, pp. 13-14, 44, 46, 224-225, no. 635 and fig. 1; S. Nihom-Nijstad in Paris 1983, pp. 122-123, no. 73 and fig. 58; Raupp 1984, pp. 126 note 404, 232 and fig. 70; Jensen Adams 1985, vol. 1, p. 181, vol. 3, fig. 91; Trnek 1992, p. 345 note 7; P. Schatborn in Amsterdam 1993, pp. 174 and 251 (under no. 81); W. Schulz in *The Dictionary of Art*, vol. 27 (1996), p. 516; W. Schulz in Turner 2000, p. 321

Seventeenth-century Dutch painters liked to depict themselves in front of their easels or with a finished example of their work. Self-portraits of the artist as draughtsman, however, are a rarity.[1] The gentleman in this small work on copper, still holding his pencil and with a somewhat quizzical expression on his face, demonstratively holds out his just-finished sheet, a study of a baboon. The painting first reappeared in 1962 and must have immediately drawn the attention of Frits Lugt, who two years earlier had organised a large-scale exhibition at the Institut Néerlandais on animals in Dutch art, mainly of works by Dutch and Flemish draughtsmen from his own collection.[2]

Shortly before the acquisition the sitter had been identified as the Rotterdam painter Cornelis Saftleven, on the basis of a likeness of the artist by Anthony van Dyck (1599-1641) of around 1632-1634 (fig. 29c).[3] It was engraved by Lucas Vorsterman the Elder (1595-1675) for the series of portraits of artists, princes and scholars after works by Van Dyck known as the *Iconographie*.[4] Saftleven spent nearly his entire life in Rotterdam, where his parents had moved in around 1609.[5] Like his younger brother Herman (1609-1685), who also became a painter, Saftleven probably received his training from his father, Herman Saftleven the Elder (*c.*1580-1627).[6] Cornelis appears to have been in Antwerp for a time in the years 1632-1634. We find mention of his work in local inventories already early on, among them in the 1640 catalogue of the estate of Peter Paul Rubens (1577-1640), which notes eight pictures by his hand, half of which were executed in collaboration with the Flemish painter himself.[7] There are also striking similarities between the Saftleven brothers' peasant and farmyard scenes, which they began painting in the 1630s, and those of David Teniers the Younger (1610-1690) and Adriaen Brouwer (1605/6-*c.*1638).[8] The Van Dyck likeness was probably made during this sojourn in Antwerp.[9] Saftleven was a multi-faceted artist who worked in a wide range of genres: he painted not only landscapes, animal pieces and stable interiors, but also portraits and figural works, as well as a number of animal allegories and nightmarish

29a

29b

29c

29d

29e

29a Cornelis Saftleven, *Cornelis and Herman Saftleven making music in the studio*, c.1634-1637. Panel, 34 x 53 cm. Vienna, Gemäldegalerie der Akademie der bildenden Künste (acquired in 1822).

29b Cornelis Saftleven, *Portrait of a man (Herman Saftleven?)*, 1629. Panel, 31 x 23 cm. Paris, Musée du Louvre (acquired in 1794).

29c Anthony van Dyck, *Portrait of Cornelis Saftleven*, c.1632-1634. Brown ink over black chalk, 22.4 x 17.6 cm. Amsterdam, Amsterdams Historisch Museum (acquired in 1860).

29d Coenraet Waumans after Herman Saftleven, *Portrait of Herman Saftleven*, c.1649. Engraving, 16.6 x 11.6 cm, second state. From: Cornelis de Bie, *Het gulden cabinet van de edel vry schilder const*, Antwerp 1661, p. 275. The Hague, Royal Cabinet of Paintings Mauritshuis, Library.

29e After Cornelis Saftleven, *Portrait of Cornelis Saftleven* (after a lost self-portrait of c.1630). Panel, 33 x 26 cm. Present whereabouts unknown (photograph: RKD, The Hague).

monster fantasies in the tradition of Jheronimus Bosch (c.1450-c.1516) and Pieter Bruegel the Elder (c.1525/30-1569).

With the help of the print in the *Iconographie* several other likenesses by Cornelis Saftleven have been identified as self-portraits. One of these is the work in Vienna depicting a violinist and cittern player surrounded by musical instruments and studio props in which the violinist is unmistakably identical to the man in the Van Dyck portrait (fig. 29a).[10] The picture is probably a double portrait of Cornelis and Herman Saftleven, painted in the period 1634-1637, while Cornelis was living with his brother in Utrecht. The portrait of a young painter at his easel in the Musée du Louvre in Paris executed a few years earlier, namely in 1629, is now also believed to be a self-portrait (fig. 29b),[11] although the expression, broad face and slightly curly hair are more like those of Herman in the work in Vienna. These features can still be recognised in later images of the artist, albeit not without difficulty as he seems to have grown much larger and fatter in his old age (fig. 29d).[12] Therefore, the 1629 picture in the Louvre seems not to be a self-portrait of Cornelis but rather a likeness of his brother, then aged 20.

A number of comparable depictions of painters at their easels – now known only through copies – are also thought to be self-portraits by Cornelis Saftleven. The most important among them (fig. 29e) shows a slender-faced young man with straight dark hair reminiscent of Saftleven in the work in the Lugt Collection, the double portrait in Vienna (fig. 29a) and the Van Dyck drawing (fig. 29c). The picture is signed and the unfinished work on the easel appears to depict a fantasy scene with monsters, a type of painting he was one of the few northern Nether-landish artists to practise.[13] The earliest examples date from 1629, the period in which the original self-portrait on which this copy is based could have been made.[14]

Saftleven appears somewhat younger in the self-portrait in the Lugt Collection than in the other works illustrated here. It seems to depict the artist between the ages of 18 and 20 and must therefore have been painted around 1625-1627. This would not only make it his earliest self-portrait, but also his earliest surviving painting overall. In terms of style it is quite different from the rest of his oeuvre: the brisk, straightforward handling of paint and uncomplicated technique stand in sharp contrast to the fine, atmospheric manner of the aforementioned portraits in Paris (fig. 29b) and Vienna (fig. 29a), and some of the details – for example,

the hands – are lacking in definition. At the same time, the expression and elegant pose are surprisingly well captured, leading one to suspect the artist was already acquainted with the work of Rubens and Van Dyck.[15] From the beginning, Cornelis Saftleven must have had a talent for drawing the human figure. His earliest known works on paper – two wonderful half-length studies of boys – date to 1626, when he was only 19 years of age.[16]

The piece of paper lying on the table under the artist's arm shows vague forms that in the past have been construed as a pair of monsters' heads.[17] An active imagination and a knowledge of the painter's later work were certainly seminal to this interpretation, as even close examination reveals nothing of the sort. Despite the fact that he remained a productive draughtsman throughout his career, producing in particular numerous studies of animals, it is equally uncertain whether the drawing he holds is meant to demonstrate his skill in this specific branch of the arts. The surviving early works in this medium – of which there are two examples in the Lugt Collection[18] – are based on known models, in many cases the animals in the paintings of Roelant Savery (1576-1639).[19] It thus seems unlikely that at this stage in his career Saftleven would have sought to distinguish himself as an animal draughtsman. The monkey is more likely meant to stand for the notion of *imitatio*, the imitation of nature, which since the Renaissance had been regarded as one of the fundamental principles of the fine arts. The monkey is a standard attribute in seventeenth-century representations of this idea, and also appears in other pictures that allude to the artist as a copyist of nature.[20] Perhaps the choice of the baboon, which is moreover represented from its least flattering side, is meant as an ironic commentary on the 'apeing' character of the painter's profession. Such indirect references and reflections on the essence of art are far from unusual in seventeenth-century Dutch painting, and probably also play a role in the other Saftleven portraits mentioned here. The particular mise-en-scène of the Vienna double portrait (fig. 29a), for example, seems to point in the direction of an – as yet undeciphered – allegory on the arts, and the inscription *[naer] 't leven* on the blank canvas in the portrait of Herman Saftleven in Paris (fig. 29b) may well have more import than simply to indicate that the work was based on observation 'after life'.[21] *HB*

Karel Slabbaert

Zierikzee 1618/19-1654 Middelburg

30 *Self-portrait, c.1650-1654*

Panel (oval),[1] 20.6 x 15.6 cm / Signed lower centre, on the balustrade: *k. slabbaert pinx* / Acquired in 1962

31 *Posthumous portrait of Cornelia Bouwers, wife of the painter, with a skull, c.1650-1654*

Panel (oval),[1] 20.3 x 15.7 cm / Signed to the left of centre: *k. slabbaert* / Acquired in 1962

Provenance

Levinus F. de Beaufort, Middelburg (sale Middelburg, 17 July 1731, lots 23 and 24, for 2.10 and 2.12 [guilders?]);[2] unknown French collection, nineteenth century (see note 12); Count Karl Lanckoronski-Brzezie (1848-1933), Vienna, and his heirs (sale London, Christie's, Manson & Woods, 18 July 1952, lot 302, unsold);[3] Countess Adelheid Lanckoronska (sale London, Christie's, Manson & Woods, 30 June 1961, lot 72, for 190 guineas to Drown);[4] Alfred Brod (1914-1973), art dealer, London; Frits Lugt, Paris, purchased from Brod on 2 July 1962;[5] inv. nos. 7667 A-B

Exhibitions

Paris 1983, nos. 76-77; Amsterdam 1984, nos. 80-81

Literature

H. Gerson in Thieme-Becker, vol. 31 (1937), p. 128; Bol 1982b, pp. 585, 588 note 8 and figs. 7-8; S. Nihom-Nijstad in Paris 1983, pp. 126-128, nos. 76-77 and figs. 64-65; Dauriac 1983, p. 279; Kingzett 1983, p. 503; G. Jansen in Amsterdam 1984, pp. 104, 276-279, nos. 80-81 (ills.); J. Sander in Frankfurt am Main 1991-1992, p. 42 (ill. of cat. no. 30)

Karel Slabbaert and several other lesser known painters, such as Jacob van Geel (cat. no. 13), are among the artists born in Middelburg who owe their renewed place in art history to the publications of Laurens J. Bol (1898-1994).[6] Unlike Van Geel, all of whose paintings are landscapes, Slabbaert did not confine himself to one genre. In addition to portraits, which make up the largest part of his oeuvre,[7] he also painted genre scenes and the occasional still life.[8] It is assumed that Slabbaert, whose oeuvre bears little or no resemblance to those of his Middelburg colleagues, went in his youth to study in Zierikzee, possibly with the portrait painter Jacob Loncke (*c.*1580-1646).[9] Of more importance to his development, however, was the time he spent in Leiden, where he is documented in 1640 and 1641, as well as in Amsterdam, where, according to another source, he was living on the Prinsengracht in 1645.[10] That same year he married the Rotterdam-born Cornelia Bouwers and entered the Middelburg Guild of St Luke, where he later served as 'beleeder' and dean.[11] The painter continued to live in the capital of Zeeland until his premature death in 1654 at the age of thirty-five or thirty-six.

These two captivating paintings were once optimistically called portraits of 'Jean de Witt' and his wife 'Jeanne de Witt', names which were recorded in black ink on the back of the portraits,[12] and which probably referred to Johan de Witt (1625-1672), the Grand Pensionary of Holland, and his wife Wendela Bicker (1635-1668).[13] These pendants are however likenesses of the painter himself and his wife, as the distinguished art historian Cornelis Hofstede de Groot (1863-1930) already surmised when viewing the paintings at the home of the former owner in Vienna, whose collection Lugt himself also visited.[14] The earliest mention of these small panels – the man's portrait was described in 1731 as 'Een Schilders Portraitje van Slabbaert, fraey geschildert' (a painter's portrait by Slabbaert, beautifully

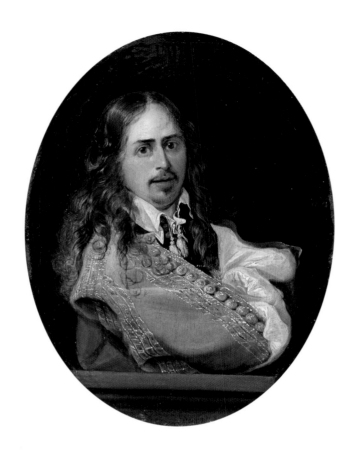 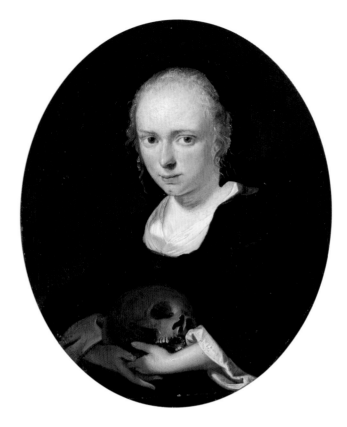

30-31a

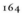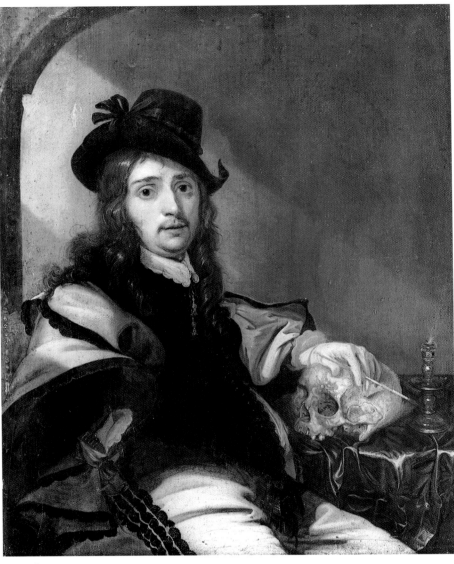

164

30-31b

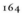

30-31a Rembrandt, *Self-portrait, leaning on a stone wall*, 1639. Etching and drypoint, 20.5 x 16.4 cm (second state). Amsterdam, Rijksmuseum, Rijksprentenkabinet.
30-31b Karel Slabbaert, *Self-portrait as a painter, with vanitas symbols*, c.1645. Panel, 32.5 x 25.3 cm. Frankfurt am Main, Städelsches Kunstinstitut (acquired in 1816).

painted) – supports this identification;[15] the depiction, after all, offers no clues as to the sitter's profession. Moreover, the word 'self-portrait' did not even exist in the seventeenth and eighteenth centuries. We know that self-portraits of Rembrandt (1606-1669) were described as portraits of the artist 'painted by himself'.[16] At any rate, the man's bearing – the attitude of someone acutely aware of the picture he presents – and the challenging gaze he directs at the viewer are both consistent with the tradition of the seventeenth-century northern Netherlandish self-portrait, and it must be noted in this case that the man's demonstratively folded arms constitute an exceptional motif. The balustrade he poses behind was most likely inspired by the well-known, etched self-portrait by Rembrandt (fig. 30-31a),[17] completed in 1639, which had a great impact, both in his studio and elsewhere.[18] We know that Slabbaert was living and working in 1645 in Amsterdam,[19] which makes the derivation from Rembrandt's etching all the more likely.

The lack of documented self-portraits has caused some doubt to be cast on the identification of this painting – signed in full on the balustrade – as a self-portrait by Slabbaert, as evidenced by the titles given to the portrait in the past.[20] In Frankfurt am Main there is another self-portrait by Slabbaert, in which recent technical examination has brought to light a number of interesting pentimenti, but this picture cannot be called with certainty a self-portrait either, even though it depicts the same man, this time with a felt hat cocked jauntily over his curly hair. The sitter is unmistakably a painter, as evidenced by the brush in his hand (fig. 30-31b).[21] The costly, fashionable clothing of the still-youthful man on this larger panel suggests an earlier date, around 1645. Furthermore, the same face is recognisable in the portrait of a man, rather discreetly included in a signed studio depiction by Slabbaert in Berlin (figs. 30-31 c-d).[22] On the basis of the composition and especially its resemblance to the likeness of the man portrayed here, this conterfeitsel could also be viewed as 'the portrait of the painter by himself'. The man, who directs a piercing gaze at the viewer, holds in his right hand an oval portrait of a woman, in all likelihood his wife. At any rate, if we take the man's portrait to be a self-portrait of Slabbaert, the woman in the pendant of our small oval painting can hardly be anyone but his wife, Cornelia Bouwers (c.1625-before 1654?), whom he married in 1645.[23] It is therefore only natural that she would be the one portrayed in the painting-within-a-painting in the studio depiction in Berlin. Unfortunately, the features on the last-mentioned portrait are difficult to distinguish.

Slabbaert also included his own likeness in a narrative representation. The features of the man in the present painting, for example, which Bol unreservedly took to be a self-portrait, are recognisable in a signed painting by Slabbaert dating from around 1650 in the Mauritshuis (fig. 30-31e).[24] In this rather curious depiction, we see a group of soldiers among the ruins of a castle, in their midst a scene recalling the work of Gerrit Dou (1613-1675): a young woman caring for a baby and two children warming themselves by a fire.[25] In the immediate foreground we see a man with a Rembrandtesque plumed cap – Karel Slabbaert himself – who looks pointedly at the viewer while resting his right hand on a cannon and holding in his left hand a pipe. The clearly legible signature is conspicuously depicted on the wheel of the cannon, just below the self-portrait of the painter, dressed as an officer. The principal figure in another picture attributed to Slabbaert has in the past been connected with his self-portrait in the Mauritshuis painting.[26] Whereas the style and choice of subject matter of certain portraits and genre scenes by Slabbaert are clearly indebted to Dou, who from around 1640 or even earlier produced portraits and also *tronies* in a comparably small format,[27] there is no such resemblance here. Besides, the technique employed by Slabbaert, who can be thought of as a follower of Dou, is considerably less refined than that of the founder of the Leiden school of 'fine painting' (*Feinmalerei*), whose representations, however, typically include both refined and loosely painted passages. The present self-portrait in particular, despite its small format, is rather pastose, lending special emphasis to the characteristically free rendering of the folds in the painter's white shirt.[28] Slabbaert apparently made quick work of this detail: his wife's portrait, on the other hand, betrays a more refined touch. The hand clasping the front of the skull displays a texture approaching the smoothness of porcelain, the effect of which is heightened by the somewhat stark illumination. The hair of both husband and wife is convincingly rendered and supplied with little white accents indicating the reflection of light. Striking indeed is the attention devoted to the eyes: the remarkably large pupils are characteristic of Slabbaert's portraits.[29]

165

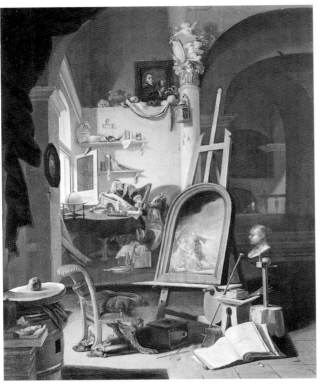

30-31c

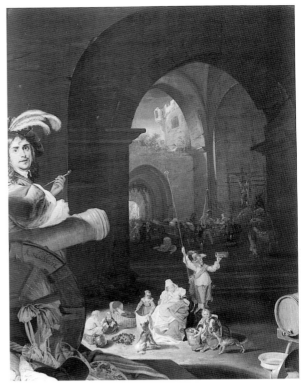

30-31e

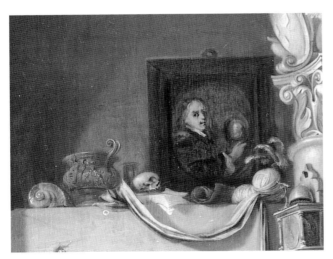

30-31d

30-31c Karel Slabbaert, *The studio of Luke the Evangelist, c.*1650?
Panel, 63 x 49 cm. Berlin, Staatliche Museen,
Gemäldegalerie (acquired in 1849).

30-31d Detail of fig. 30-31c.

30-31e Karel Slabbaert, *Soldiers and other figures among the ruins
of a castle, with a self-portrait in the foreground, c.*1650?
Panel, 50.5 x 39 cm. The Hague, Royal Cabinet of
Paintings Mauritshuis (acquired in 1876).

The format of the portraits described here – which were originally not oval but octagonal – is reminiscent not only of Dou but also of the work of his most famous pupil, Frans van Mieris the Elder (1635-1681), who also painted miniature portraits. Interesting in this context are the small portraits of similar design which Van Mieris made of himself and his wife between around 1657 and 1663,[30] although these portraits are smaller and always oval, the sitters are not represented half-length but as busts, and they date from a later period. Slabbaert, after all, died in 1654, which provides a *terminus ante quem* for the dating of the present portraits. The scarcity of dated works – a child's portrait in the Zeeuws Museum stems from 1650, the portrait of a man in the Mauritshuis from 1653 – and the lack of dated self-portraits do not make the dating of the present paintings any easier.[31] It is indeed tempting to assume that these pendants were produced on the occasion of the painter's marriage to Cornelia Bouwers in 1645, but the fashionable clothes Slabbaert wears in his self-portrait make it impossible to date it before 1650.[32] His appearance, dressed completely in the fashion of his day, contrasts greatly with the sober attire of his wife, who wears a veil draped over her shoulders, and clothing entirely lacking in such customary adornments as lace sleeves or a lace collar. Indeed, she was probably intended to have a timeless, 'antiquating' character (*op zyn antycks*), the very effect Rembrandt strove to produce in his self-portraits.[33] Considering the lack of immediately recognisable details of seventeenth-century fashion, her clothing must have been partly a product of Slabbaert's imagination. The supposition that this little portrait was painted posthumously – an assumption prompted by her serious gaze, her mainly black clothing, and especially the skull in her hands – does not seem unfounded.[34] One can therefore assume that Cornelia Bouwers died before 1654, the year in which the painter himself met his premature death. In the self-portrait in Frankfurt am Main, which must be given an earlier date, Slabbaert had already incorporated the skull motif as a means of sending a different message: *ars longa, vita brevis* (art is eternal, life is short), an interpretation rendered even more plausible in this case by the snuffed but still smouldering candle. Even the painter's fashionable and expensive clothing in this earlier self-portrait can perhaps be seen as a sign of 'sloth' (the second meaning of *vanitas*).[35] A similar vanitas motif is depicted next to the painting-within-a-painting in Berlin (fig. 30-31d), which is accompanied by a skull placed, not coincidentally, in front of an hourglass. It seems obvious that the oval portrait of a woman held by the painter was included in memory of his deceased wife.[36] *QB*

Adriaen van de Velde

Amsterdam 1636-1672 Amsterdam

32 *Landscape with horses and other livestock*, 1669

Panel, 21.5 x 28.5 cm / Signed and dated lower centre: *A. V. Velde, 1669* / Acquired in 1951

Provenance

Friedrich Wilhelm Michael Kalkbrenner (1785-1849), Paris (sold, with five other paintings, for 10,000 *francs* in or before 1849);[1] Augiot Collection, Paris (sale Paris, Hôtel Drouot, Pillet-Féral, 1-2 March 1875, lot 29, for 11,700 *francs*);[2] Etienne H., Paris (sale Paris, Hôtel Drouot, Vincent, 9 March 1951, lot 58, to Lugt);[3] Frits Lugt, Paris; inv. no. 6381

Exhibitions

Paris 1960a, no. 286; Paris 1983, no. 83

Literature

Hofstede de Groot 1907-1928, vol. 4 (1911), p. 566, no. 303, p. 604, no. 303; F. Lugt in Paris 1960a, p. 47, no. 286; S. Nihom-Nijstad in Paris 1983, pp. 136-137, no. 83 and fig. 32; Frensemeier 2001, pp. 78, 143, 155, no. 56, 187 (under no. 220) and fig. 109

Frits Lugt, a great connoisseur of animal paintings and, especially, drawings by Dutch artists (cf. cat. no. 25) bought this Adriaen van de Velde at an auction in Paris in 1951.[4] In 1960 it was included in *Bestiaire hollandais*, a large exhibition on animals in Dutch art that took place at the Institut Néerlandais (cf. also cat. no. 29). Lugt – by this time 75 years of age – organised the exhibition largely from the wonderful group of studies by Dutch and Flemish draughtsmen he himself had collected, among them drawings and prints by Van de Velde.[5] Lugt greatly admired this artist, whom he described as 'un des meilleurs paysagistes de son époque, talent d'une grande délicatesse et singulièrement distingué. En même temps excellent peintre de figures et d'animaux, ce qui fait que son paysages sont toujours agréablement animés' ('one of the best landscapists of his period, a talent of great delicacy and distinction, at the same time an extraordinary painter of figures and animals, which always makes his landscapes agreeably lively').[6]

Adriaen van de Velde was born in 1636, the son of Willem van de Velde the Elder (1611-1693) and youngest brother of Willem van de Velde the Younger (cat. nos. 33-34), both well-known marine painters.[7] He did not, however, follow in their footsteps, although he took – like his brother – lessons from his father. It is assumed he underwent a second period of training with the Haarlem landscape painter Jan Wijnants (1631/32-1684), probably before 1653, the year noted on a number of his etchings. Van de Velde's earliest dated paintings – landscapes with animals – date from 1654; thereafter, dated works are known for every remaining year of his career. Some scholars have suggested that this talented artist, who excelled at painting both animals and figures, travelled to Italy around 1654-1657, but there is no evidence to support this. The Italianate motifs that sometimes appear in his pictures are instead likely drawn from the work of others. Van de Velde was extraordinarily productive: despite the fact that he died at the age of only 36 he left behind an oeuvre that includes not only etchings and many drawings but also a large number of works on canvas and panel.[8] In addition to numerous landscapes and animal paintings

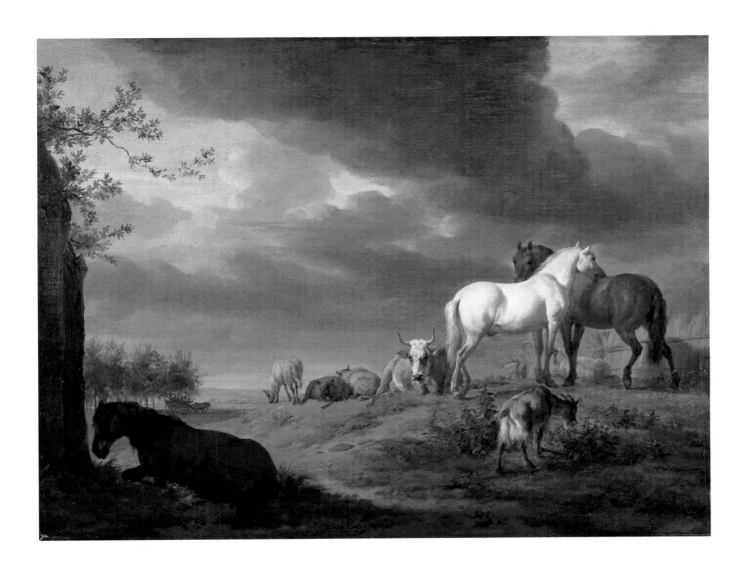

32a

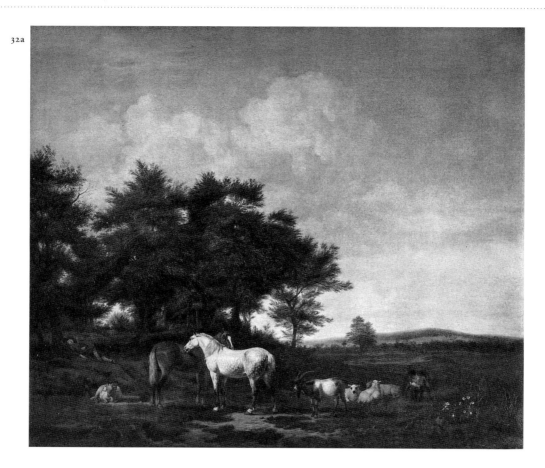

32b

32c

32a Adriaen van de Velde, *Landscape with horses, cattle and a sleeping herdsman*, 1657. Canvas, 63.5 x 72.2 cm.
London, The Royal Collection © Her Majesty Queen Elizabeth II (acquired in 1762).

32b Adriaen van de Velde, *Wooded landscape with horses and other animals*, *c.*1660-1663. Pen in brown-black and brown,
grey pencil, 14 x 20.2 cm. Amsterdam, Amsterdams Historisch Museum (acquired in 1860).

32c Adriaen van de Velde, *Landscape with horses and cattle*, 1663. Canvas, *c.*37 x 34 cm. Private collection
(photograph: RKD, The Hague).

he also executed beach scenes and winter landscapes, as well as history paintings and even the occasional portrait or genre scene. Furthermore, he was in great demand as a staffage painter: he carried out the figures in works by Meindert Hobbema (1638-1709), Frederik de Moucheron (1633-1686), Jan van der Heyden (1637-1712), Jacob van Ruisdael (cat. no. 27), and he also assisted his brother Willem.

The splendid picture in the Lugt Collection is signed in full and dated 1669, and can thus be counted among the later works of Van de Velde, who died in 1672. The small panel depicts a meadow populated by a variety of livestock: a resting cow, a grazing goat, sheep and several horses. The passengers in the horse-drawn cart are the only human figures in a landscape otherwise dominated by animals and thunderclouds.[9] The horse in the foreground – lying in the shadow near a dilapidated, overgrown building – serves as a repoussoir. Van de Velde used this compositional device in many other paintings and drawings, although other creatures sometimes take the place of the horse.[10] The most striking image, however, is the group of two horses at the right, the whitish grey resting its head on the back of its brown congener. This charming motif, which certainly derives from the artist's own observations, appears in earlier works as well, as Lugt himself noted in one of his many publications.[11] From 1657 onwards we find it in paintings (fig. 32a)[12] and in a number of drawings, all of which are undated. The sheet illustrated here (fig. 32b), now in Amsterdam, is a compositional sketch for a painting of 1663 (fig. 32c).[13] In the final work Van de Velde transformed the horizontal format of the drawing into a nearly square vertical, thereby giving the landscape a greater monumentality.

Van de Velde's paintings, drawings and etchings are all closely related.[14] This can be explained by the artist's working method, which – unusually – we know something about, especially with regard to the last ten years of his career. The remarks of the artists' biographer Arnold Houbraken are particularly important in this context. According to him, Van de Velde 'zealously drew and painted cows, bulls, sheep and landscapes and carried his equipment each day out to the countryside – a practice that he maintained until the end of his life once per week'.[15] We know that the famous animal painter Paulus Potter made many similar studies from nature (see cat. no. 25). Potter, who late in life – he died in 1654 – was Van de Velde's neighbour on Amsterdam's Muntplein, exercised a considerable influence on the artist,[16] as did the figure- and animal-filled landscapes of Italianate painters such as Nicolaes Berchem (cat. no. 4) and, above all, Karel du Jardin (cat. no. 15).[17] In addition to individual figure and animal studies or landscape drawings, Van de Velde also executed rough compositional sketches, which he then worked up into the careful and detailed drawings – so-called *modelli* – that established the final designs of his paintings.[18] Unfortunately, no such preparatory studies are known for the work in the Lugt Collection. Nonetheless, it is obvious that the painter observed and sketched the various animals from life – the grazing goat in the foreground, the two horses and the resting cow are all beautifully captured – later forging these studies into a convincing whole. Upon closer examination, however, we discover that one of the results of this approach is that the various elements are not always in proportion to one another. The grazing sheep behind the recumbent horse, for example, is as large as the lying-down cow. It is, though, the strikingly fine brushwork and perfectly observed details that are the essence of this little picture, in which mounting dark-grey clouds announce in a most verisimilar and threatening manner the coming storm. *QB*

Willem van de Velde the Younger

Leiden 1633-1707 London

33 *The council-of-war on board the Eendracht on 24 May 1665, c.1665*

Canvas, 111.5 x 165.7 cm / Signed at lower left, on a barrel floating in the sea: *WV* (or: *W VV*)[1] / Acquired in 1965

Provenance

The brothers Jan (1680-1771) and Pieter Bisschop (c.1690-1758), Rotterdam, 1752 or before;[2] Adrian Hope (1709-1781), Amsterdam; his nephew, John Hope (1737-1784), Amsterdam;[3] his son, Henry Philip Hope (1774-1839), Amsterdam and London;[4] on loan to his brother Thomas Hope of Deepdene (1769-1831), London and Deepdene House, Dorking, Surrey, from 1819;[5] his son, Henry Thomas Hope (1808-1862), London and Deepdene;[6] his widow, Adèle Hope, née Bichat (d. 1884); her grandson, Henry Francis Pelham-Clinton-Hope (1866-1941), from 1928 Eighth Duke of Newcastle-under-Lime;[7] P. & D. Colnaghi, art dealers, London;[8] Frederik Muller & Cie, auctioneers and art dealers, Amsterdam, 1912;[9] (?) Knoedler & Co, art dealers;[10] August Janssen (1865-1918), Amsterdam and Baarn, in or before 1913;[11] (?) D. Katz, art dealer, Haarlem, 1934;[12] Cornelis Johannes Karel van Aalst (1866-1939), Huis te Hoevelaken near Rotterdam; his son, N.J. van Aalst, Rotterdam; Frits Lugt, Paris, acquired on 1 December 1965; inv. no. 8549

Exhibitions

(?) London 1864, no. 65; Amsterdam 1912, no. 34; Amsterdam 1913, without no. [pl. 6]; Arnhem 1953, no. 68; Zürich-Rome-Milan 1953-1954, no. 166; Paris 1967, no. 366; Paris 1983, no. 86; Paris 1989, no. 9

Literature

Hoet-Terwesten 1752-1770, vol. 2, p. 530; De Balbian Verster 1912, pp. 516-522; De Balbian Verster 1913, pp. 6-7; Hofstede de Groot 1907-1928, vol. 7 (1918), p. 12, no. 24; Preston 1937, pl. 56; Valentiner-Von Moltke 1939, pp. 300-301 (ill.); Voorbeijtel Cannenburg 1950, pp. 202-203 (ill.); R.E.J. Weber in Boxer 1976, pp. 116-119 (ill.); Braunius 1977, p. 323 (ill.); Bosscher 1979, p. 74 (ill.); Van der Kooij 1980, p. 69 (ill.); Niemeijer 1981, p. 200, no. 239 and fig. 20; M.S. Robinson in Paris 1983, pp. 141-143, no. 86 and fig. 51; Kingzett 1983, p. 503; M. van Berge-Gerbaud in Paris 1989, p. XVI; C. van Hasselt in *idem*, pp. VI-VII, pp. 12-13, no. 9 and fig. 10; Robinson 1990, vol. 1, p. 70 (under no. 332), vol. 2, pp. 733-736, no. 162 (ill.), 736 (under no. 155), 737 (under no. 746); Dik 1993, pp. 26 (fig. 37) and 159

Willem van de Velde the Younger was the eldest son of Willem van de Velde the Elder (1611-1693), and, like his father, spent his whole life depicting ships and maritime subjects.[13] Van de Velde the Elder moved to Amsterdam shortly before the birth of his eldest son, and it was here that Van de Velde Junior undoubtedly received his first artistic training from his father, though around 1648 he was sent to study with Simon de Vlieger (1600/1-1653) in Weesp. Van de Velde the Elder's paintings were done in the old-fashioned technique of 'pen painting': drawing with pen on prepared canvas, without using colour. Apparently he was not sufficiently skilled in the art of painting. Probably starting in 1652, the year of his short-lived marriage, Willem van de Velde the Younger shared a workshop with his father in Amsterdam. Most likely his younger brother, Adriaen van de Velde (cat. no. 32), also assisted in the studio. The earliest works of Willem van de Velde the Younger are quiet water views depicting groups of ships, such as those the slightly older Jan van de Capelle (cat. no. 9) began to paint around this time. From the 1660s on he devoted himself increasingly to complicated pieces with sea battles and other historical events, generally based on sketches made by his father, who accompanied the fleet on all sorts of occasions as draughtsman-reporter. Either at the end of 1672, the 'year of catastrophe', or in the first months of the following year, both father and son Van de Velde moved to England, where Charles II (1630-1685) immediately put at their disposal a studio in Queen's House at Greenwich. In 1674 the king even offered them both a regular salary – to Willem van de Velde the Elder 'for taking and making draughts of sea fights', and to his son 'for putting the said draughts into colour for our particular use', phrases which probably reflect the division of work in the Van de Veldes' studio. Father and son stayed in England for the rest of their

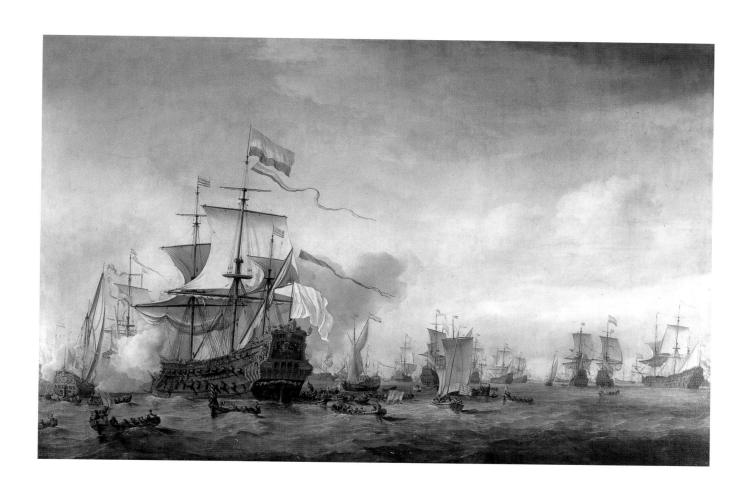

174

33a Willem van de Velde the Elder, *The council-of-war on board the Eendracht on 24 May 1665*, 1665. Pencil, grey wash, 36 x 185.5 cm.
 Greenwich, National Maritime Museum (acquired in 1961).
33b Attributed to Willem van de Velde the Younger, *A council-of-war on board the Eendracht*, c.1665? Pen and brown ink, grey wash,
 26.5 x 47.6 cm. Dresden, Kupferstichkabinett der Staatlichen Kunstsammlungen.

lives. The two sons of Willem van de Velde the Younger, Willem III (1667-after 1708) and Cornelis van de Velde (active 1699-1729) also became marine painters, though they never attained the artistic heights of their father and grandfather.

In an article published in 1912, the historian J.F.L. de Balbian Verster (1861-1939) identified for the first time the subject of this painting, which had already been consigned to oblivion by the mid-eighteenth century, the canvas then being part of the famous cabinet of the Bisschop brothers. The scene is a depiction of the council-of-war which Jacob Baron van Wassenaer Obdam (1610-1665), admiral of the Dutch fleet, convened on Whit Sunday, 24 May 1665, on board his flagship, the *Eendracht*, in preparation for the attack on the English. Charles II had declared war on the Dutch Republic in March of that year – the formal start of the so-called Second Anglo-Dutch War (1665-1667) – and the Dutch had been working for months to equip the fleet.[14] When, on 21 May, bad weather forced the English fleet to abandon its blockade of the Dutch coast, the Zeeland squadron, led by Johan Evertsen (1600-1666), was finally able to join the rest of the fleet, which had been lying at anchor for weeks in the Marsdiep, ready to sail (see also cat. no. 34). On 23 May part of the fleet set sail, leaving through the Spanjaardsgat, followed the next day by the last ships, among which was the *Eendracht*. The council-of-war depicted here was convened as soon as the fleet was at sea.

A principal role in this painting is played by the *Eendracht*, which is depicted from much closer range than the other ships, making it seem twice as big. The ship, built in 1653, was, with its 72 guns, one of the heaviest ships in the fleet. Its sculptured tafferel with the lion of the Seven United Provinces in the so-called 'Dutch garden', and the ship's name on the counter below are both clearly visible. From the stern flies a white flag, a signal for the flag officers of the fleet to make their way to the admiral's ship, while the blue pendant flying from the mizzen yard serves to call the captains of the galjoots, or reconnaissance ships.[15] Sloops and small vessels approach the admiral's ship from all sides; some of these craft answer the signal with a trumpet call. Approaching the Eendracht from the left is also the yacht of the States of Holland, firing a salute to the admiral's ship.[16] Another States yacht to the right of the ship must have arrived earlier, considering that the crew are already lowering the sails. The yacht is gaff-rigged and flies a pendant above the already lowered ensign, an indication that this is the yacht of the Amsterdam Admiralty.[17] One of the two probably carried the Grand Pensionary Johan de Witt (1625-1672), who had devoted a lot of time and effort in having the fleet fitted out and had travelled personally to Den Helder to hasten the fleet's departure.[18]

For this attack the fleet was divided into seven squadrons, an exceptional number. The flagships of the vice-admiral and the rear-admiral of the first squadron, the one commanded by Van Wassenaer Obdam himself, can be discerned in the painting by means of the flags they fly: the *Amsterdam* under the command of Abraham van der Hulst (1619-1666), in the centre of the painting, to the left behind the small fishing vessel, and *Het Huis Tijdverdrijf* under the command of rear-admiral A.C. Graeff, disappearing behind the gunsmoke to the left of the *Eendracht*.[19] Among the large ships in the middle distance there are another five from the first squadron, two belonging to the second squadron and two of the third squadron, including the admiral's ship, the *Groot-Hollandia* (second from the right), under the command of Egbert Meussen Cortenaer (1604-1665).[20] The many ships lying at anchor on the horizon suggest the size of the fleet, the largest the Republic ever mustered.[21] This dazzling display of force would be followed three weeks later by the most crushing defeat ever suffered by the Dutch Republic. The confrontation with the English on 13 June 1665, known as the Battle of Lowestoft, ended in disaster when the flagship of Van Wassenaer Obdam was blown up with all hands and it was uncertain, in the ensuing chaos, who should assume command. Van Wassenaer Obdam himself and two of his admirals, Cortenaer and Auke Stellingwerff (1635-1665), lost their lives during this battle.[22]

The council-of-war of 1665 is one of the earliest historical events to be worked up into a painting by Willem van de Velde the Younger. It is possible that the painting was a commissioned work – though no information on this score has survived – or perhaps the artist himself had the idea to immortalise the council-of-war in a monumental painting. He had a particular penchant for depicting stately moments of naval ceremony, and there are no known pen paintings by Willem van de Velde the Elder from before 1666 which depict a council-of-war, a motif he had in fact committed to paper on numerous occasions.[23] That Willem van de Velde the Younger had first-hand experience of his subject is by no means certain. It was generally his father who accompanied

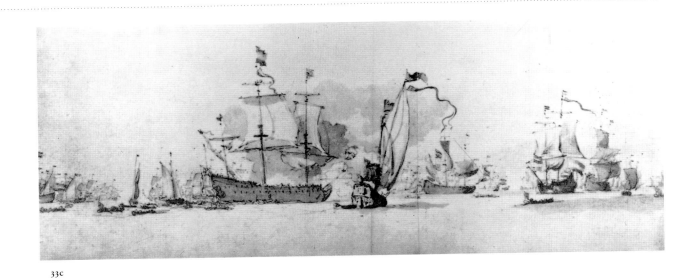

33c

the fleet into war, at first on his own initiative, later on a galjoot put at his disposal by the Dutch Republic.[24] He depicted the events taking place before his eyes in oblong sketches of considerable size, 'an account by way of Journall', as he described them in a list of his works drawn up in 1677.[25] These sketches served as the basis for the large pen paintings he made at home in his studio and also for the paintings his son made after joining him there. On this occasion as well, Willem van de Velde the Elder accompanied the Dutch fleet yet again. On the eve of the Battle of Lowestoft in 1665 he dined at the table of Van Wassenaer Obdam and after the battle's unfortunate outcome his eye-witness account was the first to reach the representatives of the Rotterdam Admiralty on 14 June.[26] A whole series of drawings by the artist has been preserved which depict the movements of the fleet from 24 May until the day of the ill-starred battle.[27] Among them is one which, according to a note written by the artist himself, depicts the council-of-war convened on 24 May (fig. 33a).[28] The drawing indeed shows sloops sailing towards the *Eendracht*. The States yachts are missing, however,

and the composition of the present painting bears almost no resemblance to the drawing.

It is not known whether Willem van de Velde the Younger ever accompanied his father on his travels with the fleet, though it is sometimes assumed that he did.[29] Drawings attributable to him on stylistic grounds suggest that he accompanied his father to Den Helder at the beginning of May 1665 to await the departure of the fleet (see also cat. no. 34). A signed and dated drawing depicts the Dutch bringing in a captured English convoy on 4 June 1665, though it could have been drawn from the land; the fleet, after all, continued to cruise along the coast for some time after the council-of-war held on 24 May.[30] The drawings attributed to him that can be connected to the painting were in any case not made on the spot. One undated drawing perhaps represents a first idea for the composition of the painting (fig. 33b).[31] The sheet also displays a number of sloops around the *Eendracht*, clearly recognisable by the decoration on the tafferel, which is depicted in exactly the same position as in the painting – including the sails and flags – only in reverse. Among the more

distant ships, it is possible to discern a number of vessels belonging to the first squadron. Another drawing can perhaps also be viewed as a compositional design which was later rejected, for it shows the yacht of the States of Holland in precisely the same position as in the painting, firing a salute, although to the right and some distance away from what is presumed to be the *Eendracht* (fig. 33c).[32] For his accurate rendering of the various ships the artist could draw from his stock of 'ships' portraits', worked-up drawings of specific ships, which his father and he had compiled. Such drawings are known of several of the ships depicted here, one of them being the *Eendracht* itself, of which no fewer than nine 'portraits' have been preserved.[33]

As early as 1953 Frits Lugt made repeated attempts to obtain the painting on loan for the Institut Néerlandais then being established, for which its quality, subject matter and not least its sizeable format made it extremely suitable.[34] Lugt did not get his way until twelve years later, when the Van Aalst Collection, to which the painting belonged, was liquidated and the owner made it possible for Lugt to buy the painting before it was to be sold by public auction in

London. A long-cherished wish must have been fulfilled at this time, for by then more than fifty years had passed since Lugt had first discovered the painting in the Hope Collection – which had moved with its owners from The Netherlands to England – and had bought it for the firm of Frederik Muller & Cie, where it was exhibited in 1912. On that occasion De Balbian Verster devoted the above-mentioned article to the painting, and a year later it figured prominently in the historical section of the 'Eerste Nederlandsche Tentoonstelling op Scheepvaartgebied' (First Dutch Exhibition on Navigation), which De Balbian Verster and Lugt had helped to organise. At that time Lugt, who at this stage in his career could not yet think of buying such a painting for himself, had managed to place it in the collection of August Janssen (1865-1918), a collection, largely built up by Lugt, from which he ultimately acquired a number of works for his own collection (see cat. no. 28). When, in 1965, Lugt finally had the opportunity to buy the painting himself, he did not hesitate to sell one of his most beautiful drawings by Albrecht Dürer (1471-1528) to finance the purchase.[35] *HB*

177

Willem van de Velde the Younger

Leiden 1633-1707 London

34 *Beach scene, c.1665*

Canvas,[1] 38.7 x 51.5 cm / Acquired in 1919

Provenance

(?) John Blackwood, London (his sale, day and month unknown, 1755?, first day's sale, lot 9, for 3 pounds and 10 shillings to Jennens);[2] Charles Jennens (1700-1773), London and Gopsall, Leicestershire; his nephew, Penn Assheton Curzon; Hon. Penn Assheton Curzon (d. 1797); his widow, Sophia Charlotte (1762-1835), Baroness Howe of Langar; by descent to Richard George Penn (1861-1929), Fourth Earl Howe Gopsall, Atherstone, Leicestershire (Gopsall sale, 21 October 1918, lot 1270,[3] for 430 pounds and 10 shillings to Colnaghi & Obach, art dealers); Frits Lugt, Amsterdam, purchased from Colnaghi & Obach on 19 May 1919;[4] his father-in-law, Joseph Klever (1861-1935), Maartensdijk and Vienna; by descent to Jacoba Lugt-Klever and Frits Lugt, The Hague and Paris; inv. no. 285

Exhibitions

Rotterdam 1938, no. 156; Paris 1950-1951, no. 95; Paris 1983, no. 88; Paris 1989, no. 11

Literature

Hofstede de Groot 1907-1928, vol. 7 (1918), p. 57, no. 191 B (?); Gerson 1942, p. 425 and note 3; J. Walsh and C.P. Schneider in Los Angeles-Boston-New York 1981-1982, pp. 107-108 (under no. 26) and fig. 2; Gerson 1942 ed. 1983, p. 425 and note 3; M.S. Robinson in Paris 1983, pp. 145-147, no. 88 and fig. 53; M. van Berge-Gerbaud in Paris 1989, p. XVI; C. van Hasselt in *idem*, pp. 15-16, no. 11 and fig. 11; Robinson 1990, vol. 2, pp. 878-879, no. 160 (ill.); Joel 2000, pp. 30-31, 134 (under no. 102A)

Willem van de Velde the Younger's beach scenes are characterised by simple, clear-cut motifs, such as ships grouped around a pier, rendered in bright, sunny light. Most of these are small, unpretentious paintings, the best originating between 1655 and 1670, relatively early in the painter's long career. Although he was perfectly capable of evoking the light and atmosphere of the North Sea coast, the artist focused mainly on portraying ships, mostly small fishing vessels, and the activity surrounding them.[5] Van de Velde's beach scenes are therefore closely related to the calms – displaying small vessels tied up at a pier or lying at anchor in groups along the coast – which are so typical of his early work. His predecessors and contemporaries generally chose a more panoramic view of the beach and preferred to depict lively staffage engaged in all kinds of activities. This holds true, for example, for his teacher, Simon de Vlieger (1600/1-1653), who played an important role in the development of the genre, as well as for his brother, Adriaen van de Velde (cf. cat. no. 32), by whom several brilliant beach scenes are known.[6] The brothers appear to have worked together a number of times, their collaboration consisting in Adriaen painting the figures into his brother's compositions.[7]

This painting is something of an exception in the oeuvre of Willem van de Velde the Younger, owing to the extremely natural quality of its main motif, comprising only a few small fishing vessels lying at a wooden pier. The foremost ship is a pink that has been hauled up on the beach by means of a roller.[8] To the right a so-called weyschuit comes ashore, and on the left, next to the pink, are three more weyschuits. Further to the right another weyschuit sails away, with a gentleman and two ladies on board, apparently on their way to one of the large ships lying at anchor in the background. Except for the sky, the painting was done almost exclusively in grey, ochre and brown hues. The light is concentrated on one sail of the departing weyschuit – the lightest of the sails, all three of which display subtle distinctions of colour – and on the white collar and cuffs of the pointing passengers. Judging from the rather robust figures, the entire

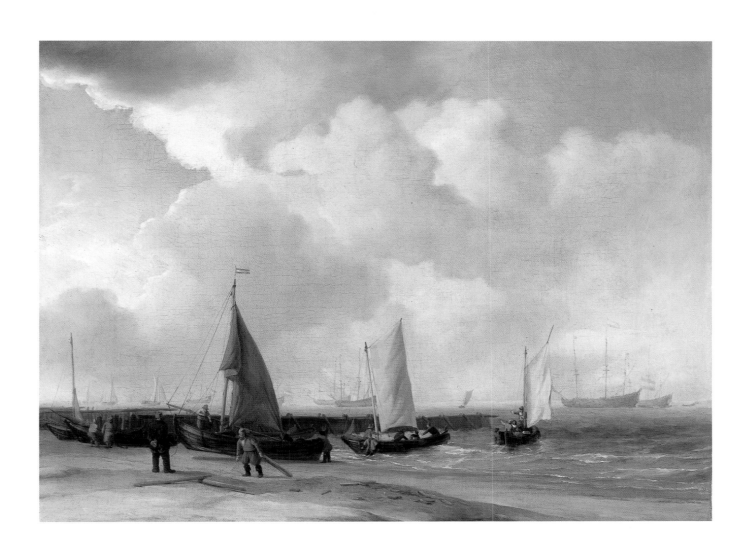

34a Willem van de Velde the Younger, *Beach scene*, c.1665.
Panel, 31.5 x 43 cm. Los Angeles, Collection of Mr and Mrs Edward
William Carter (acquired in 1973).

34b Willem van de Velde the Younger, *Beach scene near Den Helder
with a weyschuit*, 1665. Graphite, light-brown wash,
25.2 x 40.3 cm. Greenwich, National Maritime Museum
(acquired in 1934).

34c Willem van de Velde the Younger, *Beach scene with pinks and
weyschuits*, 1665. Black chalk and graphite, grey wash,
22.7 x 39.4 cm. Copenhagen, Statens Museum for Kunst.

180

painting was done by Willem van de Velde the Younger.

The scene has been identified as a view over the
Marsdiep to the island of Texel, as seen from the coast
near Den Helder. There are indeed dunes visible on
the horizon, and the Marsdiep was in fact a favourite
anchorage of large battleships and merchantmen alike.
From both written sources and depictions – drawings
by Willem van de Velde the Elder (1611-1693), for
example – it is known that the coast near Den Helder
did indeed have wooden palisades running out into the
sea, as seen here.[9] The same spot is depicted in other
paintings by Willem van de Velde the Younger, a nota-
ble example being a small beach scene in Los Angeles
(fig. 34a) that is very closely related to this painting.[10]
It, too, displays only a few small fishing craft lying at a
wooden pier, though their number is even smaller and
the viewpoint lower, allowing the pier largely to obscure
the view of the sea. The impression of an unadorned
subject observed at first hand is even stronger here,
and rightly so, for the composition of the Los Angeles
painting, including the three weyschuits lying alongside
the palisade, was taken almost exactly from a drawing
by Willem van de Velde the Younger (fig. 34b), on the
verso of which he noted the time and place: 'voor de
helder' (before Den Helder), 'wonsdach den 20 meij
1665' (Wednesday, 20 May 1665).[11]

The choice of motif in both paintings can therefore
be placed in a broader context. In the first days of May
1665 the Dutch fleet assembled at the anchorage of
Den Helder in preparation for an attack on the English
which finally took place on 13 June (see also cat. no. 33).
Willem van de Velde the Elder accompanied the fleet,
under the command of Jacob Baron van Wassenaer
Obdam (1610-1665), in the capacity of draughtsman-
reporter, producing a large number of sketches recording
the fleet's activities from the time of its departure from
the Marsdiep up to the ensuing battle.[12] There are also
a number of sheets, however, that can be attributed
to Willem van de Velde the Younger, all of them
beach scenes with small fishing vessels or views of the
assembling fleet, some of which bear precise dates
documenting their origin in Den Helder during the
last days of May and the first days of June 1665.[13] The
previously mentioned drawing (fig. 34b) belongs to
this group. Unless Willem van de Velde the Younger

accompanied his father on his 'tour of duty' with the fleet – there is however no proof of this[14] – one must assume that the painter travelled with his father to Den Helder at the beginning of May 1665 to await the fleet's departure, which finally took place on 23 and 24 May.[15] Perhaps to kill time he committed to paper suitable motifs he encountered there, for the purpose of working them up later into small paintings like those now in Los Angeles and the Frits Lugt Collection. The unremarkable motif of the beach scene, therefore, cannot have been too far removed in time or place from *The council-of-war on board the Eendracht on 24 May 1665* (cat. no. 33), which contrasts greatly with it in every respect. The immediate example for the painting described here can unfortunately not be identified. A sheet dating from 17 May 1665 – three days before the previously mentioned drawing – seems to depict the same pier and also displays large battleships in the distance. The small vessels moored at the beach, however, do not correspond exactly to those in the painting (fig. 34c).[16] Although a later date has been proposed for the painting, it probably originated not long after the series of drawings of 1665.[17] Carefully painted in fine-tuned tones, this painting shows Willem van de Velde the Younger at his best, and a dating to the mid-1660s is entirely in keeping with the style of clothing worn by the figures in the departing weyschuit.

In the eighteenth century the painting belonged to the collection of Charles Jennens (1700-1773), whom a guide to the city described in 1761 as having brought together seventeen paintings by father and son Van de Velde in his London home.[18] It was probably there that it was copied by Charles Brooking (1723-1759), possibly the most talented of the many British marine painters who attempted to imitate the work of Willem van de Velde the Younger.[19] Copies by this artist after several other paintings in Jennings's collection are also known.[20] Brooking, as was his custom, borrowed the composition of the painting discussed here in its entirety, but 'updated' his version by modernising the ships in the background.[21]

In addition to the two paintings included in this exhibition, the Frits Lugt Collection contains a third painting by Willem van de Velde the Younger, *The Four Days' Battle of 1666*.[22] Lugt felt a great affinity with the Dutch marine painters and draughtsmen of the seventeenth century, and his collection contains beautiful examples of their work. In 1989 an exhibition devoted to this subject could be put together entirely from works belonging to his collection.[23] The art of father and son Van de Velde was one of Lugt's main interests. Among the first drawings he purchased was one by Willem van de Velde the Younger, acquired in 1910, which became the starting point of a splendid ensemble of drawings by both father and son.[24] The collection now contains six sheets by Willem van de Velde the Elder, as well as sixteen drawings which can be attributed with certainty to his son.[25] Almost every aspect of their draughtsmanship is represented: ships' portraits,[26] 'journalistic' sketches by Willem van de Velde the Elder[27] and figure drawings for the staffage included in his pen paintings,[28] hasty scrawls and compositional designs by Willem van de Velde the Younger,[29] and even the instructional drawings made by the younger Van de Velde towards the end of his life, which contain detailed notes explaining his working methods.[30] *HB*

Jacobus Vrel

Active *c.*1650-1670?

35 *Woman at a window, waving at a girl, c.*1650

Panel, 45.7 x 39.2 cm / Traces of a signature on the piece of paper on the floor to the right: *J VREL* (barely legible) / Acquired in 1918

Provenance

Moritz Julius Binder (1877-in or after 1933), Berlin, 1915, seen there by Lugt in 1917;[1] Frits Lugt, Maartensdijk and Paris, acquired on 2 March 1918, together with three other paintings from the Binder Collection;[2] on loan to the Museum Boijmans Van Beuningen, Rotterdam (recorded in 1931-1932, 1935 and 1948);[3] inv. no. 174

Exhibitions

Berlin 1915, no. 151; Rotterdam 1931-1932, no. 24; Rotterdam 1935, no. 103; Paris 1965a, no. 57; The Hague-Paris 1966, no. 23; Brussels 1971, no. 116; Paris 1983, no. 94; Delft 1996, without no. [p. 181]

Literature

Plietzsch 1915, pp. 204-205 and fig. 3; Valentiner 1928-1929, p. 91; Valentiner 1929, p. xxxiv; Hannema 1932, p. 14 (ill.); Brière-Misme 1935, pp. 166 (and note 2), 168 and fig. 14; Thieme-Becker, vol. 34 (1940), p. 570; Plietzsch 1949, p. 253 and fig. 133; Magerøy 1951, fig. p. 71; Plietzsch 1960, p. 82 and fig. 137; F. Lugt in Paris 1965a, p. 32, no. 57; Bloch 1966, pp. 25-26 and fig. 18; Régnier 1968, pp. 269, 279-280, 281 note 2 and fig. 13; Reitsma 1976, pp. 253, 256, 257 note 16 and fig. 12; J. Foucart in *Le petit Larousse de la peinture*, vol. 2 (1979), p. 1955; J. Breunesse in Delft 1981, vol. 1, p. 189, vol. 2, fig. 244; S. Nihom-Nijstad in Paris 1983, pp. 156-157, no. 94 and fig. 81; Charensol 1983, p. 432; Dauriac 1983, p. 279 (ill.); Kingzett 1983, p. 503 (ill.); Prat 1983, fig. p. 128; Schlumberger 1983, pp. 48 (ill.) and 52; Hecht 1984, p. 357; P.C. Sutton in Philadelphia-Berlin-London 1984, p. 353; Todorov 1993, p. 101 and fig. 62; M.C.C. Kersten in Delft 1996, p. 181 and fig. 180, p. 224; Brejon de Lavergnée 1996, p. 16; Fock 1998, p. 231 and fig. 47, p. 246; Vollemans 1998, p. 65 and fig. p. 67; Becker 2002, pp. 54-55, 57

This panel is one of the rare works of Jacobus Vrel, about whose life nothing is known and by whom fewer than forty paintings have been preserved.[4] His earliest and probably only dated work stems from 1654 (fig. 35a), a panel which, along with two other paintings by Vrel, was already part of the collection of Archduke Leopold Wilhelm of Austria (1614-1662) at Brussels in 1659. It was perhaps acquired directly from the painter by the keeper of the archducal collection, David Teniers the Younger (1610-1690).[5] It is still not known where Vrel was active – in the past the artist has been placed in both the northern and southern Netherlands, outside the large artistic centres and even in the border regions near Germany.[6] The small size of Vrel's oeuvre, as well as his somewhat naïve style and less refined technique, has led one to believe that he was an amateur painter,[7] which is implausible, however, considering the existence of various versions of certain of his compositions (cf. fig. 35c). His surname is spelt in a number of different ways in the signatures seen on his paintings.[8] The painter's name is not to be found in any document

dating from the seventeenth century, with the exception of the inventory mentioned here.

Vrel's work consists of street scenes with figures, as well as interiors, such as *Woman at a window, waving at a girl.* Vrel's unpretentious interiors, which are certainly not among the less successful compositions by his hand,[9] are characterised by their simple design and quiet atmosphere. Again and again, we see a room with a simple floor plan, whitewashed walls and a high ceiling, the artist having taken some care with the illumination. A limited number of motifs recur in varying combinations in these scenes. For example, the figure of the woman in the present painting, with her dark clothes and tightly tied white shawl, which covers not only her hair but also her shoulders, occurs in the above-mentioned painting in Vienna (fig. 35a), as well as in other of Vrel's paintings.[10] She is often portrayed in profile or seen from the back. The painting in the Frits Lugt Collection may however be called exceptional. First of all, the motif is unusual: a woman leaning forward in her chair to make contact

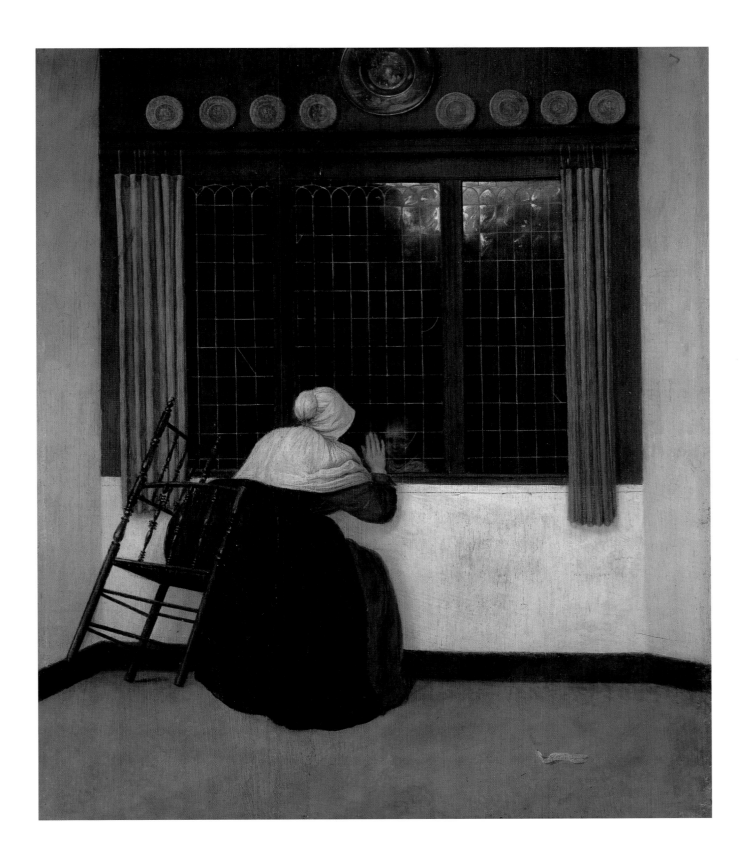

35a

35b

35a Jacobus Vrel, *Woman leaning out an open window*, 1654.
 Panel, 66 x 47.5 cm. Vienna, Kunsthistorisches Museum
 (acquired in 1908).

35b Jacobus Vrel, *Interior with woman reading*, c.1650.
 Panel, 50 x 33 cm. Formerly Schneider Collection, Paris
 (photograph: RKD, The Hague).

35c Jacobus Vrel, *A young woman watching over a sick woman
 in bed*, c.1650? Panel, 56 x 41.5 cm. Los Angeles,
 The J. Paul Getty Museum (acquired in 1971).

35c

with a barely visible girl on the other side of a dark
window. Second, the room, with its expanse of white
walls, has been kept very empty indeed. In this type of
depiction Vrel usually included at least a large fireplace,
or else several pieces of furniture, large or small.[11]
Practically nothing detracts from the figures, except for
the piece of paper on the floor and the plates placed
decoratively on the upper edge of the window, a motif
that recurs in other depictions, though always above
a fireplace or bedstead. It almost seems as though the
painter has zoomed in on the large window and the

figures' unassuming actions. Only one other painting by Vrel, the signed *Interior with woman reading* (formerly also in Paris, last recorded in the Schneider Collection), is related to the work in the Frits Lugt Collection (fig. 35b).[12] This panel also displays a low room with a similar window: the leaded panes and decorative pattern above are even identical. The atmosphere of this painting, however, is vastly different from that exuded by the Lugt panel, in that the woman is reading and, more importantly, turned towards the viewer.[13] Behind her, too, a child – though again, difficult to discern – is depicted on the other side of a dark window. This time, though, the child does not succeed in establishing contact with the woman.[14] The panel is dated slightly earlier than the Lugt painting, which in turn – considering the appearance of the same principal figure – must have been painted not long before or after the panel dated 1654 in Vienna.[15] The Vienna painting, with its more balanced composition and more refined technique, seems however to have originated somewhat later. Dating Vrel's genre scenes is no easy task, owing to the lack of other dated works, even though the simplicity of the composition described here could suggest a relatively early origin, in any case several years before the Vienna painting.

In this quiet scene with its balanced composition, the woman's chair – with both back legs off the ground, it seems to glide out from under her – provides a dramatic element.[16] This effect is heightened by the fact that the floor, painted in orange-red hues, seems to be a sloping surface, despite the presence of the dark skirting board. Nor do the walls, which recall the wings of a stage, create a convincing illusion of depth. Because the room is otherwise rather undefined, the feeling of depth is largely suggested by the contrast between the light walls and the dark clothing of the woman – who is rendered nearly in silhouette – as well as the chair on which she sits, while the dark window also stands out against the wall's white surface.[17] All things considered, the tonality of the Lugt painting is remarkably refined, which greatly benefits the quiet mood of this painting with its attractive subject.

Whereas in other scenes the window forms the only source of light, this architectural element is here placed in darkness. The face of the girl,[18] whose black cap does not completely cover her hair, is just visible behind the leaded panes. The light reflected in the window does not come from the moon (cf. also fig. 35b),[19] but from an artificial light

source in the house. The windows are in fact not in an outside wall but an inside partition wall, as Frits Lugt rightly observed, adopting the opinion of Clotilde Brière-Misme.[20] That the painter had an eye for detail emerges from the broken window panes: one to each side and as many as three in the middle section. In the upper right corner Vrel painted a nail and the shadow it casts on the wall,[21] a detail which plays a humble role in creating a feeling of depth. This detail, easily overlooked at first glance, is also seen in depictions by Johannes Vermeer (1632-1675),[22] to whom some of Vrel's paintings were optimistically attributed in the past on the basis of their subject matter and atmosphere.[23] Others to whom Vrel's works were previously ascribed include Pieter de Hooch (1629-1684) and artists inspired by him, such as Esaias Boursse (cat. no. 7) and Isaack Koedijck (1617/18-1668).[24] The attribution of this painting has never been in doubt, however, because Vrel placed his signature on the piece of paper lying on the floor.[25] Vrel is related to such painters as Vermeer and De Hooch, who was also active in Delft, only in his choice of subject – one or two figures in an interior – and not in the execution or style of his paintings. Nor can Vrel be included among their followers. In contrast to Vrel, De Hooch displays a remarkable mastery of perspective in his interiors, as well as a great interest in 'through-views' to other, often well-lit rooms. The year 1654 on the previously mentioned painting in Vienna, which appears to be one of Vrel's later works, is revealing in this context, as the earliest dated interiors by De Hooch were not done until four years later.[26] It is more likely that Vrel was active some years before such great genre painters as De Hooch and Vermeer, since the earliest genre pieces by the latter artist originated after 1655, and the above-mentioned one by De Hooch dates from 1658.[27]

Lugt once owned another painting by Vrel which he must have sold before 1929 to a Dutch collector. In 1971 it was purchased by the J. Paul Getty Museum (fig. 35c).[28] This unsigned panel is probably an autograph replica, with small changes, of a painting in Antwerp of which two other versions also exist.[29] No variation or copy is known of the panel described here, which Lugt acquired in 1918 from a German collector (see cat. no. 26). The depiction is a striking example of 'the visible world' Lugt was fond of seeing in paintings (see the introductory essay). It has all the characteristics of a depiction inspired by everyday life, containing no particular message or meaning.[30] *QB*

Emanuel de Witte

Alkmaar *c.*1616-1691/92 Amsterdam

36 *The choir of the Church of St John in Utrecht, seen from the nave,* 1654

Copper, 22.6 x 26.1 cm / Signed and dated on the pillar at the left: *E. De. W[i]tt[e] f / 16[54]* (barely legible and very abraded in places)[1]
Acquired in 1928

Provenance
Montagu Henry Edmund Cecil (1887-1963), Eighth Earl of Abingdon and Thirteenth Earl of Lindsey, Wytham Abbey, near Oxford (sale London, Sotheby's, 7 June 1928, with another painting in lot 15, as 'Neefs', for 88 pounds to Pawsey);[2] E. Douwes, art dealer, Amsterdam; Frits Lugt, Maartensdijk and Paris, purchased from Douwes on 11 June 1928;[3] inv. no. 3551

Exhibitions
Rotterdam 1935, no. 119; Paris 1983, no. 96; Rotterdam 1991, no. 36

Literature
Rotterdam 1935, no. 119 and fig. 85; E. Trautscholdt in Thieme-Becker, vol. 36 (1947), pp. 124-125; Manke 1963, pp. 32-33 (and note 1), 41, 99, no. 93, 107 (under no. 122), 150 and fig. 22; Graafhuis-Witteveen 1981, p. 20 (ill.); Liedtke 1982, pp. 85 (and note 31), 90-91 and fig. 84; S. Nihom-Nijstad in Paris 1983, pp. 160-161, no. 96 and fig. 55; G. Jansen in Rotterdam 1991, pp. 192-194, no. 36 (ill.); W. Liedtke in *The Dictionary of Art*, vol. 33 (1996), p. 267; W. Liedtke in Turner 2000, p. 402; Liedtke 2000, p. 277 note 185; L.M. Helmus in Utrecht 2000-2001, p. 15 and fig. 5; G. van Heemstra in *idem*, p. 88

Emanuel de Witte is one of the luminaries of Dutch architectural painting, even though he seems to be outshone at present by Pieter Saenredam (cat. no. 28). After training with the still-life painter Evert van Aelst (1602-1657) in Delft, De Witte entered the Alkmaar Guild of St Luke in 1636. In 1639 and 1640 the painter is recorded in Rotterdam and from 1641 he appears to have lived in Delft, where his daughter was baptised in October of that year and he became a member of the local painters' guild on 23 June 1642. After spending a decade in Delft, De Witte left the city in 1651 and moved to Amsterdam, where he died in late 1691 or early 1692. Documents mentioning the painter testify to a life of great financial setbacks and personal problems.[4] From his early years we know, among other works, history paintings and a few portraits, whereas later on, in addition to church interiors – the largest and most important part of his oeuvre – he painted market scenes and the occasional genre piece.[5] From 1650 on he devoted himself largely to painting the interiors of churches in Delft and Amsterdam, motifs derived from the latter, and even completely fantasised church interiors. Together with Gerrit Houckgeest (*c.*1600-1661), whose influence on De Witte is unmistakable,[6] De Witte is considered one of the innovators of the Dutch church interior.

The earliest dated church interior by De Witte stems from 1651 (London, The Wallace Collection),[7] a splendid, mature painting which was certainly not the painter's first exercise in the genre. The painting in the Frits Lugt Collection, whose barely legible date has been read in the past as 1654,[8] is in any case a relatively early work within the group of church interiors. For more than one reason it is unique in the oeuvre of Emanuel de Witte: its format is exceptionally small, it is painted on copper, and – more importantly – it depicts the interior of an Utrecht church, making it, as far as we know, the only portrayal the painter made of a church outside Delft or Amsterdam.[9] A year earlier, in 1653, he had produced a painting of the Amsterdam Exchange, a subject he also seems to have depicted only once.[10]

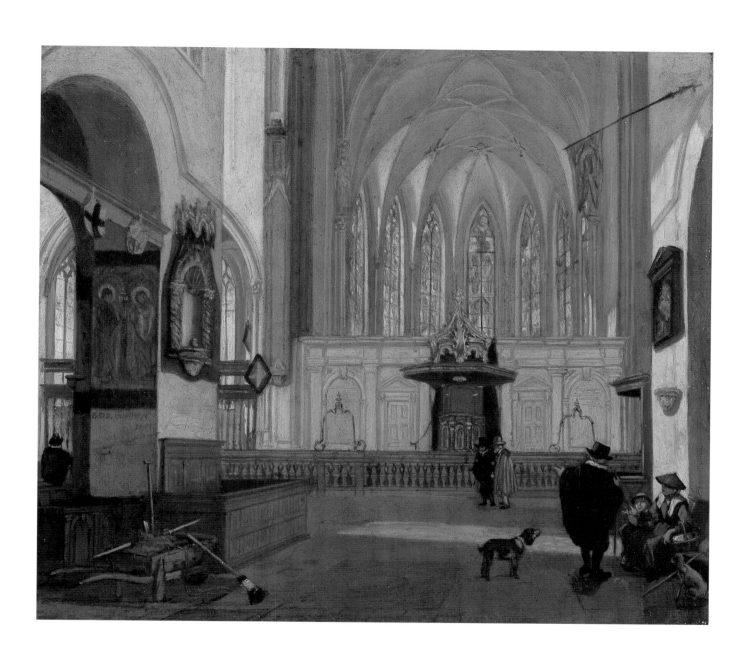

36a 36b

36a Pieter Saenredam, *The nave, the choir and St Anthony's Chapel of the Church of St John at Utrecht*, c.1650-1655. Panel, 65.6 x 83.4 cm.
 Rotterdam, Museum Boijmans Van Beuningen (acquired in 1930).
36b Pieter Saenredam, *The choir and the Van Nykercken Chapel of the Church of St John at Utrecht, seen from the north side aisle*, 1636.
 Pen, black and coloured chalk, 30.8 x 37.8 cm. Utrecht, Het Utrechts Archief (acquired in 1899).

The Church of St John (the Sint-Janskerk) at Utrecht belongs to the group of medieval churches founded by Bishop Bernold or Bernulfus (d. 1054) in the eleventh century as part of the famous cross of churches having Utrecht Cathedral at their centre. The originally Romanesque church was modernised in the course of time and renovated in Gothic style – the choir depicted here was even rebuilt in the period 1508-1539 – and, unlike the other two churches which made up the 'church cross' (introductory essay, fig. 24), it is still intact.[11] De Witte's painting reproduces the situation existing before the renovations begun in 1657, when the number of pillars between the nave and the side aisles were reduced by half.[12] As a consequence of this, the arches between the remaining pillars were drastically enlarged and given the shape of a Gothic arch, whereas to the left and right in the painting we see the characteristic rounded arches which were finally restored to their original form during renovations completed in 1981.

On the basis of the resemblance of the composition described here to the depiction of the interior of the Church of St John by Pieter Saenredam (1597-1665),

which can be dated to around 1650-1655 (fig. 36a)[13] – as far as we know, the only other seventeenth-century painting depicting the nave and choir of the church – it has been suggested that De Witte never saw St John's with his own eyes, but based his depiction either on Saenredam's painting now at Rotterdam or – an even more likely possibility – on his preparatory study of 1636 (Hamburg, Hamburger Kunsthalle).[14] That De Witte knew Saenredam's work is evidenced by other representations by his hand.[15] The composition, with its broad, frontal rendering of the nave and choir,[16] differs from the more unexpected vantage points De Witte usually chose in order to lend emphasis to ingenious perspectival effects. It therefore seems logical to assume some connection with the work of Saenredam, who was extremely popular in the 1650s and who drew or painted very similar compositions.[17] Anyone who subjects both interiors of the Church of St John to close examination sees at a glance that the two depictions were conceived differently: Saenredam rendered the full length of the northern part of the Romanesque nave and chose a lower viewpoint to show the monumentality of the building to best advantage

(we look, for example, towards the underside of an organ supported by corbels), whereas De Witte depicted only the two eastern pillars from a considerably higher vantage point. The most striking difference between the two depictions is that Saenredam painted St Anthony's Chapel, whereas De Witte's interior shows part of the Gothic Van Nykercken Chapel, situated next to the choir, which is completely lacking in the Rotterdam painting. Saenredam depicted this northern chapel in a drawing dating from as early as 1636, the year of his stay in Utrecht (fig. 36b).[18] The fact that De Witte's painting gives us a faithful picture of the existing floor plan of the church does not necessarily mean that he saw the inside of the building with his own eyes, however. If indeed he never visited Utrecht himself, he must in any case have based his depiction on Saenredam's drawing, whose drawn and painted interiors are the only other seventeenth-century depictions of the interior of the Church of St John which have been preserved.[19]

In the past all sorts of details have been pointed out which Saenredam and De Witte depicted differently. The detail most often mentioned is the rood-screen, the partition – no longer in existence – between the crossing and the choir, where the forerunner of the present-day university library was housed. De Witte's rendering shows a symmetrical construction, while it is thought that Saenredam would have depicted an asymmetrical wall.[20] This idea is certainly unfounded. The strange construction shown by Saenredam is only the result of his eccentric viewpoint and of the fact that the Gothic choir was wider than the eleventh-century nave (cf. fig. 36b).[21] Considering that Saenredam's stay in Utrecht in 1636 is completely documented,[22] and his church interiors are generally rather reliable, we can assume that De Witte permitted himself a certain amount of poetic licence in his presentation of the building, a well-known characteristic of his work. Both artists, for example, offer their own version of the rood-screen with its two feigned doors and blind niches.[23] De Witte perhaps wanted to modernise the rood-screen, displaying a wall articulated by pilasters in classicist Baroque style with a continuous architrave.[24] It is not known whether the fenced-off area used for baptisms (a Protestant 'dooptuin') in the present painting did in fact exist or whether it was a product of the painter's imagination. Perhaps the wooden trellis-work, which Saenredam did not depict, was not yet present in 1636. That the conceptions of the two painters were quite different

emerges from a comparison of their interiors of the Utrecht church: Saenredam stressed the architecture and the empty space, whereas De Witte actually strove to depict an attractive church interior full of atmosphere. Not surprisingly, he painted with much looser and freer brushstrokes, and gave much more importance to the staffage. In the right foreground we see a man conversing with a woman accompanied by a child and a dog, above whom a banner is depicted in a striking yet awkward manner. Two men saunter in front of the pulpit – the fanciful decoration on the pulpit's octagonal sounding board does not seem to reflect the existing situation[25] – and at the far left we see another man from the back. The wheelbarrow at the lower left can be seen as a *memento mori*. The diamond-shaped plates and escutcheons on the pillars remind the viewer that the church is also a place of burial, a fact explicitly referred to by the shovel stuck in the earth-filled wheelbarrow and the conspicuous broom.

Not only the representation but also the use of material can be connected with Saenredam. For this interior painted on copper, De Witte used gold paint and, in the decoration on the pillar between the choir and the Van Nykercken Chapel, even gold leaf.[26] This manner of working, which he is thought to have used only here, otherwise occurs among the architectural painters only in the work of Saenredam, who continued to use it throughout his career.[27] In seventeenth-century painting the use of gold leaf, usually associated with fifteenth- and early-sixteenth-century paintings, was certainly not uncommon.[28] De Witte's use of gold leaf has been explained as an attempt by the painter, who was not especially successful during his lifetime, to become more widely known among the buyers and famous collectors of the work of the highly successful Saenredam.[29] In this painting the use of gold leaf is clearly visible, for example, in the escutcheons hanging from a transverse beam on the left, the haloes of the two saints in the wall painting below (which disappeared long ago) and the adjacent niche with a baldachin. The painting's appeal consists mainly in its successful light effects and subtle treatment of colour. With rather broad brushstrokes the painter managed to do justice to the details of the church's interior, as evidenced, for example, by the rendering of the stained-glass windows of the choir and by the light falling on the stone floor and the pillar to the right. *QB*

Scholarly Apparatus

Notes

to the introductory essay

1 Meijers 1977, p. 59 ff.
2 Lugt 1918a, pp. 12, 36, 37.
3 Lugt 1918a, p. 11.
4 Lugt 1918a, p. 20.
5 Lugt 1918a, p. 16.
6 Van Gelder 1964, p. 17.
7 Plomp 2001, p. 286.
8 For Abraham Bredius, director of the Mauritshuis in the period 1889-1909, see The Hague 1991-1992.
9 Reitsma 1997, p. 9 ff.
10 Van Gelder 1964, p. 13.
11 Fondation Custodia Archives.
12 Reitsma 1997, p. 12.
13 Fondation Custodia Archives.
14 The occasional exception was made to this rule. In 1913 he purchased *A Carthusian monk*, then attributed to Agostino Carracci, for 100 guilders at Frederik Muller's from the collection of J.P. Richter. It was his first Italian drawing. See Byam Shaw 1983, vol. I, p. XI.
15 Sérullaz 1971, p. 40. See also Gerson 1964, pp. 33-39. For Lugt's donation, see also the first annual report of the Netherlands Institute for Art History (RKD) for 1932 (Schneider 1933, pp. 88-90, 95, 98, 100).
16 F. Lugt in Amsterdam 1903, pp. V, VI, X and XI.
17 Hennus 1950, p. 93.
18 F. Lugt in *Vincent van Gogh: Tableaux, Aquarelles-Dessins, Vente à Amsterdam. Le 3 mai 1904* (Lugt no. 62240). On the inside cover of this catalogue, which is still preserved in Paris, Lugt pencilled the note: 'bijna alles opgehouden slechts enkele voor ten hoogste 3 à 400 fl. verkocht' (almost everything withdrawn; only a few lots sold for 300 to 400 guilders).
19 Lugt 1918b.
20 Lugt purchased two paintings by Ludolf Backhuysen and Willem van de Velde the Younger (cat. nos. 3 and 33), which also belonged to Janssen's collection, in 1924 and 1965 respectively for his own collection. For the painting by Van Goyen, see S. Nihom-Nijstad in Paris 1983, pp. 55-56, no. 33 and fig. 27.
21 Lugt sold this painting to the collector E.A. Veltman; it is now in the Mauritshuis. On this painting see The Hague 1958-1959, no. 19 and fig. 19; Braun 1980, p. 104, no. 132 and fig. 132; C. Brown in Oxford 1999-2000, p. 30 and fig. 25.
22 Fondation Custodia Archives.
23 Fondation Custodia Archives.
24 Reitsma 1997, pp. 16, 17.
25 Fondation Custodia Archives.

26 Lugt 1915. See also Amsterdam-Paris 1998-1999.
27 *Boys at play* is reproduced in New York-Paris 1977-1978 (pp. 25-26, no. 14 and fig. 98). The painting by Berckheyde may be a view of the Hofvijver that was shown at Goudstikker's gallery in Amsterdam in 1916 (panel, 32.5 x 40.5 cm), mentioned in Lawrence 1991, p. 72 note 18, no. c.
28 Lugt most probably rented the building at Lange Vijverberg 14 before the purchase in 1936. See also Sutton 1976, p. 11.
29 Von Bode ed. 1997, vol. 2, p. 327.
30 For the Binder Collection and the painting by Dubbels, see cat. no. 26 note 21.
31 See the typed *Visite guidée à l'Institut Néerlandais*, p. 30 (Fondation Custodia Archives), for which Lugt himself supplied the information. It suggests that the signature had been suppressed in the hope that the panel could be attributed to a bigger name, perhaps even to Vermeer.
32 For the drawing *Farmhouse among trees*, previously attributed to Rembrandt, see M. van Berge-Gerbaud in Paris-Haarlem 1997-1998, pp. 166-168, no. 74, ill. (as Jacob I Koninck); for the sheet by Rubens, see London-Paris-Bern-Brussels 1972, pp. 119-121, no. 84 and fig. 42.
33 In an obituary written in 1963 Lugt referred to Hennus as his musical fellow art lover and a 'creditable dilettante', with a gift for making watercolour landscapes (see Lugt 1963). Hennus, who advised the collector H.E. ten Cate on his purchases of modern art, acted as the intermediary between Lugt and this textile baron, who also took an interest in old masters.
34 Hennus 1950, p. 103.
35 Fondation Custodia Archives.
36 Fondation Custodia Archives.
37 Kruidenier-Van der Spek 2000, p. 112 ff.
38 Göpel 1964, pp. 334a-b.
39 Their youngest daughter Irene was born in 1928.
40 Fondation Custodia Archives.
41 In 1906 a large part of the drawing collection of Fairfax Murray was bought up by J.P. Pierpont Morgan; Lugt nonetheless managed to purchase eight drawings from this collection at Christie's in London on 30 January 1920. See also Sutton 1976, p. 12.
42 See also Byam Shaw 1983, vol. I, p. X.

43 Dossi 1999, pp. 38-43.
44 Fondation Custodia Archives. A copy exists of a letter written to Dr Hensler in 1933 revealing that Hensler sold some Rembrandt prints from the collection on the instructions of Prince Johann-Georg, Duke of Saxony, to alleviate the duke's financial distress. The letter came from the Vermögens-verwaltung and it completely cleared Lugt's name of any blame. The copy was sent to Lugt by Erhard Göpel (the author of the article on Lugt in *Die Weltkunst*, published in 1964 to mark his eightieth birthday).
45 For the Flemish paintings in the Frits Lugt Collection, see Nihom-Nijstad 1983 (ill.).
46 For the monogrammed landscape, see S. Slive in The Hague-Cambridge 1981-1982, pp. 84-85, no. 25 (ill.); S. Nihom-Nijstad in Paris 1983, pp. 116-117, no. 70 and fig. 17.
47 Byam Shaw 1983, vol. I, pp. 218-219, no. 217, vol. 3, fig. 249.
48 Fondation Custodia Archives.
49 Van Gelder 1964, p. 5.
50 See note 53.
51 Heijbroek-Wouthuysen 1993, p. 36.
52 The fourth and last volume, on the catalogues that appeared in the period 1901-1925, was published posthumously in 1987.
53 Fondation Custodia Archives. For the history of Lange Vijverberg 14, see Van Diepen 1942; for that of the adjoining house at no. 15, see C.M.H. Kolstee in The Hague 1991, pp. 8-15 (and fig. p. 8).
54 Hennus 1950, p. 131.
55 Stechow, himself a refugee, was appointed Associate Professor of the University of Wisconsin in 1937. He was Professor of Art at Oberlin College in Oberlin, Ohio from 1940 to 1963. In 1966 he wrote a handbook on the seventeenth-century Dutch landscape (Stechow 1966).
56 On this subject, cf. the comments in Venema 1986, pp. 111, 515 note 147.
57 Gerson 1964, p. 33 ff.
58 Fondation Custodia Archives.
59 Fondation Custodia Archives.
60 M. van Berge-Gerbaud in Paris-Haarlem 1997-1998, p. VII.
61 Stechow published articles on Breenbergh, Weenix and Both, some before and some just after the war (see A. Blankert in Utrecht 1965, p. 15).
62 For Berchem's view of Tivoli, see S. Nihom-Nijstad in Paris 1983, pp. 12-14, no. 6 and fig. 39.

63 See cat. no. 33 note 35.
64 Byam Shaw 1983, vol. I, p. XIV.
65 Snoep-Reitsma 1973a, pp. 161, 162; Snoep-Reitsma 1973b, pp. 161, 162.
66 S. Nihom-Nijstad in Paris 1983, pp. 57-58, no. 34 and fig. 72.
67 Fondation Custodia Archives.
68 Fondation Custodia Archives.
69 *Corpus*, vol. I (1982), pp. 424-426, no. B 5; Bredius/Gerson 1969, no. 11.
70 E. Buijsen in London-The Hague 1999-2000, pp. 122-123, no. 18 (ill.). This portrait was stolen from the Nationalmuseum, Stockholm.
71 Fondation Custodia Archives.
72 Fondation Custodia Archives. For the painting by Rubens see Adler 1982, pp. 167-168, no. 58 and fig. 141; C. Brown in London 1996-1997, pp. 74 and 75, fig. 70.
73 For an illustration of *The pearl necklace* see Blankert 1982, no. A-168 and fig. 179; The Hague 1992, p. 104. The painting by Jan Steen is mentioned in Hofstede de Groot 1907-1928, vol. I (1907), p. 71, no. 288; Braun 1980, p. 138, no. 350 and fig. 350 (as signed and dated 1672).
74 S. Nihom-Nijstad in Paris 1983, pp. 130-133, nos. 80-81, figs. 82 and 77. For the painting by Jan Steen in Museum Boijmans Van Beuningen, see Braun 1980, p. 105, no. 143 and fig. 143; Lammertse *et al.* 1998, pp. 170-172, no. 58 (ill.).
75 Schwartz-Bok 1989, pp. 247-251. In 1937-1938 Museum Boymans mounted the first exhibition devoted wholly to this painter (Rotterdam 1937-1938, passim).
76 Fondation Custodia Archives.
77 In the 1920s Lugt purchased three more drawings: *The great organ in the Church of St Bavo in Haarlem* for 100 guilders, *The tomb of count Floris V in the Church of St Lawrence, Alkmaar* for 25 guilders, and *Interior of the Church of St Cunera, Rhenen* for 4,400 guilders. The latter is a large, beautifully elaborated drawing. He purchased them in 1925, 1926 and 1928 respectively from a French art dealer, at an anonymous auction in Paris and from Frederik Muller at the Six auction in Amsterdam. See also cat. no. 28 note 29.
78 Fondation Custodia Archives.
79 This work is now in the Carter Collection, Los Angeles; for the painting see Schwartz-Bok 1989, p. 280, no. 152 and fig. 217; J. Giltaij in Rotterdam 1991, pp. 116-119,

no. 17 (ill.); L.M. Helmus in Utrecht 2000-2001, pp. 178-179, no. 31 (ill.).
80 Fondation Custodia Archives. Lugt resold the view in the Buurkerk, Utrecht (which he wrongly referred to as Haarlem) to Fentener van Vlissingen, while he made a gift of the round view in St Bavo's to his friend Hennus. For the former work see F. Lugt in Paris 1970, no. 38 and fig. 35; Schwartz-Bok 1989, p. 275, no. 123 and fig. 220; L.M. Helmus in Utrecht 2000-2001, pp. 188-189, no. 35 (ill.). The little circular painting from the Coats Collection (panel, 9.5 cm in diameter, photograph RKD no. L 31179) was once attributed to Saenredam. Lugt must have doubted its authenticity, however, given the price. The work is not included in Utrecht 1961 or Schwartz-Bok 1989, and was last recorded at Sotheby-Mak van Waay, 29 April 1985, lot 38 (ill.).
81 Auction of the Guterman Collection, New York, Sotheby's, 12 December 1988, lot 34, ill. (with data on provenance and literature); Schwartz-Bok 1989, p. 266, no. 86 and fig. 60.
82 For this painting by Saenredam, see F. Lugt in Paris 1970, no. 19 and fig. 19; Schwartz-Bok 1989, p. 264, no. 81 and fig. 237; J. Giltaij in Rotterdam 1991, pp. 128-129, no. 20 (ill.).
83 Fondation Custodia Archives. For the painting by Saenredam acquired by the Mauritshuis, see F. Lugt in Paris 1970, no. 49 and fig. 45; Broos 1987, pp. 338-444, no. 56 (ill.); Schwartz-Bok 1989, p. 280, no. 147 and fig. 253; L.M. Helmus in Utrecht 2000-2001, pp. 98-100, no. 3 (ill.). For the painting that is now in the Frans Halsmuseum, see F. Lugt in Paris 1970, no. 55 and fig. 49; Schwartz-Bok 1989, p. 283, no. 171 and fig. 242; L.M. Helmus in Utrecht 2000-2001, pp. 226-228, no. 48 (ill.).
84 F. Lugt in Paris 1970, p. 6.

Note
to quote on p. 39

* F. Lugt in *Le Cabinet d'un Grand Amateur: P.-J. Mariette 1694-1774*, Paris (Musée du Louvre) 1967, pp. 13-15

1 Jan Asselijn

1 The painting is made of two pieces of canvas of different sizes and with a different weave density that have been sewn together and pasted to a panel. The largest of the two canvases accommodates the large trees on the right and the bridge. The dividing seam crosses the picture at a curious angle (see S. Nihom-Nijstad in Paris 1983, p. 5; A. van Suchtelen in The Hague 2001-2002, pp. 74 and 158 note 6).
2 Lugt no. 5804.
3 Lugt no. 8054. For Van der Werff's art collection, see Priem 1997, p. 146. Steland-Stief (1971, p. 163, in no. 232) mistakenly gave the purchaser's name as 'Molemans', adding without further clarification that the painting was acquired 'für v. d. Werf in Haarlem'.
4 For Meulemans as a painter, see A. Staring in Thieme-Becker, vol. 24 (1930), p. 450; as a purchaser at auctions he is mentioned, for instance, in Priem 1997, p. 146 note 111. For paintings by him, see Van Thiel *et al.* 1976, p. 380, nos. A 1174 and C 179.
5 Lugt no. 10327. Steland-Stief (1971, p. 163, in no. 232) wrongly referred to this former owner as 'Hulsuit', probably copying the reference from the sale catalogue featuring the painting in 1953 (see note 7). On Hulswit, a painter and draughtsman who collected and was also active as an art dealer, see A. Staring in Thieme-Becker, vol. 18 (1925), pp. 117-118; for paintings by him, see Van Thiel *et al.* 1976, p. 293, nos. A 1050-A 1051 (ill.).
6 For Brondgeest, who worked as a painter, etcher and art dealer, see W. Steenhoff in Thieme-Becker, vol. 5 (1911), p. 59; Van Thiel *et al.* 1976, pp. 184-185, no. C 114 (copy after Aelbert Cuyp).
7 Copy of the catalogue at the RKD, The Hague.
8 For Asselijn, see Steland-Stief 1971; Steland 1989; A.C. Steland in *The Dictionary of Art*, vol. 2 (1996), pp. 614-615 (reprinted in Turner 2000, pp. 2-3).
9 Steland-Stief 1971, p. 164, nos. 235-236. The winter landscape, accompanied by a summer landscape, that is attributed to Asselijn on the basis of a forged monogram, is certainly not by him (circular panel, 16.2 cm in diameter; sale

New York, Christie's, 21 January 1996, lot 60 and colour ill.; photograph in the Netherlands Institute for Art History (RKD), The Hague).
10 Steland-Stief 1971, pp. 55, 163, no. 233 and fig. p. XXI.
11 According to Steland-Stief (1963, vol. I, p. 84; 1964, p. 102 note 13; 1970, p. 62; 1971, p. 56), the painting in the Frits Lugt Collection, like the above-mentioned pendants, was made during Asselijn's stay in Lyon in 1644-1645 (following Stechow 1966, p. 81, who dated the winter landscape discussed here around 1645). This dating was refuted on stylistic grounds, however, by A. Chong (in Amsterdam-Boston-Philadelphia 1987-1988, p. 251 and note 3); cf. also A. van Suchtelen in The Hague 2001-2002, pp. 74, 158 note 4.
12 See the list of dated works by Asselijn in Steland-Stief 1971, p. 119.
13 A. Chong in Amsterdam-Boston-Philadelphia 1987-1988, p. 251 note 3.
14 On Asselijn's move to Amsterdam, see Steland 1989, pp. 12, 14. For the portrait of him completed around 1648, see Hollstein, vol. 13, pp. 129-130, no. 277; vol. 14, pp. 226-227 (ill.); E. Hinterding in Amsterdam-London 2000-2001, no. 56, with illustrations of the three states in colour.
15 Steland-Stief 1971, pp. 20-34 (ill.); Steland 1989, p. 11.
16 Cf. J. de Meyere in Cologne-Utrecht 1991-1992, pp. 57-59; Montreal 1990, pp. 22-27 (ill.).
17 A.C. Steland in *The Dictionary of Art*, vol. 2 (1996), p. 614 and in Turner 2000, p. 2.
18 Steland-Stief 1964; Steland-Stief 1971, pp. 102-106 (ill.).
19 Steland-Stief 1971, pp. 107-111, ill. (with a one-sided caption, 'Die Einwirkung Jan Asselijns auf Nicolaes Berchem' – 'the influence of Jan Asselijn on Nicolaes Berchem').
20 For Berchem's winter landscapes, see The Hague 2000-2001, pp. 60, 90-93, nos. 9-10 (ill.); p. 157 note 135.
21 Inv. no. SK-A-27; A. Chong in Amsterdam-Boston-Philadelphia 1987-1988, p. 251 and fig. 2; A. van Suchtelen in The Hague 2001-2002, p. 61, fig. 49. On the painting in Worcester, see the two publications already mentioned and Steland-Stief 1971, pp. 77-78, 164, no. 237 and fig. p. LI; F.J. Duparc and L.J. Graif in Montreal 1990, pp. 50-51, no. 2 (ill.); B. Broos in The Hague-San Francisco 1990-1991, pp. 134-139, no. 2 (ill).

22 According to A. Chong (in Amsterdam-Boston-Philadelphia 1987-1988, p. 251; followed by A. van Suchtelen in The Hague 2001-2002, pp. 60 and 157 note 135) it was Berchem's painting that inspired Asselijn and not the other way around. See, however, Steland-Stief 1971, pp. 78, 107 and esp. Slive 1974, pp. 77-78 and F.J. Duparc and L.J. Graif in Montreal 1990, p. 51, who rightly note the connection between a sheet that Asselijn produced in Rome and the building in the painting at Worcester.
23 Steland-Stief 1971, pp. 163-164, no. 234 and fig. p. LXXXI; A. Chong in Amsterdam-Boston-Philadelphia 1987-1988, pp. 250-251 and fig. I; F.J. Duparc and L.J. Graif in Montreal 1990, p. 50 and fig. 25.
24 Steland-Stief 1971, p. 120 ('Gliederung nach Darstellungs-themen'). Cf. also Montreal 1990, pp. 48-49, no. I, ill.
25 Steland-Stief 1971, pp. 102-103 and fig. p. LXXII; F.J. Duparc and L.J. Graif in Montreal 1990, pp. 180-181, no. 58 (ill.).
26 Steland-Stief 1971, nos. 104-107, 148, 178-204 (ill.). See also P. Huys Janssen in The Hague 1991, pp. 48-49, no. I (ill.); E. Buijsen in Tokyo-Kasama-Kumamoto-Leiden 1992-1993, pp. 213-214, no. 70 (ill.); A. van Suchtelen in The Hague 2001-2002, p. 158 note 2. Nash (1972, fig. 94) actually called the painting discussed here 'The Bridge'.
27 Steland-Stief (1971, pp. 56 and 163, no. 232) erroneously describes it as 'graugrünes Wasser, auf dem dünes Eis treibt' and 'ein Flüßchen mit Treibeis'. But snow will soon melt on an ice floe, whereas here the painter has depicted snow on various parts of the frozen water, both in front of and behind the bridge.
28 Emanuel de Witte (cat. no. 36) had a similar habit of always giving one figure a prominent role in his pictures by dressing it in a red cloak (cf. e.g. Rotterdam 1991, nos. 34, 35, 37, 38 and colour ills.).
29 A. van Suchtelen in The Hague 2001-2002, p. 37, fig. 25 and p. 74; Bellosi (1975) attributed the illumination of *Les très riches heures* to Barthélémy d'Eyck.
30 *Huntsmen in the snow*, Vienna, Kunsthistorisches Museum (Marijnissen 1988, ill. p. 266; The Hague 2001-2002, p. 39, fig. 28).
31 In Asselijn's *Landscape with company of huntsmen* in Vienna (Trnek 1992, pp. 28-30, no. 10, ill.,

193

Notes
to the catalogue entries

as *c.*1645), which according to Steland-Stief (1971, p. 56) was made in the same period, a large tree is cut off at the edge of the picture in the same abrupt way.
32 Stechow (1966, p. 92) referred early on to its 'unusual, very upright proportions'. On horizontal and vertical formats in Dutch landscapes, compare e.g. Stechow 1966; Amsterdam-Boston-Philadelphia 1987-1988; Tokyo-Kasama-Kumamoto-Leiden 1992-1993.
33 The Hague 2001-2002.
34 Steland-Stief 1971, pp. 55 and 56; F.J. Duparc in Atlanta 1985, p. 17.
35 Cf. e.g. a winter landscape with figures grouped around a bridge by Isack van Ostade (1621-1649), a panel with virtually the same dimensions possessing a far more anecdotal quality than the work described here (canvas, 45 x 36 cm; Venice, Accademia; Hofstede de Groot 1907-1928, vol. 3 (1910), p. 552, no. 278; photograph RKD, The Hague).
36 See Provenance; cf. also Priem 1997, p. 146 and fig. 47.
37 Lugt purchased from Duits paintings by Jan Both (cat. no. 6; acquired in 1949), Bartholomeus Breenbergh (in 1961) and Jan van Noordt (in 1965); see S. Nihom-Nijstad in Paris 1983, nos. 12, 15, 58 (ill.).
38 Steland-Stief 1971, p. 164, in no. 237; Slive 1974, vol. 1, p. 78.
39 Note by Lugt in sale catalogue London, Christie, Manson & Woods, 23 June 1950, lot 1: 'goed, maar stijf van compositie' (personal copy of Frits Lugt at the Netherlands Institute for Art History (RKD), The Hague); quoted by Steland-Stief 1971, p. 164, in no. 237.
40 S. Nihom-Nijstad in Paris 1983, nos. 19, 33, 60, 71, 85, 91 and figs. 24-29.
41 For the paintings by Berchem, Breenbergh and Romeyn, see S. Nihom-Nijstad in Paris 1983, nos. 6, 15, 69 (ill.).
42 Inv. nos. 7432 and 7391 respectively; Steland 1989, p. 50, fig. 38, p. 240, no. 132 ('sicher zuschreibbar'); *idem*, p. 141, fig. 135 and pp. 240-241, no. 133 ('vielleicht zuschreibbar').

2 Hendrick Avercamp

1 Lugt no. 68643.
2 For Avercamp, see Welcker 1933; Welcker ed. Hensbroek-van der Poel 1979; Amsterdam-Zwolle 1982;
A. van Suchtelen in Amsterdam 1993-1994, pp. 299, 634-639; D.B. Hensbroek-van der Poel in *Allgemeines Künstler-Lexikon*, vol. 5 (1992), p. 729; D.B. Hensbroek-van der Poel in *The Dictionary of Art*, vol. 2 (1996), pp. 854-856 (reprinted in Turner 2000, pp. 4-6); Schapelhouman-Schatborn 1998, vol. 1, pp. 1-11; A. van Suchtelen and P. van der Ploeg in The Hague 2001-2002, pp. 50-52, 58-59, 78-89.
3 Avercamp's presence in Kampen on 28 January 1613 is confirmed by an inscription on the back of a drawing in the Lugt Collection (see note 20).
4 Formerly in the collection of Mrs Van Heek-van Hoorn in Enschede; sale Amsterdam, Sotheby's Mak van Waay, 14-15 March 1983, lot 55, colour ill. (Welcker ed. Hensbroek-van der Poel 1979, p. 206, no. s XXXVIII). According to Stechow (1966, p. 197 note 15) 'possibly the only fully authenticated "non-winter" panel of the artist'. In his sketch of the chronology of Avercamp's oeuvre, A. Blankert (in Amsterdam-Zwolle 1982, p. 28), too, includes the picture among the artist's later works.
5 This apparatus was used to hoist the nets from the water (Sutton 1992, p. 16, under no. 2; Schapelhouman-Schatborn 1998, vol. 1, p. 6). A similar tackle is shown in use in a painting by Barent Avercamp in the Gemäldegalerie, Staatliche Museen, Berlin (Welcker ed. Hensbroek-van der Poel 1979, p. 331, no. BAS 11, figs. XXXVIII and 63).
6 Sutton 1992, pp. 16, 19 and 20 note 8; P.C. Sutton in Amsterdam-Boston-Philadelphia 1987-1988, p. 27 and Madrid 1994, p. 68. For an overview of Avercamp's use of the motif see S. Nihom-Nijstad in Paris 1983, pp. 7-8.
7 A. van Suchtelen in Amsterdam 1993-1994, p. 636.
8 Inv. no. 214; Paris 1989, no. 15 and fig. 21.
9 On this technique see A. van Suchtelen in The Hague 2001-2002, pp. 80 and 159 note 2. Avercamp's nephew Barent seems to have made use of it as well (A. van Suchtelen in The Hague 2001-2002, p. 76).
10 Boston, Maida & George Abrams Collection; see Amsterdam-Vienna-New York-Cambridge 1991-1992, no. 25; Plomp 2001, p. 99 and fig. 78. A framed drawing by the artist is also noted in the 1680 inventory of the artist Jan van de Cappelle (see note 12).
11 Sale Berlin, Graupe, 3 November 1931, lot 4 (ill.); Welcker ed. Hensbroek-van der Poel 1979, p. 306, no. T 548. The sheet is probably cut on the right: a copy in the Schlossmuseum in Weimar, namely, shows the same family complete with two ladies as in the work here under discussion, as well as the woman and child on the dike, the latter carrying a bundle on her head (inv. no. KK 4726; Welcker ed. Hensbroek-van der Poel 1979, p. 318, no. T XXXII.3).
12 At his death in 1679, the painter Jan van de Cappelle (see cat. no. 9) owned three portfolios containing, respectively, 286, 288 and 306 drawings by Avercamp, plus 'een teekeningh, winter, met een glaesje, van de Stomme' (a drawing, winter, with glass, of the Mute; Bredius 1892, p. 34, no. 73, p. 37, no. 14, p. 38, no. 38, p. 39, no. 73). P. Schatborn (in Amsterdam-Washington 1981-1982, p. 44) concluded that these must have represented the artist's studio stock.
13 White-Crawley 1994, p. 164, no. 263.
14 Sutton 1992, p. 15, with ills. On Cabel's familiarity with Avercamp's drawings see also Schapelhouman-Schatborn, p. 6.
15 Clara Welcker attributed the painting to Arent Arentsz, called Cabel (Welcker 1933, p. 232, no. s v). In his review of her book, Van Gelder (1934, p. 78) dismissed her assertions and D. Hensbroek-van der Poel included it in her revised edition of Welcker's monograph as the work of Avercamp (p. 241, no. s v). C. van Hasselt (in Paris 1989, p. 3) also thought it unlikely to be by Barent Avercamp. On Barent Avercamp, see Welcker ed. Hensbroek-van der Poel 1979, pp. 121-129; D.B. Hensbroek-van der Poel in Amsterdam-Zwolle 1982, pp. 57-62; A. van Suchtelen in The Hague 2001-2002, p. 76.
16 On the chronology of Avercamp's work, see A. Blankert in Amsterdam-Zwolle 1982, pp. 19-28; A. van Suchtelen in Amsterdam 1993-1994, pp. 299, 634-639; Schapelhouman-Schatborn 1998, vol. 1, pp. 1-11; A. van Suchtelen in The Hague 2001-2002, pp. 78-89.
17 S. Nihom-Nijstad noted this detail in Paris 1983, p. 7.
18 See A. van Suchtelen in Amsterdam 1993-1994, pp. 636-637; Schapelhouman-Schatborn, p. 9. W.W. Robinson (in Amsterdam-Vienna-New York-Cambridge 1991-
1992, p. 66) suggested, however, that Avercamp had made works in series even earlier.
19 It is thanks to Bob Haboldt and Goedele Wuyts that the painting can be reproduced here. The motif of the bound calf on a sleigh can also be found in a monogrammed winter landscape by Arent Arentsz in the Amsterdams Historisch Museum (The Hague 2001-2002, pp. 72-73, no. 1, ill.), which also includes, in the left background, the tents with sleighs and various figures with small variations.
20 *Landscape with a river*, inv. no. 4953 (Brussels-Rotterdam-Paris-Bern 1968-1969, no. 2 and fig. 29; Welcker ed. Hensbroek-van der Poel 1979, pp. 66, 252, no. T 1). The reverse of this oval drawing bears the inscription: 'Hendrick Avercamp heeft mij dit geleueret den 28. Januarij 1613 in Campen' and was probably executed several years before, in 1609 (A. Blankert in Amsterdam-Zwolle 1982, pp. 20-21; A. van Suchtelen in Amsterdam 1993, p. 638). In addition to the aforementioned sheet *Fishermen on a canal near Kampen* (fig. 2b and note 8), the following drawings by Avercamp can be found in the Lugt Collection: *Man on the Zuiderzee at Kampen*, inv. no. 213 (Welcker ed. Hensbroek-van der Poel 1979, p. 276, no. T 131.12 and fig. XV A; Paris 1989, no. 16 and fig. 22); *Ships on an inland waterway, with a town in the distance*, inv. no. 3656 (Welcker ed. Hensbroek-van der Poel 1979, p. 276, no. T 131.17; Paris 1989, no. 16 and fig. 22); *Study of two men*, inv. no. 785, *Study of a woman*, inv. no. 786, *Study of a fisherwoman seated on a basket*, inv. no. 787 (Welcker ed. Hensbroek-van der Poel 1979, p. 276, nos. T 131.13a, b, c); *A sailing ship being hauled*, inv. no. 809 (Welcker ed. Hensbroek-van der Poel 1979, p. 276, no. T 131.11); *View of a village with a castle*, inv. no. 5183 (Brussels-Rotterdam-Paris-Bern 1968-1969, no. 3 and fig. 31; Welcker ed. Hensbroek-van der Poel 1979, p. 276, no. T 131.16 and fig. XVI A); *Ice scene at Kampen*, inv. no. 5461 (New York-Paris 1977-1978, no. 1 and fig. 15; Welcker ed. Hensbroek-van der Poel 1979, p. 276, no. T 131.15); *Ice scene near a city gate, with a windmill*, inv. no. 5462 (Welcker ed. Hensbroek-van der Poel 1979, p. 263, no. T 65, figs. XXXV and XVIII); *Study of a woman cleaning a bowl*, inv. no. 9051.

21 *A fisherman and his wife in the reeds on the banks of a river*, inv. no. 692, acquired in 1921 (S. Nihom-Nijstad in Paris 1983, pp. 3-4, no. 1 and fig. 11).

3 Ludolf Backhuysen

1 Lot 20: '*Le même*. [BACKHUYSEN. (LUDOLF)] / Un coucher de soleil par un temps calme. Sur le premier plan, une terrasse sur laquelle sont assis deux pêcheurs. Derrière cette terrasse coule une rivière de Hollande, dans laquelle sont tendus leurs filets et qui, couverte de plusieurs barques de pêcheurs, va ensuite vers la droite à perte de vue, tandis qu'à gauche, sur le second plan, on aperçoit un village avec un moulin-à-vent. / L. 37, H. 41. T[oile].' (Lugt no. 14692; higth and width have been erroneously confused).

2 Hofstede de Groot does not mention the painting in the account of his visit to the collection of Arthur Kay in 1893 (Hofstede de Groot 1893). For Kay, see Edinburgh 1992, p. 166. A number of paintings from his collection ended up in the Michaelis Collection in Cape Town (Fransen 1997, passim).

3 For Backhuysen, see Hofstede de Groot 1907-1928, vol. 7 (1918); Bol 1973, pp. 301-307; Haak 1984, pp. 180-181; Amsterdam 1985; Emden 1985; Minneapolis-Toledo-Los Angeles 1990-1991, pp. 91-97 (nos. 2-7), 402-403; De Beer 1993; Brozius 1993; De Beer 1995; G. de Beer in *Allgemeines Künstler-Lexikon*, vol. 6 (1992), pp. 175-176; B. Broos in *The Dictionary of Art*, vol. 3 (1996), pp. 84-86 (reprinted in Turner 2000, pp. 12-13); G. de Beer in Rotterdam-Berlin 1996-1997, pp. 315-331; F. Lammertse in *idem*, pp. 50, 440-445.

4 For Backhuysen's paintings in pen and ink, probably all dating from the period 1655-1660, see F. Lammertse in Rotterdam-Berlin 1996-1997, pp. 440-445, nos. 104-105 (ill.).

5 Houbraken 1718-1721, vol. 2 (1719), pp. 236-244. For the painter's years in apprenticeship, see W.L. van de Watering in Amsterdam 1985, pp. 6-7; B. Broos in *idem*, p. 73; Davies 2001, pp. 31-32, 72-73.

6 For Backhuysen's earliest dated paintings, see De Beer 1995, pp. 366-367 (ill.).

7 For this painting, see Moes 1893; Amsterdam 1985, pp. 32-33, no. S 8 (ill.).

8 From the unfinished autobiography of Wilhelm Tischbein (1751-1829), *Aus meinem Leben* (quoted by Niemeijer 1981, p. 152). For the dramatic quality of Backhuysen's work, see also Bol 1973, pp. 301-302; W.L. van de Watering in Amsterdam 1985, p. 9.

9 See note 2.

10 Middendorf 1989, pp. 45, 128 (no. 66, ill.). Wilhelm Martin (1875-1954) had previously suggested an attribution to Dubbels (note by H. Gerson on a photograph of the painting in the Netherlands Institute for Art History, The Hague).

11 Inv. no. Sp. 546. The pendant, which depicts small fishing vessels on a wide waterway at sunrise (inv. no. Sp. 547) has the same dimensions and is signed 'LB' (*Royal Museum of Fine Arts: Catalogue of old foreign paintings*, Copenhagen 1950, nos. 15-16 (ill.); Hofstede de Groot 1907-1928, vol. 7 (1928), pp. 256, no. 73, 279, no. 157). For the titles, cf. Hoet-Terwesten 1752-1770, vol. 1, p. 377 (anon. sale Amsterdam, 21 January 1733, lot 15).

12 For the ramparts, see B. Bakker, E. Schmitz and J. Peeters in Amsterdam-Paris 1998-1999, pp. 201-205. The precise location was confirmed by B. Bakker in a letter of 31 October 2001 (Fondation Custodia Archives).

13 Inv. no. 5174 (M. van Berge-Gerbaud in Paris-Haarlem 1998-1999, no. 10 (ill.); B. Bakker, E. Schmitz and J. Peeters in Amsterdam-Paris 1998-1999, pp. 81, colour ill., 202, 204 and fig. 4.

14 Sale of the collection of D. Komter, art dealer, Amsterdam, Mak, 9 March 1926, lot 3 and fig. 3, with the note that the painting is signed with Backhuysen's initials and dated 1697. The catalogue gives a detailed description of the painting as 'La visite de Czar Pierre le Grand à Amsterdam'. It had previously been included in the I. van Idsinga sale, Amsterdam, 2 November 1840, as lot 1 (Hofstede de Groot 1907-1928, vol. 7 (1918), p. 263, no. 104, p. 317, no. 341). A monumental harbour view by the painter dating from 1681, which also shows a windmill by the water, probably depicts the Old Harbour in Rotterdam and not the Blauwhoofd in Amsterdam, as previously assumed (Hofstede de Groot 1907-1928, vol. 7 (1918), pp. 255-256, no. 169; Bol 1973, p. 302 and fig. 305). From 1952 until the end of 1954 the

painting was on loan from the then owner, B. de Geus van den Heuvel (1886-1976) of Nieuwersluis, to the Mauritshuis, The Hague, inv. no. 910 (Martin 1953, p. 99). In 1976 it was put up for auction in Amsterdam by the auctioneers Sotheby Mak van Waay, 26-27 April 1976, lot 2 (ill.).

15 Inv. no. 870. The painting in Leipzig also has a pendant of the same size, which is in the same museum: *View of the Noorder-Buitenspaarne with the sailing boat of Johan Maurits van Nassau-Siegen*, inv. no. 871 (Hofstede de Groot 1907-1928, vol. 7 (1928), pp. 342, no. 457, 271, no. 131; Amsterdam 1985, nos. S 11 and S 14, ill.). A second version of the set of paintings existed, dating from 1705, which exhibited differences, according to Hofstede de Groot's description. The two paintings were last together in the sale of the Pekstok Collection (sale Amsterdam, 17 December 1792, lots 4-5); their present whereabouts are unknown (Hofstede de Groot 1907-1928, vol. 7 (1928), pp. 264, no. 106, 271, no. 133). A third set may be identical to one of the two previous ones (anonymous sale Amsterdam, 18 January 1781, lots 4-5; Hofstede de Groot 1907-1928, vol. 7 (1928), pp. 271, no. 132, 278, no. 155a).

16 Amsterdam, Amsterdams Historisch Museum, inv. no. A 10111. According to B. Broos the structure depicted in the drawing and the painting is not the Blauwhoofd but the bastion Zeeburg, the section of Amsterdam's ramparts that lay furthest to the northeast (Amsterdam 1985, pp. 37, in no. S 14, 91, in no. T 7, ill.; *idem* in Broos-Schapelhouman 1993, p. 16, no. 5, ill.). According to B. Bakker, however, the traditional location of the Blauwhoofd is correct (see note 12).

17 The wooden sentry-box is shown clearly in the *View of the IJ from the bastion Blauwhoofd* from 1673 (fig. 3d). However, the map and the Amsterdam skyline in Commelin 1693 (between pp. 308-309 and pp. 248-249 respectively) appear to show a watchtower extension surmounted by a semicircular pinnacle. For Backhuysen's generally free approach to topography, see B. Broos in Amsterdam 1985, pp. 76-77, 91-92.

18 S. Nihom-Nijstad in Paris 1983, p. 9; C. van Hasselt in Paris 1989, p. 5, both citing Bol 1973, pp. 302-303.

19 Amsterdam, Amsterdams Historisch Museum, inv. no. A 10112

(B. Broos in Broos-Schapelhouman 1993, p. 20, no. 9, ill.); this drawing too has a pendant, also a view in the harbour of Amsterdam, in this case bathed in a radiant dawn (Cambridge, Fitzwilliam Museum, inv. no. PD 127-163; D. Scrase in Munich-Heidelberg-Braunschweig-Cambridge 1996, no. 51). The city skyline in the painting in Copenhagen and also in the etching referred to below seems to have been based on the drawn *View of the IJ looking towards Amsterdam from the tollhouse* (B. Broos in Amsterdam 1985, p. 95, no. T 11, ill.).

20 Inv. no. 1973-P.87. This is no. 7 in the series (Hollstein, vol. 1, pp. 54-57, nos. 1-10, ill.). In 1973 two proofs corrected personally by Backhuysen for nos. 6 and 9 in the series were acquired for the Frits Lugt Collection (inv. nos. 1973-P.86 and 1973-P.89; Paris 1989, nos. 95-97, figs. 140-142).

21 Cf. also Lugt's text of a guided tour around the rooms of the Institut Néerlandais, before 1965: 'un Ludolf Bakhuizen d'un éclairage que nous sommes surpris de trouver chez ce peintre plutôt froid. Il a rarement peint un ciel aussi fantastique, un coucher de soleil aussi rayonnant, formant un fond sur lequel se détache la fine silhouette du petit moulin, sur la rive'.

22 *A Dutch fleet*, 1687, inv. no. 215 (Paris 1989, no. 19, figs. VII and 19); *Ships in a river estuary*, c.1670-1690, inv. no. 794 (*idem*, no. 18 and fig. 52); *River landscape with fishermen*, c.1670-1675, inv. no. 1231 (*idem*, no. 17 and fig. 51); (?) *The arrival of William III in the Oranjepolder, January 1691*, c.1691-1692, inv. no. 1324 (*idem*, no. 23 and fig. 55); *Warship and small sailing boats offshore in a breeze*, c.1680-1700, inv. no. 1493 (*idem*, no. 20 and fig. 54); *Ships off the shore in a fresh breeze*, c.1680-1700, inv. no. 1494 (*idem*, no. 21 and fig. 54); *Imaginary view of an Amsterdam canal*, c.1670-1700, inv. no. 4367 (Amsterdam 1985, no. T 31, ill.); (?) *Ships on the river Meuse near Rotterdam*, c.1680-1700, inv. no. 2005 (Paris 1989, no. 22 and fig. 55).

23 Inv. no. 7500; acquired in 1961, from the collections of Benjamin Fillon (1819-1881) and Karl Geigy-Hagenbach (d. 1949). The sheet is dated Amsterdam, 26 December 1691; the *verso* contains three entries dated 8 August 1703 by visitors from Braunschweig. For the examples of calligraphy in the Frits

Lugt Collection, see De la Fontaine Verwey 1976.

24 For Jacob de Wilde, his collection and his visitors' book, see Van Eeghen 1959; R. van Gelder in Amsterdam 1992, pp. 278-279.

25 In a self-portrait from 1699, which Backhuysen donated to the *Kunstkamer* of Amsterdam town hall, the artist described himself as a calligrapher first and foremost (Amsterdam Historical Museum, inv. no. A 2786; Amsterdam 1985, p. 64, no. S 36, ill.).

4 Nicolaes Berchem

1 Lugt no. 272; see Hoet-Terwesten 1752-1770, vol. 1, p. 221.

2 Lugt no. 3673.

3 Lugt no. 6204.

4 Lugt no. 10095. According to Nieuwenhuys (1834, p. 81), he acquired the painting 'prior to the Reijnders sale'.

5 Lugt no. 10869.

6 Lugt no. 22145.

7 Lugt no. 32968. The text in the catalogue of the sale is accompanied by an engraved reproduction of the painting.

8 Amsterdam 1936, no. 12, gives the owner of the painting as A. Popoff & Cie. According to the dossier (Fondation Custodia Archives), the picture was brought to the Sotheby's auction by one J. Chenue for the Popoff gallery.

9 For Berchem, see Hofstede de Groot 1907-1928, vol. 9 (1926); Schaar 1958; W.A.P. Houben in *Allgemeines Künstler-Lexikon*, vol. 9 (1994), pp. 237-238 (with full bibliography); J. Kilian in *The Dictionary of Art*, vol. 3 (1996), pp. 757-760 (with bibliography; reprinted in Turner 2000, pp. 17-21); P. Schatborn in Amsterdam 2001, pp. 187-195. Various authors have attempted to make at least one and even two journeys to Italy seem plausible. On this aspect see Blankert 1978, pp. 147, 148-149 notes 10-12; Jansen 1985 (with further information in Amsterdam 1993, p. 245 note 1); Slive 1987, p. 177 note 22; P.C. Sutton in Amsterdam-Boston-Philadelphia 1987-1988, p. 262; Trnek 1992, pp. 58-59; J. Kilian in *The Dictionary of Art*, vol. 3 (1996), p. 758; Wegener 2000, p. 76; P. Schatborn in Amsterdam 2001, p. 187.

10 On the two artists' journey see Sutton 1992, pp. 166-169; Büttner-Unverfehrt 1993; P.C. Sutton in Madrid 1994, pp. 44-45, 78, 186-189; Walford 1991, pp. 74-77.

11 Inv. no. 1481; signed lower left: 'Berchem f 1656' (Hofstede de Groot 1907-1928, vol. 9 [1926], p. 81, no. 109; Madrid 1994, no. 8, colour ill.). A second painting depicting Bentheim is in the collection of His Grace The Duke of Westminster (Hofstede de Groot 1907-1928, vol. 9 [1926], p. 81, no. 110; see also P.C. Sutton in Madrid 1994, p. 78). The drawing, signed and dated 1650, is in Frankfurt am Main, Städelsches Kunstinstitut (Büttner-Unverfehrt 1993, p. 43, fig. 23, p. 107, no. 39; Madrid 1994, p. 186, fig. 1).

12 Houbraken 1718-1721, vol. 3, p. 65. Another 'Ruisdael-like' sheet by Berchem depicts the ruin of Ter Kleef castle (Amsterdam, Rijksmuseum, Rijksprentenkabinet, inv. no. RP-T-1879-A-23; Van der Wyck-Niemeijer-Kloek 1989, vol. 2, p. 99, fig. 157). Berchem was responsible for the staffage in several of Van Ruisdael's works, for example in a painting of 1652 now in Los Angeles, Collection of Mr and Mrs Edward William Carter (The Hague-Cambridge 1981-1982, no. 16, ill.; Slive 1987, p. 176), and *Woodland with inundated path*, c.1670, in Douai, Musée de la Chartreuse (on loan from the Musée du Louvre in Paris, inv. no. MR 1008, INV. 1817; Walford 1991, p. 136, fig. 145).

13 Inv. no. PA 38, signed 'N. Berchem' (Hofstede de Groot 1907-1928, vol. 9 [1926], p. 133, no. 284; with thanks to Charles Noble). Berchem also depicted the ruins of Brederode in the foreground of a landscape with herdsmen of 1650 now in Schwerin, Staatliches Museum (Jürss 1982, p. 95, no. 30 and fig. 89). On Berchem's drawings of Brederode cf. F. Stampfle in Paris-Antwerp-London-New York 1979-1980, p. 136; M. Schapelhouman in Amsterdam 1987, p. 59; Farr-Bradford 1986, p. 86; Broos-Schapelhouman 1993, p. 34; Plomp 1997, pp. 70-73. Early nineteenth-century auction catalogues also mention two paintings attributed to Berchem depicting Heemstede castle, which is also in the environs of Haarlem (Hofstede de Groot 1907-1928, vol. 9 [1926], p. 82, nos. 112-113).

14 De Leth-Bruin-Stoopendael 1719, plates 60-62.

15 On Cronenburch and its history see Roosenschoon 1940; Van

Luttervelt 1948, pp. 29, 67, 74, 81-82, 227; S. Nihom-Nijstad in Paris 1983, p. 11 (with bibliography); Van der Wyck-Niemeijer-Kloek 1989, vol. 1, p. 115, under no. 95; Munnig Schmidt 1993.

16 The engraving was published by Martynus van Buesecum (Roosenschoon 1940, pp. 38-40 and fig. 3). The preliminary drawing – reversed – is now attributed to Adam Willaerts (Leiden, Prentenkabinet der Rijksuniversiteit, inv. no. AW 896; Van der Wyck-Niemeijer-Kloek 1989, vol. 1, p. 244, fig. B6, vol. 2, p. 57, 74 note 46). On the continuing emotional impact of the murder of Floris V in the seventeenth century cf. Van der Waal 1952, vol. 1, pp. 283-287, vol. 2, pp. 135-138.

17 Respectively, Loenen, Gemeentehuis (Munnig Schmidt 1993, p. 60, fig. 1) and Vaduz, Sammlungen des regierenden Fürsten von Liechtenstein (inv. no. 914; New York 1985-1986, no. 160, ill.). The preliminary drawing for the painting in Loenen, dated 1639, is in Amsterdam, Rijksmuseum, Rijksprentenkabinet (inv. no. RP-T-1985-7; Munnig Schmidt 1993, fig. 3). With thanks to Mr J. Berghuis for the photograph of the work in Loenen.

18 A map of the castle from around 1650 is reproduced in Roosenschoon 1940, fig. 2; q.v. also references to and illustrations of a number of other depictions of the castle.

19 Inv. no. A 1814. A now-lost drawing by Roelant Roghman, part of his famous series of castles of 1646-1647, also depicted 'Cronenburg & Loenen int v[er]schiet' (from the so-called 'lijst Bentes' of 1708, the earliest list of Roghman's series; Van der Wyck-Niemeijer-Kloek 1989, vol. 1, p. 3). Another drawing by the artist, also now lost, showed a closer view of the castle, seen from the Vecht (*idem*, p. 115, no. 95, with ill. of a copy).

20 On the dovecote at Cronenburch see Karsemeijer-Overeem 1985, p. 228 and fig. 18; on the wooden raft see the permit for the construction of the bridge of 1624, published by Roosenschoon 1941, pp. 24, 26.

21 Roosenschoon 1940, p. 38.

22 Trnek 1992, pp. 58-59.

23 Stechow 1963a, pp. 113-114. Two of the animals depicted in the foreground also appear in drawings by Berchem from the second half of the 1650s, both designs for prints:

the recumbent sheep at the lower right in a drawing of 1655 in the Amsterdams Historisch Museum, the standing sheep in the group of three at the far right in a drawing of 1657 in the same collection (Broos-Schapelhouman 1993, pp. 26, no. 14, 30-31, no. 18).

24 S. Nihom-Nijstad in Paris 1983, pp. 11-12. E. Schaar placed the painting somewhat earlier, in the later 1640s, but believed it was impossible to date it exactly (Schaar 1958, pp. 22-23).

25 On the Vermeer painting: The Hague-Washington 1995-1996, no. 5 (ill.); on the Potter: The Hague 1994-1995, no. 15 (ill.); on the Dou triptych: A.K. Wheelock in Washington-London-The Hague 2000-2001, p. 19 and fig. 4. The auction catalogue was published in Hoet-Terwesten 1752-1770, vol. 1, pp. 220-226 (Amsterdam, 7 April 1706; Lugt no. 272; Dudok van Heel 1977, pp. 113-114, no. 189). For more information on the collection see Munnig Schmidt 1996, p. 56; Cornelis 1998, pp. 147-149.

26 Houbraken 1718-1721, vol. 2 (1719), pp. 5-6, 127-128. For Houbraken's remarks on Jacob van Hoek's collection see also Cornelis 1998, pp. 145-158.

27 'Hier maalde BERCHEM, hoe de donkre lucht, in 't rond, / By 't aadlyk Kronenburg de kristalynen stroomen / Der Vecht beschaduwt, daar het zonlicht op den grond / Het tierig vee, dat zich verfrischt aan hare zoomen, / Op 't lieflykst koestert, en met heldre glansen streelt. / Natuur is hier op 't schoonst, op 't levendigst verbeeld' ('Here BERCHEM painted the dark sky / and crystal waters at noble Cronenburch / The shadowy Vecht and the sunlight on the ground / the gentle animals drinking at its shores / all shown with a lovely and bright glow / Nature is depicted here at its most beautiful and alive'); *Beschouwing der uitmuntende kunsttafreelen verzameld door den heere Jacob van Hoek*, 1717, in Feitama 1764, p. 282. On Feitama see Broos 1984b, pp. 20-21.

28 The connection between the painting and Nieuwerhoek was first made by E. Munnig Schmidt in a set of four letters to Carlos van Hasselt of April-May 1983, from which much of the information given here is borrowed (Fondation Custodia Archives). With thanks to Mr Munnig Schmidt for his help in researching this entry.

29 On Adriaen van Hoek see Bierens de Haan 1957, p. 110; Munnig Schmidt 1996, passim. The catalogue of the auction of his paintings (Amsterdam, 7 April 1706; Lugt no. 196; Dudok van Heel 1975, p. 166, no. 94) is in the RKD in The Hague and is partially reproduced in Hoet-Terwesten (1752-1770, vol. 1, pp. 87-89); there is a full transcription in Munnig Schmidt 1996, pp. 65-66; the latter also includes a transcription of the inventory of paintings left with Van Hoek's widow, Cornelia Bierens (1649-1719); appraisal by Jan Pietersz Zomer and Henrick Sorgh, Amsterdam, 15 September 1719; Van Zoest 1984; Munnig Schmidt 1996, pp. 66-67. On Nieuwerhoek see De Leth-Bruin-Stoopendael 1719, pp. 24-25, figs. 57-59; Van Luttervelt 1948, pp. 18, 112-114; Van Eeghen 1975, pp. 177-178; Munnig Schmidt 1996, passim. The house was sold to Jan Tarelink in 1710.
30 Inv. no. 1836-8-1-10 (Amsterdam 1985, no. T 32, ill.; Munnig Schmidt 1996, p. 54 and fig. 6). On the painting, listed as part of Cornelia Bierens's estate in 1719, cf. Van Eeghen 1975, pp. 177-178; Munnig Schmidt 1996, pp. 54 (fig. 6), 66. Several paintings based on the drawing are known (sale New York, Christie's, 10 January 1980, no. 78, ill., as dated 1691 [sic]; Munnig Schmidt 1993, pp. 63-64 and fig. 7). On Backhuysens's work for the Van Hoek family – among others, a portrait, probably of Jacob van Hoek – see Munnig Schmidt 1996, pp. 54-56 and fig. 7.
31 One possible candidate is Jacob's great-uncle, Anthony van Hoek (1597-1688), builder of Ouderhoek, the Van Hoek family's first country manor near Loenen, which was passed to his unmarried son Adriaen (1631-1691) in 1676. The Van Hoeks seem to have had a particular fondness for topographical views: Jacob's uncle, Christiaen van Hoek (1643-1715), builder of Middenhoek and from 1688 also proprietor of Ouderhoek, was the driving force behind the publication of Ludolf Smids's *Schatkamer der Nederlandsche oudheden* (Amsterdam, 1711); with this goal in mind, he purchased the above-mentioned series of drawings by Roelant Roghman in 1708 (see note 19; Van der Wyck-Niemeijer-Kloek 1989, vol. 1, pp. 8, 14-15). His son, Anthony van Hoek (1674-1719), was the initiator of *De zegepraalende Vecht*

(De Leth-Bruin-Stoopendael 1719), in which a number of illustrations are devoted to Cronenburch and the Van Hoek houses (pp. 9-11, 18-25, figs. 47-52 [Ouderhoek], 54-56 [Middenhoek], 57-59 [Nieuwerhoek]; see also fig. 4e). On the Van Hoeks and their Vecht manors see Van Luttervelt 1948, passim; Van Eeghen 1975, p. 177; Munnig Schmidt 1996, passim.
32 On the Montribloud Collection see Perez 1980, pp. 47-48. The highest price paid at the auction for a Berchem – 6,452 *francs* – was also paid by Tolozan for lot 51, 'The stubborn ass', now in the Herzog Anton Ulrich-Museum in Braunschweig (Amsterdam-Boston-Philadelphia 1987-1988, no. 8, ill.). Among the masters of the Dutch School these prices were only exceeded by those paid for works by Gerard de Lairesse (lot 19) and Philips Wouwerman (lot 54). Claude Tolozan was 'introducteur des ambassadeurs du roi'. On his collection, which also included a large number of cabinet pieces by Dutch masters, see Perez 1980, p. 49; Aiquillière 1990; Peronnet-Fredericksen *et al.* 1998, vol. 1, pp. 3-5. Here, the prices for the Berchems remained below those paid for other Dutch artists, such as Dou (lot 28) or Adriaen van Ostade (lot 78). The highest price of the whole auction, 27,050 *francs*, was paid for Paulus Potter's *Farm near The Hague* (lot 87; Eaton Hall, Chester, His Grace The Duke of Westminster; cf. The Hague 1994-1995, no. 9, ill.). On Étienne Delessert see *Dictionnaire de biographie française*, vol. 10 (1967), cols. 806-807. Little research has been done into this important collection (Peronnet-Fredericksen *et al.* 1998, vol. 1, p. 4, vol. 2, p. 1399).
33 On Lapeyrière see Centorame 2001, passim. Lapeyrière brought together a total of four collections of paintings, auctioned in 1817, 1823, 1825 and 1832, respectively (Lugt nos. 9103, 10518, 10869). The auction of 1825 was originally supposed to take place on 14 March of that year (Lugt no. 10842a). A number of other Lapeyrière auctions noted by Lugt (nos. 10653, 11146, 12902) appear to be mistakenly annotated copies of the 1825 catalogue, which bears no date of publication.
34 Nieuwenhuys 1834, pp. 81-82. On this publication cf. F. Herrmann in London 1984, pp. 34-35.
35 'Ici pourtant, Berchem est très-fort, parce qu'il est plus sincère. Il

a vu cet effet de soir, avec les larges ombres tranquilles, qui ont décidé un ensemble vigoureux et saisissant' (Thoré-Bürger 1864, p. 307; according to the author, the painting was part of the 'galerie de M. Émile'). On Thoré-Bürger see F.S. Jowell in *The Dictionary of Art*, vol. 30 (1996), pp. 756-757 (with bibliography); for his role in the development of the new image of the Dutch School and his judgement of Berchem see Hecht 1998, p. 170.
36 On the Pereire Collection see Autin 1983, pp. 206-207; Haskell 1980, pp. 142-146; P. Sorel in *The Dictionary of Art*, vol. 24 (1996), pp. 396-397.
37 'Le grand paysage . . . est une exception dans l'œuvre du maître. En général, ses motifs sont choisis en Italie. Cette fois, il nous offre une vue typique des Pays-Bas . . .' (from a written tour by Lugt through the rooms of the Institut Néerlandais of around 1965).
38 Inv. no. 7670 (Paris 1983, no. 6 and fig. 39). The collection includes the following drawings by the artist: *Riverscape with herdsmen and animals*, inv. no. 409 (New York-Paris 1977-1978, no. 7 and fig. 117); *Study of rams and sheep*, inv. no. 783; *Italian landscape with herdsmen and animals*, 1654, inv. no. 980 (Brussels-Rotterdam-Paris-Bern 1968-1969, no. 7 and fig. 158); *Study of two donkeys*, inv. no. 1233 (Van Gelder 1976, p. 349 and fig. 8); *Mountain landscape with herdsmen*, inv. no. 2234 (Brussels-Rotterdam-Paris-Bern 1968-1969, no. 10 and fig. 159); *Elia being fed by ravens*, inv. no. 3442; *Study of sheep and a goat*, inv. no. 4089; *Study of oxen*, inv. no. 4365; *Study of sheep*, inv. no. 4366; *Design for a frontispiece with herdsmen and hunters*, 1653, inv. no. 4388; *Winter landscape with bridge and a windmill*, inv. no. 5180 (Brussels-Rotterdam-Paris-Bern 1968-1969, no. 8 and fig. 116); *Travellers outfitting their donkeys before an inn*, inv. no. 5111 A (Steland 1989, p. 201, fig. 235); *Group in front of an inn*, inv. no. 6479 (Florence 1966, no. 4, ill.).

5 Gerrit Berckheyde

1 F. Lugt in Amsterdam 1911, no. 2.
2 Information on the painting's inventory record, Fondation Custodia Archives.
3 Goudstikker's invoice is dated a day later: '1920. / Mrt. / 12. Een

schilderij van G. Berckheyde / de uitbreiding van Haarlem / uit de Collectie Janssen' (Fondation Custodia Archives). Lugt sold the Sorgh painting the same year.
4 See S. Nihom-Nijstad in Paris 1983, p. 15.
5 In 1919, a year before acquiring the painting, Lugt had sold a view of the Hofvijver in The Hague by Berckheyde to Goudstikker (see the introductory essay by Ella Reitsma). He was later able to purchase one of the rare drawings attributed to the artist: *Study of a girl seated on the ground*, inv. no. 4379; see also Paris 1967, no. 201 and fig. 52. On the Bonington see cat. no. 11 note 25; on the Guardi, see Paris 1996, no. 104 and fig. 61.
6 For Berckheyde, see Lawrence 1991; C. Lawrence in *The Dictionary of Art*, vol. 3 (1996), pp. 760-762 (reprinted in Turner 2000, pp. 22-24).
7 Lawrence 1991, pp. 44-46 and figs. 37-39.
8 Lawrence 1991, pp. 46-47 and figs. 41-44.
9 Taverne 1978, pp. 370-371; S. Nihom-Nijstad in Paris 1983, p. 15; Roos-Uittenhout-De Wagt 1992, pp. 20-21. Taverne recounts the story of the – unsuccessful – attempt to design Haarlem according to the humanist concept of the *città ideale*. On the city and its history see J.J. Temminck in *The Dictionary of Art*, vol. 13 (1996), pp. 892-894 (with additional literature).
10 F. Lugt in Amsterdam 1911, no. 2.
11 S. Nihom-Nijstad in Paris 1983, p. 15. For an illustration and brief description of a number of the buildings depicted see Roos-Uittenhout-De Wagt 1992, pp. 45 (Bakenesserkerk), 44 (Waalse Kerk), 42-43 (Sint-Janskerk), 40-41 (Stadhuis), 52 (Nieuwe Kerk). For views of Haarlem, see Slive 2001, pp. 51-60 (ill.).
12 Lawrence 1991, pp. 77-78.
13 Lawrence (1991, p. 34 note 25 and fig. 12) has already linked this painting to the work described here.
14 Lawrence 1991, p. 45 and fig. 40.
15 The drawing of the Kleine Houtpoort in the Gemeentearchief in Haarlem (Lawrence 1991, p. 45 and fig. 38, as Berckheyde) appears not to be by his hand (Plomp 1987, pp. 12-15 and fig. 20). The painting on which the drawing is based has recently reappeared on the art market (panel, 31 x 44.5 cm; Johnny van Haeften Gallery, London, 1992; see C. Lawrence in London 1992, no. 2, ill.).

16 On the depiction of labor in seventeenth-century Dutch art see Haverkamp Begemann 1995 (with a variety of examples and bibliography).
17 See Haverkamp Begemann 1995, p. 98.
18 Hollstein, vol. 2, no. 114 (ill.); see S. Slive in The Hague-Cambridge 1981-1982, pp. 209-211 and fig. 82. See also cat. no. 27 note 14.
19 Amsterdam, Gemeentearchief; Davies 1992, pp. 39, 225, no. D 5 and fig. 188.
20 Slive 1995b, pp. 452 and 454, figs. 45 and 46 (detail of the mud-mill in the painting in the Lugt Collection); Haverkamp Begemann 1995, p. 98 and fig. 1. A comparable mud-mill can be found in *Groot volkomen moolenboek*, vol. 2, Amsterdam 1736, p. xxv (see Slive 1995b, p. 452 note 8; Haverkamp Begemann 1995, pp. 98, 99 note 19 and fig. 2).
21 Slive 1995b, p. 452.
22 Cf. for this Potter-like motif the landscape with livestock and a milkmaid Berckheyde completed in 1672, i.e. in the same period as the work here under discussion (Lawrence 1991, p. 89 and fig. 100).
23 Lawrence 1991, pp. 49-75 (ill.).
24 Lawrence 1991, p. 63 and note 78.
25 Lawrence 1991, pp. 10-11, 30, 35; Q. Buvelot in Paris-Montpellier 1998, p. 17.
26 See the general remarks in Haverkamp Begemann 1995, p. 97.
27 See Provenance.
28 The picture was praised by Biermann 1911, p. 665; see also Hirschmann 1920, p. 26 and Faton 1983, p. 69.

6 Jan Both

1 The panel has been sawn off very unevenly on the left-hand side.
2 Lot 151: 'J. BOTH. A HILLY LANDSCAPE, with herdsmen and cattle; and a FARMYARD, with poultry. 2. On panel' (Lugt no. 80486); connected by Burke (1976a, p. 234) with the painting described here. Stamped in black on the back of the painting is a code number used by Christie's: '858 JG'.
3 For Both, see M.J. Bok in San Francisco-Baltimore-London 1997-1998, pp. 377-378 and P. Schatborn in Amsterdam 2001, pp. 88-98. For his oeuvre, see Hofstede de Groot 1907-1928, vol. 9 (1926); Burke 1976a; A. Blankert in *Allgemeines Künstler-Lexikon*, vol. 13 (1996), pp. 241-242 (with additional literature);

L. Trezzani in *The Dictionary of Art*, vol. 4 (1996), pp. 489-489 (with additional literature; reprinted in Turner 2000, pp. 47-50).
4 As regards this motif in the work of Jan Both, see J. Walsh and C.P. Schneider in Los Angeles-Boston-New York 1981-1982, pp. 21-22; A. Chong in Amsterdam-Boston-Philadelphia 1987-1988, pp. 279-281; F.J. Duparc and L.L. Graif in Montreal 1990, p. 82; P. Sutton in Madrid 1994, p. 86; J.A. Spicer in San Francisco-Baltimore-London 1997-1998, pp. 344-346.
5 On the Ponte Acquoria, see Burke 1976a, p. 234; Oehler 1997, p. 63.
6 See the list of drawings and prints in Oehler 1997, pp. 63-67. In addition to the paintings by Jan Asselijn named below (see note 8), the bridge also occurs in a land-scape attributed to Adriaen van Eemont at Gotha, Schlossmuseum (Harwood 1988, p. 37, fig. 27).
7 Inv. no. 5181; Brussels-Rotterdam-Paris-Bern 1968-1969, no. 149 and fig. 39; P. Schatborn in Amsterdam 2001, pp. 79, 81, fig. F.
8 Inv. no. 664; Steland-Stief 1971, p. 157, no. 203 and fig. XIII. Another painting, with a depiction of the bridge from the other side, was to be found on the art market in 1991 (The Hague 1991, no. 1, ill.). In both depictions a tree trunk leans crookedly against the largest pier of the bridge. The same motif occurs in a drawing in London, British Museum, which is no longer considered an autograph work (inv. no. Sloane 5214-84; Steland 1989, p. 237, no. 118 and fig. 187).
9 As regards these two artists' employment during their stay in Rome, see Steland 1988 and Steland 1989, pp. 64, 196.
10 A drawing by an unknown draughtsman in Kassel, depicting a view from above of the Anio valley at Tivoli, gives a picture of the actual situation (Oehler 1997, p. 59, no. 10, ill.).
11 Bock-Rosenberg 1930, vol. 1, p. 216, no. 3926, vol. 2, fig. 139, as Adam Pynacker. Both Blankert (1978, p. 121 note 6) and Oehler (1997, p. 67 note 21) attributed the drawing to Jan Both. The painting's resemblance to a drawing in Rome, Istituto Nazionale per la Grafica, Gabinetto dei Disegni e delle Stampe (Den Bosch-Rome 1992-1993, no. 53, ill.), which is also ascribed to Jan Both, is less striking than was previously assumed

(Blankert 1978, p. 121; S. Nihom-Nijstad in Paris 1983, p. 23). The composition of the drawing, on the other hand, corresponds exactly to that of another painting by Jan Both or someone in his circle (see note 16). An attribution to Johannes Collaert (*c.*1622-after 1678) has been suggested for the group to which the sheet belongs (Burke 1976b, p. 384; P. Schatborn in Amsterdam 2001, pp. 139, 209 note 7, with additional literature).
12 Private collection; Burke 1976a, p. 250, no. 117; Montreal 1990, no. 17 (ill.).
13 Bayreuth, Bayerische Staats-gemäldesammlungen, inv. no. 140; Burke 1976a, p. 228, no. 79; San Francisco-Baltimore-London 1997-1998, p. 349, fig. 1. The figures in this painting are attributed to Nicolaus Knüpfer, the white cow to Jan Baptist Weenix.
14 On the paintings made for Buon Retiro and on Jan Both's early work in general, see Waddingham 1964; Burke 1976a, pp. 81-101; Blankert 1978, pp. 115-117 (under no. 47). According to Waddingham, four paintings of the Buon Retiro series can be attributed to Both; according to Burke, five.
15 Inv. no. 1988.5; Montreal 1990, no. 16 (a study on this painting by H. Verbeek, which was announced in this publication, was apparently never published). A drawing attri-buted to Jan Both in Paris, Musée du Petit Palais, Dutuit Collection, displays the same composition and is considered to be a preparatory study for the painting (Lugt 1927, p. 13, no. 14 and fig. v; Montreal 1990, p. 85). A drawing assigned to Jan Both in London, British Museum, also shows the same composition (Hind 1915-1932, vol. 3, no. 2 and fig. xxv). H. Verbeek tentatively attributed this sheet to Jan Hackaert (Montreal 1990, p. 85 and note 8).
16 Panel, 40 x 54 cm (sale O. Held Collection, Berlin, Cassirer-Helbing, 5 December 1929, lot 5; Burke 1976a, pp. 251-252, no. 121: 'apparently an earlier version of the painting now in the Lugt Collection . . . as it is less resolved in composition'); and canvas, 71 x 85.5 cm, The Hague, Bouwens, art dealer, 1942 (photograph RKD). The composition of the latter painting is undoubtedly derived from Jan Both or a painter in his circle. It corresponds almost exactly to the drawing in Rome recorded

in note 11, which is now attributed to Johannes Collaert. A painting displaying the same composition, probably an old copy, is to be found in Dresden, Gemäldegalerie, inv. no. 1274.
17 For the works not included in the present exhibition, see Paris 1983, nos. 6, 15, 37, 69, 78, 97 (ill.). The painting by Willem Romeyn (Paris 1983, no. 69) was acquired in 1975, after Lugt's death.
18 The study of a standing man leaning on a stick (inv. no. 4486) was used by the artist in an Italian landscape in Amsterdam, Rijksmuseum (inv. no. SK-C-309; P. Schatborn in Amsterdam-Washington 1981-1982, p. 64, fig. 3 and p. 132, no. 24). *The Mountainous landscape with a round tower near a bridge over a river* (inv. no. 8804; New York-Paris 1977-1978, no. 18 and fig. 118) is sometimes attributed to Jan Hackaert. The style of two other drawings assigned to Jan Both – *View of a ruin, possibly Honingen Castle near Rotterdam*, inscribed 'JBoth 1650', and *Mountainous landscape with a fortress*, inv. nos. 33 and 34 – displays little resemblance to drawings which can be attributed to him with certainty.

7 Esaias Boursse

1 As noted in the records of Agnew art dealers (see note 3).
2 Lot 57: 'E. BOURSSE. / AN OLD WOMAN, sewing / On panel–13 in. by 9 1/2 in. [33 x 24.1 cm]' (see also note 3).
3 A letter of 5 August 1982 from Richard N. Kingzett (Agnew) to Carlos van Hasselt, former Director of the Fondation Custodia, states: 'We bought it from a Mr. A. V. Scully in March 1938 and our stock book has a note that it came origi-nally from the Bethmann-Hollweg Collection, so Mr. Lugt's memory was correct on this score. If we and Christie's measured the pictures correctly it cannot be the same as the one that appeared in their sale on the 30th May 1919 as lot 57, as they measured this as 13 by 9 1/2 inches [33 x 24.1 cm] and our stock book gives a measurement of 11 by 8 3/4 inches [27.9 x 22.2 cm]' (letter in the Fondation Custodia Archives).
4 Information taken from the painting's inventory card, Fondation Custodia Archives. Attached to the back of the panel is Agnew's label, no. 9498.

5 Bode-Bredius 1905, p. 207: 'Boursse … der … bei Rembrandt selbst in die Lehre gegangen zu sein scheint', *idem*, pp. 211, 212; Brière-Misme 1954, pp. 26-27. On Boursse, see Bode-Bredius 1905; W. Martin in Thieme-Becker, vol. 4 (1910), pp. 467-468; Valentiner 1913; Valentiner 1928b, pp. 174-180; Plietzsch 1949; Brière-Misme 1954; Plietzsch 1960, pp. 77-78; Briels 1987, p. 224 and fig. 284; F.G. Meijer in *Allgemeines Künstler-Lexikon*, vol. 13 (1996), p. 393 (with extensive bibliography); M.C.C. Kersten in Delft 1996, pp. 182-183 and figs. 181-182 a-b; Briels 1997, p. 116, fig. 176, p. 305; and the descriptions of individual paintings in Keyselitz 1957; Amsterdam 1976, nos. 4-5; P.C. Sutton in Philadelphia-Berlin-London 1984, no. 16; F. Lammertse in Giltaij 1994, pp. 160-161, no. 39 (ill.).

6 Brière-Misme 1954, p. 27.

7 Brière-Misme 1954, p. 72; S. Nihom-Nijstad in Paris 1983, p. 25.

8 Brière-Misme 1954, p. 27.

9 Bode-Bredius 1905, p. 209; Bredius 1915-1922, vol. 1, pp. 124-125, no. a; Brière-Misme 1954, pp. 26, 27.

10 Bredius 1915-1922, vol. 1, pp. 125-126, no. d; Brière-Misme 1954, p. 28 and *idem*, note 26.

11 Bredius 1915-1922, vol. 1, pp. 120-126; Bode-Bredius 1905, pp. 209-211. In 1996 the sheets produced in Sri Lanka were acquired by the Rijksprentenkabinet, Rijksmuseum, Amsterdam (inv. no. NG-1996-6); see *Bulletin van het Rijksmuseum* 45 (1997), pp. 70-72 and figs. 2-4. The album, which has not been preserved intact, has no fewer than 116 drawings by Boursse.

12 Bode-Bredius 1905, p. 207.

13 Brière-Misme 1954; photographs in the Netherlands Institute for Art History (RKD) in The Hague.

14 F. Lugt in Paris 1965a, p. 27, no. 29, as 'Pieter de Hoogh' (an attribution adopted by Régnier 1968, p. 277); see also Hecht 1994, p. 357.

15 These letters are definitely authentic. Doubt has sometimes been cast however on the authenticity of the monogram 'EB' (with the letters E and B in ligature) on paintings often misattributed to Boursse (see Valentiner 1913, p. 36; Brière-Misme 1954, pp. 87-89, 160 note 65; F. Lammertse in Giltaij 1994, p. 160). The letters that appear in this painting are not rendered as a monogram (despite the assertions to the contrary by Plietzsch 1949, p. 259 and Sumowski 1983-1994, vol. 3 (1986), p. 1966 note 100).

16 Inv. no. SK-A-767; F. Lugt in Paris 1965a, p. 23, no. 6; Amsterdam 1976, no. 5; Van Thiel *et al.* 1976, p. 139; P.C. Sutton in Philadelphia-Berlin-London 1984, no. 16, plate 112.

17 For relations between Boursse and De Hooch, see Sutton 1980, p. 53; P.C. Sutton in Philadelphia-Berlin-London 1984, pp. 155-156; P.C. Sutton in London-Hartford 1998-1999, p. 78.

18 Sutton 1980, figs. 85-86, 126 (in the background).

19 Brière-Misme 1954, p. 79; Sutton 1980, p. 53; Ingamells 1992, p. 48; Delft 1996, p. 183. For Brekelenkam, see Lasius 1992.

20 Brière-Misme (1954, p. 156 and figs. 7-8) compared the painting shown here with two works attributed to Boursse, in which the attention likewise focuses on a single figure, an old woman as here, but in which she is depicted full-length and from a greater distance. This also applies to Boursse's *Woman peeling apples* in Strasbourg (*idem*, p. 88, fig. 18), in which the figure is totally absorbed in her work.

21 For the painting in Berlin, see Brière-Misme 1954, p. 161, fig. 11; Delft 1996, p. 185, fig. 182A; for the painting in Bonn, see Brière-Misme 1954, p. 82, fig. 11; Sumowski 1983-1994, vol. 3 (1986), p. 2003 (ill.).

22 Worms, Stiftung Kunsthaus Heylshof (Krempel 2000, p. 279, no. A 3 and fig. 9); a scene in an interior dated 1655 in Ottawa, National Gallery of Canada (Krempel 2000, p. 282, no. A 10 and fig. 20).

23 Inv. no. 1101; A. Chong in Dordrecht 1992-1993, no. 61; Duparc 1994; Blankert-Grijp 1995, p. 40 and fig. 2; Krempel 2000, p. 357, no. D 18 and fig. 25. For the relationship between Maes and Boursse, see Régnier 1968, p. 277; Sumowski 1983-1994, vol. 3 (1986), p. 1962.

24 On lace pillows, see Blankert-Grijp 1995 (ill.) with select bibliography; Lambeck-Huijzen 1998, vol. 1, p. 37; Pijzel-Dommisse 2000, pp. 312-313, figs. 557-558. On sewing cushions, see Schipper-van Lottum 1975. For the Vermeer, see A. Wheelock in Washington-The Hague 1995-1996, no. 17 (ill.); A. Blankert in *idem*, p. 40.

25 The activity of the woman in the painting has always been described without any reservation as lace-making (London 1938, p. 10, no. 20: 'THE LACE-MAKER'; Plietzsch 1949, pp. 259 and 261, fig. 138: 'Klöpplerin'); see also the bibliography. Only the anonymous author of the earliest reference to the painting, in the 1919 sale catalogue, writes more cautiously 'AN OLD WOMAN, sewing' (see note 2).

26 As depicted in the lower right corner of a print by Adriaen Collaert after Maarten de Vos from 1581 (Amsterdam, Rijksmuseum, Rijksprentenkabinet), reproduced in Franits 1993, p. 27, fig. 15. In making bobbin lace, threads are plaited together using bobbins. Pins keep the lacework in place, creating holes in the pattern wherever pins have been inserted (Lambeck-Huijzen 1998, vol. 1, p. 37).

27 Cf. Amsterdam 1976, no. 5; Franits 1993, passim.

28 Pijzel-Dommisse 2000, p. 151; cf. also Sutton 1980, p. 121, no. B 2 and fig. 168. In the seventeenth-century doll's house of Petronella Dunois (Amsterdam, Rijksmuseum), one of the oldest extant examples, a little lamp of this kind hangs against the decorated tiles surrounding the fireplace, also to the left of the tiled wall beneath the mantelpiece (Pijzel-Dommisse 2000, p. 151; clearly visible on p. 93, fig. 117 and p. 231, fig. 413, far left). There is an illustration of a similar lamp in Plettenburg 1968, p. 52, fig. 37. Seventeenth-century houses were illuminated in a variety of ways: besides the light from a blazing fire, which Boursse shows in other kitchen interiors, there were oil and fat lamps – the simplest and cheapest sources of light – and candles burned in candlesticks, lanterns, sconces or chandeliers.

29 Vis-De Geus 1926-1933, vol. 2, p. 69.

30 Inv. no. BK-1955-257-n; De Jonge 1971, pp. 22, 318, no. 15 and fig. 15; for tiles with a similar motif, see also Vis-De Geus 1926-1933, vol. 1, fig. 42; vol. 2, pp. 23, 69 (later sold from the collection of the Amsterdam collector E.M. Vis in New York, American Art Association, 9-10 November 1927, lot 253, ill.); cf. also A. Poensgen in Düsseldorf 1983, p. 89, no. 3a and p. 42 (ill.). Mr J.D. van Dam (curator of ceramics at the Rijksmuseum) drew attention to a similar tile pattern in Museum Het Princessehof, Leeuwarden (Van Dam 1991, p. 49, fig. 34, caption on p. 39; cf. also D.F. Lunsingh Scheurleer in Paris 1962, fig. 6) and specified the date for the tile pattern depicted here (letter of 28 August 2001).

31 Huyghe *et al.* 1971, unpaginated, fig. 14 and caption; S. Nihom-Nijstad in Paris 1983, p. 26 note 1; F. Lugt in *Visite guidée à l'Institut Néerlandais*, Paris n.d., p. 27. In 1962 the exhibition *Carreaux de Delft et d'ailleurs* (Paris 1962) was held at the Institut Néerlandais and later in several towns in France, partly at Lugt's initiative.

32 Besides the paintings in Amsterdam and London, Sutton refers (in Philadelphia-Berlin-London 1984, p. 156) to a third dated painting, from 1658 (Brière-Misme 1954, p. 86, fig. 16, however, does not give a date for the painting). For the chronology of Boursse's oeuvre, see Plietzsch 1949, p. 256 and Valentiner 1928b, pp. 177-178.

33 The only work by Boursse that does feature a lace-worker is known from old descriptions in sale catalogues (Brière-Misme 1954, p. 158; see also the author's comments on pp. 159-160 in connection with a different picture of a lace worker).

34 Brière-Misme 1954, pp. 72, 76-79 and 77, fig. 5; Ingamells 1992, pp. 48-49, no. P 166 (ill.).

35 S. Nihom-Nijstad (in Paris 1983, p. 25) described this piece of furniture as a bed with sheets and blankets hanging over the side, one of Boursse's favourite motifs (Plietzsch 1960, p. 78; compare also Fock *et al.* 2001, p. 121). For the rest, it is unclear how we should construe the black shapes hanging behind the woman's head on both sides. They do not, in any case, represent the bottom or lid of a pot hanging against the wall.

8 Jan de Bray

1 In the literature on this painting the year has been read variously as '1667' or '1669'. However, the date was read correctly as early as October 1923 by the art historian Cornelis Hofstede de Groot (see note 2) and recorded correctly in Haarlem 1936, p. 16, no. 6 (in Rotterdam 1955, p. 32, no. 48 and Oslo 1959, no. 8 as '1667', possibly dated '1669'). For an overview of the years read by the diverse authors, see S. Walden in Paris 1994, pp. 268-269, no. 128 (who however wrongly suggests that the '7' could be read as a '5').

2 'Oct. 1923. / J. de Bray. / Levensgroot portret eener naar links gewende, zittende [sic] dame in 't

groen en wit en met een rood lint. De linkerhand op de balustrade, de rechter met sprekend gebaar uitgestrekt. Een lichtgrijze sluier, kurkentrekkerlokjes voor 't voorhoofd; parelen in 't haar, versierselen in de ooren en voor de borst. In een fijnen blondgrijzen toon. Mooie handen. / Rechts beneden gemerkt en 1667 gedateerd. / Dk. 77¹/₂: 63. / In okt. 1923 gezien bij W.E. Duits te Amsterdam' (index card of Cornelis Hofstede de Groot, Netherlands Institute for Art History, The Hague). The card has the familiar stamp: 'door Dr. C.H.d.G. zelf gezien' (seen by Dr C.H.d.G. himself).

3 As recorded on the photograph at the RKD.

4 Mentioned in Rotterdam 1936-1937, p. 5, no. 3.

5 See note 4.

6 See note 4.

7 This year is mentioned on the photograph in the RKD. In 1938, Thurkow loaned the painting to an exhibition (Rotterdam 1938, no. 59). It is unclear whether he already owned the painting in 1936 (Haarlem 1936, p. 16, no. 6: 'Particulier bezit in Nederland'; loans from Goudstikker, who sold the painting to Thurkow, were described as such, cf. e.g. *idem*, p. 17, no. 17).

8 See the correspondence of Carlos van Hasselt, former director of the Fondation Custodia, with the painting's donor in the relevant documentation in the Fondation Custodia Archives. Mrs Thurkow-van Huffel also donated another painting to the Fondation Custodia, which S. Gudlaugsson attributed to Hendrick Martensz Sorgh (1609/11-1670): *Portrait of a woman holding a piece of decorative material*, panel, 12.7 x 19.1 cm; inv. no. 1978-S.1.

9 For Jan de Bray, see Von Moltke 1938-1939 (pp. 422-449 on his portraits); A. Blankert in Washington-Detroit-Amsterdam 1980-1981, pp. 224-229, nos. 61-63 (ill.); J.W. von Moltke in *The Dictionary of Art*, vol. 4 (1996), pp. 702-704 (reprinted in Turner 2000, pp. 53-55); R.E.O. Ekkart in *Allgemeines Künstler-Lexikon*, vol. 14 (1996), pp. 31-32; Van Suchtelen 1997; J. Giltaij in Rotterdam-Frankfurt am Main 1999-2000, pp. 276-303, nos. 53-59 (ill.); Haarlem-Antwerp 2000-2001, nos. 63, 65, 71 (ill.). For a comparison between the portraits of Hals and De Bray, see P. Biesboer in Washington-London-Haarlem 1989-1990, p. 39.

10 Inv. no. 1110; see Van Suchtelen 1997.

11 Amsterdam 2000a, pp. 254, 256; J.B. Bedaux in Haarlem-Antwerp 2000-2001, p. 264.

12 A. Blankert in Rotterdam-Frankfurt am Main 1999-2000, p. 13.

13 For Salomon de Bray, see Von Moltke 1938-1939; A. Blankert in Washington-Detroit-Amsterdam 1980-1981, pp. 196-198, no. 48 (ill.); J.W. von Moltke in *The Dictionary of Art*, vol. 4 (1996), pp. 701-702 (reprinted in Turner 2000, pp. 52-53); F. Lammertse in Rotterdam-Frankfurt am Main 1999-2000, pp. 84-111, nos. 6-11 (ill.). The Frits Lugt Collection contains the following sheets by Salomon de Bray: *The adoration of the shepherds*, inv. no. 1973-T.18 (Paris 1974, no. 11 and fig. 8); a preliminary study from 1654, probably autograph, for (inv. no. 1977-T.20, dated 5 November 1654; F. Lammertse in Rotterdam-Frankfurt am Main 1999-2000, p. 103 note 9, as Salomon de Bray); a drawn copy after Maerten van Heemskerck's *St Luke paints the Madonna* from 1532 in the Frans Halsmuseum (inv. no. 4826; black and red chalk, 41.5 x 34.7 cm; Taverne 1972-1973, p. 60, fig. 6 and p. 62 note 59; for the painting, see Amsterdam 1986, pp. 191-192, no. 70, ill.). The following additional sheets are attributed to the artist: *Baptism of the eunuch*, inv. no. 773; *Study of a child, asleep*, 1666, inv. no. 5161.

14 For this painting, see Von Moltke 1938-1939, p. 443, fig. 21, p. 485, no. 189; Van Thiel *et al.* 1976, p. 142, no. A 58 (ill.).

15 For the symbolism of the wedding ring, see e.g. E. de Jongh in Haarlem 1986, pp. 138, 140 note 9.

16 For the sign language in portraits, see E. de Jongh in Haarlem 1986, pp. 50-55 (ill.); cf. also Bremmer-Roodenburg 1993.

17 Sale Amsterdam, Mak van Waay, 26 September 1972, lot 287, ill. (with incorrect dimensions); see F. Lammertse in Rotterdam-Frankfurt am Main 1999-2000, p. 102, 103 note 8 and fig. 9b. The older literature about the painting under discussion states incorrectly that the woman is depicted seated (Rotterdam 1936-1937, p. 5, no. 3; Von Moltke 1938-1939, p. 481, no. 152; S. Nihom-Nijstad in Paris 1983, p. 27; see also the quotation in note 2).

18 Jan de Bray's grandly conceived *Banquet of Anthony and Cleopatra* from 1669 is dominated by a balustrade behind which are historicising portraits of the painter's family (Rotterdam-Frankfurt am Main 1999-2000, no. 58, ill.). The 'bare' background of the portrait described here and a group portrait that De Bray completed as early as 1663 (*The regents of the Children's Home in Haarlem*; Haarlem, Frans Halsmuseum; Rotterdam-Frankfurt am Main 1999-2000, no. 55, ill.) is also characteristic of several portraits by Van Everdingen (*Portrait of Willem Jacobsz Baert*, 1671, Amsterdam, Rijksmuseum; Rotterdam-Frankfurt am Main 1999-2000, p. 222, fig. 40a).

19 Von Moltke 1938-1939, p. 425, fig. 3, p. 501, no. z. 66; cf. also the drawing from 165(8?) by Jan de Bray with two figures behind a balustrade at Haboldt & Co, New York-Paris (Von Moltke 1938-1939, pp. 511-512, no. z. 171 and fig. 77; Haboldt 2001, pp. 110-111, no. 46, ill.).

20 Von Moltke 1938-1939, p. 429, fig. 7, p. 481, no. 154; London 1952-1953, no. 638.

21 On the etching from 1639, see P. Schatborn in London-The Hague 1999-2000, no. 53; for the self-portrait in London, see P. van Thiel in Berlin-Amsterdam-London 1990-1991, vol. 1, p. 220 (with a reference to De Jongh 1969); E. Buijsen in London-The Hague 1999-2000, no. 54.

22 J. Giltaij in Rotterdam-Frankfurt am Main 1999-2000, no. 53 (ill.). De Bray's oeuvre also includes portraits in which married couples are depicted as recognisable figures from classical antiquity (see A. Blankert in Washington-Detroit-Amsterdam 1980-1981, no. 62, ill.; E. de Jongh in Haarlem 1986, no. 83, ill.).

23 A. Blankert in Washington-Detroit-Amsterdam 1980-1981, no. 48 (ill.); J. Giltaij in Rotterdam-Frankfurt am Main 1999-2000, nos. 53-59 (ill.); Amsterdam 2000a, no. 172 (ill.).

24 Inv. no. 2006; pen and brown ink, grey wash, 27.6 x 30.4 cm; see Von Moltke 1938-1939, p. 497, no. z. 29; J. Giltaij in Rotterdam-Frankfurt am Main 1999-2000, no. 56 and p. 290, fig. 56c. Other sheets by De Bray in the Frits Lugt Collection, arranged in order of their inventory nos.: *Breach in the dike near Haarlem*, 1675, inv. no. 88 (Paris 1989, no. 26 and fig. 41);

Charles II sets sail from Scheveningen, 1660, inv. no. 403 (Paris 1967, no. 327 and fig. 99; Paris 1989, no. 25 and fig. 40); *Tailor's shop*, inv. no. 3081 (Bernt 1979-1980, vol. 4, no. 119); *Half-length portrait of an old woman, traditionally identified as Besje van Meurs of the Doolhof*, Amsterdam, inv. no. 3095; *The reception of Charles II at the Binnenhof, The Hague*, 1660, inv. no. 5042 (Von Moltke 1938-1939, p. 500, no. z. 52; Paris 1967, no. 325 and fig. 99); *Study for the portrait of Abraham Casteleyn and Margaretha van Bancken*, 1663, inv. no. 5124 (preliminary study for the painting in Amsterdam, Rijksmuseum; Von Moltke 1938-1939, p. 511, no. z. 161; Haarlem 1986, p. 181, fig. 36a); *A man's head, resting on his right hand (Self-portrait?)*, inv. no. 5245 (Von Moltke 1938-1939, p. 503, no. z. 83); *Portrait of a girl aged twelve*, 1663, inv. no. 6013 (New York–Paris 1977-1978, no. 19 and fig. 110); *Hilly landscape with meadows and woods*, 1651, inv. no. 9346. Finally, the following sheets are attributed to him: *Study of seated man with glass*, 1666, inv. no. 2652 (Held 1985-1986, pp. 50-52, 53 note 19, as Jacob van Campen; however, see Q. Buvelot in Amsterdam 1995, p. 253 note 66); *Study of a man sitting by a table*, inv. no. 4888.

25 In 1987 she bequeathed paintings by Balthasar van der Ast, Jan Brueghel the Elder and Salomon van Ruysdael to the Mauritshuis; see Broos-Van Leeuwen 1991, pp. 41-42, fig. 4 and the catalogue of acquisitions published in it, nos. XXV-XXVII.

26 This painting had already been loaned to the museum in 1978; for the painting, see A. Blankert in Washington-Detroit-Amsterdam 1980-1981, no. 48 (ill.); F. Lammertse in Rotterdam-Frankfurt am Main 1999-2000, no. 6 (ill.).

27 For the Thurkow Collection, see Utrecht 1988, pp. 4-7.

9 Jan van de Capelle

1 Lugt no. 51409.

2 For Van de Capelle, see Bredius 1892; Hofstede de Groot 1907-1928, vol. 7 (1918); Russell 1975; M. Russell in *The Dictionary of Art*, vol. 5 (1996), pp. 679-682 (reprinted in Turner 2000, pp. 71-74); J. Kelch in Rotterdam-Berlin 1996-1997, pp. 287-300; F. Lammertse in

Allgemeines Künstler-Lexikon, vol. 16 (1997), p. 265.

3 Bredius 1892, p. 30; Thomassen-Gruys 1998, vol. 1, pp. 174-175, vol. 2, pp. 282-283.

4 The old, unsigned copy after the painting in the Lugt Collection that was auctioned around 1926 at Frederik Muller & Cie in Amsterdam was formerly in Lucerne (annotation by Frits Lugt on the painting's inventory card, Fondation Custodia Archives).

5 On the game of *colf* see Sutton 1992, p. 19; A. van Suchtelen in The Hague 2001-2002, p. 26.

6 To the examples already suggested by S. Nihom-Nijstad (in Paris 1983, p. 34) we may now add a sixth: a dated winter landscape of 1653 (sale London, Christie's, 12 December 2001, lot 44.). On Jan van de Cappelle's winter scenes see also Stechow 1966, pp. 95-96; Russell 1975, pp. 30-32; Russell 1988; A. Chong in Amsterdam-Boston-Philadelphia, pp. 286-287; Sutton 1992, pp. 45-46; A. van Suchtelen and P. van der Ploeg in The Hague 2001-2002, pp. 62 and 96.

7 Among the figures is a comparable group of a mother with her child, this time placed more in the foreground. The painting, formerly in the collection of Lore and Rudolf Heinemann in New York, was sold in 1997 (sale London, Christie's, 4 July 1997, lot 16, ill.). For more on this work see P.C. Sutton in Madrid 1994, pp. 94-95, no. 16 (ill.).

8 Thomassen-Gruys 1998, vol. 1, p. 102, vol. 2, pp. 132-133.

9 A. van Suchtelen in The Hague 2001-2002, p. 96.

10 Bredius 1892, p. 32, no. 15; p. 33, no. 44; p. 34, no. 74. On the Avercamp drawings in Van de Cappelle's collection see cat. no. 2 note 12.

11 Bredius 1892, p. 33, no. 50. On Porcellis' possible influence on Van de Cappelle's winter scenes see A. van Suchtelen in The Hague 2001-2002, p. 96.

12 Inv. no. 2344; Russell 1975, p. 96 and fig. 42; New York-Paris 1977-1978, no. 24 and fig. 54.

13 Inv. nos. 89 A and B; Paris 1989, nos. 27-28 and fig. 27. The sheets have also been attributed to Allaert van Everdingen (Russell 1975, pp. 33, 96-97, 102) and Simon de Vlieger (Van Eeghen 1989, p. 14). On the drawings see also Russell 1991, p.260.

14 Inv. no. 8335; S. Nihom-Nijstad in Paris 1983, pp. 96-97, no. 58 and fig. 61.

15 Nihom-Nijstad 1981. Her identification was supported by Bruyn 1984, pp. 149-150. The portrait of Jan van de Cappelle by Gerbrandt van den Eeckhout, dated 1653, is now in the Amsterdams Historisch Museum.

16 On the Rembrandt drawings in Van de Cappelle's collection see Schatborn 1981, pp. 10-12. Various Rembrandt drawings in the Lugt Collection dealing with the 'mother and child' theme could have been part of the portfolio '135 tekeningen sijnde het vrouwenleven met kinderen van Rembrandt' mentioned in the 1680 inventory (Bredius 1892, p. 37, no. 17; see Paris-Haarlem 1997-1998, nos. 3, 5, 7 and 12).

10 Pieter Codde (circle of)

1 Lugt no. 16820.

2 The large, torn and crumpled sheet in the stack in the right foreground (a scene with fantastical creatures?) appears to bear the imprint of a plate and is hence probably a print.

3 On the iconography of the studio scene see Delft-Antwerp 1964; Raupp 1984; Georgel-Lecoq 1987; Walsh 1996; Költsch 2000.

4 Walsh 1996, pp. 51-55; G. Luijten in Amsterdam 1997, pp. 349-350.

5 Gaskell 1982, pp. 17-18. We know of a number of examples of this group (among them one in London, The Wallace Collection; Mann 1931, p. 46, no. S 121 and fig. 33), which has been attributed alternately to Vincenzo de' Rossi, Giovanni da Bologna and Adriaen de Vries (Montreal 1992, pp. 180-181 and fig. 63). An ivory version is ascribed to the German sculptor Leonhard Kern (Theuerkauff 1973, p. 73 and figs. 18-19). On Michelangelo's unfinished sculpture, known only through a *bozzetto* in the Casa Buonarotti in Florence, see Hartt 1969, pp. 246-249, no. 28 (ill.).

6 Gerrit Dou, *Self-portrait*, 1647, Dresden, Gemäldegalerie, inv. no. 1704 (Leiden 2001, pp. 27-29, ill.); Jan van der Heyden, *A collector's cabinet, c.*1670, Vienna, Gemäldegalerie der Akademie der bildenden Künste, inv. no. 722 (Amsterdam-Cleveland 1999-2000, no. 67, ill.).

7 G.T.M. Lemmens in Delft-Antwerp 1964-1965, p. 26. The 'walking muscle man' is included, among others, in a portrait of an unknown artist by Gerard van

Honthorst of 1655, Amsterdam, Rijksmuseum (inv. no. SK-A-1479; Judson-Ekkart 1999, pp. 39-41, 318, no. 488, fig. 391), and in *The artist and his model* by Frans van Mieris the Elder, formerly in Dresden, Gemäldegalerie, destroyed in the Second World War (Naumann 1981, vol. 2, pp. 20-22, no. 19 and fig. 19). On the sculpture see further L. Olmstead Tonelli in Providence 1984, pp. 102, 105, and figs. 77, 79. The kneeling female nude on the table recalls the small-scale sculptures of Giambologna, for example his *Kneeling Venus* (Avery 1993, p. 260, no. 61 and fig. 136), although it resembles none of his known works exactly. The raised right arm was visibly altered in the course of painting; *pentimenti* can also be found around the head and torso of the standing Hercules (?).

8 On the 'visit to the studio' see Van de Wetering-Franken 1983; Raupp 1984, pp. 329-330; Asemissen-Schweikhart 1984, pp. 204-209; E. van de Wetering in Melbourne-Canberra 1997-1998, pp. 58-62; *idem* in Kassel-Amsterdam 2001-2002, pp. 27-32.

9 Heesakkers 1987, pp. 84-90; quoted in English translation in Kassel-Amsterdam 2001-2002, pp. 396-399. On Huygens' visit to Lievens and Rembrandt see R.E.O. Ekkart in Leiden 1991-1992, pp. 48-58; E. van de Wetering in Melbourne-Canberra 1997-1998, pp. 60-61; *idem* in Kassel-Amsterdam 2001-2002, passim.

10 On this dress see De Winkel 1995. On artists' clothing in seventeenth-century art see *idem* in The Hague-London 1999-2000, pp. 65-66.

11 It was still ascribed to Anthonie Palamedesz in the catalogue of the 1843 De Colombi sale (note 1). A drawn copy from the eighteenth century now in Vienna, Graphische Sammlung Albertina (inv. no. 8742) is inventoried under the same name (note by Frits Lugt in the painting's dossier, Fondation Custodia Archives).

12 For Codde, see D. Beaujean in *Allgemeines Künstler-Lexikon*, vol. 20 (1998), pp. 95-97 (with additional literature); N. van de Kamp in *The Dictionary of Art*, vol. 7 (1996), pp. 510-511 (reprinted in Turner 2000, pp. 76-77); Naarden 1996, passim. C. Bigler Playter's dissertation, *Willem Duyster and Pieter Codde: The 'Duystere Werelt' of Dutch genre painting* (diss. Cambridge, Mass.,

1972), was unfortunately unavailable to the author.

13 Kassel-Amsterdam 2001-2002, p. 32, fig. 10 (illustrated in colour next to the painting described here).

14 Bredius 1888, p. 189.

15 In Delft-Antwerp 1965 (p. 44, under no. 22) both this painting and the related picture in Brussels (fig. 10b) are described as 'of a higher quality than most of the works ascribed to Codde', an opinion seconded by S. Nihom-Nijstad (in Paris 1983, p. 36). In other literature (see Literature), however, the attribution to Codde is accepted, although his authorship of the work in Brussels has been doubted by some (see note 17).

16 Inv. no. 240. On this painting see P.C. Sutton in Philadelphia-Berlin-London 1984, no. 27 (ill.); W. Liedtke in New York 1992-1993, pp. 99-102 (ill.); B. Werche in Frankfurt am Main 1993-1994, pp. 172-173, no. 21 (ill.). Sutton dated it to around 1628-1630, Liedtke to somewhat later, circa 1630-1635.

17 Inv. no. 4411. The similarity between these two pictures was first noted in Delft-Antwerp 1964-1965, p. 44, under no. 22. On the Brussels painting see further G. Luijten in Amsterdam 1997, pp. 349, 350 note 5 and fig. 3 (as 'attributed to Pieter Codde'); Lammertse *et al.* 1998, p. 40 note 9 (as Pieter Codde); A. de Koomen in Filedt Kok *et al.* 2001, p. 28, pl. 25 (as 'attributed to Pieter Codde').

18 Raupp 1978, p. 127 and fig. 12, as 'Pieter Codde (?)'. Certainly not by the same hand but undoubtedly from the same circle comes the depiction of an artist's studio with an elegant visitor and a large display of objects related to art and artistic praxis (photograph RKD, The Hague; attributed to Willem Duyster by S. Gudlaugsson).

19 The study seems to be an oil sketch on paper, comparable to those executed in this technique around the same time by Dirck Hals (1591-1656). On Hals' figure studies see Amsterdam-Washington 1981-1982, pp. 74-75; Schapelhouman-Schatborn 1998, vol. 1, pp. 99-100, nos. 207-208, vol. 2 (ill.). A soldier in a similar pose, pulling on his boot, can be found in a picture by Anthonie Palamedesz (Naarden 1996, p. 23, fig. 37); for other examples of the motif in *cortegaerden*, see *idem*, figs. 35, 27 and nos. 9 and 11).

20 Chapter 1, verse 8; Van Mander ed. 1973, vol. 1, pp. 72-73, vol. 2,

pp. 359-360; Amsterdam 1976, p. 75 note 1; Gaskell 1982, pp. 17-18; Raupp 1984, p. 329.
21 Chapter 5, verse 19; Van Mander ed. 1973, vol. 1, pp. 132-133, vol. 2, p. 471; Amsterdam 1976, p. 73-74; Gaskell 1982, p. 17.
22 Raupp 1984, p. 329.
23 For representations of music-making artists see Raupp 1978.
24 On *vanitas* symbolism in artists' portraits and studio scenes see Popper-Voskuil 1973; Raupp 1984, pp. 266-288.

11 Aelbert Cuyp

1 Lot 10: 'KNYP A Landscape with Rocks' (Lugt no. 1004).
2 Catalogue in manuscript of the collection of the Second Earl of Ashburnham, p. 4: 'A Calm [sic] from Sr L. Schaubs by Cuyp. £13' (as quoted in Chong 1992, p. 376 note 1). The catalogue, which was started in 1760, contains Ashburn-ham's purchases in the years 1754-1786. Like a similar catalogue started in 1794, with purchases in 1793-1800, the manuscript contains only those paintings – one hundred in total – that were displayed at Ashburnham House, Westminster (Preface to the catalogue of the Lady Catherine Ashburnham sale, London, Sotheby's, 24 June 1954). Transcripts of both inventories can be found in the Getty Research Library, Los Angeles (Spears 1998, p. 249 note 171). The painting's presence is documented in 1793 in an inventory of Ashburnham Place as no. 39: 'Cuyp, A Calm, Mr. Holditch, late Sir L. Schaub's. £13'; but annotated copies of the 1758 sale catalogue make no mention of this Holditch, probably the dealer Houlditch (with thanks to Alan Chong, who kindly allowed me to study a revised version of Chong 1992).
3 Copy of the catalogue at the RKD, The Hague.
4 For Cuyp, see Reiss 1975; Chong 1992; P.C. Sutton in Amsterdam-Boston-Philadelphia 1987-1988, pp. 46-47; A. Chong in *idem*, pp. 290-304; P.C. Sutton in Madrid 1994, pp. 100-104; A. Chong in *The Dictionary of Art*, vol. 8 (1996), pp. 293-297 (reprinted in Turner 2000, pp. 81-86); G. Seelig in *Allgemeines Künstler-Lexikon*, vol. 23 (1999), pp. 235-237; Washington-London-Amsterdam 2001-2002. For the biographical details in particu-

lar, see W. Veerman in Dordrecht 1977-1978, pp. 11-21.
5 J.M. de Groot in Dordrecht 1992-1993, p. 117; A. Chong in *The Dictionary of Art*, vol. 8 (1996), p. 297; A.K. Wheelock in Washington-London-Amsterdam 2001-2002, p. 29. The view that Cuyp did little or no painting after his marriage is refuted by W. Veerman (in Dordrecht 1977-1978, p. 18), whose views are endorsed by Seelig (in *Allgemeines Künstler-Lexikon*, vol. 23 [1999], p. 235). Veerman refers to unpublished wills made by Cuyp's wife, all of which refer to paintings yet to be produced, to be bequeathed to the surviving spouse and to their daughter Arendina (b. 1659).
6 Chong 1992, p. 377, in no. 135: 'Both paintings [the painting discussed here and the variant in Rotterdam] are unlike anything else in Cuyp's oeuvre, being not only very Italianate in structure and atmosphere, but also in having very diminutive figures'.
7 Inv. no. 1133; panel, 40.5 x 55 cm, at lower right remnants of the signature ('C'); Reiss 1975, p. 147, no. 108 (ill.); Dordrecht 1977-1978, no. 32 (ill.); Rotterdam 1988, no. 40 (ill.); Chong 1992, pp. 376-377, no. 135, with extensive bibliography. There is another version of this painting in the Gemäldegalerie of the Staatliche Museen, Berlin (panel, 31.5 x 37.8 cm, inv. no. 861 B). Hofstede de Groot (1907-1928, vol. 2 [1908], p. 112, no. 388) and Reiss (1975, p. 146, in no. 107) accept it as autograph, but Chong (1991, pp. 376-377; 1992, pp. 376-377, no. 135a) and recent catalogues published by the museum describe it as a copy (Bock *et al.* 1986, p. 26, fig. 634; Bock *et al.* 1996, p. 37, fig. 1234). The panel is described as early as in *Beschreibendes Verzeichnis der Gemälde im Kaiser-Friedrich-Museum und Deutschen Museum*, ninth edition, Berlin 1931, as a 'veränderte Kopie' after the work in Rotterdam and tentatively attributed to Jacob (1756-1815) or Abraham (1753-1826) van Strij. Another copy after the Rotterdam painting was offered for sale before 1950 on the Amsterdam art market (Chong 1992, p. 377, no. 135b; photograph in the Netherlands Institute for Art History (RKD), The Hague).
8 Reiss 1953, p. 46; Reiss 1976, p. 146, in no. 107; A. Chong in *The Dictionary of Art*, vol. 8 (1996), p. 297.
9 According to Chong (1991, p. 375, in no. 375) the sails of the little

ships and some of the reflections in the river have been painted over. However, when Sarah Walden restored the painting in 1985 she removed older retouches, except for those close to the signature, which she thought might not be autograph (restoration report by Sarah Walden, 10 June 1985, in the painting's file, Fondation Custodia Archives).
10 Smith 1829-1842, vol. 5 (1834), p. 308, in no. 89; Reiss 1975, p. 146, in no. 107; J.M. de Groot in Dordrecht 1977-1978, p. 94, in no. 33. The variant in Rotterdam is described as such in Krefeld 1938, in no. 40; Hofstede de Groot 1920, p. 8; J.M. de Groot in Dordrecht 1977-1978, p. 92, in no. 33. Chong (1991, pp. 611-612; 1992, p. 377, in no. 135; *idem* in *The Dictionary of Art*, vol. 8 [1996], pp. 297) pointed out that these paintings cannot in any case depict any specific location on the banks of the Rhine.
11 Washington-London-Amsterdam 2001-2002, no. 76 (ill.).
12 J.G. van Gelder and I. Jost in Hartford-Hanover-Boston 1973-1974, p. 66, in no. 26. These authors reconstructed Cuyp's sketchbook of his journey in 1651-1652 as part of their preparations for a *catalogue raisonné* of the artist's drawings; their manuscript is currently being edited for publication by E. Haverkamp Begemann. For the drawings made during this journey, see also Dattenberg 1967, pp. 64-81; E. Haverkamp Begemann in Washington-London-Amsterdam 2001-2002, pp. 81-83; W. Kloek in *idem*, pp. 255-261, in nos. 87-93.
13 In the background of the *River landscape* in the Rijksmuseum, Amsterdam (inv. no. SK-A-4118) from about 1655-1660, Cuyp incorporated the drawn *View of the Wylermeer between Nijmegen and Cleves* (whereabouts unknown; De Bruyn Kops 1965; A. Rüger in Washington-London-Amsterdam 2001-2002, p. 178, in no. 42). Cuyp incorporated into two paintings his drawn *View of the Rhine valley with Upper and Lower Elten* in the Frits Lugt Collection (inv. no. 5304, see note 24); see W. Kloek in Washington-London-Amsterdam 2001-2002, p. 261, in no. 93.
14 Hofstede de Groot believed that a drawing by Cuyp in his own collection depicted a landscape in the vicinity of the Lorelei rock (*Mountain landscape with a herds-man and his herd*, present whereabouts unknown; Becker 1923, no. 11;

sale Hofstede de Groot, Leipzig, Boerner, 4 November 1931, lot 56, not ill.).
15 Inv. no. 128. For this painting, see A. Rüger in Washington-London-Amsterdam 2001-2002, no. 14, with select bibliography. Chong (1991, p. 612; 1992, p. 377, in no. 135) identified an etching by Jan Both (Bartsch no. 2; Naumann 1978, p. 8, ill.) as the possible example for the rock face in the painting discussed here and the variant in Rotterdam. The motif of a river between sheer rock faces can also be found in the work of Herman Saftleven – from whom Cuyp drew inspiration from the beginning of his career – in the late 1640s, before his journey to the Middle Rhine in 1651; see e.g. his drawing in the Kupferstichkabinett of the Staatliche Museen, Berlin (inv. no. 13849; Schulz 1982, p. 365, no. 934 and fig. 113).
16 After this Cuyp dated only his portraits (for an overview, see Chong 1991, p. 612). His *Portrait of a child with a sheep* from 1655 (John Mitchell & Sons, art dealers, London, 1996) bears the last year that has been found on Cuyp's paintings.
17 Reiss 1975, pp. 146-147, in nos. 107-108; J.M. de Groot in Dordrecht 1977-1978, pp. 92, 94, in nos. 32, 33; C. van Hasselt in Paris 1989, pp. 5-6, in no. 3.
18 Chong 1991, pp. 611-612 and note 37; A. Chong in *The Dictionary of Art*, vol. 8 (1996), p. 297. The oak panel was ready to be painted around 1649, in theory between 1647 and 1653.
19 De Bruyn Kops 1965, p. 171.
20 Aelbert Cuyp's work is first found in Britain in the sale of the Edmund Glover Collection (London, Ford, 16-22 March 1741 [Lugt no. 533]; A. Chong in Washington-London-Amsterdam 2001-2002, p. 50 note 34). For Cuyp's reception in Britain in the eighteenth and nineteenth centuries and the collection of his work there, see De Bruyn Kops 1965, pp. 167-175; A. Chong in *The Dictionary of Art*, vol. 8 (1996), p. 298; *idem* in Washington-London-Amsterdam 2001-2002, pp. 42-48.
21 For Schaub, see *The compact edition of the dictionary of national biography*, Oxford 1975, vol. 2, pp. 901-902. Schaub, a diplomat of Swiss extraction, was known as an art connoisseur; George Vertue described him as 'the King's prime

minister connaisseur in pictures' (Pears 1998, p. 196); Vertue visited Schaub's collection in 1749 (see *Walpole Society,* vol. 26 [1937-1938] [*Vertue note books,* vol. 5], p. 76).
22 Beneath the picture, at left: *A. Cnype pinx:,* at right: *T. Major sculp:,* at the centre: *TO S.¹ LUKE SCHAUB K.T this print ingrav'd from an original picture in his collection is humbly dedicated by his most obliged and obedient servant T. Major,* below, at far left: *Publish'd according to Act of Parl.ᵗ Oct.r ¹.ˢᵗ 1751.* For Thomas Major, see Clayton 1997, esp. p. 115. Major included the print in his *Collection of prints, engraved from the finest paintings of the greatest masters, chosen out of the most celebrated collections in England, and France,* London 1756 (Clayton 1997, pp. 167, 169 and fig. 187). In *A Catalogue of Prints,* a catalogue from 1754 (Clayton 1997, p. 115, fig. 130), Major oddly refers to his print as 'A View of the Needles'.
23 For the Schaub sale and the unexpectedly high prices raised there, see Pears 1998. At this sale Lord Ashburnham also acquired *The Holy Family* by Correggio for £220, but it was resold for only £28 after doubts arose as to the attribution (Pears 1998, p. 103 and p. 249 note 171). The movements of the Ashburnham Collection are described in the preface to the catalogue of the sale of 1953 (see Provenance). Bertram, Fourth Earl of Ashburnham (1797-1878), was above all a great book collector and it was to finance this activity that he sold the Second Earl's art collection in 1850 (prompting much public indignation), though he purchased most of the paintings back again. There is no reference to Cuyp's painting in this sale (London, Christie, 20 July 1850; Lugt no. 19960). Gustav Waagen (1854-1857, vol. 3, pp. 27-29) complained that he was not given an opportunity to view the collections of books and paintings properly. The Fourth Earl's books were sold at auction by Sotheby's in London in the years 1897-1901.
24 *A ruminating cow and horse,* inv. no. 458 (Washington-London-Amsterdam 2001-2002, no. 100, ill.); *The ruins of the Huis te Merwede,* inv. no. 579 (Dordrecht 1977-1978, no. 69, ill.); *View of Amersfoort,* inv. no. 744 (Brussels-Rotterdam-Paris-Bern 1968-1969,

no. 33 and fig. 102; New York-Paris 1977-1978, no. 26 and fig. 38; Washington-London-Amsterdam 2001-2002, no. 71, ill.); *Study of a rhubarb plant,* inv. no. 1011 (New York-Paris 1977-1978, no. 25 and fig. 23; Washington-London-Amsterdam 2001-2002, no. 95, ill.); *Landscape with four figures on a hill,* inv. no. 3510; *View of the church at Egmond aan Zee,* inv. no. 3509 (Brussels-Rotterdam-Paris-Bern 1968-1969, no. 31 and fig. 101); *Farmhouses on the bank of a river,* inv. no. 3512 (Brussels-Rotterdam-Paris-Bern 1968-1969, no. 30 and fig. 100); *The Schwanenburg at Cleves,* inv. no. 3506; *Two young herdsmen sitting in a field,* inv. no. 4369 (New York-Paris 1977-1978, no. 27 and fig. 22; Washington-London-Amsterdam 2001-2002, no. 106, ill.); *View of Dordrecht harbour,* inv. no. 5258 (Paris 1989, no. 30 and fig. 35; Washington-London-Amsterdam 2001-2002, no. 81, ill.); *View of the Rhine valley with Upper and Lower Elten,* inv. no. 5304 (Brussels-Rotterdam-Paris-Bern 1968-1969, no. 32 and fig. 103; Washington-London-Amsterdam 2001-2002, no. 93, ill.). Cuyp's authorship of *Coach and four* (inv. no. 2506) is disputed.
25 'Voici d'abord, d'Albert Cuyp, une vue de rivière baignée de lumière dorée. Petit tableau célèbre qui provient de la collection d'Ashburnham …; les Anglais ont toujours su s'assurer les meilleurs tableaux de ce maître et ses peintures claires et diaphanes ont exercé une grande influence sur les peintres anglais comme Turner, Crome et Bonington' (from the text of a guided tour around the rooms of the Institut Néerlandais, which Frits Lugt wrote in or before 1965; Fondation Custodia Archives). For Cuyp's influence on British artists in the late eighteenth and early nineteenth centuries, see A. Chong in Washington-London-Amsterdam 2001-2002, pp. 45-47; The Hague 1970-1971, in nos. 63-64. The drawings and watercolours by nineteenth-century British artists in the Frits Lugt Collection were exhibited in 2001 with the title *Aquarelles et dessins anglais: Une promenade* (Paris 2001). The collection also contains a painting by Richard Parkes Bonington (1802-1828), *View of the Giudecca, Venice,* inv. no. 2762, acquired in 1927 (Sutton 1976, p. 72 and fig. 7).

12 Jacob Esselens

1 On both sides the image is partly covered by irregular, coarsely painted margins in brown paint, which cannot be original; these margins (at left *c.*0.8 cm wide, at right *c.*1.3 cm wide) are concealed by the frame. Along the top, too, the frame conceals part of the image.
2 Lugt no. 16388.
3 Lugt no. 31982.
4 According to the Adolphe Schloss sale catalogue, see note 5. The painting does not occur in the sale of *jonkheer* C. Ploos van Amstel *et al.,* Amsterdam, Muller, 24-26 October 1899 (Lugt no. 57505).
5 Lugt no. 61896.
6 Lot 18: 'ESSELENS (JACOB) … A la Vente Giroux les figures et les animaux étaient attribués à Adriaen van de Velde'; copy of the catalogue at the RKD, The Hague.
7 For Esselens, see Lilienfeld 1915; Bredius 1915-1922, vol. 2 (1916), pp. 549-556, vol. 7 (1921), pp. 58-59; Bredius 1930; Gudlaugsson 1951; Hulton 1959; Stechow 1963; Stechow 1966, p. 109; Bol 1973, pp. 247-249; Broos 1981, pp. 118-126, 194-195; Haak 1984, p. 473; B. Broos in *The Dictionary of Art,* vol. 10 (1996), pp. 513-514 (reprinted in Turner 2000, pp. 104-105).
8 In the first place, the series of sheets included in the atlas compiled by the Amsterdam merchant Laurens van der Hem (1621-1678), now in the Österreichische Nationalbibliothek, Vienna. For this series, produced around 1665-1666, see Hulton 1959. Other sheets are mentioned by Stechow (1963, p. 4 note 5).
9 'Een boek over dwars met een hoorne band daarin leggen 15 stuks landschappen in Vrankryk na 't leven getekent van Jacob Esselens met nog 6 dito's' (catalogue of Zomer's *Konst-kabinet,* The Hague, RKD, no. 30; Bredius 1915-1922, vol. 7, p. 58).
10 For this journey, see C. van Hasselt in Brussels-Rotterdam-Paris-Bern 1968-1969, pp. 99-101; R.E.O. Ekkart in Braunschweig 1979, p. 31; Broos 1981, pp. 121-124 (with additional literature); Andrews 1985, p. 26; M. van Berge-Gerbaud in Paris-Haarlem 1997-1998, pp. 199-200 and 208. Some authors, it should be said, are not convinced that the three artists undertook a journey together (see Broos 1981, p. 122 note 2). According to P. Schatborn (in

Amsterdam 1988-1989, pp. 8, 82) Jan Lievens cannot have travelled to Cleves in 1663; he must have gone later, in 1664.
11 Van Eeghen 1975, pp. 176-177. A sketchbook from 1686-1687 belonging to Rutgers in Dordrecht, Museum Simon van Gijn, contains three copies, possibly more, made after drawings by Esselens (Niemeijer 1964; Broos 1981, pp. 194-195).
12 For these portraits, see Stechow 1963.
13 E.g. the *View of the Omval near Amsterdam* in Amsterdam, Amsterdams Historisch Museum (see Van Keulen 1996).
14 For an account of Esselens as a landscape painter, see Stechow 1963, p. 4; B. Broos in *The Dictionary of Art,* vol. 10 (1996), pp. 513-514 (reprinted in Turner 2000, pp. 104-105).
15 For Esselens as a draughtsman, see e.g. C. van Hasselt in Brussels-Rotterdam-Paris-Bern 1968-1969, pp. 55-56; Wegner 1973, vol. 1, pp. 80-81; C. van Hasselt in New York-Paris 1977-1978, pp. 56-57; Broos 1981, pp. 118-126; Plomp 1997, pp. 144-150. Aside from the *Beach view with fishermen and fishing boats* (fig. 12b), the artist is represented in the collection with the following drawings: *View of a wood with Diana bathing,* inv. no. 40; *View of a wood,* inv. no. 64 (Brussels-Rotterdam-Paris-Bern 1968-1969, no. 50 and fig. 96); *View of a river with fishermen,* inv. no. 223 (idem, no. 49 and fig. 98).
16 The reference works by Immerzeel (1842-1843, vol. 1, p. 224) and Kramm (1857-1864, vol. 2, p. 443) are unable to give any biographical information on the artist at all; Vosmaer (1868, p. 257 note 3) wondered whether Esselens had studied with Rembrandt.
17 The motif first appeared at the beginning of the seventeenth century in beach views by Hendrick Vroom (1566-1640), see J. Giltaij and J. Kelch in Rotterdam-Berlin 1996-1997, pp. 90 and 190-191. It is also depicted in *The sand yacht,* a large print by Willem van Swanenburg after a design by Jacques de Gheyn II from 1603 (Filedt Kok-Leesberg 2000, vol. 2, pp. 8-12, no. 172, ill.) and in a drawing by the latter from 1602, probably a preparatory sketch for the print. The drawing can be regarded as the first real beach view in seventeenth-century Dutch art (Stechow 1966, p. 102; Van Regteren

Altena 1983, vol. 2, p. 144, no. 940, vol. 3, figs. 204-205). For this motif, see also A. Chong in Amsterdam-Boston-Philadelphia 1987-1988, pp. 331-332.

18 For the fishing pinks of the 'Zijde' (the coastal villages between the Meuse estuary and the Marsdiep) in the seventeenth century, see Petrejus 1954.

19 For this artist, see Kelch 1971; G.S. Keyes in *The Dictionary of Art*, vol. 32 (1996), pp. 671-673 (with additional literature).

20 'Twee graeuwties op papier geschildert, een door de Vlieger en een door d'overledene'; Bredius 1915-1922, vol. 2, p. 550.

21 Inv. no. A 10365. Broos-Schapelhouman 1993, p. 215, no. 169. The similarities between this drawing and Esselens' beach views were noted by H. Verbeek in Haarlem 2000, in no. 60. There is a comparable drawing in the Frits Lugt Collection (Paris 1989, no. 81 and fig. 26; for other examples, see C. van Hasselt in *idem*, p. 81 note 2 and M. Bisanz-Prakken in Vienna 1993, pp. 158-159, no. 85, ill.).

22 Inv. no. 4770. See C. van Hasselt in New York-Paris 1977-1978, p. 56, no. 37, which refers to several similar drawings. For other examples, see Haarlem 2000, no. 60 (ill.); Koblenz-Göttingen-Oldenburg 2000, no. 71 (ill.).

23 This black chalk drawing of a man, standing, which is preserved in the Musée des Beaux-Arts et d'Archéologie, Besançon (Gudlaugsson 1951, ill.), was used in two different beach views, both of which belonged to the collection of Mr and Mrs Neil B. Ivory of Montreal in 1989 (one is reproduced in Bernt 1979-1980, vol. 1, fig. 389). As C. van Hasselt comments (in Paris 1989, p. 8, note 5), the dating of around 1650 proposed by Gudlaugsson cannot be right. The little figures in both paintings have a naturalness about them that is uncharacteristic of Esselens and strongly recall those of Adriaen van de Velde (cat. no. 32), whose earliest beach view dates from 1658 (for this and other beach views by Van de Velde, see P.C. Sutton in Amsterdam-Boston-Philadelphia 1987-1988, pp. 493-495, in no. 103).

24 Inv. no. 2396. See C. van Hasselt in Paris 1989, no. 5, figs. V and 6. Esselens' drawing of the breach in the Diemerzee dyke near Houtewael from 1651, which was made into a print that same year by Pieter

Nolpe (*c.*1613-*c.*1653) – making it one of his few dated works – has the same compositional scheme. Esselens had apparently absorbed this formula so thoroughly, using it in other beach views too, that he could apply it effortlessly to an existing topographical situation in 1651, in this case a dyke landscape. The drawing is in Amsterdam, Gemeentearchief, Atlas Splitgerber, no. 221; for the print, which contains a second rendering after a design by 'I. Colin' (Jacob Colijns ?), see Dozy 1897, nos. 153-154, and Hollstein, vol. 14, p. 176, no. 210 (ill.).

25 The figure concerned is the man in the right foreground. For rhinegraves, see Der Kinderen-Besier 1950, pp. 170-183.

26 Curiously, sale catalogues (see notes 5 and 6) attributed the figures in cat. no. 12 to Adriaen van de Velde. Judging by the figures' apparel, two slightly larger beach views by Esselens (Rosenthal art dealers, Amsterdam, 1964, photograph RKD, The Hague; sale London, Sotheby's, 25 November 1970, lot 92, ill.) were also made relatively early, in the 1650s.

13 Jacob van Geel

1 Information on the painting's inventory card, Fondation Custodia Archives. In 1953 Lugt also purchased from Benedict *Landscape with two huntsmen* by Hendrick ten Oever (S. Nihom-Nijstad in Paris 1983, no. 59 and fig. 22) and earlier still, in 1926, when Benedict first set up business in Berlin, he bought a winter landscape from him that is attributed to Jan van de Velde the Younger (*idem*, no. 85 and fig. 25) and a similar picture by Anthonie Verstraelen (*idem*, no. 91 and fig. 24).

2 On the painter, see Müller-Van Regteren Altena 1931; Bol 1957 (with references to extant records); Bol 1969, pp. 110-116 and figs. 92-99; Stechow 1966, pp. 69, 70 and fig. 130; Bol 1980, pp. 134-135 and figs. 9-10; Bol 1982, p. 10 (reprint of 1980 edition); Gmelin 1982, pp. 69-75; G. Jansen and N. Bakker in Amsterdam 1984, pp. 100-101, 113, 240-257, nos. 62-70 (ill.); Haak 1984, pp. 323-324 and fig. 690; Briels 1987, p. 326, 343 and figs. 417-418, 438-439; E. Buijsen in Tokyo-Kasama-Kumamoto-Leiden 1992-1993, pp. 147-148, no. 13 (ill.); J. Loughman in Dordrecht 1992-1993, pp. 159-161, nos. 32-33 (ill.); M.C. Plomp in

Delft 1996, p. 34 and fig. 25; Briels 1997, pp. 217, 224, 329-320 and fig. 344; A. Rüger in New York-London 2001, pp. 264-265, no. 22 (ill.); W. Liedtke in *idem*, pp. 84-85, 576 notes 219-222.

E. Trautscholdt (in Haverkamp Begemann 1973, pp. 116 and 128, no. Tr 32a, ill.) tentatively attributed an etched wooded landscape to Van Geel (unique impression in Braunschweig, Herzog Anton Ulrich-Museum).

3 Ideally situated for transit trade at the Scheldt estuary, Zeeland had become one of the Republic's most prosperous provinces. From the late sixteenth century onwards, hundreds of Flemish citizens had left their country for religious or economic reasons to settle in Middelburg, Zeeland's capital. The painters among them reinvigorated the city's artistic climate (see Amsterdam 1984, passim).

4 Montias 1982, p. 340, 'Table A.2'.

5 Bol 1957, p. 36, no. 6 and fig. 6.

6 A painting by Van Geel in Hannover's Niedersächsisches Landesmuseum (Bol 1957, p. 38, no. 20 and fig. 20) proves to be dated '1633', rather than '1638' (Grohn 1981, pp. 1146-1147, ill.; Gmelin 1982; A. Rüger in New York-London 2001, p. 265 note 5 and fig. 248), which makes the painting in the Herzog Anton Ulrich-Museum in Braunschweig the artist's last dated work (Bol 1957, p. 38, no. 16 and fig. 15; Haak 1984, p. 323, fig. 690).

7 Bol 1957, pp. 35-39, nos. 1-22; with an addendum consisting of six works in Bol 1980, p. 137 note 9, nos. a-f (reprinted in Bol 1982, p. 13 note 9, nos. a-f). Not included in the literature on Van Geel, as far as is known, is the signed *Landscape with imaginary architecture*, dated 1637 (canvas, 33.7 x 52.2 cm; sale New York, Christie's, 23 May 1997, lot 2, ill.), which depicts the same building as the painting in a private German collection that was completed in 1635 (Bol 1957, p. 36, no. 8; Gmelin 1982, p. 73, fig. 3). Gmelin (1982, p. 72, fig. 2) has already mentioned a wooded landscape purchased in 1942 by the Kunsthistorisches Museum, Vienna, as a work that had escaped Bol's attention. The painting referred to by Gmelin (1982, p. 75 note 2, erroneously as 'Nicht erwähnt [von] Bol') as by Van Geel, published by Bernt (1948, vol. 1, no. 299), bears a false signature and date (Bol already

had his doubts about this painting, in Bol 1957, p. 39; see also the anonymous comments on the photograph in the Netherlands Institute for Art History (RKD) in The Hague).

8 For the development of the Dutch landscape in the second quarter of the seventeenth century, see London 1986.

9 Cf. e.g. *River valley* by Segers in the Mauritshuis, The Hague (Duparc 1980, pp. 101-103, no. 1033, ill.); for the possible influence of Segers on Van Geel, see Bol 1957, p. 31.

10 Briels 1997, p. 329 and note 2.

11 See Gmelin 1982, p. 70.

12 Van Geel was evidently acquainted with Savery's prints (e.g. Stechow 1966, fig. 136).

13 On the possible influence of De Hondecoeter on Van Geel, see Briels 1987, p. 326. In 1930 Lugt acquired a fragment of a landscape by De Hondecoeter (S. Nihom-Nijstad in Paris 1983, no. 36 and fig. 1).

14 On the relationship between Keirincx and Van Geel, see Bol 1969, p. 115; A. Rüger in New-York London 2001, p. 265 note 8.

15 Bol 1957, p. 23.

16 See the full reference above the text; previously mentioned, albeit incompletely, by S. Nihom-Nijstad in Paris 1983, p. 53. The late eighteenth-century inscription can be dated on the basis of the reference to the Musée du Louvre as 'Museum N[ation]al', a name used from about 1793 onwards (as is clear, for instance, from the publication *Réflexions sur le Muséum National* by J.-B.-P. Lebrun, 1793; with thanks to Hans Buijs). The unknown author of the inscription was probably referring, *inter alia*, to the painting by Jan Brueghel the Elder from the collection of Stadholder Willem V, a tondo that was installed in the Louvre in 1795 and was never returned (inv. no. 1099; Brejon de Lavergnée-Foucart-Reynaud 1979, p. 36, ill.; Ertz 1979, p. 595, no. 225 and fig. 202).

17 Inv. no. 3230; Beye 1976, p. 216 and fig. 4; Bol 1980, p. 137 note 9, no. d; Bol 1982, p. 13 note 9, no. d; Gmelin 1982, p. 75 note 2.

18 Müller-Van Regteren Altena 1931, pp. 187-191; Bol 1957, pp. 29-33; Bol 1969, p. 112.

19 Bol 1969, p. 112.

20 L.J. Bol in a letter to Frits Lugt (see note 33) about the painting described here, 'het zal geschilderd zijn ten tijde van de Middelburgse

periode van Van Geel (vóòr 1626)'
(It must have been painted in
Van Geel's Middelburg period,
before 1626); for the dating of the
painting see also S. Nihom-Nijstad
in Paris 1983, p. 53. Besides the
paintings in Rotterdam and Paris,
Bol assigned very few works to this
early period (Bol 1969, pp. 110-112,
figs. 92-94).

21 Inv. no. 2888, acquired as part
of the bequest by Vitale Bloch; for
the painting, see Bol 1957, p. 36,
no. 3 and fig. 3 (as *c.*1620); Paris
1979, no. 15 (*idem*).

22 Bol 1957, p. 31; Bol 1969, p. 112.

23 Inv. no. 3232; Bol 1957, p. 36,
no. 5 and fig. 5, as *c.*1630.

24 Butôt 1981, pp. 100-101, no. 33
(ill.); sale Amsterdam, Sotheby's,
16 November 1993, lot 43, colour
ill.; subsequently at Douwes Bros.
art dealers, 1994 (shown that year
at the European Fine Art Fair,
Maastricht).

25 For this painting, signed 'iacob
v geel', see Bol 1957, p. 26, fig. 11,
p. 37, no. 12; Amsterdam 1984,
no. 67 (ill.); P. ten Doesschate-
Chu in Basel 1987, no. 33 (ill.);
C. Vermeeren in The Hague 1995-
1996, no. 9 (colour ill.).

26 Cf. Bol 1957, figs. 14, 17.

27 The painting in Vienna
(Gmelin 1982, p. 72, fig. 2) also
depicts a small goat, for which Van
Geel used similar white highlights.

28 Such as the *Landscape with
the Temptation of Christ* (copper,
21 x 29 cm; private collection);
Bol 1969, pp. 111-112 and fig. 94;
E. Buijsen in Tokyo-Kasama-
Kumamoto-Leiden 1992-1993,
no. 13 and p. 74, fig. 13.

29 Bol 1957, p. 37, nos. 13-14
and figs. 12-13; Dordrecht 1992-
1993, nos. 32-33 and fig.

30 The exhibition *Masters of
Middelburg* at K. & V. Waterman
Gallery at Amsterdam was dedicated
to Bol (Amsterdam 1984). On Bol,
see I. Bergström and S.H. Levie in
Amsterdam 1984, pp. 12-24 (with a
list of his numerous publications);
De Groot 1994.

31 Bol 1982, p. 10.

32 The article by Müller-Van
Regteren Altena 1931 had already
appeared.

33 Bol 1980, p. 137 note 9, no. e
(as Jacob van Geel); reprinted in
Bol 1982, p. 13 note 9, no. e. Bol
initially had his doubts about the
attribution to Van Geel, as appears
from a letter of 23 May 1957 to
Frits Lugt in the Fondation
Custodia Archives.

14 Jan Davidsz de Heem

1 Cf. Geesink 1986, p. 410.

2 Lugt no. 78112. Lugt appraised
the Braams Collection on 11 and 12
March 1918 (report in the library
of the RKD, The Hague, among the
auction catalogues).

3 On the back of the painting is a
typed label with the text: 'bruikleen
F. Lugt, Maartensdijk / Oct. 1931'.
The work is still noted as on loan
to the Rijksmuseum in Vorenkamp
1933, p. 103.

4 For Jan Davidsz de Heem, see
Bergström 1956, pp. 162-165, 189-
190, 191-216; Greindl 1983, pp. 123-
128, 241-251, 359-363 (ill.); Meijer
1988 (the earliest works, 1626-1628);
Bergström 1988; S. Segal and
L. Helmus in Utrecht-Braunschweig
1991 (ill.); S. Segal in *The Dictionary
of Art*, vol. 14 (1996), pp. 288-291
(reprinted in Turner 2000, pp. 147-
148); A. Chong, W. Kloek and
B. Wieseman in Amsterdam-
Cleveland 1999-2000, pp. 166-179 (ill.).

5 On Seghers see Hairs 1985,
pp. 117-195 (ill.).

6 Inv. no. A 558; Van Gelder 1950,
pp. 92-93, no. 34 (ill.); S. Segal in
Utrecht-Braunschweig 1991, pp. 127-
128, no. 2a (ill.). The painting is
described in detail under no. 36 in
the catalogue of the Ward
Collection by Fred. G. Meijer (in
preparation), who has also correctly
identified the figure as a self-
portrait. In addition to the still lifes
with books mentioned here, Le
Bihan (1990, p. 145 note 12) noted
another signed example whose
attribution is still uncertain.
Finally, a still life formerly in
Montreal, Museum of Fine Arts,
inv. no. 882, was tentatively
attributed to De Heem (De
Mirimonde 1970, p. 256, fig. 10).

7 Inv. no. 190; Bergström 1956,
p. 164, fig. 138; Meijer 1988, p. 36
note 8 (as dated 1629 instead of
1625); Schreuder 1997, p. 18 note 2,
no. f.

8 Inv. no. O-69; Seifertová-
Korecká 1962; Seifertová-Slavícek
1995, pp. 32-33, no. 13 (colour ill.);
Schreuder 1997, pp. 17, 18 note 2,
no. e; Amsterdam-Cleveland 1999-
2000, p. 168, fig. a.

9 Inv. no. 613; Broos 1987,
pp. 185-189, no. 32 (colour ill.;
previously published in French in
Paris 1986, pp. 239-243, no. 31,
colour ill.); S. Segal in Utrecht-
Braunschweig 1991, pp. 128-131, no.
3, colour ill. p. 72; Schreuder 1997,
p. 18 note 2, no. a.

10 Inv. no. 1022; Thiele 1973,
pp. 56-57, no. 22 (ill.); S. Segal in
Utrecht-Braunschweig 1991, p. 130,
fig. 3b; Schreuder 1997, pp. 17, 18
note 2, no. d.

11 Signed and dated on the manu-
script in the centre: 'Johannes /
de Heem / Fecit Anno / 1628'. On this
work, auctioned in London,
Christie's South Kensington, 6 July
1989, lot 44 (ill.; as 'Leyden School
1628'), later at London, Christie's, 8
December 1995, lot 52, then to be
found at Salomon Lilian, art dealer,
Amsterdam, 1997, see Schreuder
1997, pp. 17 and 18 note 2, no. c.

12 Inv. no. SK-A-2565; B. Wieseman
in Amsterdam-Cleveland 1999-2000,
pp. 168-169, no. 28 (colour ill.);
Schreuder 1997, p. 18 note 2, no. g.

13 Leiden 1970, p. 14; B. Wieseman
in Amsterdam-Cleveland 1999-2000,
p. 168. De Heem used a comparable
composition in his other early still
lifes as well (Meijer 1988, fig. 5).

14 See Bergström 1956, chapter IV;
Leiden 1970. On the iconography
of the still life with books and its
interpretation see Miedema 1975;
J. Becker in Münster-Baden-Baden
1979-1980, pp. 448-478; Bialostocki
1982; Eikemeier 1984; Schwarz 1987.

15 Van Regteren Altena 1983, vol. 2,
pp. 15-16, no. P 12, vol. 3, p. 30,
fig. 23 (painting in New Haven,
Connecticut, Yale University Art
Gallery); S. Segal in Utrecht-
Braunschweig 1991, pp. 20-21;
B. Wieseman in Amsterdam-
Cleveland 1999-2000, p. 168,
illustrated on p. 16, fig. 8; cf. also
Geesink 1986, p. 404.

16 See Leiden 1970 (ill.); for early
examples see also Amsterdam
2000b, p. 35, no. 23 and p. 63, no. 44.
It was once thought that the Leiden
painter David Bailly (1584-1657)
had played an important role in
the theme's development, a notion
already overthrown by Bruyn
(1951, p. 225). B. Wieseman (in
Amsterdam-Cleveland 1999-2000,
p. 169 note 2) correctly remarked
that Bailly's earliest dated *vanitas*
still life was only painted in 1651.
On Bailly and De Heem see also
Bergström 1988, p. 41.

17 On Lievens' still life with books
see A. Chong and W. Kloek in
Amsterdam-Cleveland 1999-2000,
pp. 146-148, ill. (paintings in
Amsterdam and Heino). In
Rembrandt's oeuvre, still lifes with
books can be found from 1625 in
both genre and history paintings;
see, for example, Bredius-Gerson
1969, nos. 420, 423, 601, 632 (ill.).

18 As already noted by Martin
1925, pp. 42-43. De Heem's use of
mainly brown and grey tones can
be related to developments in
Haarlem, where at about this time
Pieter Claesz (1596/97-1661) was
painting his monochrome still lifes
and where, from 1625, the same
tendency towards a limited palette
could be found in landscape
painting as well.

19 On the publication see Broos
1987, pp. 187-188 and 189 note 11;
S. Segal in Utrecht-Braunschweig
1991, p. 129. On Bredero see
Amsterdam 1968; Schenkeveld-van
der Dussen 1985.

20 On Bredero's tragedy see
E.K. Grootes in Amsterdam 1968,
p. 36, under no. 36, and pp. 49-50;
for a synopsis of the plot see *idem*,
p. 52. Due to the detailed love
scenes, the *Amadis* romances – the
actual title does not appear in the
Hague painting – were considered
somewhat licentious. There had also
been an international outcry against
the series in the sixteenth century.
On the reception of the work
throughout Europe see Weddige
1975, esp. pp. 235-291; on the
reception in the Netherlands, the
printing history and translation
(with a complete bibliography of
all known editions), which in the
Dutch version comprised a total of
21 volumes, see Van Selm forthco-
ming. It has proved impossible to
discover to which publication the
word 'DANOYE' refers; it is (part of?)
the title of a book at the far left in
the painting in the Lugt Collection
and is also included in the work in
The Hague.

21 On Westerbaen, see NNBW,
vol. 10 (1974), pp. 1177-1181, on his
translation of *Basia*, p. 1178; see also
Leiden 1970, pp. 13-14, under no. 14,
and Keblusek 1997, pp. 215-218.
Secundus' *Basia* poems can also be
counted among the erotic literature
of the period, not only because of
their subjects but also the tone in
which they are written. On the
reception of the poems and
Secundus' reputation see Heesakkers
1986; Guépin 1991, pp. 552-553, 614-
615 note 21; Heesakkers 1995.
Several of the 'Kusies' were also
included in an anthology of works
by various poets: *Nieu liedt-boeck
ghenaemt des minnaars harten
jacht* (The Hague, Koninklijke
Bibliotheek, inv. no. 199 C 18).

22 See S. Segal in Utrecht-
Braunschweig 1991, p. 130; on the
interpretation of De Heem's still

lifes with books cf. also Bergström 1956, pp. 162-163; Seifertová-Korecká 1962, pp. 59-60; Amsterdam 1968, p. 35; Leiden 1970, p. 14; De Mirimonde 1970, pp. 251-257; Thiele 1973, p. 56; Leiden 1976-1977, pp. 80-81, 84; see also the literature on the painting and note 14.

23 'Des Menschen leven is een strijdt . . . / Een groote Niet, besietment wel, / Een Schouw-spel vol veranderinghe'; quoted from Bredero 1890, p. 88; previously cited in Amsterdam 1968, p. 35 and Reitsma 1976, p. 257.

24 See S. Segal in Utrecht-Braunschweig 1991, p. 130.

25 See Geesink 1986, 410-411; Broos 1987, p. 189; S. Segal in Utrecht-Braunschweig 1991, pp. 129-130.

26 See B. Wieseman in Amsterdam-Cleveland 1999-2000, p. 166.

27 The end of the – also further illegible – text on the letter in the Hague painting can be deciphered with difficulty as '[W.?] L. [. . .] Arns'.

28 There was also originally a quill and inkstand in the Hague variation (fig. 14a) which was, however, later painted over by De Heem (see S. Segal in Utrecht-Braunschweig 1991, p. 130 note 2).

29 The poet Westerbaen had a relative of the same name who was a painter and who in 1629, a year after the execution of the pictures in The Hague and Paris, himself painted a still life with books (private collection; Leiden 1970, p. 29, no. 35, ill.; Geesink 1986, pp. 411 and 567, fig. 7) that is very close to De Heem's work of 1628 in the Rijksmuseum.

30 See Provenance.

31 The painting had been on loan from a private collection since 1897 and was acquired in 1912, after it had been purchased by the Vereniging Rembrandt in 1910. Also in 1912 the Rijksmuseum acquired its De Heem still life with books (see note 12), a gift from the estate of Mr C. Hoogendijk. The museum in Leipzig purchased its version in 1916 (see note 10).

32 On the painting's inventory card Lugt noted: 'Een dergelijk schilderij in 't Mauritshuis' (Fondation Custodia Archives).

33 De la Fontaine Verwey 1976, fig. 1; Reitsma 1997, pp. 36-37 (ill.).

34 De la Fontaine Verwey 1976.

35 On Lugt's collections of books and calligraphy see De la Fontaine Verwey 1976 (with ills.); on recent

purchases see Van Berge-Gerbaud et al. 2000, pp. 351-356.

36 Lugt was able to get a hold of a 1622 edition of Bredero's tragedy – De Heem depicted the edition of two years earlier – bound into *Alle de Wercken So Spelen, Gedichten, Brieven en Kluchten [van G.A. Brederode]*, Amsterdam 1638 (see M. van Berge-Gerbaud in Paris 2000, p. 21, no. 21 and fig. 22). He also bought a volume of poems by Westerbaen published in 1657. Lugt's unusual knowledge of minor seventeenth-century Dutch poets is apparent from the numerous quotations after now-forgotten authors in *Wandelingen met Rembrandt* (Lugt 1915).

15 Karel du Jardin

1 A horizontal strip of 5 to 7 mm has been added to the bottom.

2 Lugt no. 2189. On Van der Marck see Lugt 1921-1956, vol. 1, p. 564; B. Broos in The Hague-San Francisco 1990-1991, pp. 199, 341-342 (with mistaken birth and death dates); A. Blankert in Stockholm 1992-1993, pp. 52-53 and 69 note 28. Among others Van der Marck also owned Rembrandt's self-portrait of 1630, once also the property of Frits Lugt (for an illustration of the painting, see the introductory essay).

3 On Foucquet, who was a painter, art dealer and broker, see B. Broos in The Hague-San Francisco 1990-1991, p. 136.

4 Lugt no. 2808; the description of the painting is cited in Kilian forthcoming.

5 Lugt nos. 12962, 13071. On Érard see *Nouvelle biographie générale*, vol. 16 (1856), pp. 174-175. He also owned, among others, Peter Paul Rubens' portrait of Frans Francken the Elder (see O. Zeder in Paris-Montpellier 1998, no. 46, ill.).

6 On Delahante, painter and art dealer, see Thieme-Becker, vol. 8 (1913), p. 580; B. Broos in The Hague-San Francisco 1990-1991, p. 214.

7 According to the information on the inventory card, Fondation Custodia Archives.

8 Blankert 1978, pp. 195-196 note 2.

9 J. Kilian in *The Dictionary of Art*, vol. 9 (1996), p. 380.

10 The donkey in the Lugt painting seems to be a quotation from the work of Potter (cf. the donkey in three of Potter's paintings, illustrated in The Hague 1994-1995, no. 10 [our fig. 25d] and p. 170, fig. 1;

Buijsen *et al.* 1998, p. 229 and fig. 4).

11 Inv. no. 2778; New York-Paris 1977-1978, no. 32 and fig. 120; J.M. Kilian in *The Dictionary of Art*, vol. 9 (1996), p. 380; Amsterdam 2001, p. 155, fig. B and p. 210 note 7. The following drawings by Du Jardin are also in the Lugt Collection: *Roosendael Castle in Gelderland*, inv. no. 5520 (Brussels-Rotterdam-Paris-Bern 1968-1969, no. 43 and fig. 155); *Landscape with a watering place*, inv. no. 9031; and *Hamlet in the environs of Rome*, 1646, inv. no. 1982-T.28.

12 For Du Jardin, see J.M. Kilian in *The Dictionary of Art*, vol. 9 (1996), pp. 379-381 (reprinted in Turner 2000, pp. 95-97); Kilian forthcoming (with older literature). With thanks to Jennifer Kilian for making her manuscript available.

13 On the problems surrounding the dating see A. Chong in Amsterdam-Boston-Philadelphia 1987-1988, pp. 361-362; S. Nihom-Nijstad in Paris 1983, p. 46 and especially Kilian forthcoming, pp. 337-338, no. 66. Brochhagen (1957, pp. 249-250; 1958, pp. 131-132) and Stechow (1966, p. 159) have situated the work at the end of Du Jardin's career, when he did in fact paint a number of broad panoramas, while Blankert (in Utrecht 1965, p. 139 and note 6, p. 207 notes 2 and 3; reprinted in Blankert 1978) dated it to around 1660. The drawing of a Roman landscape in the Kupferstichkabinett in Berlin, which Brochhagen (1957, p. 250 and note 1; 1958, p. 132 and note 434) attributed to Du Jardin on the basis of its similarity to the picture in the Lugt Collection, is in fact the work of Jan Asselijn. The sheet is an autographic preliminary study for Asselijn's painting in the Pushkin Museum in Moscow (see Steland 1989, colour ills. p. 62, p. 63, p. 70, figs. 56-57, p. 213, no. 21). It seems likely that Du Jardin, like Asselijn, made a – now lost – sketch for his painting in Paris (for these studies in the work of Du Jardin see, among others, Amsterdam 2001, p. 156, fig. E).

14 See Kilian forthcoming, pp. 144 and 337-338, no. 66. For the signed painting in Paris, see Blankert 1978, pp. 206-207, no. 127 and fig. 127; Salerno 1977-1980, vol. 2, p. 748, fig. 124.10; Kilian forthcoming, no. 65. For the landscape in the Fitzwilliam Museum, also to be dated around 1660 (panel, 20.6 x 27 cm), see Blankert 1978, pp. 206-

207; Salerno 1977-1980, vol. 2, p. 747, fig. 124.9; Kilian forthcoming, no. 64. The works in Paris and Cambridge are slightly smaller than the landscape described here.

15 B. 11, 17-21, 32, 45-50; Hollstein, vol. 6, pp. 32, 34-35, 37, 41 (ills.); Kilian forthcoming, pp. 337-338, under no. 66.

16 Brötje 1974, p. 45.

17 A. Blankert in Utrecht 1965, p. 138; Blankert 1978, p. 138 (with reference to our fig. 15c). See also Kilian forthcoming, no. 66.

18 Inv. no. 836; Steland-Stief 1971, pp. 85-86, 140-141, no. 110 and fig. LVII; Blankert 1978, pp. 138-139, no. 66 and fig. 66; R. Trnek in Minneapolis-Houston-San Diego 1984-1985, pp. 26-27, no. 4 (colour ill.); Trnek 1992, pp. 37-40, no. 13, colour ill. (with additional bibliography). See also note 13 on the drawing by Asselijn, mistakenly attributed to Du Jardin.

19 Blankert 1978, pp. 138-139; see also Kilian forthcoming, no. 66.

20 Brötje (1974, pp. 44-46 and figs. 1-2) compared the Lugt painting with a landscape by Caspar David Friedrich in the Kunsthalle in Hamburg. In Minneapolis-Houston-San Diego 1984-1985, p. 26, a link is also made between a Dutch seventeenth-century panoramic landscape by an Italianate painter and a romantic landscape of the nineteenth century, here with reference to the painting by Asselijn (fig. 15c) that served as Du Jardin's inspiration.

21 See note 10.

16 Willem Kalf

1 Lot 35: 'Willem Kalf. Une cuisine enrichie de beaucoup d'ustensiles, un homme & une femme sont proche du feu; ce tableau, touché largement & d'un coloris vigoureux, est peint sur bois; hauteur, 9 pouces 6 lignes; largeur 8 pouces [c.25 x 21.6 cm]'(Lugt no. 2874). The painting by Kalf from the collection of François Tronchin (1704-1798) that was auctioned in Paris on 12-15 January 1780 as lot 57 (Lugt no. 3073; dimensions in catalogue text given as approximately 22 x 19 cm), cannot be identical to the slightly larger painting described here and is almost certainly the panel with a similar image formerly in the collection of Adolphe Schloss, Paris (23 x 20 cm; see S. Nihom-Nijstad in Paris 1983, p. 67 note 1 and

Grisebach 1974, pp. 116-117, no. 18 and fig. 21). Further more, the painting described here was already in Lebrun's possession that year (cf. the caption to Weisbrod's print [fig. 16b], given in full in note 12).

2 Lugt no. 8291.

3 Lugt no. 8523.

4 Lugt 1926, pp. 66-67, no. 51 (ill.). The sum that Lugt paid for Kalf's painting was published by M. Monda, 'La première vacation de la vente de la collection Warneck a dépassé 5 millions', *Le Figaro*, 28 May 1926 (cutting pasted into a copy of the catalogue at the RKD, The Hague). Another cutting in the same catalogue reveals that Lugt purchased other paintings at the Warneck sale too, including '*Le tertre*' by Jacob van Ruisdael (145,000 *francs*), a painting that he immediately sold to E.A. Veltman, however; he eventually incorporated it into his collection in 1952 (fig. 27c). At some unknown point in time, Lugt resold the two paintings optimistically attributed to Rembrandt (lots 69 and 70), along with Bonington's '*Sur l'Adriatique*' (lot 87). The Fondation Custodia Archives contain a substantial file on the catalogue made by Lugt, which reveals, among other things, that Lugt had doubts about the paintings offered for sale as Rembrandts.

5 For Kalf, see Van Gelder 1941, from p. 39; Grisebach 1974; L. Grisebach in *The Dictionary of Art*, vol. 17 (1996), pp. 736-737 (with additional literature; reprinted in Turner 2000, pp. 178-179) as well as S. Segal in Madrid 1998 and the recent descriptions of individual paintings in Rotterdam 1994-1995, no. 25 and Amsterdam-Cleveland 1999-2000, nos. 47-51.

6 For the information provided by Vleughels, see Grisebach 1974, pp. 197-198, annex 2; for the painting dated 1652, formerly in the collection of Hans Wetzlar, Amsterdam: *idem*, p. 218, no. 20 and fig. 22.

7 For Pluvier, see Grisebach 1974, pp. 199-206, annex 3.

8 For Vos, see Grisebach 1974, pp. 21-22; for Vondel, *idem*, pp. 32-33.

9 For Van Aelst, see Broos 1987, pp. 16-19, no. 1 (ill.); B. Broos in The Hague-San Francisco 1990-1991, pp. 130-133, no. 1 (ill.).

10 Grisebach 1974, pp. 73-77; Haak 1984, p. 493.

11 For Rijckhals as Kalf's teacher, see Grisebach 1974, pp. 35-36 and

note 91, pp. 76-77. Some paintings by Kalf are closely related to the work of Rijckhals (Grisebach 1974, fig. 32, 41; see also Bergström 1956, pp. 255-256, fig. 212).

12 Haak 1984, pp. 407, 510 note 407-1; see James in Rotterdam 1994-1995, pp. 133-135 and esp. *idem*, p. 141 note 1.

13 One of the few exceptions is Kalf's painting in the Musée Fabre, Montpellier (inv. no. 837-1-49; see Grisebach 1974, p. 220, no. 24 and fig. 26; Q. Buvelot in Paris-Montpellier 1998, no. 27, ill.). Numerous paintings by Kalf are very similar in composition to the one shown here, such as the work in Dresden, Staatliche Kunstsammlungen, Gemäldegalerie Alte Meister, inv. no. 1639 A (Grisebach 1974, p. 213, no. 10 and fig. 18); in a private collection (*idem*, p. 216, no. 17 and fig. 20); and the painting formerly in the collection of Adolphe Schloss in Paris (*idem*, pp. 216-217, no. 18 and fig. 21; see also note 1 above).

14 Grisebach 1974, p. 67; S. Nihom-Nijstad in Paris 1983, p. 67. On the grounds that there are no references to paintings of this type by Kalf in old Dutch sources, whereas French sale catalogues and inventories do mention them, Grisebach (1974, p. 39) concluded that all the interiors must have been made in France (see however Bergström 1956, p. 268; cf. also the comments in Van Gelder 1941, p. 42 and his note 2). On Kalf's stay in Paris, see Grisebach 1974, pp. 14-16, 28-31, 39, 59-60, 197-198.

15 Luiken 1711, pp. 34-36; see R. James in Rotterdam 1994-1995, p. 139 (with an enumeration of other meanings associated with farmhouse interiors).

16 'Tiré du Cabinet de M.ʳ le Brun / D'après le Tableau Original de Kalf, de même grandeur que l'Estampe'. At lower left 'W. Kalf. pinx.' and at lower right 'Weisbrod sculp. 1779.', included in Lebrun 1792-1796, vol. 2 (1792), facing p. 70 (the copy depicted here; for Lebrun and his influential publication, see Haskell 1976, pp. 20-33, ill.). This detail is in fact recorded on an old label attached to the back of the painting: 'gravé dans / le cabinet / Lebrun' (S. Nihom-Nijstad in Paris 1983, p. 66). For the print, see Grisebach 1974, fig. 60; Atwater 1988, p. 816; A. Forderer en J. Hietschold in Karlsruhe 1999, p. 358, no. 191, ill. (separate copy in

private collection). The print had been offered for sale separately as early as March 1780, according to an announcement entitled *Quatrième livraison de douze estampes, Gravées sous la Direction de Mr. LE BRUN, Peintre, D'après divers Tableaux des plus habiles Peintres des Ecoles Flamande & Hollandoise*: '[NOMS DES PEINTRES:] Kalf. L'intérieur d'une cuisine, où se voit une femme mettant un chaudron sur le feu. [NOMS DES GRAVEURS:] Weïsbrod ... SE VEND A PARIS, Chez BASAN & POIGNANT, Marchands de Tableaux & d'Estampes, rue & hôtel Serpente. Mars 1780' (photocopy in the Fondation Custodia Archives, Paris). The paintings issued in print in this series (which appeared in 12 series with a supplement, 1777-1791) all came from the Lebrun Collection (according to the *PREMIERE SUITE DE DOUZE ESTAMPES, Gravées sous la Direction du Sr. LE BRUN, Peintre* ... 'lesquels Tableaux ont été, ou sont encore en sa possession').

17 F. Lugt in Amsterdam 1906, p. 23, no. 67; Lugt 1926, pp. 66-67, no. 51.

18 In 1926-1927 this copy (panel, 25.4 x 20.3 cm) was at Spink & Son Ltd. in London (see Grisebach 1974, p. 214, in no. 12; London 1926-1927, no. 27, ill., as after Kalf). Another copy, with a false signature and date, echoes several elements of the painting exhibited here (private collection; Grisebach 1974, pp. 37, 289, no. C 11 and fig. 169).

19 *Still life with large drinking horn*, inv. no. 100; Grisebach 1974, pp. 163 (and note 354), 164, 282, no. 147 and fig. 155; S. Segal in Delft-Cambridge-Fort Worth 1988-1989, p. 192 and fig. 10.5.

20 Inv. no. 388; Grisebach 1974, p. 270, no. 121 and fig. 127; S. Nihom-Nijstad in Paris 1983, pp. 67-68, no. 41 and fig. 85. This painting may be the Kalf that was auctioned from the Rémond Collection in 1778 as lot 34. The painting auctioned as lot 35 was probably the one described here (see note 1).

17 Thomas de Keyser

1 Lot 20: 'P. Lastman; D. Keyzer. Een kapitale schilderij, steld voor een Turksche historie, staande een visier voor een mosquée, aan wien een Turk iets gekneild aanbied, verder Turksche stoffering van reukvaten etc. alles meesteragtig

behandeld, (getekend P. Lastman inv. D. Keyzer 1660) op doek, 3 voet 8 duim hoog, breed 2 voet 10 duim [*c.*110 x 85 cm], zwarte lijst' (Lugt no. 7876, as quoted in Fredericksen-Priem-Armstrong 1998, p. 357).

2 Lugt no. 12475.

3 According to a note by Martin B. Asscher, 1952 and 1955, in the painting's file, Fondation Custodia Archives. The reference is probably to Stephen Nicholas de Yarburgh-Bateson, Fifth Baron Deramore (1903-1964).

4 For De Keyser, see Weismann 1904; Jensen Adams 1985 (with full bibliography); De Vos tot Nederveen Cappel 1986; Vulsma-Kappers 1988; Devapriam 1990; Van Thiel 1990-1991; Jensen Adams 1995; A. Jensen Adams in *The Dictionary of Art*, vol. 18 (1996), pp. 10-11 (reprinted in Turner 2000, pp. 179-181); Wolleswinkel 2001.

5 *The osteology lesson of Dr Sebastiaen Egbertsz de Vrij* (1619) in Amsterdam, Amsterdams Historisch Museum, previously regarded as De Keyser's earliest work (Jensen Adams 1985, vol. 1, pp. 46-59, vol. 3, pp. 4-12, no. 1), is now attributed to Nicolaes Eliasz Pickenoy (R.E.O. Ekkart in Amsterdam 1993-1994, no. 268, ill.; but see N.E. Middelkoop in The Hague 1998-1999b, pp. 13-14 and fig. 7, as De Keyser). De Keyser's portrait of his father from 1621 is now known only from the print made after the painting by Jonas Suyderhoef (Hollstein, vol. 28, p. 240, no. 91; Jensen Adams 1985, vol. 3, pp. 207-210, no. P-2).

6 Wagenaar 1760-1767, vol. 2, p. 131. M. Schapelhouman (in Amsterdam 1993-1994, p. 571, in no. 244) wondered whether the glass panes had not in fact been removed under pressure from dogmatic Calvinists in the church board. However, seventeenth-century descriptions also mention the lack of light in the church, even after the panes' removal (Dapper 1663, p. 396; Commelin 1693, p. 471). Precisely when this operation took place is not known. According to Wagenaar, the stained-glass windows were 'allengskens' (gradually) taken out in the period following the decision. The descriptions of the city by Dapper (1663, p. 396) and Van Domselaer (1665, quoted by Ter Molen 1978, p. 74 note 12) make no mention of the decision to remove the panes.

7 Commelin (1693, p. 471) refers to the former glazing as 'nu vernietigt' (now destroyed). A list of the guilds that took part in the glazing project is given in Wagenaar 1760-1767, vol. 2, p. 131.

8 Inv. no. KDZ 3793. For the drawing, see Bock-Rosenberg 1930, vol. 1, p. 333; Lugt 1931, pp. 79-80, fig. 37; Bauch 1952-1953, pp. 225-226, fig. 8; A. Tümpel in Sacramento 1974, pp. 18, 20; Sumowski 1975, p. 152, fig. 2; P. Schatborn in Amsterdam 1991, no. 28 (ill.); *idem* in Amsterdam 1993-1994, no. 245 (ill.).

9 'cirus vorderd' met jonst tgebou van thuys des heren / De goVtsMeen na haer gonst, gots kerCke hIer Vereren / MDCXI' (Cyrus benevolently favoured the house of the Lord, the goldsmiths here make their gift, in accordance with their intentions, to God's church). These lines constitute a chronogram in which the capital letters spell out the year 1611. The line of verse for the panes of the pedlars' guild and the admiralty were written by Pieter Cornelisz Hooft (Hooft 1636, pp. 342, 344; Ozinga 1929, p. 30 note 4).

10 Amsterdam, Rijksmuseum, Rijksprentenkabinet, inv. no. 1899-A-4217. For the drawing, see M. Schapelhouman in Amsterdam 1993-1994, with references to the literature.

11 E.W. Braun in *Reallexikon zur Deutschen Kunstgeschichte*, vol. 3 (1954), cols. 899-912. The subject occurs in the Cyrus series after an unknown subject woven around 1550 by Jan van Tieghen in the Palacio Real, Madrid (Junquera de Vega-Herrero Carretero 1986, vol. 1, pp. 279-289, ill.). A Cyrus series of this kind was woven in 1595-1600 by Jan or Hendrick de Maeght in Middelburg, probably after designs by Karel van Mander. Only two pieces from this series have been preserved (present whereabouts unknown).

12 M. Schapelhouman in Amsterdam 1993-1994, p. 571. Dapper too suggests that there was a uniform programme for the panes: 'In the stained-glass panes round about, one may see diverse guilds commemorated, having had themselves depicted together with their handiwork' (Dapper 1663, p. 396: 'In de glazen, die ook rontom geschildert zijn, ziet men verscheide gilden, dieze ter gedachtenis daer in vereert, en zich met hun handwerk daer by hebben laten uitschilderen'). The pane of the Amsterdam admiralty was evidently an exception. According to Wagenaar (1760-1767, vol. 2, p. 131) it depicted the Battle of Gibraltar (1607), with the Amsterdam admiral Van Heemskerck in command.

13 The panes after designs by Lambert van Noort in St John's Church (also known as the Grote Kerk) at Gouda, dating from 1559-1562 will have set the tone. Later designs for the church in Gouda, too – Joachim Wtewael's design for the pane depicting *The triumph of freedom of conscience* from about 1595-1597, for instance – kept to this structure (Van Ruyven-Zeman 2000, pp. 192-198, no. 9; for the influence of Van Noort's designs, see *idem*, pp. 159-160).

14 Nice 1982, p. 141, no. 142; Jensen Adams 1985, vol. 2, p. 451.

15 A. Blankert in Washington-Detroit-Amsterdam 1980-1981, p. 222. S. Nihom-Nijstad suggested that it depicts Nebuchadnezzar's temple of the gods (Paris 1983, p. 71).

16 E.g. *The Crucifixion* (1616) in Amsterdam, Museum Het Rembrandthuis (Amsterdam 1991, no. 9, ill.) and *David gives the letter to Uriah* (1619) in The Hague, Mauritshuis, inv. no. 1074 (on loan from the Netherlands Institute for Cultural Heritage, Amsterdam/Rijswijk, since 1987; see Amsterdam 1991, no. 12, ill.; Broos 1993a, pp. 187-194, no. 22, ill.).

17 Inv. no. M.B.Z. 196. The tazza was identified by Ter Molen 1978; see also Ter Molen 1994, p. 64, no. 7a, with additional literature.

18 On Lastman's family, see Dudok van Heel 1991.

19 Amsterdam, Rijksmuseum, inv. no. RBK 1976-75. For the flagon, see Ter Molen 1984, vol. 1, pp. 11, 33, 38, 51, 67-68 and fig. 23, vol. 2, pp. 81-82, no. 409, with additional literature; R.J. Baarsen in Amsterdam 1993-1994, no. 112 (ill.). The flagon first occurs in Lastman's *Mary Magdalene beneath the Cross*, 1615 (New York, private collection; Amsterdam 1991, no. 8, ill.) and Lastman subsequently included it in other works. It was later depicted by numerous seventeenth-century painters (see Duyvené de Wit-Klinkhamer 1966; additions in Ter Molen 1984, vol. 2, pp. 81-82). Lastman's brother Seger Pietersz Coninck was probably the driving force behind the interest in the work of the Van Vianen brothers in Amsterdam (Ter Molen 1984, vol. 1, pp. 11, 69).

20 The year and the chronogram of the design probably indicate only the intended date of completion. David Vinckboons' design (see note 10) is also likely to have been made well before 1611. However, the cartoon must have been completed in or after 1614: after this point in time, Lastman would certainly have included Adam van Vianen's flagon, which was commissioned by the guild in that year and remained in its possession until 1821, in his still life.

21 Ter Molen 1978, p. 74.

22 Private collection; Ter Molen 1978, p. 72, fig. 8; Amsterdam-Toledo-Boston 1979, no. 66 (ill.).

23 Ter Molen 1978, p. 74; S. Nihom-Nijstad in Paris 1983, p. 72; Jensen Adams 1985, vol. 2, p. 452.

24 *Portrait of Loef Fredericsz*, 1626, The Hague, Mauritshuis (Jensen Adams 1985, vol. 3, p. 24, no. 8; Broos 1998b and fig. 13); *Portrait of a young silversmith*, 1630, Bath, Longleat, Lord Weymouth (Jensen Adams 1985, vol. 3, p. 55, no. 26); *Portrait of a goldsmith*, 1636, The Hague, Mauritshuis (Jensen Adams 1985, vol. 3, p. 120, no. 64); *Portrait of three goldsmiths and silversmiths*, present whereabouts unknown (Jensen Adams 1985, vol. 3, p. 40, no. 16); *Portrait of four goldsmiths and silversmiths*, 1627, Toledo, Ohio, The Toledo Museum of Art (Jensen Adams 1985, vol. 3, pp. 41-43, no. 17; Amsterdam 2000a, no. 11, ill.); *Portrait of six goldsmiths and silversmiths*, 1627, formerly in Strasbourg, Musée des Beaux-Arts (Jensen Adams 1985, vol. 3, pp. 44-45, no. 18). The latter painting was recently interpreted as a portrait of the four deans of the guild of goldsmiths and silversmiths grouped around Andries Fredericsz, De Keyser's deceased father-in-law; a figure added in 1630 is supposedly his son Simon Andries Valckenaer (Jensen Adams 1995, ill.). For De Keyser's relatives by marriage, see Jensen Adams 1985 and Wolleswinkel 2001.

25 For the triptych, see Hofstede de Groot 1930. Lastman's *Crucifixion* from 1628 was sold at auction in 1993 (London, Phillips, 7 December 1993, no. 201, ill.); the wings, one of which was also dated 1628, were formerly in the Kaiser Friedrich Museum, Berlin, and were lost (Jensen Adams 1985, vol. 3, pp. 48-51, nos. 21-22). Lastman's portrait, probably one of the two portraits of the painter listed in the 1632 inventory of his possessions, is known only from a poem by Joost van den Vondel dating from 1628 (Jensen Adams 1985, vol. 3, pp. 169-170, no. U-1).

26 E.g. compare the composition of De Keyser's *Crucifixion* from 1637 in Moscow, Pushkin Museum, inv. no. 447 (Jensen Adams 1985, vol. 3, p. 128, no. 72; Kuznetsov-Linnik 1982, no. 127, ill.), with Lastman's *Crucifixion* in the triptych of 1628 (see previous note).

27 Hendrick de Keyser designed a pane of glass that the city of Amsterdam donated to St John's Church, Gouda, *The Pharisee and the publican* from 1596-1597 (Van Ruyven-Zeman 1997; Van Ruyven-Zeman 2000, pp. 215-222, no. 13). The reason why he did not design the panes of glass himself was probably that he had too many commissions (Van Ruyven-Zeman 1997, p. 302 note 63).

28 The painting is signed and dated 'Keyser Fecit ano 1657' (with thanks to Eymert-Jan Goossens); for the painting, see Jensen Adams 1985, vol. 2, pp. 441-447, vol. 3, pp. 150-152, no. 88, with additional literature.

29 Sluijter 2000, pp. 40, 221 notes 10-11.

30 Inv. no. 4886; Paris 1983, no. 45 and fig. 71; E. de Heer in Kassel-Amsterdam 2001-2002, no. 2 (colour ill.).

31 Inv. no. 5496, acquired in 1938; Paris 1983, no. 89 and fig. 70; Bruyn 1997, pp. 163-164, fig. 1.

32 Lugt had acquired *Landscape with Mercury and Argus* (inv. no. 492; Paris 1983, no. 82 and fig. 8) by Moyses van Wttenbroeck (*c.*1600-*c.*1647) in 1920. As late as 1963 he acquired a small painting, *St Peter released from prison*, which depicts a composition by Jan Pynas (*c.*1583-1631), probably after a print by Nicolaes Lastman from 1609 (inv. no. 7997; copper, 26.5 x 20.3 cm; for the print, see Hollstein, vol. 10, p. 34, no. 4, ill.).

33 Lugt 1931, pp. 79-80 and fig. 37. Lugt's very detailed criticism, running to 44 printed pages, appeared only one year after the publication of Bock-Rosenberg 1930, in which the drawing was classified as anonymous (vol. 1, p. 333). For the way in which a proper understanding of Lastman's oeuvre of drawings devel-

208

oped in the twentieth century, see P. Schatborn in Amsterdam 1991, pp. 132-139.

34 Even today, only fourteen drawings can be attributed to Pieter Lastman. Lugt never succeeded in acquiring one; he knew that Rembrandt had owned two albums full of them (cf. Reitsma 1997, p. 52; for the two albums, see P. Schatborn in Amsterdam 1991, p. 132). It was not until 1973, after Lugt's death, that Carlos van Hasselt managed to secure a small portrait drawing, which probably depicts Lastman's brother Nicolaes (inv. no. 1973-T.1; Paris 1974, no. 40 and fig. 11; Amsterdam 1991, no. 29, ill.; P. Schatborn in London-The Hague 1999-2000, p. 102 and fig. 9b), and in 2000 one of Lastman's red chalk drawings was presented as a gift to the Fondation Custodia (*Mercury*, inv. no. 2000-T.6; Amsterdam 1991, no. 33, ill.).

18 Jan Lievens

1 The panel originally measured approximately 26 x 40 cm and has been enlarged on all sides, probably at a later date. The scene is painted over these extensions.

2 The inventory of his estate (Antwerp, 28 March-10 April 1691) mentions 'Een lantschapken met slaepende boerken van Lievens' (a little landscape with sleeping farmer[s?] by Lievens). The work was assessed by the painters Jan Erasmus Quellinus and Pieter van der Willige (Denucé 1932, p. 360, no. 158; Schneider ed. Ekkart 1973, p. 354, no. S 379). The provenance was suggested by Sumowski 1983-1994, vol. 3 (1986), p. 1813, under no. 1305.

3 For Lievens, see Schneider 1932; Schneider ed. Ekkart 1973; Braunschweig 1979; Sumowski 1979-, vol. 7 (1983), pp. 3143-3708; Sumowski 1983-1994, vol. 3 (1986), pp. 1764-1950 (ill.), vol. 5 (1991), pp. 3060, 3108-3109, 3268-3273 (ill.), vol. 6 (1994), pp. 3525, 3533, 3622-3626, 3726-3730; Amsterdam 1988-1989; Douglas Stewart 1990; Leiden 1991-1992; E. Domela Nieuwenhuis in *The Dictionary of Art*, vol. 19 (1996), pp. 347-350 (reprinted in Turner 2000, pp. 198-201); Dickey 2001; Kassel-Amsterdam 2001-2002.

4 On the *Otia delectant* series, engraved by Bloemaert's son Cornelis and probably executed in the early 1620s, see Roethlisberger

1993, vol. 1, pp. 231-236, nos. 297-312, vol. 2, figs. 434-449. Pastoral staffage can also be found in several of Lievens' other landscapes; cf. Sumowski 1983-1994, vol. 3 (1986), nos. 1303 and 1306 (ill.).

5 On Lievens' landscapes, see Schneider 1932, pp. 57-64; Stechow 1966, pp. 179-180; S. Jacob in Braunschweig 1979, pp. 21-26; Brown 1979, pp. 745-746; Sumowski 1983-1994, vol. 3 (1986), pp. 1769-1770, 1812-1816.

6 Inv. no. 1203; Paris-Haarlem 1997-1998, no. 85 (ill.).

7 Cf. the small landscape within a flower and fruit garland (Merton House, The Duke of Sutherland; Braunschweig 1979, no. 43, ill.; Sumowski 1983-1994, vol. 3 [1986], p. 1814, no. 1307, ill.), recorded already in the 1659 inventory of the collection of Archduke Leopold Wilhelm in Vienna as a by Lievens and Jan van der Hecke (1620-1684). A comparable flower wreath by Van der Hecke, this time incorporating a portrait by Lievens, was also once part of the archduke's collection and is now in the Kunsthistorisches Museum in Vienna (inv. no. 412; Sumowski 1983-1994, vol. 3 [1986], p. 1807, no. 1285, ill.).

8 Amsterdam 1988-1989 (ill.). Stijn Alsteens pointed out to me that the Latin inscription indicates the print was made after a painting. On Van Dyck's presumed influence on Lievens' landscapes see also P. Schatborn in Amsterdam 1988-1989, p. 7.

9 On Lievens' landscape drawings see Sumowski 1979-, vol. 7 (1983), pp. 3710-3893; P. Schatborn in Amsterdam 1988-1989, pp. 7-8, 75-86. Some portraits from the Amsterdam period with landscape backgrounds are illustrated in Sumowski 1983-1994, vol. 3 (1986), nos. 1292, 1297, 1298.

10 Inv. no. 816; Braunschweig 1979, no. 41 (ill.); Sumowski 1983-1994, vol. 3 (1986), p. 1813, no. 1304 (ill.). Schneider and Brown dated the Lugt painting to Lievens' Antwerp period; Jacobs and Nihom-Nijstad to the end of his stay in the city; Sumowski to around 1640 (see Literature).

11 Inv. no. 2864; Sumowski 1983-1994, vol. 3 (1986), p. 1809, no. 1289 (ill.); MacLaren-Brown 1991, pp. 232-233.

12 Brown 1979, p. 745.

13 Bruyn 1988, pp. 327-328. For the dress cf. the 1665 portrait of Gerrit Schouten by Jan Steen (private

collection; Washington-Amsterdam 1996-1997, no. 29A, ill.).

14 Inv. no. 1455; Giltaij-Jansen 1988, no. 18 (ill.). S. Jacob (in Braunschweig 1979, pp. 24, 132) had previously proposed a date around 1650. Schneider (1932, p. 165, no. 310) dated the work to the beginning of Lievens' activity as a landscape painter, as did Sumowski (1983-1994, vol. 3 [1986], p. 1812, no. 1302).

15 Schneider ed. Ekkart 1973, p. 63, tentatively attributed the figures to Nicolaes Berchem.

16 See the entries in the seventeenth-century inventories compiled in Schneider ed. Ekkart 1973, pp. 167-168, 354.

17 Unger 1884, p. 118. On the poem and Kretzer's collection see also Utrecht 1980, passim.

18 Strauss-Van der Meulen 1979, p. 351, nos. 18-19, 22. See also Van Hoogstraten 1678, p. 238. The resemblance between the description in the inventory and in Van Hoogstraten was first noted by Schneider 1932, p. 168.

19 Schneider ed. Ekkart 1973, p. 167. In 1652-1653 Leonaert Bramer drew a copy of a Lievens landscape in a Delft collection (Amsterdam, Rijksmuseum, Rijksprentenkabinet, Album Bramer, inv. no. A 704; Schneider ed. Ekkart 1973, p. 167, no. 324; Plomp 1986, p. 123, no. 31, ill.). A landscape with a castle on a mountain, presumed to be monogrammed and dated 1651, is now known only through old photographs (Plomp 1996, fig. 31a). Sumowski has reattributed two of the three Rembrandt-like landscapes Cynthia Schneider believed to by Lievens to Jacob de Villeers (Schneider 1990, pp. 156-159; Sumowski 1983-1994, vol. 4 [1989], nos. 2924-2925, ills.); on the third painting see *Corpus*, vol. 1 (1982), pp. 758-759, no. C 120 (ill.). Lievens' authorship of a Rembrandt-like *Landscape with the Flight into Egypt* in Madrid, Museo Thyssen-Bornemisza (Schneider ed. Ekkart 1973, pp. 165-166, no. 311; Gaskell 1989, pp. 360-363, no. 82), has been rejected by S. Jacob (in Braunschweig 1979, p. 26 note 20).

20 See note 2. For the Anthoine Collection see also Speth-Holterhof 1957, pp. 24-26.

21 Denucé 1932, p. 358, no. 98, p. 362, no. 223. The inventory further lists two copies after Lievens (*idem*, p. 363, nos. 254 and 276). Anthoine owned 19 works by

Adriaen Brouwer, among them at least three landscapes.

22 For Heseltine see Lugt 1921-1956, vol. 1, pp. 275-276, vol. 2, pp. 212-213 and Lugt 1929.

23 Amsterdam, Frederik Muller & Cie, 27-28 May 1913 (Lugt no. 72829). Lugt added one of the Rembrandt sheets from the Heseltine Collection (*Three studies of an old man*) to his own collection in 1924 (M. van Berge in Paris-Haarlem 1997-1998, pp. XII and 2). On Lugt's visit with Heseltine in 1901 see Reitsma 1997, p. 14 and her introductory essay.

24 Lugt 1929.

25 It is not included in *Ten little pictures* of 1909 or *Ten more little pictures* of 1910, two volumes in the series of small catalogues of parts of his collection that Heseltine published himself as New Years' gifts for his friends. On the same occasion Lugt also bought from Heseltine an important drawing by Peter Paul Rubens, *Hélène Fourment, seated*, which he sold to F. Koenigs. The drawing is now in the Museum Boijmans van Beuningen in Rotterdam (New York-Fort Worth-Cleveland 1990-1991, no. 45, ill.).

26 *A bridge and house under trees*, inv. no. 47 (Schneider ed. Ekkart 1973, p. 368, no. Z.218). For the other drawings see M. van Berge-Gerbaud in Paris-Haarlem 1997-1998, nos. 84-92 (ills.). The collection also includes a drawn copy of a history painting by Lievens in the Royal Palace in Amsterdam (inv. no. 5952; Schneider ed. Ekkart 1973, p. 326, under no. 99).

19-20 Dirck van der Lisse

1 Lot 100: 'VAN SLINGELAND, Pieter / Ecole hollandaise, 1640-1691 / Portrait de femme. Portrait d'homme. Deux pendants. Cuivre ovale. H. 0,16; L. 0,12[.] Voir planche XVII'.

2 Amsterdam 1958, unnumbered (exhibition of De Boer's sale collection).

3 Information from the painting's inventory card, Fondation Custodia Archives.

4 S. Nihom-Nijstad in Paris 1983, p. 65. Frits Lugt had already seen the pieces in 1935, as appears from an annotation in his copy of Antwerp 1935, p. 74, nos. 284-285: 'aardig paar' (RKD, The Hague).

5 S. Nihom-Nijstad in Paris 1983, p. 65 and note 2.

6 For Jonson van Ceulen, see R. Ekkart in *The Dictionary of Art*, vol. 17 (1996), pp. 644-646 (reprinted in Turner 2000, pp. 177-178).

7 Signed at lower right with the painter's monogram; see White 1982, p. 70, no. 99 and fig. 84.

8 Hecht 1984, p. 357. Millar called attention to the London painting in a letter of 22 April 1983 to Carlos van Hasselt, former director of the Fondation Custodia. De Bruyn Kops had already mentioned it in letters dated 8 and 23 March 1983, also to Van Hasselt, and dated the works to around 1635-1640. Marieke de Winkel has pointed out, however, that the shape and pattern of the lace indicate a date somewhere between 1640-1650 (written communication, 29 September 2001).

9 The passage in her will (1662) stated not only that Lambert should be given the originals in order to make copies for his six brothers and sisters – at his own expense – but also that the copies should be returned to him on the death of his siblings so that they would not fall into the hands of strangers; cf. Bredius 1915-1922, vol. I, pp. 81-85; E. de Jongh in Haarlem 1986, pp. 24-25 and figs. 15a-b. The Rembrandt portraits have since been separated and are now in New York, The Metropolitan Museum of Art and St Petersburg, Hermitage (*Corpus*, vol. 3 [1989], pp. 382-394, nos. A 140-141, ills.). On originals, replicas, copies and variations in Dutch portraiture see Ekkart 1997, pp. 20-21.

10 For Van der Lisse, see E. Buijsen in The Hague 1998-1999a, pp. 194-199 (with a complete bibliography) and E. Löffler in *idem*, p. 325. L. Pijl and P. van den Brink (in Utrecht 1993, p. 300) and Broos (1993a, p. 195) have suggested – as we now know, mistakenly – that Van der Lisse may have studied with his father, Abraham Claesz van der Lisse (*c*.1575-1635). The paintings of 'Abraham van der Lisse', known only from the sources, are probably the work of neither Van der Lisse's brother nor his father, but rather of his nephew, who was only born around 1638 (cf. M.J. Bok in San Francisco-Baltimore-London 1997-1998, p. 439 note 2).

11 Sluijter-Seijffert 1984, pp. 32-33, 113; E. Buijsen in The Hague 1998-1999a, p. 195. Houbraken (1718-1721, vol. I, p. 129) already described

Van der Lisse as a student of Van Poelenburch, but was mistaken in both his first name and place of birth ('Joan vander Lis, geboren tot Breda'; cf. Sluijter-Seijffert 1984, pp. 32-33).

12 P. van den Brink in Utrecht 1993, pp. 19, 115-119, no. 12, 200-203, no. 35, 254-258, no. 51 (ill.); N. Sluijter-Seijffert in *idem*, pp. 245-247, no. 48 (ill.); P. van der Ploeg in The Hague 1997-1998, pp. 216-225, nos. 29 a-h (ills.); on Van der Lisse's contribution to the project in particular see E. Buijsen in The Hague 1998-1999a, p. 194, figs. 1-2 and pp. 195-196.

13 E. Buijsen in The Hague 1998-1999a, p. 196; on Van der Lisse's residences in Utrecht and The Hague see M.J. Bok in San Francisco-Baltimore-London 1997-1998, p. 89, nos. 26-27 (ill.) and E. Buijsen in The Hague 1998-1999a, p. 47, no. 32 (ill.).

14 E. Buijsen in The Hague 1998-1999a, p. 198.

15 The Hague, Gemeentearchief, Rechterlijk Archief BNR 351, inv. no. 790; excerpts published in Bredius 1881; Bredius 1882; see also Broos 1993a, p. 199, fig. 4. M.J. Bok (in San Francisco-Baltimore-London 1997-1998, p. 385) counted four original Van Poelenburch paintings and five copies after him in Van der Lisse's collection.

16 Broos 1993a, pp. 195-201, no. 23 (ill.): 'Een slapende jachtnimf'; Sluijter 2000, fig. 267: 'Diana door satyrs bespied'. The sleeping woman may be identified as Diana, goddess of the hunt, but she lacks the traditional crescent moon on her forehead, meaning this must remain speculation.

17 Another pendant pair, also painted on copper and formerly in the collection of F.C. Butôt (1906-1992) – who once owned the 'DVL' monogrammed painting acquired by the Mauritshuis as a gift from his estate in 1993 (Butôt 1981, pp. 196-197, no. 81, ill.; see fig. 19-20b) – was mistakenly attributed to Van der Lisse (Butôt 1981, pp. 254-255, no. 110, ill.: 'Dirck van der Lisse (?) … The lady's portrait bears a monogram similar to that of Dirck van der Lisse'; sale Amsterdam, Sotheby's, 16 November 1993, lot 27, with colour ill., as Gerrit Lundens). According to Dr R.E.O. Ekkart, director of the Netherlands Institute for Art History in The Hague, the portraits were indeed executed in Amsterdam,

not, however, by Lundens but by a painter whose identity remains unknown (oral communication, 15 October 2001).

18 Panel, 27 x 38.5 cm; acquired in 1932. Cf. Knuttel 1935, p. 151, no. 7-32 (already described as portraits of a man and a woman); White 1982, p. 70 (as 'signed').

19 White 1982, p. 70; P. van den Brink in Utrecht 1993, p. 183 and fig. 30.1, dated to *c*.1650; E. Buijsen in The Hague 1998-1999a, p. 198 and fig. 5. Van Reede van Renswoude, like Van der Lisse, was present at Noordeinde Palace on 7 December 1646 for the wedding of Louise Henriette, the oldest daughter of Frederik Hendrik, and Friedrich Wilhelm, Elector of Brandenburg. In a note on the painting in the Iconografisch Bureau in The Hague, F. van Kretschmar identified the three girls as Maria Magdalena van Reede van Renswoude (b. *c*.1626, married in 1657 to Otto Pijnsen van der Aa, whose coat of arms appears on the picture frame), Amalia Catharina (*c*.1628-1657) and Geertruyd Margaretha (*c*.1632-1653). Geertruyd Margaretha's death in 1653 should be seen as the *terminus ante quem* in dating the painting, although the artist could also have portrayed her posthumously, taking her likeness from an earlier portrait.

20 E. Buijsen in The Hague 1998-1999a, p. 198. A large Italianate landscape with the portraits of a couple and their children in pastoral costume (canvas, 110 x 154 cm; sale F. Muller & Cie, Amsterdam, 29 November 1939, lot 973; Colnaghi, art dealers, London, 1979), was tentatively identified by J. Spicer (in San Francisco-Baltimore-London 1997-1998, p. 302, fig. 1, as 'Diderick van der Lisse', and p. 429 note 2) as the work of Van der Lisse. On the painting, whose authorship remains unclear, see McNeil Kettering 1983, pp. 174-175; Sluijter-Seijffert 1984, p. 191 note 61 (as possibly by Van der Lisse). The Iconografisch Bureau in The Hague, finally, attributes a large portrait of a man and a woman in front of a garden to Van der Lisse (canvas, 139 x 184 cm; sale Brussels, 10-11 March 1970, lot 89 and fig. 11, as 'Lissant, Niklaes').

21 E. Buijsen in The Hague 1998-1999a, p. 195.

22 Cf. the remarks in White 1982, p. 70. On Van Poelenburch's

portraits see Sluijter-Seijffert 1984, pp. 108-111, 243-246, nos. 166-194; J. Spicer in San Francisco-Baltimore-London 1997-1998, pp. 316-320, nos. 60-61 (ill.). The set of portraits of 1632 in the Rijksmuseum (inv. no. SK-A-1747 a-g) depicting a couple and their five children – still in their original frames and, like the works here under discussion painted on copper plates measuring 16 x 12.8 cm – are no longer attributed to Van Poelenburch (Van Thiel *et al.* 1976, p. 449, no. A 1747, ill., as Van Poelenburch; C.J. de Bruyn Kops in Amsterdam 1984b, pp. 114-118, no. 15, with ill. showing frame, as an anonymous Dutch artist). Two of the portraits, depicting the couple's daughters, were lent for a time to the Fondation Custodia (see fig. 9 in Huyghe *et al.* 1971). On Albert Blankert's instigation, Loughman (1991, pp. 29-36 and figs. 1-7) has tentatively attributed the group, along with two other portraits in London previously thought to be by Van Poelenburch, to the Dordrecht painter Paulus Lesire (1611-after 1656) and, on the basis of an inventory of 1676, identified the sitters as members of the Dordrecht family Van Esch.

23 Cf. note 8.

24 For Van Honthorst see L.J. Slatkes in *The Dictionary of Art*, vol. 14 (1996), pp. 727-732 (reprinted in Turner 2000, pp. 158-165); R. Ekkart in The Hague 1998-1999a, pp. 174-179; Judson-Ekkart 1999.

25 For Mijtens, see R. Ekkart in *The Dictionary of Art*, vol. 21 (1996), pp. 509-510 (reprinted in Turner 2000, pp. 218-219); R. Ekkart in The Hague 1998-1999a, pp. 206-211 (ill.).

26 With thanks to Dr R.E.O. Ekkart, The Hague. On Van Ravesteyn's individual portraits see R.E.O. Ekkart in The Hague 1998-1999a, p. 233.

27 First noted in Bredius 1881, p. 197; Bredius 1882, p. 750; see Broos 1993b, p. 6.

21 Aert van der Neer

1 On the back of the panel are three stamps in sealing wax, one of which bears the initials of E. Hirschler (see Provenance), and an eighteenth- or early-nineteenth-century inventory number, applied with brush in brown ink: 'N:49'.

oped in the twentieth century, see
P. Schatborn in Amsterdam 1991,
pp. 132-139.
34 Even today, only fourteen
drawings can be attributed to Pieter
Lastman. Lugt never succeeded in
acquiring one; he knew that
Rembrandt had owned two albums
full of them (cf. Reitsma 1997,
p. 52; for the two albums, see
P. Schatborn in Amsterdam 1991,
p. 132). It was not until 1973, after
Lugt's death, that Carlos van
Hasselt managed to secure a small
portrait drawing, which probably
depicts Lastman's brother Nicolaes
(inv. no. 1973-T.1; Paris 1974, no. 40
and fig. 11; Amsterdam 1991, no. 29,
ill.; P. Schatborn in London-The
Hague 1999-2000, p. 102 and fig.
9b), and in 2000 one of Lastman's
red chalk drawings was presented
as a gift to the Fondation Custodia
(*Mercury*, inv. no. 2000-T.6;
Amsterdam 1991, no. 33, ill.).

18 Jan Lievens

1 The panel originally measured
approximately 26 x 40 cm and has
been enlarged on all sides, probably
at a later date. The scene is painted
over these extensions.
2 The inventory of his estate
(Antwerp, 28 March-10 April 1691)
mentions 'Een lantschapken met
slaepende boerken van Lievens'
(a little landscape with sleeping
farmer[s?] by Lievens). The work
was assessed by the painters Jan
Erasmus Quellinus and Pieter van
der Willige (Denucé 1932, p. 360,
no. 158; Schneider ed. Ekkart 1973,
p. 354, no. S 379). The provenance
was suggested by Sumowski 1983-
1994, vol. 3 (1986), p. 1813, under
no. 1305.
3 For Lievens, see Schneider 1932;
Schneider ed. Ekkart 1973;
Braunschweig 1979; Sumowski
1979-, vol. 7 (1983), pp. 3143-3708;
Sumowski 1983-1994, vol. 3 (1986),
pp. 1764-1950 (ill.), vol. 5 (1991),
pp. 3060, 3108-3109, 3268-3273 (ill.),
vol. 6 (1994), pp. 3525, 3533, 3622-
3626, 3726-3730; Amsterdam 1988-
1989; Douglas Stewart 1990; Leiden
1991-1992; E. Domela Nieuwenhuis
in *The Dictionary of Art*, vol. 19
(1996), pp. 347-350 (reprinted in
Turner 2000, pp. 198-201); Dickey
2001; Kassel-Amsterdam 2001-2002.
4 On the *Otia delectant* series,
engraved by Bloemaert's son
Cornelis and probably executed in
the early 1620s, see Roethlisberger

1993, vol. 1, pp. 231-236, nos. 297-
312, vol. 2, figs. 434-449. Pastoral
staffage can also be found in several
of Lievens' other landscapes; cf.
Sumowski 1983-1994, vol. 3 (1986),
nos. 1303 and 1306 (ill.).
5 On Lievens' landscapes, see
Schneider 1932, pp. 57-64; Stechow
1966, pp. 179-180; S. Jacob in
Braunschweig 1979, pp. 21-26;
Brown 1979, pp. 745-746;
Sumowski 1983-1994, vol. 3 (1986),
pp. 1769-1770, 1812-1816.
6 Inv. no. 1203; Paris-Haarlem
1997-1998, no. 85 (ill.).
7 Cf. the small landscape within
a flower and fruit garland (Merton
House, The Duke of Sutherland;
Braunschweig 1979, no. 43, ill.;
Sumowski 1983-1994, vol. 3 [1986],
p. 1814, no. 1307, ill.), recorded
already in the 1659 inventory of
the collection of Archduke Leopold
Wilhelm in Vienna as a by Lievens
and Jan van der Hecke (1620-1684).
A comparable flower wreath by Van
der Hecke, this time incorporating
a portrait by Lievens, was also once
part of the archduke's collection
and is now in the Kunsthistorisches
Museum in Vienna (inv. no. 412;
Sumowski 1983-1994, vol. 3 [1986],
p. 1807, no. 1285, ill.).
8 Amsterdam 1988-1989 (ill.).
Stijn Alsteens pointed out to me
that the Latin inscription indicates
the print was made after a painting.
On Van Dyck's presumed influence
on Lievens' landscapes see also
P. Schatborn in Amsterdam 1988-
1989, p. 7.
9 On Lievens' landscape drawings
see Sumowski 1979-, vol. 7 (1983),
pp. 3710-3893; P. Schatborn in
Amsterdam 1988-1989, pp. 7-8,
75-86. Some portraits from the
Amsterdam period with landscape
backgrounds are illustrated in
Sumowski 1983-1994, vol. 3 (1986),
nos. 1292, 1297, 1298.
10 Inv. no. 816; Braunschweig 1979,
no. 41 (ill.); Sumowski 1983-1994,
vol. 3 (1986), no. 1304 (ill.).
Schneider and Brown dated the
Lugt painting to Lievens' Antwerp
period; Jacobs and Nihom-Nijstad
to the end of his stay in the city;
Sumowski to around 1640 (see
Literature).
11 Inv. no. 2864; Sumowski 1983-
1994, vol. 3 (1986), p. 1809, no. 1289
(ill.); MacLaren-Brown 1991,
pp. 232-233.
12 Brown 1979, p. 745.
13 Bruyn 1988, pp. 327-328. For the
dress cf. the 1665 portrait of Gerrit
Schouten by Jan Steen (private

collection; Washington-Amsterdam
1996-1997, no. 29A, ill.).
14 Inv. no. 1455; Giltaij-Jansen 1988,
no. 18 (ill.). S. Jacob (in Braunschweig
1979, pp. 24, 132) had previously
proposed a date around 1650.
Schneider (1932, p. 165, no. 310)
dated the work to the beginning of
Lievens' activity as a landscape
painter, as did Sumowski (1983-1994,
vol. 3 [1986], p. 1812, no. 1302).
15 Schneider ed. Ekkart 1973,
p. 63, tentatively attributed the
figures to Nicolaes Berchem.
16 See the entries in the seven-
teenth-century inventories compiled
in Schneider ed. Ekkart 1973,
pp. 167-168, 354.
17 Unger 1884, p. 118. On the
poem and Kretzer's collection see
also Utrecht 1980, passim.
18 Strauss-Van der Meulen 1979,
p. 351, nos. 18-19, 22. See also
Van Hoogstraten 1678, p. 238.
The resemblance between the
description in the inventory and in
Van Hoogstraten was first noted
by Schneider 1932, p. 168.
19 Schneider ed. Ekkart 1973,
p. 167. In 1652-1653 Leonaert
Bramer drew a copy of a Lievens
landscape in a Delft collection
(Amsterdam, Rijksmuseum,
Rijksprentenkabinet, Album
Bramer, inv. no. A 704; Schneider
ed. Ekkart 1973, p. 167, no. 324;
Plomp 1986, p. 123, no. 31, ill.).
A landscape with a castle on a
mountain, presumed to be mono-
grammed and dated 1651, is now
known only through old photo-
graphs (Plomp 1996, fig. 31a).
Sumowski has reattributed two of
the three Rembrandt-like landscapes
Cynthia Schneider believed to by
Lievens to Jacob de Villeers
(Schneider 1990, pp. 156-159;
Sumowski 1983-1994, vol. 4 [1989],
nos. 2924-2925, ills.); on the third
painting see *Corpus*, vol. 1 (1982),
pp. 758-759, no. C 120 (ill.). Lievens'
authorship of a Rembrandt-like
Landscape with the Flight into Egypt
in Madrid, Museo Thyssen-
Bornemisza (Schneider ed. Ekkart
1973, pp. 165-166, no. 311; Gaskell
1989, pp. 360-363, no. 82), has been
rejected by S. Jacob (in Braunschweig
1979, p. 26 note 20).
20 See note 2. For the Anthoine
Collection see also Speth-Holterhof
1957, pp. 24-26.
21 Denucé 1932, p. 358, no. 98,
p. 362, no. 223. The inventory
further lists two copies after Lievens
(*idem*, p. 363, nos. 254 and 276).
Anthoine owned 19 works by

Adriaen Brouwer, among them at
least three landscapes.
22 For Heseltine see Lugt 1921-
1956, vol. 1, pp. 275-276, vol. 2,
pp. 212-213 and Lugt 1929.
23 Amsterdam, Frederik Muller
& Cie, 27-28 May 1913 (Lugt
no. 72829). Lugt added one of
the Rembrandt sheets from the
Heseltine Collection (*Three studies
of an old man*) to his own collection
in 1924 (M. van Berge in Paris-
Haarlem 1997-1998, pp. XII and 2).
On Lugt's visit with Heseltine in
1901 see Reitsma 1997, p. 14 and her
introductory essay.
24 Lugt 1929.
25 It is not included in *Ten little
pictures* of 1909 or *Ten more little
pictures* of 1910, two volumes in the
series of small catalogues of parts of
his collection that Heseltine publis-
hed himself as New Years' gifts for
his friends. On the same occasion
Lugt also bought from Heseltine an
important drawing by Peter Paul
Rubens, *Hélène Fourment, seated*,
which he sold to F. Koenigs. The
drawing is now in the Museum
Boijmans van Beuningen in
Rotterdam (New York-Fort Worth-
Cleveland 1990-1991, no. 45, ill.).
26 *A bridge and house under trees*,
inv. no. 47 (Schneider ed. Ekkart
1973, p. 368, no. Z.218). For the
other drawings see M. van Berge-
Gerbaud in Paris-Haarlem 1997-1998,
nos. 84-92 (ills.). The collection also
includes a drawn copy of a history
painting by Lievens in the Royal
Palace in Amsterdam (inv. no. 5952;
Schneider ed. Ekkart 1973, p. 326,
under no. 99).

19-20 Dirck van der Lisse

1 Lot 100: 'VAN SLINGELAND,
Pieter / Ecole hollandaise, 1640-
1691 / Portrait de femme. Portrait
d'homme. Deux pendants. Cuivre
ovale. H. 0,16; L. 0,12[.] Voir planche
XVII'.
2 Amsterdam 1958, unnumbered
(exhibition of De Boer's sale
collection).
3 Information from the painting's
inventory card, Fondation Custodia
Archives.
4 S. Nihom-Nijstad in Paris 1983,
p. 65. Frits Lugt had already seen
the pieces in 1935, as appears from
an annotation in his copy of
Antwerp 1935, p. 74, nos. 284-285:
'aardig paar' (RKD, The Hague).
5 S. Nihom-Nijstad in Paris 1983,
p. 65 and note 2.

6 For Jonson van Ceulen, see R. Ekkart in *The Dictionary of Art*, vol. 17 (1996), pp. 644-646 (reprinted in Turner 2000, pp. 177-178).

7 Signed at lower right with the painter's monogram; see White 1982, p. 70, no. 99 and fig. 84.

8 Hecht 1984, p. 357. Millar called attention to the London painting in a letter of 22 April 1983 to Carlos van Hasselt, former director of the Fondation Custodia. De Bruyn Kops had already mentioned it in letters dated 8 and 23 March 1983, also to Van Hasselt, and dated the works to around 1635-1640. Marieke de Winkel has pointed out, however, that the shape and pattern of the lace indicate a date somewhere between 1640-1650 (written communication, 29 September 2001).

9 The passage in her will (1662) stated not only that Lambert should be given the originals in order to make copies for his six brothers and sisters – at his own expense – but also that the copies should be returned to him on the death of his siblings so that they would not fall into the hands of strangers; cf. Bredius 1915-1922, vol. I, pp. 81-85; E. de Jongh in Haarlem 1986, pp. 24-25 and figs. 15a-b. The Rembrandt portraits have since been separated and are now in New York, The Metropolitan Museum of Art and St Petersburg, Hermitage (*Corpus*, vol. 3 [1989], pp. 382-394, nos. A 140-141, ills.). On originals, replicas, copies and variations in Dutch portraiture see Ekkart 1997, pp. 20-21.

10 For Van der Lisse, see E. Buijsen in The Hague 1998-1999a, pp. 194-199 (with a complete bibliography) and E. Löffler in *idem*, p. 325. L. Pijl and P. van den Brink (in Utrecht 1993, p. 300) and Broos (1993a, p. 195) have suggested – as we now know, mistakenly – that Van der Lisse may have studied with his father, Abraham Claesz van der Lisse (c.1575-1635). The paintings of 'Abraham van der Lisse', known only from the sources, are probably the work of neither Van der Lisse's brother nor his father, but rather of his nephew, who was only born around 1638 (cf. M.J. Bok in San Francisco-Baltimore-London 1997-1998, p. 439 note 2).

11 Sluijter-Seijffert 1984, pp. 32-33, 113; E. Buijsen in The Hague 1998-1999a, p. 195. Houbraken (1718-1721, vol. I, p. 129) already described

Van der Lisse as a student of Van Poelenburch, but was mistaken in both his first name and place of birth ('Joan vander Lis, geboren tot Breda'; cf. Sluijter-Seijffert 1984, pp. 32-33).

12 P. van den Brink in Utrecht 1993, pp. 19, 115-119, no. 12, 200-203, no. 35, 254-258, no. 51 (ill.); N. Sluijter-Seijffert in *idem*, pp. 245-247, no. 48 (ill.); P. van der Ploeg in The Hague 1997-1998, pp. 216-225, nos. 29 a-h (ills.); on Van der Lisse's contribution to the project in particular see E. Buijsen in The Hague 1998-1999a, p. 194, figs. 1-2 and pp. 195-196.

13 E. Buijsen in The Hague 1998-1999a, p. 196; on Van der Lisse's residences in Utrecht and The Hague see M.J. Bok in San Francisco-Baltimore-London 1997-1998, p. 89, nos. 26-27 (ill.) and E. Buijsen in The Hague 1998-1999a, p. 47, no. 32 (ill.).

14 E. Buijsen in The Hague 1998-1999a, p. 198.

15 The Hague, Gemeentearchief, Rechterlijk Archief BNR 351, inv. no. 790; excerpts published in Bredius 1881; Bredius 1882; see also Broos 1993a, p. 199, fig. 4. M.J. Bok (in San Francisco-Baltimore-London 1997-1998, p. 385) counted four original Van Poelenburch paintings and five copies after him in Van der Lisse's collection.

16 Broos 1993a, pp. 195-201, no. 23 (ill.): 'Een slapende jachtnimf'; Sluijter 2000, fig. 267: 'Diana door satyrs bespied'. The sleeping woman may be identified as Diana, goddess of the hunt, but she lacks the traditional crescent moon on her forehead, meaning this must remain speculation.

17 Another pendant pair, also painted on copper and formerly in the collection of F.C. Butôt (1906-1992) – who once owned the 'DVL' monogrammed painting acquired by the Mauritshuis as a gift from his estate in 1993 (Butôt 1981, pp. 196-197, no. 81, ill.; see fig. 19-20b) – was mistakenly attributed to Van der Lisse (Butôt 1981, pp. 254-255, no. 110, ill.: 'Dirck van der Lisse (?) … The lady's portrait bears a monogram similar to that of Dirck van der Lisse'; sale Amsterdam, Sotheby's, 16 November 1993, lot 37, with colour ill., as Gerrit Lundens). According to Dr R.E.O. Ekkart, director of the Netherlands Institute for Art History in The Hague, the portraits were indeed executed in Amsterdam,

not, however, by Lundens but by a painter whose identity remains unknown (oral communication, 15 October 2001).

18 Panel, 27 x 38.5 cm; acquired in 1932. Cf. Knuttel 1935, p. 151, no. 7-32 (already described as portraits of a man and a woman); White 1982, p. 70 (as 'signed').

19 White 1982, p. 70; P. van den Brink in Utrecht 1993, p. 183 and fig. 30.1, dated to c.1650; E. Buijsen in The Hague 1998-1999a, p. 198 and fig. 5. Van Reede van Renswoude, like Van der Lisse, was present at Noordeinde Palace on 7 December 1646 for the wedding of Louise Henriette, the oldest daughter of Frederik Hendrik, and Friedrich Wilhelm, Elector of Brandenburg. In a note on the painting in the Iconografisch Bureau in The Hague, F. van Kretschmar identified the three girls as Maria Magdalena van Reede van Renswoude (b. c.1626, married in 1657 to Otto Pijnsen van der Aa, whose coat of arms appears on the picture frame), Amalia Catharina (c.1628-1657) and Geertruyd Margaretha (c.1632-1653). Geertruyd Margaretha's death in 1653 should be seen as the *terminus ante quem* in dating the painting, although the artist could also have portrayed her posthumously, taking her likeness from an earlier portrait.

20 E. Buijsen in The Hague 1998-1999a, p. 198. A large Italianate landscape with the portraits of a couple and their children in pastoral costume (canvas, 110 x 154 cm; sale F. Muller & Cie, Amsterdam, 29 November 1939, lot 973; Colnaghi, art dealers, London, 1979), was tentatively identified by J. Spicer (in San Francisco-Baltimore-London 1997-1998, p. 302, fig. 1, as 'Diderick van der Lisse', and p. 429 note 2) as the work of Van der Lisse. On the painting, whose authorship remains unclear, see McNeil Kettering 1983, pp. 174-175; Sluijter-Seijffert 1984, p. 191 note 61 (as possibly by Van der Lisse). The Iconografisch Bureau in The Hague, finally, attributes a large portrait of a man and a woman in front of a garden to Van der Lisse (canvas, 139 x 184 cm; sale Brussels, 10-11 March 1970, lot 89 and fig. 11, as 'Lissant, Niklaes').

21 E. Buijsen in The Hague 1998-1999a, p. 195.

22 Cf. the remarks in White 1982, p. 70. On Van Poelenburch's

portraits see Sluijter-Seijffert 1984, pp. 108-111, 243-246, nos. 166-194; J. Spicer in San Francisco-Baltimore-London 1997-1998, pp. 316-320, nos. 60-61 (ill.). The set of portraits of 1632 in the Rijksmuseum (inv. no. SK-A-1747 a-g) depicting a couple and their five children – still in their original frames and, like the works here under discussion painted on copper plates measuring 16 x 12.8 cm – are no longer attributed to Van Poelenburch (Van Thiel *et al.* 1976, p. 449, no. A 1747, ill., as Van Poelenburch; C.J. de Bruyn Kops in Amsterdam 1984b, pp. 114-118, no. 15, with ill. showing frame, as an anonymous Dutch artist). Two of the portraits, depicting the couple's daughters, were lent for a time to the Fondation Custodia (see fig. 9 in Huyghe *et al.* 1971). On Albert Blankert's instigation, Loughman (1991, pp. 29-36 and figs. 1-7) has tentatively attributed the group, along with two other portraits in London previously thought to be by Van Poelenburch, to the Dordrecht painter Paulus Lesire (1611-after 1656) and, on the basis of an inventory of 1676, identified the sitters as members of the Dordrecht family Van Esch.

23 Cf. note 8.

24 For Van Honthorst see L.J. Slatkes in *The Dictionary of Art*, vol. 14 (1996), pp. 727-732 (reprinted in Turner 2000, pp. 158-165); R. Ekkart in The Hague 1998-1999a, pp. 174-179; Judson-Ekkart 1999.

25 For Mijtens, see R. Ekkart in *The Dictionary of Art*, vol. 21 (1996), pp. 509-510 (reprinted in Turner 2000, pp. 218-219); R. Ekkart in The Hague 1998-1999a, pp. 206-211 (ill.).

26 With thanks to Dr R.E.O. Ekkart, The Hague. On Van Ravesteyn's individual portraits see R.E.O. Ekkart in The Hague 1998-1999a, p. 233.

27 First noted in Bredius 1881, p. 197; Bredius 1882, p. 750; see Broos 1993b, p. 6.

21 Aert van der Neer

1 On the back of the panel are three stamps in sealing wax, one of which bears the initials of E. Hirschler (see Provenance), and an eighteenth- or early-nineteenth-century inventory number, applied with brush in brown ink: 'N:49'.

2 Lot 26: 'A dune-like, tree-filled landscape with a very distant view, the staffage being travellers; powerfully painted by *A. van der Neer*' ('Een duinachtig boomrijk Landschap met een uitgestrekt verschiet, gestoffeerd met Reizigers; krachtig geschilderd, door *A. van der Neer*'; Lugt no. 9289). The sale contained the collection of the painter Gabriel van Roijen and 'another knowledgeable art lover' ('een ander kundig liefhebber'). The buyer of the painting, H. Vinkeles Jansz, was probably an art dealer, considering that the sale was held in his house. The low price perhaps means that the painting was bought in, as were several others in the sale.
3 Lugt no. 79159. Colnaghi probably bought the painting by order of Frederik Muller & Cie, who included it several months later in a sale held on 16 December 1919.
4 Lugt no. 79743.
5 Copy of the catalogue at the RKD, The Hague.
6 For Van der Neer, see Bachmann 1972; Bachmann 1982; P.C. Sutton and C.J. de Bruyn Kops in Amsterdam-Boston-Philadelphia 1987-1988, pp. 381-387 (with additional literature); Sutton 1992, pp. 126-131 (with additional literature); L.B.L. Harwood in *The Dictionary of Art*, vol. 22 (1996), pp. 719-720 (with list of literature; reprinted in Turner 2000, pp. 229-231). For biographical details, see Bredius 1900; Bredius 1921; Prins 2000.
7 In 1972 with P. de Boer, art dealer, Amsterdam (Bachmann 1975, p. 215 and fig. 1).
8 On Van der Neer's technique, see Zeldenrust 1983.
9 Stechow 1966, p. 134. The same author also pointed out the similarities between the evening sky in the painting and that seen in several quiet water views which the artist made in the years 1644-1646 (Stechow 1966, p. 177).
10 St Petersburg, Hermitage, inv. no. 2104 (Kuznetsov-Linnik 1982, no. 217, colour ill.).
11 A small landscape by Van der Neer with a lake or beach scene – present whereabouts unknown – in which the composition is closed off on the left by a wooded hillside with a country house or castle and a windmill, shows similarities of design to the small painting in the Frits Lugt Collection (panel, 29 x 42 cm, monogrammed; sale London, Christie's, Manson & Woods, 5 December 1969, lot 82,

ill.). According to Stechow (1966, pp. 134-135 and fig. 272), a mountainous landscape at sunset by the artist in Rotterdam, Museum Boijmans Van Beuningen, inv. no. vdV 55, did not originate until around 1660 and, owing to its greenery, cannot be compared to the bare and inhospitable landscape in the Frits Lugt Collection.
12 Inv. no. 1770; Paris 1989, no. 38 and fig. 37; Amsterdam 2000b, p. 96, no. 70, colour ill. For an overview of the artist's drawings, see Bachmann 1972; B. Broos in Broos-Schapelhouman 1993, pp. 122-123.

22 Caspar Netscher

1 See Van Lennep 1900, pp. 64-65, no. 357; Dudok van Heel 1975a, p. 140; Van Gelder 1978, pp. 235, 237; Broos 1984, pp. 36, 38, 47 note 61. Abraham van Lennep was a bachelor and designated his brothers Jacob and Jan (1634-1711) as executors of his will, writing expressly in his testament of 1675 that 'alle sijn testateurs schilderijen [uytgesondert de ses hiervooren aen sijn testateurs behuwtvader gelegateert] bij gemelde sijne broeders Jacob en Jan van Lennep … moeten werden aengenomen'. The work here under discussion is not mentioned in the description of Jan van Lennep's collection (Dudok van Heel 1975a, pp. 137-139), indicating that it belonged to Jacob. No inventory of his collection is known, making it impossible to determine exactly which paintings he owned. At the division of his estate in 1707 his children received paintings and furniture, although once again without specification (see Dudok van Heel 1975a, p. 140 and note 2).
2 Lugt no. 5243; see also Van Gelder 1978, p. 237.
3 Lot 61: '*Gaspard Netscher* | Le Portrait de l'artiste. Il est entouré de bustes et statues; il montre du doigt des estampes dans un livre, assis dans un fauteuil devant une table couverte d'un tapis; il est vétu d'une robe de satin feuilles-mortes. Ce précieux tableau ne laisse rien à desirer pour la verité. | *Dim. :* 19 pouc. larg. 16 [*c.*51,3 x 43,2 cm]' (Lugt no. 6329; quoted after Peronnet-Fredericksen *et al.* 1998, vol. 1, p. 771, no.0061).
4 Lot 171: 'G. Net[s]cher | Portrait d'Homme coiffé d'une longue Perruque, portant une main sur sa poitrine et l'autre appuyée sur un

Livre. | Supp. : sur toile Dim. : Haut. 17 po. 14 po.' (Lugt no. 7529; quoted after Peronnet-Fredericksen *et al.* 1998, vol. 1, p. 772, no. 0171).
5 Lugt no. 17682; see also Fesch 1841, p. 8, no. 142.
6 Lugt no. 23356; see also Blanc 1857-1858, vol. 2, p. 554.
7 Lugt no. 31842.
8 Lugt no. 33214.
9 Lugt no. 34004.
10 A copy of Le Roy's invoice of the sale, dated 1 February 1892 ('Pour achat de Gaspard Netscher. Savant dans son cabinet Frs 4600') can be found in the painting's records, Fondation Custodia Archives.
11 On the acquisition see Van Hasselt 1977; on the support from the Rembrandt Society, see Hijmersma 1983, p. 162.
12 For Netscher see Wieseman 1993 (with further bibliography); G. Jansen in *The Dictionary of Art* (1996), vol. 22, pp. 915-916 (reprinted in Turner 2000, pp. 233-235); C. Vermeeren in The Hague 1998-1999a, pp. 218-223.
13 Haak 1984, p. 457.
14 E. de Jongh in Haarlem 1986, pp. 189-191, no. 38 (ill.); Sluijter-Seijffert *et al.* 1993, p. 105, no. 126 (ill.).
15 On the reception of Netscher's portraits see, among others, P. Hecht in Amsterdam 1989-1990, pp. 172-175.
16 Blankert 1966 and P. Hecht in Amsterdam 1989-1990, p. 175 note 6.
17 B. / Hollstein 273; on the etching see E. Hinterding in Amsterdam-London 2000-2001, pp. 337-340, no. 84 (ill.). On the basis of this print, B. Broos (in London-The Hague 1999-2000, p. 209, fig. 77a) interpreted a drawn self-portrait by Rembrandt (Rotterdam, Museum Boijmans Van Beuningen) as a representation of the artist as art connoisseur, although the drawing is somewhat illegible. Rembrandt's highly informal portrait of the art-loving burgomaster Jan Six (1618-1700), an etching of 1647, is not intended to be a portrait of a collector (Van Gelder 1978, p. 227; on the etching see M. Royalton-Kisch in Amsterdam-London 2000-2001, pp. 235-243, no. 57, ill.). On the connoisseurs of the seventeenth century see, among others, the essay by E. van de Wetering in London-The Hague 1999-2000, pp. 23-26.
18 On Van Lennep see Van Lennep 1900, p. 136; Dudok van Heel 1975a, pp. 140-141; Van Gelder 1978.

Because he did not use a collector's mark, Van Lennep is not included in Lugt 1921-1956.
19 Quoted after Dudok van Heel 1975a, p. 140: 'vier en dartig boeken met printen en teekeningen, veele Italiaense kunst'. For Italian drawings in Dutch private collections in the seventeenth and eighteenth century, see Plomp 2001, pp. 125-152; for 'kunstboeken' (albums with prints and drawings), see *idem*, pp. 82-85.
20 Dudok van Heel 1975a, pp. 139-140; Dudok van Heel 1975b, p. 172, no. 140 and p. 173, no. 150: 'een party extra schone Papier-Konst, bestaende in veel konstige Italiaense … Tekeningen van groote Meesters, meest alle nog gekomen uyt het beroemt Cabinet van den Graef van Arundel, en schone drukken van Prenten; verscheyde welgeconditioneerde konstboeken, in jaren by een vergadert door wylen Abraham van Lennep, en nu berustende by wylen de Hr. Jan van Lennep …'. On the fate of the Arundel Collection see Weytens 1971. The paintings were only offered for sale at public auction in 1684 (Lugt no. 7); the drawings were sold privately.
21 P. Hecht in Amsterdam 1989-1990, p. 174; as already suggested by Van Gelder 1978, p. 234.
22 Cf. the quotation in note 20.
23 On Netscher's borrowings from De Bisschop see Van Gelder 1978, p. 234 and p. 232, fig. 7; Van Gelder-Jost 1985, pp. 154, 156. The artist had already used other prints from De Bisschop in portraits of 1668 and 1671 (Van Gelder 1978, p. 234; Van Gelder-Jost 1985, p. 120, in nos. 38-39, p. 121, in nos. 40-42, pp. 123-124, in no. 43, p. 176, in no. 88).
24 Van Gelder-Jost 1985, pp. 155-156.
25 On the Rubens copy (Berlin, Kupferstichkabinett, inv. no. 10.601) see Van der Meulen 1994, vol. 2, pp. 64-66, no. 50, vol. 3, fig. 93; for an illustration of the sculpture in Oxford (discussed in detail in Van Gelder-Jost 1985, pp. 153-157, in nos. 71-72) see *idem*, vol. 3, fig. 92. The statue is also included in a double portrait of 1636 in Melbourne, National Gallery of Victoria, by Thomas de Keyser (cat. no. 17), who copied it from the drawing by De Gheyn (cf. Van Gelder 1978, p. 238, ill.; Jensen Adams 1985, vol. 2, pp. 277-279, vol. 3, p. 123, no. 67; Devapriam 1990, pp. 710-713 and fig. 39; Van der Meulen 1994, vol. 2, p. 66 note 14). Van Gelder-Jost (1985, pp. 154 and 156 note 7) mentioned a second painting by

De Keyser of 1660 in which the statue features (Jensen Adams 1985, vol. 3, p. 154, no. 90).

26 Van Gelder (1978, p. 230, fig. 3 and p. 233) notes that the pseudo-Seneca bust is depicted in a similar fashion in a portrait of Jacob Cats (1577-1680) of 1660 (Amsterdam/Rijswijk, Netherlands Institute for Cultural Heritage, inv. no. AA 741) by Arnoldus van Ravesteyn (c.1615-1690). On the drawing after the bust see Van Gelder 1978, pp. 231-233 and figs. 5-6 (as Jacques de Gheyn III); Van Regteren Altena 1983, vol. 2, p. 155, no. 1027, vol. 3, p. 212, fig. 436 (as by Jacques de Gheyn II); and J.A. Poot in Rotterdam-Washington 1985-1986, p. 62 (idem).

27 Van Lennep had previously lived on Rokin, in the house of his parents, known as 't Wapen van Rome (Rokin no. 60); he left there in 1675. Cf. Dudok van Heel 1975a, pp. 140 and 141; Van Gelder 1978, p. 233.

28 Van Gelder 1978, pp. 233-234; see also, however, Van Hasselt 1977, p. 34.

29 On the print see G. Luijten in Hollstein, vol. 31 (1987), p. 179, no. 185 (with bibliography). On the example in Lille we read: 'VAN LENNEP, GROOT LIEFHEBBER'. The print was linked to Van Lennep already in Wessely (1881, p. 30, no. 50, 'Lenepp [sic], Kunstliebhaber'); the preliminary study the author mentions seems now to have disappeared. Following Wessely, the engraver Johan Philip van der Kellen (1831-1906), director of the Rijksprentenkabinet, Rijksmuseum, Amsterdam, noted the connection between the print (and thus the painting) and Van Lennep in a letter to the then-owner, Charles Rutten, although he believed it to be a depiction of Aernout and not Abraham, as had others, mistakenly, before him (Van Someren 1888-1891, vol. 2 [1890], p. 397, no. 3211; the letter of 6 June 1900 was purchased by the Fondation Custodia along with the painting in 1976; inv. no. 1976-A.575). His letter also indicates that the work was initially thought to be a self-portrait – as it was also described in the auction catalogue of 1801 (note 3, above); see also Kramm 1857-1864, vol. 4 (1860), p. 119. In Van Lennep 1900, p. 155, both the print and painting are identified as portraits of Abraham van Lennep, although without further explication; this source is

not mentioned by Dudok van Heel (1975a, pp. 147-148).

30 Cf. P. Hecht in Amsterdam 1989-1990, p. 174 and note 4.

31 On the carpet see Ydema 1991, p. 168, no. 567.

32 On Lugt's disinterest in the *Feinmaler*, see P. Hecht in Paris 1994, p. 270. There are two drawings by Netscher in the Frits Lugt Collection: *Study for a portrait of a seated woman with two putti (after a painting by Adriaen Hanneman)*, inv. no. 107a (Wieseman 1993, pp. 129, 147 note 15 and fig. 34) with, on the back, *Study for a portrait of a woman standing at a pianoforte* (Wieseman 1993, pp. 129, 147 note 15); and *Study for a full-length portrait of a woman with two dogs*, inv. no. 107b. Finally, there are two miniatures attributed to the artist: *Portrait of a boy*, inv. no. 7094 and *Portrait of a girl*, 1673, inv. no. 8990 (Reynolds 1976, p. 276, fig. 10). Lugt also bought drawings by Frans van Mieris the Elder (1635-1681), among others.

33 The painting was offered to the Musée du Louvre in Paris and plans were made to purchase it for one of the French museums that had suffered losses in the Second World War (Van Gelder 1978, p. 227).

34 A painting dating to around 1700-1710 once believed to have been a self-portrait by Arent de Gelder (1645-1727) is now thought to be a portrait of a collector holding Rembrandt's so-called 'Hundred guilder print' (St Petersburg, Hermitage; cf. J. Loughman in Dordrecht-Cologne 1998-1999, pp. 220-223, no. 42, ill.; G. Luijten in Amsterdam-London 2000-2001, p. 19 and fig. 14). It is one of the earliest eighteenth-century examples of a portrait of a connoisseur, a portrait type that would become increasingly popular throughout the century (see Van Gelder 1978, pp. 227-229; cf. Haarlem-Paris 2001-2002, figs. I, II, IV, VI, VII).

35 A few years before the acquisition of the Netscher portrait another painting depicting an art lover had been bought, namely a work of 1826 by Pieter Christoffel Wonder (1780-1852). The sitter is thought to be the well-known art dealer Christiaan Josi (1768-1828), holding a drawing by Rembrandt (see W. Niemeijer in Paris 1994, no. 130, ill.; Haarlem-Paris 2001-2002, pp. 13-15, no. VIII, ill.).

23 Isaak van Nickele

1 Lot 205: 'J.V.NICKELE. 1670. / La Vue intérieure d'un temple protestant, où l'on remarque une femme assise à terre, caressant un chat; derrière elle est un petit garçon; plus loin, un enfant à terre et un homme debout, tenant son bâton. L'on voit encore sur le devant, à droite, un chien qui aboie. Ce Tableau, de ton fin et délicat, peut être comparé aux plus parfaits ouvrages de *Dewitt* [Emanuel de Witte]; ceux de *Nickele* sont très-rares.– Haut. 0,460m, larg. 0,352m. B.' (Lugt no. 7970); first mentioned by G. Jansen in Rotterdam 1991, p. 269 and note 1.

2 As indicated on the painting's inventory card, Fondation Custodia Archives.

3 On the artist's date of birth see G. Jansen in Rotterdam 1991, p. 267 and note 1; for his guild registration see Miedema 1980, vol. 2, p. 659.

4 On Jan van Nickele, see Thieme-Becker, vol. 25 (1931), p. 444.

5 On Isaak van Nickele, see Bruinvis 1909; Thieme-Becker, vol. 25 (1931), p. 444; Jantzen 1979, pp. 88-92, 231-232 and figs. 39-41; Liedtke 1982, pp. 74-75, 128, figs. 70 and 116; Haak 1984, p. 108, fig. 192, p. 394, fig. 846; Biesboer 1985, pp. 104-108 and figs. 61-62; G. Jansen in Rotterdam 1991, pp. 267-270.

6 Cf. L. Helmus in Utrecht 2000-2001, pp. 273-275, no. 64 (ill.). Technical examination has revealed that the figures in this recently restored painting are not all by the same hand. It was once thought that the work, which was believed to have remained unfinished – due in part to the lack of a signature – had been completed by Van Nickele. The *Interior of St Lawrence in Alkmaar* (Alkmaar, Stedelijk Museum), attributed by Schwartz-Bok (1989, p. 236, no. 2 and fig. 251) to Van Nickele, is now thought to be by Saenredam (cf. J. Giltaij in Rotterdam 1991, pp. 158-161, no. 28, ill.). For another attribution to Van Nickele of a work by Saenredam see cat. no. 28 note 13.

7 The letters 'JAN[s?]' before the date could be interpreted as an abbreviation for 'JANUARI', as already suggested by S. Nihom-Nijstad in Paris 1983, p. 95 note 4. There can be no doubt about the date (1670) itself, which is not only legible but also reproduced in the eighteenth-century copy drawing, where we

read: 'I v Nickele. / Pinx. 1670'. On the occasion of the Rotterdam exhibition in 1991, finally, all architectural paintings were subjected to technical examination. No underdrawing was found beneath this work (cf. Giltaij 2000, p. 54).

8 Jantzen 1979, pp. 231-232; photographs at the RKD in The Hague. Liedtke (1982, p. 74 and note 71) mistakenly doubted the dating on this and other paintings by Van Nickele.

9 Gerson-Goodison 1960, p. 93, no. 82 and fig. 43 (as signed and dated 1668); Jantzen 1979, p. 231, no. 381.

10 Inv. no. 31/52, acquired in 1907 as part of the estate of Wilhelm Brandes (1839-1907), who must have purchased it at the E. Habich sale, Stuttgart, Gutekunst, 27 April 1899, lot 480. The drawing is practically identical to the painting, particularly as it reveals how it originally looked on the right-hand side; there are, however, slight variations in the details in the staffage (compare, for example, the man with a cane), as there are in the signature and, especially, in the date. On the drawing see Bernt 1979-1980, vol. 5, no. 443, with colour ill. (as Isaak van Nickele); Sankt Gallen 1980, p. 8, no. 42 (idem); S. Nihom-Nijstad in Paris 1983, p. 95 and note 10 (as possibly by Jan van Nickele); G. Jansen in Rotterdam 1991, p. 269 and note 2, p. 270, fig. 1 (as anonymous). That the painting has been cut down appears from the fact that the reverse of the panel is bevelled on all sides except on the side with the pier.

11 P. Provoyeur (in Nice 1982, p. 135) suggested that Van Nickele intended to depict the three stages of life: childhood, adulthood and, through the memorial plaques, death.

12 Photographs in the RKD, The Hague.

13 Signed on the base of the column in the right foreground; Jantzen 1979, p. 231, no. 376a. For comparable paintings see Jantzen 1979, p. 89 and figs. 39-40. See also the depiction in the Frans Halsmuseum in Haarlem (Biesboer 1985, p. 99, fig. 62, as dated '169.') and in the Musées Royaux des Beaux-Arts in Brussels (Jantzen 1979, fig. 39; Liedtke 1982, fig. 70).

14 Sale London, Phillips, 6 July 1999, lot 215 (ill.), as 'The Interior of the Nieuwe Kerk, Delft', sic; earlier included in sale Amsterdam,

Sotheby's, 14 November 1990, lot 21 (ill.). Compare also the similarly composed painting that was in the hands of Matthiesen gallery, London, 1959 (photograph RKD, The Hague). Van Nickele included repoussoir devices in the foreground of several other interiors of St Bavo, although these are generally horizontal supports, which reduces the perspectival effect considerably (compare, for example, the signed painting of 1694; canvas, 31 x 35 cm; cf. Jantzen 1979, pp. 89, 231, no. 373; sale Hamburg, Hauswedell, 27 November 1965, lot 26, ill.).
15 Cf. Liedtke 1982, pp. 69, 128 (under no. 116) and Biesboer 1985, p. 108.
16 The Job Berckheyde mentioned by Liedtke (1982, p. 74 note 71 and fig. 68, as '167(3?)') in conjunction with the painting by Van Nickele was once in London, in the collection of Martin B. Asscher (1904-1983), and is now in New Zeeland, Dunedin, Dunedin Art Gallery and the Otago Museum, Gift of Dr. E.S. de Beer and his sisters, 1983. The Berckheyde relies heavily on the work of Saenredam and dates, like the Van Nickele, to 1670; however, while it shows the interior as seen from the same chapel, the artist has chosen a different point of view, more or less comparable to the one Saenredam chose for his painting of 1636 now in Lugt Collection (cat. no. 28). Besides the high vantage point, which Van Nickele also used for the work here under discussion, there appears to be no direct connection between the paintings, certainly not when one considers that the Lugt picture originally had a quite different appearance, with the addition of the piece of wall next to the pier (cf. fig. 23a).
17 Jantzen 1979, pp. 89 and 231, nos. 373 and 379; S. Nihom-Nijstad in Paris 1983, pp. 94-95; see also note 14.
18 On Speelman see C. Brown in Houston-The Hague 2000-2001, pp. 9-11; Van der Ploeg 2001. In addition to the three paintings by Van Nickele, Saenredam (cat. no. 28) and De Witte (cat. no. 36), a considerable number of church interiors passed through Lugt's hands. Besides several Saenredam paintings (see the introductory essay, pp. 33-35), in 1916 and 1919 he sold church interiors by Daniël de Blieck (c.1600/20-1673), Hendrick van Vliet (c.1611-1675) and Emanuel de Witte (c.1616-1691/92), among others.

19 See note 1.
20 On St Bavo see De Boer *et al.* 1985; for depictions see Biesboer 1985.
21 Compare, for example, the painting by Gerard Houckgeest (c.1600-1661) of 1651 in the Mauritshuis in The Hague (Liedtke 1982, figs. 3a and IV; Broos 1987, pp. 218-224, no. 38, ill.), with graffiti on the pillar in the foreground. According to Schwartz (1966-1967, p. 91), these markings are to be interpreted as a playful protest against the severity of Protestant churches.

24 Pieter Post

1 Information on the inventory card of the painting, Fondation Custodia Archives. Lugt later purchased from Asscher a history piece by Thomas de Keyser in 1955 (cat. no. 17) and a landscape by Nicolaes Berchem in 1962 (S. Nihom-Nijstad in Paris 1983, no. 6 and fig. 39).
2 Inventoried in the Mauritshuis as inv. no. 931; see De Vries 1958, p. 68, no. 931; De Vries 1960, p. 68, no. 931. On the painting's return, see the annual report for 1961 (De Vries 1963, p. 148). According to correspondence of 6 October 1960 in the Mauritshuis archives, Lugt took the panel back that year.
3 Terwen-Ottenheym 1993 (ill.).
4 Terwen-Ottenheym 1993, p. 22.
5 For Post as a painter, see Gudlaugsson 1954, passim; Larsen 1962, pp. 132, 231; Bol 1969, pp. 148, 200, 247 and fig. 141; Duparc 1980, pp. 77-80 (ill.); Broos 1987, pp. 261-265, no. 46 (ill.). Since the appearance in 1954 of Gudlaugsson's monograph article on Post as a painter, the following paintings attributed to Post have been identified: *Landscape with horsemen before ruins*, c.1629-1630, Hoogsteder & Hoogsteder Gallery, The Hague, 1982, now in a private collection (panel, 42 x 79 cm, remains of signature; H.M. Cramer in Zuoz 1982, no. 39, ill.; sale London, Sotheby's, 22 February 1984, lot 74, ill.; Osaka 1988, no. 45, ill.; Montreal 1990, p. 41 and fig. 22; P. Huys Janssen in The Hague 1991, no. 31, ill.); *View of city with church* and *View of city with carts*, c.1630?, Douwes Brothers Fine Art dealers, Amsterdam, 1996 (panels, each 21 x 43.5 cm; sale London, Sotheby Parke Bernet & Co., 5 July 1984, lot 359, ill.; Amsterdam 1995-1996, no. 37); *Soldiers plundering a city*,

c.1630, Los Angeles, The J. Paul Getty Museum, inv. no. 72.PA.26 (canvas, 77.5 x 112 cm; Keyes 1975, vol. 1, p. 140 note 79; Keyes 1984, pp. 203-204, no. Rej. 61, as Pieter Post; Broos 1987, p. 265 note 13; Jaffé 1997, p. 98, ill.). A painting that Gudlaugsson rightly attributed to Post (1954, p. 61, fig. 3) turned up in 1995 at Jack Kilgore & Co art dealers (shown at the European Fine Art Fair, Maastricht, 1995) and was subsequently purchased by the Frans Halsmuseum, Haarlem. The attribution of four other paintings to Post – a church interior (Gudlaugsson 1954, p. 68, fig. 14), two history pieces (see Terwen-Ottenheym 1993, pp. 15 and 246) and *The stairs of life* (De Werd 1974, p. 33, no. 39 and fig. 24) – is highly implausible. The panoramic landscape that was exhibited in 1961 as Post seems also not to be by him (canvas, 48.5 x 75.5 cm, temporarily on loan to the Mauritshuis from the Piet and Nellie de Boer Foundation, Amsterdam, 1966; see Amsterdam 1961, no. 59 (ill.), as Pieter Post; De Sousa-Leão 1973, p. 42).
6 Unfortunately, the reference to a dune landscape dated 1629 that was probably painted by Pieter Post could not be verified (index cards C. Hofstede de Groot, Netherlands Institute for Art History (RKD), The Hague). This painting in Florence was reportedly signed and dated 'F. Post 1629'. However, the first letter is in all probability not 'F' but 'P' (see De Sousa-Leão 1973, p. 42). Haak wrongly referred to the painting shown here (1984, p. 260, fig. 550), which is up to now the earliest known dated dune landscape, as 'dated 16(..)'.
7 Mauritshuis, inv. nos. 765-766; Martin 1930; Duparc 1980, pp. 78-79 (ill.); Sluijter-Seijffert *et al.* 1993, p. 115 (ill.); a similar scene in Cologne, Wallraf-Richartz-Museum (Gudlaugsson 1954, p. 66, fig. 10; Vey-Kesting 1967, p. 85, no. 2374 and fig. 124). The fourth, signed, panel in the Schönborn Collection, Vienna, was wrongly attributed to Frans Post on the basis of a misread signature (Von Frimmel 1896, pp. 78-79, no. 115; Gudlaugsson 1954, p. 70 note 21; Plietzsch 1960, p. 117; Larsen 1962, pp. 131, 132, 133, 185, no. 1, and fig. 22, p. 227 note 338, as signed 'F.I. Post' [sic]; De Sousa-Leão 1973, p. 21).
8 Gudlaugsson 1954, p. 61, fig. 2 (Cape Town, South African National Gallery) and 3 (Haarlem,

Frans Halsmuseum), and the painting made circa 1629-1630 in a private collection (see note 5).
9 For the painting and the dating, see Broos 1987, pp. 261-265, no. 46 (ill. in colour).
10 They may have collaborated on the view of Haarlem town hall, with the arrival of Prince Maurits in 1630, painted by Saenredam (private collection; Schwartz-Bok 1989, p. 59, fig. 60, p. 266, no. 86), in which the figures are executed in a style very reminiscent of Post's fighting scenes (see above). On the attribution of the figures in this painting to Pieter Post, see Gudlaugsson 1954, pp. 68 and 67, fig. 11; Utrecht 1961, p. 131, in no. 86; Schwartz-Bok 1989, pp. 313-314 note 1. The other examples of collaboration between Post and Saenredam that are mentioned by Gudlaugsson (1954, pp. 68-69) are anything but plausible (on this subject, cf. also Schwartz-Bok 1989, pp. 76, 176, 200, 322 note 24), although the landscapes with ruins by Post and Saenredam do display similarities (see P. Huys Janssen in The Hague 1991, p. 108).
11 Terwen-Ottenheym 1993, p. 15 and figs. 5a-b.
12 This large piece was commissioned by Rijnland dike board, which still (as the District Water Control Board) manages the waterways today, and was placed as a mantel painting in the great hall of Huis Swanenburg in Leiden that Post himself had designed (1645-1648; Terwen-Ottenheym 1993, pp. 156-160). For the painting, *Count William II grants the charter to Rijnland dike board*, see: A. Blankert in Rotterdam-Frankfurt am Main 1999-2000, no. 31 (ill.).
13 Regtdoorzee Greup-Roldanus 1936, pp. 41-101; Broos 1987, p. 332.
14 Burke 1974; Broos 1987, p. 330.
15 Broos 1987, pp. 330-337, no. 55 (ill.).
16 For the development of the panoramic landscape in the seventeenth-century Netherlands, see Stechow 1966, pp. 33-49.
17 Van Mander 1604, fol. 34b; for Van Mander's poems on Haarlem, see Rutgers van der Loeff 1911, pp. 19-28 and 29-38; Broos 1987, pp. 332-333. In writing this paragraph the author made grateful use of Broos's excellent piece on Post's painting in the Mauritshuis (1987, pp. 261-265, no. 46, ill.).
18 Inv. no. 2628; C. van Hasselt in Brussels-Rotterdam-Paris-Bern

1968-1969, vol. 1, pp. 65-66, no. 90, vol. 2, fig. 10.

19 Broos 1987, p. 262, fig. 1. Some early scenes by Hercules Segers (1589/90-1633/38) are similar in structure, but were made later than those of Goltzius, including his *View of Rhenen*, an etching from about 1630 (Stechow 1966, pp. 36-37 and fig. 56).

20 Gudlaugsson 1954, p. 60, fig. 1 and p. 63, fig. 4.

21 Terwen-Ottenheym 1993, pp. 9, 12-14.

22 For Jan Post, see Thieme-Becker, vol. 27 (1933), p. 297; Larsen 1962, p. 48; De Sousa-Leão 1973, pp. 15-16; Terwen-Ottenheym 1993, p. 9; both Terwen-Ottemheym (1993, p. 12) and Duparc (1980, p. 77) believed that Post trained with his father.

23 Miedema 1980, p. 1038; Terwen-Ottenheym 1993, p. 12; see also Thieme-Becker, vol. 14 (1921), p. 318 ('Goetteeris (Gouteris), Anthoni').

24 Miedema 1980, p. 420; Terwen-Ottenheym 1993, p. 13.

25 On Van de Velde, see Keyes 1984; P.C. Sutton and C.J. de Bruyn Kops in Amsterdam-Boston-Philadelphia 1987-1988, pp. 497-503; I. Haberland in Turner 2000, pp. 350-353. The Frits Lugt Collection includes a painting from 1624 and several drawings by the master (S. Nihom-Nijstad in Paris 1983, no. 84 and fig. 3; Keyes 1984, nos. 126, D 18, D 33, D 78, D 116, D 201, D 202, Attr. D 10).

26 Terwen-Ottenheym 1993, p. 14.

27 Keyes (1975, vol. 1, p. 7) suggested that Post may have studied with Vroom. However, it is unclear whether Vroom was in fact working at the English court in 1628 (Keyes 1975, vol. 1, pp. 13-14; Terwen-Ottenheym 1993, p. 14; according to A. Chong in Amsterdam-Boston-Philadelphia 1987-1988, p. 516, this was not Cornelis, but his brother Frederick). Larsen (1962, p. 132) linked the picture described here to a landscape by Salomon de Bray from 1633, and implied that Post may have studied with De Bray.

28 Haak 1984, p. 240 and fig. 500; P.C. Sutton in Amsterdam-Boston-Philadelphia 1987-1988, no. 56; see also Bol 1969, pp. 139-141 and figs. 125-126. For De Molijn, see E.J. Allen in Turner 2000, pp. 223-225.

29 Keyes 1975, vol. 1, p. 88; vol. 2, pp. 185-187, no. P 25 and fig. 49. Bol (1969, pp. 146-147, fig. 136 and p. 369 note 202) already associated this

landscape by Vroom with the Post discussed here; cf. also the remarks of Gudlaugsson 1954, p. 64 and A. Chong in Amsterdam-Boston-Philadelphia 1987-1988, p. 519 and fig. 2. For Post and Vroom, see also Stechow 1966, pp. 38, 195 note 18; Keyes 1975, vol. 1, pp. 6, 7, 78, 93-94, 106, vol. 2, nos. P 4, P 8, P 14, P 15; P.C. Sutton in Amsterdam-Boston-Philadelphia 1987-1988, p. 34.

30 Concerning Pieter's influence on Frans, see Gudlaugsson 1954, pp. 59, 70 (the status of the landscape attributed by this author to Frans Post is extremely unclear, *idem*, fig. 15); Plietzsch 1960, p. 117; Stechow 1966, p. 169; De Sousa-Leão 1973, pp. 21, 23-24; A. Chong in Amsterdam-Boston-Philadelphia 1987-1988, pp. 412, 415. For the problems of attribution surrounding the work of both brothers, see Larsen 1962, p. 131; De Sousa-Leão 1973, p. 42. For the work of Frans Post, see Larsen 1962; De Sousa-Leão 1973; F.J. Duparc in Turner 2000, pp. 253-254; cf. also T. Kellein and U.-B. Frei in Basel-Tübingen 1990; Q. Buvelot in The Hague 1995-1996, no. 20 (ill.).

31 Four of these landscapes by Frans Post are in the Musée du Louvre, Paris (all dated either 1638 or 1639); one is in the Mauritshuis on loan from the Rijksmuseum (dated 1637); one is in a private collection in Recife (dated 1640; formerly in the collection of J. de Sousa-Leão). A canvas dated 1638 turned up in a public sale in New York (Sotheby's, 30 January 1997, lot 10) and is now in a private collection; see De Sousa-Leão 1973, pp. 54-59, nos. 1-6 (ill.); Herkenhoff 1999, pp. 225, 258-259 (ill.), p. 325, no. 7; Amsterdam 2000a, no. 89 (ill.).

Since little is known about the output of Pieter's son and pupil Johan Post, the influence from father to son is impossible to assess. The painting formerly attributed to Johan Post in the Mauritshuis (inv. no. 967; The Hague 1970, no. 49, ill.), which is exhibited today in the Gallery of Prince Willem V in The Hague, has rightly been linked by Marijke de Kinkelder of the RKD to another painting that is evidently by the same hand (panel, 24.8 x 31.1 cm, until 1995 included in the collections of the New York Historical Society, cat. 1915, no. D-137; sale New York, Sotheby's, 12 January 1995, lot 48, ill. in colour, as J. Post; Hofstede de Groot 1907-1928, vol. 8 [1923],

p. 427, no. 229, as Jan van der Heyden). Both paintings may tentatively be attributed to Jan van Nickele (1656-1721).

32 See Provenance and Exhibitions.

33 See note 2.

34 The painting was acquired in 1975 from the heirs of Wilhelm Martin (1876-1954), a former director of the Mauritshuis. It had already been exhibited in the museum from 1964 to 1966 on loan from his widow.

35 Inv. nos. 1979-A.360/362; see Lunsingh Scheurleer 1987.

25 Paulus Potter

1 Lugt no. 4796. A question-mark was added to this provenance in The Hague 1994-1995, p. 62, because it had not been possible to inspect the copy of the catalogue in the Bibliothèque Nationale, Paris. The price and buyer's name are noted in the copy of the catalogue in the Bibliothèque Municipale, Mâcon.

It is unclear whether the letters 'IW' burned into the back of the panel (see S. Nihom-Nijstad in Paris 1983, p. 108 and note 1), refer to Iacobus (Klaas) van Winkel – the likeliest explanation – or to the British animal painter James Ward (1769-1859), who in that case must have had the painting in his possession, although it is not mentioned in the auctions of his collections (note by Frits Lugt on the painting's inventory card, Fondation Custodia Archives). It is also unknown to which collections the two wax seals on the back refer: one has the initials 'GP', while the other has a coat of arms with three heads of dogs.

2 London 1847, no. 110: 'Cattle in a Landscape / P. Potter / *H. R. Willett, Esq*'. Exhibit no. 113 in this show was a painting attributed to Caravaggio, and not a second landscape by Potter from the collection of Willett, as stated by S. Nihom-Nijstad (see Paris 1983, p. 108 note 2).

3 Note by Frits Lugt on the painting's inventory card, Fondation Custodia Archives. The year is given by F. Lugt in Paris 1960a, p. 29, in no. 147.

4 An invoice from Sabin (Fondation Custodia Archives, Paris) dates from 8 March 1948.

5 Information on the photograph of the painting in the RKD, The Hague; the loan is not mentioned in

the inventory, the annual accounts or catalogues of the Mauritshuis.

6 The Hague 1994-1995, p. 21, fig. 2.

7 For Pieter Potter, see A. Walsh in *The Dictionary of Art*, vol. 25 (1996), pp. 368-369 (reprinted in Turner 2000, p. 256).

8 In 1922 Lugt purchased a vanitas still life from 1638 by Pieter Potter (see S. Nihom-Nijstad in Paris 1983, no. 66 and fig. 94).

9 See A. Walsh in The Hague 1994-1995, pp. 11, 22.

10 For Potter, see A. Walsh, E. Buijsen and B. Broos in The Hague 1994-1995 (with additional literature); Walsh 1985; Buvelot 1994; A. Walsh in *The Dictionary of Art*, vol. 25 (1996), pp. 369-371 (reprinted in Turner 2000, pp. 256-259); E. Buijsen in The Hague 1998-1999a, pp. 224-229 and figs. 1-5; as well as Brown 1995 and Lammertse 1995 (both reviews of The Hague 1994-1995).

11 See A. Walsh in The Hague 1994-1995, pp. 20-26 and E. Buijsen in *idem*, pp. 56-61, nos. 1-2.

12 That same year Potter may have painted a landscape with cows that is similarly set in a Dutch meadow (panel, 48.5 x 64.5 cm; sale London, Christie's, 29 March 1974, lot 88, ill., later at De Boer Gallery, Amsterdam, 1976); see Hofstede de Groot 1907-1928, vol. 4 (1911), p. 650, no. 83 (as around 1645); Von Arps-Aubert 1932, p. 42, no. 1 ('Zweifelhafte Potterbilder'; S. Nihom-Nijstad in Paris 1983, pp. 108 and 109 note 6). The status of both attribution and dating (read variously as 1643 and 1649) is highly tentative, however.

13 E. Buijsen in The Hague 1994-1995, no. 4 (ill.).

14 After Potter painted his first milkmaid in this painting, the motif would often recur in his work (E. Buijsen in The Hague 1994-1995, p. 66; cf. also C.J. de Bruyn Kops in Amsterdam-Boston-Philadelphia 1987-1988, p. 422 note 7). She is generally an inconspicuous figure (cf. The Hague 1994-1995, nos. 5, 9, 14, 15), but occasionally she plays a more prominent role, as in the painting dated 1646 in London, The Wallace Collection (Ingamells 1992, pp. 266-267, no. P 219, ill.; The Hague 1994-1995, p. 27, fig. 14; cf. also *idem*, p. 32, fig. 23; p. 33, fig. 24). For the introduction of this motif, see E.J. Sluijter in Utrecht 1993, pp. 50-51; for possible interpretations of the motif, see Walsh 1985, p. 345; A. Chong in

Dordrecht-Leeuwarden 1988-1989, p. 67; G. Luijten in Amsterdam 1997, pp. 260-263.

15 Signed and dated at lower left: 'Pau. Potter. f. @ i642'. Sale London, Sotheby's, 11 December 1996, lot 27 (ill. in colour); see Leeuwarden 1998-1999, fig. 27 and Buvelot 2000.

16 E. Buijsen in The Hague 1994-1995, no. 8 (ill.).

17 Houbraken 1718-1721, vol. 2, p. 129; B. Broos in The Hague 1994-1995, p. 45.

18 Potter's etching *The shepherd* from 1644 also shows sheep yoked together (see E. Buijsen in The Hague 1994-1995, p. 62 note 1 and *idem*, no. 46, ill.).

19 As already noted by Walsh 1985, p. 138; A. Walsh in The Hague 1994-1995, p. 24; A. Walsh in *The Dictionary of Art*, vol. 25 (1996), p. 369. The significance of the contemporary attire was noted in connection with another of Potter's paintings by G. Jansen in Dordrecht-Leeuwarden 1988-1989, p. 165.

20 E. Buijsen in The Hague 1994-1995, no. 2 (ill.). Potter may have based this cow's position on a print by Simon Frisius after Joos Goemare dating from 1618 (Hollstein, vol. 7, p. 28, no. 114; Briels 1987, p. 197, fig. 246), see *idem*, p. 62 note 2.

21 B. / Hollstein 14; B. Broos in The Hague 1994-1995, no. 45 (ill.); E. Buijsen in *idem*, p. 62.

22 E. Buijsen in The Hague 1994-1995, no. 10 (ill.); *idem*, p. 62. Frits Lugt acquired this painting at a London sale in 1928, it should be added, on behalf of Dr F.H. Fentener of Vlissingen (The Hague 1994-1995, p. 84); for this collector, see also note 80 of the introductory essay by Reitsma.

23 Cf. e.g. the etchings from 1643 and 1644 (The Hague 1994-1995, nos. 45-46 (ill.); Hollstein, vol. 17, nos. 14-15).

24 A. Walsh in The Hague 1994-1995, pp. 25, 27; E. Buijsen in *idem*, pp. 64, 78, 84, 87-88, 94, 116.

25 F. Lugt in Paris 1960a, p. 6; B. Broos in The Hague 1994-1995, p. 53 note 43.

26 In order of inventory number: *Cow, standing*, inv. no. 113A (Paris 1960a, no. 155); *Two cows*, inv. no. 113B (Paris 1960a, no. 156); *Cows fighting and livestock at rest*, 1648, inv. no. 253 (Paris 1960a, no. 153; New York-Paris 1977-1978, no. 81 and fig. 125; The Hague 1994-1995, p. 49, fig. 13; Haarlem-Paris 2001-2002, pp. 196-197, no. 116, ill.); *Horsemen by an inn*, inv. no. 1695; *Man standing, wearing a felt hat, arms behind his back*, inv. no. 3663; *Native pigs, standing and lying*, c.1647, inv. no. 5100 (Paris 1960a, no. 159; New York-Paris 1977-1978, no. 80 and fig. 124; The Hague 1994-1995, p. 46, fig. 11, p. 182); *The ruins of Rijnsburg, viewed from the south-east*, c.1640-1645, inv. no. 5101 (Bolten 1994, p. 31, no. 17, ill.); *Pig*, inv. no. 6172.

27 On possible interpretations of Potter's works, see Walsh 1985; Lammertse 1995, pp. 222, 225. For meanings attached to the Dutch cattle piece, see A. Chong in Leeuwarden 1988-1989, pp. 56-86 (see also note 14 above).

26 Jan van Ravesteyn

1 According to a label on the back of the painting, probably by Binder: *Hugo Grotius / von / Jo.a.Ravesteyn / gemalt / früher d.Dr.Eckhard / gehörig*. Nothing is known about this Dr Eckhard.

2 For Van Ravesteyn, see Bredius-Moes 1892; R.E.O. Ekkart in *The Dictionary of Art*, vol. 26 (1996), pp. 37-38 (reprinted in Turner 2000, pp. 265-266); R.E.O. Ekkart in Buijsen *et al.* 1998, pp. 230-237 (with select bibliography); E. Löffler in *idem*, p. 340.

3 '[E]en seer goed schilder / en conterfeyter … die een schoon en goede handelinghe heeft'; Van Mander 1604, f. 300 (Van Mander ed. 1994-1999, vol. I, pp. 458-459, vol. 5, p. 123).

4 For this series, see Spruijt 1997.

5 The panel has been bevelled all around on the back; the circum-ferential inscription, in particular, makes it unlikely that it was reduced in size. The portrait of Jan van Scorel by the latter's pupil Anthonie Mor, produced in 1559, at the Society of Antiquaries of London (J. Woodall in Amsterdam 1986, pp. 334-335, in no. 212, ill.) was cut to its present shape to fit the painter's tombstone in St Mary's Church in Utrecht, and may not have started life as a tondo (Kloek 1987, p. 249). The *Portrait of a man* by Cornelis Ketel from 1574 in the Rijksmuseum, Amsterdam, recently identified as a portrait of the London-based Hanse merchant Adam Wachendorff, bears a close stylistic relationship to the portraiture of the followers of Holbein in England, where it was made, and is in any case a half-length portrait

(R.E.O. Ekkart in Amsterdam 1986, pp. 442-443, in no. 338, ill.; for the identification, see Schulting 1997). Besides the circular pendant portraits by Pietersz referred to below (fig. 26d and note 15), the portraits of Peter and Jan Wtewael by their father Joachim Wtewael in the Centraal Museum, Utrecht are worth mentioning. However, they were made much later, in 1627-1628 (Lowenthal 1986, pp. 157-158, nos. A-96 and A-97, figs. 132-133). A circular portrait of a man dating from about 1600, very similar to the portrait of Hugo Grotius, was sold at auction in London, Sotheby's, 12 July 2001, lot 120, ill., as 'Haarlem or Amsterdam School, circa 1600'.

6 Brandt-Van Cattenburgh 1727, p. 13; Krikke 1997, p. 53. For Hugo Grotius's boyhood, see Eyffinger 1981; E. Eyffinger in Delft 1983, pp. 17-30; Krikke 1997, pp. 35-55.

7 For the portraits of Hugo Grotius, see Van Beresteyn 1929. One of the descendants of Grotius possessed a portrait of him aged 4 (from 1587) at Cuyk, but it is known only from a relative's pencil sketch made in 1845 (Van Beresteyn 1929, pp. 27-28, no. A, p. 44, no. 1 and fig. 10; R. Ekkart in Haarlem-Antwerp 2000-2001, p. 126, in no. 17, ill.).

8 For the drawing and print, see M. Schapelhouman in Amsterdam 1993-1994, no. 53; Filedt Kok-Leesberg 2000, vol. 2, no. 246, with illustrations and select bibliography.

9 Grotius had journeyed to France in January 1598 with the mission of Justinus van Nassau and Johan van Oldenbarnevelt. For a reconstruction of this journey, see Krikke 1997, pp. 50-51.

10 Van Beresteyn 1929, p. 79, no. 5. No signed and dated version of the painting is known. Van Beresteyn regarded a piece seen in the collection of Henri de Rothschild in Paris as the original (Van Beresteyn 1929, pp. 12-13, 33-34, no. 1, p. 45, no. 7, without illustration), wrongly so according to Renckens (1962a, p. 64). The University of Leiden possesses a simplified copy of it (Van Beresteyn 1929, p. 45, no. 8 and fig. 5). The portrait also served as the example for a print by Willem van Swanenburg (?) in the second edition of the Leiden 'Icones' from 1613 (*Illustris Academiae Lugd-Batava; id est virorum clarissimorum icones, elogia ac vitae, qui eam scriptis suis illustrarunt*, Leiden 1613; Van Beresteyn 1929, pp. 76-77, no. 3a,

plate 28; Hollstein, vol. 29, p. 43, no. 79, without illustration). A portrait of a man dated '1608' and signed 'Mierevelt' in the Hall Collection at Djursholm, Sweden, was published by Renckens as a portrait of Hugo Grotius, supposedly produced between 1600 and 1613 (Renckens 1962a, fig. 1; cf. also Eyffinger 1980, ill. on cover). The portrait from 1599 under discussion here is said to have served as an example for an eighteenth-century (?) print. This fictitious rendering of *Hugo Grotius as a young lawyer at the bar* is unmistakably based on Van Ravesteyn's portrait, as far as the subject's physiognomy is concerned (Leiden, Prentenkabinet der Rijksuniversiteit; Van Beresteyn 1929, pp. 30-31, no. D, p. 76, no. 2 and fig. 3).

11 See W.T. Kloek in Amsterdam 1993-1994, pp. 32-33.

12 Van Ravesteyn's place of birth is unknown. He may have been the son of the stained-glass artist Anthonis van Ravesteyn, whose presence is documented in Culemborg in 1593.

13 Ekkart 1991, pp. 9-10; R. Ekkart in Buijsen *et al.* 1998, p. 230.

14 For Pietersz's portraits, see De Vries 1934; Bruyn 1999.

15 Inv. nos. 914 and 1109. Although the lettering of the portrait was no longer in its original state, it has been reconstructed. The pendant was discovered in 1995 and has since been reunited with its counterpart, as a gift from C.W. van Blijenburgh. On these portraits, see Noble-Pottasch 1997 and Van Suchtelen 1997.

16 A. van Suchtelen in Amsterdam 1993-1994, p. 400.

17 The *Portrait of Paulus van Vianen* (?) in the Rijksmuseum, Amsterdam (Van Thiel 1980, fig. 3), the *Portrait of a man* (reduced in size) from 1601 in Museum Boijmans Van Beuningen, Rotterdam (M. Beekman in Amsterdam 1993-1994, no. 257, ill.; Schulting 1993, pp. 467-468) and the *Self-portrait*, known only from a print by Hendrik Bary (Hollstein, vol. 1, p. 128, no. 154, ill.). Stechow (1929-1930, p. 206) pointed out the similarities between the portrait of Hugo Grotius described here and the portraits produced by Cornelis Ketel. Van Thiel (1980, pp. 114-115) classified Van Ravesteyn's portrait as belonging to the small group of 'tightly framed', informal portraits that can be dated to about 1600, and most of which are self-portraits

or portraits of the artist's relatives or friends. W. Kloek (in Amsterdam 1993-1994, p. 31) noted, however, that the portrait of Grotius is not a friendship portrait.

18 For instance, the pendant portraits of Pieter van Dorp and Anna van Berckenrode, dating from around 1595, in a private Dutch collection (Van Thiel 1999, pp. 391-392, no. 245 and figs. 120a-b).

19 Frits Lugt saw a photograph in the Witt Library, London, of another – unsigned – portrait by Van Ravesteyn, also dating from 1599, which according to him was executed wholly in the style of Cornelis Ketel (note in the painting's file, Fondation Custodia Archives, Paris).

20 In Dutch: 'heerlijke en frisse manier van schilderen'. In his auto-biography Huygens also writes about Van Ravesteyn that 'He faded a little, however, when he began, long after returning from Italy, to add something of his native land, *the old leaven* so to speak, to his once so delightful and fresh manner of painting. For I once heard him avow in all sincerity, examining a piece in my father's house that he had painted years before, that he could not imagine being able to equal his earlier works, let alone improve on what he had produced as a youth'. Huygens' autobiography (translated here from the Dutch) dates from 1629-1631 (Huygens ed. 1946, pp. 75-76, 77). Huygens confuses the painter's first name with that of the printer, Paulus van Ravesteyn, and rates him less highly than Van Mierevelt (see also H. Miedema in Van Mander ed. 1994-1999, vol. 6, p. 123). Interestingly, Huygens says a little further on that Van Mierevelt too was unable to attain the standard of his early work in later life (Huygens ed. 1946, p. 77).

21 Binder, in 1911-1912 assistant at the Gemäldegalerie, Berlin, was director of the museum of weaponry in the Zeughaus, Berlin, from 1913 to 1933 (Bode ed. 1997, vol. 2, p. 327). The purchase included *Landscape with the rest on the flight into Egypt* by Jacobus Sibrandi Mancadan (inv. no. 177; Paris 1983, no. 48 and fig. 18) and *Two whaling vessels off a snow-covered coast* by Hendrick Jacobsz Dubbels. The latter painting (Middendorf 1989, pp. 180-181, no. 144, ill., as in the collection 'E.W.K.C.' at Amersfoort) was resold by Lugt almost immediately

(sale Amsterdam, Frederik Muller & Co., 28 May 1918, lot 135). On Binder, see Becker 2002.

22 Cf. the remarks by F. van Kretschmar (in Paris 1994, p. 260, in no. 124) concerning a small circular portrait of a young man from 1576, acquired for the Frits Lugt Collection in 1993. For Lugt's early years, see Reitsma 1997, pp. 9-20.

23 Most of the old editions and the manuscript are described in the catalogue of an exhibition dedicated to Hugo Grotius, which was held in the Institut Néerlandais in 1965. The manuscript is a page from Grotius' *Annotationes in libros evangeliorum* from 1641 (inv. no. 7981; Paris 1965b, no. 177); Lugt also acquired a receipt signed by Grotius for a payment made on behalf of Louis XIII in 1621, after the latter had fled from Holland (inv. no. 6818; Paris 1965b, no. 90).

24 'Verstehe hohes Gebot für Vrel aber zwei andere Bilder [Ravesteyn and Dubbels] müssen aber mässig eingeschätzt weil mehr geschichtliche Curiositäten ohne hohe Kunstwert' (original undated telegram from late February or early March 1918 in the Fondation Custodia Archives). Cf. Lugt's letter of 30 June 1926 to Jacob ter Meulen, librarian at the Peace Palace in The Hague, who had suggested that he might be willing to present the painting to the Peace Palace: 'Whether I could ever make a gift of this painting, for which I paid such a high price, is doubtful. But it is not impossible that I might wish to exchange this historical portrait, at some time, for a painting of purely aesthetic value' ('Of het ooit kan komen tot een geschenk van dit schilderij, waarvoor ik zelf een hoogen prijs betaalde, betwijfel ik. Maar het is niet buiten-gesloten, dat ik te eeniger tijd het bezit van dit historische portret zou willen vervangen door een schilderij van uitsluitend aesthetische waarde'); original document in the Fondation Custodia Archives.

25 Inv. no. 3845; New York–Paris 1977-1978, no. 84 and fig. 99. On the painting, see Amsterdam 1993-1994, no. 270 (ill.); C. Vermeeren in Buijsen *et al.* 1998, p. 66.

27 Jacob van Ruisdael

1 According to Smith (see Literature). The picture was not included in the auction of the

collection of Gerrit van der Pot, Rotterdam, 6 June 1808 (Lugt no. 7424). On the Pot Collection, see Wiersum 1931; Fredericksen-Priem-Armstrong 1998, pp. 31-32.

2 According to C. Sedelmeyer in Paris 1895 (see Literature).

3 Lugt no. 52715. The Dennistoun Collection contained several more paintings by Jacob van Ruisdael (see Slive 2001, nos. 62, 269, 367).

4 Copy of the catalogue at the RKD, The Hague.

5 For Van Ruisdael, see Hofstede de Groot 1907-1928, vol. 4 (1911); Rosenberg 1928; The Hague-Cambridge 1981-1982; Walford 1991; L. Bos in *The Dictionary of Art*, vol. 27 (1996), pp. 324-330 (reprinted in Turner 2000, pp. 305-311); Slive 2001.

6 On Van Ruisdael's winter land-scapes see Stechow 1966, pp. 96-98; The Hague-Cambridge 1980-1981, pp. 101, 120-123, 148-149; P.C. Sutton in Amsterdam-Boston-Philadelphia 1987-1988, pp. 448-449; Walford 1991, pp. 110, 156-160, 169-170, 180-184; Slive 2001, pp. 21, 468-489; The Hague 2001-2002, pp. 68-70 and 118-123, nos. 22-24.

7 Inv. no. SK-A-349; Slive 2001, p. 469, no. 662; The Hague 2001-2002, no. 22 (ill.).

8 Stechow (1966, pp. 96-96) dated the 'sombre' winter landscapes to the early 1660s, Walford and Slive operated with somewhat broader margins. We find Jan van der Heyden's streetlamps in the fore-ground of a winter landscape with Haarlem in the distance (Frankfurt am Main, Städelsches Kunstinstitut, inv. no. 1109), which were installed in Amsterdam only in 1669 (Slive 2001, p. 472, no. 670). Slive has dated two other examples to the 1670s on the basis of the figures' dress (Slive 2001, nos. 674, 681). For two of the works in the group we have a *post quem* date: the *Winter landscape, with a view of the Amstel and Amsterdam* in Kettwig, Herbert Girardet Collection, shows the Hoogesluis in the background, erected only from 1662 (Slive 2001, pp. 475-476, no. 676; The Hague 2001-2002, fig. p. 69), while the *View of the Hekelveld in Amsterdam* in a Scottish private collection includes the tower of the town hall, completed only in 1665 (Slive 2001, p. 21, no. 9).

9 See *Winter landscape by a waterway*, Enschede, Rijksmuseum Twenthe, Scholten Collection (The Hague 2001-2002, p. 62 and fig. 52).

10 Inv. no. SK-C-211; Slive 2001,

pp. 107-110, no. 81 (ill.). For the other works to be included in the series see S. Slive in The Hague-Cambridge 1981-1982, pp. 148-149, figs. 60-62; Slive 2001, pp. 480-481, no. 683, pp. 485-486, no. 688, pp. 488-489, nos. 693-694; The Hague 2001-2002, no. 24 (ill.), p. 163 note 1. Stechow (1966, p. 97) dated these pictures to the years 1665-1670; Walford (1991, p. 180) and Duparc (in The Hague 2001-2002, nos. 23-24) to 1670-1675; and Slive (2001, p. 484, under no. 686) from the late 1660s to the late 1670s.

11 On this motif in Van Ruisdael's work and its possible significance see A. Chong in Amsterdam-Boston-Philadelphia 1987-1988, pp. 458-462 (under no. 88); Walford 1991, p. 151; Slive 2001, pp. 145-152.

12 Amsterdam-Paris 1998-1999, pp. 64-65.

13 'Le lieu est un des bastions de l'enceinte d'Amsterdam, en partie supprimée pour l'extension de la ville entre 1666 et 1670' (from a typed text for a guided tour through the rooms of the Institut Néerlandais, before 1965; cf. also the caption to the illustration in Hennus 1950, p. 119).

14 Among the prints in the *Amstel-gesichjes* series, engraved by Abraham Blooteling after Jacob van Ruisdael, are six views taken outside the city walls that must have been executed around 1662-1664 (Slive 2001, pp. 506-507, under no. D 17). A view of the Heiligewegspoort certainly dates to the same period (*idem*, pp. 502-503, no. D 13). A drawing showing the Amstel and Amsterdam (Leipzig, Museum der bildenden Künste, inv. no. I 413), which formed the basis for two Van Ruisdael paintings, was only produced after 1671, possibly even after around 1681 (Slive 2001, p. 530, no. D 77). The smock mills in two other drawings of around 1650-1655, preserved together since around 1690, were identified in the eighteenth century as being near Amsterdam's Haarlemmerpoort and Zaagmolens-poort, respectively (Slive 2001, pp. 518-519, nos. D 33-D 34).

15 Slive 2001, p. 488, no. 693; The Hague 2001-2002, no. 24 (colour ill.). For the other painting see Slive 2001, pp. 480-481, no. 683 (colour ill.). The Utrechtse, Weesper- and Muiderpoort were built in 1663-1664, all three according to the same design: a tall, square building with a saddle roof, crowned by a domed tower.

16 F.J. Duparc in The Hague 2001-2002, p. 120.

17 Philadelphia Museum of Art, John G. Johnson Collection, inv. no. 603 (Amsterdam-Boston-Philadelphia 1987-1988, no. 104, ill.). The correspondence was noted by P. van der Ploeg in The Hague 2001-2002, pp. 65, 68 and fig. 56. It is uncertain if a similar winter scene in the Lugt Collection is really the work of Van de Velde (inv. no. 1920).

18 Inv. no. 6484; Paris 1983, no. 70 and fig. 17; Slive 2001, pp. 429-430, no. 611 (colour ill.). Nihom-Nijstad's doubts regarding the authenticity of the signature were dismissed by Slive, as was her suspicion that the panel was a fragment of a larger work.

19 *Kostverloren Manor on the Amstel*, inv. no. 242 (New York-Paris 1977-1978, no. 97 and fig. 41; Slive 2001, pp. 571-572, no. D 105, ill.); *Farmhouse on a riverbank*, inv. no. 2337 (New York-Paris 1977-1978, no. 128 and fig. 121; Slive 2001, p. 573, no. D 107, ill.); *Village church among trees*, inv. no. 5202 (New York-Paris 1977-1978, no. 96 and fig. 40; Slive 2001, pp. 573-574, no. D 108, ill.); *View of the dunes at Wijk aan Zee*, inv. no. 1971-T.4 (Paris 1974, no. 68 and fig. 18; Slive 2001, p. 572, no. D 106).

28 Pieter Saenredam

1 A similar abbreviated signature occurs in Saenredam's *Interior of St Peter's Church, Den Bosch*, signed 'P. Serdam 163[2?]' (private collection; see P. ten Doesschate-Chu in Basel 1987, no. 87; Schwartz-Bok 1989, p. 91, fig. 98, p. 270, no. 99; A. Wheelock in Houston-The Hague 2000-2001, pp. 28-29 and p. 55, no. 14). For the signature, see also J. Giltaij in Rotterdam 1991, p. 109.

2 Lugt no. 64834. J. Giltaij mistook an entry in an eighteenth-century sale catalogue for a reference to the painting shown here (in Rotterdam 1991, p. 109). At the Pieter Testas the Younger sale in Amsterdam (De Leth, 29 March 1757, lot 71; Lugt no. 953) one Ketelaar purchased for 27 guilders 'Een dito [Een kabinet stukje, zynde een Kerk] door den zelven [P. Zaanredam], Anno 1636' (as noted in the sale catalogue; see also Hoet-Terwesten 1752-1770, vol. 3, p. 181, no. 72 [sic; different numbering used]). However, the dimensions given – 'hoog 17 duim, breet 15 duim' [*c.*43.6 x 38.5 cm; 1 duim = 2.57 cm] –

are those of the painting in Zürich (note 18 and fig. 28b in the present catalogue), which also dates from 1636 and is the sole extant painting by Saenredam that answers to this description (the painting shown here, though virtually the same width as the Swiss panel, is six cm more in height). For Testas's collection, see *Catalogus van een uitmuntend cabinet schilderyen … by een versamelt, door den heer Pieter Testas de Jonge* (Lugt no. 953); Hoet-Terwesten 1752-1770, vol. 3, pp. 176-183 (with the three paintings by Saenredam on p. 181, nos. 70-72); Swillens 1935, p. 137, nos. 4-6; Schwartz-Bok 1989, p. 247 and 324 note 16; J. Giltaij in Rotterdam 1991, p. 105 note 2. One of the two other paintings by Saenredam in Testas's collection can be identified with the painting dated 1628 in Los Angeles, The J. Paul Getty Museum (Hoet-Terwesten 1752-1770, vol. 3, p. 181, no. 70, as 14.5 x 17.5 *duimen* [*c.*37.2 x 44.9 cm]; see also Swillens 1935, p. 137, no. 4).

3 On Janssen see the literature cited in note 25. According to Lugt 1918, Janssen's paintings hung in Baarn as well as Amsterdam.

4 Information on the painting's inventory card, Fondation Custodia Archives. The purchasing date of 25 July 1919 given there is incorrect, according to an invoice from Goudstikker dated 16 July: '1919, Juli 16 … een schilderij van Pieter Saenredam, kerkinterieur, No. 43 v/d Collectie August Janssen en een schilderijtje van Hendrik Pot, klein rond vrouwenportretje, No. 41 v/d Collectie August Janssen tezamen v. fl. 10.000.-' (Fondation Custodia Archives; with thanks to Hans Buijs); for the price paid for the painting, see also the introductory essay by Reitsma. The small round portrait by Pot is still in the Frits Lugt Collection (inv. no. 397; see S. Nihom-Nijstad in Paris 1983, no. 64 and fig. 60), as is the winter landscape by Jan van Goyen of the same origin that Lugt purchased as early as 8 July 1919 along with two other items from Goudstikker (inv. no. 394; S. Nihom-Nijstad in Paris 1983, no. 33 and fig. 27). On 27 October 1924 Lugt purchased from Goudstikker not only a painting by Ludolf Backhuysen (cat. no. 3) from the Janssen Collection, but also a winter landscape by Adriaen van de Velde from that collection (not in Paris 1983). Paintings by Gerrit Berckheyde (cat. no. 5) and Willem

van de Velde the Younger (cat. no. 33) from the Janssen Collection also ended up in Lugt's collection by a roundabout route.

5 For Saenredam, see Utrecht 1961; Ruurs 1988 (on Saenredam and his use of perspective); Schwartz-Bok 1989 (with a catalogue of his oeuvre; English edition appeared in 1990; see also the reviews by Giltaij 1990-1991, De Vries 1991 and R. van Gelder in *NRC Handelsblad*, 14 July 1989); W. Liedtke in *The Dictionary of Art*, vol. 27 (1996), pp. 507-511 (reprinted in Turner 2000, pp. 316-321). For Saenredam's stay in Utrecht, see Utrecht 2000-2001 (on the paintings and drawings with Utrecht churches).

6 For De Grebber, see e.g. P. Biesboer in Washington-London-Haarlem 1989-1990, p. 26 and fig. 1; Schwartz-Bok 1989, pp. 31-34. That Van Campen too trained with De Grebber is far from certain (see Q. Buvelot in Amsterdam 1995, p. 53 and p. 251 note 6), although this is sometimes taken for granted (L.M. Helmus in Utrecht 2000-2001, p. 9).

7 De Bie 1661, p. 246; Schwartz-Bok 1989, p. 294.

8 Samuel Ampzing, *Beschryvinge ende lof der stad Haerlem in Holland*, Haarlem 1628. On Saenredam's contributions to this book, see Schwartz-Bok 1989, pp. 43, 284-287 (ill.).

9 Schwartz-Bok 1989, p. 63, fig. 67, p. 261, no. 55.

10 See Q. Buvelot in Amsterdam 1995, p. 86.

11 Schwartz-Bok 1989, pp. 263-265, nos. 70-85 (ill.).

12 Ruurs 1987, p. 87; Schwartz-Bok 1989, p. 81 and 314 note 10 (to chapter 6).

13 Schwartz-Bok 1989, pp. 258-262, nos. 27-69 (ill.); cf. also Biesboer 1985, passim. The interior of the Church of St Bavo attributed to Saenredam in a private collection (the figures in which have been literally copied from the print published in 1628) is probably by a follower, in spite of the 'signature' discovered at lower left in 1989 (Utrecht 1961, p. 77, no. 32* and fig. 33, as a questionable attribution and probably dated 1660; sale London, Sotheby's, 9 December 1987, lot 83 (ill.) as 'Follower of Pieter Saenredam'; Ruurs 1988, p. 42 note 4, as by a follower; Schwartz-Bok 1989, p. 259, no. 32, p. 324 note 22 (to chapter 15), as probably by Isaak van Nickele;

however, see London 1989, no. 37; Giltaij 1990-1991, p. 90, no. 7 [dated 1662] and Q. Buvelot in The Hague 1995-1996, no. 25, with colour ill., all as Saenredam). In execution the painting is clearly inferior to that in paintings by Saenredam from 1662 and 1663 (Schwartz-Bok 1989, p. 243, fig. 254, p. 245, fig. 256), which are among his undisputed masterpieces. The structure of the composition, on the other hand, is comparable to that of the painting in Worcester dated 1660 (*idem*, p. 231, fig. 244).

14 Swillens 1935, p. 94, no. 83; see also note 19. The location featured in the painting exhibited here has sometimes been described incorrectly (Utrecht 1961, p. 86, no. 41*, in the title; Nash 1972, fig. 14; Reitsma 1976, p. 256; Biesboer 1985, p. 96, fig. 59, all as the interior of the church from the Brewers' Chapel, the opposite chapel on the south side). A drawing from 1634 shows the Christmas Chapel as seen from the Brewers' Chapel (Los Angeles, The J. Paul Getty Museum; Schwartz-Bok 1989, p. 112, fig. 121).

15 Inv. no. 53-1702 G; Swillens 1935, p. 97, no. 94; Utrecht 1961, p. 87, no. 42* and fig. 37; Schwartz-Bok 1989, p. 260, no. 42 and fig. 133. For Saenredam's compositional sketches, see Schwartz-Bok 1989, p. 80.

16 'dit geijndicht met teijckenen / den 3. Januarij 1636. / ende geeijndicht met / Schilderen den 23 maijus / Int Jaer 1636. Dito / even dus groot. / ende is een / gesicht inde grootte kerck / binnen haerlem'. Cf. Ruurs 1987, pp. 71-76, figs. 56-60, pp. 146-147, 196, pl. 16 and esp. the diagram on p. 147, fig. 71.

17 Swillens 1935, p. 97, no. 94: 'Achterzijde ingezwart voor overdruk. Inktlijnen ingekrast' ('Back blacked for indenting. Inked lines scored'); Utrecht 1961, p. 87, no. 42*. For this technique, see Schwartz-Bok 1989, p. 78, fig. 86 and p. 80.

18 Zürich 1958, no. 77; P. ten Doesschate-Chu in Basel 1987, no. 88; Schwartz-Bok 1989, p. 123, fig. 135, p. 260, no. 46; for the newly established provenance, see note 2. The similarities between the composition of the painting under discussion and that of the interior of the Church of St Bavo in London, National Gallery, completed in early May 1637 (Schwartz-Bok 1989, p. 127, fig. 140, 260, no. 43) are less pronounced than has been suggested (J. Giltaij in Rotterdam 1991, p. 109). Rather, this panel is directly related to the paintings

in Warsaw dating from 1635 and especially to the panel from 1636 in Amsterdam (Schwartz-Bok 1989, p. 115, fig. 123; p. 119, fig. 130), in which the pillars at left and right have clearly been used as a repoussoir and hence frame the view in the church.

19 The situation in the Christmas Chapel is instantly clarified in Schwartz-Bok (1989, p. 122, figs. 133-134), in which the construction drawings of the two paintings have been reproduced beside one another. It has sometimes been suggested that the surviving design (Zeist, Department for the Preservation of Monuments and Historic Buildings) for the painting in Zürich, which was completed earlier, was originally twice its present width, and that the left half, now lost, depicted the part of the church that appears in the painting shown here. Tempting though this theory may be, the preliminary design for this painting has still not surfaced (Liedtke 1975-1976, p. 152 note 16; J. Giltaij in Rotterdam 1991, p. 110; for the sheet concerned see Schwartz-Bok 1989, p. 125, fig. 137, p. 260, no. 47). Saenredam occasionally based more than one painting on a single sheet (Liedtke 1975-1976, p. 152; S. Nihom-Nijstad in Paris 1983, p. 121).

20 For the plaque above the gates of the choir screen and the one attached to the pillar at left, see Van Swigchem 1987, pp. 215, 216 and Mochizuki 2001, pp. 161-162. The small organ features prominently in a painting from 1635 in Berlin; Schwartz-Bok 1989, no. 52 and fig. 120; Rotterdam 1991, no. 14 (ill.).

21 Schwartz-Bok 1989, pp. 124, 317 note 29 (cf. esp. p. 126, fig. 138). The lion, black on a gold ground, could conceivably be a vague allusion to a family coat of arms, given that the Dutch lion of the province of Holland is always red (cf. also the comments of Schwartz-Bok 1989, p. 317 notes 24-26). The escutcheons in the church were removed in 1795.

22 The same boy is depicted on the panel in Zürich (fig. 28b). According to Biesboer (1985, pp. 88-89) the children are an allusion to the triviality of human life, a notion justly rejected by J. Giltaij (in Rotterdam 1991, p. 109). For children at play see also the observations of Honig 1996, p. 523. Biesboer's suggestion that the men

are waiting to be issued with tags proving poverty (to obtain a daily loaf of bread) is implausible. Schwartz-Bok (1989, p. 123, caption to fig. 135; pp. 200, 322 note 26) described the figures as impoverished, which may be related to the Biblical texts on the plaque at left in the picture (Van Swigchem 1987, p. 216, 'hebt Uw naaste lief als U zelve' ['Thou shalt love thy neighbour as thyself']).

23 Cf. Schwartz-Bok 1989, p. 115, fig. 123 (Warsaw, 15 October 1635), p. 119, fig. 130 (Amsterdam, 15 April 1636), p. 127, fig. 140 (London, early May 1637).

24 Inv. no. 53-1718 M. This copy is already mentioned by S. Nihom-Nijstad in Paris 1983, p. 121 and by J. Giltaij in Rotterdam 1991, p. 110. For De Frey, see Thieme-Becker, vol. 12 (1916), p. 440. For possible buyers of the painting shown here and similar scenes, see Schwartz-Bok 1989, p. 129.

25 Lugt 1918, p. 7. On Janssen, see Hirschmann 1918; Hirschmann 1920; B. Broos in Washington-The Hague 1995-1996, p. 207 (in connection with a painting attributed to Vermeer in Washington, National Gallery of Art; it belonged briefly to Janssen's collection). Janssen also owned *inter alia* an early history piece by Rembrandt from 1627 (Basel, Öffentliche Kunstsammlung; Bredius-Gerson 1969, no. 488; Basel 1987, no. 80).

26 See the section on Saenredam and Lugt in the introductory essay by Reitsma.

27 Inv. no. R.F. 1983-100; Foucart 1987, pp. 93-95 (ill.); Schwartz-Bok 1989, p. 65, fig. 72, p. 261, no. 49. Lugt knew this painting, since it had been sold at auction at Frederik Muller and Cie where he worked at the time (sale Amsterdam, 15-18 November 1904, lot 26).

28 This has been pointed out by several authors in connection with Paris 1983 (Charensol 1983, p. 432; Prat 1983, p. 126; Hecht 1984, p. 357); cf. also Foucart 1985, p. 67 and Foucart 1987, p. 93.

29 Drawings by Saenredam in the Frits Lugt Collection, arranged in order of inventory number: *Interior of the Church of Our Lady in Utrecht*, 3 July 1636, inv. no. 181 (Paris 1970, no. 54 and fig. 48; Schwartz-Bok 1989, no. 163 and fig. 148; Utrecht 2000-2001, no. 17, ill.); *The great organ in the Church of St Bavo in Haarlem*, inv. no. 2218 (Utrecht 1961, no. 66; New York–

Paris 1977-1978, no. 99 and fig. 42; Edinburgh 1984, no. 21, ill.; Schwarz–Bok 1989, no. 66 and fig. 127); *The tomb of count Floris V in the Church of St Lawrence, Alkmaar*, 30 May 1661, inv. no. 2725 (Schwartz–Bok 1989, no. 7 and fig. 247; M.C. Plomp in Utrecht 2000-2001, p. 55); *Interior of Church of St Cunera, Rhenen*, 5-6 July 1644, inv. no. 3599 (New York–Paris 1977-1978, no. 100 and fig. 45; Schwartz–Bok 1989, no. 109, fig. 207); *Portrait of an unknown man*, inv. no. 1976-T.9 (Giltaij 1977; Schwartz-Bok 1989, no. 205A and fig. 193; J. Giltaij in Paris 1994, no. 24, ill.; Utrecht 2000-2001, pp. 281, 283).

30 J. Giltaij in Paris 1994, p. 60; see above for the literature.

29 Cornelis Saftleven

1 Raupp 1984, pp. 329-336. Other artist's portraits in which the sitter presents the viewer with a drawing include: Lodewijk van der Helst, *Portrait of Willem van de Velde the Younger*, Amsterdam, Rijksmuseum (inv. no. SK-A-2236; Van Thiel et al. 1976, p. 270, ill.); Gerrit van Honthorst, *Portrait of an unknown artist*, 1655, Amsterdam, Rijksmuseum (inv. no. SK-A-1479; Judson-Ekkart 1999, pp. 39-41, 318, no. 488 and fig. 391).

2 Paris 1960a. For the ensemble of animal studies in the Lugt Collection, see Van Gelder 1976.

3 Inv. no. A 10150; Schapelhouman 1979, pp. 36-37, no. 16 (ill.). For the identification see Renckens 1962b, pp. 59-61.

4 Mauquoy-Hendrickx 1991, vol. I, p. 158, no. 90, vol. 2, fig. 56. On the *Iconographie* see also G. Luijten in Antwerp-Amsterdam 1999-2000, pp. 73-91, 92-217, nos. 5-30 (with additional literature).

5 For Saftleven, see Schulz 1978; R. James in Rotterdam 1994-1995, pp. 133-135, 222 (under no. 44); W. Schulz in idem, pp. 203-222 (under nos. 40-43); W. Schulz in *The Dictionary of Art*, vol. 27 (1996), pp. 516-517 (reprinted in Turner 2000, pp. 321-323).

6 Few works are known either by Herman Saftleven the Elder or by his third son, Abraham Saftleven (b. 1613). For Herman Saftleven the Younger, see Schulz 1982; W. Schulz in *The Dictionary of Art*, vol. 27 (1996), pp. 517-521 (reprinted in Turner 2000, pp. 323-325).

7 Muller 1989, pp. 142-143, nos. 292-301. One of the four has been identified as *Landscape with peasants driving their cattle near a farm* in a private collection in London (idem, p. 142, no. 294 and fig. 110).

8 On the mutual influence of the Saftleven brothers and David Teniers the Younger see R. James in Rotterdam 1994-1995, pp. 133-135.

9 Renckens 1962b, p. 61. Van Gelder (1959a, pp. 50-52) has, however, pointed out that the portrait could also have been painted during Van Dyck's journey through the Republic in 1632.

10 Inv. no. 696; Renckens 1962b, p. 61; Schulz 1978, pp. 225-226, no. 639 and fig. 10; Trnek 1992, pp. 342-345 (ill.).

11 Inv. no. 1975; Renckens 1962b, p. 61; Schulz 1978, p. 225, no. 637; Brejon de Lavergnée-Foucart-Reynaud 1979, p. 126 (ill.).

12 Hollstein, vol. 51, p. 128, no. 35. Two etched portraits of Herman Saftleven by Jan Gerritsz Bronckhorst probably date to the same period (Hollstein, vol. 3, p. 230, no. 17, ill.). A portrait etched by the artist himself a decade later (dated 1660) was probably – as the inscription indicates – after a portrait by his son, Dirck (Hollstein, vol. 23, p. 143, no. 39, ill.). On these portraits see Schulz 1982, pp. 5-6.

13 Rapp, art dealer, Stockholm, 1947. The panel is supposed to be signed on the painting on the easel, 'C. Saft Leuen' (Schulz 1978, p. 225, no. 636).

14 Schulz 1978, pp. 9-13. It seems possible that the lost original was painted as a pendant to the presumed portrait of Herman Saftleven (fig. 29b). The composition and dress in both pictures are similar and the panels are also very close in size. On other artist's portraits regarded to be self-portraits by Cornelis Saftleven (or copies thereafter) see Schulz 1978, pp. 14, 225. Trnek (1992, p. 344) also recognised Cornelis' likeness in two genre paintings by his hand.

15 Renckens 1962b, p. 62.

16 Schulz 1978, pp. 115-116, nos. 115-116. The drawings are in Amsterdam, Rijksmuseum, Rijksprentenkabinet (inv. no. 48-411; P. Schatborn in Amsterdam-Washington 1981-1982, pp. 78, 142, ill.) and Berlin, Staatliche Museen, Kupferstichkabinett (inv. no. 12092; Bock-Rosenberg 1930, vol. 1, p. 262, vol. 2, fig. 191).

17 Renckens 1962b, p. 60.

18 *Head of a stag*, inv. no. 4359; *Head of a dog*, inv. no. 5931 (Schulz 1978, p. 143, nos. 331-332 and figs. 93-94). The following drawings in the Lugt Collection have also been attributed to Cornelis Saftleven: *Woman reading*, inv. no. XVII (Schulz 1978, p. 114, no. 202); *Seated man warming himself by the fire*, inv. no. XXXIX (Schulz 1978, p. 97, no. 120); *The cellar stairs*, inv. no. XLIII (Schulz 1978, p. 123, no. 232); *Study of a broken-down bed, a chair and a cask*, inv. no. LXXIII (Schulz 1978, p. 180, no. 469); *Interior with children at a table*, inv. no. 53 (Schulz 1978, pp. 122-123, no. 231); *The pedlar and Death*, 1652, inv. no. 1916 (Schulz 1978, p. 74, no. 10 and fig. 114); *Seated young man with a letter*, 1668, inv. no. 2972 (Schulz 1978, p. 119 and fig. 73); *Church roof with a stork's nest*, 1646, inv. no. 4790 (Schulz 1978, p. 174, no. 440); *Perseus and Andromeda*, inv. no. 7958 (Schulz 1978, p. 73, no. 9 and fig. 118).

19 Schulz 1978, pp. 46, 50, 56-61. Among Saftleven's animal studies the *Study of a recumbent lion* was probably already executed around 1626 (Berlin, Staatliche Museen, Kupferstichkabinett; Schulz 1978, p. 132, no. 282). Studies after live animals are first found in the 1640s. Schulz regards the Lugt self-portrait as proof that Saftleven executed such studies already at the beginning of his career.

20 Raupp 1984, p. 232 note 283; P. Schatborn in Amsterdam 1993, p. 174 (under no. 81). On the monkey as an attribute of and play on the notion of *imitatio* see Ripa ed. 1971, p. 350; Janson 1952, pp. 287-314; Georgel-Lecoq 1987, pp. 56-59.

21 On the image of the music-making artists see Raupp 1978. On the concept of 'naer het leven' see Miedema 1981, pp. 122-128; P. Schatborn in Amsterdam-Vienna-New York-Cambridge 1991-1992, pp. 7-12.

30-31 Karel Slabbaert

1 The panels were originally octagonal, as can be seen with the naked eye. At some unknown time, probably after the portraits were completed, the octagonal panels were rounded out to ovals: small differences in colour are discernible and the technique of the passages on the added pieces is definitely less painstaking. Modifying the format of the self-portrait probably resulted in a small reduction in size on the right-hand side, which means that the figure was originally more toward the right in the picture plane.

2 Lot 23: 'A painter's portrait of Slabbaert, beautifully painted' (Een Schilders Portraitje van Slabbaert, fraey geschildert) and lot 24: 'A woman's portrait by the same. Colourfully painted' (Een Vrouws Portraitje van den zelven. Keurlijk geschildert). This sale is not mentioned in either Hoet-Terwesten 1752-1770 or Lugt; record of this sale was first published by Bol 1982b, p. 588 note 8, without mention of source.

3 That the paintings were put up for sale by the heirs of Karl Lanckoronski emerges from a letter written by Francis Russell (Christie's, Manson & Woods Ltd.) to Carlos van Hasselt, then director of the Fondation Custodia ('A brief note to say that the pictures were offered by the Lanckoronskis here on 18 July 1952, lot 302, and bought in'). For the Lanckoronski Collection, see Von Frimmel 1913-1914, vol. 2, pp. 487-496; Marandel 1994, passim (with more details regarding Karl Lanckoronski on p. 72); see note 14 for Cornelis Hofstede de Groot's visit to this collection.

4 Russell wrote to Van Hasselt (see note 2) that 'by 1961, these [Lanckoronski's paintings] had all been inherited by Countess Adelheid Lanckoronska'.

5 Information on the inventory card, Fondation Custodia Archives.

6 On Slabbaert, see Bol 1982b (for additions to his oeuvre, see the paintings mentioned in notes 7, 22 and 25 below). See also Bol 1969, pp. 84-86 and fig. 73 (a still life by Slabbaert); Hollstein, vol. 27 (1983), pp. 83-84 (etched portraits); Sumowski 1983-1994, vol. 1 (1983), pp. 501-502, 516-519 (ill.); Amsterdam 1984, pp. 83-84; 102, 104; 115, 198-199, no. 41 (ill.), pp. 272-279, nos. 78-81 (ill.). For biographical information on this painter in particular, see Bol 1982b, p. 588 notes 3-4; N. Bakker in Amsterdam 1984, p. 115; Briels 1997, p. 384.

7 Bol 1982b, pp. 583-586 and figs. 4-10, p. 588 and fig. 14, p. 588 note 16, nos. 1-2. To Bol's list may be added an important portrait of a young lady by Slabbaert: panel, 58 x 43.5 cm, signed at lower right: 'K. Slabbaert', Zhitomir, Museum of Art and Local Lore, inv. no. 40 (published by Kuznetsov-Linnik 1982, no. 40, colour ill., dated between 1640-1650).

8 For Slabbaert's genre scenes, see Bol 1982b, pp. 586-587 and figs. 11-13; Müllenmeister 1972. The still life in a private collection (Amsterdam 1984, no. 41, ill.), signed and dated 1641, had meanwhile changed hands (sale London, Sotheby's, 8 July 1999, lot 11 and colour ill.). In addition to the signed still life in the Museum Bredius at The Hague (inv. no. 104-1946; Blankert 1991, p. 203, no. 150 and fig. p. 189), there is a third still life which is known only from a document dating from 1676 (Bol 1982b, pp. 583, 588 note 6).

9 Bol 1982b, pp. 582 and 588 note 5a; for Loncke, see Thieme-Becker, vol. 23 (1929), p. 351.

10 Bol 1982b, pp. 582, 588 notes 3-4.

11 Bol 1982b, pp. 582, 588 note 5.

12 See S. Nihom-Nijstad in Paris 1983, pp. 126, 127. In 1952 and 1961 the paintings were offered as such (see provenance). Both the Gallicised names and those mentioned by Nihom-Nijstad (recorded by Albert Grand, a nineteenth-century restorer working in Paris, on labels to be found on the back of the panels) suggest a stay in France long before the paintings were studied in Vienna by Hofstede de Groot.

13 Bol 1982b, p. 585; S. Nihom-Nijstad in Paris 1983, p. 127 note 2. For portraits of Johan de Witt in the Rijksmuseum, see Van Thiel *et al.* 1976, p. 94, no. A 13; p. 95, no. A 4648; p. 414, no. C 175 (ill.).

14 Hofstede de Groot's visit to the Viennese collection prompted him to write, 'K. Slabbaert, Two small pieces, representing his own portrait and that of a woman. Both signed (Lanskoronski at Vienna)' and 'K. Slabbaert. Two bust-length portraits, a man and a woman in oval format, the format usually used by Van Mieris. Called the portraits of Jan and Jeanne de Wit (Lanskoronsky)' (in translation; undated index cards, RKD, The Hague). Horst Gerson earlier described the portraits – as he himself said, following Hofstede de Groot – as a self-portrait of the painter and a portrait of his wife (in Thieme-Becker, vol. 31 (1937), p. 128). Lugt visited the Lanckoronski Collection on 8 March 1923.

15 See note 1.

16 See E. van de Wetering in London-The Hague 1999-2000, pp. 17 and 37 note 17.

17 Hollstein 21; see P. Schatborn in London-The Hague 1999-2000, no. 53 (ill.). This contradicts Müllenmeister 1972, p. 1344: 'in the oeuvre he left behind there is no recognisable borrowing from Rembrandt' (in translation).

18 See, among others, A. van Suchtelen in London-The Hague 1999-2000, no. 94 (with reference to a self-portrait by Flinck).

19 On Rembrandt and Slabbaert, cf. also Bol 1982b, p. 582.

20 S. Nihom-Nijstad in Paris 1983, nos. 76-77, as 'Portrait d'homme (Probablement autoportrait)' and 'Portrait de femme (Probablement Cornelia Bouwers, épouse du peintre)'; G. Jansen in Amsterdam 1984, nos. 80-81, as 'Portrait of a man (probably selfportrait)' and 'Portrait of a woman with skull (Cornelia Bouwens [sic], the painters wife?)'; cf. also G. Jansen in *idem*, p. 104 ('so-called *Self-Portrait*').

21 Inv. no. 445; J. Sander in Frankfurt am Main 1991-1992, pp. 42-43 and plate 15 ('Bildnis eines Malers mit Totenkopf, möglicherweise Selbstbildnis des Künstlers'). Léon Krempel reported that infrared reflectography had meanwhile brought to light a number of remarkable pentimenti, including an underpainting revealing a portrait on the wall that was never executed in the final stages, another (unexecuted) seated male figure above the painter's left arm and possibly, further to the right, a woman, whom he describes in the forthcoming catalogue of Dutch paintings in the Städelsches Kunstinstitut (verbal communication, 30 October 2001). Since the publication of the museum catalogue by Weizsäcker (1900, pp. 322-323, no. 198), the painting has been attributed to Slabbaert, on the basis of statements made by Abraham Bredius, then director of the Mauritshuis, who noticed its close relationship to the signed painting in the Mauritshuis (fig. 30-31e; see Bredius-Hofstede de Groot 1895, p. 376, 'son portrait peint par lui-même au musée Städel à Frankfort s/Main'). Moes (1897-1905, vol. 2, p. 384, no. 7252) published the panel in 1905 unreservedly as a self-portrait by Slabbaert (these early references are not included in the museum catalogues of the

Städelsches Kunstinstitut). Only in the 1995 museum catalogue was the painting published as a self-portrait by Slabbaert (Sander-Brinkmann 1995, p. 53 and fig. 90).

22 Inv. no. 770A (not in Bol 1982b); traces of Slabbaert's signature at lower left, read as 'karel … f.'; see Bock *et al.* 1986, pp. 70-71 and 338, fig. 849 (convincingly attributed to Slabbaert in 1984 by the Hague art historian Willem van de Watering).

23 See S. Nihom-Nijstad in Paris 1983, p. 128. Regarding the marriage, see Bol 1982b, p. 588 note 4; Isaack Koedijck (1617/8-1668), who is recorded as having been in contact with Slabbaert from 1640, witnessed the drawing up of the marriage settlement on 9 March 1645, the marriage itself probably being solemnised several days later (see Bol 1982b, p. 588 notes 3-4). Koedijck's wife Sophia is documented as the 'stepmother' (stieffmoeder) of Cornelia Bouwers, who had lost her parents at an early age (see however C. von Bogendorf-Rupprath in Philadelphia-Berlin-London 1984, p. 228, who refers to Cornelia as the 'former sister-in-law' of Sophia).

24 Inv. no. 410; signed 'k. slabbaert.' on the wheel of the cannon. Bol (1982b, p. 587, ill.) described the man on the left as the painter himself, following information on the painting recorded in nineteenth-century catalogues of the Mauritshuis (De Stuers 1877a, p. 13, no. 131a; De Stuers 1877b, p. 30, no. 131a; Bredius-Hofstede de Groot 1893, p. 56, no. 336: 'Scene in a Camp In the fore-ground the painter's own portrait'; Bredius-Hofstede de Groot 1895, pp. 376-377, no. 410). In the museum's most recent catalogue mention is no longer made of the self-portrait (Sluijter-Seijffert *et al.* 1993, p. 137, no. 410: 'Soldiers among the ruins of a castle').

25 For comparable scenes painted by Dou after Slabbaert's death, see Washington-London-The Hague 2000-2001, nos. 21 and especially 38 (the last number included in the Dutch edition only). In a genre scene correctly attributed to Slabbaert (not in Bol 1982b; panel, 39.5 x 33 cm, private collection, Switzerland, 1965; photograph RKD, The Hague) a woman and child are depicted in a similar way. Finally, another genre scene, also not included in Bol's monographic article and formerly at Noortman Gallery, Maastricht, 1985 (panel, 45 x 35 cm; photograph RKD,

The Hague), is also related to a signed painting by Slabbaert (Müllenmeister 1972, p. 1344, ill.; Bol 1982b, p. 587, fig. 11).

26 Copper, 27.5 x 19.5 cm; sale Vienna, Dorotheum, 9-12 June 1970, lot 121 and pl. 2, as attributed to Karel Slabbaert, possibly a portrait of Rembrandt (Bénézit 1976, vol. 9, p. 643); Sumowski 1983-1994, vol. 1 (1983), pp. 502, 503 note 32 and 32a, fig. p. 518 (previously attributed to Rembrandt, assigned to Slabbaert by Kurt Bauch; without record of the above-mentioned sale). The resemblance of the self-portrait illustrated here to this alleged self-portrait – in which a man, who stands in front of a pillar, is decked out as an officer, complete with a Rembrandtesque beret with a feather and soldiers in the back-ground – is not very great, nor is the attribution of this very freely painted depiction to Slabbaert entirely convincing. Neither is there any noticeable resemblance to a fashionably dressed young man in another painting, this time correctly attributed to Slabbaert (panel, 42 x 26 cm; S. Nijstad, art dealer, The Hague; Bol 1982b, p. 586, fig. 10; see however S. Nihom- Nijstad in Paris 1983, p.127).

27 For instance, Washington-London-The Hague 2000-2001, nos. 9 (*c.*1635-1640; 21.2 x 17.6 cm) and 11 (*c.*1642-1645; 18.4 x 14.9 cm). On Dou and his influence on Slabbaert, see Bol 1982b, pp. 582, 586, 587, 588. In particular, the composition of the painting in Copenhagen (Bol 1982b, p. 585 and fig. 6), which displays exceptionally fine brushwork, is closely related to Dou's work. The portrait of a young man, attributed to the Leiden master (Pieter de Boer, art dealer, Amsterdam, 1958; sale Amsterdam, Sotheby's Mak van Waay, 14 March 1983, no. 45, fig.; later sale London, Sotheby's, 30 October 1996, no. 123, fig., still as Dou), of which Slabbaert produced a variation (Bol 1982b, pp. 585-586 and fig. 10), is possibly not by Dou but by Slabbaert himself.

28 Cf. the remarks in Bol 1982b, pp. 582 and especially 584.

29 Bol 1982b, p. 583.

30 Listed in chronological order: *c.*1657-1660: panel (oval), 11 x 9 cm (Berlin, Staatliche Museen, Gemäldegalerie and London, The National Gallery); 1661 and 1662: panel (oval), 11 x 8 cm (formerly

Schloss Collection; sale London, Sotheby's, 11 December 1985, lot 77, colour ill.; O. Naumann, art dealer, 1990); 1662: panel (oval), 11 x 8 cm (Munich, Bayerische Staatsgemälde-sammlungen, Alte Pinakothek); see Naumann 1981, vol. 2, nos. 29-30, 38-39, 41-42 (ill.).

31 Bol 1982b, p. 584, fig. 4 and p. 585; the Mauritshuis painting is reproduced in Sluijter-Seiffert *et al.* 1993, p. 137, no. 751.

32 With thanks to Marieke de Winkel, Amsterdam, who examined the clothing in the portraits described here. Slabbaert's collar in particular is very similar to the one seen in the 1654 *Posthumous portrait of Paulus Potter (1625-1654)* by Bartholomeus van der Helst (The Hague, Mauritshuis, inv. no. 54; The Hague 1994-1995, p. 10, fig. 1 and frontispiece), where the sitter is portrayed with an open collar with tassels (as regards this detail, see also Rembrandt's early *Portrait of Nicolaes Bruyningh (1629/30-1680)* of 1652 in Kassel; inv. no. GK 243; Bredius-Gerson 1969, no. 268). A similar piece of clothing, trimmed with lots of buttons, is worn by Jan Six in the famous portrait by Rembrandt dating from 1654 (Amsterdam, Six Collection; Bredius-Gerson 1969, no. 276). S. Nihom-Nijstad (in Paris 1983, p. 126) also dated Slabbaert's paintings to around 1650-1654 on the basis of the clothing.

33 M. de Winkel in London-The Hague 1999-2000, pp. 67-72; cf. also E. Buijsen in *idem*, pp. 173-175.

34 S. Nihom-Nijstad in Paris 1983, p. 128.

35 Bol 1982b, p. 585; J. Sander in Frankfurt am Main 1991-1992, p. 42.

36 Cf. Raupp 1984, pp. 338-339; Langedijk 1992, pp. 118-121, no. 22, ill. (self-portrait of Michiel van Musscher dating from 1692, with the portrait of his wife, who died in 1690); E. de Jongh in Haarlem 1986, p. 23 and fig. 13; see also Popper-Voskuyl 1973. Portraits of the deceased were included in (self-)portraits from the sixteenth century on (cf. *Jacob Cornelisz van Oostsanen, painting his wife's portrait* of around 1550 by Dirck Jacobsz; Amsterdam 1986, pp. 197-198, no. 74, ill.; Raupp 1984, fig. 19; cf. also the print dating from 1600 by Aegidius Sadeler after Bartholomeus Spranger; Eckardt 1971, p. 55, fig. 41; J.P. Filedt-Kok in Paris 1994, pp. 160-161, no. 74, ill.).

32 Adriaen van de Velde

1 Kalkbrenner was a German pianist and composer who spent most of his life in Paris. No works by Van de Velde were included in the auction of his collection (Laneuville-Bonnefons, 14 January 1850; Lugt no. 19607). According to an annotated copy of the catalogue in the RKD in The Hague, our painting was sold before the auction (see S. Nihom-Nijstad in Paris 1983, p. 137 note 2).

2 Lugt no. 35409.

3 In Paris 1983, p. 136, the lot number is mistakenly given as '59'.

4 See Provenance.

5 On the animal studies in the Frits Lugt Collection see Van Gelder 1976. The following Van de Velde drawings can be found in the collection: *Landscape with herdsmen and animals*, inv. no. 60 (Paris 1960a, no. 287); *Landscape with livestock*, inv. no. 61; *Study of a hunter and other figures*, inv. no. 263; *Shepherdess and livestock near ruined buildings*, inv. no. 463 (Paris 1960a, no. 288; Robinson 1979, pp. 7, 19, no. B-14 and pl. 4; Broos-Schapelhouman 1993, p. 182 note 2); *Orpheus playing the harp*, inv. no. 1174; *Juda and Tamar*, inv. no. 4005; *Study of cattle*, inv. no. 4381; *Mountainous landscape with a herd wading a river*, inv. no. 4382; *'The little ferry'*, inv. no. 4776 (Brussels-Rotterdam-Paris-Bern 1968-1969, no. 153 and fig. 162); *Study of two herdswomen*, inv. no. 4784 (New York-Paris 1977-1978, no. 108 and fig. 109; Robinson 1979, p. 21, no. D-7 and pl. 9). There is also a Van de Velde drawing that has been worked over by Jacob de Wit, *Design for a title page*, inv. no. 1980-T.12. The attribution of *Seated woman* (inv. no. 1369) to Van de Velde is uncertain.

6 F. Lugt in Paris 1960a, p. 47.

7 For Adriaen van de Velde, see A. Chong in Amsterdam-Boston-Philadelphia, p. 492 (with older literature); W.W. Robinson in *The Dictionary of Art*, vol. 32 (1996), pp. 144-146 (reprinted in Turner 2000, pp. 358-360; Frensemeier 2001 (ill.).

8 See Hofstede de Groot 1907-1928, vol. 4 (1911), pp. 481-607, nos. 1-387.

9 Both the cart and the branches at the upper left were left out of the mediocre copy formerly in the collection of the New York Historical Society (panel, 22.2 x 29.2 cm); on this painting see Hofstede de Groot

1907-1928, vol. 4 (1911), p. 541, no. 220; S. Nihom-Nijstad in Paris 1983, p. 137; Frensemeier 2001, p. 187, no. 220; sale New York, Sotheby's, 12 January 1995, lot 45 (colour ill.).
10 In a drawing by Van de Velde of 1662 we also find a horse used as a repoussoir device, this time in the right foreground (Paris, Musée du Louvre, inv. no. 23.067; Lugt 1929-1933, vol. 2, p. 41, no. 784 and fig. 55).
11 Lugt 1929-1933, vol. 2, p. 41, under no. 785.
12 On the signed painting of 1657 in London (fig. 32a) see White 1982, p. 129, no. 201 and fig. 174; Frensemeier 2001, pp. 152-153, no. 43 and fig. 6; on the signed painting of 1663 in a private collection (fig. 32c) see Hofstede de Groot 1907-1928, vol. 4 (1911), p. 564, no. 295 (and p. 582, no. 343a?); London 1952-1953, p. 95, no. 506; Broos-Schapelhouman 1993, p. 178, no. 87. Cf. further for the motif the signed painting of 1664 in Paris, Musée du Louvre, inv. no. 1918 (Hofstede de Groot 1907-1928, vol. 4 [1911], pp. 514-515, no. 120; Frensemeier 2001, p. 176, no. 155 and fig. 108). A signed and dated sheet of 1671 with a scene similar to the one found in the 1664 painting is in the Musée du Petit Palais, Dutuit Collection, Paris (Lugt 1927, pp. 33-34, no. 77 and fig. 41; Robinson 1979, p. 20, no. C-3; Dordrecht-Leeuwarden 1988-1989, pp. 174-176, no. 31 and fig. 118).
13 Inv. no. A 10347; Broos-Schapelhouman 1993, p. 178, no. 135 (ill.). Two sheets with an identical scene, probably both copies after the signed drawing in Amsterdam, are in the Musée du Louvre, Paris (Lugt 1929-1933, vol. 2, p. 41, no. 785 and fig. 66) and the École des Beaux-Arts, Paris, respectively (Lugt 1950, vol. 1, p. 81, no. 663; photograph RKD, The Hague). On the motif of the two horses compare also the drawing with Mercury and Battus in a private collection (Hannema 1961, p. 32, no. 14; Robinson 1979, pp. 6, 19-20, no. B-16 and pl. 2a), a sketch for a painting of 1671 in the Nationalmuseum in Prague (Hofstede de Groot 1907-1928, vol. 4 [1911], p. 486, no. 22; Frensemeier 2001, p. 147, no. 15 and fig. 136).
14 See Hollstein, vol. 32, pp. 213-239 (ill.).
15 Houbraken 1718-1721, vol. 3, p. 90.
16 A. Walsh in The Hague 1994-1995, p. 37; E. Buijsen in *idem*, p. 148 and fig. 3; W.W. Robinson in

The Dictionary of Art, vol. 32 (1996), pp. 144, 146.
17 Frensemeier 2001, pp. 46-51.
18 See Robinson 1979 and pls. 1-13. Van de Velde often used his animal studies for more than one painting, as appears from, among others, two landscapes of 1666 and 1667 which include a white cow that is clearly based on one and the same study (see Q. Buvelot in Paris-Montpellier 1998, pp. 223-225 and fig. 61a).

33 Willem van de Velde the Younger

1 According to Robinson, the signature with angular letters represents the studio of father and son and is not the personal signature of Willem van de Velde the Younger (Robinson 1990, vol. 2, p. 734). For the various ways in which the artist signed his name, see Robinson 1990, passim; Russell 1992, pp. 24-25.
2 In the notarial document (Rotterdam, notary J. van der Mey Junior, 13 April 1777), drawn up at the purchase *en bloc* of the cabinet of paintings belonging to Adria(e)n and John Hope, the painting is described as follows: 'A beautiful piece, representing the sea with many battleships, yachts, boats and other vessels' ('Een schoon stuk, verbeeldende een zee met veel oorlogschepen, jagten, booten en ander vaertuig'), 'high 3:6¹/₂, wide 5:3. [*c*.129 x 164.7 cm]'; quoted from Wiersum 1910, p. 172). The printed catalogue of the Bisschop Collection dating from 1768 (Amsterdam, Rijksmuseum) contains the same description. For the vicissitudes of the Hope Collection, see B. Broos in The Hague-San Francisco 1990-1991, pp. 419-422, with additional literature.
3 'Velde [Willem van de]. A beautiful piece being the sea with many battleships, yachts and other vessels. 42¹/₂ x 63 thumbs (*c*.109.2 x 161.9 cm; 'Velde [Willem van de]. Een schoon stuk zynde een zee met veel oorlogschepen, jagten en ander vaartuig. 42¹/₂ x 63 d.'); quoted from the second of three hand-written catalogues of the John Hope Collection, The Hague, RKD; Niemeijer 1981, p. 200. On the painting's stretcher is a black seal with a coat of arms containing an anchor and the number '98', probably the seal of the Hope family (Robinson 1990, vol. 2, p. 735).

4 The painting cabinet of John Hope passed by descent to his three sons, of whom the eldest, Thomas Hope (1769-1831), collector and amateur architect, is the best known. When the collection was moved to England a division took place on 18 June 1794, whereby the paintings became the property of his younger brothers, Adrian Elias (1772-1834) and Henry Philip; afterwards ownership was transferred at some unknown date to Henry Philip alone (Niemeijer 1981, pp. 168-169). The painting probably figures as 'Do. [W.ᵐ van de Velde] 1 Do. [Seapiece]', valued at 400 pounds in one of the lists drawn up for the insurance in connection with the removal in 1795 of the collection to England (Buist 1974, p. 492).
5 In 1819 Henry Philip Hope lent the collection to his brother Thomas Hope (Watkin 1968, pp. 35, 121-124). As regards the latter, see Baumgarten 1958; Watkin 1968; D. Watkin in *The Dictionary of Art*, vol. 14 (1996), pp. 744-745.
6 The painting is visible in a watercolour by Robert William Billings (1813-1874), which depicts the picture gallery that Thomas Hope built onto the house of his brother Henry Philip in 1819 (New York, The Metropolitan Museum of Art; Watkin 1968, pp. 120-121 and fig. 41). It is however not mentioned by Waagen in the account of his visit to the Hope Collection in 1835 (Waagen 1854-1857, vol. 2, pp. 112-125). Robinson (1990, vol. 2, p. 735) rightly observed that the painting's subsequent vicissitudes in the Hope Collection cannot be ascertained. The last trace of it is to be found in the accounts of John Smith, who restored a painting of nearly the same measurements by Van de Velde for Henry Philip Hope in 1836 (MS, London, Victoria & Albert Museum, p. 556, 13 March 1856). Unfortunately, the measurements are not recorded of the 'Sea-Piece with Men of War and Boats' sent in 1864 by one 'Mrs Hope' to an exhibition at the British Institution.
7 The painting was not included in the catalogue of eighty-three paintings from the Hope Collection which were sold by Henry Francis in 1889 to Asher Wertheimer (Robinson 1990, vol. 2, p.735).
8 According to Robinson 1990, vol. 2, p. 735.
9 It is possible that the sixteen-year-old Lugt saw the painting as

early as 1901 during his trip to London, before entering the employ of Frederik Muller & Cie. There is however no indication that he bought it at that time, as recorded by Robinson (see note 8). Years later Lugt himself remembered having bought the painting 'around 1910' as an employee of Frederik Muller (see note 34).
10 According to Robinson (see note 7), two numbers on the back of the painting are Knoedler's 'stock numbers'; Robinson also reported that Knoedler sold the painting in April 1913. According to Lugt's letter of 1953 (see note 34), the painting was sold by Muller's to Janssen.
11 The painting was probably in Janssen's possession already in 1913: in the *Eerste Nederlandsche Tentoonstelling op Scheepvaartgebied*, held in Amsterdam from June to September of that year, the lender of the painting was recorded as 'an owner remaining unnamed, fortunately a Dutchman' (in translation; De Balbian Verster 1913, p. 6).
12 According to Robinson (see note 7).
13 For Van de Velde the Younger, see Robinson 1990; Russell 1992; D. Cordingly in *The Dictionary of Art*, vol. 32 (1996), pp. 142-143 (with additional literature; reprinted in Turner 2000, pp. 355-357); J. Giltaij in Rotterdam-Berlin 1996-1997, pp. 333-360.
14 For historical details of the event depicted, see especially De Balbian Verster 1912, whose information was partly derived from two contemporary ships' logs. For the historical context, see De Jonge 1858-1862, vol. 2 (1859), pp. 1-18; Mollema 1939-1942, vol. 2 (1940), pp. 343-350; Warnsinck 1940; Boxer 1976, pp. 35-51; Scholten 1995, pp. 63-65.
15 De Balbian Verster 1912, pp. 516, 518.
16 Robinson (1990, vol. 2, p. 733) identified the yacht as that of the States General. The lion on the tafferel, flags and pendants is however that of the province of Holland, as De Balbian Verster (1912, p. 517) rightly observed, as the shield also displays the maxim 'Vigilate deo confidentes' below the coat of arms. The same yacht is depicted in two other paintings by Willem van de Velde the Younger (Robinson 1990, vol. 2, no. 341, pp. 786-791, and no. 342, pp. 784, ills.), as well as in a painting by Lieven Verschuier (Rotterdam-Berlin 1996-1997, no. 85, ill.).

17 Robinson 1990, vol. 2, p. 733. According to De Balbian Verster, the yacht is that of the States General. The same two yachts are probably to be seen in *The Dutch fleet in the roads of Goeree on 23 October 1664*, a depiction by Willem van de Velde the Younger of an event which occurred several months previously, now in Madrid at the Museo Thyssen-Bornemisza (inv. no. 1960.2; Gaskell 1990, pp. 328-333, no. 73, ill.; Robinson 1990, vol. 1, pp. 272-275, no. 158, ill.). As regards this painting, see also Weber 1979, especially pp. 155-158, on the differences in rigging and in the flags and pendants flown from the masts of the two State yachts.

18 De Balbian Verster 1912, pp. 519-520.

19 De Balbian Verster 1912, p. 517; Robinson 1990, vol. 2, p. 733. For a list of the fleet's flagships and their commanders dating from June 1665 (with an indication of the flags flown), see Robinson-Weber 1979, vol. 1, p. 30.

20 De Balbian Verster recognised to the right of the *Eendracht*, from left to right: a ship with the coat of arms of Zeeland (either the *Cruyningen* or the *Zeelandia*), the *Amsterdam*, the *Vrede*, the *Dom van Utrecht*, *Het raadhuis van Haarlem*, the *Groot Hollandia* and the *Hilversum*. In the sloop on the immediate left in front of the *Eendracht*, flying the flag of Rotterdam, he recognised the figure of Egbert Meussen Cortenaer, who is being conveyed to the admiral's ship. In this sloop there is indeed an officer with a sash, who takes off his hat to the ship. These identifications cannot be accepted unreservedly, however. The tafferels of the *Vrede* and *Dom van Utrecht* pointed out by De Balbian Verster are scarcely discernible, while that of the *Raadhuis van Haarlem*, at the far right, shows a different building. Robinson rightly pointed out that the ship is an East Indiaman (1990, vol. 2, p. 734). Comparison with a drawn 'ship's portrait' by Willem van de Velde the Elder shows that it is undoubtedly the *Maarsseveen*, one of the merchantmen which the Dutch East India Company put at the disposal of the States and one of the finest ships in the fleet (Rotterdam, Museum Boijmans Van Beuningen, inv. no. MB 1866/T 249; Robinson-Weber 1979, vol. 1, p. 101, vol. 3, pl. 142). This ship also perished on 13 June (Warnsinck 1940, pp. 287-288).

21 The fleet included 103 battleships, 7 yachts, 11 fireships and 12 galjoots; De Jonge 1858-1862, vol. 2 (1859), p. 7.

22 For the Battle of Lowestoft, see Warnsinck 1940.

23 His *Council-of-war on board the Zeven Provinciën in 1666* in the Rijksmuseum at Amsterdam was perhaps inspired by the painting discussed here (inv. no. SK-A-4289; Robinson 1990, vol. 1, pp. 70-72, no. 332, ill.).

24 There is little doubt that the galjoot from which the painter followed the action in May and June 1665 was put at his disposal by the Dutch Republic. In a design for a tapestry dating from 1674 – from a series of four tapestries with depictions of the Battle of Lowestoft, commissioned by Charles II – he wrote next to the portrayal of his galjoot: 'Van de Velde's galjoot on orders and with permission from the State' ('Van de Velde zijn gallijodt met ordre & kennis vande staet'; Robinson 1990, vol. 1, p. XIII; for the drawing, see Robinson 1958-1974, vol. 1, pp. 85, 126, no. 448 and fig. 103). The Dutch Republic had probably put a galjoot at his disposal as early as 1658 (Robinson 1958-1974, vol. 1, p. 6).

25 Published in Robinson 1990, vol. 1, pp. XXI-XXII.

26 Published by Leupe 1870.

27 See the series at Greenwich, National Maritime Museum (Robinson 1958-1974, vol. 1, nos. 107-110, vol. 2, nos. 877-878), London, British Museum (Croft-Murray-Hulton 1960, nos. 7-10) and especially Rotterdam, Museum Boijmans Van Beuningen (Robinson-Weber 1979, nos. 20-36). See also Robinson 1958-1974, vol. 1, p. 48, and vol. 2, pp. 15-16, where sheets in other collections are recorded. The drawing of the council-of-war of 24 May (see the following note and fig. 33a) is the earliest of the series.

28 Inv. no. 877 (Robinson 1958-1974, pp. 15, 68, figs. 36-37). The drawing bears the inscription 'the admiral awaits the ships / and [a council-of-war] is convened [on] Whit Sunday' (den adr v'wacht de schepen bij een / & wert gepiets'rt pijnxsterdach), and on the verso the inscription 'very fine view at Texel and at sea 1665' (int Tessel als in see seer fraaij gesichte 1665). The word *gepiets[ee]rt* is probably a misspelling of *gepitsiaard*, an old term for convening a council-of-war (WNT, s.v. *Pitsjaren*).

29 Robinson 1958-1974, vol. 1, pp. 8, 15; Robinson 1990, vol. 1, p. XXV. Robinson is contradicted by Weber (1978, pp. 129-131; 1979, p. 160).

30 See M.S. Robinson in sale catalogue London, Christie's, 1 December 1970, no. 104 (ill.). The drawing, signed with the initials 'W.V.VJ' bears the inscription '1665 the 4th of June as the State fleet nears land, escorting the captured boyers of Hamburg / there are 6 out of the picture the weather being very [calm?] in the afternoon' (1665 den 4 juni soo d staet vloot naert lant gadet met d' genomen boeyers van Hamborcht / daer sijnder 6 die uijt beelde het weeder seer legge des after middags). For the surprise attack on the English convoy returning from Hamburg, see Warnsinck 1940, p. 269; Boxer 1976, p. 48.

31 Inv. no. C 1731. According to Robinson 1990, vol. 2, p. 734, this drawing is the preparatory sketch for the painting.

32 Inv. no. 191 (Robinson 1958-1974, vol. 1, pp. 57, 24 and fig. 38). Robinson dates the drawing to around 1665. A third drawing by Willem van de Velde the Younger, also depicting a council-of-war on the *Eendracht*, is also connected by Robinson to the painting (Robinson 1990, vol. 2, p. 734). Stylistically, the sheet seems more characteristic of the later drawings by Willem van de Velde the Younger from his English period. As Robinson observed, the paper has a watermark that is also to be seen in two drawings by Willem van de Velde the Elder dating from 1673 or after (Greenwich, National Maritime Museum, inv. no. 451; Robinson 1958-1974, vol. 1, pp. 104, 124 and fig. 104).

33 According to Robinson (1990, vol. 2, p. 734), the portrayal of the ship in the painting most closely resembles the drawing at Greenwich, National Maritime Museum, inv. no. 236 (Robinson 1958-1974, vol. 1, pp. 61, 148 and fig. 51). For the other known drawings of the ship, see D. Scrase in Munich-Heidelberg-Braunschweig-Cambridge 1996, under no. 55; to this list can be added the drawing at Brielle, Trompmuseum (Dik 1993, p. 26, fig. 35).

34 Compare the original of Lugt's letter to N.J. van Aalst dated 3 March 1954 (Fondation Custodia Archives): 'You must forgive my thinking first of all of your W. van de Velde, because this painting is a precious souvenir to me. I bought it around 1910 in England and was happy at that time to place it in a Dutch collection. Moreover, the fact that you often lend out the painting, lately also to [exhibitions in] Zürich and Rome, has given me the courage to ask you for it' (in translation).

35 C. van Hasselt in Paris 1989, pp. VI-VII. The Dürer drawing in question is the *Study for the arm of Eve*, 1507, a preparatory drawing for the painting dating from the same year which is at the Museo del Prado in Madrid. The drawing is now in the Cleveland Museum of Art (inv. no. 65.470; Washington 1971, no. XV, ill.).

34 Willem van de Velde the Younger

1 Robinson (1990, vol. 2, p. 878), when examining the painting in 1976, found no trace of a presumed signature (possibly 'W.V.V J') which is faintly visible in an old photograph of the painting in the National Maritime Museum at Greenwich, London. Recent restoration of the painting carried out by Sarah Walden in 2001 yielded no trace of a signature.

2 Lot 8: 'A view of Scheveling De Vlieger £ 6.10.0', with lot 9, 'its companion Van de Veld', for £ 3.10.0 to Jennens (quoted from Robinson 1990, vol. 2, p. 879; after a hand-written copy of the sale catalogue in the Victoria & Albert Museum, inv. no. RC S1, vol. 1, pp. 242, 244). Robinson connected the record of the painting by De Vlieger with the painting in the Wallraf-Richartz-Museum at Cologne (inv. no. 2563), twice copied by Charles Brooking (Joel 2000, p. 134, nos. 101A-101B, ill.), who also copied the painting discussed here (see note 19).

3 Lot 1270: 'A beach scene, with fishermen and boats on the foreshore (Canvas 19 1/2 in. by 14 1/2 in.) [c.49,5 x 36,8 cm]' (copy of the catalogue at the RKD, The Hague).

4 As Robinson (1990, vol. 1, p. 879) observed, the documentation on the painting in the Fondation Custodia Archives contains a note written by Lugt, from which it emerges that the painting was not offered at the Gopsall sale, but had been acquired by Lugt from A.L. Nicholson, who had bought it from Earl Howe. This probably refers to another painting, however: a bill from Colnaghi & Obach charged Lugt for a 'W. van

de Velde Boat scene canvas 14¹/₂ x 19¹/₂ inch' on 21 May 1919 (Fondation Custodia Archives, 3 July 1919).

5 For a sketch of the development of the beach scene in Dutch painting of the seventeenth century, and the place of Willem van de Velde the Younger therein, see Stechow 1966, pp. 101-109.

6 For the beach scenes by Adriaen van de Velde, see Stechow 1966, pp. 107-109; J. Walsh and C.P. Schneider in Los Angeles-Boston-New York 1981-1982, pp. 98-101 (under no. 24); P.C. Sutton in Amsterdam-Boston-Philadelphia 1987-1988, pp. 493-496 (under no. 103).

7 For example, *View of the beach at Scheveningen* of around 1660 at London, The National Gallery, inv. no. 873 (Robinson 1990, vol. 2, pp. 856-858, no. 206, ill.; Rotterdam-Berlin 1996-1997, no. 77, colour ill.). For other examples, see Robinson 1990, vol. 2, pp. 846-849, nos. 352-354, pp. 854-856, no. 270, pp. 858-861, no. 195, pp. 863-864, no. 21, pp. 864-867, nos. 265-266 (ill.).

8 Robinson observed that the ship is difficult to identify, considering the rigging is that of a weyschuit.

9 *Tegenwoordige staat der Vereenigde Nederlanden*, vol. 8, Amsterdam 1750, pp. 376-377; Sigmond 1989, p. 147. The rows of poles are clearly visible in a large drawing, *The Dutch fleet lying at anchor before Den Helder*, which Willem van de Velde the Elder made from the island of Texel in August 1653 (Rotterdam, Museum Boijmans Van Beuningen, inv. no. MB 1866/T II; Robinson-Weber 1979, vol. 1, pp. 19-20, vol. 2, figs. 8-9; see also Weber 1976, pp. 123-125 and fig. 5), as well as in a drawing by Hendrick Dubbels at Amsterdam, Rijksmuseum, Rijksprentenkabinet (inv. no. A 3605; Middendorf 1989, p. 183, no. 146, ill.) and in a drawing attributed to Ludolf Backhuysen at Haarlem, Rijksarchief Noord-Holland (Sigmond 1989, p. 147, ill.).

10 Signed 'WVV' (Los Angeles-Boston-New York 1981-1982, no. 26, colour ill.; Robinson 1990, vol. 2, pp. 876-878, no. 61, ill.). For other depictions of the Marsdiep in the work of Willem van de Velde the Younger, see, for instance, Robinson 1990, vol. 1, pp. 269-270 (no. 478), 374-375 (no. 398), 413-416 (nos. 374-376), 432-433 (no. 213), 457-459 (no. 395), 459-461 (no. 397), 488-492 (no. 204), 496-497 (no. 310), vol. 2, p. 780 (no. 563), ill. For depictions by Hendrick Dubbels, see Middendorf

1989, pp. 150-155, nos. 96-101 (ill.).

11 Inv. no. 971; Robinson 1958-1974, vol. 2, pp. 23, 103 (ill.).

12 See cat. no. 33 note 27.

13 In addition to the above-mentioned drawing (fig. 34b) and the sheet at Copenhagen (fig. 34c), there are a number of such drawings at Greenwich, National Maritime Museum; Robinson 1958-1974, vol. 1, pp. 57, 124, no. 190, fig. 38 (dated 12 May 1665), pp. 58, 187, no. 204, fig. 41 (20 May), vol. 2, pp. 20, 68, no. 932, fig. 50 (14 May), pp. 20, 69, no. 933 (13 May). A group of fifteen undated drawings at Greenwich are also attributed by Robinson to Willem van de Velde the Younger and dated to the same period (Robinson 1958-1974, vol. 2, pp. 21-22, 92, 104, 122, nos. 934-948); the first of these shows a number of battleships lying at anchor in the Texel roadstead. In the Statens Museum for Kunst at Copenhagen there is yet another sheet with ships before the coast, dated 20 May 1665. Two other drawings (17 May and 4 June 1665) were offered on 1 December 1970 at Christie's in London: lots 103-104, ill. (entries in sale catalogue written by M.S. Robinson). The Teylers Museum at Haarlem has a beach scene with a small vessel near a palisade running into the sea and large battleships in the background (Scholten 1904, pp. 249-250, portfolio R 24), whose relationship to the Lugt painting had already been noticed by Lugt himself (note in the painting's documentation, Fondation Custodia Archives). This carefully worked-out drawing, signed and dated 1687, bears on the verso the inscription 'view in Texel in 1665 as the State fleet was lying [at anchor] there' (t gesigt in Tessel @ 1665 als de vloot van desen Staet daer lag; with thanks to Carel van Tuyll van Serooskerken). It is probably a later repetition of a sheet done in 1665. The composition is depicted in reverse in a painting at Greenwich, National Maritime Museum (inv. no. 410104; Robinson 1990, vol. 2, pp. 879-880, no. 816, ill., as a copy after a lost work by Willem van de Velde the Younger).

14 See cat. no. 33 note 24.

15 De Jonge 1858-1862, vol. 2 (1859), p. 7; Robinson-Weber 1979, vol. 1, p. 30. The long wait was caused by the English blockade, which prevented the Zeeland squadron from joining the fleet until 21 May.

16 Inv. no. 9437; inscribed on the

verso 'Sunday 17 May 1665 [they] lay in front of Den Helder and these going forth to the Nieuwe Diep observe mo a' (in translation; 'Sondach den 17 maey 1665 sitten regt voorde helder ende dese voort / gaende naert neuwediep merck mo a'; the first line is partly cut off; with thanks to Jan Garff and Matthias Wivel for the photograph of both recto and verso). The drawing was identified by Robinson (1990, vol. 2, pp. 878-879) as the example for the painting. A drawing in the New Orleans Museum of Art, also depicting fishing vessels alongside a palisade, was in his opinion perhaps the example for the departing weyschuit; however, the drawing displays only a general resemblance to the painting (inv. no. 68-12, from the H.E. ten Cate Collection; Hannema 1955, vol. 1, p. 169, no. 304).

17 Robinson (1990, vol. 2, p. 877) dated the painting to the first years following the Van de Veldes' move to England in the winter of 1672-1673, owing to its resemblance to the beach scene in Los Angeles (fig. 34a). The departing sailing boat in the latter painting flies the 'double prince's' flag (twice three stripes of orange, white and blue above one another). According to J. Walsh and C.P. Schneider (in Los Angeles-Boston-New York 1981-1982, p. 107, without mention of source), this flag fell into disuse around 1665 and was only restored in 1673 by Cornelis Tromp. The painting could therefore not have originated before 1673. It is in fact known that Cornelis Tromp introduced 'multiple prince's flags' as commando flags for the squadron under his command at the Second Battle of Schooneveld on 7 June 1673 (Van Foreest-Weber 1984, p. 92). Little research seems to have been done regarding the use of this flag in the preceding period (and the flags flown by Dutch ships in general). The 'double prince's flag' was depicted a number of times by Willem van de Velde the Younger in what were very accurate, factual portrayals of sea battles taking place in the years between 1665 and 1673, especially the Four Days' Battle of 1666; Robinson 1990, vol. 1, pp. 134-137 (nos. 424 1-3), 138-139 (no. 114), 140-143 (no. 159), 146-148 (no. 161), 148-150 (no. 109), 153-154 (no. 110). According to Robinson, however, Van de Velde's depictions of ships' flags are unreliable (and this opinion

is seconded by both Weber 1978, p. 134, and Van Foreest-Weber 1984, p. 93).

18 For Jennens, see R. Smith and R. Williams in *The Dictionary of Art*, vol. 17 (1996), p. 476 (with additional literature).

19 Canvas, 37.4 x 57.7 cm, signed 'C. Brooking', painted circa 1755-1759, National Maritime Museum, Greenwich, inv. no. 1963-26 (London 1982, no. 148, ill.; *Concise catalogue of the oil paintings in the National Maritime Museum*, [London] 1988, p. 102, BHC 1033, fig. a; Joel 2000, pp. 134, no. 102A, 136, ill.). Another version, at Colnaghi's in London, 1946, is now in a private collection (Joel 2000, p. 134, no. 102B; Lugt saw this painting already in 1936 at Colnaghi's). Lugt saw a third version in 1942 at a museum in Omaha, Nebraska, on loan from a private collector. According to Gerson (1942 and ed. 1983, see Literature), the painting in the Frits Lugt Collection was also copied by Charles Gore (1729-1806) in a drawing in the National Maritime Museum in Greenwich.

20 See note 2.

21 Joel 2000, pp. 30, 49. On this artist, see also G. de Beer in *Allgemeines Künstler-Lexikon*, vol. 14 (1996), pp. 375-376.

22 Inv. no. 5807, acquired in 1944 (Paris 1983, no. 87 and fig. 52; Paris 1989, no. 10, figs. VIII and 9; Robinson 1990, vol. 1, pp. 146-148, no. 161, ill.).

23 Paris 1989. As regards Lugt's interest in seventeenth-century marine artists, see the introduction by C. van Hasselt in *idem*, pp. V-VII.

24 *A Dutch fleet lying by*, inv. no. X; Paris 1989, no. 52 and fig. 68.

25 Paris 1989, nos. 43-58, figs. 61-66.

26 Willem van de Velde the Elder, *The Dutch ship Tholen (?)*, inv. no. 3447 (Paris 1989, no. 48 and fig. 63); Willem van de Velde the Younger, *The English ship Mountagu*, inv. no. 1028 (Paris 1989, no. 55 and fig. 73).

27 *The Dutch fleet in the Haringvliet in 1664*, inv. no. 5 (Paris 1989, no. 47 and fig. 64); *A fleet off Terschelling*, inv. no. 6 (Paris 1989, no. 46 and fig. 65).

28 *Fishing pinks on the beach*, inv. no. 4631 (Paris 1989, no. 44 and fig. 61).

29 *Two flutes at anchor in a light breeze*, inv. no. 7 (Paris 1989, no. 54 and fig. 72); *Fishermen on the beach, gazing out to sea*, inv. no. 3454 (Paris 1989, no. 63 and fig. 77); *A beach-comber at water's edge, a fishing*

vessel in the sea, inv. no. 3455 (Paris 1989, no. 64 and fig. 76);
30 *A Dutch admiral's ship close-hauled at sea in a breeze*, inv. no. 3450 (Paris 1989, no. 62 and fig. 74); *Instructions for the rendering of light and shadow on ships*, inv. no. 7585 (Paris 1989, no. 58 and fig. 78).

35 Jacobus Vrel

1 Berlin 1915, no. 151: 'Dr M. J. Binder'. Binder, from whom Lugt acquired at the same time Van Ravesteyn's portrait of Hugo Grotius, among other paintings (cat. no. 26), also lent other paintings from his collection to this exhibition (Berlin 1915, nos. 1, 2, 20 and 42). For Binder, see cat. no. 26 note 21.

2 Date of purchase recorded on the painting's inventory card in the Fondation Custodia Archives.

3 According to a label dated 1948 on the back of the panel, the painting was lent in that year to the Rotterdam museum. According to Hannema (1932, p. 14, ill.; 1933, p. 7), the painting was lent not only to the 'Christmas exhibition' in December-January 1931-1932 (Rotterdam 1931-1932, p. 14, no. 24 and fig. VIII), but afterwards as well. Brière-Misme (1935, pp. 166 and 167, fig. 14) still records the painting as 'prêté par M. Lugt au Musée de Rotterdam'.

4 For Vrel, see Thoré-Bürger 1866, p. 469; Brière-Misme 1935 (with older literature); Bernt 1948, vol. 3, nos. 971-973; Régnier 1968; C. von Bogendorf-Rupprath and P.C. Sutton in Philadelphia-Berlin-London 1984, pp. 352-354; Haak 1984, pp. 159, 453, figs. 336 and 994; Honig 1989; M.C.C. Kersten in Delft 1996, pp. 177-181 and figs. 175-180 (interiors); D.H.A.C. Lokin in *idem*, pp. 103-105 and figs. 85-88 (street scenes); E.A. Honig in *The Dictionary of Art*, vol. 32 (1996), p. 728 (reprinted in Turner 2000, pp. 384-385).

5 See P.C. Sutton in Philadelphia-Berlin-London 1984, no. 123 and fig. 111; M.C.C. Kersten in Delft 1996, p. 178 and fig. 175. The painting in the Kunsthistorisches

Museum at Vienna, where the collection of Leopold Wilhelm is now to be found with the old imperial collection, had to be bought back in 1908. The description of an equally large painting by Vrel from the archduke's collection, a depiction of an interior with a sick woman in bed, has been linked to a panel that was last seen in a private collection (Brière-Misme 1935, p. 165 and fig. 12; see P.C. Sutton in Philadelphia-Berlin-London 1984, pp. 353, 354 note 5 and fig. 2; Honig 1989, p. 55 note 29). Another painting by Vrel, which surfaced only recently (Delft 1996, p. 179 and fig. 176), seems more to fit the description in the inventory: not only does it have the same measurements as the painting in Vienna, but its style and technique suggest that it was painted at the same time, unlike the panel which has until now been connected with the inventory. For a description of this interior and a third painting by Vrel – a peasant scene depicting two men and a woman – in the inventory of Leopold Wilhelm's collection, see Honig 1989, p. 53 note 8 (with the complete text of the relevant passages in the inventory); E.A. Honig in *The Dictionary of Art*, vol. 32 (1996), p. 728; *idem* in Turner 2000, p. 385.

6 A list of the various hypotheses by P.C. Sutton in Philadelphia-Berlin-London 1984, p. 354 note 1; see also Haak 1984, pp. 453 and 511 note 453: 19 and E.A. Honig in *The Dictionary of Art*, vol. 32 (1996), p. 728 (reprinted in Turner 2000, p. 385).

7 Plietzsch 1949, pp. 248 and 253; Plietzsch 1960, p. 81.

8 Brière-Misme 1935, p. 101.

9 Haak (1984, p. 453) was rather negative about Vrel's interiors.

10 Brière-Misme 1935, figs. pp. 97 and 158, as well as figs. 8, 9, 10, 11, 12, 13 and 16 (interiors); cf. also *idem*, fig. 5 (street scenes).

11 Brière-Misme 1935, pp. 157-172 (ill.). White walls are also a dominant motif in Vrel's interior in Detroit (Valentiner 1928a; Brière-Misme 1935, p. 162 and fig. 16; Bernt 1948, vol. 3, no. 972, ill.; Plietzsch 1949, p. 252, fig. 135).

12 First connected with our painting by Valentiner (1928-1929, p. 91), at that time still in the Adolphe Schloss Collection at Paris. As regards the painting, see also Brière-Misme 1935, pp. 100, 165-168, 166 note 1 and fig. 15; S. Nihom-Nijstad in Paris 1983, p. 157; Honig 1989, pp. 52, 56 note 48 and fig. 13.

13 As observed by S. Nihom-Nijstad in Paris 1983, p. 157.

14 Whereas the gaze of the girl in our painting is clearly directed at the woman, in other interiors the painter intentionally placed the staring gaze of children outside the viewer's field of vision (cf. Honig 1989, pp. 46-47 and figs. 5 and 7).

15 Plietzsch 1949, p. 253; Plietzsch 1960, p. 82. The same author pointed out another early work, with a weaver at a loom (present whereabouts unknown; Rotterdam 1935, no. 100 and fig. 134; Honig 1989, p. 53 note 12).

16 Valentiner (1928-1929, pp. 88 and 91) already focused on this striking aspect and pointed out another painting by Vrel, formerly in the McIlhenny Collection in Philadelphia. The woman in this panel, attributed to Vrel (16.2 x 12.7 cm; Valentiner 1913, p. 36 and fig. 16; sale London, Christie's, 5 July 1985, lot 6 with colour ill.) does not seem to balance on her chair, however. At any rate, the perspective of the floor in this painting is so inadequate that there is only the merest hint of a wobbly chair.

17 According to Valentiner (1928-1929, p. 91), our painting is characterised by a 'flat treatment which is almost without parallel in Dutch painting of that period'.

18 In the past this girl has been explicitly described by several authors as a boy (Valentiner 1928-1929, p. 91: 'a boy'; Brière-Misme 1935, p. 166: 'le bambin'; Régnier 1968, p. 280, 'un petit garçon'); S. Nihom-Nijstad (in Paris 1983, p. 156) and other authors opted for a more neutral description as a 'child', though Frits Lugt correctly identified her as a girl (Paris 1965a, p. 32, no. 57: 'une petite fille'). The child, after all, wears a black cap over her hair and a white collar or shawl. The woman, seen from the back, has been described as the mother or grandmother of the child (Brière-Misme 1935, p. 166; Bloch 1966, p. 26).

19 Scant attention is paid in the literature to the source of light (Régnier 1968, p. 270: 'des reflets de lumière'); cf. Honig 1989, p. 52, with reference to fig. 35b.

20 Brière-Misme (1935, pp. 166 and 168: 'des verrières intérieures') was the first to understand the function of this wall (cf. also Honig 1989, p. 56 note 48, with reference to fig. 35b). Frits Lugt (in Paris 1965a,

p. 32, no. 57), however, described the child as standing behind a glass partition, by which he meant a partition wall with a window; on the inventory card he described Vrel's painting as an 'Interior with a woman [seated] on a chair next to a glass partition, speaking to a girl behind it' (in translation). Finally, Fock (1998, p. 231) pointed out that the window's design displays similarities to that of the seventeenth-century bedstead.

Vrel thus painted two interiors with views to an adjacent space, that space being however invisible, as opposed to the brightly lit rooms or streets seen in De Hooch (see however Sutton 1980, p. 53: 'Vrel's interiors differ from De Hooch's ... in the absence of views to adjoining rooms'; a viewpoint which the author repeated in Philadelphia-Berlin-London 1984, p. 353 and London-Hartford 1998-1999, p. 78). In a picture by De Hooch dating from around 1660-1663 we see a similar window functioning as a partition between the living quarters and the entrance hall (Sutton 1980, fig. 51; cf. also his figs. 56, 139 and 143).

21 Cf. also Brière-Misme 1935, p. 165 note 2 and fig. 12 (with a nail on a white fireplace).

22 Such as *The milkmaid* from around 1658-1660 (Amsterdam, Rijksmuseum) and *Woman with a pair of scales* of around 1664 (Washington, National Gallery of Art); see Washington-The Hague 1995-1996, nos. 5, 10, ill. As regards this detail, cf. also Jan Steen's *'Soo voer gesongen, soo na gepepen'* of around 1665 in the Mauritshuis (Broos 1987, no. 59, ill.; H. Perry Chapman in Washington-Amsterdam 1996-1997, no. 23, ill.).

23 As is known, Étienne-Joseph-Théophile Thoré (1807-1869), the French art critic whose publications appeared under the pseudonym William Bürger, attributed paintings by Vrel to Vermeer in his important article, published in 1866 in the *Gazette des Beaux-Arts* (Thoré-Bürger 1866; on this subject, see, among others, Brière-Misme 1935, pp. 99-100; Broos 1998, pp. 23-25 and figs. 7-9; Jowell 1998, p. 39).

24 Brière-Misme 1935, including pp. 100, 160 notes 1-3 (Koedijck, Boursse, De Hooch). For the relationship between De Hooch-Vrel, see also Sutton 1980, pp. 22, 53; P.C. Sutton in Philadelphia-Berlin-London 1984, p. 353;

P.C. Sutton in London-Hartford 1998-1999, pp. 76, 78.

25 In other paintings as well, Vrel placed his signature on a slip of paper lying on the floor, examples being the pictures in Detroit (Valentiner 1928-1929, p. 87 note 2; Brière-Misme 1935, p. 162 note 4), Lille (Brière-Misme 1935, p. 160 note 2) and fig. 35b (Brière-Misme 1935, p. 166).

26 P.C. Sutton in Philadelphia-Berlin-London 1984, p. 353; M.C.C. Kersten in Delft 1996, p. 177.

27 Vermeer's *Procuress* (Dresden, Staatliche Kunstsammlungen, Gemäldegalerie) bears the date 1656; *The sleeping girl* (New York, The Metropolitan Museum of Art, Bequest of Benjamin Altman) is dated around 1657.

28 Inv. no. 71.PB.61. Valentiner 1928-1929, p. 88: 'a painting formerly owned by Mr. F. Lugt in Maartensdijk (Holland)'. Sold by Lugt before this time to P. van Leeuwen Boomkamp at Hilversum (see Brière-Misme 1935, p. 162 note 1, no. 2 and Rotterdam 1955, p. 62). The panel was purchased by the J. Paul Getty Museum at a sale in London, Sotheby's, 8 December 1971, lot 45; for the painting, see Valentiner 1928-1929, p. 88; Brière-Misme 1935, p. 162; Rotterdam 1955, pp. 61-62, no. 135 and fig. 141; Jaffé 1997, p. 134, ill. (as 'ca. 1654-1662').

29 For the painting in the Koninklijk Museum voor Schone Kunsten at Antwerp, inv. no. 790: see Brière-Misme 1935, pp. 160, 162 and fig. 17; Bernt 1948, vol. 3, no. 971 (ill.); Delft 1996, p. 180, fig. 177. In the replica illustrated here (fig. 35c) not only are the slippers missing, but the floor is rendered as a uniform surface, whereas in the Antwerp panel the floor is tiled. The representation in the latter painting is continued on all sides, so that to the right of the fireplace, for example, there are not two plates but three.

The other two replicas of the painting in Antwerp (cf. Honig 1989, p. 53 note 7), no longer in private hands, had already been identified: Oxford, Ashmolean Museum, acquired in 1972 from the estate of Miss Jean Alexander (Brière-Misme 1935, pp. 160 and 162 note 1, no. 1; London 1952-1953, no. 442; White 1999, p. 3, 163 and fig. p. 164, as nearly identical with the painting in Los Angeles); San Diego, The Fine Arts Gallery,

Gift of the Misses Anne and Amy Putnam, 1950 (formerly in the McIlhenny Collection, Philadelphia; Valentiner 1928-1929, p. 88; Brière-Misme 1935, pp. 160 and 162 note 1, no. 3; cat. 1960, p. 31, ill.; Régnier 1968, p. 277, fig. 8). In this last painting, which seems to be of lesser quality, there is no sick woman in bed. At any rate, it has long been known that Vrel occasionally introduced small changes into repetitions of his works; with regard to this, see Brière-Misme 1935, p. 108 and note 2 (a signed replica of the painting in Hamburg, her fig. 2); Honig 1989, p. 53 note 7; E.A. Honig in *The Dictionary of Art*, vol. 32 (1996), p. 728 (*idem* in Turner 2000, p. 384).

30 Reitsma (1976, p. 256): 'seems merely to portray a domestic scene for its own sake'; Hecht (1984, p. 357): 'an enigmatic interior by Jacob Vrel indeed suggest[s] little more than careful observation of everyday reality, *saisie au vif* '.

36 Emanuel de Witte

1 Three letters of the painter's surname and the last two figures of the date are by now very worn and scarcely legible; both the signature and the date were first recorded in Rotterdam 1935, no. 119 (as 'E. de Witte ft 1654'; see also note 8). In that catalogue the painting was described neutrally as a 'church interior'. However, by 1929, one year after the painting was acquired, the depiction had already been identified by O. ter Kuile as the interior of the Church of St John, as appears from a note written by Lugt, to whom it was communicated verbally (Fondation Custodia Archives).

2 Lot 15: 'NEEFS. / Interior of a church / *Panel* / 10 *in.* by 15 *in.* / And another [= cat. no. 36], *on copper*'. The Antwerp painter Pieter Neeffs the Elder (c.1578-c.1655/56) devoted himself, as did his sons Pieter (1620-after 1675) and Lodewijck (1617-after 1648), to painting church interiors.

3 Information on the inventory card in the Fondation Custodia Archives.

4 For De Witte, see Manke 1963; Manke 1972; Liedtke 1982, especially pp. 76-96; G. Jansen in Rotterdam 1991, pp. 183-209; W. Liedtke in *The Dictionary of Art*, vol. 33 (1996), pp. 266-268 (reprinted in Turner

2000, pp. 400-402); Liedtke 2000, pp. 121-127; W. Liedtke in New York-London 2001, pp. 107-111, 432-439.

5 See Manke 1963.

6 Liedtke 1982, pp. 13-18, 80-82; W. Liedtke in *The Dictionary of Art*, vol. 33 (1996), pp. 266-267; W. Liedtke in Turner 2000, p. 401; Liedtke 2000, pp. 123-127.

7 Manke 1963, p. 80, no. 12 and fig. 15; Ingamells 1992, 437-440, no. P 254 (ill.).

8 See note 1; cf. also the remarks in Manke 1963, p. 99, under no. 93 and G. Jansen in Rotterdam 1991, p. 193. For dated paintings by De Witte dating from 1654, see Manke 1963, p. 150, 'Liste der datierten Bilder'; with addenda and corrigenda in Liedtke 2000, p. 277 notes 185 and 192.

9 Manke 1963, p. 41.

10 See Manke 1963, p. 122, no. 210 and fig. 17; G. Jansen in Rotterdam 1991, pp. 188-191, no. 35 (ill.). Mention of another painting of the subject probably refers to a work by Job Berckheyde (see G. Jansen in Rotterdam 1991, pp. 189-190).

11 For the eventful history of the Church of St John, see, among others, Graafhuis-Witteveen 1981 (ill.); Van Hulzen 1988, pp. 55-58 (ill.); A. de Groot in Utrecht 2000-2001, pp. 30-31.

12 Haakma Wagenaar 1979, pp. 96-97, 102 note 32 and figs. 64-65.

13 Regarding this painting, see Schwartz-Bok 1989, p. 278, no. 138 and fig. 214; L.M. Helmus in Utrecht 2000-2001, pp. 259-261, no. 59, ill. (with a list of the various datings of the painting in older literature). According to Helmus, the Rotterdam painting dates from the same period as a church interior by Saenredam from 1654 (p. 35, fig. 23; Schwartz-Bok 1989, p. 283, no. 171 and fig. 242; L.M. Helmus in Utrecht 2000-2001, no. 48, ill.).

14 Schwartz-Bok 1989, p. 278, no. 139 and fig. 186; A. de Groot in Utrecht 2000-2001, pp. 256-258, no. 58 (colour ill.).

15 Liedtke 1982, pp. 85-86, 89, 90 (with reference to the painting discussed here), 91-93; W. Liedtke in *The Dictionary of Art*, vol. 33 (1996), pp. 266-268; W. Liedtke in Turner 2000, p. 402.

16 The resemblance noticed by Manke (1963, p. 41) of the windows and the vaulting in the choir depicted here to those in a lost church interior of 166(.) by De Witte appears to be very superficial (formerly Berlin, Kaiser-Friedrich-Museum, lost in

the Second World War; see Manke 1963, pp. 41, 107, no. 121, fig. 55 and S. Nihom-Nijstad in Paris 1983, p. 160), as does the resemblance she claims to have noticed to the undated painting by De Witte in Amsterdam/Rijswijk (Netherlands Institute for Cultural Heritage, inv. no. NK 2730; Manke 1963, pp. 41, 108, no. 126 and S. Nihom-Nijstad in Paris 1983, p. 161).

17 Cf. especially the remarks made by Liedtke (1982, p. 90), who refers convincingly to a drawing by Saenredam of 1632 (Amsterdam, Rijksmuseum, Rijksprentenkabinet) of the choir and rood-screen of the Church of St Peter's at Den Bosch (see Schwartz-Bok 1989, p. 270, no. 100 and fig. 96); see also Liedtke 1982, p. 91.

18 Schwartz-Bok 1989, p. 278, no. 140 and fig. 187; A. de Groot in Utrecht 2000-2001, pp. 268-269, no. 62 (colour ill.).

19 For the three drawings Saenredam made in 1636 of the interior of the Church of St John and the two paintings, which did not originate until years after the studies on which they were based, including fig. 36a, see Schwartz-Bok 1989, p. 278, nos. 138-142 and figs. 185-187, 213-214 (with a floor plan of the church on p. 278); A. de Graaf and L.M. Helmus in Utrecht 2000-2001, nos. 58-62 (colour ills.). Helmus (*idem*, p. 261 and note 12) records a painted interior of the Church of St John by Saenredam, which is known only from an old description. It seems natural to assume that this is a worked-up version of the only sheet that cannot be connected with an existing painting (fig. 36b). Liedtke (1982, p. 90) has already suggested the possibility that De Witte took unknown paintings or drawings by Saenredam as examples for the painting discussed here.

20 Such as assumed by Manke (1963, pp. 33 notes 1, 41), Nihom-Nijstad (in Paris 1983, p. 160) and G. Jansen (in Rotterdam 1991, p. 193). Liedtke (1982, p. 90) even assumes that the entire rood-screen was a product of De Witte's imagination.

21 A. de Graaf in Utrecht 2000-2001, p. 256.

22 Utrecht 2000-2001, passim.

23 See Manke 1963, pp. 33 notes 1, 41; cf. also G. Jansen in Rotterdam 1991, p. 193.

24 According to Manke (1963, pp. 41 and 107, no. 122) and Nihom-

225

Nijstad (in Paris 1983, p. 160), there is a similar choir screen in a depiction, dated to around 1655, of the interior of an unidentified church in the Museum voor Schone Kunsten at Ghent. The similarity is however very superficial. As regards the painting, see Manke 1963, p. 107, no. 122; Jantzen 1979, p. 243, no. 681; Ghent 1963-1964, p. 32, no. 93 and fig. LIX.

25 In both the drawing and the painting by Saenredam which is based on it (fig. 36a) the wooden decoration above the sounding board of the pulpit is largely hidden behind two diamond-shaped plates with the coat of arms of the Godin (Godijn) family; as regards the furniture, see A. de Groot in Utrecht 2000-2001, pp. 256, 258. Cf. also Liedtke 1982, p. 90.

Assuming that De Witte never saw the church with his own eyes, the Baroque-like decoration above the sounding board in his painting must necessarily have been based at least in part on his own imagination. For a rather far-fetched interpretation of the staffage in De Witte's paintings, see Heisner 1980, pp. 110-114.

26 See G. Jansen in Rotterdam 1991, p. 193; G. van Heemstra in Utrecht 2000-2001, p. 88 (where this decoration is described as a tapestry).

27 G. Jansen in Rotterdam 1991, p. 193 note 1; G. van Heemstra in Utrecht 2000-2001, pp. 82-89 and figs. 13-17.

28 Regarding this phenomenon, see Phoenix-Kansas City-The Hague 1998-1999, under nos. 39, 46; G. van Heemstra in Utrecht 2000-2001, pp. 86-89.

29 See G. Jansen in Rotterdam 1991, p. 193; G. van Heemstra in Utrecht 2000-2001, p. 88; cf. also Liedtke 1982, p. 90.

Key to abbreviated literature

A

Adler 1982
W. Adler, *Landscapes* (*Corpus Rubenianum Ludwig Burchard*, vol. 18), Oxford-New York 1982

Aiquillière 1990
B. Aiquillière, 'Une collection d'art au XVIIIᵉ siècle: La collection Claude Tolozan', *Travaux de l'Institut d'Histoire de Lyon* (September 1990), no. 13, pp. 27-33

Allgemeines Künstler-Lexikon
Saur Allgemeines Künstler-Lexikon: Die bildenden Künstler aller Zeiten und Völker, vol. 1- , Munich-Leipzig 1992-

Amsterdam 1903
F. Lugt, *Catalogue des oeuvres de Jan van Goyen*, Amsterdam (Frederik Muller & Cie) 1903

Amsterdam 1906
A.W.M. Mensing, F. Lugt, *Catalogue de l'exposition de maîtres hollandais du XVIIᵉ siècle organisée par Mm. Frederik Muller & Cᵢₑ dans leurs galeries Doelenstraat 16/18 à Amsterdam en l'honneur du tercentenaire de Rembrandt*, Amsterdam (Frederik Muller & Cie) 1906

Amsterdam 1911
F. Lugt, *Catalogue d'importants tableaux anciens de l'école hollandaise*, Amsterdam (Frederik Muller & Cie) 1911

Amsterdam 1912
Catalogue d'importants tableaux anciens de l'école hollandaise, Amsterdam (Frederik Muller & Cie) 1912

Amsterdam 1913
Eerste Nederlandsche tentoonstelling op zeevaartgebied, Amsterdam (location unknown) 1913

Amsterdam 1919-1920
Catalogue de la collection Goudstikker d'Amsterdam, Amsterdam (Goudstikker Gallery) 1919

Amsterdam 1932
Bruikleen voor de periode 1932, Amsterdam (Rijksmuseum) 1932

Amsterdam 1933
Het stilleven, Amsterdam (Goudstikker Gallery) 1933

Amsterdam 1936
Catalogus van de tentoonstelling van oude kunst uit het bezit van den internationalen handel, Amsterdam (Rijksmuseum) 1936

Amsterdam 1938
Pieter Jansz. Saenredam 1597-1665, Amsterdam (Museum Fodor) 1938

Amsterdam 1958
Catalogue of Old Pictures Exhibited at the Gallery of C.V. Kunsthandel P. de Boer, Amsterdam (P. de Boer Gallery) 1958

Amsterdam 1961
Catalogue of Old Pictures Exhibited at the Gallery of C.V. Kunsthandel P. de Boer, Amsterdam (P. de Boer Gallery) 1961

Amsterdam 1968
E.K. Grootes, *'t Kan verkeeren: Gerbrand Adriaensz. Bredero 1585-1618*, Amsterdam (Amsterdams Historisch Museum) 1968

Amsterdam 1975
Leidse universiteit 400: Stichting en eerste bloei, Amsterdam (Rijksmuseum) 1975

Amsterdam 1976
E. de Jongh *et al.*, *Tot lering en vermaak: Betekenissen van Hollandse genrevoorstellingen uit de zeventiende eeuw*, Amsterdam (Rijksmuseum) 1976

Amsterdam 1978
E. Bergvelt *et al.*, *Het land van Holland: Ontwikkelingen in het Noord- en Zuidhollandse landschap*, Amsterdam (Amsterdams Historisch Museum) 1978 (no catalogue; accompanied by a special issue of *Holland* 10 (1978), no. 3)

Amsterdam 1984a
N. Bakker, I. Bergström, G. Jansen, S.H. Levie, S. Segal, *Masters of Middelburg: Exhibition in the Honour of Laurens J. Bol*, Amsterdam (K. & V. Waterman Gallery) 1984

Amsterdam 1984b
P.J.J. van Thiel, C.J. de Bruyn Kops, *Prijst de Lijst: De Hollandse schilderijlijst in de zeventiende eeuw*, Amsterdam (Rijksmuseum) 1984

Amsterdam 1985
B. Broos, R. Vorstman, W.L. van de Watering, *Ludolf Bakhuizen, 1631-1708: Schryfmeester–teyckenaer–schilder*, Amsterdam (Nederlands Scheepvaartmuseum) 1985 (see also *Emden 1985*)

Amsterdam 1986
J.P. Filedt Kok, W. Halsema-Kubes, W.T. Kloek (eds.), *Kunst voor de beeldenstorm: Noordnederlandse kunst 1525-1580*, Amsterdam (Rijksmuseum) 1986

Amsterdam 1987
M. Schapelhouman, P. Schatborn, *Land & water: Hollandse tekeningen uit de 17de eeuw in het Rijksprentenkabinet / Dutch drawings from the 17th century in the Rijksmuseum Print Room*, Amsterdam (Rijksmuseum, Rijksprentenkabinet) 1987

Amsterdam 1988-1989
P. Schatborn, E. Ornstein-van Slooten, *Jan Lievens: Prenten en tekeningen / Prints and Drawings*, Amsterdam (Museum Het Rembrandthuis) 1988-1989

Amsterdam 1989-1990
P. Hecht, *De Hollandse fijnschilders: Van Gerard Dou tot Adriaen van der Werff*, Amsterdam (Rijksmuseum) 1989-1990

Amsterdam 1991
A. Tümpel, P. Schatborn *et al.*, *Pieter Lastman: Leermeester van Rembrandt / The man who taught Rembrandt*, Amsterdam (Museum Het Rembrandthuis) 1991

Amsterdam 1992
E. Bergvelt, R. Kistemaker *et al.*, *De wereld binnen handbereik: Nederlandse kunst- en rariteitenverzamelingen, 1585-1735*, Amsterdam (Amsterdams Historisch Museum) 1992

Amsterdam 1993
M. Schapelhouman, P. Schatborn, *Tekeningen van oude meesters: De verzameling Jacobus A. Klaver*, Amsterdam (Rijksmuseum, Rijksprentenkabinet) 1993

Amsterdam 1993-1994
G. Luijten, A. van Suchtelen, R. Baarsen *et al.* (eds.), *Dawn of the Golden Age: Northern Netherlandish art 1580-1620*, Amsterdam (Rijksmuseum) 1993-1994

Amsterdam 1995
K. Ottenheym, Q. Buvelot *et al.*, *Jacob van Campen: Het klassieke ideaal in de Gouden Eeuw*, Amsterdam (Royal Palace) 1995

Amsterdam 1995-1996
Selling Exhibition of Old Master Paintings of the 17th, 18th and Early 19th Century, Amsterdam (Douwes Fine Art Gallery) 1995-1996

Amsterdam 1997
G. Luijten, E. de Jongh, *Spiegel van alledag: Nederlandse genreprenten 1550-1700*, Amsterdam (Rijksmuseum, Rijksprentenkabinet) 1997

Amsterdam 2000a
J. Kiers, F. Tissink, J.P. Filedt Kok *et al.*, *De Glorie van de Gouden Eeuw: Schilderijen, beeldhouwkunst en kunstnijverheid*, Amsterdam (Rijksmuseum) 2000

Amsterdam 2000b
E. Runia, *De Glorie van de Gouden Eeuw: Nederlandse kunst uit de 17de eeuw. Tekeningen en prenten*, Amsterdam (Rijksmuseum, Rijksprentenkabinet) 2000

Amsterdam 2001
P. Schatborn, *Tekenen van warmte: 17de-eeuwse Nederlandse tekenaars in Italië*, Amsterdam (Rijksmuseum, Rijksprentenkabinet) 2001

Amsterdam-Boston-Philadelphia 1987-1988
P.C. Sutton *et al.*, *Masters of 17th-Century Dutch Landscape Painting*, Amsterdam (Rijksmuseum) Boston (Museum of Fine Arts) Philadelphia (Philadelphia Museum of Art) 1987-1988

Amsterdam-Cleveland 1999-2000
A. Chong, W. Kloek *et al.*,
Het Nederlandse Stilleven 1550-1720,
Amsterdam (Rijksmuseum)
Cleveland (The Cleveland Museum
of Art) 1999-2000

Amsterdam-Jerusalem 1991
C. Tümpel, J. Boonen, P. van
der Coelen *et al.*, *Het Oude
Testament in de schilderkunst van
de Gouden Eeuw*, Amsterdam (Joods
Historisch Museum) Jerusalem
(Israel Museum) 1991

Amsterdam-London 2000-2001
E. Hinterding, G. Luijten,
M. Royalton-Kisch *et al.*, *Rembrandt
the Printmaker*, Amsterdam (Rijks-
museum, Rijksprentenkabinet)
London (British Museum) 2000-2001

Amsterdam-Paris 1998-1999
B. Bakker, M. van Berge-Gerbaud
et al., *Het landschap van Rembrandt:
Wandelingen in en om Amsterdam*,
Amsterdam (Gemeentearchief) Paris
(Institut Néerlandais) 1998-1999

**Amsterdam-Toledo-Boston
1979-1980**
A.L. den Blaauwen, J.H. Leopold,
B. ter Molen-den Outer *et al.*,
*Nederlands zilver / Dutch silver 1580-
1830*, Amsterdam (Rijksmuseum)
Toledo (The Toledo Museum of
Art) Boston (Museum of Fine Arts)
1979-1980

**Amsterdam-Vienna-New York-
Cambridge 1991-1992**
W.W. Robinson, P. Schatborn,
*Seventeenth-century Dutch drawings:
A selection from the Maida and
George Abrams collection*, Amsterdam
(Rijksmuseum, Rijksprentenkabinet)
Vienna (Graphische Sammlung
Albertina) New York (The Pierpont
Morgan Library) Cambridge, Mass.
(The Fogg Art Museum, Harvard
University) 1991-1992

**Amsterdam-Washington
1981-1982**
P. Schatborn, *Figuurstudies:
Nederlandse tekeningen uit de 17de
eeuw*, Amsterdam (Rijksmuseum,
Rijksprentenkabinet) Washington
(National Gallery of Art) 1981-1982

Amsterdam-Zwolle 1982
A. Blankert, D. Hensbroek-van der
Poel, G. Keyes *et al.*, *Frozen silence:
Hendrick Avercamp (1585-1634) –
Barent Avercamp (1612-1679).
Paintings from museums and private
collections*, Amsterdam (K. & V.
Waterman Gallery) Zwolle
(Provinciehuis) 1982

Andrews 1985
K. Andrews, *Catalogue of the
Netherlandish Drawings in the
National Gallery of Scotland*
(2 vols.), Edinburgh 1985

Antwerp 1935
*Tentoonstelling van kunstwerken uit
Antwerpsche verzamelingen*, Antwerp
(location unknown, 'Antwerpsche
Propagandaweken') 1935

Arian 1999
M. Arian, 'De vrije zee', *De Groene
Amsterdammer* 113 (28 July 1999),
no. 30, pp. 28-29

Arnhem 1953
17de eeuwse meesters uit Gelders bezit,
Arnhem (Gemeentemuseum) 1953

Von Arps-Aubert 1932
R. von Arps-Aubert, *Die
Entwicklung des reinen Tierbildes
in der Kunst des Paulus Potter*
(dissertation), Halle 1932

Asemissen-Schweikhart 1984
H.U. Asemissen, G. Schweikhart,
Malerei als Thema der Malerei,
Berlin 1984

Ashton-Slive-Davies 1982
P.S. Ashton, S. Slive, A.I. Davies,
'Jacob van Ruisdael's Trees', *Arnoldia*
42 (Winter 1982), no. 1, pp. 2-31

Atlanta 1985
F.J. Duparc, *Masterpieces of the
Dutch Golden Age*, Atlanta (High
Museum of Art) 1985

Atwater 1988
V.L. Atwater, *A catalogue and
analysis of eighteenth-century prints
after Netherlandish baroque paintings*
(dissertation; 4 vols.), Washington
1988

Autin 1983
J. Autin, *Les frères Pereire: Le
bonheur d'entreprendre*, Paris 1983

Avery 1993
C. Avery, *Giambologna: The complete
sculpture*, London 1993

B

B. + number
A. [von] Bartsch, *Le peintre graveur*
(21 vols.), Vienna 1803-1821

Bachmann 1972
F. Bachmann, *Aert van der Neer
als Zeichner*, Neustadt an der
Aisch 1972

Bachmann 1982
F. Bachmann, *Aert van der Neer
1603/4-1677*, Bremen 1982

De Balbian Verster 1912
J.F.L. de Balbian Verster, 'De
Nederlandse vloot onder Van
Wassenaer Obdam in 1665', *Eigen
Haard* (17 August 1912), pp. 516-522

De Balbian Verster 1913
J.F.L. de Balbian Verster, *Overzicht
van de historische afdeeling op de
eerste Nederlandsche tentoonstelling op
scheepvaartgebied*, Amsterdam 1913

Basel 1987
P. ten Doesschate-Chu,

P.H. Boerlin, *Im Lichte Hollands:
Holländische Malerei des 17. Jahr-
hunderts aus den Sammlungen des
Fürsten von Lichtenstein und aus
Schweizer Besitz*, Basel
(Kunstmuseum) 1987

Basel-Tübingen 1990
T. Kellein, U.-B. Frei, *Frans Post
1612-1680*, Basel (Kunsthalle)
Tübingen (Kunsthalle) 1990

Bauch 1952-1953
K. Bauch, 'Handzeichnungen Pieter
Lastmans', *Münchener Jahrbuch
der bildenden Kunst* (1952-1953),
nos. 3-4, pp. 225-226

Baumgarten 1958
S. Baumgarten, *Le crépuscule néo-
classique: Thomas Hope*, Paris 1958

Becker 1923
F. Becker, *Handzeichnungen
holländischer Meister aus der
Sammlung Dr. C. Hofstede de
Groot im Haag*, Leipzig 1923

Becker 2002
J. Becker, *Die niederländischen
Gemälde aus der Sammlung Binder
im Kunstmuseum Düsseldorf*,
Hamburg 2002

De Beer 1993
G. de Beer, *Seesturm und Schiffbruch
im Werk des Ludolf Backhuysen*
(dissertation), Kiel 1993

De Beer 1995
G. de Beer, 'Backhuysen – ja oder
nein. Fehlzuschreibungen an den
Seemaler Ludolf Backhuysen',
Weltkunst 65 (1995), pp. 366-370

Bellosi 1975
L. Bellosi, 'I Limbourg precursori
di Van Eyck? Nuove osservazioni sui
"Mesi" di Chantilly', *Prospettiva* 1
(1975), pp. 23-34

Bénézit 1976
E. Bénézit (ed.), *Dictionnaire
critique et documentaire des peintres,
sculpteurs, dessinateurs et graveurs
de tous les temps et de tous les pays*
(10 vols.), Paris 1976 (first edition
1911-1924)

Berendsen 1962
A. Berendsen, *Verborgenheden uit het
oude Delft, een stille en rijke stad*,
Zeist 1962

Van Beresteyn 1925
[E.A. van Beresteyn], 'Fragment-
Genealogie van het geslacht de
Groot', *De Nederlandsche Leeuw* 43
(1925), cols. 163-182

Van Beresteyn 1929
E.A. van Beresteyn, *Iconographie van
Hugo Grotius*, The Hague 1929

Van den Berg 1953
H.M. van den Berg, 'De kerk van
Loenen aan de Vecht', *Jaarboekje
"Oud-Utrecht"* (1953), pp. 131-140

Van Berge-Gerbaud *et al.* 2000
M. van Berge-Gerbaud, R. Blok,

H. Buijs, *Acquisitions Collection
Frits Lugt 1994-1999*, Paris 2000

Bergström 1956
I. Bergström, *Dutch Still-Life
Painting in the Seventeenth Century*,
London 1956

Bergström 1988
I. Bergström, 'Another Look at
De Heem's Early Dutch Period,
1626-1635', *Hoogsteder-Naumann
Mercury* (1988), no. 7, pp. 37-50

Van Berkel 1994
K. van Berkel, 'Onschuldig aan
het schenden van de maagd' [book
review], *NRC Handelsblad: Cultureel
Supplement Literair*, 21 January
1994, p. 6

Berlin 1915
*Ausstellung von Werken alter Kunst
aus Berliner Privatbesitz zum besten
des Zentral-Comitees des Preussischen
Landesvereins vom roten Kreuz*,
Berlin (Paul Cassirer Gallery) 1915

Berlin 1974
W. Schulz, *Die holländische
Landschaftszeichnung 1600-1740:
Hauptwerke aus dem Berliner
Kupferstichkabinett*, Berlin
(Kupferstichkabinett) 1974

Berlin 1989
H. Budde, A. Paape, G. Sievernich,
E. Delius *et al.*, *Europa und der
Orient: 800-1900*, Berlin (Martin-
Gropius-Bau) 1989

**Berlin-Amsterdam-London
1991-1992**
C. Brown, J. Kelch, P.J.J. van Thiel
(eds.), *Rembrandt: De Meester & zijn
Werkplaats*, vol. 1: *Schilderijen*;
H. Bevers, P. Schatborn, B. Welzel
(eds.), vol. 2: *Tekeningen & etsen*,
Berlin (Altes Museum) Amsterdam
(Rijksmuseum) London (National
Gallery) 1991-1992

Bernt 1948
W. Bernt, *Die Niederländischen
Maler des 17. Jahrhunderts* (3 vols.),
Munich 1948

Bernt 1979-1980
W. Bernt, *Die Niederländischen
Maler und Zeichner des 17. Jahr-
hunderts* (5 vols.), Munich 1979-1980

Beye 1976
[P. Beye], 'Staatsgalerie Stuttgart:
Neuerwerbungen 1975', *Jahrbuch der
Staatlichen Kunstsammlungen in Baden-
Württemberg* 13 (1976), pp. 213-241

Bialostocki 1982
J. Bialostocki, 'Books of wisdom
and books of vanity', in *In
Memoriam J.G. van Gelder*, Utrecht
1982, pp. 37-67

De Bie 1661
C. de Bie, *Het gulden cabinet van de
edel vry schilder-const*, Antwerp 1661

Bierens de Haan 1957
J.A. Bierens de Haan, 'Het huis van

een 18e eeuwsen mercator sapiens',
Jaarboek Amstelodamum 49 (1957),
pp. 110-128

Biermann 1911
G. Biermann, 'Altholländische
Bilder bei Frederik Muller & Co in
Amsterdam', *Der Cicerone* 3 (1911),
pp. 664-668

Biesboer 1985
P. Biesboer, 'Schilderijen over de
kerk: De Bavo in de beeldende
kunst van de 17de eeuw', in
De Boer et al. 1985, pp. 80-109

Le Bihan 1990
O. le Bihan, *L'or & l'ombre:
Catalogue critique et raisonné des
peintures hollandaises du dix-septième
et du dix-huitième siècles, conservées
au Musée des Beaux-Arts de
Bordeaux*, Bordeaux 1990

Bille 1961
C. Bille, *De tempel der kunst, of
het kabinet van den heer Braamcamp*
(2 vols.), Amsterdam 1961

Blanc 1857-1858
C. Blanc, *Le trésor de la curiosité
tiré des catalogues de vente* (2 vols.),
Paris 1857-1858

Blankert 1966
A. Blankert, 'Invul-portretten door
Caspar en Constantyn Netscher',
Oud Holland 81 (1966), pp. 263-269

Blankert 1978
A. Blankert, *Nederlandse 17e eeuwse
Italianiserende landschapschilders /
Dutch 17th Century Italianate
Landscape Painters* (revised and
enlarged edition of *Utrecht 1965*),
Soest 1978

Blankert 1982
A. Blankert, *Ferdinand Bol (1616-1680):
Rembrandt's Pupil (Aetas Aurea: Mono-
graphs on Dutch & Flemish Painting*,
vol. 2), Doornspijk 1982

Blankert 1991
A. Blankert, *Museum Bredius:
Catalogus van de schilderijen en
tekeningen*, second, revised edition,
Zwolle-The Hague 1991

Blankert-Grijp 1995
A. Blankert, L.P. Grijp, 'An
Adjustable Leg and a Book:
Lacemakers by Vermeer and Others,
and Bredero's *Groot Lied-boeck* in
One by Dou', in *Shop Talk: Studies
in Honor of Seymour Slive*, Cambridge,
Mass. 1995, pp. 40-43, 289-292

Bloch 1951
V. Bloch, 'Dutch landscapes at
the Orangerie', *The Burlington
Magazine* 93 (1951), pp. 166-169

Bloch 1955
V. Bloch, 'A landscape by Jan
Lievens', *The Burlington Magazine*
97 (1955), pp. 319-320

Bloch 1966
V. Bloch, 'Over het stilleven',

*Bulletin Museum Boymans-van
Beuningen* 17 (1966), no. 1, pp. 23-31

Bock *et al.* 1986
H. Bock, R. Grosshans, J. Kelch,
W.H. Köhler, E. Schleier,
*Gemäldegalerie Berlin:
Gesamtverzeichnis der Gemälde /
Complete Catalogue of the Paintings*,
Berlin-London 1986

Bock *et al.* 1996
H. Bock, I. Geismeier, R. Grosshans
et al., *Gemäldegalerie Berlin:
Gesamtverzeichnis*, Berlin 1996

Bock-Rosenberg 1930
E. Bock, J. Rosenberg, *Staatliche
Museen zu Berlin: Die Zeichnungen
alter Meister im Kupferstichkabinett.
Die niederländischen Meister* (2 vols.),
Berlin 1930

Von Bode ed. 1997
W. von Bode, *Mein Leben*, edited
by T.W. Gaehtgens, B. Paul *et al.*
(2 vols.; *Quellen zur deutschen
Kunstgeschichte vom Klassizismus bis
zur Gegenwärt*, vol. 4), Berlin 1997

Bode-Bredius 1905
W. [von] Bode, A. Bredius, 'Esaias
Boursse, ein Schüler Rembrandts',
*Jahrbuch der königlich preuszischen
Kunstsammlungen* 26 (1905),
pp. 205-214

Böhmer 1940
G. Böhmer, *Der Landschafter
Adriaen Brouwer*, Munich 1940

De Boer *et al.* 1985
J.N. de Boer *et al.*, *De Bavo te Boek
bij het gereedkomen van de restauratie
van de Grote of St.-Bavo kerk te
Haarlem*, Haarlem 1985

Bol 1957
L.J. Bol, 'Een Middelburgse
Breughel-groep. vi. Jacob Jacobsz.
van Geel (1584/85-1638 of later)',
Oud Holland 72 (1957), pp. 20-39

Bol 1969
L.J. Bol, *Holländische Maler des
17. Jahrhunderts nahe den grossen
Meistern: Landschaften und Stilleben*,
Braunschweig 1969

Bol 1973
L.J. Bol, *Die Niederländische
Marinemalerei des 17. Jahrhunderts*,
Braunschweig 1973

Bol 1980
L.J. Bol, '"Goede Onbekenden":
Hedendaagse herkenning en
waardering van verscholen,
voorbijgezien en onderschat talent',
Tableau 2 (1980), no. 3, pp. 132-137

Bol 1982a
L.J. Bol, *'Goede Onbekenden':
Hedendaagse herkenning en waar-
dering van verscholen, voorbijgezien
en onderschat talent*, Utrecht 1982

Bol 1982b
L.J. Bol, '"Goede onbekenden": heden-
daagse herkenning en waardering

van verscholen, voorbijgezien en
onderschat talent. Karel Slabbaert',
Tableau 4 (1982), pp. 582-588

Bolten 1994
J. Bolten *et al.*, 'Catalogus [to the
exhibition *De ruïne van Rijnsburg
in prent en tekening 1600-1812* in
Leiden, Stedelijk Museum De
Lakenhal]', *Delineavit et Sculpsit*
(1994), no. 13, pp. 17-122

Den Bosch-Rome 1992-1993
J. Bruintjes, N. Köhler, *Da Van
Heemskerck a Van Wittel: Disegni
fiamminghi e olandesi del XVI-XVII
secolo dalle collezioni del Gabinetto
dei Disegni e delle Stampe*, Den
Bosch (Noordbrabants Museum)
Rome (Istituto Nazionale per la
Grafica, Gabinetto dei Disegni
e delle Stampe) 1992-1993

Bosscher 1979
P.M. Bosscher, *Een nuchter volk
en de zee*, Bussum 1979

Boxer 1976
C.R. Boxer, with a contribution
by R.E.J. Weber, *De Ruyter en de
Engelse Oorlogen in de Gouden Eeuw*,
Bussum 1976

Brandt-Van Cattenburgh 1727
C. Brandt, A. van Cattenburgh,
*Historie van het leven des heeren Huig
de Groot*, Dordrecht-Amsterdam 1727

Braun 1980
K. Braun, *Alle tot nu toe bekende
schilderijen van Jan Steen*, Rotterdam
1980

Braunius 1977
S.W.P.C. Braunius, 'Oorlogsvaart',
in L.M. Aveld, S. Hart,
W.J. van Hoboken (eds.), *Maritieme
geschiedenis der Nederlanden* (vol. 2),
Bussum 1997, pp. 316-354

Braunschweig 1979
J. Bialostocki, S. Jacob, R.E.O. Ekkart
et al., *Jan Lievens: Ein Maler im
Schatten Rembrandts*, Braunschweig
(Herzog Anton Ulrich-Museum) 1979

Bredero ed. 1890
J. ten Brink *et al.*, *De werken van
G.A. Bredero* (3 vols.), Amsterdam 1890

Bredius 1881
A. Bredius, 'Aanvullingen op
Kramm. V. Diederick van de Lisse',
*Nederlandsche Kunstbode: Beeldende
Kunst, Oudheidkunde, Kunstnijverheid* 3
(1881), pp. 196-198

Bredius 1882
A. Bredius, 'Aus den Haager
Archiven', *Kunst-Chronik: Beiblatt
zur Zeitschrift für bildende Kunst* 17
(1882), cols. 747-750

Bredius 1888
A. Bredius, 'Iets over Pieter Codde
en Willem Duyster', *Oud-Holland* 6
(1888), pp. 187-194

Bredius 1892
A. Bredius, 'De schilder Johannes

van der Cappelle', *Oud-Holland* 10
(1892), pp. 26-40, 133-136

Bredius 1900
A. Bredius, 'Aernout (Aert) van
der Neer', *Oud-Holland* 18 (1900),
pp. 69-81

Bredius 1915-1922
A. Bredius, with O. Hirschmann,
*Künstler-Inventare: Urkunden zur
Geschichte der hollämdischen Kunst
des XVI[ten], XVII[ten] und XVIII[ten]
Jahrhunderts* (8 vols.), The Hague
1915-1922

Bredius 1921
A. Bredius, 'Waar is Aernout van
der Neer begraven?', *Oud-Holland*
39 (1921), p. 114

Bredius 1930
A. Bredius, 'Drie landschappen van
Jacob Esselens', *Oud-Holland* 47
(1930), pp. 277-279

Bredius-Gerson 1969
A. Bredius, revised by H. Gerson,
*Rembrandt: The Complete Edition
of the Paintings*, London 1969

Bredius-Hofstede de Groot 1893
A. Bredius, C. Hofstede de Groot,
*Catalogue of the Pictures and
Sculptures in the Royal Picture
Gallery (Mauritshuis) at The Hague*,
The Hague 1893

Bredius-Hofstede de Groot 1895
A. Bredius, C. Hofstede de Groot,
*Musée Royal de La Haye: Catalogue
raisonné des tableaux et des sculptures*,
The Hague 1895

Bredius-Moes 1892
A. Bredius, E.W. Moes,
'De schildersfamilie Ravesteyn',
Oud-Holland 10 (1892), pp. 41-52

Brejon de Lavergnée 1996
A. Brejon de Lavergnée, [review of
Delft 1996], *Gazette des Beaux-Arts*
138 (1996), vol. 128, no. 1533, p. 16

**Brejon de Lavergnée-Foucart-
Reynaud 1979**
A. Brejon de Lavergnée, J. Foucart,
N. Reynaud, *Catalogue sommaire
illustré des peintures du Musée
du Louvre, 1: Écoles flamande et
hollandaise*, Paris 1979

Bremmer-Roodenburg 1993
J. Bremmer, H. Roodenburg (eds.),
*Gebaren en lichaamshouding van de
oudheid tot heden*, Nijmegen 1993

Briels 1987
J. Briels, *Vlaamse schilders in de
Noordelijke Nederlanden in het begin
van de Gouden Eeuw 1585-1630*,
Antwerp 1987

Briels 1997
J. Briels, *Vlaamse schilders en de
dageraad van Hollands Gouden Eeuw
1585-1630*, Antwerp 1997

Brière-Misme 1935
C. Brière-Misme, 'Un "intimiste"
hollandais: Jacob Vrel', *La Revue de*

l'Art Ancien et Moderne 68 (1935), pp. 97-114, 157-172

Brière-Misme 1954
C. Brière-Misme, 'Un "intimiste" hollandais: Esaias Boursse 1631-1672', *Oud Holland* 69 (1954), pp. 18-30, 72-91, 150-166, 213-221

Brinkgreve 1960
G. Brinkgreve, 'Saenredam: Le plus extraordinaire peintre d'architectures d'église. Une froide maîtrise élucidée et jugée ici par un Hollandais du xxe siècle', *Connaisance des Arts* (January 1960), pp. 32-41

Brinkgreve 1994
C. Brinkgreve, *In Haarlem staat een Huis: 600 jaar zorgen voor kinderen*, Haarlem 1994

Brochhagen 1957
E. Brochhagen, 'Karel Dujardins späte Landschaften', *Bulletin des Musées Royaux des Beaux-Arts Bruxelles* 6 (1957), pp. 236-255

Brochhagen 1958
E. Brochhagen, *Karel Dujardin: Ein Beitrag zum Italianismus in Holland im 17. Jahrhunderts* (dissertation), Cologne 1958

Brötje 1974
M. Brötje, 'Die Gestaltung der Landschaft im Werk C.D. Friedrichs und in der Holländischen Malerei des 17. Jahrhunderts', *Jahrbuch der Hamburger Kunstsammlungen* 19 (1974), pp. 43-46

Broos 1981
B. Broos, *Oude tekeningen in het bezit van de Gemeentemusea van Amsterdam, waaronder de collectie Fodor*, vol. 3, *Rembrandt en kunstenaars uit zijn omgeving*, Amsterdam 1981

Broos 1984a
B.P.J. Broos, '"Antoni Waterloo f(ecit)" in Maarsseveen', *Jaarboekje Niftarlake* (1984), pp. 18-48

Broos 1984ab
B.P.J. Broos, '"Notitie der Teekeningen van Sybrand Feitama": de boekhouding van drie generaties verzamelaars van oude Nederlandse schilderkunst', *Oud Holland* 98 (1984), pp. 13-36

Broos 1987
B. Broos, *Meesterwerken in het Mauritshuis*, The Hague 1987

Broos 1993a
B. Broos, with a contribution by M. de Boer, *Liefde, list & lijden: Historiestukken in het Mauritshuis*, The Hague-Ghent 1993 (English edition: *Intimacies & Intrigues: History Painting in the Mauritshuis*)

Broos 1993b
B. Broos, 'Een schilderende burgervader', *Kunstschrift* 37 (1993), p. 6

Broos 1998a
B. Broos, 'Vermeer: Malice and Misconception', I. Gaskell, M. Jonker (eds.), *Vermeer Studies* (*Studies in the History of Art*, vol. 55), Washington 1998, pp. 18-33

Broos 1998b
B. Broos, 'Portretten in het Mauritshuis: een voorpublicatie / Portraits in the Mauritshuis: a prepublication)', *Mauritshuis in focus* 11 (1998), no. 3, pp. 25-30

Broos-Van Leeuwen 1991
B. Broos, R. van Leeuwen *et al.*, *Twee decennia Mauritshuis: Ter herinnering aan Hans R. Hoetink, directeur 1972-1991*, The Hague-Zwolle 1991

Broos-Schapelhouman 1993
B. Broos, M. Schapelhouman, *Oude tekeningen in het bezit van de Gemeentemusea van Amsterdam, waaronder de collectie Fodor*, vol. 4, *Nederlandse tekenaars geboren tussen 1600 en 1660*, Amsterdam-Zwolle 1993

Brown 1979
C. Brown, 'Jan Lievens at Brunswick [review of *Braunschweig 1979*]', *The Burlington Magazine* 121 (1979), pp. 741-746

Brown 1984
C. Brown, *Scenes of everyday life: Dutch genre painting of the seventeenth century*, London-Amsterdam 1984

Brown 1995
C. Brown, 'The Hague: Paulus Potter [review of *The Hague 1994-1995*], *The Burlington Magazine* 137 (1995), pp. 265-267

Brozius 1993
J.R. Brozius, 'Marineschilder Ludolf Bakhuysen in Hoorn', *Oud-Hoorn: Kwartaalblad van de Vereniging Oud Hoorn* 15 (1993), pp. 139-141

Bruinvis 1909
C.W. Bruinvis, 'Isaäc van Nickelen, schilder en zijdewever', *Oud Holland* 26 (1909), pp. 241-244

Brussels 1971
Rembrandt et sons temps, Brussels (Palais des Beaux-Arts) 1971

Brussels-Rotterdam-Paris-Bern 1968-1969
C. van Hasselt, *Dessins de paysagistes hollandais du XVIIe siècle* (2 vols.), Brussels (Bibliothèque Royale Albert Ier) Rotterdam (Museum Boijmans Van Beuningen) Paris (Institut Néerlandais) Bern (Kunstmuseum) 1968-1969

Bruyn 1950
J. Bruyn, *Le paysage hollandais au XVIIe siècle* (*Art et style*, vol. 17), Paris 1950

Bruyn 1951
J. Bruyn, 'David Bailly', *Oud Holland* 66 (1951), pp. 148-164, 212-227

Bruyn 1988
J. Bruyn, [review of *Sumowski 1983-1994, vol. 3* (1986)], *Oud Holland* 102 (1988), pp. 322-333

Bruyn 1997
J. Bruyn, 'François Venant: Enige aanvullingen', *Oud Holland* 111 (1997), pp. 163-176

Bruyn 1999
J. Bruyn, 'Een portret van Pieter Aertsen en de Amsterdamse portret-schilderkunst 1550-1600, met een postscriptum van Huybrecht Beuckelaer (alias Hubbert/Hubbard)', *Oud Holland* 113 (1999), pp. 107-136

De Bruyn Kops 1965
C.J. de Bruyn Kops, 'Kanttekeningen bij het nieuw verworven landschap van Aelbert Cuyp', *Bulletin van het Rijksmuseum* 13 (1965), pp. 162-176

Büttner-Unverfehrt 1993
N. Büttner, G. Unverfehrt, *Jacob van Ruisdael in Bentheim: Ein niederländischer Maler und die Burg Bentheim im 17. Jahrhundert*, Bielefeld 1993

Buijsen *et al.* 1998
E. Buijsen *et al.*, *Haagse Schilders in de Gouden Eeuw. Het Hoogsteder Lexicon van alle schilders werkzaam in Den Haag 1600-1700*, The Hague-Zwolle 1998 (see also *The Hague 1998-1999a*)

Buist 1974
M.G. Buist, *At spes non fracta: Hope & Co. 1770-1815. Merchant bankers and diplomats at work*, The Hague 1974

Burke 1974
J.D. Burke, 'Haarlem vue par Ruisdaël: Ruisdael and his Haarlempjes', *Bulletin of the Montreal Museum of Fine Arts* 6 (1974), pp. 3-11

Burke 1976a
J.D. Burke, *Jan Both: Paintings, drawings and prints*, New York-London 1976

Burke 1976b
J.D. Burke, 'A drawing by Johannes Collaert', *Master Drawings* 14 (1976), pp. 384-386

Butôt 1981
F.C. Butôt, L.J. Bol, G.S. Keyes, *Netherlandish Paintings and Drawings from the Collection of F. C. Butôt by little known and rare masters of the seventeenth century*, New York 1981

Buvelot 1994
Q. Buvelot, 'Paulus Potter (1625-1654): een veelzijdig "beesten-schilder" / Paulus Potter (1625-1654): a multifaceted "animal painter"', *Mauritshuis in focus* 7 (1994), no. 3, pp. 15-20

Buvelot 2000
[Q. Buvelot], 'Bruikleen Potter / A Potter on loan', *Mauritshuis in focus* 13 (2000), no. 1, p. 10

Byam Shaw 1983
J. Byam Shaw, *The Italian Drawings of the Frits Lugt Collection* (3 vols.), Paris 1983

C

Calzoni 1975-1976
L. Calzoni, *Aspetti del paesaggismo italianizzante: Karel Dujardin e la persistenza del gusto olandese* (dissertation), Padua 1975-1976

Centorame 2001
B. Centorame (ed.), *La Nouvelle Athènes: Haut lieu du romantisme*, Paris 2001

Charensol 1983
G. Charensol, 'Les Beaux-Arts [...] Reflets du siècle d'or à l'Institut néerlandais', *La Revue des Deux Mondes* (May 1983), pp. 429-433

Chong 1991
A. Chong, 'New dated works from Aelbert Cuyp's early career', *The Burlington Magazine* 133 (1991), pp. 606-612

Chong 1992
A. Chong, *Aelbert Cuyp and the Meanings of Landscape* (dissertation New York University 1992), Ann Arbor 1993

Clayton 1997
T. Clayton, *The English Print, 1688-1802*, New Haven-London 1997

Cologne-Utrecht 1991-1992
D.A. Levine, E. Mai (eds.), *I Bamboccianti: Niederländische Malerrebellen in Rom des Barock*, Cologne (Wallraf-Richartz-Museum) Utrecht (Centraal Museum) 1991-1992

Commelin 1693
C. Commelin, *Beschryvinge van Amsterdam, desselfs eerste oorspronk uyt de huyse der heeren van Aemstel en Aemstellant; met een verhaal van haar leven en dappere krijgsdaden* [etc.], Amsterdam 1693

Commemorative catalogue 1930
Commemorative catalogue of the exhibition of Dutch art held in the galleries of the Royal Academy, Burlington House, London, January-March 1929, London 1930

Cornelis 1998
B. Cornelis, 'Arnold Houbraken's *Groote schouburgh* and the canon of seventeenth-century Dutch painting', *Simiolus* 26 (1998), pp. 145-161

Corpus
J. Bruyn, B. Haak, S.H. Levie, P.J.J. van Thiel, E. van de Wetering, *A Corpus of Rembrandt Paintings*, vol. 1- , Rembrandt Research Project Foundation 1982-

Croft-Murray-Hulton 1960

E. Croft-Murray, P. Hulton, *Catalogue of British drawings, volume one: XVI and XVII centuries* (2 vols.), London 1960

D

Van Dam 1991
J.D. van Dam, *Nederlandse tegels*, Utrecht-Antwerp 1991

Dapper 1663
O. Dapper, *Historische beschryving der stadt Amsterdam* [etc.], Amsterdam 1663

Dattenberg 1967
H. Dattenberg, *Niederrheinansichten holländischer Künstler des 17. Jahrhunderts* (*Die Kunstdenkmäler des Rheinlands*, Beiheft 10), Düsseldorf 1967

Dauriac 1983
J.P. Dauriac, [review of *Paris 1983*], *Pantheon* 41 (1983), no. 3, p. 279

Davies 1992
A. Davies, *Jan van Kessel (1641-1680)* (*Aetas Aurea: Monographs on Dutch & Flemish Painting*, vol. 10), Doornspijk 1992

Davies 2001
A.I. Davies, with the collaboration of F.J. Duparc, *Allaert van Everdingen, 1621-1675: First painter of Scandinavian landscape* (*Aetas Aurea: Monographs on Dutch & Flemish Painting*, vol. 15), Doornspijk 2001

Dayot 1912
[A.P.M.?] Dayot, *Grands et petits maîtres hollandais*, Paris 1912

Delft 1981
De Stad Delft: Cultuur en maatschappij van 1572 tot 1667, Delft (Stedelijk Museum Het Prinsenhof) 1981

Delft 1983
G.E. Langemeijer, A.C.G.M. Eyffinger, H.J.M. Nellen *et al.*, *Het Delfts orakel Hugo de Groot 1583-1645*, Delft (Stedelijk Museum Het Prinsenhof) 1983

Delft 1996
M.C.C. Kersten, D.H.A.C. Lokin, M.C. Plomp, *Delftse meesters: Tijdgenoten van Vermeer*, Delft (Stedelijk Museum Het Prinsenhof) 1996

Delft-Antwerp 1964-1965
A.A. Moerman, O. ter Kuile, J.A. Emmens *et al.*, *De schilder in zijn wereld: Van Jan van Eyck tot Van Gogh en Ensor*, Delft (Stedelijk Museum 'Het Prinsenhof') Antwerp (Koninklijk Museum voor Schone Kunsten) 1964-1965

Delft-Cambridge-Fort Worth 1988-1989
S. Segal, *A Prosperous Past: The Sumptuous Still Life In The Netherlands 1600-1700*, Delft (Stedelijk Museum Het Prinsenhof) Cambridge, Mass. (Fogg Art Museum) Fort Worth, Texas (Kimbell Art Museum) 1988-1989

Den Bosch: *see under Bosch*

Denucé 1932
J. Denucé, *De Antwerpsche "Konstkamers": Inventarissen van kunstverzamelingen te Antwerpen in de 16e en 17e eeuwen* (*Bronnen voor de geschiedenis van de Vlaamsche kunst*, vol. 2), Amsterdam 1932

Déon 1860
H. Déon, 'Cabinets d'Amateurs à Paris de Quelques Collections de Tableaux', *Annuaire des Artistes et des Amateurs* 1 (1860), pp. 156-170

Devapriam 1990
E. Devapriam, 'A double portrait by Thomas De Keyser in the National Gallery of Victoria', *The Burlington Magazine* 132 (1990), pp. 710-713

Dickey 2001
S.S. Dickey, 'Van Dyck in Holland: The Iconography and its impact on Rembrandt and Jan Lievens', in H. Vlieghe (ed.), *Van Dyck 1599-1999: Conjectures and refutations*, Turnhout 2001, pp. 289-303

Dictionary of Art
J. Turner (ed.), *The Dictionary of Art* (34 vols.), London-New York 1996 (see also *Turner 2000*)

Van Diepen 1942
H.J.J.M. van Diepen, 'Het Hof van Friesland', *Jaarboek Die Haghe* (1942), pp. 52-81

Dik 1993
G.C. Dik, *De Zeven Provinciën: Een poging tot reconstructie, mede aan de hand van de nog bestaande Van de Velde-tekeningen, van 's lands schip De Zeven Provinciën van 80-86 stukken, gebouwd voor de admiraliteit van de Maze in 1665*, Franeker 1993

Dordrecht 1977-1978
W. Veerman, J.M. de Groot, J.G. van Gelder, *Aelbert Cuyp en zijn familie, schilders te Dordrecht: Gerrit Gerritsz. Cuyp, Jacob Gerritsz. Cuyp, Benjamin Gerritsz. Cuyp, Aelbert Cuyp, schilderijen/tekeningen*, Dordrecht (Dordrechts Museum) 1977-1978

Dordrecht 1992-1993
C. Brusati, A. Chong, J. Loughman *et al.* (eds.), *De Zichtbaere Werelt: Schilderkunst uit de Gouden Eeuw in Hollands oudste stad*, Dordrecht (Dordrechts Museum) 1992-1993

Dordrecht-Cologne 1998-1999
Arent de Gelder (1645-1727). Rembrandts laatste leerling, Dordrecht (Dordrechts Museum) Cologne (Wallraf-Richartz-Museum) 1998-1999

Dordrecht-Leeuwarden 1988-1989
F. Grijzenhout *et al.*, *Meesterlijk vee: Nederlandse veeschilders 1600-1900*, Dordrecht (Dordrechts Museum) Leeuwarden (Fries Museum) 1988-1989

Dossi 1999
B. Dossi, *Albertina: The History of the Collection and its Masterpieces*, Munich-London-New York 1999

Douglas Stewart 1990
J. Douglas Stewart, 'Before Rembrandt's "Shadow" fell: Lievens, Van Dyck and Rubens: Some reconsiderations', *The Hoogsteder Mercury* (1990), no. 11, pp. 42-47

Dozy 1897
C.M. Dozy, 'Pieter Nolpe, 1613/14-1652/53', *Oud-Holland* 15 (1897), pp. 24-50, 94-120, 139-158, 220-244

Dudok van Heel 1975a
S.A.C. Dudok van Heel, 'De kunstverzamelingen Van Lennep met de Arundel-tekeningen', *Jaarboek Amstelodamum* 67 (1975), pp. 137-148

Dudok van Heel 1975b
S.A.C. Dudok van Heel, 'Honderdvijftig advertenties van kunstverkopingen uit veertig jaargangen van de Amsterdamsche Courant 1672-1711', *Jaarboek Amstelodamum* 67 (1975), pp. 149-173

Dudok van Heel 1977
S.A.C. Dudok van Heel, 'Ruim honderd advertenties van kunstverkopingen uit de Amsterdamsche Courant 1712-1725', *Jaarboek Amstelodamum* 69 (1977), pp. 107-122

Dudok van Heel 1991
S.A.C. Dudok van Heel, 'De familie van de schilder Pieter Lastman (1583-1633): Een vermaard leermeester van Rembrandt van Rijn', *Jaarboek Centraal Bureau voor Genealogie en het Iconographisch Bureau* 45 (1991), pp. 111-132

Düsseldorf 1983
A. Poensgen, *Niederländische Fliesen 16.-19. Jhdt.*, Düsseldorf (Hetjens Museum-Deutsches Keramikmuseum) 1983

Dunthorne 1991
H. Dunthorne, 'Games and goodliness in old Holland', *History Today* 41 (October 1991), pp. 25-31

Duparc 1980
F.J. Duparc, *Mauritshuis: Hollandse schilderijen. Landschappen 17de eeuw*, The Hague 1980

Duparc 1994
F.J. Duparc, 'Een aanwinst: De oude kantwerkster … Nicolaes Maes / An Acquisition: The Old Lace-Maker … Nicolaes Maes', *Mauritshuis in focus* 7 (1994), no. 2, pp. 10-14

Duyvené de Wit-Klinkhamer 1966
T.M. Duyvené de Wit-Klinkhamer, 'Een vermaarde zilveren beker', *Nederlands Kunsthistorisch Jaarboek* 17 (1966), pp. 79-103

E

Eckardt 1971
G. Eckardt, *Selbstbildnisse niederländischer Maler des 17. Jahrhunderts*, Berlin 1971

Edinburgh 1984
H. Macandrew, *Dutch Church Painters: Saenredam's Great Church at Haarlem in context*, Edinburgh (National Gallery of Scotland) 1984

Edinburgh 1992
J. Lloyd Williams, *Dutch Art and Scotland: A Reflection of Taste*, Edinburgh (National Gallery of Scotland) 1992

Edwards 1996
J.L. Edwards, *Alexandre-Joseph Paillet: Expert et marchand de tableaux à la fin du XVIIIe siècle*, Paris 1996

Van Eeghen 1959
I.H. van Eeghen, 'De verzameling van Jacob de Wilde met het Museum Wildeanum op Keizersgracht 333', *Jaarboek Amstelodamum* 51 (1959), pp. 72-92

Van Eeghen 1975
I.H. van Eeghen, 'Abraham en Antoni Rutgers: De kunstzin van grootvader en kleinzoon', *Jaarboek Amstelodamum* 67 (1975), pp. 174-188

Van Eeghen 1989
C.P. van Eeghen, 'Tekeningen van Jan van de Cappelle nader bezien', in *"En dan is nu het moment aangebroken", 14 opstellen aangeboden aan Mr Jan Reinier Voûte ter gelegenheid van zijn tachtigste verjaardag en dertig jaar actief verzamelen van prenten, door de leden van de Amsterdamsche Prenkring, op 28 januari 1989 te 's-Gravenhage*, s.l. [1989], pp. 8-17

Eikemeier 1984
P. Eikemeier, 'Bücher in Bildern', in *De Arte et Libris*, Amsterdam 1984, pp. 61-67

Ekkart 1991
R.E.O. Ekkart, 'The portraits of "The Vrijdags van Vollenhoven Family" by Jan Anthonisz. van Ravesteyn ', *The Hoogsteder Mercury* (1991), no. 12, pp. 3-16

Ekkart 1997
R.E.O. Ekkart, *Portrettisten en portretten: Studies over portretkunst in Holland 1575-1650* (dissertation), Amsterdam 1997

Emden 1985
H. Nannen, B. Broos, R. van Gelder *et al.*, *Ludolf Backhuysen, Emden 1630-Amsterdam 1708: Ein Versuch, Leben und Werk des Künstlers zu beschreiben*, Emden (Ludolf Backhuysen Gesellschaft) 1985 (see also *Amsterdam 1985*)

Ertz 1979
K. Ertz, *Jan Brueghel der Ältere (1568-1625): Die Gemälde mit kritischem Oeuvrekatalog*, Cologne 1979

Eyffinger 1980
A. Eyffinger, 'The Portrait on the Cover', *Grotiana: A Journal under the auspice of the Foundation Grotiana* 1 (1980), pp. 138-139

Eyffinger 1981
A. Eyffinger, *Grotius poeta: Aspecten van Hugo Grotius' dichterschap* (dissertation), Amsterdam 1981

F

Farr-Bradford 1986
D. Farr, W. Bradford, *The Northern landscape: Flemish, Dutch and British drawings from the Courtauld Collections*, London 1986

Faton 1983
L. Faton, 'A la découverte du siècle d'or hollandais: La collection Frits Lugt exposée à l'Institut Néerlandais de Paris', *L'Estampille* (March 1983), no. 155, pp. 67-74

Feitama 1764
S. Feitama, *Nagelaten dichtwerken van S.F. onder de zinspreuk Studio Fovetur Ingenium*, Amsterdam 1764

Fesch 1841
Catalogue de la Galerie de feu Son Eminence le Cardinal Fesch, Rome 1841

Filedt Kok-Baarsen-Cornelis et al. 2001
J.P. Filedt Kok, R. Baarsen, B. Cornelis *et al.*, *Netherlandish art in the Rijksmuseum, 1600-1700*, Amsterdam-Zwolle 2001

Filedt Kok-Leesberg 2000
J.P. Filedt Kok, M. Leesberg, *The De Gheyn family (The New Hollstein Dutch & Flemish etchings, engravings and woodcuts 1450-1700, 2 vols.)*, Rotterdam 2000

Florence 1966
C. van Hasselt, A. Blankert, *Artisti Olandesi e Fiamminghi in Italia: Mostra di disegni del Cinque e Seicento della Collezione Frits Lugt*, Florence (Istituto Universitario Olandese di Storia dell'Arte) 1966

Fock 1998
C.W. Fock, 'Werkelijkheid of schijn. Het beeld van het Hollandse interieur in de zeventiende-eeuwse genreschilderkunst', *Oud Holland* 112 (1998), pp. 187-246

Fock et al. 2001
C.W. Fock *et al.*, *Het Nederlandse interieur in beeld 1600-1900*, Zwolle 2001

De la Fontaine Verwey 1976
H. de la Fontaine Verwey, '"Ex Libris Veteribus F. Lugt"', *Apollo* 104 (1976), no. 176, pp. 282-289 (reprinted in *Sutton 1976*, pp. 46-53)

Van Foreest-Weber 1984
H.A. van Foreest, R.E.J. Weber, with J.F. van Dulm, J.A. van der Kooij, *De Vierdaagse Zeeslag 11-14 juni 1666* (*Verhandelingen der Koninklijke Nederlandse Akademie van Wetenschappen, Afd. Leterkunde*, new series 126; *Werken uitgegeven door de Commissie voor Zeegeschiedenis*, vol. 16), Amsterdam-Oxford-New York 1984

Foucart 1985
J. Foucart, 'Manières du Nord', *Connaissance des Arts* (April 1985), no. 398, pp. 61-69

Foucart 1987
J. Foucart, *Nouvelles acquisitions du Département des Peintures (1983-1986)*, Paris 1987

Franits 1993
W.E. Franits, *Paragons of virtue: Women and Domesticity in Seventeenth-Century Dutch Art*, Cambridge, Mass. 1993

Frankfurt am Main 1991-1992
J. Sander, H.-J. Ziemke, M. Maek-Gérard, *Städels Sammlung im Städel: Gemälde. Eine Ausstellung des Städelschen Kunstinstitutes und der Städtischen Galerie aus Anlass des 175jährigen Bestehens des Städelschen Kunstinstitutes Frankfurt am Main*, Frankfurt am Main (Städelsches Kunstinstitut) 1991-1992

Frankfurt am Main 1993-1994
A. Jensen Adams, J. Becker, G. Cavalli-Björkman *et al.*, *Leselust: Niederländische Malerei von Rembrandt bis Vermeer*, Frankfurt am Main (Schirn Kunsthalle) 1993-1994

Fransen 1997
H. Fransen *et al.*, *Michaelis Collection, The Old Town House, Cape Town: Catalogue of the collection of paintings and drawings*, Zwolle 1997

Fredericksen-Priem-Armstrong 1998
B. Fredericksen, R. Priem, J. Armstrong, *Corpus of paintings sold in the Netherlands during the nineteenth century (The provenance index of the Getty Information Institute*, vol. 1, *1801-1810)*, Los Angeles 1998

Frensemeier 2001
M. Frensemeier, *Studien zu Adriaen van de Velde (1636-1672)* (dissertation Bonn), Aachen 2001

Von Frimmel 1896
T. von Frimmel, *Kleine Galeriestudien. Neue Folge. III. Lieferung. Die Gräflich Schönborn-Buchheim'sche Gemäldesammlung in Wien. Mit 2 Vollbildern und 6 Abbildungen im Text*, Leipzig 1896

Von Frimmel 1913-1914
T. von Frimmel, *Lexikon der Wiener Gemäldesammlungen* (2 vols.), Munich 1913-1914

G

Gaskell 1982
I. Gaskell, 'Gerrit Dou, his patrons and the art of painting', *The Oxford Art Journal* 5 (1982), no. 1, pp. 15-23

Gaskell 1989
I. Gaskell, *The Thyssen-Bornemisza Collection: Seventeenth-century Dutch and Flemish painting*, London 1989

Gaunt 1975
W. Gaunt, *History of marine painting*, Amsterdam-London 1975

Geesink 1986
M. Geesink, 'Gerbrand Adriaenszoon Bredero en het boekenstilleven', in P.A. Tichelaar *et al.* (ed.), *Opstellen over de Koninklijke Bibliotheek en andere studies*, Hilversum 1986, pp. 400-412, 564-567

Van Gelder 1934
J.G. van Gelder, [review of *Welcker 1933*], *Zeitschrift für Kunstgeschichte* 3 (1934), pp. 78-79

Van Gelder 1941
H.E. van Gelder, *W.C. Heda, A. van Beyeren, W. Kalf*, Amsterdam [1941]

Van Gelder 1950
J.G. van Gelder, *Ashmolean Museum: Catalogue of the Collection of Dutch and Flemish Still-life Pictures Bequeathed by Daisy Linda Ward*, Oxford 1950

Van Gelder 1959a
J.G. van Gelder, 'Anthonie van Dyck in Holland in de zeventiende eeuw', *Bulletin des Musées Royaux des Beaux-Arts Bruxelles* 8 (1959), pp. 43-86

Van Gelder 1959b
H.E. van Gelder, *Holland by Dutch artists*, Amsterdam 1959

Van Gelder 1964
J.G. van Gelder, 'Frits Lugt: Inspirator-Organisator-Documentator 80 jaar. De activiteiten van de laatste vijftien jaar', in *Frits Lugt: Zijn leven en zijn verzamelingen 1949-1964* (*Publicaties van het Rijksbureau voor Kunsthistorische Documentatie*, no. 2), The Hague 1964, pp. 4-27

Van Gelder 1976
J. van Gelder, 'The Animal and his "Lettres de Noblesse"', *Apollo* 104 (1976), no. 176, pp. 346-353 (reprinted in *Sutton 1976*, pp. 88-95)

Van Gelder 1978
J.G. van Gelder, 'Caspar Netscher's portret van Abraham van Lennep uit 1672', *Jaarboek Amstelodamum* 70 (1978), pp. 227-238

Van Gelder-Jost 1985
J.G. van Gelder, I. Jost, *Jan de Bisschop and his Icones & Paradigmata: Classical Antiquities and Italian Drawings for Artistic Instruction in Seventeenth Century Holland*, Doornspijk 1985

Georgel-Lecoq 1987
P. Georgel, A.-M. Lecoq, *La peinture dans la peinture*, Paris 1987

Gerson 1942
H. Gerson, *Ausbreitung und Nachwirkung der holländischen Malerei des 17. Jahrhunderts: De expansie der 17e-eeuwsche Hollandsche schilderkunst*, Haarlem 1942

Gerson 1952
H. Gerson, *Het tijdperk van Rembrandt en Vermeer*, Amsterdam 1952

Gerson 1964
H. Gerson, 'Frits Lugt als boeken-verzamelaar en schrijver' in *Frits Lugt: Zijn leven en zijn verzamelingen 1949-1964* (*Publicaties van het Rijksbureau voor Kunsthistorische Documentatie*, no. 2), The Hague 1964, pp. 33-39

Gerson ed. 1983
H. Gerson, enlarged and edited by B.W. Meijer (ed.), *Ausbreitung und Nachwirkung der holländischen Malerei des 17. Jahrhunderts. De expansie der 17e-eeuwsche Hollandsche schilderkunst*, Amsterdam 1983

Gerson-Goodison 1960
H. Gerson, J.W. Goodison *et al.*, *Fitzwilliam Museum Cambridge: Catalogue of Paintings. Volume I. Dutch and Flemish. French, German, Spanish*, Cambridge 1960

Ghent 1963-1964
De vrienden van het museum van Gent 65 jaar op de bres, Ghent (Museum voor Schone Kunsten) 1963-1964

Giltaij 1977
J. Giltaij, 'Pieter Saenredam as portraitist', *Master Drawings* 15 (1977), pp. 26-28

Giltaij 1990-1991
J. Giltaij, [review of *Schwartz-Bok 1989*], *Simiolus* 20 (1990-1991), pp. 87-90

Giltaij 1994
J. Giltaij *et al.*, *De verzameling van de Stichting Willem van der Vorm in het Museum Boymans-van Beuningen Rotterdam / Collection of the Willem van der Vorm Foundation at the Boymans-van Beuningen Museum Rotterdam*, Rotterdam 1994

Giltaij 2000
J. Giltaij, 'Scientific examination of the underdrawing of seventeenth-century architectural painters', J.R.J. van Asperen de Boer, L.M. Helmus (eds.), *The Paintings of Pieter Jansz. Saenredam (1597-1665): Conservation and Technique*, Utrecht 2000, pp. 32-55

Giltaij-Jansen 1999
J. Giltaij, G. Jansen, *Een gloeiend palet: Schilderijen van Rembrandt en zijn school / A glowing palette: Paintings by Rembrandt and his school*, Rotterdam 1988

Gmelin 1982
H.G. Gmelin, 'Zu drie wenig bekannten Landschaftbildern des Jacob Jacobsz van Geel', *Niederdeutsche Beiträge zur Kunstgeschichte* 21 (1982), pp. 69-75

Göpel 1964
E. Göpel, 'Frits Lugt: Zum 80. Geburtstag', *Die Weltkunst* 34 (May 1964), no. 9, pp. 334a-b

Gorissen 1964
F. Gorissen, *Conspectus Cliviae: Die klevische Residenz in der Kunst des 17. Jahrhunderts*, Cleves 1964

Graafhuis-Witteveen 1981
A. Graafhuis, K.M. Witteveen, *In en om de Janskerk, bij de opening van de gerestaureerde Janskerk 19 september 1981*, Utrecht 1981

Greindl 1983
E. Greindl, *Les peintres flamands de nature morte au XVIIe siècle*, Brussels 1983

Grisebach 1974
L. Grisebach, *Willem Kalf 1619-1693*, Berlin 1974

Grohn 1981
H.W. Grohn, 'Hannover Niedersächsisches Landesmuseum: Neuerworbene Werke', *Weltkunst* 51 (1981), no. 8, pp. 1146-1148

De Groot 1994
J.M. de Groot, 'In memoriam Laurens J. Bol (1898-1994)', *Bulletin Dordrechts Museum* 19 (1994), no. 3, p. 19

Gudlaugsson 1951
S.J. Gudlaugsson, 'Een figuurstudie van Jacob Esselens te Besançon', *Oud-Holland* 66 (1951), pp. 62-63

Gudlaugsson 1954
S.J. Gudlaugsson, 'Aanvullingen omtrent Pieter Post's werkzaamheid als schilder', *Oud-Holland* 69 (1954), pp. 59-71

Gudlaugsson 1964a
S.J. Gudlaugsson, 'Hendrik Avercamp', *Kindlers Malerei Lexikon* (vol. 1), Zürich 1964, pp. 158-159

Gudlaugsson 1964b
S.J. Gudlaugsson, 'Jan van de Cappelle', *Kindlers Malerei Lexikon* (vol. 1), Zürich 1964, pp. 618-619

Guépin 1991
J.P. Guépin, with a contribution by P. Tuynman, *De kunst van Janus Secundus: De 'Kussen' en andere gedichten*, Amsterdam 1991

H

Haak 1984
B. Haak, *Hollandse schilders in de Gouden Eeuw*, Amsterdam 1984

Haakma Wagenaar 1979
T. Haakma Wagenaar, 'Janskerk', *Restauratie vijf hervormde kerken in de binnenstad van Utrecht. Jaarverslag 1977-1978*, no. 5, Utrecht [1979], pp. 96-102

Haarlem 1936
Oude Kunst, Haarlem (Frans Halsmuseum) 1936

Haarlem 1986
E. de Jongh, *Portretten van echt en trouw: Huwelijk en gezin in de Nederlandse kunst van de zeventiende eeuw*, Haarlem (Frans Halsmuseum) 1986

Haarlem 2000
H. Verbeek, R.-J. te Rijdt, *Travels through town and country: Dutch and Flemish landscape drawings 1550-1830*, Haarlem (Teylers Museum) 2000

Haarlem-Antwerp 2000-2001
J.B. Bedaux, R. Ekkart, *Kinderen op hun mooist: Het kinderportret in de Nederlanden 1500-1700*, Haarlem (Frans Halsmuseum) Antwerp (Koninklijk Museum voor Schone Kunsten) 2000-2001

Haarlem-Paris 2001-2002
M. van Berge-Gerbaud et al., *Hartstochtelijk Verzameld: Beroemde tekeningen in 18de-eeuwse Hollandse collecties*, Haarlem (Teylers Museum) Paris (Fondation Custodia) 2001-2002 (see also *Plomp 2001*)

Haboldt 2001
B. Haboldt, *Haboldt & Co.: Northern European Old Master Drawings and Oil Sketches*, Zwolle 2001

The Hague 1919
Catalogue de la collection Goudstikker d'Amsterdam, The Hague (Pulchri Studio) 1919

The Hague 1925
Grotiustentoonstelling, The Hague (Gemeentemuseum) 1925

The Hague 1926
Nederlandsche stillevens uit vijf eeuwen, The Hague (Gemeentemuseum) 1926 (catalogue in *Mededelingen van den Dienst voor Kunsten en Wetenschappen der Gemeente 's-Gravenhage* 2 [March 1926], no. 1, pp. 33-39)

The Hague 1936-1937
Oude kunst uit Haagsch bezit, The Hague (Gemeentemuseum) 1936-1937

The Hague 1946
J.G. van Gelder, *Herwonnen kunstbezit: Tentoonstelling van uit Duitschland teruggekeerde Nederlandsche kunstschatten*, The Hague (Mauritshuis) 1946

The Hague 1953
A.B. de Vries, *Maurits de Braziliaan*, The Hague (Mauritshuis) 1953

The Hague 1958-1959
P.N.H. Domela Nieuwenhuis, *Jan Steen*, The Hague (Mauritshuis) 1958-1959

The Hague 1970
Vijfentwintig jaar aanwinsten Mauritshuis: 1945-1970, The Hague (Mauritshuis) 1970

The Hague 1970-1971
A.G.H. Bachrach, L. Thijssen, D. van Karnebeek-van Roijen, *Schok der herkenning: Het Engelse landschap van de Romantiek en zijn Hollandse inspiratie*, The Hague (Mauritshuis) 1970-1971

The Hague 1991
P. Huys Janssen, P.C. Sutton, *The Hoogsteder Exhibition of Dutch Landscapes*, The Hague (Hoogsteder & Hoogsteder Gallery) 1991

The Hague 1991-1992
M. de Boer, J. Leistra, B. Broos, *Bredius, Rembrandt en het Mauritshuis!!!: Een eigenzinnig directeur verzamelt*, The Hague (Mauritshuis) 1991-1992

The Hague 1992
P. Huys Janssen, W. Sumowski, *The Hoogsteder Exhibition of Rembrandt's Academy*, The Hague (Hoogsteder & Hoogsteder Gallery) 1992

The Hague 1994-1995
A. Walsh, E. Buijsen, B. Broos, *Paulus Potter: Schilderijen, tekeningen en etsen*, The Hague (Mauritshuis) 1994-1995

The Hague 1995-1996
B. Broos, Q. Buvelot et al., *Uit de schatkamer van de verzamelaar: Hollandse zeventiende-eeuwse schilderijen uit Nederlands particulier bezit*, The Hague (Mauritshuis) 1995-1996

The Hague 1997-1998
P. van der Ploeg, C. Vermeeren et al., *Vorstelijk Verzameld: De kunst-collectie van Frederik Hendrik en Amalia*, The Hague (Mauritshuis) 1997-1998

The Hague 1998-1999a
E. Buijsen et al., *Haagse Schilders in de Gouden Eeuw: Het Hoogsteder Lexicon van alle schilders werkzaam in Den Haag 1600-1700*, The Hague (Haags Historisch Museum) 1998-1999

The Hague 1998-1999b
N. Middelkoop et al., *Rembrandt onder het mes: De anatomische les van Dr Nicolaes Tulp ontleed*, The Hague (Mauritshuis) 1998-1999

The Hague 2001-2002
A. van Suchtelen et al., *Winters van weleer: Het Hollandse winterlandschap in de Gouden Eeuw*, The Hague (Mauritshuis) 2001-2002

The Hague-Cambridge 1981-1982
S. Slive, *Jacob van Ruisdael*, The Hague (Mauritshuis) Cambridge, Mass. (Fogg Art Museum) 1981-1982

The Hague-Paris 1966
In het licht van Vermeer: Vijf eeuwen schilderkunst, The Hague (Mauritshuis) Paris (Musée de l'Orangerie) 1966

The Hague-San Francisco 1990-1991
B. Broos et al., *Hollandse meesters uit Amerika*, The Hague (Mauritshuis) San Francisco (The Fine Arts Museums of San Francisco) 1990-1991

The Hague-Washington 1995-1996
A.K. Wheelock, A. Blankert, B. Broos et al., *Johannes Vermeer*, The Hague (Mauritshuis) Washington (National Gallery of Art) 1995-1996

Hairs 1985
M.-L. Hairs, *Les peintres flamands de fleurs au XVIIe siècle*, third edition (2 vols.), Brussels 1985

Van Hall 1963
H. van Hall, *Portretten van Nederlandse beeldende kunstenaars: Repertorium / Portraits of Dutch painters and other artists of the Low Countries: Specimen of an iconography*, Amsterdam 1963

Hannema 1932
D. Hannema, *Verslag omtrent den toestand en de aanwinsten van het Museum Boijmans over het jaar 1931*, Rotterdam [1932]

Hannema 1933
D. Hannema, *Verslag omtrent den toestand en de aanwinsten van het Museum Boijmans over het jaar 1932*, Rotterdam [1933]

Hannema 1955
D. Hannema, *Catalogue of the H.E. ten Cate collection* (2 vols.), Rotterdam 1955

Hannema 1961
D. Hannema, *Oude tekeningen uit de verzameling Victor de Stuers*, s.l. 1961

Hartford-Hanover-Boston 1973
F.W. Robinson, *One Hundred Master Drawings from New England Private Collections*, Hartford (Wadsworth Atheneum) Hanover (Hopkins Center Art Galleries) Boston (Museum of Fine Arts) 1973

232

Hartt 1969
F. Hartt, *Michelangelo: The complete sculpture*, London 1969

Harwood 1988
L.B. Harwood, *Adam Pynacker (c.1620-1673)* (*Aetas Aurea: Monographs on Dutch & Flemish Painting*, vol. 7), Doornspijk 1988

Haskell 1976
F. Haskell, *Rediscoveries in Art: Some Aspects of Taste, Fashion and Collecting in England and France*, London 1976

Haskell 1980
F. Haskell, *Rediscoveries in art: Some aspects of taste, fashion and collecting in England and France*, Oxford 1980

Van Hasselt 1977
C. van Hasselt, 'Portret van Abraham van Lennep, Caspar Netscher (1639-1684)', *Vereniging Rembrandt tot behoud en vermeerdering van kunst-schatten in Nederland: Verslag over 1976*, Amsterdam 1977, pp. 34-36

Haverkamp Begemann 1973
E. Haverkamp Begemann, with K.G. Boon, E. Trautscholdt, *Hercules Segers: The Complete Etchings. And A Supplement: Johannes Ruischer*, Amsterdam-The Hague 1973

Haverkamp Begemann 1995
E. Haverkamp Begemann, 'Jacob van Ruisdael's Interest in Construction', in *Shop Talk: Studies in Honor of Seymour Slive*, Cambridge, Mass. 1995, pp. 97-99, 319-320

Hecht 1984
P. Hecht, 'Reflets du siècle d'or: Tableaux Hollandais du dix-septième siècle [review of *Paris 1983*]', *The Burlington Magazine* 126 (1984), p. 357

Hecht 1998
P. Hecht, 'Rembrandt and Raphael back to back: The contribution of Thoré', *Simiolus* 26 (1998), pp. 162-178

Heesakkers 1986
C. Heesakkers, 'Secundusverering in Nederland', *Handelingen van de Koninklijke Kring voor Oudheidkunde, Letteren en Kunst van Mechelen* 90 (1986), pp. 25-37

Heesakkers 1987
C.L. Heesakkers (ed.), *Constantijn Huygens: Mijn jeugd*, Amsterdam 1987

Heesakkers 1995
C. Heesakkers, 'De Nederlandse muze in latijns gewaad', *Tijdschrift voor Nederlandse taal- en letterkunde* III (1995), pp. 142-162

Heijbroek-Wouthuysen 1993
J.F. Heijbroek, E.L. Wouthuysen, *Kunst, Kennis en Commercie: De Kunsthandelaar J.H. de Bois 1878-1946*, Amsterdam-Antwerp 1993

Heisner 1980
B. Heisner, 'Mortality and faith: The figural motifs within Emanuel de Witte's Dutch church interiors', *Studies in Iconography. Northern Kentucky University* 6 (1980), pp. 107-121

Held 1985-1986
J. Held, 'Some Studies of Heads by Flemish and Dutch Seventeenth-Century Artists', *Master Drawings* 23-24 (1985-1986), pp. 46-53

Hennus 1950
M.F. Hennus, 'Frits Lugt: Kunst-vorser-Kunstkeurder-Kunstgaarder', *Maandblad voor Beeldende Kunsten* 26 (1950), pp. 76-140

Herkenhoff 1999
P. Herkenhoff (ed.), *Brazil and the Dutch 1630-1654*, Rio de Janeiro 1999

Hijmersma 1983
H.J. Hijmersma, *100 jaar Vereniging Rembrandt: Een eeuw particulier kunstbehoud in Nederland*, Amsterdam 1983

Hind 1915-1932
A.M. Hind, *Catalogue of drawings by Dutch and Flemish artists preserved in the Department of Prints and Drawings in the British Museum* (5 vols.), London 1915-1932

Hirschmann 1918
O. Hirschmann, 'Personalien: Amsterdam [obituary August Janssen]', *Der Cicerone* 10 (1918), pp. 140-141

Hirschmann 1920
O. Hirschmann, 'Die Sammlung August Janssen (Firma J. Goudstikker, Amsterdam) Mit 17 Abbildungen', *Der Cicerone* 12 (1920), pp. 17-26 en 69-77

Hoet-Terwesten 1752-1770
G. Hoet, P. Terwesten, *Catalogus of naamlyst van schilderyen, met derzelver prysen* (3 vols.), The Hague 1752-1770

Hoetink et al. 1985
H. Hoetink (ed.), *The Royal Picture Gallery Mauritshuis*, Amsterdam-New York-The Hague 1985

Hofstede de Groot 1893
C. Hofstede de Groot, 'Hollandsche kunst in Schotland', *Oud-Holland* 11 (1893), pp. 129-148, 210-228

Hofstede de Groot 1907-1928
C. Hofstede de Groot, *Beschreibendes und kritisches Verzeichnis der Werke der hervorragendsten holländischen Maler des XVII. Jahrhunderts* (10 vols.), Esslingen a.N.-Paris 1907-1928

Hofstede de Groot 1920
C. Hofstede de Groot, 'Künstlerische Beziehungen zwischen Holland und Deutschland im 17. Jahrhundert', *Zeitschrift für bildende Kunst* 55 (1920), pp. 3-10

Hofstede de Groot 1930
C. Hofstede de Groot, 'Pieter Lastman en Thomas de Keyser', *Oud-Holland* 47 (1930), pp. 237-240

Hollstein
F.W.H. Hollstein, *Dutch and Flemish Etchings, Engravings and Woodcuts, ca. 1450-1700*, vols. 1-58, Amsterdam 1949-

Honig 1989
E. Honig, 'Looking in(to) Jacob Vrel', *Yale Journal of Criticism* 3 (1989), no. 1, pp. 37-56

Honig 1996
E.A. Honig, 'Country Folk and City Business: A Print Series by Jan van de Velde', *The Art Bulletin* 78 (1996), pp. 511-526

Hooft 1636
P.C. Hooft, ed. J. van der Burch, *Gedichten*, Amsterdam 1636

Van Hoogstraten 1678
S. van Hoogstraten, *Inleyding tot de hooge schoole der schilderkonst; anders de zichtbaere werelt*, Rotterdam 1678

Houbraken 1718-1721
A. Houbraken, *De groote schouburgh der Nederlantsche konstschilders en schilderessen* (3 vols.), Amsterdam 1718-1721 (second edition The Hague 1753)

Houston-The Hague 2000-2001
A.K. Wheelock, C. Brown, *The Golden Age of Dutch and Flemish Painting: The Edward and Sally Speelman Collection*, Houston (Museum of Fine Arts) The Hague (Mauritshuis) 2000-2001

Hulton 1959
P.H. Hulton, *Drawings of England in the seventeenth century by Willem Schellinks, Jacob Esselens & Lambert Doomer from the Van der Hem Atlas of the National Library, Vienna* (*Walpole Society*, vol. 35, 1954-1956), Glasgow 1959

Van Hulzen 1988
A. van Hulzen, *Utrechtse kerken en kerkgebouwen*, Baarn 1988

Huygens ed. 1946
De jeugd van Constantijn Huygens, door hemzelf beschreven, translated and edited by A.H. Kan with a contribution of G. Kamphuis, Rotterdam-Antwerp 1946

Huyghe et al. 1971
R. Huyghe, with G. Wiarda, S. de Gorter, J. Lugt, *Hommage à Frits Lugt*, Paris 1971

I

Immerzeel 1842-1843
J. Immerzeel, *De levens en werken der Hollandsche en Vlaamsche kunstschilders, beeldhouwers, graveurs en bouwmeesters van het begin der vijftiende eeuw tot heden* (3 vols.), Amsterdam 1842-1843

Ingamells 1992
J. Ingamells, *The Wallace Collection Catalogue of Pictures IV: Dutch and Flemish*, London 1992

J

Jaffé 1997
D. Jaffé, *Summary Catalogue of European Paintings in the J. Paul Getty Museum*, Los Angeles 1997

Jansen 1985
G. Jansen, 'Berchem in Italy: Notes on an unpublished painting', *Hoogsteder-Naumann Mercury* 2 (1985), pp. 13-17

Janson 1952
H.W. Janson, *Apes and ape lore in the Middle Ages and the Renaissance*, London 1952

Jantzen 1910
H. Jantzen, *Das Niederländische Architekturbild*, Leipzig 1910

Jantzen 1979
H. Jantzen, *Das Niederländische Architekturbild*, second edition, Braunschweig 1979 (first edition Leipzig 1910)

Jensen Adams 1985
A. Jensen Adams, *The paintings of Thomas de Keyser (1596/97): A study of portraiture in seventeenth-century Amsterdam* (dissertation; 4 vols.), Cambridge, Mass. 1985

Jensen Adams 1995
A. Jensen Adams, 'Thomas de Keyser's *Portrait of Six Gold- and Silversmiths* of 1627: Friendship Portrait and Posthumous Tribute to Andries Fredericsz', in *Shop talk: Studies in Honor of Seymour Slive*, Cambridge, Mass. 1995, pp. 28-32, 284-285

Joel 2000
D. Joel, *Charles Brooking 1723-1759 and the 18th Century British Marine Painters*, Woodbridge, Suffolk 2000

De Jonge 1858-1862
J.C. de Jonge, *Geschiedenis van het Nederlandsche zeewezen*, second, enlarged edition by J.K.J. de Jonge (6 vols.), Haarlem 1858-1862

De Jonge 1969
E. de Jongh, 'The Spur of Wit: Rembrandt's response to an Italian Challenge', *Delta: A Review of Arts, Life and Thought in the Netherlands* 12 (1969), no. 2, pp. 49-67

De Jonge 1971
C.H. de Jonge, *Nederlandse tegels*, Amsterdam 1971

Jowell 1998
F.S. Jowell, 'Vermeer and Thoré-Bürger: Recoveries of Reputation',

I. Gaskell, M. Jonker (eds.), *Vermeer Studies* (*Studies in the History of Art*, vol. 55), Washington 1998, pp. 34-57

Judson-Ekkart 1999
J.R. Judson, R.E.O. Ekkart, *Gerrit van Honthorst*, Doornspijk 1999

Jürss 1982
L. Jürss, *100 Jahre Staatliches Museum Schwerin: Bestandskatalog I. Holländische und flämische Malerei des 17. Jahrhunderts*, Schwerin 1982

Junquera de Vega-Herrero Carretero 1986
P. Junquera de Vega, C. Herrero Carretero, *Catalogo de tapices del Patrimonio Nacional* (2 vols.), Madrid 1986

K

Karlsruhe 1999
D. Hempelmann *et al.*, *Jean Siméon Chardin 1699-1779: Werk-Herkunft-Wirkung*, Karlsruhe (Staatliche Kunsthalle) 1999

Karsemeijer-Overeem 1995
H.N. Karsemeijer, G.A. Overeem, 'Duifhuizen in Nederland', *Bulletin KNOB* 84 (1985), pp. 220-230

Kassel-Amsterdam 2001-2002
E. van de Wetering, B. Schnackenburg *et al.*, *The Mystery of the Young Rembrandt*, Kassel (Gemäldegalerie Alte Meister) Amsterdam (Museum Het Rembrandthuis) 2001-2002

Keblusek 1997
M. Keblusek, *Boeken in de hofstad: Haagse boekcultuur in de Gouden Eeuw* (dissertation Leiden), Hilversum 1997

Kelch 1971
J. Kelch, *Studien zu Simon de Vlieger als Marinemaler* (dissertation), Berlin 1971

Van Keulen 1996
C. van Keulen, 'De Omval door Jacob Esselens: Fraaie aanwinst voor het Amsterdams Historisch Museum', *Ons Amsterdam* 48 (1996), p. 118

Keyes 1975
G.S. Keyes, *Cornelis Vroom: Marine and Landscape Artist* (2 vols.), Alphen aan den Rijn 1975

Keyes 1984
G.S. Keyes, *Esaias van den Velde 1587-1630* (Aetas Aurea: Monographs on Dutch & Flemish Painting, vol. 4), Doornspijk 1984

Keyselitz 1957
R. Keyselitz, '"Die beiden Seifenbläser" des Esaias Boursse im Aachener Suermondt-Museum – eine Allegorie der Vanitas', *Aachener Kunstblätter* 16 (1957), pp. 19-26

Kilian forthcoming
J. Kilian, *The Paintings of Karel du Jardin (1626-1678)* (forthcoming)

Der Kinderen-Besier 1950
J.H. der Kinderen-Besier, *Spelevaart der mode: De kledij onzer voorouders in de zeventiende eeuw*, Amsterdam 1950

Kingzett 1983
R.N. Kingzett, 'The Paris Arts Scene: "Reflets Du Siècle D'or" in the Institut Néerlandais', *Apollo* 117 (1983), no. 256, p. 503

Kingzett 1986
R.N. Kingzett, 'Dutch Treat for Atlanta', *Apollo* 123 (1986), no. 287, pp. 19-23

Kloek 1987
W.T. Kloek, 'Onderzoek tijdens de tentoonstelling "Kunst voor de beeldenstorm"', *Bulletin van het Rijksmuseum* 35 (1987), pp. 242-251

Knuttel 1935
G. Knuttel, *Gemeentemuseum 's-Gravenhage: Catalogus van de schilderijen[,] aquarellen en teekeningen*, The Hague 1935

Koblenz-Göttingen-Oldenburg 2000
G. Unverfehrt, N. Büttner, G. Girgensohn *et al.*, *Zeichnungen von Meisterhand: Die Sammlung Uffenbach aus der Kunstsammlung der Universität Göttingen*, Koblenz (Mittelrhein-Museum) Göttingen (Kunstsammlung der Universität) Oldenburg (Landesmuseum für Kunst und Kulturgeschichte) 2000

Költsch 2000
G.-W. Költsch, *Der Maler und sein Modell: Geschichte und Deutung eines Bildthemas*, Cologne 2000

König 1985
H.J. König, 'Hollands Glanz in Atlanta, Ga.', *Weltkunst* 55 (November 1985), no. 21, pp. 3322-3323

Van der Kooij 1980
J.A. van der Kooij, 'De naamgevers en voorgangers van de standaard-fregatten', *Marineblad* (1980), pp. 65-75

Koomen 1932
P. Koomen, 'Wat erop staat', *Maandblad voor Beeldende Kunsten* 9 (1932), pp. 171-178

Koomen 1933
P. Koomen, 'Het portret van de kerk', *Maandblad voor Beeldende Kunsten* 10 (1933), pp. 259-268

Kramm 1857-1864
C. Kramm, *De levens en werken der Hollandsche en Vlaamsche kunstschilders, beeldhouwers, graveurs en bouw-meesters: Van den vroegsten tot op onzen tijd* (6 vols.), Amsterdam 1857-1864

Krefeld 1938
Deutsche Landschaften und Städte in der niederländischen Kunst des 16. bis 18. Jahrh., Krefeld (Kaiser Wilhelm-Museum) 1938

Krempel 2000
L. Krempel, *Studien zu den datierten*

Gemälden des Nicolaes Maes (1634-1693) (Studien zur internationalen Architektur- und Kunstgeschichte, vol. 9), Petersberg 2000

Krikke 1997
A. Krikke, *Ruit hora: Bibliografie van de bibliotheca Grotiana uit de verzameling van Kornelis Pieter Jongbloed (1913-1994)*, s.l. 1997

Kruidenier-Van der Spek 2000
M. Kruidenier, J. van der Spek, *Maartensdijk: Geschiedenis en Architectuur*, Zeist-Utrecht 2000

Kuznetsov-Linnik 1982
Y. Kuznetsov, I. Linnik, *Dutch Painting in Soviet Museums*, Amsterdam-St Petersburg 1982

L

Lademacher 1993
H. Lademacher, *Die Niederlände: Politische Kultur zwischen Individualität und Anpassung*, Berlin 1993

Lambeck-Huijzen 1998
J. Lambeck-Huijzen, *Kant op portretten uit de Gouden Eeuw: Een onderzoek naar de bruikbaarheid van portretten voor de kantgeschiedenis* (unpublished thesis Vrije Universiteit Amsterdam, 2 vols.), Amsterdam 1998

Lammertse 1995
F. Lammertse, [review of *The Hague 1994-1995*], *Oud Holland* 109 (1995), pp. 222-226

Lammertse *et al.* 1998
F. Lammertse *et al.*, *Dutch Genre Paintings of the 17th Century: Collection of Museum Boijmans Van Beuningen*, Rotterdam 1998

Langedijk 1992
K. Langedijk, *Die Selbstbildnisse der Holländischen und Flämischen Künstler in der Galleria degli Autoritratti der Uffizien in Florenz*, Florence 1992

Larsen 1960
E. Larsen, 'Brouwer ou Lievens: Étude d'un problème dans le paysage flamand', *Belgisch Tijdschrift voor Oudheidkunde en Kunstgeschiedenis / Revue Belge d'Archéologie et d'Histoire de l'Art* 29 (1960), pp. 37-48

Larsen 1962
E. Larsen, *Frans Post: Interprète du Brésil*, Amsterdam-Rio de Janeiro 1962

Lasius 1992
A. Lasius, *Quiringh van Brekelenkam*, Doornspijk 1992

Lawrence 1991
C. Lawrence, *Gerrit Adriaensz. Berckheyde (1638-1698): Haarlem Cityscape Painter*, Doornspijk 1991

Lebrun 1792-1796
J.-B.-P. Lebrun, *Galerie des peintres*

flamands, hollandais et allemands (3 vols.), Paris 1792-1796

Leeuwarden 1998-1999
M. Stoter, *Van Jan Steen tot Jan Sluijters: De smaak van Douwes*, Leeuwarden (Fries Museum) 1998-1999

Leiden 1970
M.L. Wurfbain, I. Bergström, *IJdelheid der ijdelheden: Hollandse Vanitas-voorstellingen uit de zeventiende eeuw*, Leiden (Stedelijk Museum De Lakenhal) 1970

Leiden 1976-1977
Geschildert tot Leyden anno 1626, Leiden (Stedelijk Museum De Lakenhal) 1976-1977

Leiden 1991-1992
C. Vogelaar, P.J.M. Baar, I. Moerman *et al.*, *Rembrandt en Lievens in Leiden: 'Een jong en edel schildersduo' / 'A Pair of Young and Noble Painters'*, Leiden (Stedelijk Museum De Lakenhal) 1991-1992

Leiden 2001
A. Laabs, C. Stölzel, *De Leidse fijnschilders uit Dresden*, Leiden (Stedelijk Museum De Lakenhal) 2001

Van Lennep 1900
F.K. van Lennep, *Verzameling van Oorkonden Betrekking Hebbende op Het Geslacht Van Lennep (1093-1900)* (vol. 1), Amsterdam 1900

De Leth-Bruin-Stoopendael 1719
A. de Leth, C. Bruin, D. Stoopendael, *De zegepraalende Vecht, vertoonende verscheidene gesichten van lustplaatsen, heeren huysen en dorpen; beginnende van Uitrecht en met Muyden besluijtende / La triomphante rivière de Vecht, remontant diverses veüs des lieux de plaisances & maisons seignorales & villages; commençant de Uitrecht & finissant avec Muyden*, Amsterdam 1719

Leupe 1870
[P.A. Leupe], 'Bericht van Willem van de Velde, over den ongelukkigen zeeslag op den 13en Junij 1665', *Kroniek van het Historisch Genootschep, gevestigd te Utrecht* 26 (sixth series, vol. 1, 1870), pp. 302-304

Leymarie 1956
J. Leymarie, *La peinture hollandaise*, Genève-Paris-New York 1956

Liedtke 1971
W.A. Liedtke, 'Saenredam's Space', *Oud Holland* 86 (1971), pp. 116-141

Liedtke 1975-1976
W.A. Liedtke, 'The New Church in Haarlem series: Saenredam's sketching style in relation to perspective', *Simiolus* 8 (1975-1976), pp. 145-166

Liedtke 1982
W.A. Liedtke, *Architectural Painting in Delft: Gerard Houckgeest*Hendrick van Vliet*Emanuel de Witte* (Aetas

234

Aurea: Monographs on Dutch & Flemish Painting, vol. 3), Doornspijk 1982

Liedtke 2000
W. Liedtke, A View of Delft: Vermeer and his Contemporaries, Zwolle 2000

Van der Linde 1954
S. van der Linde, 1000 jaar dorpsleven aan de Vecht, 953-1953, Loenen aan de Vecht 1953

London 1819
British Institution for promoting the fine arts in the United Kingdom, London (British Institution) 1819

London 1847
Fine Arts in the United Kingdom, London (British Institution) 1847

London 1864
Exhibition of the works of ancient masters, London (British Institution) 1864

London 1904
Dutch exhibition, London (White Chapel) 1904

London 1926-1927
A Selection of Fine Pictures, London (Spink & Son's Galleries) 1926-1927

London 1929
Dutch art 1450-1900, London (Royal Academy of Arts) 1929

London 1938
Exhibition of Fine Pictures by Italian and Dutch Masters, London (Thos. Agnew & Sons Gallery) 1938

London 1952-1953
Dutch Pictures 1450-1750, London (Royal Academy of Arts) 1952-1953

London 1956
Paintings by old masters, London (P. & D. Colnaghi Gallery) 1956

London 1964
The Orange and the Rose: Holland and Britain in the Age of Observation, London (Victoria & Albert Museum) 1964

London 1971
A.G.H. Bachrach, L. Thijssen, D. van Karnebeek-van Roijen, 'Shock of recognition': The landscape of English Romanticism and the Dutch seventeenth-century school, London (Tate Gallery) 1971

London 1982
W. Percival-Prescott, D. Cordingly, The art of the Van de Veldes: Paintings and drawings by the great Dutch marine artists and their English followers, London (National Maritime Museum) 1982

London 1984
R. Hermer, D. Garstang, F. Herrmann et al., Art-commerce-scholarship: A window onto the art world – Colnaghi 1760 to 1984, London (P. & D. Colnaghi Gallery) 1984

London 1986
C. Brown, Dutch Landscape: The Early Years, Haarlem and Amsterdam

1590-1650, London (National Gallery) 1986

London 1989
Six centuries of Old Master paintings, London (Harari & Johns Gallery) 1989

London 1992
Dutch and Flemish Old Master Paintings, London (Johnny van Haeften Gallery) 1992

London 1996-1997
C. Brown, Making & Meaning: Rubens's Landscapes, London (National Gallery) 1996-1997

London-The Hague 1999-2000
C. White, Q. Buvelot (eds.), Rembrandt zelf, London (National Gallery) The Hague (Mauritshuis) 1999-2000

London-Hartford 1998-1999
P.C. Sutton, Pieter de Hooch, 1629-1684, London (Dulwich Picture Gallery) Hartford, Conn. (Wadsworth Atheneum) 1998-1999

London-Paris-Bern-Brussels 1972
Dessins flamands du dix-septième siècle, Collection Frits Lugt, Institut Néerlandais, Paris, London (Victoria & Albert Museum) Paris (Institut Néerlandais) Bern (Musée des Beaux-Arts) Brussels (Bibliothèque Royale Albert Ier) 1972

Los Angeles 1992-1993
J. Walsh, C.P. Schneider, A Mirror of Nature: Dutch Paintings from the Collection of Mr. and Mrs. Edward William Carter, Los Angeles (Los Angeles County Museum of Art) 1992-1993 (see below)

Los Angeles-Boston-New York 1981-1982
J. Walsh, C.P. Schneider, A Mirror of Nature: Dutch Paintings from the Collection of Mr. and Mrs. Edward William Carter, Los Angeles (Los Angeles County Museum of Art) Boston (Museum of Fine Arts) New York (The Metropolitan Museum of Art) 1981-1982 (see above)

Loughman 1991
J. Loughman, 'Dordrecht Family Portraits Identified and Attributed to Paulus Lesire', The Hoogsteder Mercury (1991), no. 12, pp. 29-36

Lowenthal 1986
A.W. Lowenthal, Joachim Wtewael and Dutch Mannerism (Aetas Aurea: Monographs on Dutch & Flemish Painting, vol. 6), Doornspijk 1986

Lugt + no.
F. Lugt, Répertoire des catalogues de ventes publiques intéressant l'art ou la curiosité (4 vols.), The Hague-Paris 1938-1987

Lugt 1915
F. Lugt, Wandelingen met Rembrandt in en om Amsterdam, Amsterdam 1915

Lugt 1918a
F. Lugt, Het redderen van den nationalen kunstboedel, Amsterdam 1918

Lugt 1918b
F. Lugt, 'De kunstverzamelaar August Janssen', De Amsterdammer: Weekblad voor Nederland (20 April 1918), no. 2130, p. 7

Lugt 1921-1956
F. Lugt, Les marques de collections de dessins & d'estampes (2 vols.), Amsterdam-The Hague 1921-1956

Lugt 1926
F. Lugt, Collection Warneck: Tableaux anciens et modernes [...] vente aux enchères publiques, catalogue of sale in Paris (Galerie Georges Petit) 27-28 May 1926

Lugt 1927
F. Lugt, Les dessins des écoles du Nord de la collection Dutuit au Musée des Beaux-Arts de la Ville de Paris (Petit Palais), Paris 1927

Lugt 1929
F. Lugt, 'In Memoriam: Dr. W. von Bode and Mr. J.P. Heseltine', Apollo 9 (1929), no. 49, pp. 263-264

Lugt 1929-1933
F. Lugt, Musée du Louvre: Inventaire général des dessins des écoles du Nord. École hollandaise (2 vols.), Paris 1929-1933

Lugt 1931
F. Lugt, 'Beiträge zu dem Katalog der niederländischen Handzeichnungen in Berlin', Jahrbuch der preussischen Kunstsammlungen 52 (1931), pp. 36-80

Lugt 1950
F. Lugt, École nationale supérieure des Beaux-Arts: Inventaire général des dessins des écoles du Nord. École hollandaise, Paris 1950

Lugt 1963
F. Lugt, 'Michiel Frederik Hennus (Arnhem, 27 december 1873-Hilversum, 25 juli 1961)' in Jaarboek van de Maatschappij der Nederlandsche Letterkunde te Leiden (1963), pp. 109-114

Luiken 1711
J. Luiken, Het Leerzaam Huisraad, Vertoond in Vyftig Konstige Figuuren, Met Godlyke Spreuken En Stichtelyke Verzen, Amsterdam 1711

Lunsingh Scheurleer 1987
T.H. Lunsingh Scheurleer, 'Drie brieven van de architect Pieter Post over zijn werk voor Constantijn Huygens en stadhouder Frederik Hendrik in de Fondation Custodia te Parijs', A.T. van Deursen et al., Veelzijdigheid als levensvorm: Facetten van Constantijn Huygens' leven en werk, Deventer Studiën no. 2, Deventer 1987, pp. 38-51

Van Luttervelt 1948
R. van Luttervelt, De buitenplaatsen aan de Vecht, Lochem 1948

M

MacLaren ed. Brown 1991
N. MacLaren, National Gallery Catalogues: The Dutch school, 1600-1900, revised and expanded by C. Brown (2 vols.), London 1991

Madrid 1921
Catalogo de pintores Holandeses; dibujos escultura, litografia y arte aplicado, llevados por la cómision del consejo para las artes representativas de la cómision Holandesa en el extranjero, Madrid (location unknown) 1921

Madrid 1994
P.C. Sutton, J. Loughman, The Golden Age of Dutch Landscape Painting, Madrid (Museo Thyssen Bornemisza) 1994

Madrid 1998
S. Segal, U. Sedano, Willem Kalf: Original y copia, Madrid (Museo Thyssen-Bornemisza) 1998

Magerøy 1951
E.M. Magerøy, Hollandsk interiørmalerei i det 17. århunde, Oslo 1951

Van Mander 1604
K. van Mander, Het Schilder-boeck, Haarlem 1604

Van Mander ed. 1973
K. van Mander, Den grondt der edel vry schilder-const, ed. H. Miedema (2 vols.), Utrecht 1973

Van Mander ed. 1994-1999
K. van Mander, The lives of the illustrious Netherlandish and German Painters, ed. Hessel Miedema (6 vols.), Doorspijk 1994-1999

Manke 1963
I. Manke, Emanuel de Witte 1617-1692, Amsterdam 1963

Manke 1972
I. Manke, 'Nachträge zum Werkkatalog von Emanuel de Witte', Pantheon 30 (1972), pp. 389-391

Mann 1931
J.G. Mann, Wallace Collection catalogues: Sculpture, marbles, terra-cottas and bronzes, carvings in ivory and wood, plaquettes, medals, coins, and wax-reliefs, London 1931

Marandel 1996
J.-P. Marandel, 'Cachée depuis plus de 50 ans, la célèbre collection Lanckoronski retourne en Pologne', Connaissance des Arts (January 1996), no. 524, pp. 70-77

Marijnissen 1988
R.H. Marijnissen et al., Bruegel: Het volledige oeuvre, Antwerp 1988

Martin 1911
W. Martin, 'Ausstellung alt-

holländischer Bilder in Pariser Privatbesitz', *Monatshefte für Kunstwissenschaft* 4 (1911), pp. 433-441

Martin 1925
W. Martin, 'Figuurstukken van Jan Davidszoon de Heem', *Oud Holland* 42 (1925), pp. 42-45

Martin 1930
W. Martin, 'Ein Gemälde des Pieter Post im Wallraf-Richartz-Museum der Stadt Köln', *Wallraf-Richartz-Jahrbuch* 6 (1930), pp. 231-235

Martin 1935-1936
W. Martin, *De Hollandsche schilderkunst in de zeventiende eeuw* (2 vols.), Amsterdam 1935-1936

Martin 1953
W. Martin, 'Koninklijk Kabinet van Schilderijen (Mauritshuis)', *Verslagen 's rijks verzamelingen van geschiedenis en kunst* 74 (1952), The Hague 1953, pp. 96-104

Mauquoy-Hendrickx 1991
M. Mauquoy-Hendrickx, *L'Iconographie d'Antoine van Dyck: Catalogue raisonné*, second, revised and augmented edition (2 vols.), Brussels 1991

McNeil Kettering 1983
A. McNeil Kettering, *The Dutch Arcadia: Pastoral Art and its Audience in the Golden Age*, Montclair 1983

Meijer 1988
F.G. Meijer, 'Jan Davidsz. de Heem's Earliest Paintings, 1626-1628', *Hoogsteder-Naumann Mercury* (1988), no. 7, pp. 29-36

Meijers 1977
D.J. Meijers, 'De democratisering van schoonheid: Plannen voor museumvernieuwingen in Nederland 1918-1921', *Nederlands Kunsthistorisch Jaarboek* 28 (1977), pp. 55-104

Meischke 1953
R. Meischke, 'Schilder en architect', *Forum* 9 (1953), pp. 315-325

Melbourne-Canberra 1997-1998
A. Blankert, M. Blokhuis, B. Broos *et al.*, *Rembrandt: A Genius and His Impact*, Melbourne (National Gallery of Victoria) Canberra (National Gallery of Australia) 1997-1998

Ter Meulen 1925
J. ter Meulen, *Concise bibliography of Hugo Grotius*, Leiden 1925

Van der Meulen 1994
M. van der Meulen, *Rubens: Copies after the Antique* (3 vols.; *Corpus Rubenianum Ludwig Burchard*, vol. 23), London 1994

Middendorf 1989
U. Middendorf, *Hendrik Jacobsz. Dubbels (1621-1707): Gemälde und Zeichnungen, mit kritischem Oeuvrekatalog*, Freren 1989

Miedema 1975
H. Miedema, 'Over het realisme in de Nederlandse schilderkunst van de zeventiende eeuw', *Oud Holland* 89 (1975), pp. 2-18

Miedema 1980
H. Miedema, *De archiefbescheiden van het St. Lucasgilde te Haarlem. 1497-1798* (2 vols.), Alphen aan den Rijn 1980

Miedema 1981
H. Miedema, *Kunst, kunstenaar en kunstwerk bij Karel van Mander: Een analyse van zijn levensbeschrijvingen*, Alphen aan den Rijn 1981

Milan 1954
Mostra di pittura olandese del Seicento, Milan (Palazzo Reale) 1954

Minneapolis-Houston-San Diego 1984-1985
R. Trnek, *Dutch and Flemish Masters: Paintings from the Vienna Academy of Fine Arts*, Minneapolis (Minneapolis Institute of Arts) Houston (Museum of Fine Arts) San Diego (San Diego Museum of Art) 1984-1985

Minneapolis-Toledo-Los Angeles 1990-1991
G. Keyes, D. de Vries, J.A. Welu *et al.*, *Mirror of empire: Dutch Marine Art of the Seventeenth Century*, Minneapolis (The Minneapolis Institute of Arts) Toledo (The Toledo Museum of Art) Los Angeles (Los Angeles County Museum of Art) 1990-1991

De Mirimonde 1970
A.P. De Mirimonde, 'Musique et symbolisme chez Jan-Davidszoon de Heem, Cornelis-Janszoon et Jan II Janszoon de Heem', *Jaarboek Koninklijk Museum voor Schone Kunsten Antwerpen* (1970), pp. 241-296

Mochizuki 2001
M.M. Mochizuki, *The Reformation of Devotional Art and the Great Church in Haarlem* (dissertation), Ann Arbor 2001

Moes 1897-1905
E.W. Moes, *Iconographia Batava: Beredeneerde lijst van geschilderde en gebeeldhouwde portretten van Noord-Nederlanders in vorige eeuwen* (2 vols.), Amsterdam 1897-1905

Moes 1910
E.W. Moes, 'Een geschenk van de stad Amsterdam aan den marquis de Lionne', *Oud-Holland* 11 (1893), pp. 30-33

Ter Molen 1978
J.R. ter Molen, 'De "Susanna-schaal" van Paulus van Vianen nader belicht', in *Boymans bijdragen: Opstellen van medewerkers en oud-medewerkers van het Museum Boymans-van Beuningen voor J.C. Ebbinge Wubben*, Rotterdam 1978, pp. 65-76

Ter Molen 1979
J.R. ter Molen, 'Adam van Vianen's Silverware in Relation to Seventeenth-Century Dutch Painting', *Apollo* 90 (1979), no. 214, pp. 482-489

Ter Molen 1984
J.R. ter Molen, *Van Vianen, een Utrechtse familie van zilversmeden met een internationale faam* (dissertation Leiden; 2 vols.), s.l. 1984

Ter Molen 1994
J.R. ter Molen, *Zilver: Catalogus van de voorwerpen van edelmetaal in de collectie van het Museum Boymans-van Beuningen*, Rotterdam 1994

Mollema 1939-1942
J.C. Mollema, *Geschiedenis van Nederland ter zee* (4 vols.), Amsterdam 1939-1942

Von Moltke 1938-1939
J.W. von Moltke, 'Salomon de Bray', 'Jan de Bray', *Marburger Jahrbuch für Kunstwissenschaft* 11-12 (1938-1939), pp. 309-420, 421-523

Montias 1982
J.M. Montias, *Artists and Artisans in Delft: A Socio-Economic Study of the Seventeenth Century*, Princeton, New Jersey 1982

Montreal 1990
F.J. Duparc, L.J. Graif, *Italian Recollections: Dutch Painters of the Golden Age*, Montreal (Montreal Museum of Fine Arts) 1990

Montreal 1992
K. Weil-Garris Brandt, L. Berti, M.T. Fioro *et al.*, *The Genius of the Sculptor in Michelangelo's Work*, Montreal (Montreal Museum of Fine Arts) 1992

Müllenmeister 1972
K.J. Müllenmeister, 'Karel Slabbaert, ein Interieur- und Bildnismaler aus Middelburg (1619-1654)', *Weltkunst* 42 (1972), no. 19, p. 1344

Muller 1989
J.M. Muller, *Rubens: The artist as collector*, Princeton, New Jersey 1989

Müller-Van Regteren Altena 1931
C. Müller, J.Q. van Regteren Altena, 'Der Maler Jacob van Geel', *Jahrbuch der Preussischen Kunstsammlungen* 52 (1931), pp. 182-200

Münster-Baden-Baden 1979-1980
G. Langemeyer *et al.*, *Stilleben in Europa*, Münster (Westfälisches Landesmuseum für Kunst und Kulturgeschichte) Baden-Baden (Staatliche Kunsthalle) 1979-1980

Munich-Heidelberg-Braunschweig-Cambridge 1996
D. Scrase, *Das Goldene Jahrhundert: Holländische Zeichnungen aus dem Fitzwilliam Museum Cambridge*, Munich (Lenbachhaus) Heidelberg (Kurpfälzisches Museum) Braunschweig (Herzog Anton Ulrich-Museum) Cambridge (Fitzwilliam Museum) 1996 (also in English edition)

Munière 1984
L. Munière, 'Jan Davidsz de Heem', *L'Estampille* (January 1984), no. 165, pp. 59-60

Munnig Schmidt 1993
E. Munnig Schmidt, 'Een onbekend schilderij van Kasteel Cronenburgh te Loenen', *Jaarboekje Niftarlake* (1993), pp. 60-66

Munnig Schmidt 1996
E. Munnig Schmidt, 'De zilveren-huwelijkspenning van de naamgevers van Nieuwerhoek', *Jaarboekje Niftarlake* (1996), pp. 46-73

N

Naarden 1996
E. Borger, *De Hollandse kortegaard: Geschilderde wachtlokalen uit de Gouden Eeuw*, Naarden (Nederlands Vestingmuseum) 1996

Nash 1972
J.M. Nash, *The Age of Rembrandt and Vermeer*, London 1972

Naumann 1978
O. Naumann (ed.), *The Illustrated Bartsch*, vol. 7, *Netherlandish artists*, New York 1978

Naumann 1981
O. Naumann, *Frans van Mieris (1635-1681) the Elder* (2 vols.; *Aetas Aurea: Monographs on Dutch & Flemish Painting*, vol. 1), Doornspijk 1981

New York 1985-1986
G.C. Bauman, R. Baumstark, K. Christiansen *et al.*, *Liechtenstein: The Princely Collections*, New York (The Metropolitan Museum of Art) 1985-1986

New York 1992-1993
M. Fumaroli, A. Brejon de Lavergnée, W. Liedtke *et al.*, *Masterworks from the Musée des Beaux-Arts, Lille*, New York (The Metropolitan Museum of Art) 1992-1993

New York-Fort Worth-Cleveland 1990-1991
G. Luijten, A.W.F.M. Meij, *From Pisanello to Cézanne: Master drawings from the Museum Boymans-van Beuningen Rotterdam*, New York (The Pierpont Morgan Library) Fort Worth (Kimbell Art Museum) Cleveland (The Cleveland Museum of Art) 1990-1991

New York-London 2001
W.A. Liedtke, M.C. Plomp, A. Rüger *et al.*, *Vermeer and the Delft School*, New York (The Metropolitan Museum of Art) London (National Gallery) 2001

New York-Paris 1977-1978
C. van Hasselt et al., Rembrandt and his Century: Dutch Drawings of the Seventeenth Century From the Collection of Frits Lugt, Institut Néerlandais, Paris, New York (The Pierpont Morgan Library) Paris (Institut Néerlandais) 1977-1978

Nice 1982
P. Provoyeur, C. Provoyeur, M. Sinor et al., Le Temple: Représentations de l'architecture sacrée, Nice (Musée National Message Biblique Marc Chagall) 1982

Niemeijer 1964
J.W. Niemeijer, 'Varia topografica IV: Een album met Utrechtse gezichten door Abraham Rutgers', Oud-Holland 79 (1964), pp. 127-129

Niemeijer 1978
J.W. Niemeijer, 'A conversation piece by Aert Schouman and the founders of the Hope collection', Apollo 108 (1978), no. 199, pp. 182-189

Niemeijer 1981
J.W. Niemeijer, 'De kunstverzameling van John Hope (1737-1784)', Nederlands Kunsthistorisch Jaarboek 32 (1981), pp. 127-232

Nieuwenhuys 1834
C.J. Nieuwenhuys, A review of the lives and works of some of the most eminent painters, London 1834

Nihom-Nijstad 1983
S. Nihom-Nijstad, 'Frits Lugt: de Hollandse schilderijen uit de 17de eeuw', Tableau 5 (April 1983), p. 364 and following pages (unnumbered)

NNBW
P.C. Molhuysen et al. (ed.), Nieuw Nederlandsch Biografisch Woordenboek (10 vols. and index), Amsterdam 1974

Noble-Pottasch 1997
P. Noble, C. Pottasch, 'Portret van een vrouw door Pieter Pietersz / Portrait of a woman by Pieter Pietersz', Mauritshuis in focus 10 (1997), no. 2, pp. 8-15

O

Oehler 1997
L. Oehler, Rom in der Graphik des 16. Bis 18. Jahrhunderts: Ein niederländischer Zeichnungsband der Graphischen Sammlung Kassel und seine Motive im Vergleich, Berlin 1997

Oldenbourg 1911
R. Oldenbourg, Thomas de Keysers Tätigkeit als Maler, Leipzig 1911

Osaka 1988
The Golden Age of the Seventeenth Century Dutch Painting from the Collection of [the] Frans Hals Museum, Osaka (The National Museum of Art) 1988

Oslo 1959
Fra Rembrandt til Vermeer, Oslo (Nasjonalgalleriet) 1959

Oxford 1999-2000
C. Brown, Scenes of everyday life: Dutch genre paintings from the Mauritshuis, Oxford (Ashmolean Museum) 1999-2000

Ozinga 1929
M.D. Ozinga, De protestantsche kerkenbouw in Nederland, Paris-Amsterdam 1929

P

Paris 1895
Illustrated catalogue of the second series of hundred paintings by old masters belonging to the Sedelmeyer Gallery, Paris (Sedelmeyer Gallery) 1895

Paris 1911
Exposition rétrospective des grands et petits maîtres hollandais, Paris (Salle du Jeu de Paume) 1911

Paris 1950-1951
J. Bruyn, C.H. van Otterloo, L.C.J. Frerichs, Le paysage hollandais au XVIIe siècle, Paris (Orangerie des Tuileries) 1950-1951

Paris 1960a
[F. Lugt], Bestiaire Hollandais: Exposition de tableaux, aquarelles, dessins et gravures par des artistes hollandais des XVIIe - XVIIIe siècles et d'un choix de livres de la même période, Paris (Institut Néerlandais) 1960

Paris 1960b
La nature morte et son inspiration, Paris (Galerie André Weil) 1960

Paris 1962
D.F. Lunsingh Scheurleer, Carreaux de Delft et d'ailleurs, Paris (Institut Néerlandais) 1962

Paris 1965a
S. de Gorter, F. Lugt, Le décor de la vie privée en Hollande au XVIIe siècle, Paris (Institut Néerlandais) 1965

Paris 1965b
La vie et l'oeuvre de Grotius (1583-1645), Paris (Institut Néerlandais) 1965

Paris 1967
P. Zumthor, La vie en Hollande au XVIIe siècle: Tableaux, dessins, estampes, argenterie monnaies, médailles et autres témoignages. Exposition organisée par l'Institut Néerlandais, Paris (Musée des Arts Décoratifs) 1967

Paris 1970
Saenredam 1597-1665: Peintre des églises, Paris (Institut Néerlandais) 1970

Paris 1970-1971
J. Foucart, J. Lacambre, J.H. Martin et al., Le siècle de Rembrandt: Tableaux hollandais des collections publiques françaises, Paris (Musée du Petit Palais) 1970-1971

Paris 1974
C. van Hasselt, M. van Berge, Acquisitions récentes de toutes époques, Fondation Custodia, Collection Frits Lugt, Paris (Institut Néerlandais) 1974

Paris 1979
J.C. Ebbinge Wubben, B. Nicolson, A. Meij, J. Giltaij, J.A. Poot, Le choix d'un amateur éclairé: Oeuvres de la collection Vitale Bloch provenant du musée Boymans-van Beuningen avec quelques apports de la Fondation Custodia, Paris (Institut Néerlandais) 1979

Paris 1983
S. Nihom-Nijstad, Reflets du Siècle d'Or: Tableaux hollandais du dix-septieme siècle, Collection Frits Lugt, Fondation Custodia, Paris (Institut Néerlandais) 1983

Paris 1986
B. Broos et al., De Rembrandt à Vermeer: Les peintres hollandais au Mauritshuis de La Haye, Paris (Galerie nationales du Grand Palais) 1986

Paris 1989
C. van Hasselt, M. van Berge-Gerbaud, Eloge de la navigation hollandaise au xviie siècle: Tableaux, dessins et gravures de la mer et de ses rivages dans la Collection de Frits Lugt, Paris (Institut Néerlandais) 1989

Paris 1994
Hommage à un collectioneur: 25 ans d'acquisitions de la Collection Frits Lugt, Paris (Institut Néerlandais) 1994 (exhibition accompanied by M. van Berge-Gerbaud, H. Buijs [eds.], Morceaux Choisis parmi les acquisitions de la Collection Frits Lugt realisées sous le directorat de Carlos van Hasselt 1970-1994, Paris 1994)

Paris 1996
H. Buijs, J. de Scheemaker, Dessins vénitiens de la Collection Frits Lugt, complétés par des lettres autographes, Paris (Institut Néerlandais) 1996

Paris 2000
M. van Berge-Gerbaud, Le Cercle de Muiden: Un Salon littéraire et scientifique dans la Hollande du XVIIe siècle, Paris (Fondation Custodia, Hôtel Turgot) 2000

Paris 2001
O. Meslay, Aquarelles et dessins anglais: Une promenade, Paris (Fondation Custodia, Hôtel Turgot) 2001

Paris-Antwerp-London-New York 1979-1980
F. Stampfle, Le siècle de Rubens et de Rembrandt: Dessins flamands et hollandais du XVIIe siècle de la Pierpont Morgan Library de New York, Paris (Institut Néerlandais) Antwerp (Koninklijk Museum voor Schone Kunsten) London (British Museum) New York (The Pierpont Morgan Library) 1979-1980

Paris-Haarlem 1997-1998
M. van Berge-Gerbaud, Rembrandt en zijn school: Tekeningen uit de Collectie Frits Lugt, Paris (Institut Néerlandais) Haarlem (Teylers Museum) 1997-1998

Paris-Montpellier 1998
Q. Buvelot, M. Hilaire, O. Zeder, Tableaux flamands et hollandais du Musée Fabre de Montpellier, Paris (Institut Néerlandais) Montpellier (Musée Fabre) 1998

Pears 1988
I. Pears, The discovery of painting: The growth of interest in the arts in England, 1680-1768, New Haven-London 1988

Perez 1980
M.-F. Perez, 'Collectionneurs et amateurs d'art à Lyon au XVIIIe siècle', Revue de l'art (1980), no. 47, pp. 43-52

Peronnet-Fredericksen et al. 1998
B. Peronnet, B.B. Fredericksen et al., Répertoire des tableaux vendus en France au XIXe siècle (2 vols.; The provenance index of the Getty Information Institute, vol. 1, 1801-1810), Los Angeles 1998

Perth-Adelaide-Brisbane 1997-1998
N. Middelkoop, The Golden Age of Dutch Art: Seventeenth Century Paintings from the Rijksmuseum and Australian Collections, Perth (Art Gallery of Western Australia) Adelaide (Art Gallery of South Australia) Brisbane (Queensland Art Gallery) 1997-1998

Petrejus 1954
E.W. Petrejus, De bomschuit, een verdwenen scheepstype (Publicaties van het Museum voor Land- en Volkenkunde en het Maritiem Museum "Prins Hendrik" Rotterdam), s.l. 1954

Philadelphia-Berlin-London 1984
C. Brown, J. Kelch, O. Naumann, W. Robinson, P.C. Sutton, Masters of Seventeenth-Century Dutch Genre Painting, Philadelphia (Philadelphia Museum of Art) Berlin (Staatliche Museen Preussischer Kulturbesitz) London (Royal Academy of Arts) 1984

Phoenix-Kansas City-The Hague 1998-1999
M.K. Komanecky et al., Copper as Canvas: Two Centuries of Masterpiece Paintings on Copper, 1575-1775, Phoenix (Phoenix Art Museum) Kansas City (The Nelson-Atkins Museum of Art) The Hague (Mauritshuis) 1998-1999

237

Pijzel-Dommisse 2000
J. Pijzel-Dommisse, *Het Hollandse pronkpoppenhuis: Interieur en huishouden in de 17de en 18de eeuw*, Zwolle-Amsterdam 2000

Plettenburg 1968
M. Plettenburg, *Licht in huis: Kienspaan-Kaars-Olielamp*, Arnhem 1968

Plietzsch 1915
E. Plietzsch, 'Ausstellung von Werken alter Kunst aus Berliner Privatbesitz. Mit 16 Abbildungen', *Der Cicerone* 7 (1915), nos. 11-12, pp. 201-214

Plietzsch 1949
E. Plietzsch, 'Jacobus Vrel und Esaias Boursse', *Zeitschrift für Kunst* 3 (1949), no. 1, pp. 248-263

Plietzsch 1960
E. Plietzsch, *Holländische und flämische Maler des XVII. Jahrh.*, Leipzig 1960

Van der Ploeg 2001
P. van der Ploeg, 'Te mooi voor de handel: Uit de privé-collectie van Edward en Sally Speelman / Too good to trade: From the private collection of Edward and Sally Speelman', *Mauritshuis in focus* 14 (2001), no. 1, pp. 8-21

Plomp 1986
M. Plomp, '"Een merkwaardige verzameling Teekeningen" door Leonaert Bramer', *Oud Holland* 100 (1986), pp. 81-153

Plomp 1987
M.C. Plomp, 'Sprokkelingen rond de Kleine Houtpoort te Haarlem', *Teylers Museum Magazijn* 15 (1987), pp. 12-15

Plomp 1997
M.C. Plomp, *The Dutch drawings in the Teyler Museum: Artists born between 1575 and 1630*, Haarlem-Ghent-Doornspijk 1997

Plomp 2001
M.C. Plomp, *Hartstochtelijk Verzameld: 18de-eeuwse Hollandse verzamelaars van tekeningen en hun collecties*, Paris-Bussum 2001

Popper-Voskuyl 1973
N. Popper-Voskuyl, 'Selfportraiture and vanitas still-life painting in 17th-century Holland in reference to David Bailly's vanitas oeuvre', *Pantheon* 31 (1973), pp. 58-74

Prat 1983
V. Prat, 'Les inédits du siècle d'or hollandais à Paris', *Le Figaro Magazine* (12 March 1983), pp. 126-132

Preston 1937
L. Preston, *Sea and rivers painters of the Netherlands in the seventeenth century*, London-New York-Toronto 1937

Priem 1997
R. Priem, 'The "most excellent collection" of Lucretia Johanna van Winter: the years 1809-22, with a catalogue of the works purchased', *Simiolus* 25 (1997), nos. 2-3, pp. 103-235

Prins 2000
Y. Prins, 'Een familie van kunstenaars en belastingpachters: De kunstschilders Aert en Eglon van der Neer en hun verwanten', *Jaarboek Centraal Bureau voor Genealogie* 54 (2000), pp. 189-253

Providence 1984
L. Rubin, E. Levy, G. Bleeke-Byrne et al., *Children of Mercury: The Education of Artists in the Sixteenth and Seventeenth Centuries*, Providence (Bell Gallery, List Art Center) 1984

R

Raupp 1978
H.-J. Raupp, 'Musik im Atelier. Darstellungen musizierender Künstler in der niederländischen Malerei des 17. Jahrhunderts', *Oud Holland* 92 (1978), pp. 106-129

Raupp 1984
H.-J. Raupp, *Untersuchungen zu Künstlerbildnis und Künstler-darstellung in den Niederlanden im 17. Jahrhundert*, Hildesheim-Zürich-New York 1984

Reallexikon
Reallexikon zur Deutschen Kunstgeschichte, ed. O. Schmitt et al., vol. 1- , Munich 1983-

Régnier 1968
G. Régnier, 'Jacob Vrel, un Vermeer du pauvre', *Gazette des Beaux-Arts* 110 (1968), vol. 71, pp. 269-282

Regtdoorzee Greup-Roldanus 1936
S.C. Regtdoorzee Greup-Roldanus, *Geschiedenis der Haarlemsche bleekerijen* (dissertation Amsterdam), Haarlem 1936

Van Regteren Altena 1983
I.Q. van Regteren Altena, *Jacques de Gheyn: Three generations* (3 vols.), The Hague-Boston-London 1983

Reiss 1953
S. Reiss, 'Aelbert Cuyp', *The Burlington Magazine* 95 (1953), pp. 42-47

Reiss 1975
S. Reiss, *Aelbert Cuyp*, London 1975

Reitsma 1976
E. Reitsma, 'A Connoisseur's Collection of Paintings', *Apollo* 104 (1976), no. 176, pp. 250-257 (reprinted in *Sutton 1976*, pp. 14-21)

Reitsma 1997
'Frits Lugt: Een jongen met een roeping', in *Rembrandt: Een biografie door / Une biographie par / A biography by / Frits Lugt 1899*, Paris 1997, pp. 8-20

Renckens 1962a
B.J.A. Renckens, 'Een onbekend portret van Hugo de Groot', *Oud Holland* 77 (1962), pp. 63-65

Renckens 1962b
B.J.A. Renckens, 'Enkele notities bij vroege werken van Cornelis Saftleven', *Bulletin Museum Boymans-van Beuningen* 13 (1962), pp. 59-74

Reynolds 1976
G. Reynolds, 'Portrait Miniatures from Holbein to Augustin', *Apollo* 104 (1976), no. 176, pp. 274-281 (reprinted in *Sutton 1976*, pp. 38-45)

Ripa ed. 1971
C. Ripa, *Iconologia of uytbeeldinghe des verstands*, ed. J. Becker, Soest 1971 (reprint of first Dutch edition 1644)

Robinson 1958-1974
M.S. Robinson, *Van de Velde Drawings: A Catalogue of Drawings in the National Maritime Museum Made by the Elder and the Younger Willem van de Velde* (2 vols.), Cambridge 1958-1974

Robinson 1979
W.W. Robinson, 'Preparatory studies by Adriaen van de Velde', *Master Drawings* 17 (1979), pp. 3-23

Robinson 1990
M.S. Robinson, *Van de Velde: A Catalogue of the Paintings of the Elder and the Younger Willem van de Velde* (2 vols.), London 1990

Robinson-Weber 1979
[M.S. Robinson en R. Weber], *The Willem van de Velde Drawings in the Boymans-van Beuningen Museum Rotterdam* (3 vols.), Rotterdam 1979

Roethlisberger 1993
M. Roethlisberger, with M.J. Bok, *Abraham Bloemaert and his sons: Paintings and prints* (2 vols; Aetas Aurea: Monographs on Dutch and Flemish Painting, vol. 11), Doornspijk 1993

Rome 1954
Mostra di pittura olandese del Seicento, Rome (Palazzo delle Esposizioni) 1954

Roos-Uittenhout-De Wagt 1992
P. Roos, B. Uittenhout, W. de Wagt (ed.), *Architectuurgids Haarlem*, Haarlem 1992

Roosenschoon 1940
J.H. Roosenschoon, 'Het land en het kasteel van Cronenburch, voorheen en thans', *Jaarboekje Niftarlake* (1940), pp. 34-48

Roosenschoon 1941
J.H. Roosenschoon, 'Een en ander over de oude ophaalbrug van Loenen a/d Vecht', *Jaarboekje Niftarlake* (1941), pp. 19-29

Rosenberg 1928
J. Rosenberg, *Jacob van Ruisdael*, Berlin 1928

Rotterdam 1927-1928
Kersttentoonstelling, Rotterdam (Museum Boymans) 1927-1928

Rotterdam 1929-1930
Kersttentoonstelling, Rotterdam (Museum Boymans) 1929-1930

Rotterdam 1931-1932
D. Hannema, J.G. van Gelder, *Catalogus van de kersttentoonstelling in het Museum Boymans*, Rotterdam (Museum Boymans) 1931-1932

Rotterdam 1935
Vermeer: Oorsprong en invloed. Fabritius, De Hooch, De Witte, Rotterdam (Museum Boymans) 1935

Rotterdam 1936-1937
Tentoonstelling van schilderijen en antiquiteiten geëxposeerd door den kunsthandel J. Goudstikker N.V., Rotterdam (Rotterdamsche Kunstkring) 1936-1937

Rotterdam 1937-1938
Pieter Jansz. Saenredam 1597-1665, Rotterdam (Museum Boymans) 1937-1938

Rotterdam 1938
Meesterwerken uit vier eeuwen: 1400-1800. Tentoonstelling van schilderijen en teekeningen uit particuliere verzamelingen in Nederland, bijeengebracht gedurende de veertigjarige regeering van H.M. koningin Wilhelmina, Rotterdam (Museum Boymans) 1938

Rotterdam 1955
Kunstschatten uit Nederlandse verzamelingen, Rotterdam (Museum Boymans) 1955

Rotterdam 1988
G. Jansen, G. Luijten, *Italianisanten en Bamboccianten: Het Italianiserend Landschap en Genre door Nederlandse Kunstenaars uit de Zeventiende Eeuw*, Rotterdam (Museum Boijmans Van Beuningen) 1988

Rotterdam 1991
J. Giltaij, G. Jansen, *Perspectiven: Saenredam en de architectuurschilders van de 17e eeuw*, Rotterdam (Museum Boijmans Van Beuningen) 1991

Rotterdam 1994-1995
N. Schadee, L. van der Zeeuw et al., *Rotterdamse Meesters uit de Gouden Eeuw*, Rotterdam (Historisch Museum) 1994-1995

Rotterdam-Berlin 1996-1997
J. Giltaij, J. Kelch et al., *Lof der zeevaart: De Hollandse zeeschilders van de 17e eeuw*, Rotterdam (Museum Boijmans Van Beuningen) Berlin (Staatliche Museen, Gemälde-galerie im Bodemuseum) 1996-1997

Rotterdam-Frankfurt am Main 1999-2000
A. Blankert et al., *Hollands Classicisme in de zeventiende-eeuwse*

schilderkunst, Rotterdam (Museum Boijmans Van Beuningen) Frankfurt am Main (Städelsches Kunstinstitut) 1999-2000

Rotterdam-Washington 1985-1986
A.W.F.M. Meij, J.A. Poot, *Jacques de Gheyn II als tekenaar 1565-1629*, Rotterdam (Museum Boijmans Van Beuningen) Washington (National Gallery of Art) 1985-1986

Russell 1975
M. Russell, *Jan van de Cappelle 1624/1626-1679*, Leigh-on-Sea 1975

Russell 1988
M. Russell, 'A winter landscape after Jan van de Cappelle', *The Burlington Magazine* 130 (1988), pp. 606-607

Russell 1991
M. Russell, [review of *Paris 1989*], *The Burlington Magazine* 133 (1991), pp. 260-261

Russell 1992
M. Russell, *Willem van de Velde de Jonge: Het IJ voor Amsterdam met de Gouden Leeuw*, Bloemendaal 1992

Russell 1997
F. Russell, 'Old master pictures from the Heinemann collection', *Christie's International Magazine* 14 (June 1997), no. 5, pp. 32-35

Rutgers van der Loeff 1911
J.D. Rutgers van der Loeff, *Drie lofdichten op Haarlem: Het middelnederlandsch gedicht van Dirck Mathijszen en Karel van Mander's Twee Beelden van Haarlem*, Haarlem 1911

Ruurs 1987
R. Ruurs, *Saenredam: The Art of Perspective*, Amsterdam-Philadelphia-Groningen 1987

Ruurs 1988
R. Ruurs, 'Un tableau de Pieter Saenredam (1597-1665) au Louvre: Intérieur de l'église Saint-Bavon à Haarlem', *La revue du Louvre et des Musées de France* 38 (1988), pp. 39-42

Van Ruyven-Zeman 1997
Z. van Ruyven-Zeman, 'Hendrick de Keyser: Draftsman and designer of stained glass', *Simiolus* 25 (1997), pp. 283-302

Van Ruyven-Zeman 2000
Z. van Ruyven-Zeman, *The stained-glass windows in the Sint Janskerk at Gouda 1556-1604* (*Corpus vitrearum Netherlands*, vol. 3), Amsterdam 2000

S

Sacramento 1974
A. Tümpel, C. Tümpel, *The Pre-Rembrandtists*, Sacramento (E.B. Crocker Gallery) 1974

Salerno 1977-1980
L. Salerno, *Pittori di Paesaggio del Seicento a Roma / Landscape Painters of the Seventeenth Century in Rome*, Rome 1977-1980

Salzburg-Vienna 1986
R. Trnek, *Die Niederländer in Italien: Italianisante Niederländer des 17. Jahrhunderts aus Österreichischem Besitz*, Salzburg (Residenzgalerie) Vienna (Gemäldegalerie der Akademie der bildenden Künste) 1986

Sambon 1925
A. Sambon, 'Intérieur rustique par Guillaume Kalf (1621 ou 22-1693)', *Le Musée: Revue d'Art Mensuelle Illustrée* 8 (May 1925), p. 67

Sander-Brinkmann 1995
J. Sander, B. Brinkmann, *Niederländische Gemälde vor 1800 im Städel*, Frankfurt am Main 1995

San Francisco-Baltimore-London 1997-1998
J. Spicer, L. Federle Orr *et al.*, *Masters of Light: Dutch Painters in Utrecht during the Golden Age*, San Francisco (Fine Arts Museums of San Francisco) Baltimore (The Walters Art Gallery) London (National Gallery) 1997-1998

Sankt Gallen 1980
R. Hanhart (ed.), *Handzeichnungen 16.-18. Jahrhundert aus der Brandes-Sammlung der Städtischen Wessenberg-Gemäldegalerie Konstanz*, Sankt Gallen (Kunstverein St. Gallen) 1980

Schaar 1957
E. Schaar, *Studien zu Nicolaes Berchem* (dissertation), Cologne 1957

Schapelhouman 1979
M. Schapelhouman, *Oude tekeningen in het bezit van de Gemeentemusea van Amsterdam, waaronder de collectie Fodor*, vol. 2, *Tekeningen van Noord- en Zuidnederlandse kunstenaars geboren voor 1600*, Amsterdam 1979

Schapelhouman 1987
M. Schapelhouman, *Catalogus van de Nederlandse tekeningen in het Rijksprentenkabinet, Rijksmuseum, Amsterdam / Catalogue of the Dutch and Flemish drawings in the Rijksprentenkabinet, Rijksmuseum, Amsterdam*, vol. 3, *Nederlandse tekeningen omstreeks 1600 / Netherlandish drawings circa 1600*, The Hague 1987

Schapelhouman-Schatborn 1998
M. Schapelhouman, P. Schatborn, with I. Oud, T. Dibbits, *Catalogue of the Dutch and Flemish drawings in the Rijksprentenkabinet, Rijksmuseum, Amsterdam*, vol. 6, *Dutch drawings of the seventeenth century in the Rijksmuseum,*

Amsterdam. Artists born between 1580 and 1600 (2 vols.), Amsterdam-London 1998

Schatborn 1981
P. Schatborn, 'Van Rembrandt tot Crozat: Vroege verzamelingen met tekeningen van Rembrandt', *Nederlands Kunsthistorisch Jaarboek* 32 (1981), pp. 1-54

Schatborn 1989
P. Schatborn, 'Notes on early Rembrandt drawings', *Master Drawings* 27 (1989), pp. 118-127

Schenkeveld-van der Dussen 1985
M.A. Schenkeveld-van der Dussen (ed.), *Bredero*, Groningen 1985

Schipper-van Lottum 1975
M.G.A. Schipper-van Lottum, 'Een naijmantgen met een naijcussen', *Antiek* 10 (1975), pp. 137-163

Schlumberger 1983
E. Schlumberger, 'Hollande intime', *Connaissance des Arts* (March 1983), no. 373, pp. 48-53

Schneider 1932
H. Schneider, *Jan Lievens: Sein Leben und seine Werke*, Haarlem 1932

Schneider 1933
H. Schneider, 'Rijksbureau voor Kunsthistorische en Ikonografische Documentatie', *Verslagen omtrent 's Rijks verzamelingen van geschiedenis en kunst* 55 (1932), The Hague 1933, pp. 87-103

Schneider ed. Ekkart 1973
H. Schneider, *Jan Lievens: Sein Leben und seine Werke*, revised and edited by R.E.O. Ekkart, Amsterdam 1973

Schneider 1990
C.P. Schneider, *Rembrandt's Landscapes*, New Haven-London 1990

Scholten 1904
H.J. Scholten, *Musée Teyler à Haarlem: Catalogue raisonné des dessins des écoles française et hollandaise*, Haarlem 1904

Scholten 1995
F. Scholten, 'De apotheose van de held: Bartholomeus Eggers en het monument voor Jacob van Wassenaer Obdam in Den Haag, 1667', *Oud Holland* 109 (1995), pp. 63-88

Schreuder 1997
M. Schreuder, 'A newly discovered early barn interior by Jan Davidsz. de Heem (1606-1683/84)', *Oud Holland* 111 (1997), pp. 13-18

Schulting 1997
T. Schulting, 'Cornelis Ketel en de gebroeders Wachendorff: Geschiedenis van een identificatie', *De Nederlandsche Leeuw* 114 (1997), cols. 135-166

Schulz 1978
W. Schulz, *Cornelis Saftleven,*

1607-1681: Leben und Werke. Mit einem kritischen Katalog der Gemälde und Zeichnungen (Beiträge zur Kunstgeschichte, vol. 14), Berlin-New York 1978

Schulz 1982
W. Schulz, *Herman Saftleven, 1609-1685: Leben und Werke. Mit einem kritischen Katalog der Gemälde und Zeichnungen (Beiträge zur Kunstgeschichte*, vol. 18), Berlin-New York 1982

Schwartz 1966-1967
G. Schwartz, 'Saenredam, Huygens and the Utrecht Bull', *Simiolus* 1 (1966-1967), pp. 69-93

Schwartz-Bok 1989
G. Schwartz, M.J. Bok, *Pieter Saenredam: De schilder in zijn tijd*, Maarssen-The Hague 1989 (English edition 1990)

Schwarz 1987
S. Schwarz, *Das Bücherstilleben in der Malerei des 17. Jahrhunderts*, Wiesbaden 1987

Scott 1989
M.A. Scott, 'An unknown painting by Moeyaert and its reconstruction', *Hoogsteder-Naumann Mercury* (1989), no. 9, pp. 20-30

Seifertová-Korecká 1962
H. Seifertová-Korecká, 'Stilleben von Jan Davidsz de Heem in der Gemäldegalerie der Stadt Liberec (Reichenberg)', *Oud Holland* 77 (1962), pp. 58-60, 70-71

Seifertová-Slavícek 1995
H. Seifertová, L. Slavícek, *Dutch Painting of 16th-18th Centuries From the Collection of the Regional Art Gallery in Liberec*, Liberec 1995

Van Selm forthcoming
B. van Selm, *De Amadis de Gaule: productie, distributie en consumptie in de Nederlanden*, ed. P.B.P.M. Dongelmans, E. Zeeman, S.M. van Zanen (forthcoming)

Sérullaz 1971
M. Sérullaz, 'Hommage à Frits Lugt', *La Revue du Louvre et des musées de France* 21 (1971), no. 1, pp. 39-44, 50-54

Sigmond 1989
J.P. Sigmond, *Nederlandse zeehavens tussen 1500 en 1800*, Amsterdam 1989

Simon 1930
K.E. Simon, *Jacob van Ruisdael: Eine Darstellung seiner Entwicklung*, Berlin [1930]

Slive 1961
S. Slive, 'Frans Hals studies', *Oud Holland* 76 (1961), pp. 173-200

Slive 1974
S. Slive *et al.*, *European Paintings in the Collection of the Worcester Art Museum* (2 vols.), Worcester 1974

239

Slive 1987
S. Slive, 'Dutch pictures in the collection of Cardinal Silvio Valenti Gonzaga (1690-1756)', *Simiolus* 17 (1987), pp. 169-190

Slive 1995a
S. Slive, *Dutch Painting 1600-1800*, New Haven-London 1995

Slive 1995b
S. Slive, 'Additions to Jacob van Ruisdael: II', *The Burlington Magazine* 137 (1995), pp. 452-457

Slive 2001
S. Slive, *Jacob van Ruisdael: A Complete Catalogue of his Paintings, Drawings and Etchings*, New Haven-London 2001

Sluijter 2000
E.J. Sluijter, *De 'heydensche fabulen' in de schilderkunst van de Gouden Eeuw: Schilderijen met verhalende onderwerpen uit de klassieke mythologie in de Noordelijke Nederlanden circa 1590-1670*, Leiden 2000

Sluijter-Seijffert 1984
N. Sluijter-Seijffert, *Cornelis van Poelenburch (ca. 1593-1667)* (dissertation), Enschede 1984

Sluijter-Seiffert et al. 1993
N. Sluijter-Seiffert et al., *Mauritshuis: Illustrated General Catalogue*, Amsterdam-The Hague 1993

Smith 1829-1842
J. Smith, *A Catalogue Raisonné of the Works of the Most Eminent Dutch, Flemish, and French painters* (9 vols.), London 1829-1842

Snoep-Reitsma 1973a
E. Snoep-Reitsma, *Verschuivende betekenissen van zeventiende eeuwse nederlandse genrevoorstellingen / Shifting meanings of seventeenth-century Dutch genre paintings* (dissertation), Utrecht 1973

Snoep-Reitsma 1973b
E. Snoep-Reitsma, 'Chardin and the Bourgeois Ideals of his Time', *Nederlands Kunsthistorisch Jaarboek* 24 (1973), pp. 147-243 (also in *Snoep-Reitsma 1973a*)

Van Someren 1888-1891
J.F. van Someren, *Beschrijvende catalogus van gegraveerde portretten van Nederlanders* (3 vols.), Amsterdam 1888-1891

De Sousa-Leão 1973
J. De Sousa-Leão, *Frans Post 1612-1680*, Amsterdam 1973

Speth-Holterhof 1957
S. Speth-Holterhof, *Les peintres flamands de cabinets d'amateurs* (*Les peintres flamands du XVIIe siècle*, vol. 7), Brussels 1957

Spruijt 1997
C. Spruijt, 'Nieuw licht op Jan van Ravesteyns reeks officiersportretten / New light on Jan van Ravesteyn's series of officers' portraits', *Mauritshuis in focus* 10 (1997), no. 2, pp. 22-30

Stechow 1929-1930
W. Stechow, 'Cornelis Ketels Einzelbildnisse', *Zeitschrift für bildende Kunst* 63 (1929-1930), pp. 200-206

Stechow 1963a
Wolfgang Stechow, 'A portrait by Jacob Esselens', *Allen Memorial Art Museum Bulletin* 21 (Fall 1963), pp. 2-9

Stechow 1963b
W. Stechow, 'Über das Verhältnis zwischen Signatur und Chronologie bei einigen holländischen Künstlern des 17. Jahrhunderts', *Festschrift Dr. Eduard Trautscholdt*, Hamburg 1963, pp. 111-117

Stechow 1966
W. Stechow, *Dutch Landscape Painting of the Seventeenth Century*, London 1966

Steland-Stief 1963
A.C. Steland-Stief, *Jan Asselyn* (dissertation), Freiburg 1963

Steland-Stief 1964
A.C. Steland-Stief, 'Jan Asselyn und Willem Schellinks', *Oud-Holland* 79 (1964), pp. 99-110

Steland-Stief 1970
A.C. Steland-Stief, 'Drie Winterlandschaften des Italianisanten Jan Asselyn und ihre Auswirkungen', *Kunst in Hessen und am Mittelrhein* 10 (1970), pp. 59-65

Steland-Stief 1971
A.C. Steland-Stief, *Jan Asselijn nach 1610 bis 1652*, Amsterdam 1971

Steland 1988
A.C. Steland, 'Beobachtungen zu frühen Zeichnungen des Jan Both und zum Verhältnis zwischen Jan Both und Jan Asselijn in Rom vor 1641', *Niederdeutsche Beiträge zur Kunstgeschichte* 27 (1988), pp. 115-138

Steland 1989
A.C. Steland, *Die Zeichnungen des Jan Asselijn*, Fridingen 1989

Stockholm 1992-1993
G. Cavalli-Björkman et al., *Rembrandt och hans tid: Människan i centrum / Rembrandt and his age: Focus on man*, Stockholm (Nationalmuseum) 1992-1993

Strauss-Van der Meulen 1979
W.L. Strauss, M. van der Meulen, with S.A.C. Dudok van Heel, P.J.M. de Boer, *The Rembrandt Documents*, New York 1979

De Stuers 1877a
V. de Stuers, *Notice historique et descriptive des tableaux et des sculptures exposés dans le Musée Royal de La Haye: Supplément [to the 1874 catalogue] Août 1877*, The Hague 1877

De Stuers 1877b
V. de Stuers, *Beknopte beschrijving van de kunstvoorwerpen tentoongesteld in het Koninklijk Kabinet van Schilderijen te 's Gravenhage. Vierde uitgave*, The Hague 1877

Van Suchtelen 1997a
A. van Suchtelen, '*De aanbidding der herders* door Jan de Bray / *The adoration of the shepherds* by Jan de Bray', *Mauritshuis in focus* 10 (1997), no. 1, pp. 10-16

Van Suchtelen 1997b
A. van Suchtelen, ' Twee portretten van Pieter Pietersz herenigd in het Mauritshuis ', in *Album discipulorum J.R.J. van Asperen de Boer*, Zwolle 1997, pp. 203-210

Sumowski 1975
W. Sumowski, 'Zeichnungen von Pieter Lastman und aus dem Lastman-Kreis', *Giessener Beiträge zur Kunstgeschichte* 3 (1975), pp. 149-186

Sumowski 1979-
W. Sumowski, *Drawings of the Rembrandt school*, vol. 1-, New York 1979-

Sumowski 1980
W. Sumowski, 'Zur Jan Lievens-Ausstellung in Braunschweig', *Kunstchronik* 33 (1980), pp. 6-14

Sumowski 1983-1994
W. Sumowski, *Gemälde der Rembrandt-Schüler* (6 vols.), Landau/Pfalz 1983[-1994]

Sutton 1964
[D. Sutton], 'The finest things in nature', *Apollo* 80 (1964), no. 33, pp. 346-351

Sutton 1976
D. Sutton (ed.), *Treasures from the Collection of Frits Lugt at the Institut Néerlandais, Paris* (reprint of articles in *Apollo* 104 (1976), nos. 176-177, pp. 242-305, 332-404), London 1976

Sutton 1980
P.C. Sutton, *Pieter de Hooch: Complete Edition*, Oxford-New York 1980

Sutton 1982
D. Sutton, 'Jacob van Ruisdael – Solitary Wanderer', *Apollo* 115 (1982), no. 241, pp. 182-185

Sutton 1992
P.C. Sutton, *Dutch & Flemish Seventeenth-Century Paintings: The Harold Samuel Collection*, Cambridge-New York-Oakley 1992

Van Swigchem 1987
C.A. van Swigchem, 'Kerkborden en kolomschilderingen in de St.-Bavo te Haarlem 1580-1585', *Bulletin van het Rijksmuseum* 35 (1987), pp. 211-223

Swillens 1935
P.T.A. Swillens, *Pieter Jansz. Saenredam: Schilder van Haarlem 1597-1665*, Amsterdam 1935

T

Taverne 1972-1973
E. Taverne, 'Salomon de Bray and the reorganization of the Haarlem Guild of St. Luke in 1631', *Simiolus* 6 (1972-1973), pp. 50-69

Taverne 1978
E. Taverne, *In 't land van belofte: in de nieue stadt. Ideaal en werkelijkheid van de stadsuitleg in de Republiek, 1580-1680*, Maarssen 1978

Terwen-Ottenheym 1993
J.J. Terwen, K.A. Ottenheym, *Pieter Post (1608-1669), Architect*, Zutphen 1993

Den Tex 1960-1972
J. den Tex, *Oldenbarnevelt* (5 vols.), Haarlem-Groningen 1960-1972

Theuerkauff 1973
C. Theuerkauf, 'Notes on the work of the sculptor Leonhard Kern', *The Burlington Magazine* 115 (1973), pp. 163-167

Van Thiel et al. 1976
P.J.J. van Thiel et al., *Alle schilderijen van het Rijksmuseum te Amsterdam: Volledig geïllustreerde catalogus*, Amsterdam-Haarlem 1976

Van Thiel 1980
P.J.J. van Thiel, 'De betekenis van het portret van Verdonck door Frans Hals', *Oud Holland* 94 (1980), pp. 112-140

Van Thiel 1990-1991
P.J.J. van Thiel, 'Catholic elements in seventeenth-century Dutch painting, apropos of a children's portrait by Thomas de Keyser', *Simiolus* 20 (1990-1991), pp. 39-62

Thiele 1973
R. Thiele, *Meister der niederländischen Kunst des 17. Jahrhunderts. Museum der bildenden Künste Leipzig: Kataloge der Gemäldegalerie Heft 2*, Leipzig 1973

Thieme-Becker
U. Thieme, F. Becker (eds.), *Allgemeines Lexikon der bildenden Künstler von der Antike bis zur Gegenwart* (37 vols.), Leipzig 1907-1950

Van Thienen 1937
F.W.S. van Thienen, 'Alte Kunst in Haager Privatbesitz', *Pantheon* 19 (1937), pp. 67-71

Thomassen-Gruys 1998
K. Thomassen, J.A. Gruys (eds.), *The album amicorum of Jacob Heyblocq: Introduction, transcriptions, paraphrases & notes to the facsimile* (2 vols.), Zwolle 1998

Thoré-Bürger 1864
W. Bürger (E.-J.-T. Thoré), 'Les cabinets d'amateurs à Paris: Galerie de MM. Pereire', *Gazette des Beaux-Arts* (1864), vol. 16, pp. 193-213, 297-317

Thoré-Bürger 1866
W. Bürger (E.-J.-T. Thoré), 'Van der
Meer de Delft', *Gazette des Beaux-Arts*
(1866), vol. 21, pp. 297-330, 458-470,
542-575

Todorov 1993
T. Todorov, *Éloge du Quotidien:
Essai sur la peinture hollandaise
du XVIIe siècle*, Paris 1993

**Tokyo-Kasama-Kumamoto-
Leiden 1992-1993**
E. Buijsen *et al.*, *Tussen fantasie en
werkelijkheid: 17de eeuwse Hollandse
landschapschilderkunst / Between fan-
tasy and reality: 17th Century Dutch
Landscape Painting*, Tokyo (Tokyo
Station Gallery) Kasama (Kasama
Nichido Museum of Art)
Kumamoto (Kumamoto Prefectual
Museum of Art) Leiden (Stedelijk
Museum De Lakenhal) 1992-1993

Trnek 1982
R. Trnek, *Niederländer und Italien:
Italianisante Landschafts- und
Genremalerei von Niederländern des
17. Jahrhunderts*, Vienna 1982

Trnek 1992
R. Trnek, *Die holländischen
Gemälde des 17. Jahrhunderts
in der Gemäldegalerie der Akademie
der bildenden Künste in Wien*,
Vienna-Cologne-Weimar 1992

Turner 2000
J. Turner (ed.), *The Grove
Dictionary of Art. From Rembrandt
to Vermeer: 17th-century Dutch
Artists*, London 2000 (see also
Dictionary of Art)

U

Unger 1884
J.H.W. Unger, 'Vondeliana, II:
Vondel's handschriften', *Oud-
Holland* 2 (1884), pp. 11-33, 111-134,
224-232, 293-308

Utrecht 1953
*Nederlandse architectuurschilders 1600-
1900*, Utrecht (Centraal Museum) 1953

Utrecht 1961
P.T.A. Swillens, J.Q. van Regteren
Altena, B.H.J. de Smedt, *Pieter
Jansz. Saenredam*, Utrecht (Centraal
Museum) 1961 (English edition:
*Catalogue raisonné of the works by
Pieter Jansz. Saenredam published on
the occasion of the exhibition Pieter
Jansz. Saenredam*)

Utrecht 1965
A. Blankert, *Nederlandse 17e eeuwse
Italianiserende landschapschilders*,
Utrecht (Centraal Museum) 1965
(see also *Blankert 1978*)

Utrecht 1979
S. Groenveld, H.L.P. Leeuwenberg,
N. Mout, W.M. Zappey, *De kogel

*door de kerk?: De opstand in de
Nederlanden en de rol van de Unie
van Utrecht, 1559-1609*, Utrecht
(Centraal Museum) 1979

Utrecht 1980
E. de Jongh, *Een schilderij centraal:
De Slapende Mars van Hendrick ter
Brugghen*, Utrecht (Centraal
Museum) 1980

Utrecht 1984-1985
I. van Zijl, *Zeldzaam zilver uit de
Gouden Eeuw: De Utrechtse edelsmeden
Van Vianen*, Utrecht (Centraal
Museum) 1984-1985

Utrecht 1988
P. Dirkse *et al.*, *Vermaakt aan de
staat: Het legaat Thurkow-van Huffel*,
Utrecht (Museum Catharijne-
convent) 1988

Utrecht 1993
P. van den Brink *et al.*, *Het
Gedroomde Land: Pastorale
schilderkunst in de Gouden Eeuw*,
Utrecht (Centraal Museum) 1993

Utrecht 2000-2001
L.M. Helmus *et al.*, *Pieter Saenredam,
het Utrechtse werk: Schilderijen en
tekeningen van de 17de-eeuwse groot-
meester van het perspectief*, Utrecht
(Centraal Museum) 2000

Utrecht-Braunschweig 1991
S. Segal, with a contribution by
L. Helmus, *Jan Davidsz de Heem
en zijn kring*, Utrecht (Centraal
Museum) Braunschweig (Herzog
Anton Ulrich-Museum) 1991

V

Valentiner 1913
W.R. Valentiner, 'Esaias Boursse',
*Art in America: An Illustrated
Quarterly* 1 (1913), pp. 30-39

Valentiner 1928a
W.R. Valentiner, 'Paintings by
Pieter de Hooch and Jacobus Vrel',
*Bulletin of The Detroit Institute of
Arts* 9 (1928), no. 7, pp. 78-81

Valentiner 1928b
W.R. Valentiner, 'Dutch painters
of the School of Pieter de Hooch',
Art in America 16 (1928), pp. 168-180

Valentiner 1928-1929
W.R. Valentiner, 'Dutch Genre
Painters in the Manner of Pieter
de Hooch. II. Jacobus Vrel', *Art
in America* 17 (1928-1929), no. 2,
pp. 86-92

Valentiner 1929
W.R. Valentiner, *Pieter de Hooch.
Des Meisters Gemälde in 180
Abbildungen mit einem Anhang über
die Genremaler um Pieter de Hooch
und die Kunst Hendrik van der
Burchs* (*Klassiker der Kunst*, vol. 35),
Stuttgart-Berlin-Leipzig 1929

Valentiner-Von Moltke 1939
W.R. Valentiner, J.W. von Moltke,
*Dutch and Flemish Old Masters in
the Collection of Dr. C.J.K. van
Aalst*, Verona 1939

Vandamme 1988
E. Vandamme *et al.*, *Catalogus
Schilderkunst Oude Meesters.
Koninklijk Museum voor Schone
Kunsten - Antwerpen*, Antwerp 1988

Venema 1986
A. Venema, *Kunsthandel in Nederland
1940-1945*, Amsterdam 1986

Vey-Kesting 1967
H. Vey, A. Kesting, *Katalog der
Niederländischen Gemälde von 1550
bis 1800 im Wallraf-Richartz-Museum
und im Öffentlichen Besitz der Stadt
Köln mit Ausnahme des Kölnischen
Stadtmuseums*, Cologne 1967

Vienna 1993
M. Bisanz-Prakken, *Die Landschaft
im Jahrhundert Rembrandts:
Niederländische Zeichnungen des
17. Jahrhunderts aus der Graphischen
Sammlung Albertina*, Vienna
(Graphische Sammlung Albertina)
1993

Vis-De Geus 1926-1933
E.M. Vis, C. de Geus, with
contributions by F.W. Hudig,
Altholländische Fliesen (2 vols.),
Amsterdam 1926-1933 (reprint
Schiedam 1978)

Vollemans 1998
K. Vollemans, *Het raadsel van de
zichtbare wereld: Philips Koninck,
of een landschap in de vorm van
een traktaat*, Amsterdam 1998

Voorbeijtel Cannenburg 1950
W. Voorbeijtel Cannenburg,
'The Van de Velde's', *The Mariner's
Mirror* 36 (1950), pp. 185-204

Vorenkamp 1933
A.P.A. Vorenkamp, *Bijdrage tot
de geschiedenis van het Hollandsch
stilleven in de zeventiende eeuw*
(dissertation), Leiden 1933

De Vos tot Nederveen Cappel 1986
H.A.E. de Vos tot Nederveen
Cappel, 'Het voorgeslacht van
Hendrick de Keyser, stads-
bouwmeester tot Amsterdam',
De Nederlandsche Leeuw 103
(1986), cols. 67-69

Vosmaer 1868
A. Vosmaer, *Rembrandt Harmens
van Rijn: Sa vie et ses oeuvres*,
The Hague 1868

De Vries 1934
A.B. de Vries, *Het Noord-Nederlandsch
portret in de tweede helft van de
zestiende eeuw* (dissertation),
Amsterdam 1934

De Vries 1958
A.B. de Vries, *Abridged Catalogue
of the Pictures and Sculptures: Royal

*Picture Gallery Mauritshuis The
Hague*, The Hague 1958

De Vries 1960
A.B. de Vries, *Kurzgefasster Katalog
der Gemälde und Skulpturen-
sammlung: Königliche Gemälde
Galerie Mauritshuis / Den Haag*,
The Hague 1960

De Vries 1963
A.B. de Vries, 'Koninklijk Kabinet
van Schilderijen (Mauritshuis)',
*Verslagen der rijksverzamelingen
van geschiedenis en kunst* 83 (1961),
The Hague 1963, pp. 145-150

De Vries 1991
L. de Vries, [review of *Schwartz-Bok
1989*], *The Burlington Magazine* 133
(1991), pp. 456-457

Vulsma-Kappers 1988
M. Vulsma-Kappers, 'Het na-
geslacht van Hendrick de Keyser',
in E.W.A. Elenbaas-Bunschoten
et al. (ed.), *Uw Amsterdam:
Jubileumboek ter gelegenheid van het
40-jarig bestaan van de Nederlandse
Genealogische Vereniging afdeling
Amsterdam en omstreken*, Amsterdam
1988, pp. 231-232

W

Waagen 1854-1857
G.F. Waagen, *Treasures of Art in Great
Britain: Being an Account of the Chief
Collections of Paintings, Drawings,
Sculptures, Illuminated Mss., &c.,
&c.* (4 vols.), London 1854-1857

Van der Waal 1952
H. van der Waal, *Drie eeuwen
vaderlandsche geschied-uitbeelding,
1500-1800: Een iconologische studie*
(2 vols.), The Hague 1952

Waddingham 1964
M.J. Waddingham, 'Andries and
Jan Both in France and Italy',
Paragone (March 1964), no. 171,
pp. 13-43

Wagenaar 1760-1767
Jan Wagenaar, *Amsterdam, in zyne
opkomst, aanwas, geschiedenissen,
voorregten, koophandel, gebouwen,
kerkenstaat, schoolen, schutterye,
gilden en regeeringe beschreeven*
(3 vols.), Amsterdam 1760-1767

Walford 1991
E.J. Walford, *Jacob van Ruisdael
and the Perception of Landscape*,
New Haven-London 1991

Walsh 1985
A.L. Walsh, *Paulus Potter:
His Works and Their Meaning*
(unpublished dissertation),
Columbia University 1985

Walsh 1996
J. Walsh, *Jan Steen: The Drawing
Lesson*, Los Angeles 1996

241

Walsh-Schneider 1981-1982
See: *Los Angeles-Boston-New York 1981-1982*

Warnsinck 1940
J.C.M. Warnsinck, 'De laatste tocht van Van Wassenaer van Obdam. Voorjaar 1665', in *idem, Van vlootvoogden en zeeslagen*, Amsterdam 1940, pp. 242-300

Washington 1971
C.W. Talbot, G.R. Ravenel, J.A. Leveson, *Dürer in America: His Graphic Work*, Washington (National Gallery of Art) 1971

Washington-Amsterdam 1996-1997
H. Perry Chapman, W.T. Kloek, A.K. Wheelock *et al.*, *Jan Steen: Schilder en verteller*, Washington (National Gallery of Art) Amsterdam (Rijksmuseum) 1996-1997

Washington-Detroit-Amsterdam 1980-1981
A. Blankert *et al.*, *God en de goden: Verhalen uit de bijbelse en klassieke oudheid door Rembrandt en zijn tijdgenoten*, Washington (National Gallery of Art) Detroit (The Detroit Institute of Arts) Amsterdam (Rijksmuseum) 1980-1981

Washington-The Hague 1995-1996
B. Broos, A.K. Wheelock *et al.*, *Johannes Vermeer*, Washington (National Gallery of Art) The Hague (Mauritshuis) 1995-1996

Washington-London-Amsterdam 2001-2002
A.K. Wheelock, A. Chong, E.E.S. Gordencker *et al.*, *Aelbert Cuyp*, Washington (National Gallery of Art) London (National Gallery) Amsterdam (Rijksmuseum) 2001-2002

Washington-London-Haarlem 1989-1990
S. Slive *et al.*, *Frans Hals*, Washington (National Gallery of Art) London (Royal Academy of Arts) Haarlem (Frans Halsmuseum) 1989-1990

Washington-London-The Hague 2000-2001
R. Baer, A. Wheelock, A. Boersma, *Gerrit Dou: Master Painter in the Age of Rembrandt*, Washington (National Gallery of Art) London (Dulwich Picture Gallery) The Hague (Mauritshuis) 2000-2001

Watkin 1968
D. Watkin, *Thomas Hope and the Neo-Classical Idea*, London 1968

Weber 1976
R.E.J. Weber, 'Willem van de Velde de Oude als topograaf van onze zeegaten', *Oud Holland* 90 (1976), pp. 115-131

Weber 1978
R.E.J. Weber, 'Willem van de Velde als ooggetuige in het Goerese gat op 16 juni 1666', in *Boymans*

bijdragen: Opstellen van medewerkers en oud-medewerkers van het Museum Boymans-van Beuningen voor J.C. Ebbinge Wubben, Rotterdam 1978, pp. 129-135

Weber 1979
R.E.J. Weber, 'The artistic relationship between the ship draughtsman Willem van de Velde the Elder and his son the marine painter in the year 1664', *Master Drawings* 17 (1979), pp. 152-161

Weddige 1975
H. Weddige, *Die "Historien vom Amadis auss Frankreich": Dokumentarische Grundlegung zur Entstehung und Rezeption (Beiträge zur Literatur des XV. bis XVIII. Jahrhunderts*, vol. 2), Wiesbaden 1975

Wegener 2001
U. Wegener, *Niedersächsisches Landesmuseum Hannover, Landesgalerie: Die holländischen und flämischen Gemälde des 17. Jahrhunderts*, Hannover 2000

Wegner 1973
W. Wegner, *Die niederländischen Handzeichnungen des 15.-18. Jahrhunderts* (2 vols.; *Kataloge der Staatlichen Graphischen Sammlung München*, vol. 1), Berlin 1973

Weijtens 1971
F.H.C. Weijtens, *De Arundel-Collectie: Commencement de la fin, Amersfoort 1655*, Utrecht 1971

Weismann 1904
A.W. Weissmann, 'Het geslacht De Keyser', *Oud-Holland* 22 (1904), pp. 65-91

Weizsäcker 1900
H. Weizsäcker, *Catalog der Gemälde-Gallerie des Städelschen Kunstinstituts in Frankfurt am Main: Erste Abtheilung. Die Werke der älteren Meister vom vierzehnten bis zum achtzehnten Jahrhundert*, Frankfurt am Main 1900

Welcker 1933
C.J. Welcker, *Hendrick Avercamp, 1585-1634, bijgenaamd "De stomme van Campen" en Barent Avercamp, 1612-1679, "schilders tot Campen"*, Zwolle 1933

Welcker ed. Hensbroek-van der Poel 1979
C.J. Welcker, *Hendrick Avercamp, 1585-1634, bijgenaamd "De stomme van Campen" en Barent Avercamp, 1612-1679, "schilders tot Campen"*, revised edition by D.J. Hensbroek-van der Poel, Doornspijk 1979

De Werd 1974
G. de Werd, *Städtisches Museum Haus Koekkoek Kleve. Katalog: Gemälde, Zeichnungen, Skulpturen und Kunstgewerbe*, Cleves 1974

Wessely 1881
J.E. Wessely, *Wallerant Vaillant: Verzeichniss seiner Kupferstiche und Schabkunstblätter*, Vienna 1881

Van de Wetering-Franken 1983
E. van de Wetering, M. Franken, 'Op bezoek in het atelier', *Kunstschrift* 27 (1983), pp. 3-9

Wieseman 1993
M.E. Wieseman, *Caspar Netscher and late seventeenth century Dutch painting* (dissertation 1991), Ann Arbor 1993

Wheelock 1977
A.K. Wheelock, *Perspective, Optics and Delft Artists Around 1650*, New York 1977

White 1982
C. White, *The Dutch Pictures in the Collection of Her Majesty the Queen*, Cambridge 1982

White 1999
C. White, *Ashmolean Museum Oxford. Catalogue of the Collection of Paintings: Dutch, Flemish, and German Paintings Before 1900 (Excluding the Daisy Linda Ward Collection)*, Oxford 1999

White-Crawley 1994
C. White, C. Crawley, *The Dutch and Flemish Drawings of the Fifteenth to the Early Nineteenth Centuries in the Collection of Her Majesty the Queen at Windsor Castle*, Cambridge-New York-Oakley 1994

Wiersum 1910
E. Wiersum, 'Het schilderijenkabinet van Jan Bisschop te Rotterdam', *Oud-Holland* 28 (1910), pp. 161-186

Wiersum 1931
E. Wiersum, 'Het ontstaan van de verzameling schilderijen van Gerrit van der Pot van Groeneveld te Rotterdam', *Oud-Holland* 48 (1931), pp. 201-214

De Winkel 1995
M. de Winkel, '"Eene der deftigsten dragten". The iconography of the *Tabbaard* and the sense of tradition in Dutch seventeenth-century portraiture', *Nederlands Kunsthistorisch Jaarboek* 46 (1995), pp. 145-167

Wolleswinkel 2001
E.J. Wolleswinkel, 'De schoonfamilie van de (portret)schilder Thomas de Keyser', *De Nederlandsche Leeuw* 118 (2001), cols. 309-328

Wuestman 1996
G. Wuestman, 'Nicolaes Berchem in print: Fluctuations in the function and significance of reproductive engraving', *Simiolus* 24 (1996), pp. 19-53

Von Wurzbach 1906-1911
A. von Wurzbach, *Niederländisches Künstler-Lexikon, auf Grund archivalischer Forschungen bearbeitet* (3 vols.), Vienna-Leipzig 1906-1911

Van der Wyck-Niemeijer-Kloek 1989
H.W.M. van der Wyck, J.W. Niemeijer, W.T. Kloek, *De kasteeltekeningen van Roelant Roghman* (2 vols.), Alphen aan den Rijn 1989

Y

Yamey 1989
B.S. Yamey, *Art & accounting*, New Haven-London 1989

Ydema 1991
O. Ydema, *Carpets and their Datings in Netherlandish Paintings 1540-1700*, Zutphen 1991

Z

Zaremba Filipczak 1987
Z. Zaremba Filipczak, *Picturing Art in Antwerp*, Princeton 1987

Zeldenrust 1983
M. Zeldenrust, 'Aert van der Neers "Rivierlandschap bij maanlicht" opgehelderd', *Bulletin van het Rijksmuseum* 31 (1983), pp. 99-104

Van Zoest 1984
R. van Zoest, *Leidsegracht nr. 41: Het woonhuis van Cornelia Bierens, weduwe van Adriaan van Hoek* (unpublished thesis), University of Amsterdam 1984

Van Zoest 1994
R. van Zoest, *Collection Frits Lugt, Paris*, Paris 1994

Zürich 1953
Holländer des 17. Jahrhunderts, Zürich (Kunsthaus) 1953

Zürich 1958
Sammlung Emil G. Bührle: Festschrift zu Ehren Emil G. Bührle zur Eröffnung des Kunsthaus-Neubaus und Katalog der Sammlung Emil G. Bührle, Zürich (Kunsthaus) 1958

Zürich-Rome-Milan 1953-1954
Holländer des 17. Jahrhunderts, Zürich (Kunsthaus) Rome (Palazzo delle Esposizioni) Milan (Palazzo Reale) 1953-1954 (Italian edition: *Mostra di pittura olandese del Seicento*)

Zuoz 1986
H.M. Cramer, *"Holland im Engadin": Dutch Painting of the Golden Age from the Royal Picture Gallery Mauritshuis and the Galleries of Hans M. Cramer and John Hoogsteder The Hague Netherlands*, Zuoz (Chesa Planta) 1986

Zwartendijk 1928
J. Zwartendijk, 'Oude kunst in het Museum Boymans. Kersttentoonstelling en bruikleenen', *Maandblad voor Beeldende Kunsten* 5 (1928), pp. 67-71

Further reading on Frits Lugt

Hennus 1950
M.F. Hennus, 'Frits Lugt: Kunstvorser-Kunstkeurder-Kunstgaarder', *Maandblad voor Beeldende Kunsten* 26 (1950), pp. 76-140

Van Gelder 1964
J.G. van Gelder, 'Frits Lugt: Inspirator-Organisator-Documentator 80 jaar. *De activiteiten van de laatste vijftien jaar*', in *Frits Lugt: Zijn leven en zijn verzamelingen 1949-1964* (*Publicaties van het Rijksbureau voor Kunsthistorische Documentatie*, no. 2), The Hague 1964, pp. 4-27

De Gorter 1964
S. de Gorter, 'Frits Lugt: Octogénaire', in *Frits Lugt: Zijn leven en zijn verzamelingen 1949-1964*, The Hague 1964, pp. 28-32

Gerson 1964
H. Gerson, 'Frits Lugt als boekenverzamelaar en schrijver', in *Frits Lugt: Zijn leven en zijn verzamelingen 1949-1964*, The Hague 1964, pp. 33-39

Göpel 1964
E. Göpel, 'Frits Lugt: Zum 80. Geburtstag', *Die Weltkunst* 34 (May 1964), no. 9, pp. 334a-b

Anonymous 1970
D.H.G., 'In Memoriam: Frits Lugt', *Apollo* (1970), no. 104, p. 313

Van Gelder 1970
J.G. van Gelder, 'Obituaries: Frits Lugt', *The Burlington Magazine* 112 (1970), pp. 762-763

De Gorter 1970
S. de Gorter, 'Un centre culturel unique: L'Institut néerlandais de Paris', *Ons Erfdeel* 14 (1970), no. 1, pp. 73-80

Van Gelder 1971
J.G. van Gelder, 'Herdenking van Frederik Johannes Lugt', in *Jaarboek der Koninklijke Nederlandse Akademie van Wetenschappen* (1971), pp. 261-267; reprinted in *Flemish Drawings of the Seventeenth Century from the collection of Frits Lugt*, London (Victoria and Albert Museum), Paris (Institut Néerlandais), Bern (Musée des Beaux-Arts), Brussels (Bibliothèque Albert I^er)

Huyghe *et al.* 1971
R. Huyghe, with G. Wiarda, S. de Gorter, J. Lugt, *Hommage à Frits Lugt*, Paris 1971

Sérullaz 1971
M. Sérullaz, 'Hommage à Frits Lugt', *La Revue du Louvre et des musées de France* 21 (1971), no. 1, pp. 39-44, 50-54 (with complete list of Lugt's publications)

Reitsma 1976
E. Reitsma, 'A Connoisseur's Collection of Paintings', *Apollo* 104 (1976), no. 176, pp. 250-257 (reprinted in *Sutton 1976*, pp. 14-21)

Sutton 1976
D. Sutton (ed.), *Treasures from the Collection of Frits Lugt at the Institut Néerlandais, Paris* (reprint of articles in *Apollo* 104 (1976),

nos. 176-177, pp. 242-305, 332-404), London 1976

Storm van Leeuwen 1979
J. Storm van Leeuwen, 'Lugt, Frederik Johannes (Frits)', in J. Charité *et al.* (ed.), *Biografisch Woordenboek van Nederland* (vol. 1), The Hague 1979, pp. 357-358

Nihom-Nijstad 1983
S. Nihom-Nijstad, 'Frits Lugt: de Hollandse schilderijen uit de 17de eeuw', *Tableau* 5 (April 1983), p. 364 and following pages (unnumbered)

Ergmann 1986
R. Ergmann, 'L'oeil de l'aigle: Frits Lugt et l'Institut Néerlandais de Paris', *Connaissance des Arts* (April 1986), no. 410, pp. 68-79

Reitsma 1989
E. Reitsma, 'Het bedreigde levenswerk van een klassiek verzamelaar: De collectie-Lugt in het Institut néerlandais in Parijs', *Vrij Nederland* 50 (2 December 1989), no. 48, pp. 26-35

Van Berge-Gerbaud *et al.* 1993
M. van Berge-Gerbaud, M. Verscheure-Nelissen (ed.), *Institut Néerlandais Paris: 1957-1992*, Paris 1993

Reitsma 1994
E. Reitsma, 'Een huis voor geleerden en liefhebbers: Zeldzame tekeningen te Parijs', *Vrij Nederland* 55 (24 December 1994), nos. 51-52, pp. 82-83

Van Zoest 1994
R. van Zoest, *Collection Frits Lugt, Paris*, Paris 1994

Van Berge-Gerbaud 1996
M. van Berge-Gerbaud, 'Lugt, Frits', in J. Turner (ed.), *The Dictionary of Art*, vol. 19 (1996), pp. 782-783

Reitsma 1997
E. Reitsma, 'Frits Lugt, wonderkind met een passie voor Rembrandt: Een hekel aan dorre geleerdheid', 'Alleen met de meester: De Rembrandts en niet-Rembrandts van Frits Lugt', *Vrij Nederland* 58 (20 September 1997), no. 38, pp. 50-53, 54-56

Reitsma 1997
E. Reitsma, 'Frits Lugt: Een jongen met een roeping', in *Rembrandt: Een biografie door / Une biographie par / A biography by / Frits Lugt 1899*, Paris 1997, pp. 8-20

Van Berge-Gerbaud 1997-1998
M. van Berge-Gerbaud, 'Frits Lugt en Rembrandt', in *Rembrandt en zijn school: Tekeningen uit de Collectie Frits Lugt*, Paris (Institut Néerlandais) Haarlem (Teylers Museum) 1997-1998, pp. XI-XVI

Van Berge-Gerbaud 1998-1999
M. van Berge-Gerbaud, 'Frits Lugt en zijn *Wandelingen met Rembrandt*', in *Rembrandt aan de Amstel: Wandelingen in en om Amsterdam*, Amsterdam (Gemeentearchief) Paris (Institut Néerlandais) 1998-1999, pp. 69-78

Credits

This publication has appeared on the occasion of the exhibition *A Choice Collection: Seventeenth-Century Dutch Paintings from the Frits Lugt Collection* in the Royal Cabinet of Paintings Mauritshuis, The Hague, from 28 March through 30 June 2002

EDITOR
Quentin Buvelot
TRANSLATION
Beverley Jackson (essay and cat. nos. 1, 3, 7, 8, 11, 12, 13, 16, 17, 24, 25, 26, 28), Rachel Esner (foreword and cat. nos. 2, 4, 5, 9, 10, 14, 15, 18, 19-20, 22, 23, 27, 29, 32), and Diane Webb (cat. nos. 6, 21, 30-31, 33, 34, 35, 36)
COPY-EDITING
Quentin Buvelot, assisted by Hans Buijs and the translators' team
DESIGN
DeLeeuwOntwerper(s), The Hague
PRODUCTION
Royal Cabinet of Paintings Mauritshuis Foundation, The Hague
PRINT
Waanders Printers, Zwolle
PUBLISHING
Waanders Publishers, Zwolle

© 2002 Royal Cabinet of Paintings Mauritshuis Foundation, The Hague,
© 2002 Uitgeverij Waanders b.v., Zwolle

ISBN 90 400 9674 0 (hardback)
ISBN 90 400 8685 0 (paperback)
NUGI 921, 911

For more information on Waanders, see www.waanders.nl
For more information on the Mauritshuis, see www.mauritshuis.nl

FRONTISPIECE
Exterior of the Hôtel Turgot, Paris, 2001
COVER
Jacobus Vrel, *Woman at a window, waving at a girl (detail)*, c.1650 (cat. no. 35)
SPINE
Frits Lugt, *Self-portrait (detail)*, 1901 (Paris, Fondation Custodia)
BACK
Paintings by Hendrick Avercamp, Pieter Post, Adriaen van de Velde, Willem van de Velde the Younger, Pieter Saenredam, Jan van Ravesteyn and Caspar Netscher (cat. nos. 2, 24, 32, 33, 28, 26, 22 respectively)